Ancient Bronzes,
Ceramics, and Seals

Ancient Bronzes Ceramics and Seals

P. R. S. Moorey
Emma C. Bunker
Edith Porada
Glenn Markoe

*The
Nasli M. Heeramaneck
Collection of
Ancient Near Eastern,
Central Asiatic, and
European Art*

Gift of
The Ahmanson
Foundation

Los Angeles
County
Museum of Art

Library of Congress
Cataloging in Publication Data

Los Angeles County Museum of Art.

 Ancient bronzes, ceramics, and seals

 Includes bibliographies.
 1. Bronzes, Ancient–Exhibitions.
2. Pottery, Ancient–Exhibitions.
3. Seals (Numismatics)–Exhibi-
tions. 4. Heeramaneck, Nasli M.–
Art collections–Exhibitions. 5. Los
Angeles County Museum of Art–
Exhibitions. I. Moorey, P.R.S.
(Peter Roger Stuart), 1937– . II.
Markoe, Glenn, 1951– . III. Title.
NK7907.L67 1981 730'.093 81-1270
ISBN 0-87587-100-3 AACR2

Published by the
Los Angeles County Museum of Art
5905 Wilshire Boulevard
Los Angeles, California 90036

Copyright © 1981 by
Museum Associates of the
Los Angeles County Museum of Art

All rights reserved
Printed in the U.S.A.

Cover:
Cheekpiece from a Horse Bit,
Luristan (detail)
catalog number 151

Glenn Markoe, Editor

Editing and production supervision
by Jeanne D'Andrea
and Phil Freshman

Photography by Lawrence S. Reynolds

Art direction by Ken Parkhurst and
Design by Julie Riefler of
Bright & Associates, Inc.

Text set in Bembo typefaces by
R S Typographics, Los Angeles

Printed in an edition of 50,000 on
Mead Offset Enamel Dull paper by
Anderson Lithograph Company,
Los Angeles

Contents

Director's Preface 8

Preface and Acknowledgments 9

List of Abbreviations 11

The Art of Ancient Iran 13
 P. R. S. Moorey

Ancient Art of Central Asia, Mongolia, and Siberia 139
 Emma C. Bunker

Stamp and Cylinder Seals of the Ancient Near East
 Edith Porada
 Stamp Seals 187
 Cylinder Seals 209

Ancient Art of Europe and the Eastern Mediterranean 235
 Glenn Markoe

Appendix I 258
 Concordance of Spellings of Chinese Names
 in the Catalog; Pinyin-Wade Giles

Appendix II 260
 Selected Bibliography of Recently Excavated Sites
 in the USSR and the People's Republic of China

Appendix III 261
 Inventory of Seal Inscriptions

Appendix IV 263
 Glossary of Geological Terms

Bibliographies 264

Trustees and Supervisors 271

Director's Preface

The Los Angeles County Museum of Art is extremely fortunate to have acquired this extraordinary collection of ancient art of Western and Central Asia and Europe. Assembled over a fifty-year period by the late Nasli M. Heeramaneck, eminent collector and art dealer, this group of objects encompasses an area from Ireland in the west to Mongolia in the east; it has been supplemented with more than 600 related works of art from Mrs. Alice Heeramaneck, an honorary Museum trustee, in her husband's memory. Altogether comprising some 1600 pieces—in bronze, ceramics, and stone— the collection is of inherent interest both for its art historical value and for the beauty and subtle diversity of the objects it contains. Moreover, it offers the Los Angeles community a unique opportunity to view major works of Near Eastern and Central Asiatic art of a caliber and variety rarely accessible outside museum collections in Iran and the Soviet Union.

The present acquisition forms a valuable and welcome addition to the Museum's existing collections of Chinese and Islamic, as well as Indian, Nepalese, and Tibetan art which also have been acquired from the Heeramanecks. All have immeasurably enriched the Museum's permanent holdings in these areas.

The acquisition of the Heeramaneck Collection bears testimony to the generous and untiring support of the Ahmanson Foundation whose contributions made possible its purchase. Within the last decade, the foundation has been responsible for initiating the acquisition of a number of major works of art, primarily in the area of Renaissance painting. As the Heeramaneck Collection so dramatically illustrates, however, the contributions of the foundation have not been restricted to the field of European art. To this impressive list of acquisitions may be added several Indian and Nepalese works of art.

Lastly, the Museum would like to extend its gratitude to the National Endowment for the Arts which so generously provided funds for the publication of this catalog.

Earl A. Powell III
 Director

Preface and Acknowledgments

Perhaps the most striking feature of the Heeramaneck Collection is the immense geographical range of cultures it encompasses, from Western Europe to the eastern stretches of the Mongolian steppe. No less astonishing is the span in date of manufacture, ranging over five thousand years from the fourth millennium B.C. to the early second millennium A.D. With the exception of the seals and ceramics, the great majority of the objects themselves are made of bronze, either hammered into sheet metal or cast in the *cire perdue* (lost wax) technique, their surfaces often embellished by the use of a chisel or metal punch. On the whole, the pieces are of remarkably small scale. The compact size of the objects from Iran and Central Asia clearly reflects the dictates imposed by a mobile nomadic or semi-nomadic society whose possessions— personal ornaments, figurines, weapons, pole tops—had to be portable. The stamp and cylinder seals, too, although largely owned by sedentary townsmen rather than nomads, were made to be worn easily about the neck or to be carried by hand.

The technical prowess of the ancient smith may be seen in the broad variety of forms and shapes represented in the collection, ranging from the silhouette of an openwork composition with its play of light and shadow, to the intricate surface detail of a hammered and engraved sheetwork design, to the modeled contours of an object cast in the round. Within a single category of object, such as the finial, one often finds a complete spectrum of design, from the elegantly simple to the most ornate and baroque; the sinuous curves of one piece contrast with the rigid, angular contours of another. This quality of abstraction in the rendering of animals often manifests itself in the systematic exaggeration of individual features, such as a panther's eye, a bird of prey's beak, or a mouflon's horns. This process of exaggeration, or stylization, explains how a frontal feline mask may be transformed into a pair of voluted scrolls, or a pair of confronted animals into a lyre-shaped configuration of elongated, sweeping necks. The seemingly infinite number of ways in which the artist is able to exploit and manipulate the animal form, adapting it to the function of the artifact or object he is creating, is a remarkable characteristic of the collection as a whole. Hence, the sweeping horns of a mouflon head become a pair of looping arcs atop the central attachment ring of a harness trapping; a gaping feline's jaws serve to mask the junction of ax handle and blade, creating the impression that the latter actually springs from the beast's mouth.

If one were to isolate a single common denominator for the collection, it would certainly be the artist's preoccupation with animals, both real and imaginary. Often depicted alone, they are more frequently rendered in groups or confronted pairs, revealing the ancient artist's fondness for symmetry of composition. The subjects are alternately represented at rest or in flight, peacefully grazing or entangled in fierce combat.

The repertoire, as one might expect, is drawn largely from animals central to the life and activities of a herder or breeder –the horse, goat, sheep, cow, and camel. An occasional cylinder seal may directly illustrate some feature of herding activity–a shepherd with his flock or a herd within a corral. A subject of equal concern is the protection of the herd; the theme of predator and prey, which occurs commonly on the seals and bronzes, may reflect this concern. The aggressor may take the form of a lion, wolf, or bird of prey, the victim an unsuspecting bull, stag, or gazelle. Another closely related theme is that of the hunt; this subject may assume a variety of forms, such as a kneeling archer taking aim at a fleeing ostrich, or an archer in a chariot pulled by the least likely of harness animals–a lion. On seals, the hunt is often represented in shorthand; the huntsman is eliminated, leaving a single animal with an arrow aimed at its breast, about to hit its mark.

The kingdom of creatures is, of course, not restricted to the realm of nature. Of the mythical beasts, the most frequently represented are the sphinx, griffin, and winged goat. These fantastic creatures, like their natural counterparts, are often shown flanking a central object, usually a sacred tree, thus creating a tripartite composition with the two animals perfectly poised on either side. Some of the more elaborate compositions make use of contorted, often acrobatic, postures and occasionally render pairs of animals in mirror image.

Man's concern with the forces of nature is commonly expressed in another theme, that of the master or mistress of animals, flanked by a pair of beasts which he grasps or restrains in some fashion. In the art of Luristan, the central figure itself may assume a variety of forms, ranging from a nude, beardless personage, frontally rendered with legs spread, to a stately, bearded figure elaborately clad in a long, fringed robe, with a feathered crown or domed, horned tiara. The latter is sometimes shown full face, but is more frequently represented in a profile, bent-knee stance which indicates running. Alongside these heroes or deities of largely human appearance are figures of ''subhuman'' variety, characterized by a human torso and animal hindquarters, with a distinctive face with trunk-like nose and horned headdress. Figures such as these may have served a function comparable to the genii, or protective deities, of the Mesopotamian realm, there often represented as guardians of the sacred tree. In Iranian art, they are often shown holding branches or leaves, and are occasionally depicted with plant-like forms emanating from their bodies. Closely related is the theme of the sacred tree, usually a variety of palm, flanked by heraldic animals, both real and imaginary, which guard or nibble at it.

The identity of such scenes and figures is not often clear. Unlike the Mesopotamian realm, where they may be associated with a variety of deities and heroes known from the ancient texts, the Iranian figures present far greater problems of interpretation due to the lack of surviving texts and documents. Certain scholars have suggested that these subhuman, often sexless, sometimes faceless figures may represent some form of nature demon. The frequent association with fertility symbols such as the palm leaf, the pomegranate, and the serpent (these latter with chthonic overtones as well) lends credence to such an interpretation. To judge from the art, then, the balance of natural powers was an overriding concern of the sedentary pastoralist and the nomadic herdsman alike.

It is this very interest in the spirited and often abstract rendering of the phenomena of nature that makes the images in this collection so appealing to the modern eye.

It has been my honor and pleasure to collaborate with the eminent scholars Dr. P.R.S. Moorey, Mrs. Emma C. Bunker, and Dr. Edith Porada. All have been extremely helpful and generous with their time and knowledge. The Museum has benefited enormously from their expertise and scholarly contributions.

In an undertaking of this size there are, of course, a great many people who contribute significantly to its successful completion. I would like to thank those who have been most instrumental in this process. The Museum has profited immensely from the expert observations of Dr. Peter Calmeyer and his wife, Dr. Ursula Seidl Calmeyer, Professor Ann Farkas, Dr. Oscar Muscarella, Professor David Stronach, and Professor Louis Vanden Berghe. Dr. Johannes Renger is to be thanked for his skillful translation of the cuneiform inscriptions on the Near Eastern cylinder seals. We were also fortunate to have the services of Dr. Pieter Meyers of The Metropolitan Museum of Art, who made a preliminary examination of the Sasanian silver vessels in preparation for a comprehensive study of this material, to be published in collaboration with Dr. Prudence Harper. Equal thanks go to Sorena Sorensen for the time she so graciously donated toward identification of the various stones of which the stamp and cylinder seals are made. Patrick Finnerty and Georgia Lee are similarly to be commended for their deft illustrations of some of the bronze objects in the collection.

The Museum also owes a debt of gratitude to those Chinese and Russian archaeologists whose reports have made possible a fresh evaluation of the Central Asian material in the collection.

On behalf of Dr. Moorey, Mrs. Bunker, Dr. Porada, and myself, I would like to extend my gratitude to the following individuals who have generously supplied help and information: Shirley Alexander, Sylvia Chia, Marija Gimbutas, Prudence Harper, Alfred Janata, Karl Jettmar, S.P. Kiang, Mary Littauer, Emeline Richardson, William Samolin, Paul Singer, Alex Soper, and William Watson.

This catalog would not have taken shape without the participation and cooperation of the entire Museum staff. My sincere appreciation goes to Jeanne D'Andrea and Stephen West for coordinating the publication; to Phil Freshman for his expert and diligent editing of the text; to Betty Foster for donating her skills as a proofreader; to Ruby Hanan and Lynda De Coite for their agile and tireless typing of the manuscript; to Lawrence Reynolds and his staff, Kent Kiyomura and Adam Avila, of the Photography Department for their exceptional handling of the difficult and diverse objects in the collection; to William Leisher and the Conservation Department staff for their expert assistance; and to Jeannine Boyles and Lisa Rabin for the many long hours they spent organizing and installing the collection. Above all, I would like to thank Rexford Stead, former deputy director of the Museum. Apart from the critical role he played in acquiring the collection for the Museum, he expended a great deal of time and energy over and above his administrative responsibilities toward the research and supervision of the material it contains.

Without his concern and devotion, this project would not have been realized.

Research on this extensive collection is still in its formative stages. The reader must therefore accept a great many of the attributions as tentative. Because of the collection's importance, however, and the art historical interest of many of the objects in it—a large number of which have been widely exhibited but few adequately published—it was felt that the immediate cataloging of the material was essential. It is hoped that this publication will stimulate further research into the collection by scholars and experts and lead to a more definitive study.

Due to the limitations of time, only a small portion of the collection has been subjected to laboratory examination. Even with the aid of scientific analysis, however, the problems involved in determining authenticity for a collection of such a varied nature are formidable. For the purposes of this catalog, we have qualified those objects about which doubts have been raised as to authenticity by the remarks "authenticity doubtful," "questionable," or "uncertain." These follow the physical descriptions of the relevant entries. For those objects which are clearly pastiches (i.e., modern assemblies), the word "modern" has been inserted in place of a date. All bibliographic references in the text and checklist are presented in abbreviated form, consisting simply of author and publication date. These are keyed to a full listing of citations, arranged by chapter, to be found at the back of the catalog. The use of this system does not necessarily reflect the individual bibliographic preferences of the authors.

Finally, the reader should bear in mind that all the objects in this catalog are without securely recorded sources; the designations "Luristan," "Northern Iran," "Southern Siberia," "Inner Mongolia," "Central Europe," and the like are based on typological comparisons by the catalogers, not on any reports or records made by Nasli M. Heeramaneck.

Glenn Markoe
Assistant Curator
Ancient Art

List of Abbreviations

AA	*Artibus Asiae*, Ascona, Switzerland
AASOR	*Annual, American Schools of Oriental Research*, New Haven, Connecticut
AfO	*Archiv für Orientforschung*, Graz, Austria
AJA	*American Journal of Archaeology*, Cambridge, Massachusetts
AMI	*Archäologische Mitteilungen aus Iran*, Berlin
BMFEA	*Bulletin*, Museum of Far Eastern Antiquities, Stockholm
BMMA	*Bulletin*, The Metropolitan Museum of Art, New York
Corpus I	E. Porada and B. Buchanan, *Corpus of Ancient Near Eastern Seals in North American Collections*, I, 1948
ESA	*Eurasia Septentrionalis Antiqua*, Helsinki
Gawra I	E. Speiser, *Excavations at Tepe Gawra*, I, Philadelphia, 1935
Gawra II	A. J. Tobler, *Excavations at Tepe Gawra*, II, Philadelphia, 1950
ILN	*Illustrated London News*, London
IrAn	*Iranica Antiqua*, Leiden, the Netherlands
JdI	*Jahrbuch des deutschen archäologischen Instituts*, Berlin
JGS	*Journal of Glass Studies*, Corning, New York
JNES	*Journal of Near Eastern Studies*, Chicago
JRAS	*Journal of the Royal Asiatic Society*, London
KG	*Kaogu*, Peking
KGXB	*Kaogu Xuebao*, Peking
LAAA	*Liverpool Annals of Archaeology and Anthropology*
MDAI	*Mémoires de la délégation archéologique en Iran*, Paris
MDOG	*Mitteilungen der Deutschen Orient-Gesellschaft zu Berlin*
MIA	*Materialy i issledovaniia po arkheologii*, Moscow
MMJ	*Metropolitan Museum Journal*, New York
New York, 1940	*Guide to the Exhibition of Persian Art*, Iranian Institute
OIC	*Oriental Institute Communications*, Chicago
OIP	*Oriental Institute Publications*, Chicago
PBA	*Proceedings of the British Academy*, London
PKG	*Propyläen Kunstgeschichte*, Berlin
PSAS	*Proceedings of the Society of Antiquaries of Scotland*, Edinburgh
SA	*Sovetskaia arkheologia*, Moscow
TTKY	*Türk Tarih Kurumu Yayinlarindan*, Ankara
UA	*Untersuchungen zur Assyriologie und vorderasiatische Archäologie*, Berlin
Ur Excav	*Ur Excavations Reports*, London
WW	*Wenwu*, Peking
WWCKZL	*Wenwu Cankao Ziliao*, Peking
ZA	*Zeitschrift für Assyriologie und vorderasiatische Archäologie*, Berlin

The Art of Ancient Iran

P.R.S. Moorey
Senior Assistant Keeper
Department of Antiquities
Ashmolean Museum, Oxford

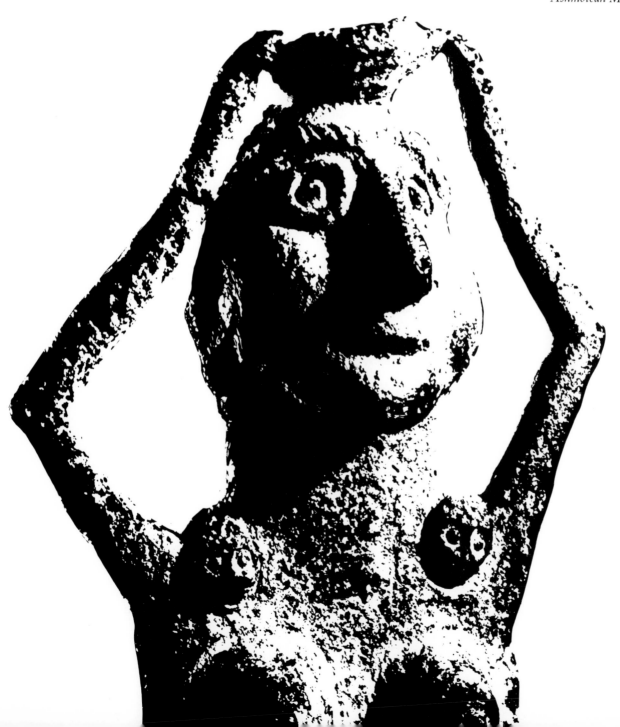

Introduction

Pre-Achaemenid Metalwork

For well over half a century peasants digging in ancient cemeteries in Iran, or more rarely on the sites of settlements and shrines, have unearthed a vast quantity of metalwork, usually of copper or bronze. The greater part of the material so far uncovered comes either from the general area of Luristan and southern Kurdistan in western Iran (Luristan bronzes) or from Gilan in the north on the shores of the Caspian Sea, where the town of Amlash was the center of trade in such objects, especially in the 1960s (Amlash bronzes). Fresh areas of such exploitation, notably in south-central Iran and eastward into Afghanistan, have only been opened up to the antiquities market since the Heeramaneck Collection was formed. Neither the term "Luristan" nor "Amlash" has any significant meaning. At worst they were regularly applied by dealers to objects unrelated geographically or archaeologically to either area, in response to demands by collectors for the products of one or the other of these areas. Even when they are applied to objects from these regions, they describe an incoherent and varied range of artifacts torn from the ground in circumstances that preserve none of the evidence archaeologists normally rely on to date objects and to establish their role in contemporary life and culture.

Why, then, should we bother to study these objects seriously, particularly if in doing so we may encourage further clandestine excavations? In the first place, experience elsewhere in the Near East has shown that firm controls on the spot control tomb robbing most effectively; second, these objects still provide, regrettably, by far the larger part of our evidence for ancient metalworking in Iran. They are crucial for want of better. They are also often objects of great inherent interest and striking appearance. In the last forty years these scattered artifacts have been grouped by form and function for comparison with better-dated relatives elsewhere and have been assimilated in varying degrees with an ever-growing body of vital information from controlled archaeological field surveys and excavations throughout Iran. What emerges is a mere sketch, in which the outlines are probably trustworthy but the details ever open to correction. Present ignorance in this field of study still completely overshadows the small body of reliable knowledge. It is an ignorance compounded by the activities of forgers, who have regularly made modern imitations of the most salable of these bronzes or else have "improved" plain examples with added fittings or linear designs.

Luristan (or Western Iranian) Bronzes

At the end of the 1920s the antiquities markets of Tehran, Paris, London, and New York were suddenly flooded with bronze objects, often of elaborate form and decoration, said to have come from the western Iranian province of Luristan. The Heeramaneck Collection was started at this time and "Luristan bronzes" form by far the greatest number of the Iranian objects in it. It was said that in the autumn of 1928 a local Lur, who had discovered a well-equipped grave on his land, found he could exchange bronze objects from it for food in the local town of Harsin. Thereupon the commercial value of his find was rapidly realized and the graveyards of Luristan and southern Kurdistan were ravaged. There rapidly accumulated in the museums of the world a huge collection of bronze tools and weapons, personal ornaments, vessels, horse trappings, votive objects, and painted pottery whose precise origins and range of date were unknown. Apart from French excavations at Tepe Giyan and the Holmes Luristan Expedition of the late 1930s, which excavated an important but isolated shrine at Surkh Dum, it was not until after the Second World War that systematic excavation in Luristan began to assist with study of this heterogeneous collection. The Danish Luristan Expedition, Dr. Clare Goff's excavations at Baba Jan Tepe in eastern Luristan in 1966 and 1968, and above all the work of the Belgium Luristan Expedition in the west of the region since 1966, under the direction of Professor L. Vanden Berghe, have substantially increased the evidence upon which to base chronologies and comparative typologies. A general reconstruction of the cultural development of Luristan and adjacent regions based on proper field research is now a possibility, though recent political circumstances have reduced it.

Luristan is the mountainous region of the central Zagros range, bounded by the Mesopotamian plain (modern Iraq) in the west, by Khuzistan (ancient Elam) in the south, by the Baghdad-to-Hamadan highway in the north, and by the central Iranian plateau in the east. Its mountain ranges run parallel to one another from northwest to southeast, with deep and narrow valleys between. The valleys are intersected by small rivers which mark out the access routes, the most important of which is the Saimarreh, dividing Luristan in two. To the east lies the Pish-i Kuh, with two main natural divisions within it: the warm, low-lying winter pastures to the west (Garmsir) and the high, cooler summer grazing grounds to the east (Sardsir). From this area, particularly the eastern Pish-i Kuh, came the clandestinely excavated bronzes in the early years (initially known as "Harsin bronzes"). To the west of the Saimarreh River lies the Pusht-i-Kuh, running into the Mesopotamian plain. Here the Belgium Luristan Expedition has excavated a whole series of graveyards spanning the history of the region from the fifth millennium B.C. to the Sasanian period.

The natural condition and climate of Luristan have not changed significantly in the last five thousand years, though human exploitation has radically reduced the forests of the region. Scholars have consequently assumed that local ways of life observed by modern travelers and anthropologists in Luristan, until very recently, may be taken as a reliable general guide to human activity there from about 2700 B.C. to 650 B.C., the period covered by the relevant sections of this catalog. The tribal Lur communities support themselves primarily by a mixture of pastoralism—maintaining breeding horses and flocks of sheep and goats—and crop farming. The main permanent settlements of the ancient inhabitants are now marked by mounds (tepes), the larger ones lying in the Garmsir, where

the most important towns and larger villages were located. Even here there were also tented encampments, at least in winter when the pastoralists resided in this region. The Assyrian king Sennacherib's (c. 704–681 B.C.) account of a campaign east of the Tigris River illustrates this contrast: "And their small cities which were numberless, I destroyed, I devastated, I turned into ruins. The houses of the steppe (namely) their tents, wherein they dwelt, I set on fire." The flocks are able to live in western Pish-i Kuh in winter. In summer, when the sun scorches the area, they have to be moved to the high, fertile plains of eastern Luristan (Sardsir), where there is sufficient water and fresh pasture to keep them through the season before returning to the lowlands when winter again makes the highlands inhospitable. In the eastern highlands the mounds marking ancient settlements are usually smaller than in the lowlands, probably representing villages clustering around a fort or large fortified dwelling such as that excavated at Baba Jan Tepe. This annual cycle of migration, known as transhumance, is fundamental to the survival of large tribal communities in the natural conditions prevailing in Luristan. It meant that even if, as seems most likely, the bronze objects were made primarily in the larger lowland settlements, the annual migration would regularly have carried them into the eastern highlands, where so many were robbed from graveyards by Lurs in the 1930s.

Scholars were long puzzled by the absence of obvious signs of human settlement in the vicinity of many of these cemeteries, which appear clearly on aerial photographs and, particularly after peasant looting, are very visible on the ground. If we assume that transhumance is a very ancient way of life in Luristan, their apparent isolation from inhabited sites is more easily explained. Although mounds indicate to the archaeologist where ancient permanent settlements lie, pastoral nomads living in temporary camps leave no such obvious traces of their presence. To the casual observer the isolated cemeteries seem to have no relation to any human occupation, but when they are assumed to be part of an ancient pattern of seasonal migration they make much better sense. In recent years archaeologists have traveled with modern Lur nomads to study the debris of their camps, in the hopes of recognizing clues as to what might be looked for in seeking camps that were abandoned between two and four thousand years ago. It is a complex and difficult quest. Some broad indication of their location may indeed be offered by the position of the cemeteries, which cluster particularly in the foothills of valleys and plains. Their distribution follows the course of rivers, which have always been the arteries along whose banks men have moved back and forth across the rugged, mountain-river landscape of Luristan. A few isolated shrines are also known, in the open and in caves, serving as the focus for those elements in the local population either out hunting or moving with their flocks.

If ancient ways of life in Luristan remain obscure due to the absence of the proper excavation of a representative series of mounds and nomad camps, we are little better informed about the social structure of the local communities which used this metalwork, particularly at the peak of production in Iron Age I–III (c. 1350–550 B.C.). What information we have has been derived entirely from the objects themselves, assessed in the light of our knowledge of ancient societies elsewhere and

of modern transhumant peoples. Such comparisons reveal the Luristan metal repertory to be surprisingly elaborate. In an ancient Near Eastern context it is also very unusual. Apart from royal tombs, it is rare for such quantities of metalwork to be placed in graves. This may not be explained just as an accident of archaeological discovery or the result of unusually good conditions for the survival of bronze in the tombs of Luristan. It attests to peoples not only much preoccupied with the afterlife and with the proper equipment for their members in the hereafter, but also rich enough to deposit large quantities of finely made metalwork in their graves. None of it is gold or silver, but it is often richly decorated and may be taken to represent the work of highly skilled craftsmen working in a long-established craft tradition for wealthy patrons.

Among all the evils of tomb robbing, its destruction of all evidence for context and association of objects is the most crippling for archaeological research and interpretation. We are unable to tell how the Luristan bronzes were distributed within cemeteries. Were they concentrated in a few richly equipped graves, perhaps set apart within the cemetery, or were they more evenly allocated? Evidence now available from the Belgium Luristan Expedition's excavations in western Luristan, on the edge of the Mesopotamian plain, and from Ghirshman's earlier excavation of two Iron Age cemeteries at Tepe Sialk on the Iranian plateau, to the east of Luristan, indicates that marked differences in the material equipment of graves within any one cemetery is the most likely. In other words, only certain individuals or groups of individuals of high status within a community were entitled to the greatest diversity and quality of metal funerary equipment. Weapons would have been regular equipment, with status marked only by greater quantity and better workmanship. Horse trappings, elaborate personal ornaments, and above all the standard finials are likely to have been the most specific indicators of rank, perhaps of special roles in society, which even in controlled excavation will be difficult to define more accurately. The owners of the fine metalwork from Luristan may, provisionally, be best identified as members of a warrior aristocracy distinguished, as so often in the past, by the possession of horses and, much more rarely, of chariots, as well as by the means to equip themselves and their households for war. They would have been the leading element within tribal societies supported by a fully integrated combination of pastoralism and agriculture.

In a region such as Luristan, a natural refuge zone to some extent insulated from a constant flow of goods and ideas, cultural change is likely to be slow and unpredictable, with age-old religious beliefs and social customs deeply entrenched. Difficulties of communication would also have tended to diversify the local cultures more than would be expected in an area of comparable size less riven by natural obstacles. Yet it would be an error to regard Luristan as a cultural backwater. Although relations with her neighbors in adjacent highly urbanized communities might be stormy, they were regular, as major routes passed along the peripheries of the region. In the Pusht-i Kuh, particularly, contacts with the Sumerians, Babylonians, and Assyrians were influential and had an important cultural effect that was not necessarily operative deep within eastern Luristan.

When Godard published the first major book on Luristan bronzes in 1931, it was recognized that some of the simpler axeheads and daggers (cat. nos. 1–6; 64–69) had close parallels in Elam and Sumer, dating to the second quarter of the third millennium B.C. One of the earliest publications, an article by Ernst Herzfeld, was about such early weapons, and some vessels, reported to be from a large stone-built chamber tomb in eastern Luristan. These communal tombs are now well-known both in eastern Luristan, where they tend to have pitched gable roofs of huge coping stones, and in western Luristan, where roofs tend to be flat. Dr. Goff has persuasively explained their distribution as the first archaeological indication of a shift from predominantly agricultural communities to communities of stock breeders and farmers whose way of life in such a region would inevitably involve transhumance. The metalwork of Luristan at this time is in no significant way different from that of its neighbors to the west and south. Such affinities are the natural complement to the close political contacts between all these regions, which are clear from surviving inscriptions (some on metal objects) from the mid-third millennium B.C. for over five hundred years. Only one feature, zoomorphic decoration on tools and weapons, perhaps Elamite in origin, presages future developments. Copper and arsenical copper are the primary metals; alloys of copper and tin (bronze) are rare. So far as is known, all metals used in Luristan were imported. Copper came from elsewhere in Iran, tin from an unknown source to the east, either in Iran or the region of modern Afghanistan. Local timber would have provided ample charcoal for fuel in the local manufacture of objects from imported metal ingots.

Although we may identify and date the objects made in Luristan between about 2650 and 1800 B.C. with increasing confidence, there is still a five-hundred-year period, extending to the fourteenth century B.C., into which neither comparative typology nor excavated evidence allows us to place any of the clandestinely excavated bronzes. No large cemeteries have yet been identified by archaeologists and were presumably not found in the 1920s and 1930s by peasant plunderers. Dr. Goff's surveys in eastern Luristan revealed a pattern of settlement in easily defended positions and down isolated valleys, indicating disturbed conditions that culminated in major changes in the period now known as Iron Age I (1350–1000 B.C.), though bronze was still the primary base metal in use. Exactly what happened during this crucial period is still largely a matter of surmise.

In western Luristan Professor Vanden Berghe has found graves of this time containing many distinctive weapons, long common in Luristan bronze collections and, most important of all, decorated whetstone sockets and simple wild goat finials (cat. nos. 109–27; 202–12). These finials and their more elaborate successors are the hallmark of the local Luristan industry in the earlier Iron Age. Even before this carefully excavated evidence became available, some indication of the date of the distinctive weapons had been available through inscribed examples distributed by the antiquities market. These included spike-butted axes (cf. cat. nos. 24–36) inscribed for King Silhak-Inshushinak of Elam (c. 1135–1105 B.C.) and King Nebuchadnezzar I of Babylon (c. 1125–1104 B.C.), who inflicted a crushing defeat on the Elamites. There were also a number of daggers inscribed for kings of Babylon and their

officers between about 1280 and 990 B.C. (cf. cat. no. 76) and bronze arrowheads with royal names inscribed on them over the period from about 1025 to 940 B.C. Of the decorated *situlae* (drinking goblets) (cf. cat. nos. 429–37), several extant examples are inscribed with Babylonian royal names of the tenth century B.C.

This in itself is valuable cultural information. The metal industry of Luristan that was to produce the most distinctive artifacts was emerging in a period of renewed local independence after a devastating defeat of the Elamites, the regular overlords of Luristan, by the Babylonians in the late twelfth century B.C. After this, Elam disappears from Mesopotamian written sources, and there are no local records for at least three centuries. The inscribed objects are the best evidence for an unusually clear Babylonian presence in Luristan at this time. This was concentrated in western Luristan and down the vital trade route, from Babylon onto the Iranian plateau, that ran along Luristan's northern border. The richly decorated bronzes of Iron Age I and II in Luristan have no known close relatives in Babylonia or Elam. The new element, a marked upsurge in production for anonymous local patrons, is most likely to have been an indigenous development, not the result of a major intrusion from outside. The traditional imagery of the native huntsmen and pastoralists was now to flourish in particularly congenial economic and social conditions. Again, it was a tribal society of mixed, small-scale agriculturalists and transhumant pastoralists, raising sheep and goats, many horses, and perhaps using chariots where the terrain permitted. Wealth probably depended on a mixture of trade in horses and wool as well as on brigandage, and was concentrated in the hands of a warrior aristocracy who patronized the smiths.

Among the most characteristic products of the Luristan metal workshops at their most prolific, between about 1000 and 650 B.C. (Iron Age II–III), are the often elaborately decorated harnesses and other horse trappings. Although simple harness fittings have been found in controlled excavations, so far none of the elaborate examples has. Here only comparative typology is available for dating. Metal horse bits–primarily, perhaps exclusively, for chariot harnessing–appeared in the Near East in the fifteenth century B.C. in Syria and Palestine and were first equipped with plain plaque or wheel-shaped cheekpieces. Both forms are known from Luristan, though the wheel-shaped cheekpiece is very rare. The plaque is found in Luristan in a form known from sculptured reliefs in Assyrian palaces dated to the ninth century B.C.; but in Luristan, unlike Assyria, it is zoomorphically decorated (cat. nos. 128, 129). Most spectacular among Luristan horse bits are those with the whole cheekpiece cast as a single beast (real or imaginary) or as a more complex combination of demons and monsters (cat. nos. 135–59). Such cheekpieces, in the shape of horses, appear in Assyria on sculptured reliefs dated to the reign of the Assyrian king Sennacherib (c. 704–681 B.C.) and early in the reign of Ashurbanipal (c. 668–627 B.C.). Actual examples have been found at Nimrud in Assyria itself, and on the islands of Rhodes and Samos off the coast of Turkey. These Assyrian animal cheekpieces have no groundline; those of Luristan invariably have. It would seem, in view of their relative isolation, that the Assyrians were copying an Iranian fashion. At this time Assyrian armies not only received many of their horses from western Iran, but were increasingly in-

volved in military campaigns on the northern and northwestern frontiers of Luristan. Apart from animals that were part of the local fauna, albeit sometimes given wings, there are sphinxes and griffins (traditional monsters in Mesopotamian imagery) in the repertory used on these remarkable cheek-pieces. The bits are complementary to a whole range of harness trappings, like modern "horse brasses" used to decorate the collar and headstall. Some of them exemplify the Lur craftsman's great skill in modeling and casting by the lost-wax process (cat. nos. 162–98) and the remarkable combination of naturalism and fantasy in his imagery.

A number of scholars working on the Luristan bronzes in the 1960s suspected that in the history of the enigmatic standard finials (cat. nos. 202–59) there was a chronological development from the naturalistic rampant wild goats, which Professor Vanden Berghe's excavations have now revealed in graves of Iron Age I (c. 1350–1000 B.C.), through to the most elaborate "master/mistress of animals" finials. It was the find of an elaborate finial of this latter type at Tepe Tatulban (Chi-nan) in the Pusht-i Kuh in a grave with iron weapons, dated by Professor Vanden Berghe to the eighth century B.C., that for the first time gave support from controlled excavations for dating the most elaborate of the finials relatively late in the production of the most characteristic Luristan bronzes. Before this find the only well-documented Luristan master/mistress of animals finial came, surprisingly, from the island of Samos, where it had arrived with other Iranian metal objects late in the eighth or early in the seventh century B.C. It is a fragment of a relatively plain finial of the master of animals type.

One of the most significant sites excavated in Luristan is the small stone shrine of Surkh Dum, cleared by the American Holmes Luristan Expedition in the late 1930s. This shrine had been built about 900/850 B.C., probably on the site of an earlier one, and was then twice altered before being destroyed or abandoned sometime in the seventh century B.C. It was rich in votive pins, both in cast and hammered bronze, many of them built into the walls. In the earliest levels of this building pins were simple, with bird- and animal-shaped heads. The more elaborate cast pinheads and some of the decorated disk-headed sheet metal pins first appeared in the ninth-century levels and became progressively more common. These pinheads have decoration, whether in cast openwork or incised, sharing many of the motifs used on the standard finials. The more extended surface of the disk-headed pins (cat. nos. 368–99) allows for such motifs to be grouped, suggesting ritual scenes or narratives, perhaps of local myths. Without relevant written records their full and proper explanation is impossible. Only the primary elements, and their ancestry, may be defined. In this way three strands may be isolated, each with its own intricate history. First, there is the foundation of themes indigenous to Luristan since time immemorial. They describe the world of the hunter and the hunted in a few distinctive images, notably the nature demon, who is half-human and either half-caprid, -mouflon, or -lion. Second, there is the repertory of motifs deriving ultimately from the long-established urban civilization of Babylonia and Elam with which Luristan had always had important, if sporadic, contacts. The third strand is less simply defined, for it seems to derive from an elusive source. Sometime in the middle of the second millennium B.C. an aristocracy of chariot warriors, using

Aryan (Indo-European) names and worshiping Aryan gods such as Mitra, Varuna, and Indra, established a brief political supremacy in northern Syria, known as the Mitannian kingdom. Within Iran, whence they came, their earlier history is obscure; but the motifs of Mitannian art, as revealed primarily on their seals, recurred later in Luristan, most notably in the standard finials and on some of the decorated quiver plaques and related sheet metal objects.

In the eighth century B.C. (Iron Age III) the balance of power had been slowly changing in Luristan at a time when Assyrian records begin to give us glimpses of the situation. They indicate that the earliest groups of Iranian-speaking peoples were not yet found at this time in certain major areas of the western Zagros region, notably the present Iraqi-Iranian frontier zone–the Pusht-i Kuh–and in ancient Ellipi, modern northwestern Luristan. The extent of Assyrian penetration south of the Baghdad-Hamadan road may not yet be fully charted, but its impact was increasingly felt. Theirs was not the only Western cultural influence now evident in Luristan. The Assyrians deported large numbers of people to the eastern fringes of Mesopotamia from the conquered areas of Syria. This is reflected by a growing range of objects, and some new imagery, with strong Western affinities among the Luristan bronzes. Tools and weapons were now almost exclusively made of iron, or in a combination with bronze, as in the case of some maceheads, that were new types to the area but had an earlier history in Assyria and Syria. It was at this time also that the *fibula,* the ancient safety pin of Western origin, virtually replaced the straight pin in Luristan. Sheet metal vessels particularly–in form, decoration, and occasionally in Aramaic inscriptions–reflect a "Syrian" penetration. Such are the so-called Phoenician bowls reported from Iran (cat. nos. 1310–15). Historical sources also now reveal the revival of Elam, and its influence is increasingly evident in artifacts, especially faience vessels placed in graves in Pusht-i Kuh and in the Surkh Dum shrine.

When Ellipi received its last clear mention in an ancient Assyrian text, at the time of King Esarhaddon (c. 680–669 B.C.), it was on the brink of an alliance with the Medes and their Cimmero-Scythian confederates moving in from the east. This important group of Iranian-speaking peoples, whose material culture is still virtually unknown, were by now established around a capital at Ecbatana (modern Hamadan), controlling the east-west route through the Zagros. With them are probably to be associated the fortified sites of Godin Tepe and Tepe Nush-i Jan, with columned halls and in the latter case "fire temples," excavated in the last ten years. The increasing penetration of these peoples into Luristan and its periphery impoverished the patrons of the local metal industry by superseding their authority and cutting off their lines of metal supply. The distinctive Luristan bronzes completely disappeared by the later seventh century B.C., leaving no clear legacy in the artifacts of the subsequent Achaemenid period in Iran.

Amlash (or Northwestern Iranian) Bronzes

Luristan was most widely exploited by clandestine excavators in the late 1920s and 1930s, while the region around Amlash, in the Iranian province of Gilan, was explored in the late 1950s

and 1960s. Both areas are natural refuge zones, especially Gilan; but the natural settings differ markedly. Gilan lies between mountains and sea, between the Elburz Mountains and the Caspian. The valley of the river that flows through it, the Safid Rud, is the major route from central Iran to the Caspian coast. The very fertile lowland part of the region, today one of the most densely populated parts of Iran, has a climate allowing year-long cultivation of crops normally confined to the monsoon regions of the world. Although communications have always been difficult, there has regularly been some access to the region from the Caucasus in the northwest and from the plains of Central Asia away to the northeast. It is a region where formidable natural barriers have encouraged failing regimes to take refuge and retain some of their authority long after losing their strength elsewhere in Iran. Within the province, settled communities harvest the rich plain and marshes of the river delta. Transhumant pastoralists move between summer pastures in the mountains and winter grazing in the foothills.

At the very end of the nineteenth century French excavators in cemeteries along the southwestern shores of the Caspian, in the Talish hills, had shown the existence of flourishing communities there in the period from about 1450 to 800 B.C. A full repertory of metal tools and weapons, though lacking the elaborate decoration found in Luristan, bore witness to the existence of a vigorous metal industry. The primary zone of exploitation by illicit excavators half a century later lay farther to the east, in the foothills of Gilan. Controlled survey work followed by the excavation of a few selected sites, notably by the Iran Archaeological authorities at Marlik and Kaluraz, and by a Japanese expedition in the Dailaman region, has revealed a number of cemeteries spanning almost two millennia, the earliest in the mid-second millennium B.C., the latest running well into the Sasanian period. Late graves were often dug down into earlier cemeteries, explaining the confusion of objects of many different dates that marked the original flood of Amlash objects on the antiquities markets of the world. Gold and silver, virtually unknown in Luristan, were more common here; but the base-metal industry lacked any such range of objects as the standard finials and richly decorated harness trappings of Luristan. Although its precise affinities remain obscure, the cultural setting of this industry was clearly distinct from its counterpart in Luristan.

This region, remote from links with literate peoples, has even less history than Luristan in the period with which this catalog is concerned. It has been suggested, primarily on the evidence of pottery, that the users of the earliest known objects, arriving there sometime in the second millennium B.C., were members of the Iranian-speaking tribes infiltrating into Iran down the shores of the Caspian from regions to the north, in the present-day USSR. Such may have been the ruling group who patronized the local metal industry. However, the artisans owed much to older craft traditions whose evolution is only slowly becoming apparent as more excavation is done on sites just to the south of the Elburz range and in northeastern Iran. The superb designs on some of the gold and silver bowls and beakers (widely imitated and reproduced by modern craftsmen), notably those from Marlik, are reminiscent of contemporary iconography in Assyria off to the west and, more rarely, of the Caucasus in the second half of

the second millennium B.C. The similarity is so great that they might well be imports from the West. The bronzes, more probably reflecting local taste, use an imagery in which daily life is rather more evident than in Luristan. Although many of the animal motifs—here predominantly the zebu (humped bull) and various types of deer—are brilliantly stylized, there is little fantasy. The human figure appears in statuettes and in tiny models of vehicles or ploughs. The earlier objects appear to concentrate in the periods Iron Age I–II (c. 1350–800 B.C.); thereafter, although dating is still extremely hazardous, there is a decline of activity until the Parthian and Sasanian periods. Whether this reflects the true state of affairs or is merely an accident of archaeological research remains to be seen.

Pre-Achaemenid Pottery

Apart from metalwork, the illicit excavations just described have yielded a steady flow of decorated or modeled pottery vessels. Plain vessels were generally discarded by the peasants. Their proper archaeological attribution has been rather easier to fix than much of the metalwork, since pottery appears in quantity in controlled excavations. Indeed, it is the primary archaeological guide to the prehistory of Iran. At this first stage in the systematic exploration of that country's earliest settlement, only crude descriptions of the anonymous peoples who developed it may be attempted through the most obvious evidence of their presence: the potsherds they left behind. Thus it is that archaeologists, using a technical shorthand, divide up the prehistory of Iran's various regions by the pottery types prevalent at different periods. These are designated either by the sequence of levels in a primary excavation (Geoy Tepe B; Giyan II) or, now more rarely, by such terms as "Northern Gray Ware Horizon." The common extension of this terminology into "pots-equal-peoples" equations, though almost unavoidable in the present state of research, is dangerous if it is not realized that such definitions are mere conventions. Whether or not, for example, the marked contrasts in the pottery traditions of the Iron Age I–II cemeteries A and B at Tepe Sialk, excavated by Ghirshman, reflect changes in the local population or merely a decisive switch in ceramic taste and fashion owing its origin to social and economic, not demographic, pressures may only be assessed in the light of the widest spectrum of evidence.

Bearing this major reservation in mind, the various pottery styles illustrated in this catalog may be rapidly reviewed. With the Amlash metalwork came fine monochrome burnished pottery, in shades of red, gray, and black, often formed into exotic shapes or modeled as animals or human beings. The best of them have already found a place among the most remarkable ceramic sculpture ever made (so attractive that modern copies abound). This pottery is primarily of Iron Age I–II date (c. 1350–800 B.C.), but local styles persisted long and later types are still little known. From Luristan in the late 1920s first came strikingly painted pottery, named by its French publishers as "genre Luristan." Subsequent excavation, particularly at Baba Jan Tepe (Goff, 1966, 1968), has given it a proper archaeological context in Iron Age II–III (c. 1000–650 B.C.) and has also identified the earlier Bronze Age pottery of the area. The pioneering French excavations at Tepe Giyan in eastern Luristan provided a long sequence of painted pottery jars and

goblets extending from the third into the first millennium B.C. Many vessels of the Giyan style (subdivided by the excavators' levels from I, in the early Iron Age, to IV in the third millennium) reached the antiquities market. After the excavations at Tepe Sialk on the Iranian plateau in 1933, 1934, and 1937, examples of the remarkable painted pottery of cemetery B (Iron Age II–III) found their way into collections. Less common are examples of the plainer wares of the earlier, Iron Age I, cemetery A at Tepe Sialk. Although many other individual and distinctive pottery styles are now known from controlled excavations—from all periods and from the length and breadth of Iran—they are not included in the Heeramaneck Collection.

Objects from the Early Historic Periods (c. 550 B.C.–650 A.D.)

Iran became a political force in the ancient Near East under Cyrus the Great (c. 559–530 B.C.), who welded the Medes and Persians into a coherent state and exploited the fine army he had inherited from his Persian father and Median father-in-law to conquer the declining Babylonian Empire. Under his immediate successors, notably Darius I (c. 522–486 B.C.), an empire extending from Arabia to the Caucasus, from the Aegean to the Indus, was ruled from two capital cities, Babylon and Susa. As the home of the ruling dynasty, Iran held a privileged position in the empire but was, in the modern sense, something of an underdeveloped country. It was overshadowed by the wealthy provinces of Egypt, Phoenicia, and Babylonia, and by the ancient kingdoms of Lydia and Phrygia in Turkey, each with its own long-established political, social, and economic systems. Throughout the empire the presence of rich patrons attached to the courts of the local governors stimulated local craftsmen to adjust their traditional skills and styles to the new fashions in gold and silver plate, in jewelry, in fine cut glass, and in textiles, particularly the Iranian love of animal designs and rich color contrasts. Although something is known of this international court style, very little is yet known of the more ordinary artifacts of the Achaemenid period, especially in Iran. Neither in Luristan nor in Gilan has much yet been revealed of this time, either in controlled or in clandestine excavations.

The following period, when Iran passed under the control of the dynasty founded by Alexander the Great's general Seleucus, is even more of an archaeological dark age (c. 330–150 B.C.). The Seleucids, who slowly Hellenized the urban culture of Iran, were finally overthrown after long harrassment by Parthian tribesmen from the region of modern Khorasan, in northeastern Iran and beyond, in the present-day USSR. Nomadic in origin, the Parthians accepted the Hellenized organs of government and administration in Iran. Their army, distinguished particularly by its fine cavalry units, was feared even by the Romans. Wealth came to the Parthian Empire (which also embraced much of modern Iraq and parts of Syria) from overland trade with China and seaborne commerce up the Persian Gulf, bringing with it spices and oriental luxuries for sale westward throughout the Roman Empire. In art, major and minor, the nomadic traditions of the Parthians blended, often distinctively, with the varied Greco-Roman styles by now current in Iran. Objects of this period

are reported from cemeteries in the north and northwest, but are far less evident among finds made so far in Luristan.

Unruly feudal lords had constantly threatened the authority of the Parthian kings. In the Iranian province of *Persis* the old Achaemenid imperial traditions and native Iranian aspirations had been maintained throughout the centuries of foreign domination. In the second quarter of the third century A.D., in circumstances not fully clear, Ardashir, from the family of the hereditary chief priest of Anahita's temple in the provincial capital Istakhr (near Persepolis) and a descendant of one Sasan, overthrew the last of the Parthian kings and established the Sasanian dynasty. Under his immediate successors, links with the Achaemenid past were consciously revived and royal authority was directed to the creation of a highly centralized administration, with orthodox Zoroastrianism as the state religion. Again, as under the Achaemenids, it was the court art, using the ancient Near Eastern motifs of the royal hunt, the investiture of a king, or his triumphs in battle, which predominated. Luxury tableware, fine gems, and textiles were all decorated with such motifs, as were the monumental reliefs carved on rock most distinctive of the period. Much of the available evidence for the minor arts of the Sasanian period from Iran is said to come from clandestinely excavated cemeteries in Gilan and Mazanderan on the shores of the Caspian Sea. Thus it may well belong predominantly to the end of the period, bearing witness more to those who survived for some time after the Islamic conquest of Iran than to the centuries of Sasanian supremacy (c. 225–650 A.D.). The Caspian provinces had long been, and were to remain, a primary refuge zone for superseded political authorities.

P. R. S. Moorey
Senior Assistant Keeper
Department of Antiquities
Ashmolean Museum, Oxford

Chronology

There is no standard chronology for early Iran. The following scheme is followed in this catalog:

Early Bronze Age	c. 3000–2400 B.C.
Late Bronze Age	c. 2400–1350 B.C.
Iron Age I	c. 1350–1000 B.C.
Iron Age II	c. 1000–800 B.C.
Iron Age III	c. 800–550 B.C. (the end of the Luristan bronze industry is placed c. 650–600 B.C.)
Achaemenid Period	c. 550–330 B.C.
Seleucid Period	c. 330–150 B.C.
Parthian Period	c. 150 B.C.–225 A.D.
Sasanian Period	c. 225–650 A.D.

Weapons and tools formed the major component of production in
western and northern Iranian metal workshops from the first period
of extensive production, about the middle of the third millennium B.C.
when copper and arsenical copper were the primary materials, until
well into the first millennium B.C. when iron superseded bronze,
an alloy of copper and tin. At first, and for well over a thousand
years, weapons and tools (as indeed much of the other metalwork of
Luristan) shared a common repertory of forms with Mesopotamia
and Elam. Only in a growing taste for zoomorphic decoration can the
potential originality of the Luristan smiths be observed.

 Throughout the second millennium B.C. bronze steadily became
the primary medium, though knowledge of the period from about
1750 to 1350 B.C. is sparse (see Introduction). By the thirteenth
century B.C. distinctive forms had begun emerging, such as the spike-
butted axeheads so richly exploited in Luristan. Over the next five
hundred years (Iron Ages I–II) iron was slowly introduced. At
first iron was only a minor constituent in bronze objects, but from
about 800 B.C. weapons and tools were regularly made of it. The
Heeramaneck Collection is highly representative in its range of
Luristan axeheads and related tools, daggers, and whetstone sockets.
Spearheads and arrowheads are largely absent. This is a common
feature of Luristan bronze collections; at this stage it is difficult to
tell whether this reflects their rarity in ancient Luristan or the fact
that the peasants, thinking the pieces were not worth trading, threw
them away.

 Tools used for farming, carpentry, metalworking, and other crafts
are rarely included in Luristan bronze collections, as such objects
were not usually put in graves. The social status of the men who used
them was too low for such valuable equipment to be included in their
graves. When settlement sites are excavated a very different picture
emerges. At Baba Jan Tepe, in habitation levels of the eighth and
seventh centuries B.C., the excavator found a representative collection
of iron agricultural tools: spades, hoes, and sickles. As more of the
ancient mounds of Luristan are properly excavated, a fuller repertory
of metal objects may be expected to emerge, correcting this serious
imbalance in evidence predominantly derived from tombs.

1

Shaft-hole Axehead
Luristan; c. 2600–2350 B.C.
h: 10.2 cm.; l: 12 cm.
Bronze, cast; Deshayes, 1960,
haches à collet, type A.1.a; leonine
creature passant on the butt.
M.76.97.425

2

Shaft-hole Axehead
Luristan; c. 2600–2350 B.C.
h: 8.8 cm.; l: 12 cm.
Bronze, cast; Deshayes, 1960,
haches à collet, type A.1.a; "snake
band" down the back of the butt.
M.76.97.450

3

Shaft-hole Axehead
Luristan; c. 2600–2350 B.C.
h: 5.5 cm.; l: 14 cm.
Bronze, cast; Deshayes, 1960,
haches à collet, type A.3.a; butt
decorated with a face in modern
times, perhaps before the
twentieth century A.D.
M.76.97.415

4

Shaft-hole Axehead
Luristan; c. 2600–2350 B.C.
h: 11 cm.; l: 13 cm.
Bronze, cast; Deshayes, 1960,
haches à collet, type A.3.b; snake in
relief on shaft.
M.76.97.462

5

Shaft-hole Axehead
Luristan; c. 2600–2350 B.C.
h: 7.5 cm.; l: 10.8 cm.
Bronze, cast; Deshayes, 1960,
haches à collet, type A.3.c; shaft-
hole cross-hatched; semi-circular
open butt crest with vertical
centerpiece.
M.76.97.459

6

Shaft-hole Axehead
Luristan; c. 2600–2350 B.C.
h: 10 cm.; l: 16.7 cm.
Bronze, cast; Deshayes, 1960,
haches à collet, type A.4.a; plain.
M.76.97.451

1

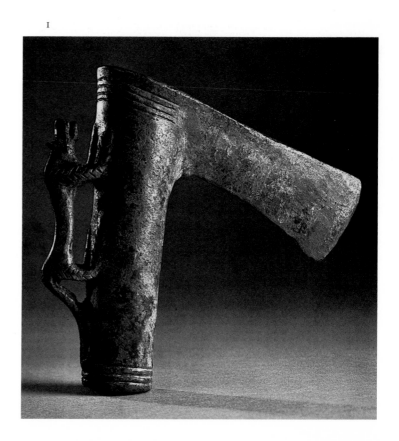

7

Miniature Shaft-hole Axehead
Luristan; c. 2350–2000 B.C.
h: 3.5 cm.; l: 6 cm.
Bronze, cast; Deshayes, 1960,
haches à collet, type A.5.b; plain.
M.76.97.464

8

Shaft-hole Axehead
Luristan; c. 2350–2000 B.C.
h: 6.8 cm.; l: 10.5 cm.
Bronze, cast; Deshayes, 1960,
haches à collet, type A.5.c; four curls
on the butt.
M.76.97.426

9

Shaft-hole Axehead
Luristan; c. 2350–2000 B.C.
h: 7.7 cm.; l: 14.1 cm.
Bronze, cast; Deshayes, 1960,
haches à collet, type A.5.c; hunting
dog with heavy collar in relief on
either side of the butt.
M.76.97.444

10

Shaft-hole Axehead
Luristan; c. 2100–1750 B.C.
h: 7.7 cm; l: 22 cm.
Bronze, cast; Deshayes, 1960,
haches à collet, type B.2.b; butt
protuberance; blade springs from
a lion's jaws.
M.76.97.448

11

Shaft-hole Axehead
Luristan; c. 2100–1750 B.C.
h: 5.8 cm.; l: 13.8 cm.
Bronze, cast; Deshayes, 1960,
haches à collet, type B.2.b; small
horned animal heads at top and
bottom of the butt curve.
M.76.97.452

12

Shaft-hole Axehead
Luristan; c. 2100–1750 B.C.
h: 6.5 cm.; l: 15.7 cm.
Bronze, cast; Deshayes, 1960,
haches à collet, type B.2.b; plain.
M.76.97.453

13

Shaft-hole Axehead
Luristan; c. 2100–1750 B.C.
h: 6 cm.; l: 13.8 cm.
Bronze, cast; Deshayes, 1960,
haches à collet, type B.3.b; blade
springs from a snake's head; bird
head on upper rear of shaft-hole;
two-layered butt crest; possibly a
modern after-cast.
M.76.97.427

cf. Moorey, 1971, pp. 46–47.

14

Shaft-hole Axehead
Luristan; c. 2100–1750 B.C.
h: 6.7 cm.; l: 11.5 cm.
Bronze, cast; Deshayes, 1960,
haches à collet, type B.3.b; plain.
M.76.97.470

15

Shaft-hole Axehead
Luristan; c. 2100–1750 B.C.
h: 7 cm.; l: 11.5 cm.
Bronze, cast; Deshayes, 1960,
haches à collet, type B.3.b; plain.
M.76.174.40

8

13

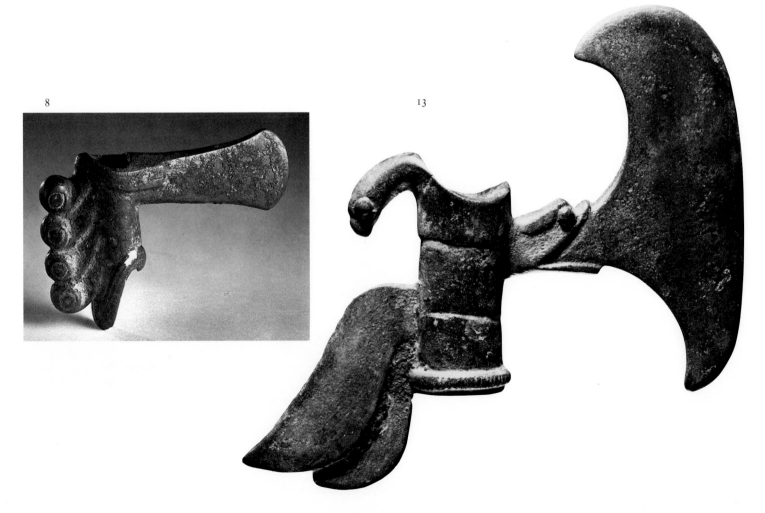

16

Shaft-hole Axehead
Luristan, Middle Elamite;
c. 1350–1200 B.C.
h: 6.5 cm.; l: 15 cm.
Bronze, cast; Deshayes, 1960,
haches à collet, type B.5; decorated
with the following figures exe-
cuted in relief: a lion and bull in
combat on the butt; a humped bull
on each face of blade; a lion on
cutting edge; a lion couchant on
upper and lower blade edges; orig-
inally, a zebu walking toward a lion
on both edges, upper one now
lost; blade springs from a lion's
jaw and two dogs in relief on the
shaft attack it; unique piece.
M.76.97.413

As no close parallels are known, it
is difficult to attribute and date
this axehead. A typologically re-
lated piece of bronze and iron
from Tchoga-Zanbil in Khuzistan
(Iran), inscribed for King Untash
Gal, suggests the dating given
here and the attribution to an
Elamite workshop. Preliminary
laboratory tests reveal no obvious
reason to doubt its antiquity.

17

Shaft-hole Axehead
Luristan; c. 2100–1750 B.C.
h: 7 cm.; l: 18.3 cm.
Bronze, cast; Deshayes, 1960,
haches à collet, type C; blade cast as
the body of a rampant lion with
jaws agape, head and front legs
forming the shaft-hole; incised
decoration.
M.76.97.416; ex-Holmes
Collection

Pub. Pope, 1938, IV, pl. 52 A;
Potratz, *IrAn* 3, 1963, pl. XXX;
Calmeyer, 1969, p. 40, fig. 42; cf.
British Museum, 1920, p. 176,
fig. 188.

18

Shaft-hole Axehead
Luristan; c. 2100–1750 B.C.
h: 5.7 cm; l: 15.2 cm.
Bronze, cast; Deshayes, 1960,
haches à collet, type E.1; lion in low
relief on shaft spitting midrib of
blade from its jaws.
M.76.97.422

19

Shaft-hole Axehead
Luristan; c. 2100–1750 B.C.
h: 6.1 cm.; l: 15.8 cm.
Bronze, cast; Deshayes, 1960,
haches à collet, type C.1; decoration
of relief lines.
M.76.97.446

20

Shaft-hole Axehead
Luristan; c. 2100–1750 B.C.
h: 4.2 cm.; l: 15 cm.
Bronze, cast; Deshayes, 1960,
haches à collet, type C.1; plain.
M.76.97.467

21

Shaft-hole Axehead
Luristan; c. 2100–1750 B.C.
h: 4.6 cm.; l: 27 cm.
Bronze, cast; Deshayes, 1960,
haches à collet, type C.3.b;
pronounced butt curl.
M.76.97.447

22

Shaft-hole Axehead
Luristan; date uncertain
h: 3.5 cm.; l: 20 cm.
Bronze, cast; Deshayes, 1960,
haches à collet, type C.3.c; blade
springs from a lion's jaws; small
caprid head on upper rear edge of
shaft-hole; a predatory bird's head
with deep eye sockets curving up
on butt.
M.76.97.441

This unusual axehead is difficult
to date and attribute; preliminary
laboratory tests have not chal-
lenged its authenticity. The basic
form is of the early second millen-
nium B.C. (cf. Deshayes, as quoted
here; Calmeyer, 1969, group 24).
If this axehead is that early, the
bird head is a precursor of a motif
popular much later in Asiatic
nomad art.

16

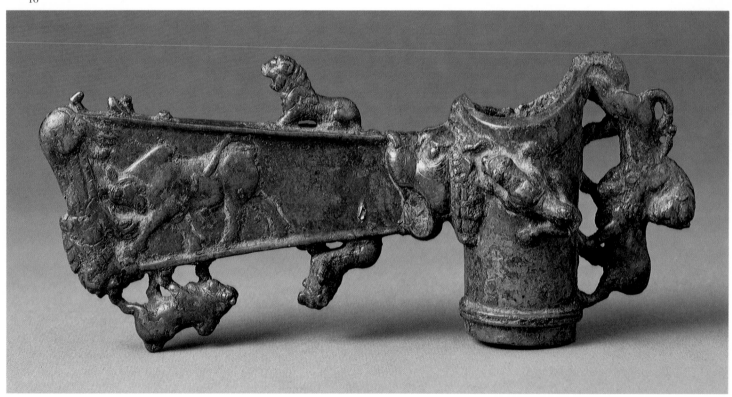

23

Shaft-hole Axehead
Luristan; c. 2100–1750 B.C.
h: 5 cm.; l: 19 cm.
Bronze, cast; Calmeyer, 1969,
group 72b; flaring blade and long
tail behind butt; eye on front and
back of shaft-hole.
M.76.97.424

For related hammers, cf.
Deshayes, *Syria* 35, 1958,
pp. 284ff.

24

Miniature Shaft-hole Axehead
Luristan; Iron Age I
(c. 1350–1000 B.C.)
h: 2.1 cm.; l: 6.2 cm.
Bronze, cast; Deshayes, 1960,
haches à collet, type D; three plain
butt spikes.
M.76.174.117

25

Shaft-hole Axehead
Luristan; Iron Age I
(c. 1350–1000 B.C.)
h: 4.8 cm.; l: 19.7 cm.
Bronze, cast; Deshayes, 1960,
haches à collet, type D; five butt
spikes with conical heads; relief
arrow on blade; modern incised
decoration on blade.
M.76.97.437

22

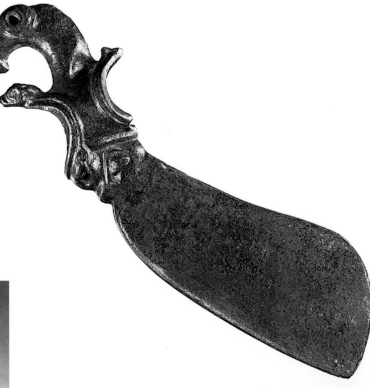

17

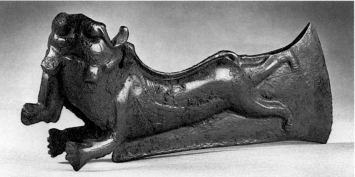

18

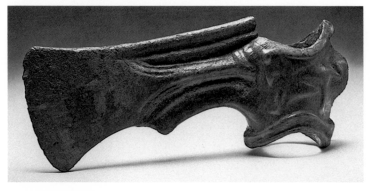

23

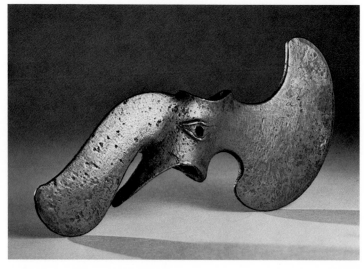

31

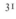

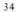

26

Shaft-hole Axehead
Luristan; Iron Age I
(c. 1350–1000 B.C.)
h: 5.7 cm.; l: 19 cm.
Bronze, cast; Deshayes, 1960,
haches à collet, type D; four long,
conical butt spikes; relief lines on
blade; modern incised decoration
on face of each blade.
M.76.97.438

27

Shaft-hole Axehead
Luristan; Iron Age I
(c. 1350–1000 B.C.)
h: 3.7 cm.; l: 21 cm.
Bronze, cast; Deshayes, 1960,
haches à collet, type D; four short,
blunt butt spikes; modern incised
decoration on blade surface.
M.76.97.439

28

Shaft-hole Axehead
Luristan; Iron Age I
(c. 1350–1000 B.C.)
h: 6 cm.; l: 21.8 cm.
Bronze, cast; Deshayes, 1960,
haches à collet, type D; four tapering
butt spikes; sharply angled cutting
edge.
M.76.97.458

29

Shaft-hole Axehead
Luristan; Iron Age I
(c. 1350–1000 B.C.)
h: 5.5 cm.; l: 21.5 cm.
Bronze, cast; Deshayes, 1960,
haches à collet, type D; four long,
conical butt spikes; relief arrow-
head on blade.
M.76.97.463

30

Shaft-hole Axehead
Luristan; Iron Age I
(c. 1350–1000 B.C.)
h: 5 cm.; l: 21 cm.
Bronze, cast; Deshayes, 1960,
haches à collet, type D; four butt
spikes, three with plain conical
heads, the upper one cast as a
lion's head facing upward.
M.76.97.423

31

Shaft-hole Axehead
Luristan; Iron Age I
(c. 1350–1000 B.C.)
h: 3.7 cm.; l: 19.8 cm.
Bronze, cast; Deshayes, 1960,
haches à collet, type D; shaft-hole
cast as a lion's head, muzzle facing
downward; three flared butt spikes
flanked on each side by the head
of a game bird; traces of incised
decoration.
M.76.97.436

cf. Amiet, 1976, no. 55.

32

Shaft-hole Axehead
Luristan; Iron Age I
(c. 1350–1000 B.C.)
h: 5.3 cm.; l: 19 cm.
Bronze, cast; Deshayes, 1960,
haches à collet, type D; plain shaft-
hole with three flared butt spikes
flanked on each side by the head of
a game bird as in cat. no. 31.
M.76.97.465

34

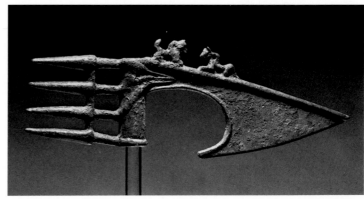

33

Shaft-hole Axehead
Luristan; Iron Age I
(c. 1350–1000 B.C.)
h: 6.4 cm.; l: 23.7 cm.
Bronze, cast; Deshayes, 1960,
haches à collet, type D; four long,
square-sectioned butt spikes;
lion's head spews forth the blade;
crouching felines in relief on
shaft-hole.
M.76.97.440

34

Shaft-hole Axehead
Luristan; Iron Age I
(c. 1350–1000 B.C.)
h: 6.7 cm.; l: 26.8 cm.
Bronze, cast; Deshayes, 1960,
haches à collet, type D; four long,
conical butt spikes; confronted
felines in relief on top of blade.
M.76.97.449

35

Shaft-hole Axehead
Luristan; Iron Age I
(c. 1350–1000 B.C.)
h: 4.8 cm.; l: 22.5 cm.
Bronze, cast; Deshayes, 1960,
haches à collet, type D; four long,
conical butt spikes; stylized relief
lion lying on upper edge as if to
spring; leaf terminal on midrib.
M.76.97.457

36

Shaft-hole Axehead
Luristan; Iron Age I
(c. 1350–1000 B.C.)
h: 5.2 cm.; l: 20.5 cm.
Bronze, cast; Deshayes, 1960,
haches à collet, type D; blade
emerges from stylized lion's jaws;
four long, conical butt spikes;
feline creature crouching on upper
edge; relief arrow on blade.
M.76.97.434

cf. Pope, 1938, IV, pl. 48 B, D.

37

Shaft-hole Axehead
Luristan; Iron Age I
(c. 1350–1000 B.C.)
h: 3.2 cm.; l: 19 cm.
Bronze, cast; Deshayes, 1960,
haches à collet, type D; blade
springs from lion's jaws; four butt
spikes end in boars' (?) heads.
M.76.97.431

38

Shaft-hole Axehead
Luristan; Iron Age I
(c. 1350–1000 B.C.)
h: 3.7 cm.; l: 20.2 cm.
Bronze, cast; Deshayes, 1960,
haches à collet, type D; blade springs
from lion's jaws; four butt spikes
terminate in grotesque human
heads, the central two facing for-
ward, the end ones facing outward.
M.76.97.432

38

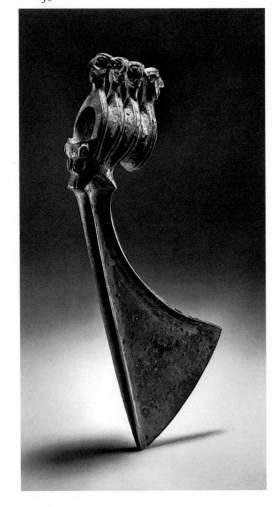

36

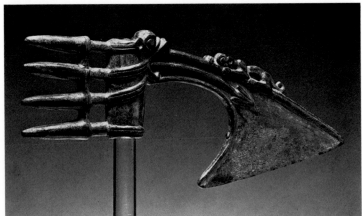

39

Shaft-hole Axehead
Luristan; Iron Age I
(c. 1350–1000 B.C.)
h: 4.5 cm.; l: 20.8 cm.
Bronze, cast; Deshayes, 1960,
haches à collet, type D; blade springs
from lion's (?) jaws; four butt
spikes cast as stylized lions with
jaws agape; fishbone pattern
engraved on upper edge.
M.76.97.435

40

Shaft-hole Axehead
Luristan; Iron Age I
(c. 1350–1000 B.C.)
h: 4.1 cm.; l: 21 cm.
Bronze, cast; Deshayes, 1960,
haches à collet, type D; relief cross
on shaft-hole; four butt spikes cast
as long-snouted animal heads,
perhaps boars.
M.76.97.455

41

Shaft-hole Axehead
Luristan; Iron Age I
(c. 1350–1000 B.C.)
h: 3.8 cm.; l: 18.2 cm.
Bronze, cast; Deshayes, 1960,
haches à collet, type D; blade springs
from lion's jaws; relief cross on
shaft-hole; two rows of four con-
fronted animal heads form the
butt spikes; entwined snakes en-
graved on upper edge.
M.76.97.461

42

Shaft-hole Axehead
Luristan; Iron Age I
(c. 1350–1000 B.C.)
h: 5.5 cm.; l: 22.8 cm.
Bronze, cast; Deshayes, 1960,
haches à collet, type D; a distinctive
variant; butt cast as a creature with
an equid's head at the upper end
and a spread feather tail at the
lower; nude female figure stand-
ing in the center of its back clasp-
ing her breasts; hair swept up
into a broad curl on the nape of
her neck.
M.76.97.414

Pub. Rome, 1956, no. 82; Ghirsh-
man, 1964, p. 64, fig. 80.

43

Shaft-hole Axehead
Luristan; modern
h: 8.3 cm.; l: 17 cm.
Bronze, cast; similar in basic shape
to Deshayes, 1960, *haches à collet,*
B.2.b; very elaborate; four stand-
ing bulls with bodies fused on the
butt; eagle heads projecting from
upper and lower shaft-hole cor-
ners and on opposite sides of
blade base.
M.76.97.870

Metal analysis and surface condi-
tion indicate that this remarkable
axehead is a modern object.

44

Crescentic Axehead
Northern or western Iran;
c. 2600–2350 B.C.
h: 32.3 cm.; w: 8 cm.
Bronze, cast; Calmeyer, 1969,
group 13; flat silhouette; three rear
projections, each pierced with a
single hole; incised on one side
with a long antlered stag hatched
in with vertical lines (probably a
modern addition).
M.76.97.466

cf. Moorey, 1971, nos. 22, 23.

45

Crescentic Axehead of Anchor Shape
Northern Iran; c. 2350–2000 B.C.
h: 8.7 cm.; w: 9.5 cm.
Bronze, cast; Calmeyer, 1969,
group 13; plain.
M.76.97.468

cf. Moorey, 1971, no. 24.

42

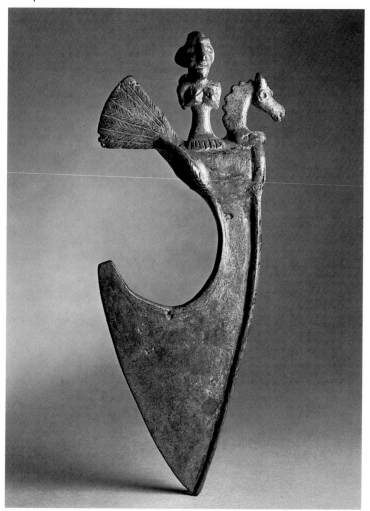

41

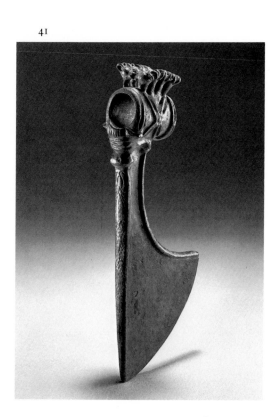

46

Crescentic Axehead
Northern Iran; Iron Age I
(c. 1350–1000 B.C.)
h: 35 cm.; w: 9 cm.
Bronze, cast; long narrow blade;
short shaft-hole with six butt
spikes.
M.76.97.430

cf. Negahban, 1964, fig. 25 (from
Marlik Tepe); Vanden Berghe,
1964, pl. XXXVI, no. 247 (from
Khurvin); for discussion of type,
cf. Moorey, 1971, no. 26.

47

Crescentic Axehead
Luristan; Iron Age I
(c. 1350–1000 B.C.)
h: 5.2 cm.; w: 7.2 cm.
Bronze, cast; Calmeyer, 1969,
group 34; recumbent lion on shaft
top; no trace of an iron blade;
authenticity doubtful.
M.76.97.418

For discussion of type, cf.
Moorey, 1971, no. 27.

48

Crescentic Axehead
Luristan; Iron Age I
(c. 1350–1000 B.C.)
h: 21 cm.; w: 8 cm.
Bronze, cast; Calmeyer, 1969,
group 34; lion couchant on shaft-
hole back; profile lion mask with
"feather" in jaws; blade never
sharpened.
M.76.97.419; ex-Holmes
Collection

Pub. New York, 1940, p. 110 U.

49

Crescentic Axehead
Luristan; Iron Age I
(c. 1350–1000 B.C.)
h: 19.5 cm.; w: 8.5 cm.
Bronze, cast; Calmeyer, 1969,
group 34; bronze socket and re-
mains of iron blade; lion couchant
on shaft-hole back; full-face lion
mask with "feather" in jaws.
M.76.97.420

50

Crescentic Axehead
Luristan; Iron Age I
(c. 1350–1000 B.C.)
h: 15 cm.; w: 9.5 cm.
Bronze, cast; Calmeyer, 1969,
group 34; bronze socket and re-
mains of iron blade; lion couchant
on shaft-hole back; full-face lion
mask with "feather" in jaws.
M.76.97.421

51

Crescentic Axehead
Luristan; Iron Age I
(c. 1350–1000 B.C.)
h: 23.5 cm.; w: 9.5 cm.
Bronze, cast; Calmeyer, 1969,
group 34; highly rubbed, lustrous
surface with finely incised de-
tails; lion couchant on shaft-hole
back; full-face lion mask with
"feather" in jaws.
M.76.97.428

52

Crescentic Axehead
Luristan; Iron Age I
(c. 1350–1000 B.C.)
h: 15 cm.; w: 8.5 cm.
Bronze, cast; Calmeyer, 1969,
group 34; lion couchant on shaft-
hole back; full-face lion mask
with "feather" in jaws.
M.76.97.456

53

Crescentic Axehead
Luristan; Iron Age I
(c. 1350–1000 B.C.)
h: 14.6 cm.; w: 10.5 cm.
Bronze, cast; Calmeyer, 1969,
group 34; stylized lion standing
on the butt; full-face lion mask
with "feather" in jaws; antiquity
doubtful.
M.76.97.460

54

Adze-head
Luristan; c. 2600–2350 B.C.
h: 11.8 cm.; l: 14 cm.
Bronze, cast; Deshayes, 1960,
houes et herminettes à collet, type
B.2.a; lion crouching on the butt.
M.76.97.445

55

Adze-head
Luristan; Iron Age I
(c. 1350–1000 B.C.)
h: 3.8 cm.; l: 13.3 cm.
Bronze, cast; blade emerges from
the jaws of an animal not precisely
identifiable; three blunt-nosed
animal protomes on the butt (up-
side-down in relation to blade).
M.76.97.433

49

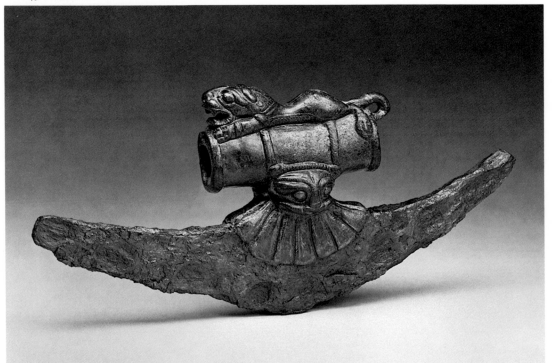

56

Adze-head
Luristan; Iron Age I
(c. 1350–1000 B.C.)
h: 4.2 cm.; l: 16.8 cm.
Bronze, cast: wild boar couchant
on the butt; rosette at base of blade
near shaft-hole.
M.76.97.443

57

Adze-head
Luristan; Iron Age I
(c. 1350–1000 B.C.)
h: 4.5 cm.; l: 18 cm.
Bronze, cast; blade springing from
lion's jaws; four ridges on a rectan-
gular butt crest.
M.76.97.454

58

Adze-axehead
Luristan; Iron Age III
(c. 800–650 B.C.)
h: 9.7 cm.; l: 19 cm.
Bronze, cast; stylized bearded
human face at junction of shaft
and blade.
M.76.97.417

cf. Vanden Berghe, 1968, pl. 29a,b.

59

Pickaxe-head
Luristan; c. 2350–2100 B.C.
h: 7 cm.; l: 19.8 cm.
Bronze, cast; Deshayes, 1960,
haches à collet, type A.5.c; double
mouflon head with side horn
sweep set on the butt.
M.76.97.442

cf. Calmeyer, 1969, fig. 35.

60

Pickaxe
Luristan; c. 2350–2100 B.C.
h: 5.3 cm.; l: 14.3 cm.
Bronze, cast; Deshayes, 1960,
haches à collet, type A.5.c; Cal-
meyer, 1969, group 14; shaft-hole
miscast (?); human face engraved
on single butt spike; this seems
to be an ancient object modified
in modern times.
M.76.97.469

61

Hammerhead
Luristan; c. 2100–1750 B.C.
h: 11 cm.; l. of head: 3.2 cm.
Bronze, cast; goat's head on top
with crest extending back from
the base of the neck along the top
of the socket; "eye" on shaft.
M.76.97.429

cf. Deshayes, *Syria* 35, 1958, pp.
284ff.; Porada, 1965, p. 55, pl. 10
(silver, from Susa).

62

Hammerhead
Luristan; c. 2100–1750 B.C.
h: 8.3 cm.; l. of head: 3.2 cm.
Bronze, cast; in the shape of a re-
cumbent mouflon, the animal's
hindquarters forming hammer-
head; fragmentary.
M.76.97.515

cf. cat. no. 61.

63

Hammerhead (?)
Source uncertain; possibly
c. 2100–1750 B.C.
h: 4 cm.; l. of head: 10.5 cm.
Bronze, cast; crouching lion or
panther, rather stylized, with
modern metal tube in eye-sockets;
shaft-hole through shoulders.
M.76.97.813

The date and attribution of this
object are uncertain; it may be a
relative of catalog numbers 61
and 62 here.

64

Dagger
Luristan; c. 2600–2350 B.C.
l. of hilt: 5 cm.; l. of blade:
16.5 cm.
Bronze, cast; Calmeyer, 1969,
group 6; open-cast hilt riveted to
blade; damaged.
M.76.97.481

cf. Moorey, 1971, nos. 45, 46.

65

Dagger
Luristan; c. 2600–2350 B.C.
l. of hilt: 12.8 cm.; l. of blade:
17.2 cm.
Bronze, cast; Calmeyer, 1969,
group 6; openwork hilt riveted to
blade; hilt modified in modern
times by the addition of an open-
work, cage-shaped pommel with
a cutout frieze of three human
figures.
M.76.97.482

66

Dagger
Luristan; c. 2600–2350 B.C.
l. of hilt: 9.3 cm.; l. of blade:
15.6 cm.
Bronze, cast; Calmeyer, 1969,
group 6; hilt with relief pattern of
lines and pellets riveted to blade.
M.76.97.483

cf. cat. no. 64.

67

Dagger
Luristan; c. 2600–2350 B.C.
l. of hilt: 7 cm.; l. of blade: 13 cm.
Bronze, cast; Calmeyer, 1969,
group 6; hilt cast as a fish and riv-
eted to blade; this very unusual
hilt is quite probably genuine.
M.76.97.485

cf. cat. no. 64.

68

Dagger
Luristan; c. 2600–2350 B.C.
l. of hilt: 8.5 cm.; l. of blade:
15.7 cm.
Bronze, cast; Calmeyer, 1969,
group 6; hilt with relief pattern of
ridges and pellets.
M.76.97.500

cf. cat. no. 64.

69

Dagger
Luristan; c. 2600–2350 B.C.
l. of hilt: 8.5 cm.; l. of blade:
15.7 cm.
Bronze, cast; Calmeyer, 1969,
group 6; hilt with relief pattern of
pellets.
M.76.97.501

cf. cat. no. 64.

62

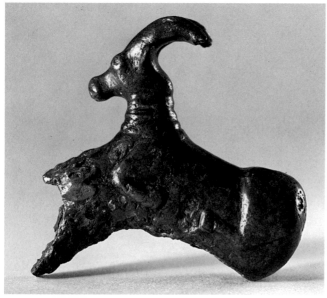

63

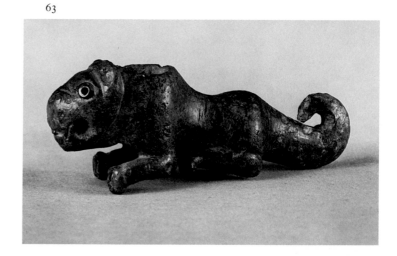

70

Dagger
Luristan; Iron Age I
(c. 1350–1000 B.C.)
l. of hilt: 14 cm.; l. of blade: 24 cm.
Bronze, cast; Calmeyer, 1969,
group 31; flange-hilted; inlay
plaques lost; bowman incised on
one side of blade base, feline on
other; palmette frieze below–all
probably modern embellishments.
M.76.97.478

cf. Moorey, 1971, no. 47.

71

Dagger
Luristan; Iron Age I
(c. 1350–1000 B.C.)
l. of hilt: 11.8 cm.; l. of blade:
24.3 cm.
Bronze, cast; Calmeyer, 1969,
group 31; flange-hilted; two dome-
headed rivets hold bone inlay
plaques in place; incised geometric
decoration around edges of hilt.
M.76.97.479

cf. Moorey, 1971, no. 50.

72

Dagger
Luristan; Iron Age I
(c. 1350–1000 B.C.)
l. of hilt: 13 cm.; l. of blade:
26.5 cm.
Bronze, cast; Calmeyer, 1969,
group 31; flange-hilted; inlays lost;
incised decoration around edge
of pommel and floral ornaments
on blade; decoration may be a
modern addition.
M.76.97.487

73

Dagger
Luristan; Iron Age I
(c. 1350–1000 B.C.)
l. of hilt: 12 cm.; l. of blade:
28 cm.
Bronze, cast; Calmeyer, 1969,
group 31; flange-hilted; inlays lost;
on either side of blade is a long
undulating snake in relief; a quad-
ruped wearing a collar set above
each snake head–all probably mod-
ern additions.
M.76.97.488

74

Dagger
Luristan; Iron Age I
(c. 1350–1000 B.C.)
l. of hilt: 14.5 cm.; l. of blade:
26.5 cm.
Bronze, cast; Calmeyer, 1969,
group 31; flange-hilted; inlays lost;
at the base of the blade on one side
is an incised sheep with curling
horns standing on superimposed
circles; on the other, a sheep with
woolly coat and horns curling
around the side of its head set on a
horizontal row of half-circles; this
incised decoration may be ancient.
M.76.97.490

75

Dagger
Luristan; Iron Age I
(c. 1350–1000 B.C.)
l. of hilt: 12.8 cm.; l. of blade:
27.6 cm.
Bronze, cast; Calmeyer, 1969,
group 31; flange-hilted; original
inlays lost and replaced by
modern gold or gilt bronze
substitutes.
M.76.97.492

76

Dagger
Luristan; Iron Age I
(c. 1350–1000 B.C.)
l. of hilt: 13 cm.; l. of blade:
28.7 cm.
Bronze, cast; Calmeyer, 1969,
group 31; flange-hilted; inlays lost;
two lines of cuneiform at base of
blade read: "Marduk-nadin-aḫe,
King of the Universe, King of
Babylon, King of Sumer and
Akkad."
M.76.97.498

Pub. Pope, *ILN*, Oct. 29, 1932,
p. 666, figs. 4, 5; Weidner, *AfO* VIII,
1932–33, pp. 258–59; Pope, 1938,
I, p. 283, no. VIII (Langdon incor-
rectly restores ša at beginning of
inscription); IV, pl. 55 D, E; Nagel,
AfO XIX, 1959–60, no. 6;
Brinkman, 1968, p. 330, no. 6.2.2;
Calmeyer, 1969, p. 164, no. 35;
Moorey, 1971, p. 32, no. 9.

67

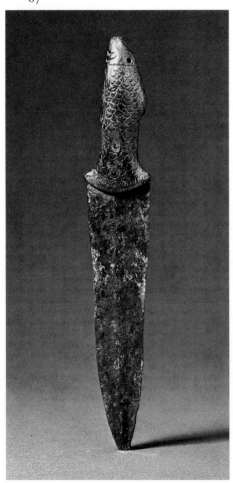

76

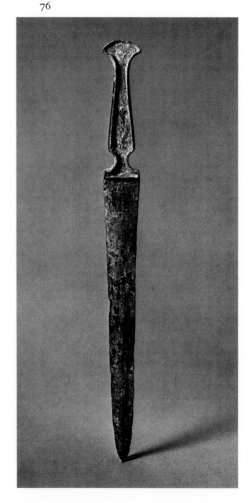

29

The following seven objects are, in all probability, modern pastiches, consisting of an ancient blade that has been joined to a hilt that was not original to the object. Such objects were imitations of authentic articles from Luristan.

92

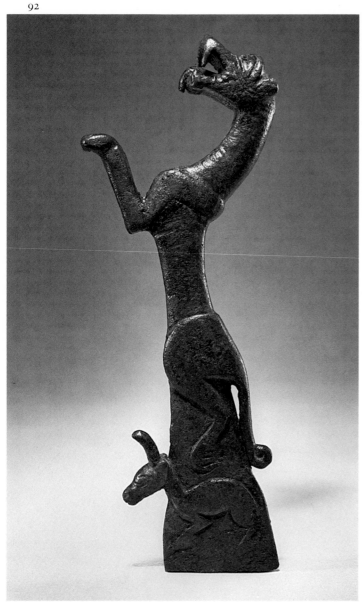

77

Dagger
"Luristan"; modern
l. of hilt: 10 cm.; l. of blade: 35.7 cm.
Bronze, cast; hilt with split pommel; small globules on the edges; grotesque faces at junction of grip and pommel; ridged grip; blade is ancient, but hilt is not original and may be modern.
M.76.97.471

78

Dagger
"Luristan"; modern
l. of hilt: 10.5 cm.; l. of blade: 24.7 cm.
Bronze, cast; anthropomorphic hilt in the form of a Janus head with body tapering toward blade; blade is probably ancient, but hilt may be modern.
M.76.97.472

79

Dagger
"Luristan"; modern
l. of hilt: 13.8 cm.; l. of blade: 34.6 cm.
Bronze, cast; hilt shaped as a double-sided nude female figure of uncertain antiquity; blade ancient.
M.76.97.473

80

Dagger
"Luristan"; modern
l. of hilt: 11.2 cm.; l. of blade: 23.6 cm.
Bronze, cast; hilt with split pommel, decorated with a horned nude woman on one side and an ithyphallic horned man on the other; antiquity uncertain; blade ancient.
M.76.97.474

For similar hilt, cf. Herzfeld, 1941, p. 133, fig. 251.

81

Dagger
"Luristan"; modern
l. of hilt: 11 cm.; l. of blade: 23.5 cm.
Bronze, cast; hilt with split pommel in the form of animals' ears and with an equid head projecting on each side; decorated on both sides with three superimposed horned human faces in relief; antiquity uncertain; ancient blade.
M.76.97.475

82

Dagger
"Luristan"; modern
l. of hilt: 14 cm.; l. of blade: 25.7 cm.
Bronze, cast; hilt with an animal, perhaps a lion couchant; pommel is probably modern; ancient blade.
M.76.97.489

83

Dagger
"Luristan"; modern
l. of hilt: 14 cm.; l. of blade: 38 cm.
Bronze, cast; multi-channelled ancient blade on a hilt, with conical pommel and calcite guard that is a pastiche of various ancient fragments.
M.76.97.494

84

Dagger
Northern Iran; Iron Age I
(c. 1350–1000 B.C.)
l. of hilt: 10.2 cm.; l. of blade:
25.8 cm.
Bronze, cast; crescentic pommel;
ribbed grip.
M.76.97.480

cf. Negahban, 1964, fig. 47, no. 123
(Marlik); Vanden Berghe, 1964,
pl. XXXIV, no. 226 (Khurvin).

85

Dagger
Northern Iran; Iron Age I
(c. 1350–1000 B.C.)
l. of hilt: 8.8 cm.; l. of blade:
32.2 cm.
Bronze, cast; penannular rib at top
of blade; nearly cone-shaped pommel
and grip decorated with long
and short triangular depressions.
M.76.97.493

cf. Moorey, 1971, no. 49.

86

Dagger
Northern Iran; Iron Age I
(c. 1350–1000 B.C.)
l. of hilt: 12 cm.; l. of blade:
48 cm.
Bronze, cast; solid hilt with spiral
grip; penannular guard and hollow,
conical pommel with five
holes in it.
M.76.97.495

cf. Moorey, 1971, no. 57.

87

Dagger
Northern Iran; Iron Age I
(c. 1350–1000 B.C.)
l. of hilt: 17 cm.; l. of blade:
33 cm.
Bronze, cast; crescentic split pommel
with downward-projecting
ends; ribbed and cross-hatched
grip and guard.
M.76.97.496

For simpler example, cf. Moorey,
1971, no. 56.

88

Dagger
Northern Iran; Iron Age I
(c. 1350–1000 B.C.)
l. of hilt: 12 cm.; l. of blade:
35.5 cm.
Bronze, cast; open crescentic
pommel; ribbed grip and square
guard.
M.76.97.499

cf. Moorey, 1971, no. 55.

89

Dagger
Northern Iran; Iron Age I
(c. 1350–1000 B.C.)
l. of hilt: 15.5 cm.; l. of blade:
25.5 cm.
Bronze, cast; winged pommel
with a ram's head facing outward
on each side; square grip and rectangular
guard; pommel, grip,
and blade may not be an original
combination; poorly preserved.
M.76.97.502

90

Dagger
Northern Iran; Iron Age I
(c. 1350–1000 B.C.)
l. of hilt: 11.5 cm.; l. of blade:
35.3 cm.
Bronze, cast; no surviving pommel;
four encircling ribs on grip;
very prominent midrib; edges
honed down.
M.76.97.503

91

Dagger Hilt
Western Iran; Iron Age II
(c. 1000–800 B.C.)
l: 10.3 cm.
Bronze, cast; split pommel terminating
in a double boss at each
side; a central boss or double-headed
rivet at pommel center;
originally on an iron blade.
M.76.97.505

92

Knife Handle (?)
Source uncertain; Iron Age I–II
(c. 1350–800 B.C.)
h: 7 cm.; l: 18.4 cm.
Bronze, cast; in the form of a
stylized lion passant, with a standing
gazelle in low relief, head
projecting at right angles to it at
top of blade; attribution of object
to Luristan is questionable.
M.76.97.653

Pub. Pope, 1938, IV, pl. 58 B.

93

Spearhead
Luristan; c. 2230–2100 B.C.
l: 39.8 cm.
Bronze, cast; Calmeyer, 1969,
group 16; poker-shaped; inscribed
along one end with the name
of a local ruler of Susa, Putzur- or
Kutik-Inshushinak.
M.76.97.486; ex-Holmes
Collection

94

Spearhead
Northern Iran; Iron Age I
(c. 1350–1000 B.C.) or earlier
l: 36.2 cm.
Bronze, cast; rat-tanged with
button base.
M.76.97.484

For early types, cf. Schmidt, 1937,
pls. L, LI; for later types, cf. Negahban,
1964, figs. 44, 46 (Marlik).

95

Spearhead
Northern Iran (?); Iron Age I
(c. 1350–1000 B.C.) or earlier
l: 27.5 cm.
Bronze, cast; short socket with
rivet holes; parallel incised lines
from socket base to tip along
the midrib; incised chevrons on
each side.
M.76.97.116

96

Arrowhead
Iran; Iron Age III–Achaemenid
period (c. 800–330 B.C.)
l: 4.2 cm.
Bronze, cast; trefoil; socketed.
M.76.174.119

cf. Moorey, 1971, nos. 81–83;
Cleuziou, 1977, pp. 187ff.

93

97

Macehead
Luristan; c. 2350–2100 B.C.
h: 15.8 cm.; w: 5.9 cm.
Bronze, cast; Calmeyer, 1969,
group 10; three lions couchant
facing upward, separated by three
pairs of segments; long tails
extended around tube; hole in
flange.
M.76.97.76

cf. Moorey, 1971, nos. 93, 94.

98

Macehead
Western or northern Iran;
Iron Age I (c. 1350–1000 B.C.)
h: 8.6 cm.; w: 3.5 cm.
Bronze, cast; eight protuberances
with spiral design at top and
bottom; date uncertain.
M.76.97.78

99

Macehead
Western or northern Iran;
Iron Age I (c. 1350–1000 B.C.)
h: 11.4 cm.; w: 6.3 cm.
Bronze, cast; Calmeyer, 1969,
group 27; triple faces on boss with
three projecting horns to serve all
three; noses form mace segments.
M.76.97.95

cf. Pope, 1938, IV, pl. 43 C.

100

Macehead
Luristan; Iron Age III
(c. 800–650 B.C.)
h: 11.5 cm.; w: 5.4 cm.
Bronze, cast; diamond-patterned
swelling; lower tube decorated
with two animals in relief; these
may be a recent embellishment.
M.76.97.83

101

Macehead
Luristan; Iron Age III
(c. 800–650 B.C.)
h: 14.7 cm.; w: 2.4 cm.
Bronze, cast; hollow tube with
five oval bosses at top.
M.76.174.72

For type, cf. Vanden Berghe, 1968,
pl. 30.

102

Macehead
Western Iran; Middle Elamite
(c. 1450–1200 B.C.)
h: 8 cm.; diam. 4.4 cm.
Bronze, cast; rounded top taper-
ing to base; low relief frieze of
standing figures: three men in
knee-length garments carrying
sheep on their shoulders toward a
standing man in ankle-length
robe, one hand on his chest, the
other on his waist; curled hair-
lock on the nape of his neck.
M.76.97.901

This object is not easily attributed.
The scene and style suggest an
Elamite workshop active in the
second half of the second millen-
nium B.C.

103

Handle or Socket
Luristan; c. 2600–2400 B.C.
h: 23.3 cm.
Bronze, cast; Calmeyer, 1969,
group 8; panels of herringbone in
relief at upper end.
M.76.174.77

cf. Moorey, 1971, no. 95.

104

Socket
Western Iran; c. 2600–2200 B.C.
h: 14.7 cm. w: 4.3 cm.
Bronze, cast; hollow tube closed
at one end; in a double frieze, three
male figures set foot to foot, arms
variously disposed; hole in base;
date uncertain.
M.76.97.24; ex-Farhadi Collection

Pub. New York, 1940, p. 107 C.

105

Socket
Western Iran; 2600–2200 B.C.
h: 12.4 cm.; diam: 3.2 cm.
Bronze, cast; hollow tube closed
at one end; three snakes in relief
on shaft, alternating with vertical
rows of tiny spikes; wire in two
holes at base.
M.76.97.25

cf. Moorey, 1971, no. 97.

97

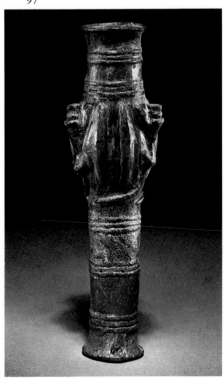

102

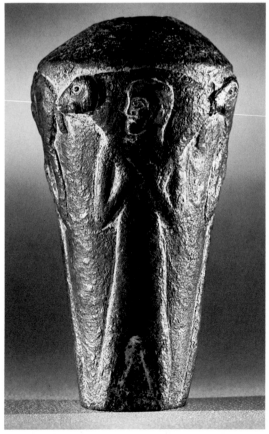

106

Socket
Western Iran; c. 2600–2200 B.C.
h: 16.8 cm.; w: 3.3 cm.
Bronze, cast; hollow tube with a
low relief frieze of two standing
goats; date uncertain.
M.76.97.51

cf. Moorey, 1971, p. 95.

Similar "handles" were used in
Sumer and Elam in the mid-third
millennium B.C.; this unusual
object may be a provincial variant.

107

Cylindrical Tube
Source and date uncertain
h: 13 cm.
Bronze, cast; central molding; no
distinguishing features.
M.76.97.88

108

Bident
Western Iran; Iron Age I–II
(c. 1350–800 B.C.)
h: 15.2 cm.; w: 9 cm.
Bronze, cast and hammered; long
socket and omega-shaped prongs.
M.76.97.49

cf. Moorey, 1971, no. 101.

109

Whetstone Socket
Luristan; Iron Age I
(c. 1350–1000 B.C.)
h. of socket: 9.5 cm.; l. of socket:
16.8 cm.; l. of hone: 17.5 cm.
Bronze, cast; Potratz, 1968, form A
(fig. 56); hone (possibly modern)
in place; wild goat's head terminal,
horns curving back to neck.
M.76.97.507

For type, cf. Moorey, *Archaeology*
24, 1971, nos. 103–107; for dating,
Vanden Berghe, 1971, p. 44,
figs. 17, 20.

110

Whetstone Socket
Luristan; Iron Age I
(c. 1350–1000 B.C.)
h. of socket: 10 cm.; l. of socket:
12 cm.; l. of hone: 12.5 cm.
Bronze, cast; Potratz, 1968, form A
(fig. 56); hone (possibly modern)
in place; wild goat's head terminal
with horns projecting forward
and slightly turned over at ends.
M.76.97.508

cf. cat. no. 109.

111

Whetstone Socket
Luristan; Iron Age I
(c. 1350–1000 B.C.)
h: 10.2 cm.; l: 10.5 cm.
Bronze, cast; Potratz, 1968, form A
(fig. 56); wild goat's head terminal
with horns curving back to touch
lower neck.
M.76.97.509

cf. cat. no. 109.

112

Whetstone Socket
Luristan; Iron Age I
(c. 1350–1000 B.C.)
h: 11 cm.; l: 6.6 cm.
Bronze, cast; Potratz, 1968, form A
(fig. 56); wild goat's head terminal
with horns curving back to touch
upper neck; animal wears some
kind of neck ring with a pendant;
a horned quadruped extending
from goat's chest is probably a
modern addition.
M.76.97.510

cf. cat. no. 109.

113

Whetstone Socket
Luristan; Iron Age I
(c. 1350–1000 B.C.)
l. of socket: 7.3 cm.; l. of hone:
12 cm.
Bronze, cast; Potratz, 1968, form A
(fig. 56); hone (possibly modern)
in place; wild goat's head terminal
with horns curving back to touch
upper neck; ring in suspension
hole; unusual patina.
M.76.97.512

cf. cat. no. 109.

114

Whetstone Socket
Luristan; Iron Age I
(c. 1350–1000 B.C.)
h. of socket: 6 cm.; l. of socket:
4.8 cm.; l. of hone: 12.3 cm.
Bronze, cast; Potratz, 1968, form A
(fig. 56); hone (possibly modern)
in place; a chain about 14 cm. long
is attached to beard of wild goat's
head terminal at one end and to
side loop of a pin at the other.
M.76.97.513; ex-Holmes Collection

cf. cat. no. 109.

106

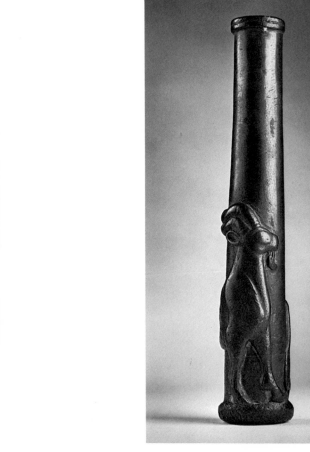

104

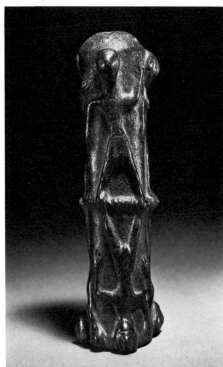

115

Whetstone Socket
Luristan; Iron Age I
(c. 1350–1000 B.C.)
h: 5.3 cm.; l: 5.6 cm.
Bronze, cast; Potratz, 1968, form A
(fig. 56); wild goat's head terminal
with horns curved back to touch
tips of prominent pointed ears; a
twisted rod extends from beard to
chest; loop on the back.
M.76.97.516

cf. cat. no. 109.

116

Whetstone Socket
Luristan; Iron Age I
(c. 1350–1000 B.C.)
h. of socket: 7.3 cm.; l. of socket:
9.9 cm.; l. of hone: 5.2 cm.
Bronze, cast; Potratz, 1968, form A
(fig. 56); part of hone (possibly
modern) in place; wild goat's head
terminal with horns turned over
to touch upper neck.
M.76.97.518

117

Whetstone Socket
Luristan; Iron Age I
(c. 1350–1000 B.C.)
h: 9.3 cm.; l: 9.5 cm.
Bronze, cast; double goats' heads
with a second small horned head,
perhaps a bovid, projecting for-
ward from their chests; this may
have been added in recent times.
M.76.97.511

118

Whetstone Socket
Luristan; Iron Age I
(c. 1350–1000 B.C.)
l. of socket: 6.9 cm.; l. of hone:
13.8 cm.
Bronze, cast; part of hone
(possibly modern) in place; socket
cast as the head of an animal with
spirally ribbed horns rendered flat
against the top of its head.
M.76.97.519a,b

119

Whetstone Socket
Luristan; Iron Age I
(c. 1350–1000 B.C.)
h: 8.6 cm.; l: 10.5 cm.
Bronze, cast; Potratz, 1968, form E
(fig. 64); forepart of a cervid with
a second head rising from the top
of the rear end of the socket; main
animal has a collar.
M.76.97.860

120

Whetstone Socket
Luristan; Iron Age I
(c. 1350–1000 B.C.)
l. of socket: 4.6 cm.; l. of hone:
11 cm.; w. of socket: 1.8 cm.
Bronze, cast; hone in place; termi-
nal cast as a boar's head; wire loop
through attachment holes.
M.76.97.520

121

Whetstone Socket
Luristan; Iron Age I
(c. 1350–1000 B.C.)
h: 5.3 cm.; l: 8.2 cm.
Bronze, cast; Potratz, 1968, form D
(fig. 62); terminal cast as a horn-
less creature of uncertain identity
(possibly a predator) holding a
detached wild goat's head in its
paws; horns curve out to touch
base of predator's neck.
M.76.97.517

122

Whetstone Socket
Luristan; Iron Age I–II
(c. 1350–800 B.C.)
l. of socket: 3 cm.; l. of hone:
12 cm.; w. of socket: 2.7 cm.
Bronze, cast; hone (possibly
modern) in place; terminal cast as
a stylized lion's head; suspension
loop below.
M.76.97.521

120

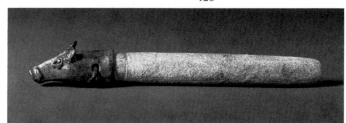

115

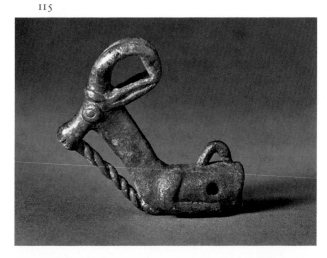

121

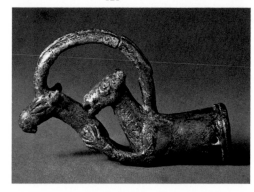

119

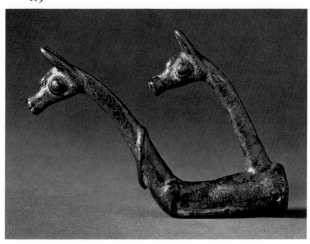

122

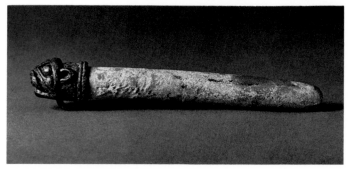

123

Whetstone Socket
Luristan; Iron Age I–II
(c. 1350–800 B.C.)
h: 4.5 cm.; l: 7.8 cm.
Bronze, cast; grotesquely stylized
feline creature couchant with jaws
agape; wire in place for securing
a hone now lost.
M.76.97.523

124

Whetstone Socket
Luristan; Iron Age I–II
(c. 1350–800 B.C.)
h. of socket: 6.6 cm.; l. of socket:
6.6 cm.; l. of hone: 10 cm.
Bronze, cast; hone in place; wild
goat terminal with horns curled
over at top and joined to back by a
straight rod; socket is decorated
with three snakes in relief; a highly
stylized subhuman face is set on
animal's chest.
M.76.97.514

125

Whetstone Socket
Luristan; Iron Age II–III
(c. 1000–650 B.C.)
h: 8.8 cm.; w: 8 cm.
Bronze, cast; master/mistress
of animals in the most distinctive
Luristan style; central head
threatened by lions.
M.76.97.38; ex-Holmes Collection

Pub. New York, 1940, p. 105 O.

126

Whetstone Socket
Luristan; Iron Age II–III
(c. 1000–650 B.C.)
h: 9.5 cm.; w: 7.2 cm.
Bronze, cast; master/mistress of
animals in the most distinctive
Luristan style; central figure
threatened by lions.
M.76.97.39

cf. cat. no. 125.

127

Whetstone Socket
Luristan; Iron Age II–III
(c. 1000–650 B.C.)
h: 12.5 cm.; w: 6 cm.
Bronze, cast; tube closed at one
end by a recumbent lion in typical
Luristan style; rivet holes at base;
damaged.
M.76.97.26

125

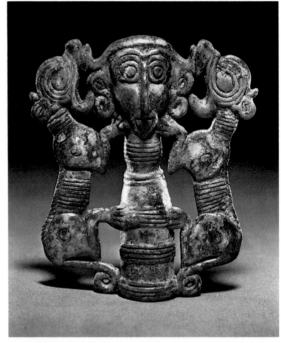

123

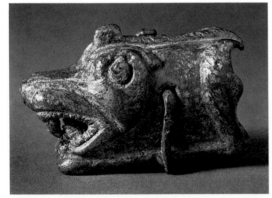

124

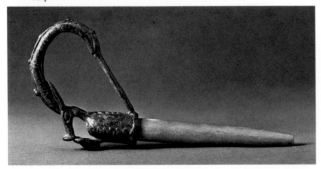

127

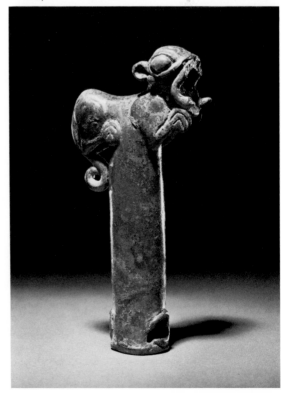

Horse Trappings

The horse played an important role in the life of Luristan long before its presence is documented by metal harness trappings, none of which may yet be securely dated before 1000 B.C. The horse bits and decorative fittings listed here were primarily for chariot and parade horses. Organic materials would have sufficed for routine daily use on horses, for which neither the saddle nor the stirrup had yet been developed. None of these richly decorated objects has yet been found in a controlled excavation, so it is not yet positively known whether they accompanied burials of animals or were placed in human graves. Horse burials have been excavated in western Iran, but the equipment is relatively simple. For example, a horse burial of Iron Age III date (seventh century B.C.) at Baba Jan Tepe in eastern Luristan contained an iron bit, five bronze decorative studs, and a bronze bowl and lamp. (For further information, see Potratz, 1966, and Moorey, 1971, pp. 101ff.)

128

Horse Bit
Luristan; Iron Age II–III
(c. 1000–650 B.C.)
h. of cheekpieces: 11.3 cm.; l. of cheekpieces: 11.5 cm.; l. of mouthpiece: 17.6 cm.
Bronze, cast; Potratz, 1966, type I; subrectangular openwork plaques; wild goat's head on the upper front corner of each cheekpiece; rigid mouthpiece may not be original; cheekpieces largely restored.
M.76.97.109; ex-Holmes Collection

Pub. New York, 1940, p. 52 K; cf. Potratz, 1966, pp. 103ff.; Calmeyer, 1969, pp. 76–78; Moorey, 1971, pp. 107–109.

129

Horse Bit
Luristan; Iron Age II–III
(c. 1000–650 B.C.)
h. of cheekpieces: 8.5 cm.; l. of cheekpieces: 12.5 cm.; l. of mouthpiece: 19 cm.
Bronze, cast; Potratz, 1966, type I; subrectangular openwork plaques; mouflon head facing sideways on the upper front corner of each cheekpiece; rigid mouthpiece.
M.76.97.115

cf. cat. no. 128.

130

Horse Bit
Luristan; Iron Age II–III
(c. 1000–650 B.C.)
h. of cheekpieces: 3.5 cm.; l. of cheekpieces: 16 cm.; l. of mouthpiece: 25.8 cm.
Bronze, cast; Potratz, 1966, type III; jointed mouthpiece; bar cheekpieces with some incised decoration; rings at ends of mouthpieces cast as one piece.
M.76.97.113

cf. Potratz, 1966, pp. 135ff.; Moorey, 1971, pp. 111–12.

131

Horse Bit
Luristan; Iron Age II–III
(c. 1000–650 B.C.)
h. of cheekpieces: 4.5 cm.; l. of cheekpieces: 18.5 cm.; l. of mouthpiece: 31.5 cm.
Bronze, cast; Potratz, 1966, type III; jointed mouthpiece; plain bar cheekpieces with rein rings moving freely in a hand at each end of mouthpiece.
M.76.97.114

cf. cat. no. 130.

132

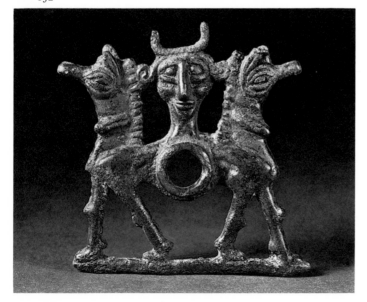

133

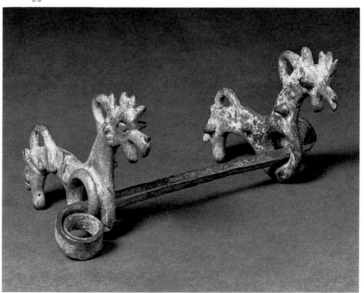

132

Cheekpiece from a Horse Bit
Luristan; Iron Age II–III
(c. 1000–650 B.C.)
h: 12.2 cm.; l: 12 cm.
Bronze, cast; Potratz, 1966, type IV
D; addorsed equid heads and front
feet with a female face set between
them, the latter with bull's horns
and curling sidelocks.
M.76.97.97

cf. Potratz, 1966, p. 141, fig. 32f.

133

Horse Bit
Luristan; Iron Age II–III
(c. 1000–650 B.C.)
h. of cheekpieces: 6.6 cm.; l. of
cheekpieces: 12.2 cm.; l. of mouth-
piece: 17.3 cm.
Bronze, cast; Potratz, 1966, type
IV; v-shaped cheekpieces with
a bird head at one end, an equid
head at the other; rigid mouth-
piece.
M.76.97.111

cf. Potratz, 1966, pp. 138ff.;
Moorey, 1971, pp. 112–14.

134

Horse Bit
Luristan; Iron Age II–III
(c. 1000–650 B.C.)
h. of cheekpieces: 5.7 cm.; l. of
cheekpieces: 10.8 cm.; l. of mouth-
piece: 20.5 cm.
Bronze, cast; Potratz, 1966, type
IV; v-shaped cheekpieces termi-
nating in the heads of predatory
birds; jointed mouthpiece with
D-shaped rein rings; some modern
restoration.
M.76.97.117

cf. Moorey, 1971, no. 115; cat.
no. 133.

135

Horse Bit
Luristan; Iron Age II–III
(c. 1000–650 B.C.)
h. of cheekpieces: 11.2 cm.; l. of
cheekpieces: 12.5 cm.; l. of mouth-
piece: 19.2 cm.
Bronze, cast; Potratz, 1966, type
V.D.a; horse-shaped cheekpieces
with an ancient repair; rigid
mouthpiece with traces of wear
on holes.
M.76.97.118

cf. Potratz, 1966, pp. 160ff.;
Moorey, 1971, nos. 117–19.

136

Cheekpiece from a Horse Bit
Luristan; Iron Age II–III
(c. 1000–650 B.C.)
h: 8.8 cm.; l: 12 cm.
Bronze, cast; Potratz, 1966, type
V.D.a; in the shape of a horse
advancing left; wears a collar.
M.76.97.121

cf. cat. no. 135.

135

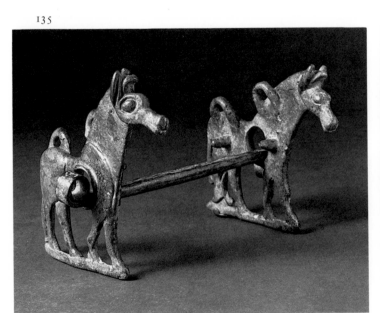

136

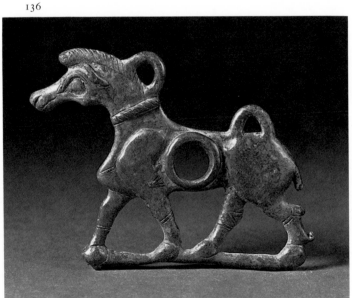

137

Cheekpiece from a Horse Bit
Luristan; Iron Age II–III
(c. 1000–650 B.C.)
h: 8.6 cm.; l: 8.8 cm.
Bronze, cast; Potratz, 1966, type
V.D.; in the shape of a horse facing
left, its front left and rear right
legs hobbled together; wears a
collar with a pendant.
M.76.97.128; ex-Holmes Collection

Pub. New York, 1940, p. 521 L; cf.
Orthmann, 1975, pl. 319b.

138

Cheekpiece from a Horse Bit
Luristan; Iron Age II–III
(c. 1000–650 B.C.)
h: 8 cm.; l: 9.2 cm.
Bronze, cast; Potratz, 1966, type
V.D.a; in the shape of a horse ad-
vancing right.
M.76.97.131

cf. cat. no. 135.

139

Cheekpiece from a Horse Bit
Luristan; Iron Age II–III
(c. 1000–650 B.C.)
h: 14.5 cm.; l: 11.3 cm.
Bronze, cast; Potratz, 1966, type
V.C.b; in the shape of a winged
mouflon, head turned forward,
advancing right; incised details;
signs of wear on mouthpiece hole;
one horn broken off.
M.76.97.98

cf. Potratz, 1966, pp. 156ff.;
Moorey, 1971, pp. 118ff.

140

Cheekpiece from a Horse Bit
Luristan; Iron Age II–III
(c. 1000–650 B.C.)
h: 12.4 cm.; l: 13 cm.
Bronze, cast; Potratz, 1966, type
V.C.b; in the shape of a winged
mouflon, head turned forward,
advancing left; animal is shown
trampling on a pair of addorsed
wild goats; rosette incised on
haunch; tail and horn repairs.
M.76.97.100

Pub. Potratz, 1966, p. 156, pl. LXIII,
fig. 147, right; cf. cat. no. 139.

141

Cheekpiece from a Horse Bit
Luristan; Iron Age II–III
(c. 1000–650 B.C.)
h: 13.5 cm.; l: 15 cm.
Bronze, cast; Potratz, 1966, type
V.C.b; in the shape of a winged
mouflon, head forward, advanc-
ing left; twisted tail; incised
decoration.
M.76.97.101

cf. cat. no. 139.

142

Cheekpiece from a Horse Bit
Luristan; Iron Age II–III
(c. 1000–650 B.C.)
h: 10.1 cm.; l: 9.5 cm.
Bronze, cast; Potratz, 1966, type
V.C.b; in the shape of a winged
mouflon, head forward, advanc-
ing right; incised details; authen-
ticity uncertain.
M.76.97.110

143

Horse Bit
Luristan; Iron Age II–III
(c. 1000–650 B.C.)
h. of cheekpieces: 11.5 cm.; l. of
cheekpieces: 9 cm.; l. of mouth-
piece: 17 cm.
Bronze, cast; Potratz, 1966, type
V.C.a; mouflon-shaped cheek-
pieces; rigid mouthpiece.
M.76.97.112

The absence of raised collars
around the holes for the mouth-
piece, or of any sign of wear,
suggest a modern date of manu-
facture for the cheekpieces.

144

Pair of Cheekpieces from a Horse Bit
Luristan; Iron Age II–III
(c. 1000–650 B.C.)
h. of a: 14.3 cm.; l. of a: 13.7 cm.;
h. of b: 16 cm.; l. of b: 13.5 cm.
Bronze, cast; Potratz, 1966, type
V.C.b; in the shape of a winged
mouflon; incised rosettes on
shoulders and haunches; tips of
groundline modeled as animal
heads; extremities of wings
damaged.
M.76.97.124a,b; ex-Mozaffar
Cohen Collection

Pub. Pope, 1938, IV, pl. 34 A;
Potratz, 1966, p. 156, fig. 64f
(M.76.97.124a).

137

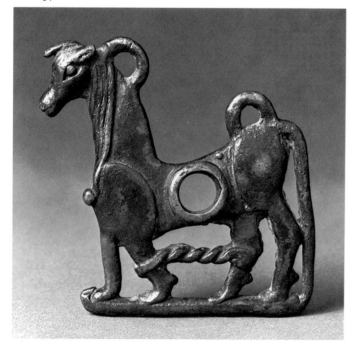

141

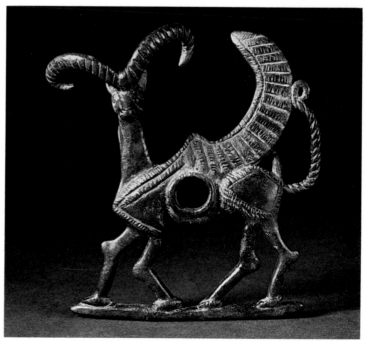

Cheekpiece from a Horse Bit
Luristan; Iron Age II–III
(c. 1000–650 B.C.)
h: 6.8 cm.; l: 12.3 cm.
Bronze, cast; Potratz, 1966, type
V.B.a; in the shape of a lion advanc-
ing left, its head in profile and its
jaws agape; traces of wear on
mouthpiece hole.
M.76.97.104; ex-Farhadi Collection

Pub. New York, 1940, p. 100 K;
Potratz, 1966, p. 151, pl. LVIII, fig.
141a, right (after a 1931 Sotheby
catalog).

144

145

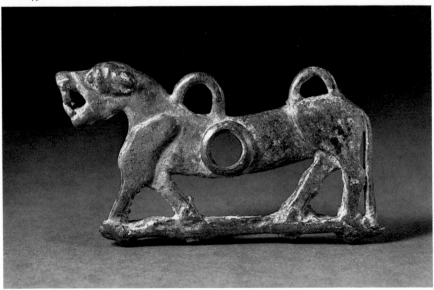

146

Cheekpiece from a Horse Bit
Luristan; Iron Age II–III
(c. 1000–650 B.C.)
h: 8.5 cm.; l: 9.5 cm.
Bronze, cast; Potratz, 1966, type
V.B.d; in the shape of a stylized
winged lion advancing left; traces
of wear on mouthpiece hole.
M.76.97.105; ex-Farhadi Collection

Pub. New York, 1940, p. 98 KK;
Potratz, 1966, p. 153, pl. 58, fig.
141b, right (after a 1931 Sotheby
catalog).

147

Horse Bit
Luristan; Iron Age II–III
(c. 1000–650 B.C.)
h. of cheekpieces: 8 cm.; l. of
cheekpieces: 9.2 cm.; l. of mouth-
piece: 23.5 cm.
Bronze, cast; Potratz, 1966, type V;
cheekpieces in the shape of Asiatic
water buffalo, recumbent with
heads forward; rigid mouthpiece.
M.76.97.107

148

Cheekpiece from a Horse Bit
Luristan; Iron Age II–III
(c. 1000–650 B.C.)
h: 8.3 cm.; l: 7.3 cm.
Bronze, cast; Potratz, 1966,
type V.A.a; in the shape of a young
bovid advancing right, head
turned forward.
M.76.97.125

For type, cf. Potratz, 1966, p. 146.

149

Cheekpiece from a Horse Bit
Luristan; Iron Age II–III
(c. 1000–650 B.C.)
h: 5 cm.; l: 12 cm.
Bronze, cast; Potratz, 1966, type
V.F.; in the shape of a recumbent
wild boar facing left.
M.76.97.129

cf. Pope, 1938, IV, pl. 31 A; Potratz,
1966, p. 168; Moorey, 1971, no. 124.

150

Cheekpiece from a Horse Bit
Luristan; Iron Age II–III
(c. 1000–650 B.C.)
h: 12.3 cm.; l: 10.5 cm.
Bronze, cast; Potratz, 1966, type
V.A.b; in the shape of a winged
sphinx advancing left; crescentic
wing and full-face subhuman head
with bovid horns and sidelocks;
wears a necklace.
M.76.97.96

cf. Pope, 1938, IV, pl. 33 A; Pope,
1945, pl. 11; Potratz, 1966, pp.
148ff.; Moorey, 1971, no. 125.

147

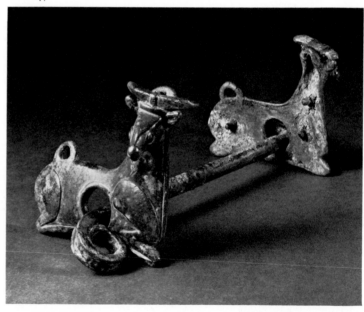

149

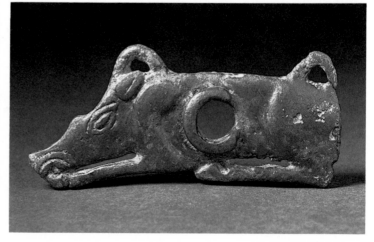

146

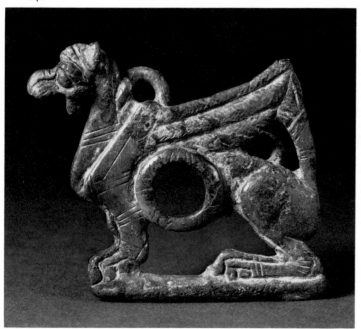

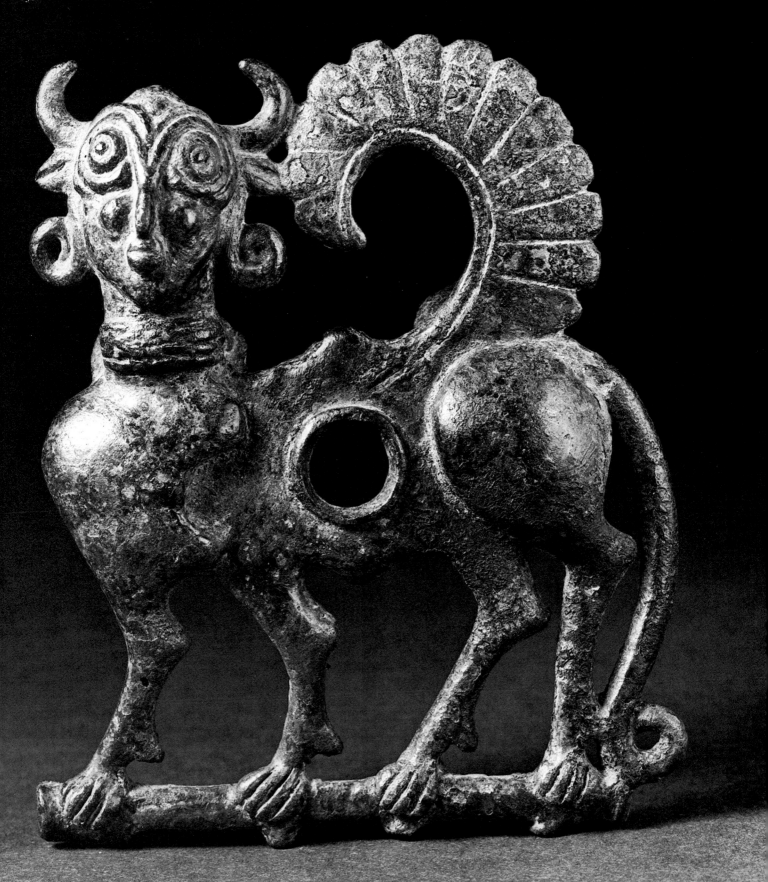

151

Cheekpiece from a Horse Bit
Luristan; Iron Age II–III
(c. 1000–650 B.C.)
h: 18.5 cm.; l: 16.7 cm.
Bronze, cast; Potratz, 1966, type
V.A.b; in the shape of a winged
sphinx advancing left; frontal
subhuman face with prominent
sweep of bovid horns and curling
sidelocks; wears a necklace.
M.76.97.99; ex-Farhadi Collection

Pub. Rome, 1956, p. 84, no. 115,
pl. X; possibly the mate to Pope,
1938, IV, pl. 32 B (Potratz, 1966,
p. 149, fig. 63c).

152

Pair of Cheekpieces from a Horse Bit
Luristan; Iron Age II–III
(c. 1000–650 B.C.)
h. of a: 13.4 cm.; l. of a: 11 cm.;
h. of b: 13 cm.; l. of b: 10.8 cm.
Bronze, cast; Potratz, 1966, type
V.A.b; in the shape of winged
sphinxes standing on pairs of ad-
dorsed, crouching wild goats;
sphinxes have frontal female faces
with bovid horns.
M.76.97.108a,b.

cf. cat. no. 150.

153

Cheekpiece from a Horse Bit
Luristan; Iron Age II–III
(c. 1000–650 B.C.)
h: 8.2 cm.; l: 7.5 cm.
Bronze, cast; Potratz, 1966, type
V.D.d; in the shape of a sphinx
facing left; profile head with
broad band of hair; rosette incised
on haunch.
M.76.97.120

154

Pair of Cheekpieces from a Horse Bit
Luristan; Iron Age II–III
(c. 1000–650 B.C.)
h: 14.2 cm.; l: 15 cm.
Bronze, cast; Potratz, 1966, type
V.H.a.; in the shape of a horned
master/mistress of animals flanked
by winged feline creatures with
profile heads, the whole set upon a
pair of addorsed goats; signs of
wear on mouthpiece holes.
M.76.97.102 and .103; ex-Colls.
Farhadi and Holmes

Pub. London, 1931, entry 13–g;
Pope, 1938, IV, pl. 28 A; Rome,
1956, no. 117, pl. XII; Potratz, 1966,
p. 173, fig. 75.

151

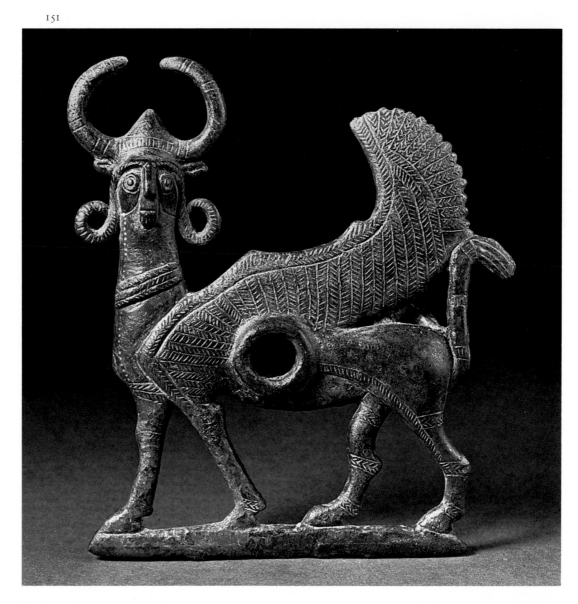

152

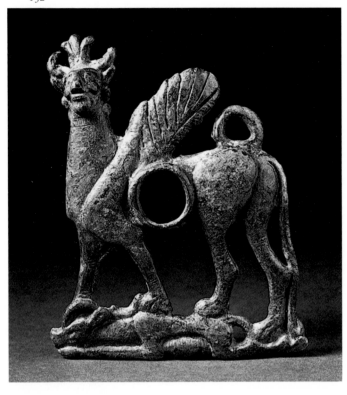

153

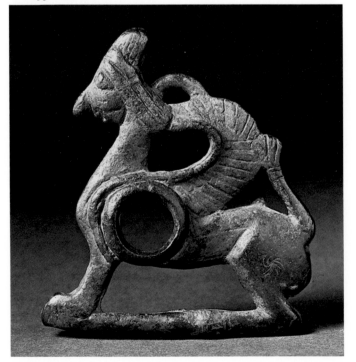

154

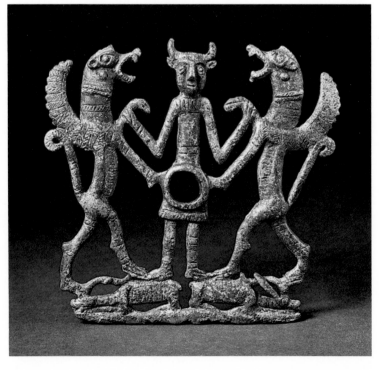

155

Cheekpiece from a Horse Bit
Luristan; Iron Age II–III
(c. 1000–650 B.C.)
h: 15.2 cm.; l: 22 cm.
Bronze, cast; Potratz, 1966, type
v.H.a; in the shape of a horned
master/mistress of animals flanked
by rampant winged lions with
heads turned forward, jaws agape,
standing on a pair of addorsed
wild goats; left-hand head and
lower-right section are modern
restorations.
M.76.97.106; ex-Colls. Mozaffar
Cohen and Holmes

Pub. Pope, 1938, IV, pl. 29 A; Diez,
1944, fig. 3; Pope, 1945, pl. 9;
Potratz, 1966, p. 172, pl. LXX, fig.
169a (after a 1931 Sotheby catalog);
cf. Godard, 1962, pl. 16.

156

Cheekpiece from a Horse Bit
Luristan; Iron Age II–III
(c. 1000–650 B.C.)
h: 10.1 cm.; l: 10.6 cm.
Bronze, cast; Potratz, 1966, type
v.H.d; shaped as a pair of winged
and kilted genii, their outer hands
grasping rings set on their heads,
their inner hands the branches of a
central tree; foliage is topped by
stylized goats' heads.
M.76.97.122

Pub. Columbus, 1951, no. 42, ill.

The authenticity of the distinctive
cheekpieces of this design has been
questioned. Although at least some
seem to be ancient (note the wear
on cat. nos. 157 and 158 here),
this example has the appearance
of a modern copy.

157

Cheekpiece from a Horse Bit
Luristan; Iron Age II–III
(c. 1000–650 B.C.)
h: 10.9 cm.; l: 9.6 cm.
Bronze, cast; Potratz, 1966, type
v.H.d; type as in cat. no. 156,
although varying much in work-
manship; hole for mouthpiece
shows signs of wear.
M.76.97.123; ex-Farhadi Collection

Pub. New York, 1940, p. 98 EE.

158

Cheekpiece from a Horse Bit
Luristan; Iron Age II–III
(c. 1000–650 B.C.)
h: 11.5 cm.; l: 12.7 cm.
Bronze, cast; Potratz, 1966, type
v.H.d; type as in cat. no. 156; wear
on mouthpiece hole.
M.76.97.126; ex-Farhadi Collection

Pub. New York, 1940, p. 98 DD.

159

Cheekpiece from a Horse Bit
Luristan; Iron Age II–III
(c. 1000–650 B.C.)
h: 10.5 cm.; w: 10.8 cm.
Bronze, cast; Potratz, 1966, type
v.H.c; in the form of a bowlegged
central demon flanked by rampant
animals; all have curled horns;
entire motif is framed within bars
and blobs.
M.76.97.127; ex-Holmes Collection

Pub. New York, 1940, p. 106 R,
possibly a pair with Potratz, 1966,
pl. LXXI, no. 170 (Stora Collec-
tion); cf. Moorey, 1974, nos. 46, 47.

This cheekpiece is from a group
regarded with suspicion because
of its stylistic isolation; however,
nothing clearly identifies it to the
naked eye as modern.

160

Cheekpiece from a Horse Bit
Luristan; Iron Age II–III
(c. 1000–650 B.C.)
h: 9 cm.; l: 11 cm.
Bronze, cast; Potratz, 1966, type
v.N.; in the shape of an archer with
bow, taking aim in a chariot with
four-spoked wheel, drawn by a
lion toward the left.
M.76.97.130; ex-Ackermann-Pope
Collection

Pub. Pope, 1938, I, p. 861, fig. 299;
New York, 1940, pp. 100–101 N;
Bowie, 1966, p. 63, pl. 80; Potratz,
1966, p. 178.

Some of the detached cheekpieces
with this distinctive design are
known to be modern copies; the
status of this example has yet to be
established. The Louvre has an
example of the corresponding
cheekpiece, moving to the right
(Ghirshman, 1964, fig. 73).

158

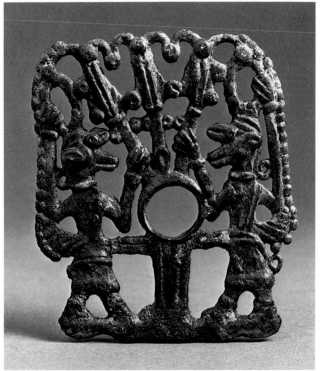

159

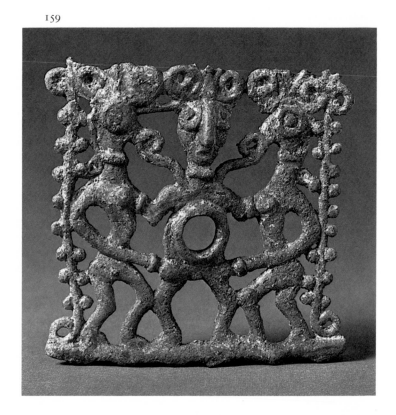

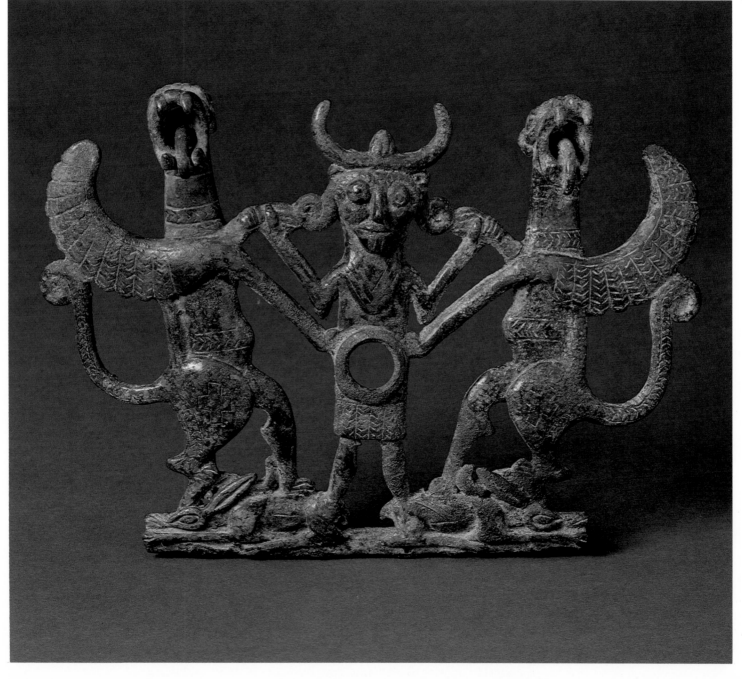

161

Horse Bit
Northwestern Iran; Iron Age II
(c. 1000–800 B.C.)
h. of cheekpieces: 9 cm.; l. of
cheekpieces: 8 cm.; l. of mouth-
piece: 17 cm.
Bronze, cast; cheekpieces in the
form of flat, spread-winged birds
with striated bodies; heads exe-
cuted in relief; cheek strap loops
on wing tops; rigid mouthpiece
with both terminal loops curved
in the same direction.
M.76.97.116

The antiquity of this bit is an open
question; similar fittings were
used as bowl handles at Hasanlu in
Azerbaijan in level IV (Iron Age II).

162

Harness Rings
Luristan; Iron Age II–III
(c. 1000–650 B.C.)
h: 11 cm.; w: 10.5 cm.
Bronze, cast; Potratz, 1968, form
O; pair of open rings, each with
four spokes around a central aper-
ture; mouflon head on top, its
horns arching over to touch preda-
tory beasts standing on each side
of ring; rear loop.
M.76.97.180 and .181

For these objects, cf. Moorey,
1971, pp. 127ff.

166

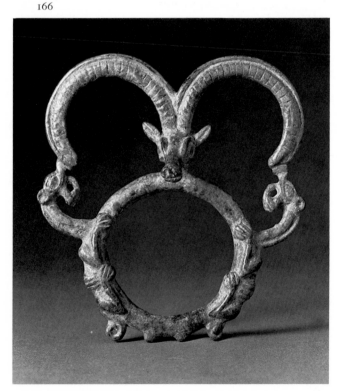

163

Harness Ring
Luristan; Iron Age II–III
(c. 1000–650 B.C.)
h: 8.8 cm.; w: 10.5 cm.
Bronze, cast; Potratz, 1968,
form B; open ring with mouflon
head on top, its horns sweeping
around to touch predatory beasts
on either side of ring; their heads
rendered frontally; rear loop.
M.76.97.192

cf. cat. no. 162.

164

Harness Ring
Luristan; Iron Age II–III
(c. 1000–650 B.C.)
h: 9.5 cm.; w: 8.2 cm.
Bronze, cast; Potratz, 1968, form
A; open ring with mouflon head on
top, its horns arching over to
touch nose tips of predatory
beasts standing on either side
on outer edges of ring; rear loop.
M.76.97.194

cf. Pope, 1938, IV, pl. 39 E; cf. cat.
no. 162.

165

Harness Ring
Luristan; Iron Age II–III
(c. 1000–650 B.C.)
h: 10.2 cm.; w: 8.3 cm.
Bronze, cast; Potratz, 1968, form A;
open ring with mouflon head on
top flanked by a pair of preda-
tory beasts standing on ring
edges; rear loop.
M.76.97.195

cf. cat. no. 162.

166

Harness Ring
Luristan; Iron Age II–III
(c. 1000–650 B.C.)
h: 10.6 cm.; w: 10 cm.
Bronze, cast; Potratz, 1968, form A;
open ring with mouflon head on
top, its sweeping horns touching
predatory beasts crouching on
either side of loop; rear loop.
M.76.97.200; ex-Colls. Holmes
and Stora

Pub. Pope, 1938, IV, pl. 39 F.

167

Harness Ring
Luristan; Iron Age II–III
(c. 1000–650 B.C.)
h: 8.8 cm.; w: 4.3 cm.
Bronze, cast; Potratz, 1968,
form N; open ring with mouflon
standing on upper edge; rear
loop; probably one of a pair.
M.76.97.219

cf. Moorey, 1974, no. 53.

168

Harness Ring
Luristan; Iron Age II–III
(c. 1000–650 B.C.)
h: 8.5 cm.; w: 8.5 cm.
Bronze, cast; Potratz, 1968, form D;
open ring with mouflon head
on top; to the left, a predatory
head on a long neck projecting
up from ring; long neck curl;
rear loop.
M.76.97.196

Such asymmetrical rings are nor-
mally part of a pair.

169

Harness Rings
Luristan: Iron Age II–III
(c. 1000–650 B.C.)
h: 13.2 cm.; w: 12.5 cm.
Bronze, cast; Potratz, 1968, form L;
a pair of rings, each with a mou-
flon head on top, the arc of its
horns framing a grotesque horned
head on each side; a predatory
beast set on either side of the cir-
cumference; another horned face,
framed by spiral coils, set in the
main circle; rear and lower loops.
M.76.97.179a,b; ex-Holmes
Collection

Pub. Pope, 1938, I, p. 262, fig. 56;
Pope, 1945, pl. 8.

170

Harness Ring
Luristan; Iron Age II–III
(c. 1000–650 B.C.)
h: 8.2 cm.; w: 7.3 cm.
Bronze, cast; Potratz, 1968,
form O; ring with eight spokes
around a central aperture; mou-
flon head on top, its horns curved
around to touch a grotesque
face set on either side of ring;
below them, a spiral coil; rear loop.
M.76.97.197

171

Harness Ring
Luristan; Iron Age II–III
(c. 1000–650 B.C.)
h: 8.3 cm.; w: 8.8 cm.
Bronze, cast; Potratz, 1968, form K;
open ring with a mouflon head
on top, the arc of its horns framing
a grotesque horned head set on
ring; lower on either side, a preda-
tory beast standing on circumfer-
ence; rear loop.
M.76.97.198; ex-Holmes Collection

Pub. New York, 1940, p. 94 B.

172

Harness Ring
Luristan; Iron Age II–III
(c. 1000–650 B.C.)
h: 6 cm.; w: 7.6 cm.
Bronze, cast; Potratz, 1968, form S;
ring with four spokes; grotesque
horned face at top, flanked by
a predatory beast on either side
climbing up sides of ring; rear
and lower loops.
M.76.97.199

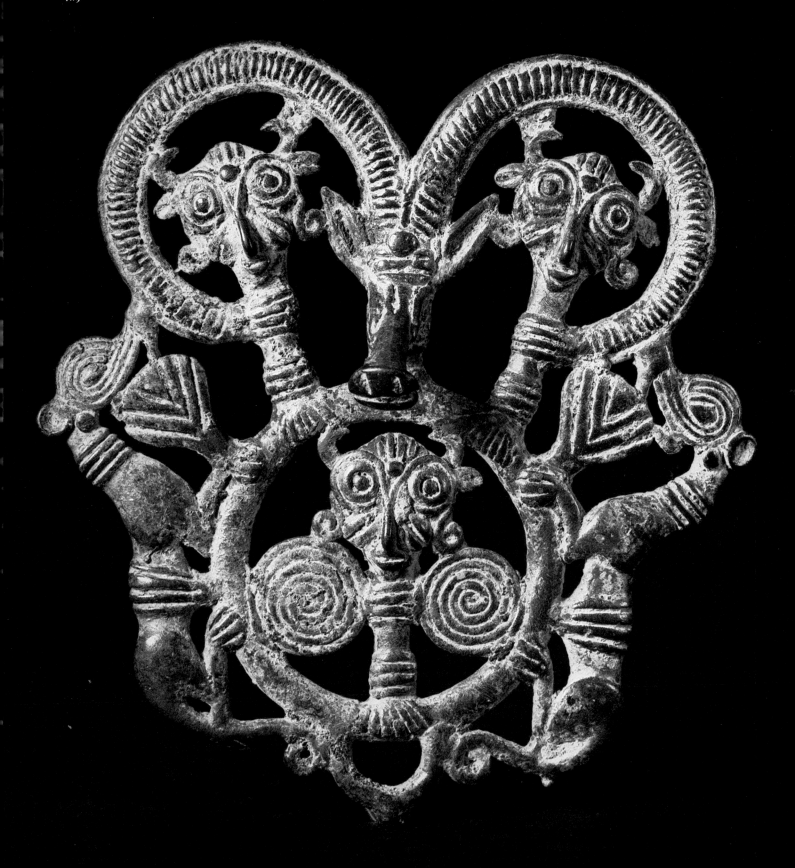

173

Harness Ring
Luristan; Iron Age II–III
(c. 1000–650 B.C.)
h: 5 cm.; w: 4.4 cm.
Bronze, cast; open ring with an
elongated lion on either side
grasping rim.
M.76.97.221

174

Harness Ring
Luristan; Iron Age II–III
(c. 1000–650 B.C.)
h: 6 cm.; diam: 4 cm.
Bronze, cast; open ring with two
roaring lions' heads paired at top;
vertical loop between them; small
open circles punched or incised
on ring.
M.76.97.218

175

Harness Ring
Luristan; Iron Age II–III
(c. 1000–650 B.C.)
diam: 3.9 cm.
Bronze, cast; open ring with juxta-
posed stylized lion heads at top;
rear loop.
M.76.97.345

176

Harness Ring
Luristan; Iron Age II–III
(c. 1000–650 B.C.)
diam: 3.2 cm.
Bronze, cast; open ring decorated
with two swimming ducks set on
either side of hoop; break in hoop.
M.76.174.88

177

Harness Ring
Luristan; Iron Age II–III
(c. 1000–650 B.C.)
w: 9.3 cm.
Bronze, cast; open ring, its upper
surface decorated with juxtaposed
profile lion heads in distinctive
Luristan style; side loops.
M.76.97.897

178

Harness Ring
Luristan; Iron Age II–III
(c. 1000–650 B.C.)
h: 11.5 cm.; w: 11 cm.
Bronze, cast; figure-eight loop
with a mouflon head rising verti-
cally from each ring, its rump
summarily rendered in relief on
ring edge; between the heads, a
predatory beast.
M.76.97.191; ex-Mabon Collection

Pub. Pope, 1938, IV, pl. 390; New
York, 1940, p. 549 GGG.

179

Harness Ring
Luristan; Iron Age II–III
(c. 1000–650 B.C.)
h: 7.5 cm.; w: 9.5 cm.
Bronze, cast; partly of iron, onto
which the bronze has been cast;
figure eight; stylized lion mask at
ring junction surmounted by a
mouflon head with sweeping
horns; each arc frames a grotesque
subhuman creature on the back
of a stylized lion moving outward;
loop on each side.
M.76.97.193

180

Harness Ring
Western Iran; Iron Age II–III
(c. 1000–650 B.C.)
h: 7.3 cm.; w: 10.5 cm.
Bronze, cast; figure eight; recum-
bent ram at top of each ring with
a lion in the center; a third lion
threatening the right-hand ram;
double spiral at ring junction;
chased chevrons and dots on inner
ring diameter; atypical Luristan
style.
M.76.97.217

cf. Moorey, 1974, no. 56 A.

181

Harness Ring
Luristan; Iron Age II–III
(c. 1000–650 B.C.)
h: 7.8 cm.; w: 4.6 cm.
Bronze, cast; fragmentary figure
eight in coil technique; a standing
mouflon on the surviving open
ring.
M.76.97.220

182

Harness Ring
Luristan; Iron Age II–III
(c. 1000–650 B.C.)
h: 12.5 cm.; w: 13 cm.
Bronze, cast; quadruple ring
formed by two juxtaposed mou-
flon heads whose ribbed horns
form complete circles; small loops
at the back, one above each head.
M.76.97.201

183

Harness Fitting
Luristan; Iron Age II–III
(c. 1000–650 B.C.)
h: 6 cm.; l: 20 cm.
Bronze, cast; rectangular, ridged
plaque with a loop at each end;
along the top, a line of five
mouflon heads in relief, horns
touching, with a triangular floral
device between each one.
M.76.97.202

cf. Pope, 1938, IV, pl. 59 K.

The function of such fittings is
unknown.

174

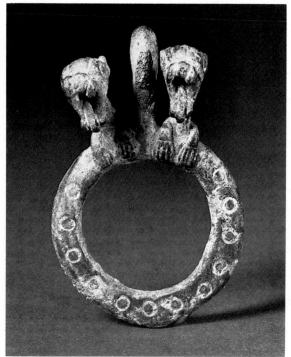

179

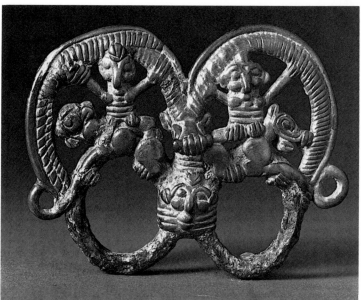

184

Harness Fitting
Luristan; Iron Age II–III
(c. 1000–650 B.C.)
h: 5 cm.; l: 23 cm.
Bronze, cast; bar with a loop at
each end; along the top in relief, a
row of six mouflon heads with
grotesque subhuman faces set be-
tween them.
M.76.97.203

cf. cat. no. 183.

185

Harness Fitting
Luristan; Iron Age II–III
(c. 1000–650 B.C.)
h: 7 cm.; w: 12 cm.
Bronze, cast; narrow openwork
plaque, with a lion passant; two
mouflon heads in relief on upper
edge with a roundel between;
broken at one end.
M.76.97.216

186

Harness Fitting ("Bow Ring")
Luristan; 1st millennium B.C.
h: 4.6 cm.; w: 2.8 cm.
Bronze, cast; horizontal figure
eight with a bovid head rising
from the center; ring in one ear.
M.76.97.829

For this type of object, whose
function is uncertain, cf. Moorey,
1971, pp. 134ff.

187

Harness Fitting ("Bow Ring")
Luristan; 1st millennium B.C.
h: 6.1 cm.; w: 2 cm.
Bronze, cast; horizontal figure
eight with a wild goat's head ris-
ing from the center, horns curved
over to form a loop.
M.76.97.830

cf. cat. no. 186.

188

Harness Fitting ("Bow Ring")
Luristan; 1st millennium B.C.
h: 4.9 cm.; w: 2.2 cm.
Bronze, cast; horizontal figure
eight with a vertical wild goat's
head at the center, horns sweeping
back to touch ring.
M.76.97.958

cf. cat. no. 186.

189

Harness Fitting ("Bow Ring")
Luristan; 1st millennium B.C.
h: 4.1 cm.; w: 2 cm.
Bronze, cast; double ring with a
vertical suspension loop rising at
right angles where the two are
joined; on either side, a carefully
modeled horned animal head.
M.76.97.959

cf. Moorey, 1971, no. 149.

190

Bell
Western Iran; Iron Age II–III
(c. 1000–650 B.C.)
h: 7.7 cm.; w: 10.9 cm.
Bronze, cast; oval openwork cage
with one ball inside; top suspen-
sion loop; plain bars curving
downward from a top ridge sur-
mounted at one end by a wild
goat protome.
M.76.97.528

For this and the following bells,
cf. Moorey, 1971, pp. 137ff.; ibid.,
1974, pp. 97ff.

184

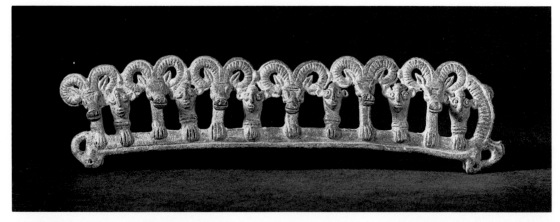

180

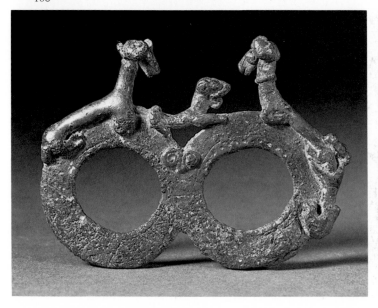

182

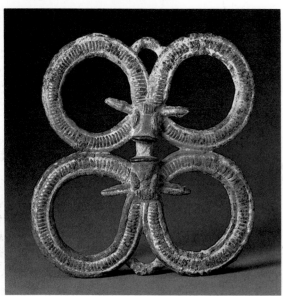

49

191

Bell
Western Iran; Iron Age II–III
(c. 1000–650 B.C.)
h: 12.7 cm.; w: 6.7 cm.
Bronze, cast; pear-shaped open-work cage of plain vertical bars with two balls inside; top suspension loop between two out-ward-facing goat heads; four low projections on base; length of chain still attached.
M.76.97.529

192

Bell
Western Iran; Iron Age II–III
(c. 1000–650 B.C.)
h: 7.1 cm.; w: 4.6 cm.
Bronze, cast; pear-shaped cage of wide vertical bars with one ball inside; top suspension loop flanked by two wild goat heads set flat against loop.
M.76.97.530

193

Bell
Western Iran; Iron Age II–III
(c. 1000–650 B.C.)
h: 5.7 cm.; w: 9.5 cm.
Bronze, cast; oval cage of broad horizontal bars with two balls inside; top suspension loop; in front of loop, a large bird with outstretched wings protects two younger birds.
M.76.97.532

194

Bell
Western Iran; Iron Age II–III
(c. 1000–650 B.C.)
h: 9.7 cm.; w: 9.5 cm.
Bronze, cast; oval openwork cage with two balls inside; top loop and stud at each end; broad bars in swirling geometric pattern.
M.76.97.531

195

Bell
Western Iran; Iron Age II–III
(c. 1000–650 B.C.)
h: 22 cm.; w: 14.8 cm.
Bronze, cast; oval openwork cage with two balls inside; stud at each end; grotesque subhuman faces alternate in opposite directions on the central panels.
M.76.97.526

196

Bell
Western Iran; Iron Age II–III
(c. 1000–650 B.C.)
h: 8 cm.; w: 13.7 cm.
Bronze, cast; oval openwork cage with two balls inside; stud at each end; plain vertical and horizontal bars forming chevrons.
M.76.97.527

197

Bell
Western Iran; Iron Age II–III
(c. 1000–650 B.C.)
h: 11.5 cm.; w: 18.4 cm.
Bronze, cast; openwork cage with two balls inside; divided in half with zigzag bars around both halves; two side loops, one verti-cal, one horizontal.
M.76.174.97

198

Bell
Western Iran; Iron Age II–III
(c. 1000–650 B.C.)
h: 14.5 cm.; w: 21.3 cm.
Bronze, cast; openwork cage with two balls inside; elaborate pattern of loops and circles; two side loops, one vertical, one horizontal.
M.76.174.98

199

Forehead Plaque for a Horse
Western Iran; Iron Age II–III
(c. 1000–650 B.C.)
h: 18.5 cm.; w: 12 cm.
Bronze, hammered; repoussé design of lines and blobs.
M.76.97.177

cf. Moorey, 1971, nos. 159, 160.

200

Chariot Model
Western Iran; c. 2100–1900 B.C.
l: 4 cm.
Bronze, cast; straddle car with tall front and solid wheels.
M.76.97.896

cf. Calmeyer, 1964 (1), no. 11, pl. 5 (sheet metal).

201

Chariot Rein Ring
Elamite; c. 2600–2400 B.C.
h: 12.7 cm.; w: 11.1 cm.
Bronze, cast; Calmeyer, 1969, group 1; omega-shaped with cen-tral support passing up through body of an ass or half-ass, with shell inlay in one eye; below, a triple-ridged bar with a stylized bird or snake head on each side at the base; broken.
M.76.97.574

For a full discussion of these rein rings, cf. Calmeyer, 1964 (1), pp. 68ff.

Parts of this object, notably the animal, may be ancient, but the authenticity of the present assem-bly is open to doubt.

201

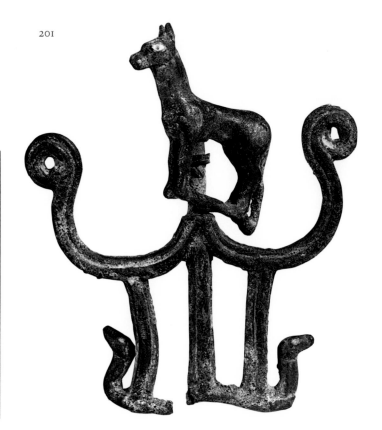

191

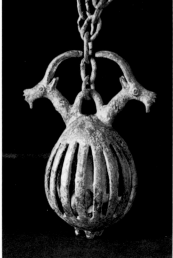

195

Standard Finials
and Decorated Tubes

The enigmatic objects in this section are the hallmark of Luristan's metal industry at its most prolific in the Iron Age. These "finials" and decorated tubes (cat. nos. 203–76) are thought to have been mounted vertically on the bottle-shaped supports (cat. nos. 277–92) with the aid of sheet metal tubes and pins passing down through the central apertures to form small standards. As some of the tubes clearly have a horizontal axis, their role would seem to have been different.

Finials have been excavated from both tombs and shrines, where they have been thought to represent both personal and community gods and demons. In the absence of relevant written records, their complex imagery, hard enough to describe precisely, is impossible to interpret in specific religious terms, although attempts have been made. These attempts depend upon identifying the underlying myths as part of either the Assyro-Babylonian or the Iranian mythological tradition, for which some scant written evidence is available. It is doubtful whether either of these mythologies was that of the people who made and worshiped these objects.

Three major types of finals may be distinguished: rampant wild goats; rampant lions, often highly stylized; and masters or mistresses of animals, on which exotic leonine creatures threaten a central subhuman demon with whose often multi-faced body they are fused. A close relationship of subhuman demons and the lion is also evident in the tubes. Here also appear the nude female—a widely dispersed fertility figure in the ancient Near East, whose familiar animal is commonly the lion—and various androgynous demons. Two elements in this imagery are striking: the predominance of wild animals—indeed, domesticated animals are virtually never shown—and the prevalence of nature demons, half man, half wild beast. It is the world of the mountain hunter, of the animals he hunts, and of the lion, their prime natural threat.

In the absence of definitive evidence, these bizarre objects may best be interpreted as representations of local gods and demons, some perhaps specific clan deities, created and venerated for much the same reasons as the religious statues and pictures to be seen in many Christian shrines and homes. (For a detailed discussion, see Moorey, 1971, pp. 140ff.)

202

Standard Finial
Luristan; Iron Age I–II
(c. 1350–800 B.C.)
h: 11.5 cm.; w: 8.2 cm.
Bronze, cast; Potratz, 1968, form A;
a pair of confronted rampant
wild goats, with fore- and hind
legs each joined to form a ring
for insertion of a central pin;
prominently knobbed horns.
M.76.97.48

For a discussion of type and accompanying bibliography, cf. Moorey, 1971, pp. 146ff.

203

Standard Finial
Luristan; Iron Age I–II
(c. 1350–800 B.C.)
h: 13.2 cm.; w: 11.5 cm.
Bronze, cast; Potratz, 1968,
form A; rampant wild goats as in
cat. no. 202; greatly attenuated
bodies bowing gracefully inward;
prominently knobbed horns.
M.76.97.52

204

Standard Finial
Luristan; Iron Age I–II
(c. 1350–800 B.C.)
h: 13.5 cm.; w: 5.8 cm.
Bronze, cast; Potratz, 1968,
form C; rampant wild goats as in
cat. no. 202; long curving necks
with serrated manes; horns have
paired knobs.
M.76.97.53

205

Standard Finial
Luristan; Iron Age I–II
(c. 1350–800 B.C.)
h: 17.2 cm.; w: 9.8 cm.
Bronze, cast; Potratz, 1968, form C;
rampant wild goats as in cat. no.
202; knobbed horns and serrated
manes; spiral curls at neck base.
M.76.97.60

206

Standard Finial
Luristan; Iron Age I–II
(c. 1350–800 B.C.)
h: 21 cm.; w: 11.5 cm.
Bronze, cast; Potratz, 1968, form K;
rampant wild goats as in cat. no.
202; a snake head projecting
from each neck on the inside; a
predatory head on a neck rising
from the haunch of each goat;
elongated sweeping horns with
beaded ridge along the front;
tall pointed ears and long twisted
tail; about one-quarter of this
object is modern restoration.
M.76.97.63

207

Standard Finial
Luristan; Iron Age I–II
(c. 1350–800 B.C.)
h: 8.3 cm.; w: 10 cm.
Bronze, cast; Potratz, 1968, form A;
rampant wild goats as in cat.
no. 202; heads angled upward;
plain modeling.
M.76.97.61

208

Standard Finial
Luristan; Iron Age I–II
(c. 1350–800 B.C.)
h: 11.6 cm.; w: 6.4 cm.
Bronze, cast; Potratz, 1968, form A;
rampant wild goats as in cat. no.
202; knobby horns; prominent
upper ring.
M.76.97.64

209

Standard Finial
Luristan; Iron Age I–II
(c. 1350–800 B.C.)
h: 19.5 cm.; w: 9.2 cm.
Bronze, cast; Potratz, 1968, form
M; rampant wild goats as in
cat. no. 202; greatly attenuated
arching necks; predator perched
on the back of each goat, facing
upward, with twisted torso and a
spiral curl at the haunch and base
of the neck.
M.76.97.65

cf. Moorey, 1971, p. 148 and no. 163.

210

Standard Finial
Luristan; Iron Age I–II
(c. 1350–800 B.C.)
h: 5.7 cm.; w: 4.3 cm.
Bronze, cast; Potratz, 1968,
form A; small rampant wild goats
as in cat. no. 202; prominent
"cowry shell" ears and hind feet;
metal mounting tube in place.
M.76.97.952

211

Standard Finial
Luristan; Iron Age I–II
(c. 1350–800 B.C.)
h: 11.8 cm.; w: 6.3 cm.
Bronze, cast; rampant wild goats
as in cat. no. 202; the whole is set
on a support into which a tube has
been inserted, surmounted by a
grotesque horned face; into this is
set a pin with geometric molded
head; the parts are largely ancient,
but the assembly is modern.
M.76.97.20

cf. Moorey, 1971, pp. 146ff.

212

Standard Finial
Luristan; Iron Age I–II
(c. 1350–800 B.C.)
h: 13 cm.; w: 9.5 cm.
Bronze, cast; Potratz, 1968,
form G; rampant winged wild
goats; elongated vertical horns
with prominent knobs along
front, each pair joined by a hori-
zontal bar near the top; crescentic
wing; twisted tails; some parts
may be modern restoration.
M.76.97.62

213

Standard Finial
Luristan; Iron Age I–II
(c. 1350–800 B.C.)
h: 12.2 cm.; w: 5.8 cm.
Bronze, cast; Potratz, 1968,
group I, form B; pair of rampant
lions; long necks with notched
manes terminating in large feline
heads, the latter with prominent
eye-coils and gaping jaws with
protruding tongues; long pendent
tails curling at the ends; forelegs
upraised "holding" upper inser-
tion ring; fore- and hind feet
clearly marked.
M.76.97.21a,c; ex-Holmes
Collection

Pub. Pope, 1938, IV, pl. 44 A. For a
discussion of type and accom-
panying bibliography, cf. Moorey,
1971, pp. 148ff.

213

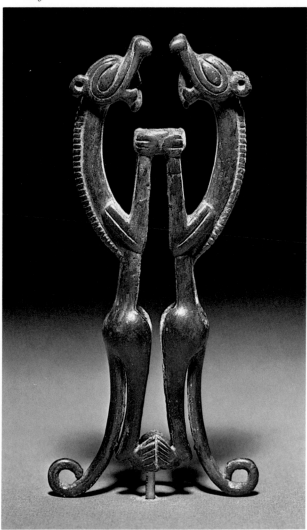

209

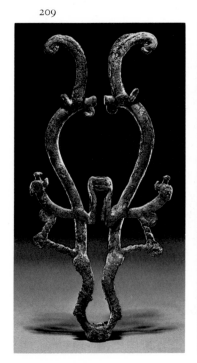

212

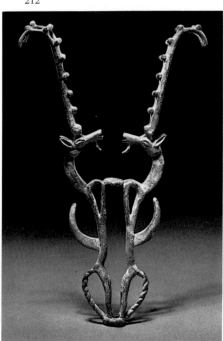

214

Standard Finial
Luristan; Iron Age I–II
(c. 1350–800 B.C.)
h: 12.2 cm.; w: 6 cm.
Bronze, cast; Potratz, 1968, group I,
form B; rampant lions as in cat.
no. 213.
M.76.97.34

215

Standard Finial
Luristan; Iron Age I–II
(c. 1350–800 B.C.)
h: 13.3 cm.; w: 5.8 cm.
Bronze, cast; Potratz, 1968, group I,
form J; rampant lions as in cat.
no. 213; ridged girdle binds bodies tightly together.
M.76.97.35

216

Standard Finial
Luristan; Iron Age I–II
(c. 1350–800 B.C.)
h: 18 cm.; w: 6.7 cm.
Bronze, cast; Potratz, 1968, group I,
form B; rampant lions as in cat.
no. 213.
M.76.97.36

217

Standard Finial
Luristan; Iron Age I–II
(c. 1350–800 B.C.)
h: 9.8 cm.; w: 5 cm.
Bronze, cast; Potratz, 1968, group
I, form B; rampant lions as in cat.
no. 213; short necks and bodies and
prominent hindquarters.
M.76.97.47

218

Standard Finial
Luristan; Iron Age I–II
(c. 1350–800 B.C.)
h: 16 cm.; w: 7 cm.
Bronze, cast; Potratz, 1968,
group I, form G; rampant lions as
in cat. no. 213; each has a miniature lion set on its back, attacking
its haunch.
M.76.97.50; ex-Holmes Collection

219

Standard Finial
Luristan; Iron Age I–II
(c. 1350–800 B.C.)
h: 14.3 cm.; w: 6.3 cm.
Bronze, cast; rampant lions as in
cat. no. 213; a small goat's head
protrudes outward from the center of each back.
M.76.97.56

cf. Moorey, 1971, no. 169.

218

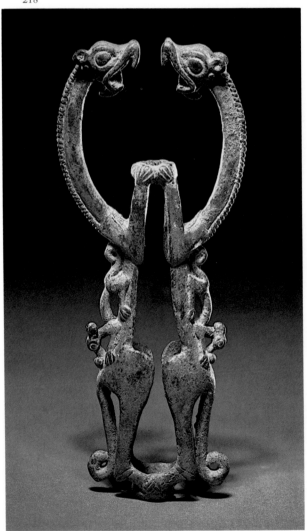

219

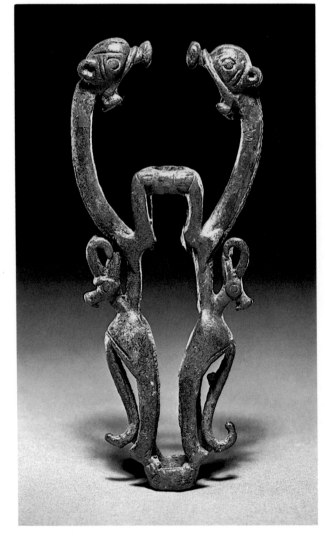

220

Standard Finial
Luristan; Iron Age I–II
(c. 1350–800 B.C.)
h: 11.5 cm.; w: 4.7 cm.
Bronze, cast; Potratz, 1968,
group 1, form A; rampant lions as
in cat. no. 213; highly stylized
faces with large eye-coils and ears;
double spiral-shaped lion masks
on the bodies; tails terminate in
small lion heads.
M.76.97.41

221

Standard Finial
Luristan; Iron Age I–II
(c. 1350–800 B.C.)
h: 12.8 cm.; w: 7.5 cm.
Bronze, cast; Potratz, 1968,
group 2, form A; rampant lions as
in cat. no. 213; a second neck and
head on each side emerging from
the haunch; a small goat's head
facing outward on either side of
top ring; one tail damaged.
M.76.97.9

222

Standard Finial
Luristan; Iron Age I–II
(c. 1350–800 B.C.)
h: 16.3 cm.; w: 6.2 cm.
Bronze, cast; rampant lions as in
cat. no. 213, their tails forming a
mirror image of the upper necks
(a most unusual feature); on the
upper ring, a goat's head on each
side facing outward; a tiny lion's
head facing outward at the base of
each neck, below which an en-
circling girdle binds both bodies
together.
M.76.97.30

cf. Pope, 1945, pl. 6 (upper right).

223

Standard Finial
Luristan; Iron Age I–II
(c. 1350–800 B.C.)
h: 9.1 cm.; w: 4.6 cm.
Bronze, cast; Potratz, 1968,
group 2, form C; rampant lions as
in cat. no. 213; in their forepaws
they hold an object incised with a
stylized floral motif; thick necks
and full, rounded haunches.
M.75.97.44

224

Standard Finial
Luristan; Iron Age I–II
(c. 1350–800 B.C.)
h: 15.2 cm.; w: 9 cm.
Bronze, cast; Potratz, 1968,
group 1, form C; rampant winged
lions; semicircular wing joining
back and neck.
M.76.97.49

cf. Potratz, 1968, figs. 193, 198.

225

Standard Finial
Luristan; Iron Age I–II
(c. 1350–800 B.C.)
h: 9.5 cm.; w: 5.5 cm.
Bronze, cast; rampant quadrupeds
with long snouts (wild pigs?),
flanking a plain central tube; full,
rounded haunches with thin wiry
legs and tails.
M.76.97.45

226

Standard Finial
Luristan; Iron Age I–II
(c. 1350–800 B.C.)
h: 11.2 cm.; w: 5.8 cm.
Bronze, cast; rampant equids with
prominently ridged manes.
M.76.97.69

cf. Moorey, 1974, no. 79; Amiet,
1976, nos. 202, 203.

221

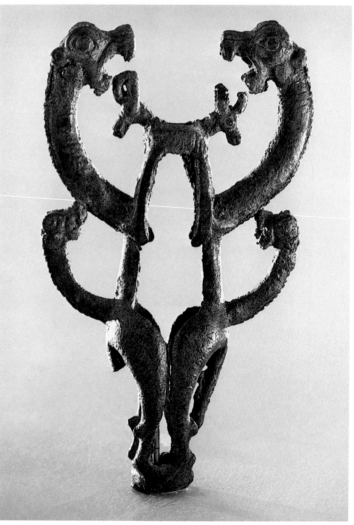

220

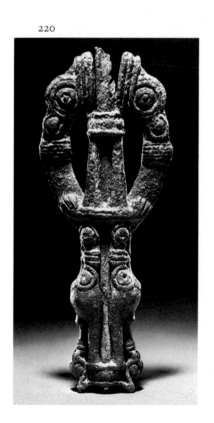

227

Standard Finial
Luristan; Iron Age II–III
(c. 1000–650 B.C.)
h: 10.3 cm.; w: 5.3 cm.
Bronze, cast; anthropomorphic
tube; subhuman face at top, animal
body below; hunchbacked sub-
human's head facing outward on
each shoulder.
M.76.97.6

cf. Moorey, 1971, no. 183 and
pp. 159ff.

228

Standard Finial
Luristan; Iron Age II–III
(c. 1000–650 B.C.)
h: 9 cm.; w: 5.6 cm.
Bronze, cast; anthropomorphic
tube as in cat. no. 227; subhuman
face at top, animal body below;
grotesque head facing inward on
each shoulder.
M.76.97.7

cf. Moorey, 1971, no. 183 and
pp. 159ff.

229

Standard Finial
Luristan; Iron Age II–III
(c. 1000–650 B.C.)
h: 10.3 cm.; w: 5.2 cm.
Bronze, cast; anthropomorphic
tube as in cat. no. 227; subhuman
face at top, animal body below;
grotesque subhuman head on
animal forelegs rising from each
shoulder and facing inward.
M.76.97.17

cf. Moorey, 1971, no. 183 and
pp. 159ff.

230

Standard Finial
Luristan; Iron Age II–III
(c. 1000–650 B.C.)
h: 10.9 cm.; w: 6.5 cm.
Bronze, cast; anthropomorphic
tube as in cat. no. 227; subhuman
face at top, animal body below;
animal protome springing from
each shoulder.
M.76.97.29

cf. Moorey, 1971, no. 181.

229

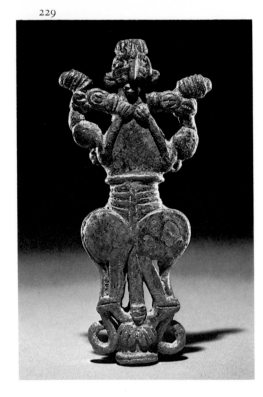

222

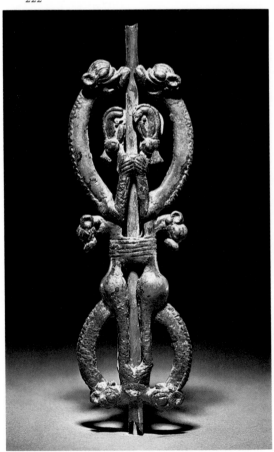

227

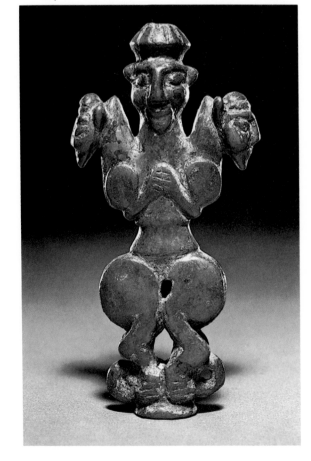

231

Standard Finial
Luristan; Iron Age II–III
(c. 1000–650 B.C.)
h: 14.8 cm.; w: 7.6 cm.
Bronze, cast; anthropomorphic
tube as in cat. no. 227; subhuman
face at top, animal body below;
animal protome facing inward on
each shoulder.
M.76.97.54

cf. Moorey, 1971, no. 181.

232

Standard Finial
Luristan; Iron Age II–III
(c. 1000–650 B.C.)
h: 12.8 cm.; w: 5.8 cm.
Bronze, cast; Potratz, 1968, group
2, form C; rampant lions holding a
subhuman face in their forepaws.
M.76.97.42

cf. Moorey, 1971, nos. 173, 174;
Amiet, 1976, no. 207.

233

Standard Finial
Luristan; Iron Age II–III
(c. 1000–650 B.C.)
h: 10.2 cm.; w: 4.1 cm.
Bronze, cast; Potratz, 1968, group
2, form C; rampant lions holding a
subhuman face in their forepaws
as in cat. no. 232; tails end in lion
heads.
M.76.97.43

cf. Moorey, 1971, nos. 173, 174.

234

Standard Finial
Luristan; Iron Age II–III
(c. 1000–650 B.C.)
h: 8.2 cm.; w: 3.1 cm.
Bronze, cast; Potratz, 1968, group
2, form B; rampant lions holding a
grotesque subhuman face as in cat.
no. 232; central face has prominent
"cowry shell" ears; lions have
notched manes and forepaws.
M.76.97.46

cf. Moorey, 1971, nos. 173, 174.

235

Standard Finial
Luristan; Iron Age II–III
(c. 1000–650 B.C.)
h: 8.7 cm.; w: 6.4 cm.
Bronze, cast; Potratz, 1968, group
2, form C; rampant lions holding a
subhuman face in their forepaws
as in cat. no. 232; short bodies with
bent hind legs.
M.76.97.15

cf. Moorey, 1971, nos. 173, 174.

236

Standard Finial
Luristan; Iron Age II–III
(c. 1000–650 B.C.)
h: 17.5 cm.; w: 6.5 cm.
Bronze, cast; Potratz, 1968, group
3, form B; faceless central tube
flanked by predatory heads on
long curving necks, each with a
cock's head facing outward at base;
rich surface decoration.
M.76.97.1

237

Standard Finial
Luristan; Iron Age II–III
(c. 1000–650 B.C.)
h: 12.2 cm.; w: 6.5 cm.
Bronze, cast; anthropomorphic
tube as in cat. no. 227; subhuman
face at top, animal body below;
feline head on long curving neck
rising from either shoulder, each
nibbling at ear of central head on
the tube.
M.76.97.16

cf. Moorey, 1971, no. 175.

238

Standard Finial
Luristan; Iron Age II–III
(c. 1000–650 B.C.)
h: 19.5 cm.; w: 6.4 cm.
Bronze, cast; master/mistress of
animals in the form of an armless
anthropomorphic tube flanked by
predatory heads on long curving
necks, each with cock's crest and
prominent ears; a flanking cock's
head facing outward at the base of
each neck; moldings and ridges
on central tube.
M.76.97.33

231

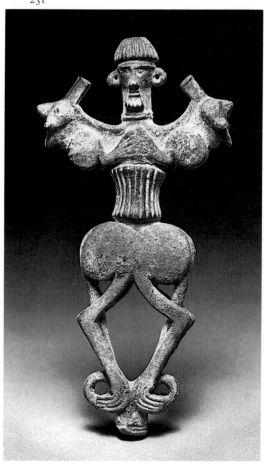

232

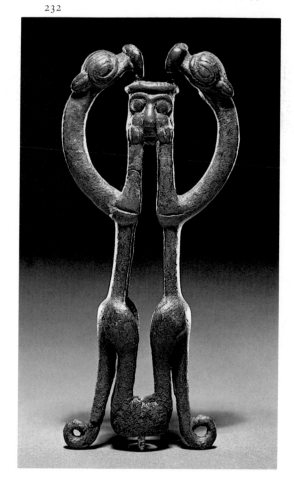

239

Standard Finial
Luristan; Iron Age II–III
(c. 1000–650 B.C.)
h: 11.5 cm.; w: 6 cm.
Bronze, cast; Potratz, 1968, group
2, form C; master/mistress of
animals; subhuman face and upper
torso above, animal body below;
flanked by predatory heads on
curving necks which grip shoul-
ders of central figure with their
upraised forepaws; figure has
a tightly coiled girdle and incised
circular breasts.
M.76.97.40

240

Standard Finial
Luristan; Iron Age II–III
(c. 1000–650 B.C.)
h: 19.9 cm.; w: 7.8 cm.
Bronze, cast; Potratz, 1968, group
3, form G; master/mistress of
animals in the form of an anthro-
pomorphic tube flanked by
rampant animals; central figure
has stylized arms which grasp the
necks of the flanking lions; two
faces on the tube, one at the top,
the other in the middle; a third
face inverted at the feet; double
predatory heads on either side,
with a cock's head facing outward
at the base of each neck; a preda-
tory head on each haunch; very
unusual type.
M.76.97.3

For discussion of type, cf.
Moorey, 1971, nos. 177–80 and
pp. 156ff.

Illustrated on page 59.

241

Standard Finial
Luristan; Iron Age II–III
(c. 1000–650 B.C.)
h: 16 cm.; w: 7.9 cm.
Bronze, cast; master/mistress of
animals as in cat. no. 240; two
faces on the tube, the lower un-
usually broad and prominent with
large oval ears; flanking necks
terminate in predatory heads; no
flanking cocks' heads; atypical
in form and style.
M.76.97.10

Illustrated on following page.

242

Standard Finial
Luristan; Iron Age II–III
(c. 1000–650 B.C.)
h: 18.5 cm.; w: 8.1 cm.
Bronze, cast; Potratz, 1968, group
3, form C; master/mistress of ani-
mals as in cat. no. 240; two faces
on the tube; a stylized bird's head
at the end of each flanking neck,
with a cock's head on either side at
base; elongated forms.
M.76.97.13

243

Standard Finial
Luristan; Iron Age II–III
(c. 1000–650 B.C.)
h: 18.3 cm.; w: 16 cm.
Bronze, cast; Potratz, 1968, group
3, form C; master/mistress of ani-
mals as in cat. no. 240; two faces
on the tube; flanking necks termi-
nate in predatory heads, a cock's
head on either side at the base of
each; rich surface decoration.
M.76.97.14

236

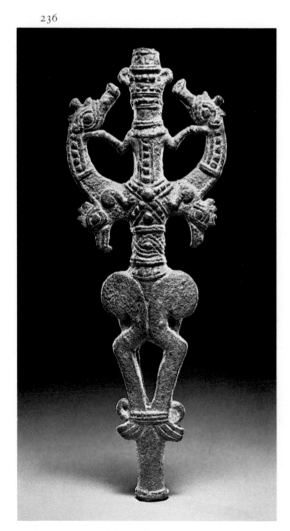

239

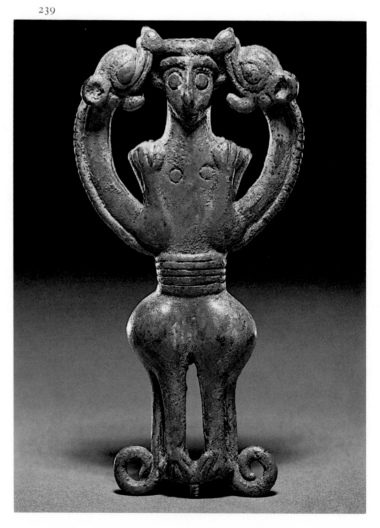

244

241

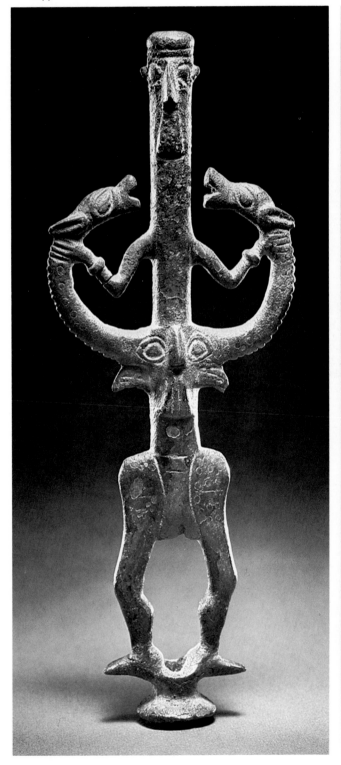

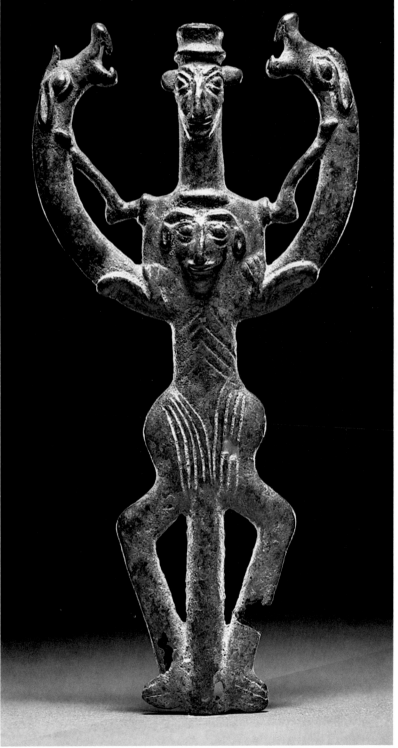

244

Standard Finial
Luristan; Iron Age II–III
(c. 1000–650 B.C.)
h: 17.8 cm.; w: 6.8 cm.
Bronze, cast; master/mistress of
animals as in cat. no. 240; two
faces on the tube; flanking necks
with notched manes terminate
in predatory heads.
M.76.97.19

245

Standard Finial
Luristan; Iron Age II–III
(c. 1000–650 B.C.)
h: 18.5 cm.; w: 6.2 cm.
Bronze, cast; Potratz, 1968, group
3, form G; master/mistress of ani-
mals as in cat. no. 240; two faces
on the tube; flanking necks termi-
nate in predatory heads with
cocks' crests, each with a cock's
head facing outward at base; a
small bird perched on each haunch.
M.76.97.57

246

Standard Finial
Luristan; Iron Age II–III
(c. 1000–650 B.C.)
h: 19.2 cm.; w: 6.4 cm.
Bronze, cast; Potratz, 1968, group
3, form C; master/mistress of ani-
mals as in cat. no. 240; two faces
on the tube; flanking necks termi-
nate in predatory heads with
closed jaws, each with a cock's
head facing outward at base; a
modern pastiche.
M.76.97.92

247

Standard Finial
Luristan; Iron Age II–III
(c. 1000–650 B.C.)
h: 19.2 cm.; w: 8 cm.
Bronze, cast; Potratz, 1968, group
3, form G; master/mistress of ani-
mals as in cat. no. 240; two faces
on tube; flanking necks terminate
in predatory heads, with a cock's
head at middle and base of each
neck and on haunches.
M.76.97.93

240

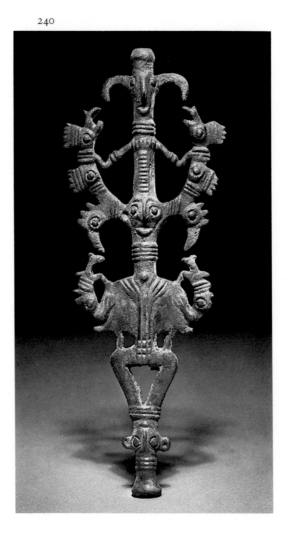

245

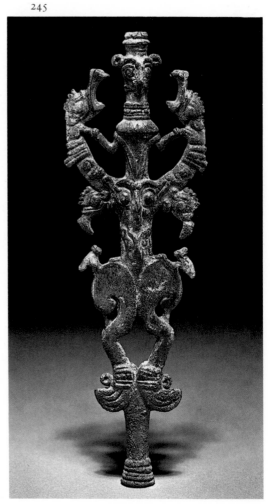

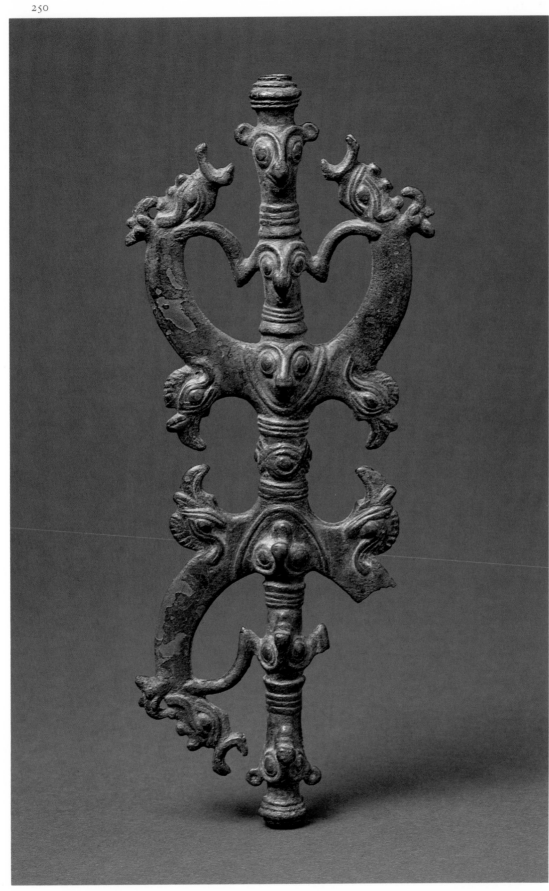

248

Standard Finial
Luristan; Iron Age II–III
(c. 1000–650 B.C.)
h: 18.3cm.; w: 7.7 cm.
Bronze, cast; master/mistress of
animals as in cat. no. 240; three
faces on the tube; a goat's head on
each side of top face; flanking
necks terminate in predatory
heads, each with a horned goat's
head facing outward; a cock's head
at base of each neck; a fourth tiny
head above second face on the
tube; animal heads (damaged) on
tail tips.
M.76.97.2

249

Standard Finial
Luristan; Iron Age II–III
(c. 1000–650 B.C.)
h: 15.3 cm.; w: 5.9 cm.
Bronze, cast; Potratz, 1968, group
3, form E; master/mistress of ani-
mals as in cat. no. 240; three faces
on the tube with a fourth face set
at the feet; flanking necks termi-
nate in predatory heads, a cock's
head at the base of each.
M.76.97.55

250

Standard Finial
Luristan; Iron Age II–III
(c. 1000–650 B.C.)
h: 20 cm.; w: 8.4 cm.
Bronze, cast; master/mistress of
animals as in cat. no. 240; three
faces on each half of the tube; each
flanking neck terminates in a pred-
atory head with cock's crest, a
goat's head projecting outward at
the top and a cock's head at the
base; lower half is executed in
mirror image, one neck now
broken off.
M.76.97.89

251

Standard Finial
Luristan; Iron Age II–III
(c. 1000–650 B.C.)
h: 21.4 cm.; w: 7.5 cm.
Bronze, cast; master/mistress of
animals as in cat. no. 240; three
faces on the tube; a double set of
predatory creatures springing
from lower two faces; a goat's
head projecting from each side of
top head; a cock's head projecting
from base of each neck; a bird
on each side at base of haunch.
M.76.97.90

cf. Amiet, 1976, nos. 223, 224.

252

Standard Finial
Luristan; Iron Age II–III
(c. 1000–650 B.C.)
h: 19.2 cm.; w: 7 cm.
Bronze, cast; Potratz, 1968, group
3, form C; master/mistress of ani-
mals as in cat. no. 240; three faces
on the tube; flanking necks, each
with a cock's head projecting from
base, terminate in predatory heads.
M.76.97.91

253

Standard Finial
Luristan; Iron Age II–III
(c. 1000–650 B.C.)
h: 20.5 cm.; w: 8.5 cm.
Bronze, cast; Potratz, 1968, group
3, form E; master/mistress of ani-
mals as in cat. no. 240; three faces
on the tube; flanking necks, each
with a cock's head projecting from
base, terminate in predatory heads.
M.76.97.94

251

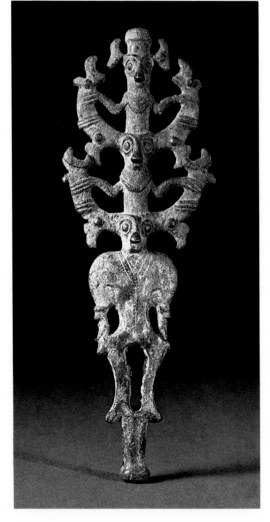

248

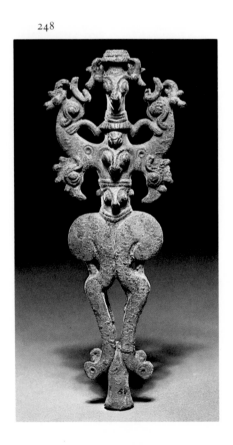

254

Standard Finial
Luristan; Iron Age II–III
(c. 1000–650 B.C.)
h: 20.2 cm.; w: 7.2 cm.
Bronze, cast; master/mistress of
animals as in cat. no. 240; four
faces on the tube; flanking necks,
each with a cock's head projecting
from base, terminate in predatory
heads; necks are decorated with an
interior chain of minute squares.
M.76.97.5

cf. Amiet, 1976, no. 215.

255

Standard Finial
Luristan; Iron Age II–III
(c. 1000–650 B.C.)
h: 20 cm.; w: 7 cm.
Bronze, cast; master/mistress of
animals as in cat. no. 240; five
faces on the tube, the topmost
with a goat's head projecting from
either side, the middlemost with
three eyes and two noses; two
pairs of arms grasp the flanking
necks; a cock's head on either side
at the base of each.
M.76.97.4

256

Standard Finial
Luristan; Iron Age II–III
(c. 1000–650 B.C.)
h: 12.9 cm.; w: 4.5 cm.
Bronze, cast; anthropomorphic
tube, subhuman face at top, ani-
mal body below; flanking necks
terminate in lions' heads; rounded
animal haunches in center of tube
serve as the upper half and as a
repeat of the upper motif in mir-
ror image below.
M.76.97.58

cf. Amiet, 1976, no. 212.

257

Standard Finial
Luristan; Iron Age II–III
(c. 1000–650 B.C.)
h: 18.8 cm.; w: 7.8 cm.
Bronze, cast; master/mistress of
animals as in cat. no. 240; executed
in mirror image, the lower half the
reverse of the upper; two faces on
upper tube half; flanking necks
terminate in predatory heads with
cocks' crests; a cock's head pro-
jects on either side from base of
each neck; the anthropomorphic
figure wears a baldric.
M.76.97.37

Pub. Rome, 1956, no. 134, pl. XIII.

This very unusual finial seems
to have been made in one piece and
not joined at the center.

258

Standard Finial
Luristan; Iron Age I–II
(c. 1350–800 B.C.)
h: 8.3 cm.; w: 7.7 cm.
Bronze, cast; Potratz, 1968, form P;
triple rampant mouflon facing
inward, fore- and hind legs each
joined to form a ring for insertion
of central pin.
M.76.97.68

259

Standard Finial
Luristan; Iron Age I–II
(c. 1350–800 B.C.)
h: 8.2 cm.; w: 4.7 cm.
Bronze, cast; Potratz, 1968, form
P; triple rampant mouflon with
heads turned back looking over
their shoulders; possibly a modern
casting imitating cat. no. 258.
M.76.97.67

Finials of this type are extremely
rare.

260

Decorated Tube
Luristan; Iron Age II–III
(c. 1000–650 B.C.)
h: 8.2 cm.; w: 2.6 cm.
Bronze, cast; grotesque human
figure with horned crown and
curling sidelocks (one missing);
wears a knee-length tunic with
ridged lower edge; two loops on
either side at bottom.
M.76.97.8

For decorated tubes, cf. Moorey,
1971, pp. 160ff.; for posture of
hands, cf. Amiet, 1976, no. 221.

261

Decorated Tube
Luristan; Iron Age II–III
(c. 1000–650 B.C.)
h: 14.2 cm.; w: 2.3 cm.
Bronze, cast; anthropomorphic
figure, armless, with a necklace
and an apronlike projecting gar-
ment; loop to one side; two loops
behind head.
M.76.97.66

254

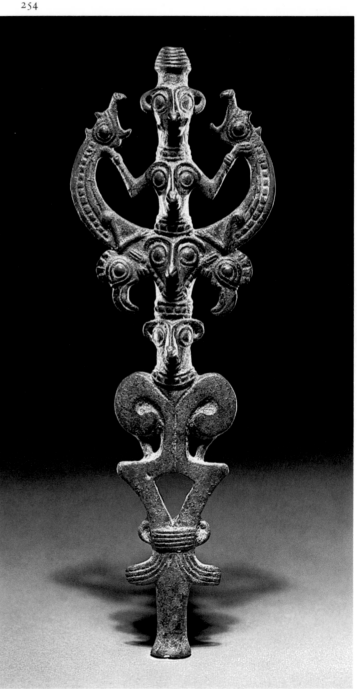

258

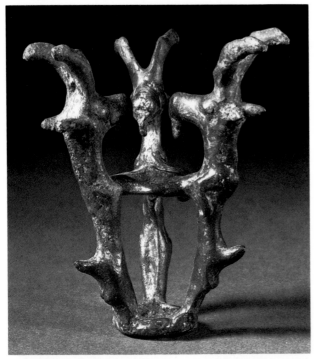

262

Decorated Tube
Luristan; Iron Age II–III
(c. 1000–650 B.C.)
h: 14.7 cm.; w: 2.4 cm.
Bronze, cast; turbaned, bearded
male figure with hands held to
breasts in a pose characteristic of
female tubes; casting fault.
M.76.97.72a

cf. cat. no. 264.

263

Decorated Tube
Luristan; Iron Age II–III
(c. 1000–650 B.C.)
h: 17.6 cm.; w: 4.3 cm.
Bronze, cast; highly stylized
female figure with breasts cupped
in hands and a cock's head project-
ing from each shoulder; forward-
pointing protuberance near base.
M.76.97.18

264

Decorated Tube
Luristan; Iron Age II–III
(c. 1000–650 B.C.)
h: 14 cm.; w: 3.1 cm.
Bronze, cast; nude female with
hands held to breasts; notched
necklace; ribbed design at base
with flanking loops; on the
reverse, the breasts appear as
stylized rosettes.
M.76.97.22

265

Decorated Tube
Luristan; Iron Age II–III
(c. 1000–650 B.C.)
h: 14.7 cm.; w: 2.4 cm.
Bronze, cast; nude female with
breasts cupped in hands; heart-
shaped headdress with projecting
tabs; necklace and girdle; pudenda
shown.
M.76.97.70

cf. Potratz, 1968, pl. XXII and
figs. 15, 16.

266

Decorated Tube
Luristan; Iron Age II–III
(c. 1000–650 B.C.)
h: 15.7 cm.; w: 2 cm.
Bronze, cast; nude female with
breasts cupped in hands as in cat.
no. 265; horned headdress; neck-
lace and girdle; pudenda shown.
M.76.97.71

cf. Potratz, 1968, pl. XXII and
figs. 15, 16.

267

Decorated Tube
Luristan; Iron Age II–III
(c. 1000–650 B.C.)
h: 10.5 cm.; w: 7.4 cm.
Bronze, cast; skirted female with a
grotesque animal protome spring-
ing from each shoulder.
M.76.97.73

262
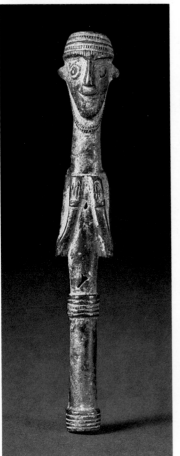

265
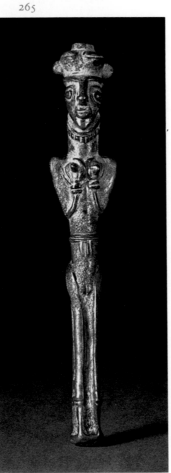

266
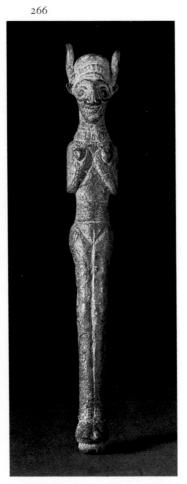

268

Decorated Tube
Luristan; Iron Age II–III
(c. 1000–650 B.C.)
h: 15.4 cm.; w: 2.1 cm.
Bronze, cast; tube cast as a lion
at full stretch, the tail forming a
loop; large, highly ornamental
face; genitals modeled in relief.
M.76.97.23

cf. Amiet, 1976, no. 228.

269

Decorated Tube
Luristan; Iron Age II–III
(c. 1000–650 B.C.)
h: 8.3 cm.; w: 2 cm.
Bronze, cast; opposed recumbent
lions with attenuated bodies and
highly stylized lion masks with
horns and side curls (characteristic
of female faces) at one end; long,
curling tails project at base.
M.76.97.74; ex-Holmes Collection

Pub. New York, 1940, p. 94 c.

270

Decorated Tube
Luristan; Iron Age II–III
(c. 1000–650 B.C.)
h: 5.7 cm.; w: 2 cm.
Bronze cast; two lions in distinc-
tive Luristan style in relief along
full length of tube.
M.76.97.956

271

Decorated Tube
Luristan; Iron Age II–III
(c. 1000–650 B.C.)
h: 7.4 cm.; w: 8.5 cm.
Bronze, cast; grotesque subhuman
head at one end; five lion masks
stylized as double spirals on sur-
face of tube.
M.76.97.28

272

Decorated Tube
Luristan; Iron Age II–III
(c. 1000–650 B.C.)
h: 8.5 cm.; w: 1.4 cm.
Bronze, cast; double subhuman
face at one end, a double lion mask
at the other.
M.76.97.32

273

Decorated Tube
Luristan; Iron Age II–III
(c. 1000–650 B.C.)
h: 11.2 cm.; w: 2.2 cm.
Bronze, cast; grotesque double
head at one end, the stylized fore-
part of a lion facing downward
on each side at the other end.
M.76.97.85

274

Decorated Tube
Luristan; Iron Age II–III
(c. 1000–650 B.C.)
h: 7.2 cm.; w: 2 cm.
Bronze, cast; a pair of grotesque
horned subhuman heads, situated
one at the top and one in the cen-
ter; lower end decorated with tiny
feline creatures in relief; interven-
ing ribbed bands.
M.76.97.705

275

Decorated Tube
Luristan; Iron Age II–III
(c. 1000–650 B.C.)
h: 10.2 cm.
Bronze, cast; terminating at one
end in a snake's head.
M.76.97.31

276

Decorated Tube
Luristan; Iron Age II–III
(c. 1000–650 B.C.)
h: 10.5 cm.; w: 3.9 cm.
Bronze, cast; terminating at one
end in a bearded face flanked by
projecting bovid heads facing
downward, both with carefully
modeled features; both terminals
cast in the shape of a crown with
inward-folded petals.
M.76.97.79

268

269

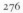

276

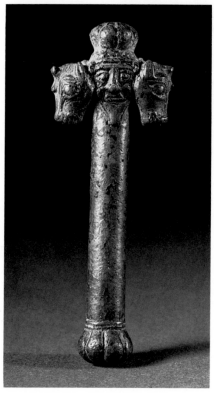

Finial Supports

The basic features of the following objects—bell-shaped body with cylindrical neck and flanged top—always remain constant, but a great variety in form is achieved by altering the proportions of the various parts.

277

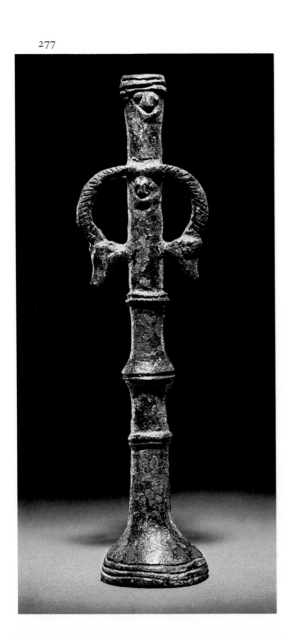

277
Finial Support
Luristan; Iron Age II–III
(c. 1000–650 B.C.)
h: 19 cm.
Bronze, cast; grotesque face at the top followed by a second slightly below; beneath, a pair of projecting mouflon heads with long, ribbed horns that join the tube above lower head; horizontal row of squares at base.
M.76.97.11

For these supports, cf. Moorey, 1971, pp. 166ff.

278
Finial Support
Luristan; Iron Age II–III
(c. 1000–650 B.C.)
h: 20.3 cm.
Bronze, cast; three grotesque faces, each with jutting rectangular nose, around shaft at the center.
M.76.97.12

279
Finial Support
Luristan; Iron Age II–III
(c. 1000–650 B.C.)
h: 9.5 cm.
Bronze, cast; two horned animal heads at the top; if original to the construction, their position would obstruct use as a mount.
M.76.97.27

280
Finial Support
Luristan; Iron Age II–III
(c. 1000–650 B.C.)
h: 12.9 cm.
Bronze, cast; two opposed felines at the top, with curling tails, protruding eyes, and flattened ears; position of forelimbs entwined above the neck of the support would make mounting of anything but a pin impossible.
M.76.97.59

281
Finial Support
Luristan; Iron Age II–III
(c. 1000–650 B.C.)
h: 19.7 cm.
Bronze, cast; three faces in low relief around upper edge of lower half; the two halves divided by a shoulder decorated with two concentric petaled rings; similar molding on shoulder above and at base.
M.76.97.72b

282
Finial Support
Luristan; Iron Age II–III
(c. 1000–650 B.C.)
h: 15.3 cm.
Bronze, cast; grotesque face on one side beneath the flange; a frontal bird with outspread wings on the other; flat rectangular shoulder collar with projecting squares at corners.
M.76.97.77

283
Finial Support
Luristan; Iron Age II–III
(c. 1000–650 B.C.)
h: 14.7 cm.
Bronze, cast; grotesque face on either side beneath top flange; boldly projecting nose and ear.
M.76.97.82

284
Finial Support
Luristan; Iron Age I–III
(c. 1350–650 B.C.)
h: 14 cm.
Bronze, cast; flat rectangular shoulder collar with projecting squares at corners.
M.76.97.21b

285
Finial Support
Luristan; Iron Age I–III
(c. 1350–650 B.C.)
h: 10.3 cm.
Bronze, cast; cylindrical body with everted neck (unusual shape); plain.
M.76.97.80

286
Finial Support
Luristan; Iron Age I–III
(c. 1350–650 B.C.)
h: 6.3 cm.
Bronze, cast; collars of seven and three ridges respectively around neck and shoulder.
M.76.97.84

287
Finial Support
Luristan; Iron Age I–III
(c. 1350–650 B.C.)
h: 13.2 cm.
Bronze, cast; plain.
M.76.97.86

288

Finial Support
Luristan; Iron Age I–III
(c. 1350–650 B.C.)
h: 18.4 cm.
Bronze, cast; tall, narrow form;
four groups of three relief ridges
on shoulder; petaled ring at base;
neck and shoulder collars of three
lines.
M.76.97.87; ex-Holmes Collection

289

Finial Support
Luristan; Iron Age I–III
(c. 1350–650 B.C.)
h: 5.6 cm.
Bronze, cast; raised ridge around
center of neck.
M.76.174.47

290

Finial Support
Luristan; Iron Age I–III
(c. 1350–650 B.C.)
h: 6 cm.
Bronze, cast; neck collar of two
lines.
M.76.174.49

291

Finial Support
Luristan; Iron Age I–III
(c. 1350–650 B.C.)
h: 6 cm.
Bronze, cast; thick neck collar.
M.76.174.50

292

Finial Support
Luristan; Iron Age I–III
(c. 1350–650 B.C.)
h: 3.5 cm.
Bronze, cast; small; plain.
M.76.174.65

301

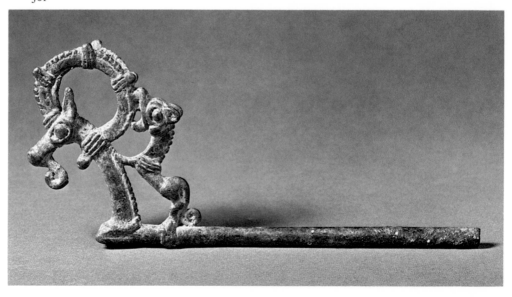

Pins

Numerous pins have been reported from clandestine excavations in western Iran, especially from Luristan, where the Surkh Dum shrine excavations showed that they were deposited in large numbers in temples. They appear regularly in graves and occasionally in settlements. Simple straight garment pins with plain or molded upper shanks were common from the third millennium B.C. and were not entirely superseded until after the eighth century B.C., when the fibula, or safety pin (cat. no. 501), replaced them. In the late Bronze and early Iron Ages they were increasingly decorated with animal- or floral-shaped heads. Some of the animals and monsters are stylized in the manner particularly associated with the metal workshops of Luristan. The more elaborate, perhaps mostly votive pins, are of two main types: one of cast bronze, with an openwork head often set on an iron shank; the other of hammered bronze, with linear designs worked in a combination of repoussé and incision. Although some of these pins are small and light enough to be worn as dress pins, many are much too large and heavy. Both types were represented in the Surkh Dum shrine, often built into the stone walls, where they would have served as religious symbols or icons. The imagery of their designs has much in common with the finials, listed in the previous section, which also served this purpose. The disk-headed pins have been copied and imitated in modern times to such an extent that it is often very difficult to judge with the naked eye whether specific examples are ancient or modern. Detailed laboratory research, still to be undertaken on the examples listed here, is the only reliable guide.

293

Pin
Western Iran; 2nd millennium B.C.
l: 18.1 cm.
Bronze, cast; domed head; molding on upper shank; date uncertain.
M.76.97.257

cf. Moorey, 1971, nos. 249ff.

294

Pin
Western Iran; 2nd millennium B.C.
l: 22 cm.
Bronze, cast; flat head; incised decoration on upper shank; date uncertain.
M.76.97.262

cf. Moorey, 1971, nos. 231ff.

295

Pin
Western Iran; 2nd millennium B.C.
l: 16.2 cm.
Bronze, cast; club-shaped head; pierced shank with molded decoration; date uncertain.
M.76.97.265

cf. Moorey, 1971, nos. 219ff.

296

Pin
Western Iran; 2nd millennium B.C.
l: 11.7 cm.
Bronze, cast; conical head; square-sectioned shank, pierced, with incised geometrical decoration; date uncertain.
M.76.97.274

cf. Moorey, 1971, nos. 243ff.

297

Pin
Luristan; Iron Age I–II
(c. 1350–800 B.C.)
l: 24.5 cm.
Bronze, cast; head shaped as an elongated oval cage with floral top; side loop.
M.76.97.241

For type, cf. Moorey, 1971, nos. 305, 306.

298

Pin
Luristan; Iron Age I–II
(c. 1350–800 B.C.)
l: 22.4 cm.
Bronze, cast; stylized poppy head with four ridged holes set around the ovary; side loop.
M.76.97.253

For type, cf. Moorey, 1971, no. 299.

299

Pin
Luristan; Iron Age I–II
(c. 1350–800 B.C.)
l: 13.5 cm.
Bronze, cast; stylized poppy head with four regular projections around the ovary.
M.76.97.275

300

Pin
Luristan; Iron Age I–II
(c. 1350–800 B.C.)
l: 30 cm.; h: 9.5 cm.
Bronze, cast; heavy pin terminating in the foreparts of two wild goats with arching horns, attacked from behind by a stylized lion with a bird beneath its front feet.
M.76.97.234; ex-Holmes Collection

301

Pin
Luristan; Iron Age I–II
(c. 1350–800 B.C.)
l: 18 cm.; h: 7.8 cm.
Bronze, cast; heavy pin terminating in the forepart of a mountain goat threatened by a grotesque lion.
M.76.97.239

302

Pin
Luristan; Iron Age I–II
(c. 1350–800 B.C.)
l: 18 cm.
Bronze, cast; shank terminating in an antelope head.
M.76.97.245

cf. Moorey, 1971, nos. 312, 313.

303

Pin
Luristan; Iron Age I–II
(c. 1350–800 B.C.)
l: 14.7 cm.
Bronze, cast; shank terminating in an animal head; identity uncertain.
M.76.97.263

304

Pin
Luristan; Iron Age I–II
(c. 1350–800 B.C.)
l: 16.4 cm.
Bronze, cast; shank terminating in
an antelope head.
M.76.97.279

cf. cat. no. 302.

305

Pin
Luristan; Iron Age I–II
(c. 1350–800 B.C.)
l: 23.2 cm.
Bronze, cast; head in the shape of
a roaring lion's head.
M.76.97.276

306

Pin
Luristan; Iron Age I–II
(c. 1350–800 B.C.)
l: 18.7 cm.
Bronze, cast; shank terminating in
a recumbent lion of relatively nat-
ural form; molded upper shank.
M.76.97.272

307

Pin
Luristan; Iron Age I–II
(c. 1350–800 B.C.)
l: 8.5 cm.
Bronze, cast; type as in cat.
no. 306.
M.76.97.273

308

Pin
Luristan; Iron Age I–II
(c. 1350–800 B.C.)
l: 12 cm.
Bronze, cast; type as in cat.
no. 306.
M.76.97.278

309

Pin
Luristan; Iron Age I–II
(c. 1350–800 B.C.)
l: 21.5 cm.
Bronze, cast; shank terminating in
a stylized crouching lion; ribbed
moldings.
M.76.97.246

For type, cf. Moorey, 1971, no. 318.

310

Pin
Luristan; Iron Age I–II
(c. 1350–800 B.C.)
l: 13.2 cm.
Bronze, cast; type as in cat.
no. 309.
M.76.97.254

311

Pin
Luristan; Iron Age I–II
(c. 1350–800 B.C.)
l: 14.8 cm.
Bronze, cast; type as in cat.
no. 309.
M.76.97.259

312

Pin
Luristan; Iron Age I–II
(c. 1350–800 B.C.)
l: 17.8 cm.
Bronze, cast; shank terminating in
a stylized lion's mask.
M.76.174.59

cf. Moorey, 1971, nos. 319–22.

313

Pinhead
Luristan; Iron Age I–II
(c. 1350–800 B.C.)
l: 13.2 cm.
Bronze, cast; head shaped as a
stylized lion's mask; origin
uncertain.
M.76.97.524

314

Pin
Luristan; Iron Age I–II
(c. 1350–800 B.C.)
l: 6.1 cm.
Bronze, cast; head shaped as a
recumbent winged monster.
M.76.97.247

For type, cf. Moorey, 1971,
nos. 328ff.

315

Pin
Luristan; Iron Age I–II
(c. 1350–800 B.C.)
l: 10.6 cm.
Bronze, cast; shank terminating in
a winged monster.
M.76.97.248

cf. cat. no. 314.

316

Pin
Luristan; Iron Age I–II
(c. 1350–800 B.C.)
l: 18.6 cm.
Bronze, cast; shank terminating in
a winged monster.
M.76.97.256

cf. cat. no. 314.

317

Pin
Luristan; Iron Age I–II
(c. 1350–800 B.C.)
l: 14.3 cm.
Bronze, cast; shank terminating in
a winged monster, a second ani-
mal head at its rear, its snout fixed
to the shank; possibly a modern
pastiche.
M.76.97.258

318

Pinhead
Luristan; Iron Age I–II
(c. 1350–800 B.C.)
l: 8.1 cm.
Bronze, cast; originally on an iron
shank; head shaped as a winged
horse.
M.76.97.862

For type, cf. Potratz, 1968, figs.
141–50; Moorey, 1971, nos. 342–47.

319

Pinhead
Luristan; Iron Age I–II
(c. 1350–800 B.C.)
l: 6.4 cm.
Bronze, cast; same type as cat.
no. 318.
M.76.97.863

320

Pinhead
Luristan; Iron Age I–II
(c. 1350–800 B.C.)
l: 6.1 cm.
Bronze, cast; same type as cat.
no. 318.
M.76.97.945

321

Pinhead
Luristan; Iron Age I–II
(c. 1350–800 B.C.)
l: 6.7 cm.
Bronze, cast; same type as cat.
no. 318.
M.76.97.946

322

Pinhead
Northwestern Iran; Iron Age II
(c. 1000–800 B.C.)
l: 11.4 cm.
Bronze, cast; originally on a heavy
iron shank; head shaped as a re-
cumbent lion; a triangular cavity
in the head for inlay.
M.76.97.807

cf. Pope, 1945, pl. 21; Vanden
Berghe, 1959, pl. 147d,e; Ghirsh-
man, 1964, pls. 28–29; Porada,
1965, pl. 29.

323

Pinhead
Northwestern Iran; Iron Age II
(c. 1000–800 B.C.)
l: 7 cm.
Bronze, cast; same type as cat.
no. 322.
M.76.97.808

324

Pin
Luristan; Iron Age I–II
(c. 1350–800 B.C.)
l: 8.5 cm.
Bronze, cast; shank terminating in
a grotesque subhuman head,
changing into a goat's head below;
the whole framed by a pair of
crescentic horns with incised dec-
oration; origin uncertain.
M.76.97.244

325

Pin
Luristan; Iron Age I–II
(c. 1350–800 B.C.)
l: 13.7 cm.
Bronze, cast; shank terminating in
a swimming duck; moldings on
upper shank.
M.76.97.266

For type, cf. Moorey, 1971,
nos. 314–16.

326

Pin
Luristan; Iron Age I–II
(c. 1350–800 B.C.)
l: 14.8 cm.
Bronze, cast; same type as cat.
no. 325.
M.76.97.267

327

Pin
Northwestern Iran; Iron Age I–II
(c. 1350–800 B.C.)
l: 19.6 cm.
Bronze, cast; square-sectioned
shank terminating in the figure of
a standing ram situated at right
angles to it.
M.76.97.229

328

Pin
Northwestern Iran; Iron Age I–II
(c. 1350–800 B.C.)
l: 35.5 cm.
Bronze, cast; shank terminating in
a horned animal, its horns sweep-
ing back; a tiny dog set behind
them (possibly a modern addi-
tion); moldings on upper shank.
M.76.97.230

329

Pin
Northwestern Iran; Iron Age I–II
(c. 1350–800 B.C.)
l: 32 cm.
Bronze, cast; shank terminating in
a zebu passant.
M.76.97.235

330

Pin
Northwestern Iran; Iron Age I–II
(c. 1350–800 B.C.)
l: 20.6 cm.
Bronze, cast; shank terminating
in two addorsed roe deer standing
on a platform; shank possibly
modern.
M.76.97.238

331

Pin
Western Iran; date uncertain
l: 18 cm.
Bronze, cast; shank terminating in
four standing wild goats clustered
together.
M.76.97.240

Some of the earliest zoomorphic
pinheads known from the Near
East, at the outset of the Bronze
Age, are similar to this, but a safer
attribution at present would be
Iron Age I–II.

332

Pin
Northwestern Iran; Iron Age I–II
(c. 1350–800 B.C.)
l: 10.4 cm.
Bronze, cast; shank terminating in
a stylized wild goat standing on a
platform; modern shank.
M.76.97.243

333

Pinhead
Northwestern Iran; Iron Age I–II
(c. 1350–800 B.C.)
l: 6.3 cm.
Bronze, cast; originally on an iron
shank; head shaped as a recumbent
zebu(?).
M.76.97.850

334

Pinhead
Northwestern Iran; Iron Age I–II
(c. 1350–800 B.C.)
l: 4.9 cm.
Bronze, cast, same type as cat.
no. 333.
M.76.97.857

331

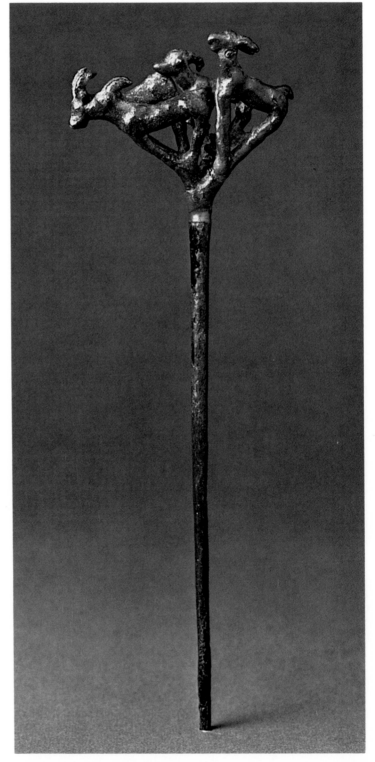

Crescentic Frames

335

Openwork Pinhead
Luristan; Iron Age II–III
(c. 1000–650 B.C.)
h: 8.2 cm.; w: 7.6 cm.
Bronze, cast; mistress of animals
framed by lion heads on long
curving necks; lion mask at junction of head and shank; the latter,
originally of iron, now missing.
M.76.97.211

For discussion of type, cf.
Moorey, 1971, no. 347 and pp.
203ff.; Amiet, 1976, nos. 178–81.

336

Openwork Pin
Luristan; Iron Age II–III
(c. 1000–650 B.C.)
h: 23.5 cm.; w: 6 cm.
Bronze, cast; grotesque face, with
horns and curling sidelocks,
framed by leonine heads on long
curving necks; bronze shank.
M.76.97.227; ex-Holmes
Collection

337

Openwork Pin
Luristan; Iron Age II–III
(c. 1000–650 B.C.)
h: 26.3 cm.; w: 10 cm.
Bronze, cast; mistress of animals
framed by goat heads on long
curving necks; spiral filling motifs;
bronze shank.
M.76.97.228

338

Openwork Pin
Luristan; Iron Age II–III
(c. 1000–650 B.C.)
h: 19.5 cm.; w: 6.6 cm.
Bronze, cast; grotesque face with
horns and side-curls on tall ribbed
neck, framed by predatory heads
on long curving necks; spiral filling motifs; bronze shank, possibly secondary.
M.76.97.231

339

Openwork Pin
Luristan; Iron Age II–III
(c. 1000–650 B.C.)
h: 15.6 cm.; w: 8.2 cm.
Bronze, cast; mistress of animals
framed by goat heads on long
curving necks; floral filling motifs.
M.76.97.242

340

Openwork Pinhead
Luristan; Iron Age II–III
(c. 1000–650 B.C.)
h: 22.8 cm.; w: 11.8 cm.
Bronze, cast; mistress of animals
framed by predatory heads on
long curving necks; inverted lions
at her flank; lion mask at junction
of head and shank; the shank is
certainly secondary, the pinhead
possibly a modern aftercast.
M.76.97.182

341

Openwork Pinhead
Luristan; Iron Age II–III
(c. 1000–650 B.C.)
h: 12 cm.; w: 10.5 cm.
Bronze, cast; mistress of animals
framed by mouflon heads on long
curving necks; inverted lions at her
flank with two reversed recumbent lions below, two secondary
lion heads at the top; secondary
faces on either side at center; lion
mask at junction of head and shank;
side loop at base; iron shank
missing.

M.76.97.184

342

Openwork Pinhead
Luristan; Iron Age II–III
(c. 1000–650 B.C.)
h: 8.8 cm.; w: 7.2 cm.
Bronze, cast; mistress of animals
framed by goat (?) heads on long
curving necks; inverted lions at
her flank; two base loops; iron
shank missing.
M.76.97.186

343

Openwork Pinhead
Luristan; Iron Age II–III
(c. 1000–650 B.C.)
h: 10.7 cm.; w: 10.2 cm.
Bronze, cast; mistress of animals
framed by lion heads on long
curving necks; inverted lions at
her flank, with a rampant goat between each lion and the framing
necks; iron shank missing.
M.76.97.187

Illustrated on page 72.

339

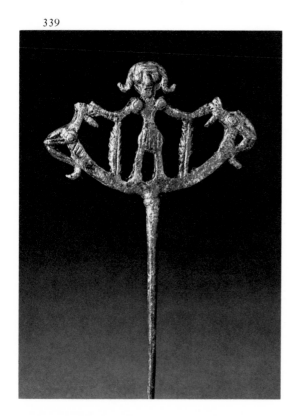

341

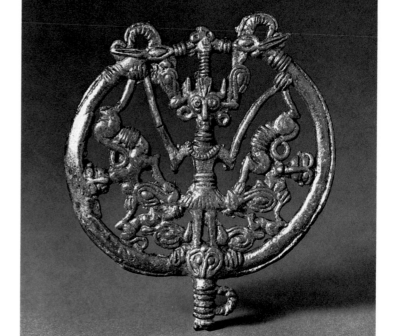

344

Openwork Pinhead
Luristan; Iron Age II–III
(c. 1000–650 B.C.)
h: 9.8 cm.; w: 9.1 cm.
Bronze, cast; mistress of animals
framed by lion heads on long
curving necks; inverted goats
within the frame; lion mask at the
junction of head and shank; iron
shank missing.
M.76.97.189

345

Openwork Pinhead
Luristan; Iron Age II–III
(c. 1000–650 B.C.)
h: 10 cm.; w: 9.1 cm.
Bronze, cast; mistress of animals
framed by lion heads on long
curving necks; inverted lions at
her flank, with rampant lions be-
tween each and the framing necks;
iron shank missing.
M.76.97.190

346

Openwork Pinhead
Luristan; Iron Age II–III
(c. 1000–650 B.C.)
h: 10.7 cm.; w: 8.9 cm.
Bronze, cast; mistress of animals
framed by lion heads on long
curving necks; rampant mouflon
with long, looped horns at her
flank; lion mask at junction of
head and shank; one side loop;
iron shank missing.
M.76.97.185

347

Openwork Pinhead
Luristan; Iron Age II–III
(c. 1000–650 B.C.)
h: 11.7 cm.; w: 9.2 cm.
Bronze, cast; mistress of animals
framed by goat (?) heads on long
curving necks; rampant lions at
her flank; lion mask at junction of
head and shank; two base side
loops, iron shank missing; very
distinctive style with braided pat-
terning on outer frame.
M.76.97.188

348

Openwork Pinhead
Luristan; Iron Age II–III
(c. 1000–650 B.C.)
h: 7.2 cm.; w: 7.2 cm.
Bronze, cast; mistress of animals
framed by goat heads on long
curving necks; rampant goats at
her flank; a second figure in relief
within the central one; lion mask
at junction of head and shank, the
latter originally of iron.
M.76.97.210

349

Openwork Pinhead
Luristan; Iron Age II–III
(c. 1000–650 B.C.)
h: 6.9 cm.; w: 10.7 cm.
Bronze, cast; winged mistress of
animals framed by caprid heads
on long curving necks; between
each and the central head, leonine
foreparts facing outward; dam-
aged secondary devices spring
from outside curve of the necks;
originally on an iron shank;
fragmentary.
M.76.97.212

350

Openwork Pin
Luristan; Iron Age II–III
(c. 1000–650 B.C.)
h: 19.9 cm.; w: 5.1 cm.
Bronze, cast; mistress of animals
with arms and legs outspread, set
within a frame of two curving
goat necks, the head (unusually)
facing outward; present shank a
modern replacement for the origi-
nal iron one.
M.76.97.270

351

Openwork Pin
Luristan; Iron Age II–III
(c. 1000–650 B.C.)
h: 25.6 cm.; w: 7 cm.
Bronze, cast; central columnar
mistress of animals framed by a
pair of predatory heads on long
curving necks, one set within the
other; each beast has a plaited
mane; plaited bar across lower
part; twisted side loop; bronze
shank.
M.76.97.226

342

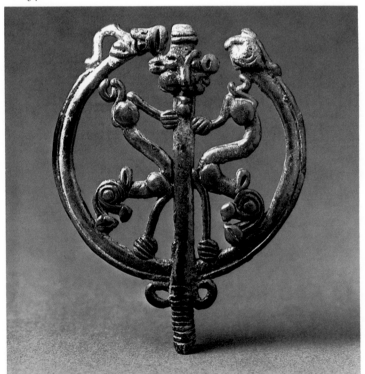

345

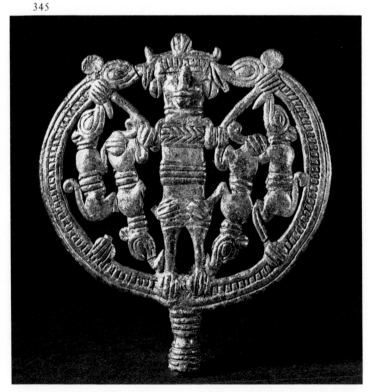

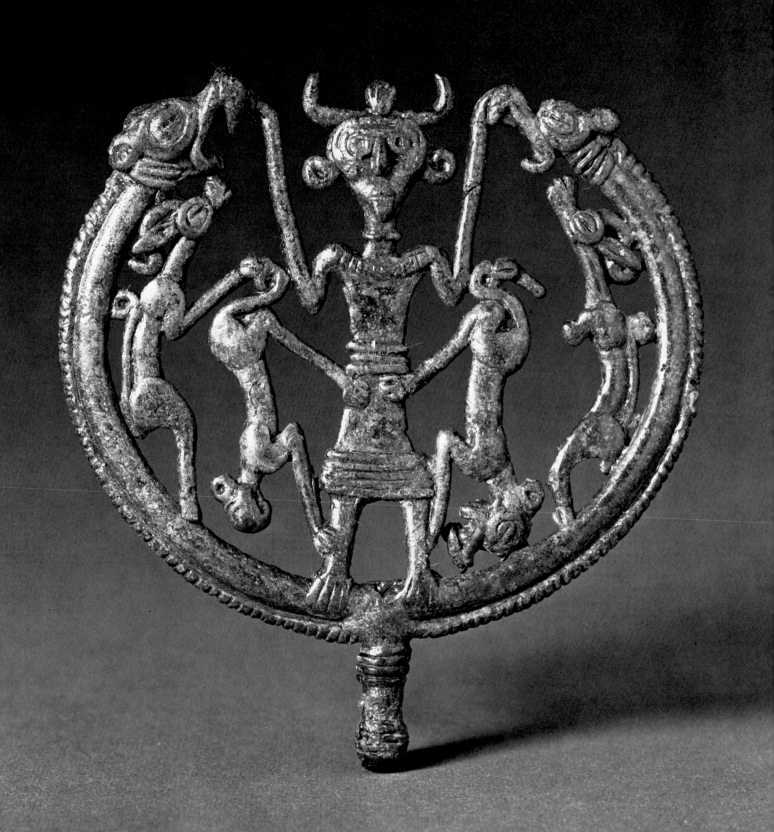

Closed Circular Frames

352

Openwork Pinhead
Luristan; Iron Age II–III
(c. 1000–650 B.C.)
h: 11.2 cm.; w: 9.2 cm.
Bronze, cast; closed, plaited, circular frame; within, a mistress of animals flanked by rampant lions; two side loops; iron shank missing.
M.76.97.183

For discussion of type, cf. Moorey, 1971, no. 344 and p. 202.

353

Openwork Pinhead
Luristan; Iron Age II–III
(c. 1000–650 B.C.)
h: 8.2 cm.; w: 6 cm.
Bronze, cast; closed circular frame; within, a central element formed of two addorsed pairs of stylized profile lion heads set face to face; rampant lions on the outside facing outward; iron shank missing.
M.76.97.213

354

Openwork Pinhead
Luristan; Iron Age II–III
(c. 1000–650 B.C.)
h: 7.6 cm.; w: 6.2 cm.
Bronze, cast; closed circular frame (now broken in places); within, a central tree flanked by rampant lions; iron shank missing.
M.76.97.214

355

Openwork Pin
Luristan; Iron Age II–III
(c. 1000–650 B.C.)
h: 32.5 cm.; w: 7.8 cm.
Bronze, cast; circular frame (slightly distorted); within, a standing demon, arms outstretched to grasp the frame; lion head at junction of head and shank; mouflon head with fully recurved horns and prominent ear originally projecting from either side of frame, the left one now lost.
M.76.97.225

356

Openwork Pin
Luristan; Iron Age II–III
(c. 1000–650 B.C.)
h: 27.4 cm.; w: 4.2 cm.
Bronze, cast; closed, plaited, circular frame; within, a column flanked by double-spiral lion masks; two loops flank top of shank.
M.76.97.255

Square Frames

357

Openwork Pinhead
Luristan; Iron Age II–III
(c. 1000–650 B.C.)
h: 16 cm.; w: 11.5 cm.
Bronze, cast; plaited, square frame; within, opposed sweeps of mouflon horns with reversed faces; horns frame advancing lions facing outward; side loop; stub of original iron shank survives.
M.76.97.204

For discussion of type, cf. Moorey, 1971, nos. 350–52 and p. 206; Amiet, 1976, nos. 82–85.

358

Openwork Pinhead
Luristan; Iron Age II–III
(c. 1000–650 B.C.)
h: 8 cm.; w: 7.5 cm.
Bronze, cast; plaited, square frame; within, two superimposed faces, the upper with mouflon horns, the lower with rosettes on either side of forehead; flanked by inverted lions; rosette filling motifs; iron shank missing.
M.76.97.205

359

Openwork Pinhead
Luristan; Iron Age II–III
(c. 1000–650 B.C.)
h: 9.8 cm.; w: 8.8 cm.
Bronze, cast; plaited, square frame; within, a central figure with mouflon horns; rampant lions facing outward; rosette filling motifs; iron shank missing.
M.76.97.206

Illustrated on following page.

352

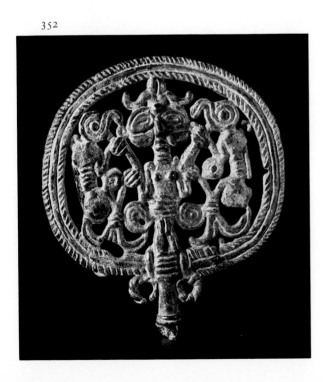

357

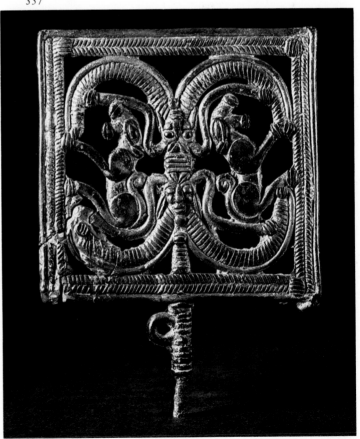

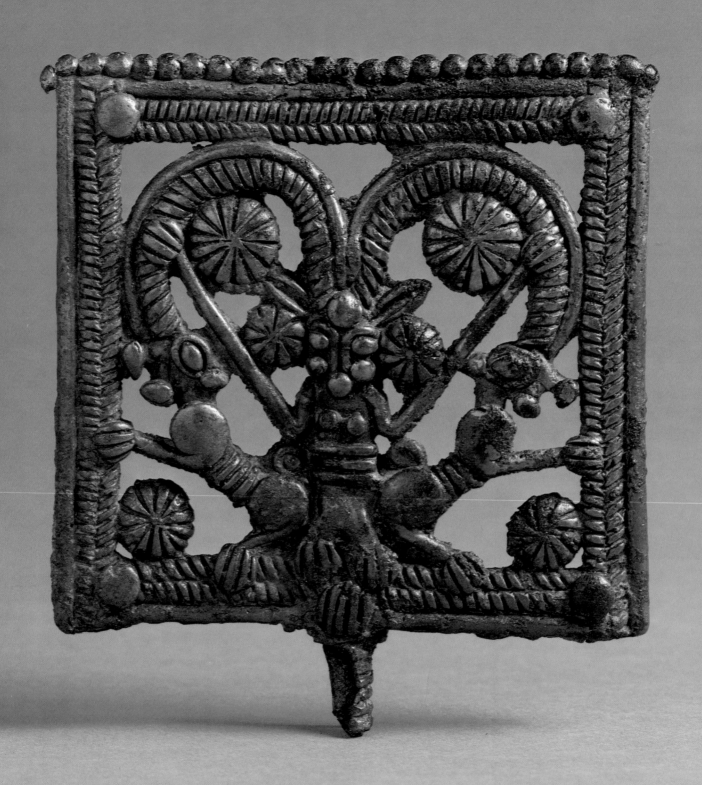

360

Openwork Pinhead
Luristan; Iron Age II–III
(c. 1000–650 B.C.)
h: 13.2 cm.; w: 9.8 cm.
Bronze, cast; plaited, square frame;
within, a central figure with mouflon
horns; inverted lions; rosette
filling motifs; side loop; iron shank
missing.
M.76.97.207

361

Openwork Pinhead
Luristan; Iron Age II–III
(c. 1000–650 B.C.)
h: 12.2 cm.; w: 6.7 cm.
Bronze, cast; plaited, square
frame; within, a mistress of animals
holds inverted lions; side
loop; original iron shank missing.
M.76.97.208

Frameless

362

Openwork Pinhead
Luristan; Iron Age II–III
(c. 1000–650 B.C.)
h: 9.5 cm.; w: 6.8 cm.
Bronze, cast; nude master of animals
in running posture; with his
left hand he grasps one of two
flanking lions, with his right, the
horizontal frame above; both he
and the lions are poised on the
backs of two addorsed goats;
snake-like members extend from
necks of lions and mouths of
goats; a bronze sleeve originally
united the head and an iron shank
(now missing).
M.76.97.209

363

Openwork Pin
Luristan; Iron Age II–III
(c. 1000–650 B.C.)
h: 22.3 cm.; w: 5.3 cm.
Bronze, cast; rampant lions with
jaws agape climbing a tree terminating
above in three leaves;
base loop.
M.76.97.233

364

Openwork Pin
Luristan; Iron Age II–III
(c. 1000–650 B.C.)
h: 21.6 cm.; w: 5.2 cm.
Bronze, cast; mistress of animals
standing on a lion mask and
framed by goats with heads
turned outward.
M.76.97.251

365

Openwork Pinhead
Luristan; Iron Age II–III
(c. 1000–650 B.C.)
h: 6.2 cm.; w: 3.9 cm.
Bronze, cast; columnar central
figure with hatched body; on each
side, a pair of addorsed profile lion
heads set vertically; original iron
shank now lost.
M.76.97.215

366

Openwork Pinhead
Luristan; Iron Age II–III
(c. 1000–650 B.C.)
h: 6.9 cm.; w: 7.7 cm.
Bronze, cast; a pair of winged
monsters originally juxtaposed,
with horns set full-face on profile
head; spiral filling motifs; only
one head survives; fragmentary.
M.76.97.673

364

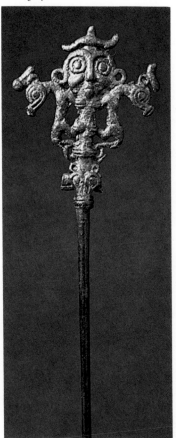

360

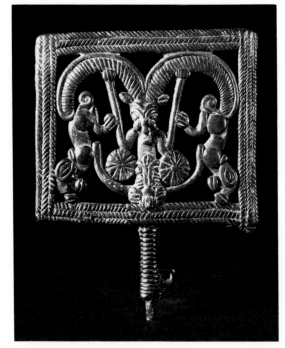

362

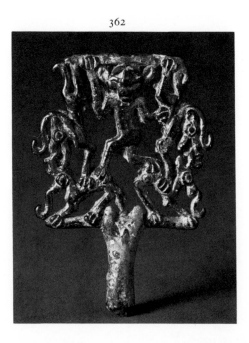

367

Openwork Pinhead
Luristan; Iron Age II–III
(c. 1000–650 B.C.)
h: 6.3 cm.; w: 4.8 cm.
Bronze, cast; grotesque lion
mask framed by a pair of inverted
crouching felines; a double-spiral
lion mask at the top; original iron
shank now lost.
M.76.97.892

368

Disk-headed Pin
Luristan; Iron Age II–III
(c. 1000–650 B.C.)
l: 23.5 cm.; w. of head: 12.2 cm.
Bronze, hammered; plain central
boss; in the field surrounding, a
pair of lions with heads turned
back and a pair of addorsed ram-
headed griffins; floral and geomet-
ric filling motifs; damaged.
M.76.97.141

For this type of pin, cf. Moorey,
1971, pp. 207ff.; Amiet, 1976, nos.
187–90; Clercq-Fobé, 1978.

369

Disk-headed Pin
Luristan; Iron Age II–III
(c. 1000–650 B.C.)
l: 31 cm.; w. of head: 13.3 cm.
Bronze, hammered; plain center
surrounded by two elaborate flo-
ral friezes; distinctive projections
at junction of head and shank;
when the piece was originally
cleaned, the outlines of the lower
part of the design were recut.
M.76.97.156

370

Disk-headed Pin
Luristan; Iron Age II–III
(c. 1000–650 B.C.)
l: 16.8 cm.; w. of head: 9.5 cm.
Bronze, hammered; plain center
with surrounding floral band;
center margin consists of square
frames alternately filled with
rosettes and lion heads.
M.76.97.158

371

Disk-headed Pin
Luristan; Iron Age II–III
(c. 1000–650 B.C.)
l: 24.5 cm.; w. of head: 12.5 cm.
Bronze, hammered; lion head in
the center; in the field surround-
ing, a pair of confronted winged
griffins in the upper section; con-
fronted lions, rendered on a larger
scale, in the lower; floral filling
motifs.
M.76.174.73; ex-Holmes Collection

372

Disk-headed Pin
Luristan; Iron Age II–III
(c. 1000–650 B.C.)
h: 25.5 cm.; w: 16 cm.
Bronze, hammered; central lion
head; an encircling frieze composed
of two winged horses, two
sphinxes, a lion, a bull, and a bird
freely arranged around it; pin bent
over; authenticity doubtful.
M.76.97.132

373

Disk-headed Pin
Luristan; Iron Age II–III
(c. 1000–650 B.C.)
l: 20 cm.; w. of head: 8.7 cm.
Bronze, hammered; central lion
head; most of right side lost; in the
field remaining, a standing bull-
demon with staff and horned
crown, a winged quadruped, and
a crouching figure; rosettes flank
a stylized tree at the bottom; authen-
ticity doubtful.
M.76.97.160

374

Disk-headed Pin
Luristan; Iron Age II–III
(c. 1000–650 B.C.)
l: 24.6 cm.; w. of head: 13.8 cm.
Bronze, hammered; central female
face with bone and bitumen eye
inlays; in the field surrounding,
two demons flank a tree at top and
bottom; various animals, bird, and
demonic figures in the four sec-
tions of the field; largely ancient,
with some modern repairs.
M.76.97.133

Pub. Rome, 1956, no. 150, pl. XV;
Godard, 1962, fig. 55; Egami, 1965,
pl. 65; Muscarella, 1977, p. 173
questions its antiquity.

368

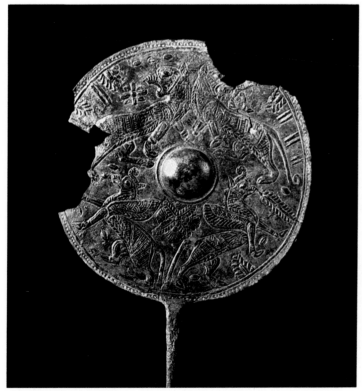

370

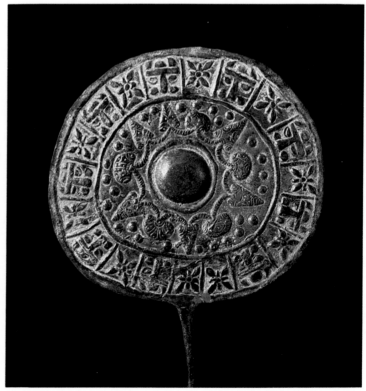

371

375

Disk-headed Pin
Luristan; Iron Age II–III
(c. 1000–650 B.C.)
l: 29.5 cm.; w. of head: 18 cm.
Bronze, hammered; central female
face; lions, demons, and other
figures set around it at random;
authenticity doubtful.
M.76.97.134

376

Disk-headed Pin
Luristan; Iron Age II–III
(c. 1000–650 B.C.)
l: 18.5 cm.; w. of head: 8.8 cm.
Bronze, hammered; central female
face flanked by subhuman figures
in ankle-length robes; floral filling
motifs; authenticity doubtful.
M.76.97.143

377

Disk-headed Pin
Luristan; Iron Age II–III
(c. 1000–650 B.C.)
l: 25 cm.; w. of head: 10.7 cm.
Bronze, hammered; large, promi-
nent female face in the center with
one piece of ivory or bone inlay
surviving; goats browsing in lower
left and right sections; right-hand
figure largely obliterated.
M.76.97.144

378

Disk-headed Pin
Luristan; Iron Age II–III
(c. 1000–650 B.C.)
h: 20.3 cm.; w: 8 cm.
Bronze, hammered; central female
face; in the field surrounding, a
frieze of lotus and pomegranates
surrounded by a pair of long-
horned goats and winged quadru-
peds facing outward; authenticity
doubtful.
M.76.97.146

373

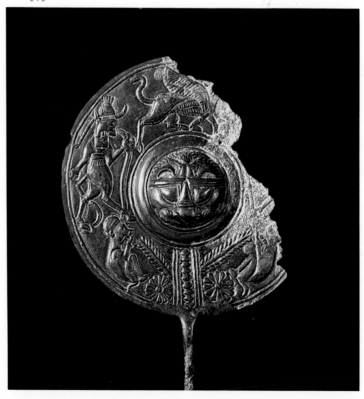

379

Disk-headed Pin
Luristan; Iron Age II–III
(c. 1000–650 B.C.)
l: 14.6 cm.; w. of head: 8.9 cm.
Bronze, hammered; large central
female face within a border of
repoussé bosses.
M.76.97.150

380

Disk-headed Pin
Luristan; Iron Age II–III
(c. 1000–650 B.C.)
l: 30.5 cm.; w. of head: 8.8 cm.
Bronze, hammered; large central
female face with elaborate hair-
style and earrings.
M.76.97.153

381

Disk-headed Pin
Luristan; Iron Age II–III
(c. 1000–650 B.C.)
l: 23 cm.; w. of head: 13.2 cm.
Bronze, hammered; central female
face within an undecorated field;
disk has been fitted in modern
times to a pin terminating in a
stylized lion head; both parts are
probably ancient.
M.76.97.154

382

Disk-headed Pin
Luristan; Iron Age II–III
(c. 1000–650 B.C.)
h: 17.2 cm.; w: 7 cm.
Bronze, hammered; most of the
disk is filled by a grotesque sub-
human face with remains of a fixa-
tive for inlays in the eye cavities;
disk may have been trimmed in
modern times.
M.76.97.162

383

Disk-headed Pin
Luristan; Iron Age II–III
(c. 1000–650 B.C.)
l: 14.5 cm.; w. of head: 8.8 cm.
Bronze, hammered; central
female face; in the field surround-
ing, a frieze of fish; authenticity
uncertain.
M.76.97.170

384

Disk-headed Pin
Luristan; Iron Age II–III
(c. 1000–650 B.C.)
l: 35.5 cm.; w. of head: 12 cm.
Bronze, hammered; central nude
female flanked by rampant lions;
authenticity of design uncertain.
M.76.97.135

385

Disk-headed Pin
Luristan; Iron Age II–III
(c. 1000–650 B.C.)
l: 25 cm.; w. of head: 9.9 cm.
Bronze, hammered; central
subhuman figure in a kneeling
position holding a lion by the
forelegs in his right hand, another
by the hind legs in his left; some
restoration.
M.76.97.137

Pub. Rome, 1956, no. 153, pl. XVI;
Muscarella, 1977, p. 173 (with
wrong cat. no.) challenges its
authenticity.

386

Disk-headed Pin
Luristan; Iron Age II–III
(c. 1000–650 B.C.)
l: 28.3 cm.; w. of head: 12 cm.
Bronze, hammered; central stand-
ing bearded man in long, patterned
robe with a double pair of wings
and a feather crown; holds a lion
inverted by its tail in each hand;
three horned animals in the field,
one winged; floral filling motifs;
damaged; lower part restored.
M.76.97.138; ex-Holmes Collection

Pub. Pope, 1945, pl. 16 (said to
come from Surkh Dum); Ghirsh-
man, 1964, p. 74, fig. 96.

379

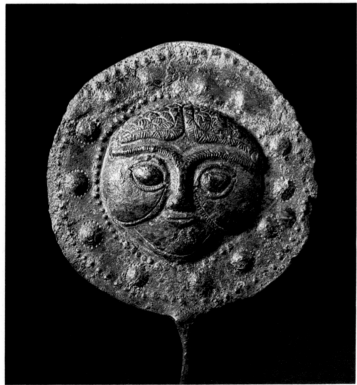

385

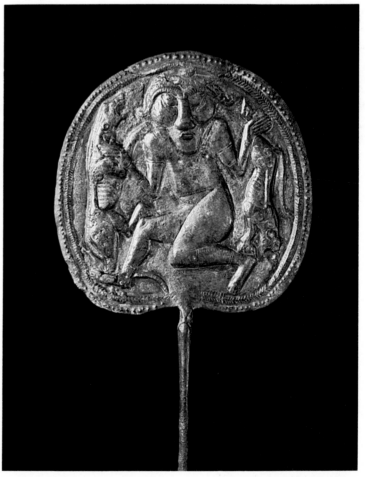

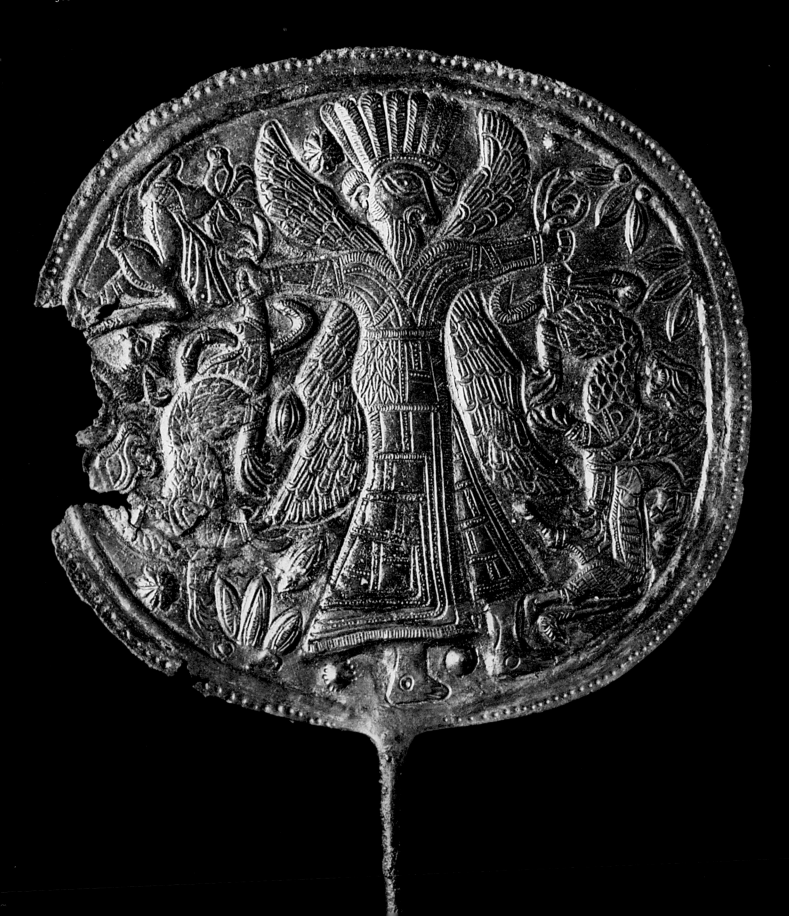

387

Disk-headed Pin
Luristan; Iron Age II–III
(c. 1000–650 B.C.)
l: 19.6 cm.; w. of head: 8.6 cm.
Bronze, hammered; nude female
with legs spread, holding branches.
M.76.97.140

Pub. Speiser, 1952, pl. 100 (lower);
Pope, 1960, p. 32, pl. 16; Calmeyer,
1969, p. 193, fig. 6.

388

Disk-headed Pin
Luristan; Iron Age II–III
(c. 1000–650 B.C.)
h: 19.9 cm.; w: 9.3 cm.
Bronze, hammered; floral border
with motifs set in frames; in the
center, a standing figure in ankle-
length robe, holding a goat in-
verted in each hand with a vulture
attacking each one from above; au-
thenticity of design uncertain.
M.76.97.142

Pub. Rome, 1956, no. 154, pl.
XVI; Culican, 1965, fig. 4a; Mus-
carella, 1977, p. 173 questions its
authenticity.

389

Disk-headed Pin Fragment of Umbo
Luristan; Iron Age III
(c. 800–650 B.C.)
w: 8.4 cm.
Bronze, hammered; lion's head in
low relief, centrally situated at
the waist of a bearded and robed
standing man; a lion on each side
above his outstretched arms with
a rosette below; damaged; authen-
ticity of such designs with figures
like this open to doubt.
M.76.97.169

390

Disk-headed Pin
Luristan; Iron Age II–III
(c. 1000–650 B.C.)
l: 13.8 cm.; w. of head: 6.3 cm.
Bronze, hammered; design set at
right angles to the shank; central
standing figure flanked by rampant,
winged wild goats.
M.76.97.167

391

Disk-headed Pin
Luristan; Iron Age II–III
(c. 1000–650 B.C.)
l: 14.5 cm.; w. of head: 6.5 cm.
Bronze, hammered; design set
at right angle to the shank; a
winged figure seated on a stool
with a bird above his hand; an-
other figure places offerings on
a high table in front of him; recum-
bent lion at base; filling motifs;
authenticity of design doubtful.
M.76.97.149

392

Disk-headed Pin
Luristan; Iron Age II–III
(c. 1000–650 B.C.)
l: 14.7 cm.; w. of head: 7.1 cm.
Bronze, hammered; seated pro-
file female in the center holding a
writhing snake by the neck in each
hand; damaged.
M.76.97.161

For a disk-headed pin with the
same subject, cf. Amiet, *Syria*
LVI, 1979, p. 351, fig. 23. Like the
Heeramaneck example, the figure
depicted here is apparently seated
on the coiled body of one of the
serpents.

393

Disk-headed Pin
Luristan; Iron Age II–III
(c. 1000–650 B.C.)
l: 15.2 cm.; w. of head: 8.2 cm.
Bronze, hammered; a central tree(?)
dividing two circular fields; on the
left, a tree with flanking winged
griffins set above three human
figures in procession; field to right
largely lost, with only traces of
animals remaining; rosette filling
motifs; fragmentary.
M.76.97.163

394

Disk-headed Pin
Luristan; Iron Age II–III
(c. 1000–650 B.C.)
l: 11.5 cm.; w. of head: 6.6 cm.
Bronze, hammered; design set at
right angles to the shank; rampant
goats flanking a central tree.
M.76.97.168

395

Disk-headed Pin
Luristan; Iron Age II–III
(c. 1000–650 B.C.)
l: 17 cm.; w. of head: 8 cm.
Bronze, hammered; crouching
horned animals set in quadrants
about a central bearded male face;
animals are arranged in two pairs
(the lower inverted) separated
by plant motifs; authenticity of
design uncertain.
M.76.97.148

391

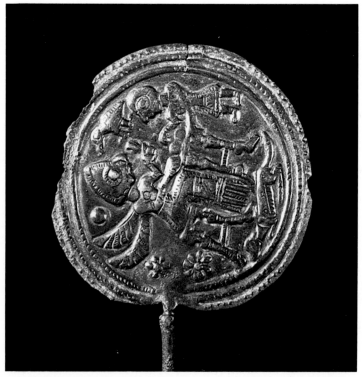

392

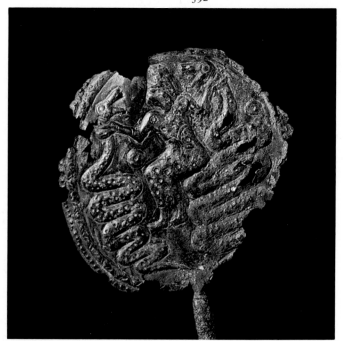

396

Disk-headed Pin
Luristan; Iron Age II–III
(c. 1000–650 B.C.)
l: 21.7 cm.; w. of head: 8.5 cm.
Bronze, hammered; four animals
set at random, one behind the
other; four small embossed dots in
the field; authenticity of design
uncertain.
M.76.97.166

397

Disk-headed Pin
Luristan; Iron Age II–III
(c. 1000–650 B.C.)
l: 13.3 cm.; w. of head: 5 cm.
Bronze, hammered; "Greek
cross" with a central circle; lines
ending in circles project between
each arm.
M.76.97.165

398

Disk-headed Pin
Luristan; Iron Age II–III
(c. 1000–650 B.C.)
l: 17.1 cm.; w. of head: 6.8 cm.
Bronze, hammered; standing
skirted figure with arms upraised;
filling motifs; authenticity of
design uncertain.
M.76.97.152

399

Disk-headed Pin
Luristan; Iron Age II–III
(c. 1000–650 B.C.)
l: 14.9 cm.; w. of head: 6.4 cm.
Bronze, cast; central rosette with
an encircling frieze of stylized
frontal lion masks in relief placed
side by side in a wreath-like pat-
tern; lion mask at junction of head
and shank.
M.76.97.269

Pub. New York, 1940, p. 132 YY.

400

Mounting Pin for a Finial
Luristan; Iron Age II–III
(c. 1000–650 B.C.)
l: 70.9 cm.
Bronze, cast; recumbent lion on a
very long wire shank, ending in a
small loop which passes around its
body.
M.76.97.222

The function of this object and of
catalog numbers 401–403 is un-
known. They may be modern
contrivances, but there is no obvi-
ous indication of this. Indeed, the
careful loop at the base suggests
otherwise.

401

Mounting Pin for a Finial
Luristan; Iron Age II–III
(c. 1000–650 B.C.)
l: 63 cm.
Bronze, cast; recumbent mouflon
set on a very long wire shank
ending in a tiny loop; function
uncertain.
M.76.97.223

cf. cat. no. 400.

402

Mounting Pin for a Finial
Luristan; Iron Age II–III
(c. 1000–650 B.C.)
l: 59 cm.
Bronze, cast; squatting man, arms
broken off; set on a very long wire
shank ending in a tiny loop; func-
tion uncertain.
M.76.97.224

cf. cat. no. 400.

403

Mounting Pin for a Finial
Luristan; Iron Age II–III
(c. 1000–650 B.C.)
l: 5.2 cm.
Bronze, cast; seated human with
arms raised, palms held open; set
on a long, coiled wire shank; func-
tion uncertain.
M.76.97.252

404

Needle
Origin and date uncertain
l: 15 cm.
M.76.97.264

For needles in western Iran in an-
tiquity, cf. Moorey, 1971, p. 96.

405

Openwork Pinhead Fragment
Luristan; Iron Age II–III
(c. 1000–650 B.C.)
h: 5 cm.; w: 7.7 cm.
Bronze, cast; mountain goat, with
lion (both in distinctive Luristan
style) rising to attack its head from
the front; all on a base line.
M.76.97.861

The role of this fragment is uncer-
tain; it might be part of an open-
work pinhead.

395

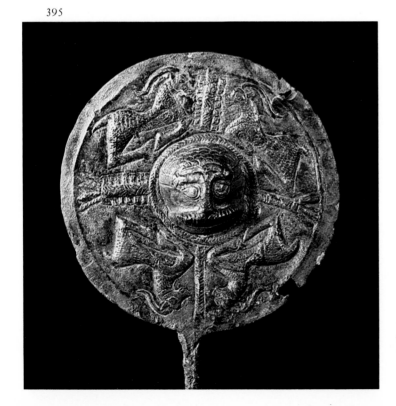

399

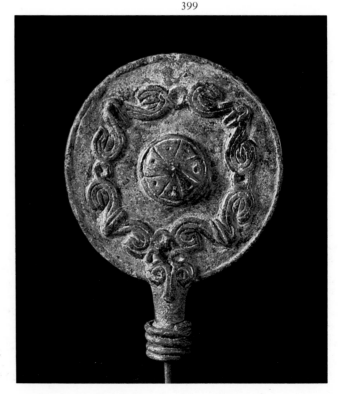

Pre-Achaemenid Metal Vessels

Hammered sheet metal vessels had been produced in western Iranian metal workshops since the third millenium B.C. With the increase of productivity in the Iron Age, particularly in Luristan, the range of forms and the numbers of vessels placed in graveyards increased. The very presence of metal vessels, even in copper or bronze, in graves implies a degree of wealth and good living, so it is perhaps not surprising that most of these objects are vessels either for holding liquids or for drinking them. Fine original decoration is represented here by one outstanding jar (cat. no. 415) and an unusually complete series of situlae (cat. nos. 429-37). These simple goblets (for which the conventional description of situlae is really a misnomer) are decorated with designs of Babylonian or Elamite origin. On the evidence of a few inscribed examples they may be dated primarily to the tenth century B.C. The only inscribed vessel here is a bowl of unusual shape, which may have been made in eastern Mesopotamia rather than in Iran (cat. no. 417). As so many of the sheet metal vessels produced in western Iranian workshops were plain, there has been a marked tendency for modern dealers to have them ornamented to increase their value, either by attaching alien cast-bronze fittings or by incising them with designs based on ancient patterns. Such secondary decoration is found on a number of the vessels here (cf. the same problem with disk-headed pins, cat. nos. 368-97).

406

Beaker
Western Iran; Bronze Age
h: 11.7 cm.; diam: 9 cm.
Bronze, hammered; Calmeyer, 1969, group 26; cylindrical beaker with flaring rim and flanged base.
M.76.174.99

This simple type of vessel was in active use from the third through the second millennium B.C. The cuneiform inscription beneath the rim is probably a modern addition.

407

Beaker
Western Iran; Iron Age II–III (c. 1000–650 B.C.)
h: 16.1 cm.; diam: 12.5 cm.
Bronze, hammered; bell-shaped beaker with rounded base, steep vertical sides, and flaring rim; lower half decorated with eleven bands, some undecorated, others filled with incised concentric circles; tongue pattern above and around base; raised channel below rim.
M.76.97.362

408

Beaker
Western Iran; Iron Age II–III (c. 1000–650 B.C.)
h: 9.8 cm.; diam: 8.5 cm.
Bronze, hammered; beaker with rounded walls incurving at bottom; nipple base; narrow frieze of eight incised horned animals passant below rim, within patterned border of multiple rows of inverted u's; a third such border surrounding base rosette; ancient repair on rim.
M.76.97.363

For type of vessel and decoration, cf. Calmeyer, 1969, pp. 80–81 and pl. 6:3.

409

Beaker
Western Iran; Iron Age II–III (c. 1000–650 B.C.)
h: 14.6 cm.; diam: 14.6 cm.
Bronze, hammered; tall beaker with flaring walls and flanged base; on the upper side, within a raised border, a repoussé frieze of wild goats grazing; rosette filling motifs; a third raised channel near base; below rim, a wide border of multiple rows of minute punched dots; much damaged and restored.
M.76.97.364

Pub. New York, 1940, p. 116 D; Pope, 1938, IV, pl. 68 B; Muscarella, *MMJ* 5, 1972, p. 38, no. 6. For type of vessel, cf. Moorey, 1971, no. 510.

408

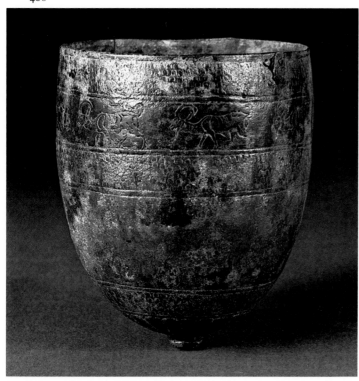

410

Beaker
Iran; Iron Age II–III
(c. 1000–650 B.C.)
h: 7.6 cm.; diam: 8.8 cm.
Bronze, hammered; cylindrical
beaker with flat base and concave
sides flaring out at the rim; on
the outside, two pairs of incised
rampant goats, with heads turned
back, on either side of a tree; two
more stylized trees set between
them; guilloche pattern around rim.
M.76.97.354

This vessel is probably ancient,
but the design is a modern addition.

411

Beaker
Iran; Iron Age II–III
(c. 1000–650 B.C.)
h: 7.5 cm.; diam: 6.5 cm.
Bronze, hammered; cylindrical
beaker with flat, flanged base and
slightly concave sides; on the
outside, a chased frieze consisting
of two pairs of griffin-genii flank-
ing stylized trees.
M.76.97.360

The vessel is probably ancient, but
the design is a modern addition.

412

Beaker
Iran; Iron Age II–III
(c. 1000–650 B.C.)
h: 8.2 cm.; diam: 10 cm.
Bronze, hammered; beaker with
small flat base and straight, flaring
sides; on the outside, an incised
frieze of four stylized trees within
patterned borders of scales and
guilloche; authenticity uncertain.
M.76.97.394

413

Beaker
Western Iran; Iron Age II–III
(c. 1000–650 B.C.)
h: 16.5 cm.; diam: 8.3 cm.
Bronze, hammered; tall cylindrical
beaker with flat base and straight
sides flaring outward as they rise;
on the outside, sixteen rows of
tiny tear-shaped depressions; in-
cised guilloche border beneath rim.
M.76.174.113

414

Goblet
Western Iran; Iron Age I
(c. 1350–1000 B.C.)
h: 10 cm.
Bronze, hammered; goblet with
button base, globular body, and
tall everted neck.
M.76.97.395

This appears to be a metal version
of the ceramic button-based
goblets typical of Iron Age I in
western Iran.

409

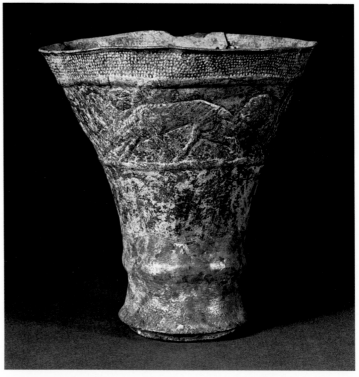

415

Jar
Western Iran; Iron Age II–III
(c. 1000–650 B.C.)
h: 32.4 cm.; diam: 20.4 cm.
Bronze, hammered; tall ovoid jar
with flat shoulder and tall everted
neck (restored) with flaring rim,
on a ring base; formed in parts and
riveted together; four raised
channels encircling neck; on the
outside, four friezes of repoussé
designs: (from top) 1) a narrow
register of birds facing left with
rosette filling motifs; 2) vultures,
facing right, alternating with
rosettes; 3) winged mouflon, fac-
ing left, with tree and rosettes;
4) grazing goats, facing right, and
rosettes; all the animal and bird
bodies are richly patterned.
M.76.97.365

For a similar vessel in The Met-
ropolitan Museum of Art, cf.
Muscarella, *MMJ* 5, 1972, pp. 25ff.;
Muscarella, 1977 (1), fig. 14.

416

Jar
Western Iran; Iron Age II–III
(c. 1000–650 B.C.)
h: 26.7 cm.; diam: 6.4 cm.
Bronze, hammered, with cast
handles; tall jar with cylindrical
body and rounded bottom with
nipple base, tall, slightly concave
neck, and everted rim; a cast
rampant goat in the style of the
Luristan finials is riveted to
each side.
M.76.97.412; ex-Colls. Holmes
and Stora

Pub. Calmeyer, 1973, p. 136, fig.
114 (with earlier bibliography); for
a similar undecorated example,
cf. Pope, 1938, IV, pl. 65.

The vessel is probably ancient, but
the handles are a modern addition
made by dismantling a wild goat
finial.

417

Bowl
Iraq; 9th century B.C.
h: 8.1 cm.; diam: 11.2 cm.
Bronze, hammered; cylindrical
bowl with slightly rounded sides
and flat base; underside decorated
with an incised rosette; on the
exterior walls, a design of chased
lotus leaves pointing upward from
the base; around the lip, a guil-
loche band with an inscription in
the cuneiform script: "belonging
to Abdi-il, Šaknu official of Adinu
of the Dakkuru tribe" (Brinkman,
1968, p. 198, note 1208); Adinu
was a contemporary of the Assyr-
ian king Shalmaneser III (c. 858-
824 B.C.).
M.76.97.361; ex-Holmes Collection

Pub. Godard, 1933, pp. 132ff., fig.
17; Pope, 1938, I, p. 285, no. XIV;
ibid., IV, pl. 68 A; New York, 1940,
p. 118 E; Brinkman, 1968, p. 363;
Calmeyer, 1969, pp. 78–79, no. 40
and fig. 80; Moorey, 1971, p. 34.

418

Bowl
Western Iran; Iron Age I–II
(c. 1350–800 B.C.)
h: 7.6 cm.; diam: 8.8 cm.
Bronze, hammered; bowl with
deep, rounded body and slightly
concave, vertical neck; six incised
lines encircle shoulder.
M.76.97.377

417

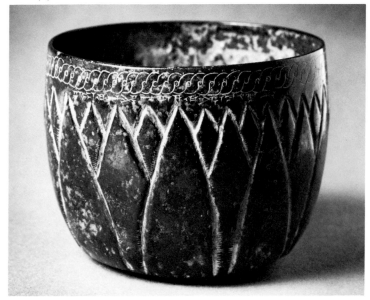

415

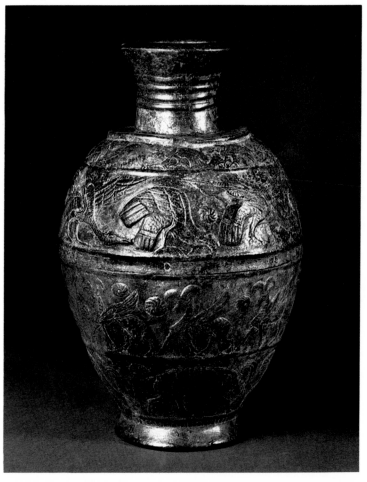

detail, 415

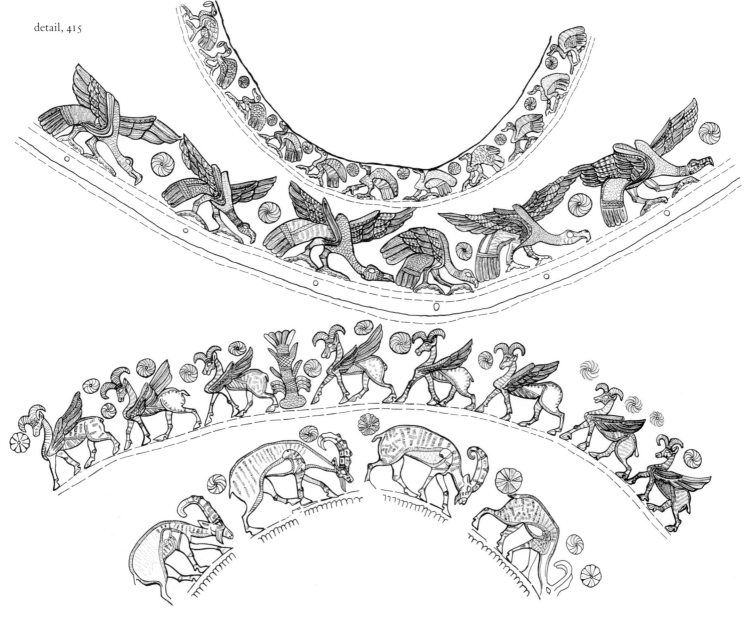

419

Bowl
Western Iran; Iron Age I–II
(c. 1350–800 B.C.)
h: 3.9 cm.; diam: 18.5 cm.
Bronze, hammered; Calmeyer,
1969, group 28; shallow bowl
with central omphalos; on the in-
side, a frieze of four long-horned
deer with stippled bodies divided
by four vine-like trees with
spreading branches and birds, the
whole executed in repoussé with
incised detail.
M.76.97.383

Doubts have been expressed about
the authenticity of some bowls in
this group, but examination by
eye does not raise suspicions about
this one.

420

Bowl
Western Iran; Iron Age I–II
(c. 1350–800 B.C.)
h: 4 cm.; diam: 17.5 cm.
Bronze, hammered; shallow bowl
with large central omphalos; on
the inside, a frieze of three long-
horned deer with stippled bodies
grazing in foliage similar to that
on preceding bowl.
M.76.97.384

cf. cat. no. 419.

421

Bowl
Western Iran; Iron Age III
(c. 800–650 B.C.)
h: 3.5 cm.; diam: 14.6 cm.
Bronze, hammered(?); Luschey,
1939, type I.C.8; shallow bowl
with central omphalos; gadrooned
interior frieze of twelve promi-
nent egg-shaped bosses divided
by a series of ridged, radiating,
leaf-shaped tongues terminating
in double-incised lotus buds; the
calyx petals of these latter en-
close outer contour of the bosses,
forming a continuous looped
chain; the base of each tongue is
delineated by a double engraved
arc, the whole forming a star-
shaped medallion.
M.76.97.375

422

Bowl
Western Iran; Iron Age III
(c. 800–650 B.C.)
h: 3.5 cm.; diam: 17.7 cm.
Bronze, hammered; shallow bowl
with low ring base and everted
rim; interior decorated in repoussé
with three alternating segments of
parallel ridges and crisscross net-
works of diamond-shaped units;
raised central medallion circum-
scribed by a channel and containing
a small raised umbo within.
M.76.97.401

423

Bowl
Western Iran; Iron Age III
(c. 800–650 B.C.)
h: 7.5 cm.; diam: 14.2 cm.
Bronze, hammered; Luschey,
1939, type I.A.2; shallow bowl
with undecorated center sur-
rounded by a lozenge network of
overlapping leaf-shaped tongues
terminating at the shoulder in a
frieze of tear-shaped bosses.
M.76.97.403

424

Bowl
Western Iran; Iron Age II–III
(c. 1000–650 B.C.)
h: 6.9 cm.; diam: 13.1 cm.
Bronze, hammered; hemispheri-
cal bowl; ring base decorated
with an eight-petaled rosette
medallion surrounded by three
concentric raised rings; a fourth
raised ring below lip; alternating
rows of a leaf motif executed in
repoussé around the outer body.
M.76.174.96

425

Bowl
Western Iran; Iron Age II–III
(c. 1000–650 B.C.)
h: 6.1 cm.; diam: 12.8 cm.
Bronze, hammered; hemispheri-
cal bowl; ring base decorated
with an eight-petaled rosette sur-
rounded by tongues; straight lip
inset decorated with a dentate
pattern framed below by a raised
channel; two rows of six-petaled
rosettes executed in repoussé
around the outer body.
M.76.174.120

419

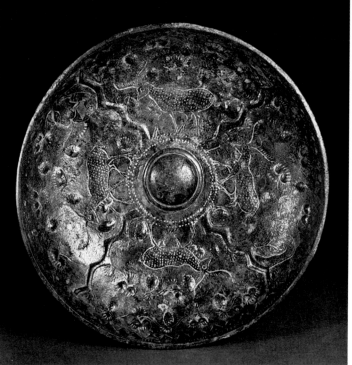

428

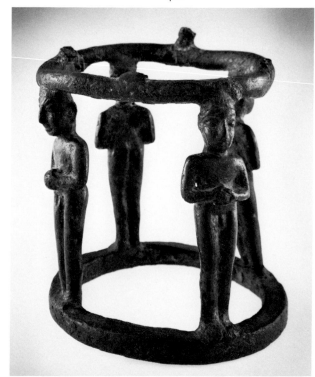

426

Bowl

Iran; modern

h: 4.9 cm.; diam: 7.1 cm.
Bronze, cast; small deep bowl
with ring foot and everted rim;
three ridges encircle the shoulder;
a stylized lion facing upward on
one side, its muzzle resting on the
rim; a spread-winged bird
perched opposite on the rim.
M.76.97.397; ex-Holmes Collection

Pub. New York, 1940, p. 119 J.

The individual parts of the vessel
may be ancient, but the assembly
is modern.

427

Spouted Dish

Western Iran; Iron Age II–III
(c. 1000–650 B.C.)
h: 3.6 cm.; diam: 12 cm.
Bronze, hammered; shallow dish
with everted lip, carinated body,
and flat base; long, flat, horizontal
spout; cast bird handle attached to
shoulder and lip opposite spout.
M.76.97.400; ex-Holmes Collection

Pub. New York, 1940, p. 121 E;
for type, cf. Moorey, 1971, no. 506.

428

Vessel Stand

Elamite; Bronze Age

h: 14 cm.; diam: 14 cm.
Bronze, cast; Calmeyer, 1969,
group 7; four nude men with
hands clasped at the waist, stand-
ing at equal intervals on a circular,
square-sectioned bar; another
circular bar on their heads, which
supported a second frieze of fig-
ures, now lost.
M.76.97.390

Although its authenticity is cer-
tain, this object may not yet be
accurately dated and attributed. It
may be from a provincial Elamite
workshop of the second half of
the third millennium B.C. which
produced maces and cudgels
decorated in relief with nude
figures.

429

Situla

Luristan; Iron Age II
(c. 1000–800 B.C.)
h: 13.4 cm.; diam: 6.2 cm.
Bronze, hammered; Calmeyer,
1973, type A; situla with cylindri-
cal body tapering to a button
base, the latter rendered as the
center of a chased rosette; in
the central panel, a chased scene
consisting of an enthroned man
seated before a table, approached
by a servant with fly whisk, and a
musician playing a lute; between
servant and musician, a vessel
with straw set on a lion-footed
stand; the whole framed by a
border of tongues with a second
guilloche band above (below the
rim); damaged.
M.76.97.348

Pub. Muscarella, *AJA* 78, 1974,
pl. 49, figs. 13, 14.

430

Situla

Luristan; Iron Age II
(c. 1000–800 B.C.)
h: 13.5 cm.; diam: 7.2 cm.
Bronze, hammered; Calmeyer,
1973, type A; shape and decoration
as in cat. no. 429; the authen-
ticity of this example is suspect.
M.76.97.349

431

Situla

Luristan; Iron Age II
(c. 1000–800 B.C.)
h: 11.1 cm.; diam: 5 cm.
Bronze, hammered; Calmeyer,
1973, type F; shape as in cat. no.
429; exterior frieze depicts a
kneeling archer aiming at a horned
animal, its head turned back
toward the archer.
M.76.97.357

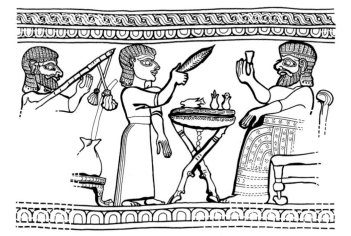

detail, 429

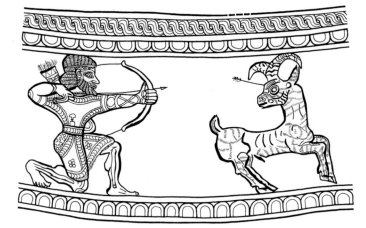

detail, 431

432

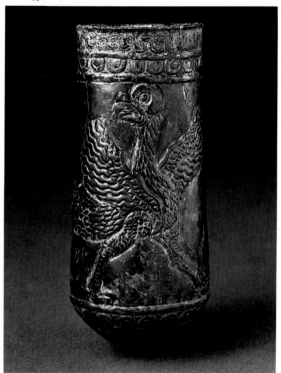

detail, 432

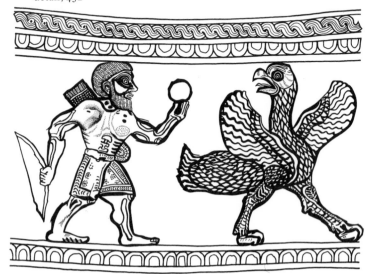

433

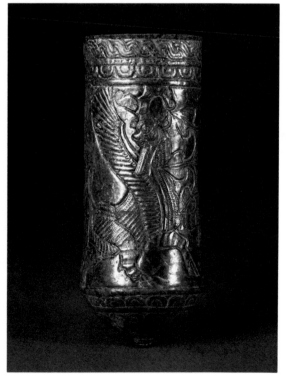

detail, 433

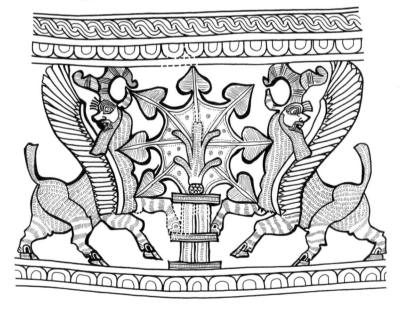

432

Situla
Luristan; Iron Age II
(c. 1000–800 B.C.)
h: 14.3 cm.; diam: 5.5 cm.
Bronze, hammered; Calmeyer,
1973, C.4; shape as in cat. no. 429;
exterior frieze depicts a standing
bowman pursuing an ostrich.
M.76.97.355; ex-Holmes Collection

Pub. Pope, 1938, IV, pl. 71 C, D;
Pope, 1945, pls. 12, 13; Contenau,
1947, no. 2172; Frankfort, 1956,
fig. 102a; Calmeyer, 1973, p. 38
(full bibliography).

433

Situla
Luristan; Iron Age II
(c. 1000–800 B.C.)
h: 16 cm.; diam: 6 cm.
Bronze, hammered; Calmeyer,
1973, H.1; shape as in cat. no. 429;
exterior frieze depicts two
slightly rearing, human-headed,
winged bulls with heads reverted,
flanking a stylized tree.
M.76.97.350

Pub. Porada, 1964, p. 71, pl. 15,
left; Calmeyer, 1973, p. 62 (full
bibliography).

434

Situla
Luristan; Iron Age II
(c. 1000–800 B.C.)
h: 13.6 cm.; diam: 6 cm.
Bronze, hammered; Calmeyer,
1973, type L; shape as in cat.
no. 429; exterior frieze depicts
two confronted bulls; damaged.
M.76.97.356

Pub. Rome, 1956, no. 163, pl.
XVIII; Muscarella, *AJA* 78, 1974,
pl. 49, figs. 15, 16.

435

Situla
Luristan; Iron Age II
(c. 1000–800 B.C.)
h: 14.8 cm.; diam: 6.5 cm.
Bronze, hammered; Calmeyer,
1973, type L.2; shape as in cat.
no. 429; exterior frieze depicts
two confronted winged bulls.
M.76.97.351

436

Situla
Luristan; Iron Age II
(c. 1000–800 B.C.)
h: 14.4 cm.; diam: 6 cm.
Bronze, hammered; Calmeyer,
1973, type L.3; shape as in cat.
no. 429; exterior frieze depicts
two confronted, human-headed
winged bulls.
M.76.97.352

437

Situla
Luristan; Iron Age II
(c. 1000–800 B.C.)
h: 12.5 cm.; diam: 5.5 cm.
Bronze, hammered; Calmeyer,
1973, type L; shape as in cat. no.
429; exterior frieze depicts two
confronted bulls, rearing slightly,
with heads turned back; stylized
mountains(?) beneath their feet.
M.76.97.353

Pub. Muscarella, *AJA* 78, 1974,
pl. 49, fig. 17.

detail, 434

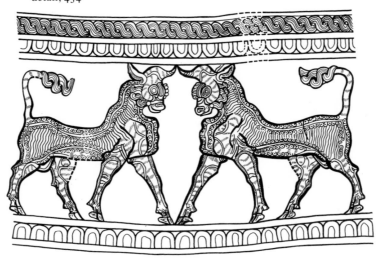

*Miscellaneous Pre-Achaemenid
Sheet Metal Objects*

*The objects grouped here have less cultural and functional coherence
than those considered so far. They represent particularly well the
unfortunate confusion and uncertainty arising when objects are torn
from the ground by clandestine excavation. Some were purely orna-
mental; some formed parts of belts or body armor, probably sewn onto
fabric or leather backing; others are related by form and decoration
to the disk-headed pins (cf. cat. nos. 368–97) and may have served a
comparable votive role in shrines or been sewn to the garments of
priests or officials.*

438

Helmet
Western Iran; Iron Age III
(c. 800–650 B.C.)
h: 20.8 cm.; diam: 20.4 cm.
Bronze, hammered; Calmeyer,
1969, group 44; conical helmet
decorated on one side with two
groups of three embossed snakes;
substantially restored.
M.76.174.148

cf. Overlaet, *IrAn* XIV, 1979,
pp. 51ff.

439

Belt Clasp
Western Iran; Iron Age II–III
(c. 1000–650 B.C.)
h: 8.5 cm.; l: 17.5 cm.
Bronze, hammered; bronze wire
curved around to form a long,
narrow loop, the sides of which
are hammered flat to form a pair
of rectangular plaques decorated
with a crude geometric design in
repoussé blobs and stippled lines.
M.76.97.925

cf. Moorey, 1971, no. 458; Amiet,
1976, no. 192.

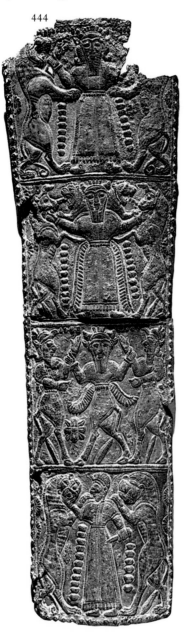

444

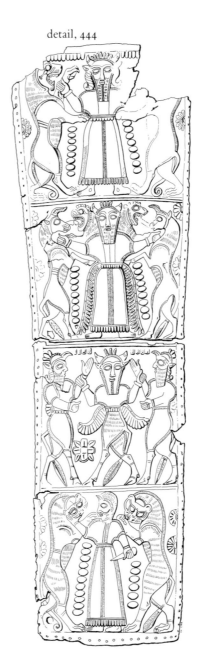

detail, 444

440

Belt
Western Iran; Iron Age II–III
(c. 1000–650 B.C.)
h: 6.3 cm.; w: 49.5 cm.
Bronze, hammered; both ends
rounded; margin pierced with
holes for attachment; surface
divided into panels with incised
geometric decoration at each end;
various animals and figures
between.
M.76.97.924a–c

The belt is probably ancient; but
some, if not all, of the design is
recent.

441

Headband or Belt
Western Iran; Iron Age II–III
(c. 1000–650 B.C.)
h: 5.5 cm.; w: 18.3 cm.
Bronze, hammered; flat band tap-
ering toward either end; terminals
laced with wire; crudely incised
design consisting of a spread-
winged bird flanked to the right
by a goat with large bird perched
on its back, the latter facing to the
rear, and confronted by a large
undulating serpent; to the left,
two goats (?) followed by a bird of
the previous type, similarly con-
fronted by a serpent; all animals
are decorated with incised chev-
rons; the plaque is framed above
and below by a border of repoussé
blobs.
M.76.97.918; ex-Holmes Collection

442

Rectangular Plaque
Western Iran; Iron Age II–III
(c. 1000–650 B.C.)
h: 9.6 cm.; w: 11.5 cm.
Bronze, hammered; rectangular
plaque with rounded corners dec-
orated in repoussé; central panel
framed by a double border of
floral friezes; in the center stand
two long-robed figures with a
subhuman frontal face between
them; part, if not all, of the design
may be recent; fragmentary.
M.76.97.159

443

Rectangular Plaque
Western Iran; Iron Age II–III
(c. 1000–650 B.C.)
h: 29 cm.; w: 10 cm.
Bronze, hammered; tall rectan-
gular plaque, composed of three
panels; from top to bottom: a pair
of goats or mouflon on either
side of a sacred palmette; an in-
verted master/mistress of animals,
legs spread, flanked by rampant
lions; and a pair of rampant goats or
mouflon, with heads turned
back, on either side of a browsing
goat; in the area below, a pair of
confronted animals; rounded
bosses in field; fragmentary.
M.76.97.172

Possibly from a quiver, the crude,
lively style of this plaque and some
of its motifs suggest a provincial
Elamite source distinct from the
workshops of the Zagros region
commonly represented here.

444

Quiver Plaque
Luristan; Iron Age II–III
(c. 1000–650 B.C.)
h: 43.5 cm.; w: 13 cm.
Bronze, hammered; tall vertical
plaque in two fragments, each
consisting of two registers, one
above the other; finely decorated
in shallow repoussé with outlines
and details engraved; from top to
bottom: a robed, bearded figure
flanked by rampant lions; a similar
robed figure, with secondary lion
heads, flanked by rampant bulls; a
winged bullman flanked by a pair
of wingless bullmen whom he grabs
by the wrists; and a robed cen-
tral figure with dagger, facing left,
flanked by rampant lions, heads
turned full face; the first, second,
and fourth panels are decorated
with a pair of vertical beaded
chains flanking the lower portion
of the central figure; on panel
three, a single rosette in the field;
decorated on all four sides with
a narrow perforated border.
M.76.97.178a,b

Pub. Rome, 1956, no. 48, pl. XIII
(right); Porada, 1965, pl. 15,
right (detail); Moorey, *Iran* XIII,
1975, p. 21, fig. 1.

445

Belt Fragment
Western Iran; Iron Age II–III
(c. 1000–650 B.C.)
h: 5.4 cm.; l: 17.4 cm.
Bronze, hammered; pierced with
attachment holes along the mar-
gins; outer surface decorated with
an engraved design consisting of
a vulture between two lions (?)
(the left-hand figure mostly lost),
followed by a goat on the right;
the body of the preserved lion is
decorated with a series of punched
circles; origin and date uncertain.
M.76.97.923a,b

446

Rectangular Plaque
Western Iran; Iron Age II–III
(c. 1000–650 B.C.)
h: 15.5 cm.; w: 12.5 cm.
Bronze, hammered; two squares
in the upper part with repeated
motif of rampant goats, perched
on mountain symbols, flanking a
stylized tree; the whole bordered
above by a stylized palmette
frieze; below, a blank panel framed
beneath by a row of four small
panels, each containing a couchant
winged bull; plain border (frag-
mentary); perhaps from a quiver.
M.76.174.75

447

"Kizil Kuh" Plaque
Western Iran; Iron Age II
(c. 1000–800 B.C.)
h: 7 cm.; w: 13.8 cm.
Bronze, hammered; thin bronze
plaque with concave upper and
lower edges and convex sides;
wire loop on the right side; trape-
zoidal frame of stamped concen-
tric circles continuing down the
center, dividing the field into two
panels; within, a pair of incised
opposed bulls; iron staining.
M.76.97.173

cf. Calmeyer, 1964 (I), nos. 59–62;
Moorey, 1971, no. 494 A.

This object and the following two
belong to a category of artifacts
said to have been found at Kizil
Kuh, near Kermanshah, in west-
ern Iran. They seem to occur in
pairs; no convincing explanation
of their use is yet available.

448

"Kizil Kuh" Plaque
Western Iran; Iron Age II
(c. 1000–800 B.C.)
h: 7.2 cm.; w: 13.8 cm.
Bronze, hammered; same type as
cat. no. 447; wire loop on the left
side; field decorated with a pair of
opposed bulls; iron staining and
some iron loops extant.
M.76.97.174

446

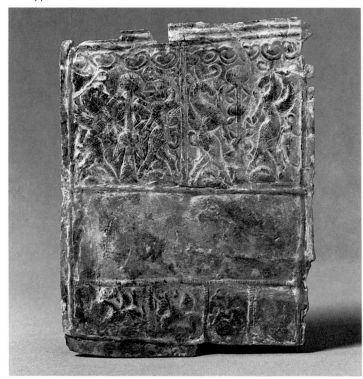

449

"Kizil Kuh" Plaque
Western Iran; Iron Age II
(c. 1000–800 B.C.)
h: 7.6 cm.; w: 15.1 cm.
Bronze, hammered; same type as
cat. no. 447; no loop; field deco-
rated with a figure of a lion con-
fronting a bull; traces of iron rings.
M.76.97.175

450

Disk
Western Iran; Iron Age II–III
(c. 1000–650 B.C.)
diam: 12 cm.
Bronze, hammered; surface deco-
rated with a central female face
flanked by demons with profile
heads and full-face bodies hold-
ing branches; a winged griffin
above; fragmentary; authenticity
doubtful.
M.76.97.139

451

Disk
Western Iran; Iron Age or
possibly Parthian period
diam: 19 cm.
Bronze, hammered; large, plain,
central boss; surrounded by a
frieze of five bosses, each ringed
by a series of smaller ones; be-
tween, a series of five crudely in-
cised bird-headed animals with
heads reverted; around the edge,
a border of minute bosses; pairs
of holes for attachment on the
periphery.
M.76.97.147

cf. Moorey, 1971, no. 478.

452

Disk
Western Iran; Iron Age II–III
(c. 1000–650 B.C.)
preserved w: 16.4 cm.
Bronze, hammered; central umbo
in the form of a frontal female
face; in the field surrounding, a
full-face human head, with sec-
ondary profile heads, flanked by
a pair of rampant lions (the left
figure mostly lost); below, a goat
facing right before a stylized
plant; rosette filling ornaments in the
field; a ring of dots around the
margin.
M.76.97.155

Pub. Pope, 1945, pl. 17 (said to
come from Surkh Dum); Rome,
1956, no. 150, pl. XV; Goldman,
Berytus XIV, 1961, pl. II: 2; Ghirsh-
man, 1964, p. 51, fig. 63; Moorey,
IrAn XIII, 1975, p. 23, fig. 3.

453

Disk
Western Iran; Iron Age II–III
(c. 1000–650 B.C.)
diam: 4.5 cm.
Bronze, hammered; gamboling
mountain goat with a chased
rosette above.
M.76.97.164

454

Boss
Western Iran; Iron Age II–III
(c. 1000–650 B.C.)
diam: 9.4 cm.
Bronze, hammered; circular sheet
metal disc gradually rising to a
point at the center, surrounded by
a narrow flange; central boss
decorated with highly stylized full
frontal bull mask, outlined in
repoussé, with rosettes in field;
flange decorated with a border of
minute bosses and perforated with
single paired holes.
M.76.97.738

cf. Belloni and d'Arsen, 1969, pl. 31.

Discs such as this may in them-
selves be ancient, but designs like
this have yet to be authenticated.

455

Terminal
Western Iran; Iron Age III–
Achaemenid period
(c. 800–330 B.C.)
h: 7.5 cm.; w: 9 cm.; l: 11.5 cm.
Bronze, hammered; hollow ter-
minal in the shape of a ram's
head; ribbed horns curved around to
frame the face.
M.76.97.664; ex-Holmes Collection

Pub. Pope, 1938, III, p. 2630, fig.
860a; New York, 1940, p. 52 G;
Pope, 1945, pl. 20.

This may come from a piece of
furniture, where it would have
formed a decorative terminal for
an arm. It does not appear to have
been part of a metal drinking
vessel.

456

Silhouette
Western Iran; Iron Age II–III
(c. 1000–650 B.C.)
h: 11.4 cm.; w: 3.2 cm.
Bronze, hammered; made from a
single strip of sheet metal; human
figure in silhouette with arms held
up to its chest; ornamented with
a girdle and neck band decorated
with incised x's.
M.76.97.790

cf. Herzfeld, 1941, pl. XXXII, right.

Figures such as this may have
been cheap substitutes for the
cast-bronze figures also produced
in the region at this time (see the
following section).

452

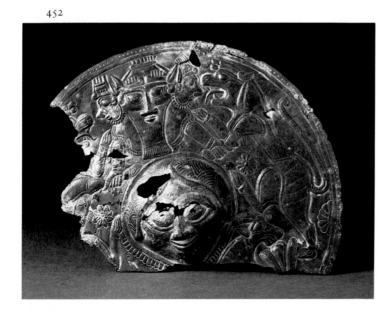

455

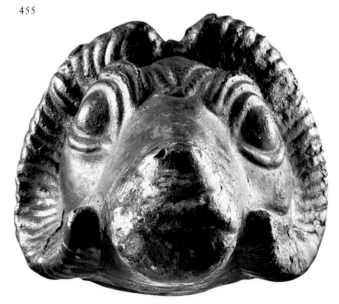

Pre-Achaemenid Bronze
Personal Ornaments

Bracelets dominate the collection of Iron Age personal ornaments. Although a few of them, notably those with terminals cast as stylized lion heads, may be associated with the distinctive Luristan bronzes, many have zoomorphic decoration less securely identified with particular regions of western Iran. The heavy, two-part bracelets (and anklets) are particularly distinctive. Here again the decoration suggests production in Luristan, to which region they may have been confined. Examples are also known both in iron and in lead. Anklets are virtually impossible to isolate by size from bracelets, as the latter were, in antiquity, often worn by men on their upper arms; weight is more indicative. The fibula, or safety pin (cat. no. 501), was an object introduced to Iran from the Syro-Mesopotamian area in the eighth century B.C., and its increasing popularity after that time marked the eclipse of the straight garment pin. Both the earrings and the finger rings are forms common to much of western Iran, though these particular examples may well have been found in Luristan.

458

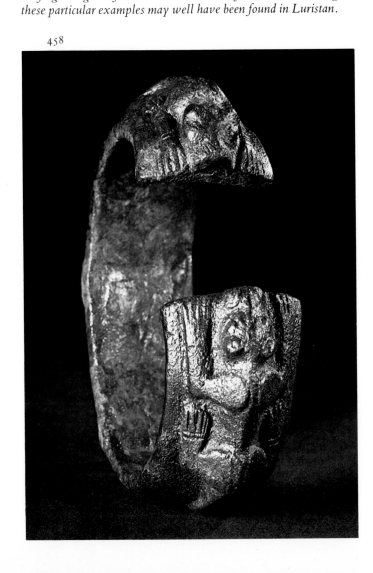

457
Bracelet
Western Iran; Iron Age II–III
(c. 1000–650 B.C.)
diam: 7.3 cm.
Bronze, cast; terminals in the form of recumbent roaring lions; broad band decorated with geometric designs.
M.76.97.286

For bracelets with various zoomorphic terminals, cf. Moorey, 1971, pp. 218ff.

458
Bracelet
Western Iran; Iron Age II–III
(c. 1000–650 B.C.)
diam: 8.5 cm.
Bronze, cast; terminals in the form of crouching lions; broad, flat band.
M.76.97.329

459
Bracelet
Western Iran; Iron Age II–III
(c. 1000–650 B.C.)
diam: 7.8 cm.
Bronze, cast; terminals in the form of lion heads; broad band decorated with geometric designs.
M.76.97.287

460
Bracelet/Anklet
Western Iran; Iron Age II–III
(c. 1000–650 B.C.)
diam: 10.4 cm.
Bronze, cast; terminals in the form of lion heads; thick, plain hoop.
M.76.97.301

461
Bracelet
Western Iran; Iron Age II–III
(c. 1000–650 B.C.)
diam: 6.2 cm.
Bronze, cast; terminals in the form of lion heads; broad band with incised geometric decoration.
M.76.97.313

462
Bracelet
Western Iran; Iron Age II–III
(c. 1000–650 B.C.)
diam: 7.3 cm.
Bronze, cast; terminals in the form of double-headed lions couchant, heads turned outward; rounded hoop.
M.76.97.296

463
Bracelet
Western Iran; Iron Age II–III
(c. 1000–650 B.C.)
diam: 9.2 cm.
Bronze, cast; terminals in the form of stylized double lion heads; rounded hoops.
M.76.97.302

464
Bracelet
Western Iran; Iron Age II–III
(c. 1000–650 B.C.)
diam: 2.7 cm.
Bronze, cast; terminals in the form of stylized lion masks; rounded hoop.
M.76.97.290

465
Bracelet
Western Iran; Iron Age II–III
(c. 1000–650 B.C.)
diam: 8 cm.
Bronze, cast; terminals in the form of stylized lion heads; rounded hoop (distorted).
M.76.97.297

466
Bracelet
Western Iran; Iron Age II–III
(c. 1000–650 B.C.)
diam: 4.7 cm.
Bronze, cast; terminals in the form of stylized lion masks (one missing); flat band incised with geometric decoration.
M.76.97.315

467
Bracelet
Western Iran; Iron Age II–III
(c. 1000–650 B.C.)
diam: 7.3 cm.
Bronze, cast; terminals in the form of recumbent goats with heads turned back; rounded hoop with incised geometric decoration.
M.76.97.285

468
Bracelet
Western Iran; Iron Age II–III
(c. 1000–650 B.C.)
diam: 6.9 cm.
Bronze, cast; terminals in the form of goat heads; rounded hoop.
M.76.97.288

469

Bracelet
Western Iran; Iron Age II–III
(c. 1000–650 B.C.)
diam: 6.7 cm.
Bronze, cast; terminals in the form
of goat heads; coiled hoop.
M.76.97.306

470

Bracelet/Anklet
Western Iran; Iron Age II–III
(c. 1000–650 B.C.)
diam: 12.4 cm.
Bronze, cast; terminals in the form
of calf (?) heads; rounded hoop.
M.76.97.318

471

Bracelet
Western Iran; Iron Age II–III
(c. 1000–650 B.C.)
diam: 7.5 cm.
Bronze, cast; terminals in the form
of double boar heads; rounded
hoop.
M.76.97.289; ex-Holmes Collection

472

Bracelet
Western Iran; Iron Age II–III
(c. 1000–650 B.C.)
diam: 7.6 cm.
Bronze, cast; terminals in the
form of addorsed bull heads;
rounded hoop.
M.76.97.282; ex-Holmes Collection

Pub. New York, 1940, p. 128 U.

473

Bracelet
Western Iran; Iron Age II–III
(c. 1000–650 B.C.)
diam: 7.9 cm.
Bronze, cast; terminals in the form
of snake heads; rounded hoop,
flattened on the inside; the attribu-
tion of this bracelet is uncertain.
M.76.97.304

474

Bracelet
Western Iran; Iron Age II–III
(c. 1000–650 B.C.)
diam: 7.2 cm.
Bronze, cast; terminals in the form
of double swimming ducks; broad
band incised with linear designs.
M.76.97.284

475

Bracelet
Western Iran; Iron Age II–III
(c. 1000–650 B.C.)
diam: 7.1 cm.
Bronze, cast; terminals shaped as a
pair of sleeping ducks.
M.76.97.307

476

Bracelet
Western Iran; Iron Age II–III
(c. 1000–650 B.C.)
diam: 6.7 cm.
Bronze, cast; terminals in the form
of caprid heads (?) with a duck's
head rising from them; rounded
hoop with incised decoration.
M.76.97.291

477

Bracelet
Western Iran; Iron Age II–III
(c. 1000–650 B.C.)
diam: 5.8 cm.
Bronze, hammered; broad band
with slightly projecting flat termi-
nals; incised geometric decoration.
M.76.97.330

For such bracelets, cf. Moorey,
1971, nos. 364–69.

478

Bracelet
Western Iran; Iron Age II–III
(c. 1000–650 B.C.)
diam: 6.4 cm.
Bronze, hammered; straight ter-
minals with band swelling out-
ward at the opposite end; stippled
decoration including an archer
(possibly a modern addition).
M.76.97.332.

479

Bracelet
Western Iran; Iron Age II–III
(c. 1000–650 B.C.)
diam: 4.8 cm.
Bronze, hammered; straight ter-
minals with band swelling out-
ward from terminals to the central
section; incised with crudely ren-
dered rosettes, foliage, and birds.
M.76.97.333

480

Bracelet
Iran; date uncertain
diam: 8.5 cm.
Bronze, cast; spiral of four turns;
plain terminals.
M.76.97.731

cf. Schmidt, 1937, pl. XXVII B (Tepe
Hissar).

Plain bracelets such as these ap-
pear in Iran beginning in the third
millennium B.C.

481

Bracelet
Iran; date uncertain
diam: 7.2 cm.
Bronze, cast; spiral of five turns;
plain terminals.
M.76.97.732

cf. cat. no. 480.

482

Bracelet
Iran; Iron Age II–III
(c. 1000–650 B.C.) or later
diam: 5.3 cm.
Bronze, cast; spiral of five turns;
one terminal is plain, the other in
the form of a ram's head.
M.76.97.729

483

Bracelet
Western Iran; Iron Age II–III
(c. 1000–650 B.C.)
diam: 8.2 cm.
Bronze, cast; in two sections origi-
nally joined by pins or rivets;
the concave lower segment has
pierced square tangs at each end
and is decorated along the edges
with geometric patterns in relief;
the upper segment is divided into
three sections, those at the ends
containing grotesque faces in re-
lief, the one in the center a master
of animals.
M.76.97.293a,b

For this type of bracelet, cf.
Moorey, 1971, nos. 372, 373.

484

Bracelet
Western Iran; Iron Age II–III
(c. 1000–650 B.C.)
diam: 8.4 cm.
Bronze, cast; in two sections as
cat. no. 483; lower segment is
decorated with linear and rope-
like ridges; the upper has three
protruding flanges; two opposed
grotesque faces in relief at each
end, pierced for rivets; between
the ridges are relief faces, each
with hands (or paws) and a shared
midriff, one frontal, the other
inverted.
M.76.97.294a,b

For type, cf. Amiet, 1976, nos.
153–55.

485

Bracelet/Anklet
Western Iran; Iron Age II–III
(c. 1000–650 B.C.)
diam: 9.2 cm.
Bronze, cast; in two sections as
cat. no. 483; lower segment is
plain; the upper has three project-
ing flanges with grotesque relief
faces in the end panels.
M.76.97.295a,b

486

Bracelet
Western Iran; Iron Age II–III
(c. 1000–650 B.C.)
diam: 8.6 cm.
Bronze, cast; in two sections as
cat. no. 483; lower segment has
low relief geometric decoration;
the upper has four stylized animal
heads in the center panels and a
pair of superimposed grotesque
human heads at each end.
M.76.97.334

487

Bracelet
Western Iran; Iron Age II–III
(c. 1000–650 B.C.)
diam: 9.3 cm.
Bronze, cast; in two sections as cat.
no. 483; both segments are un-
decorated; the upper has three
flanges.
M.76.174.41

488

Bracelet
Western Iran; Iron Age II–III
(c. 1000–650 B.C.)
l: 9 cm.
Bronze, cast; upper segment only
of a bracelet like cat. no. 483;
two opposed stylized lion heads
in relief, one at each end.
M.76.174.118

489

Bracelet
Western Iran; Iron Age II–III
(c. 1000–650 B.C.)
diam: 7.5 cm.
Bronze, cast; lower segment only
of a bracelet like cat. no. 483;
decorated border.
M.76.174.130

490

Bracelet
Western Iran; Iron Age II–III
(c. 1000–650 B.C.)
diam: 8.1 cm.
Bronze, cast; upper segment only
of a bracelet like cat. no. 483; di-
vided into panels with grotesque
faces in the center and at each end.
M.76.174.131

491

Bracelet/Anklet
Western Iran; Iron Age II–III
(c. 1000–650 B.C.)
diam: 10.2 cm.
Bronze, cast; lower segment only
of a bracelet like cat. no. 483; plain.
M.76.174.132

492

Bracelet
Western Iran; Iron Age II–III
(c. 1000–650 B.C.)
diam: 8.6 cm.
Bronze, cast; in two parts as cat.
no. 483; lower segment is plain;
the upper has three flanges with
grotesque human faces in relief
at each end.
M.76.174.136 and .137

493

Anklet
Western Iran; Iron Age II–III
(c. 1000–650 B.C.)
diam: 14.5 cm.
Bronze, cast; in two parts; lower,
heavy segment is cast plain, its end
tapered and pierced for rivets; the
smaller part, which fits over the
opening and was originally riveted
to the terminals, has a pair of
opposed stylized lions crouching
along the top and two grotesque
heads on the sides.
M.76.97.298a,b

494

Anklet/Bracelet
Western Iran; Iron Age II–III
(c. 1000–650 B.C.)
diam: 11.5 cm.
Bronze, cast; in two parts;
lower part is cast plain, its ends
tapered and pierced for rivets; the
smaller upper part is hollow cast;
pierced at the ends for fixing and
decorated with stylized addorsed
lion masks.
M.76.97.299a,b

495

Anklet/Bracelet
Western Iran; Iron Age II–III
(c. 1000–650 B.C.)
diam: 12.4 cm.
Bronze, cast; in two parts as cat.
no. 494; on each side of the upper
part are a pair of stylized addorsed
lion profiles.
M.76.97.300; ex-Holmes Collection

Pub. New York, 1940, p. 129 H.

496

Anklet/Bracelet
Western Iran; Iron Age II–III
(c. 1000–650 B.C.)
diam: 11.2 cm.
Bronze, cast; in two parts as cat.
no. 494.
M.76.97.324a,b

497

Anklet/Bracelet
Western Iran; Iron Age II–III
(c. 1000–650 B.C.)
diam: 10.1 cm.
Bronze, cast; plain hoop with
overlapping terminals.
M.76.97.322

498

Anklet/Bracelet
Western Iran; Iron Age II–III
(c. 1000–650 B.C.)
diam: 11.2 cm.
Bronze, cast; plain hoop with
closely abutting flat terminals; in-
cised decoration on hoop behind
terminals.
M.76.97.323

499

Anklet/Bracelet
Western Iran; Iron Age
diam: 15.2 cm.
Bronze, cast; thick hoop with flat
terminals; incised all over with
a secondary inscription in an un-
identified alphabetic script; date
uncertain.
M.76.97.341

483

484

95

500

Anklet/Bracelet
Western Iran; Iron Age II–III
(c. 1000–650 B.C.)
diam: 10.7 cm.
Bronze, cast; plain hoop with flat
terminals; incised geometric deco-
ration on hoop behind terminals.
M.76.174.122

501

Fibula
Western Iran; Iron Age II–III
(c. 1000–650 B.C.)
l: 5 cm.
Bronze, cast; triangular, with
prominent moldings and a
catch plate in the shape of a
human hand; pin lost.
M.76.97.982

cf. Stronach, *Iraq* XXI, 1959, pp.
189–90, fig. 5:3; Vanden Berghe,
IrAn XIII, 1978, pp. 35ff.

502

Earrings
Western Iran; Iron Age II–III
(c. 1000–650 B.C.)
diam: 5.7 cm.
Bronze, cast; perhaps a pair; open
ring with a row of granulated
blobs around much of the circum-
ference; presumably once fitted
to a second smaller ring.
M.76.97.309 and .310

cf. Moorey, 1971, nos. 408, 409.

503

Torque (neck ring)
Northwestern Iran; Iron Age I–II
(c. 1350–800 B.C.)
diam: 17 cm.
Bronze, cast; open-ended hoop
with terminals turned back, one
parallel to the ring, the other at
right angles to it; hoop swells and
has a slight ridge opposite the
opening; incised linear decoration
of triangles.
M.76.97.725

Pub. Bowie, 1966, p. 68, pl. 90 C;
cf. Moorey, 1974, fig. 110.

504

Torque (neck ring)
Northwestern Iran; Iron Age I–II
(c. 1350–800 B.C.)
diam: 12.5 cm.
Bronze, cast; open-ended hoop
with flat terminals rolled back;
over two thirds of hoop's surface
decorated with spiral ribbing;
undecorated terminals of square
section.
M.76.97.727

Pub. Bowie, 1966, p. 68, pl. 90 B;
cf. Pope, 1938, IV, pl. 57 A.

The twisted torque with recurved
terminals is difficult to pinpoint
geographically as it was in wide
distribution over an area extend-
ing from Central Europe to
northern Iran.

505

Finger Ring
Western Iran; Iron Age II–III
(c. 1000–650 B.C.)
diam: 2.9 cm.
Bronze, hammered; wide tapering
band with slightly overlapping
ends; bezel decorated with crudely
incised rosettes within a herring-
bone border.
M.76.174.279

506

Finger Ring
Western Iran; Iron Age I–II
(c. 1350–800 B.C.)
diam: 3 cm.
Bronze, hammered; bezel deco-
rated with a winged demon stand-
ing on two recumbent horned
animals; a vulture with outspread
wings on either side.
M.76.174.280

Pub. Porada, 1965, p. 76, fig. 48.

507

Finger Ring
Western Iran; Iron Age I–II
(c. 1350–800 B.C.)
diam: 2.8 cm.
Bronze, hammered; bezel deco-
rated with rosettes and a small,
horned animal in "drilled style."
M.76.174.281

508

Finger Ring
Western Iran; Iron Age I–II
(c. 1350–800 B.C.)
diam: 2.5 cm.
Bronze, hammered; bezel deco-
rated with a central tree (?) flanked
by bovids; worn.
M.76.174.282

509

Finger Ring
Western Iran; Iron Age I–II
(c. 1350–800 B.C.)
diam: 2.5 cm.
Bronze, hammered; bezel deco-
rated with a pair of profile,
recumbent, shaggy bulls flanking
bushy trees.
M.76.174.283

Pub. Porada, 1964, pl. I, fig. 3.

510

Finger Ring
Western Iran; Iron Age I–II
(c. 1350–800 B.C.)
diam: 2.3 cm.
Bronze, hammered; bezel deco-
rated with an equid (?) facing
a tree.
M.76.174.284

Pub. Porada, 1964, pl. II, fig. 1a.

511

Finger Ring
Western Iran; Iron Age I–II
(c. 1350–800 B.C.)
diam: 5 cm.
Bronze, hammered; bezel deco-
rated with a central rosette in
a panel framed by incised linear
border.
M.76.174.286

512

Finger Ring
Western Iran; Iron Age I–II
(c. 1350–800 B.C.)
diam: 2 cm.
Bronze, hammered; bezel deco-
rated with a pair of confronted
bulls; floral filling motifs.
M.76.174.305

Pub. Porada, 1964, pl. II, fig. 2.

Pre-Achaemenid Bronze Pendants, Statuettes, and Stamp Seals

The Iron Age pendant animals and animal statuettes of Luristan (western Iran) and Amlash (northwestern Iran) may be separated with some confidence on the basis of their style and form. Certain animals such as the stag and zebu appear in the Amlash range but not in Luristan, where the equids, the lion, the mouflon, and the wild goat are prevalent. In the north such pendants are commonly pierced through the body for suspension; in Luristan they would usually have back suspension loops. No such simple distinction may be made with the anthropomorphic pendants and statuettes, which present recurrent problems of classification not yet resolved and often evident in the attribution given in the entry. Indeed, some of these statuettes may not be from Iran and some may be later than the pre-Achaemenid period. There is little certain information on how these pendants were used. We might assume some were worn on necklaces; controlled excavations in northern Iran have shown that they were worn there suspended from belts. In Luristan, at least, they may sometimes have decorated horse harnesses.

Metal stamp seals of various forms were used in many parts of Iran from the third millennium B.C. onward, but the various local forms and their chronology have not yet been systematically worked out.

513

Pendant
Luristan; Iron Age II–III
(c. 1000–650 B.C.)
h: 4.9 cm.; w: 1.9 cm.
Bronze, cast; in the form of a grotesque head above a bell-like cage.
M.76.97.533

cf. Moorey, 1971, no. 435.

514

Pendant
Western Iran; Iron Age II–III
(c. 1000–650 B.C.)
h: 3 cm.; w: 2.4 cm.
Bronze, cast; in the form of a boot.
M.76.97.866

cf. Moorey, 1971, nos. 431, 432.

515

Pendant
Western Iran; Iron Age II–III
(c. 1000–650 B.C.)
h: 4.2 cm.; w: 8.9 cm.
Bronze, cast; in the form of a double spiral loop.
M.76.97.671; ex-Holmes Collection

Pub. Pope, *ILN* Oct. 29, 1932, p. 666, fig. 1; ibid., 1938, I, p. 276; New York, 1940, p. 126 H.

516

Pendant
Western Iran; Iron Age II–III
(c. 1000–650 B.C.)
h: 3.5 cm.; w: 2 cm.
Bronze, cast; in the form of a sleeping duck; loop at the back of the neck.
M.76.97.619

517

Pendant
Luristan; Iron Age II–III
(c. 1000–650 B.C.)
h: 3 cm.; w: 2.4 cm.
Bronze, cast; in the form of a game bird or "cock"; very worn and rubbed; loop broken.
M.76.97.677

cf. Moorey, 1971, nos. 413ff.

518

Pendant
Luristan; Iron Age II–III
(c. 1000–650 B.C.)
h: 5 cm.; w: 5.4 cm.
Bronze, cast; in the form of a game bird or "cock" as in cat. no. 517.
M.76.97.864

519

Pendant
Luristan; Iron Age II–III
(c. 1000–650 B.C.)
h: 5.5 cm.; w: 5.6 cm.
Bronze, cast; in the form of a game bird or "cock" as in cat. no. 517.
M.76.97.949

520

Pendant
Luristan; Iron Age II–III
(c. 1000–650 B.C.)
h: 3.5 cm.; w: 2.6 cm.
Bronze, cast; in the form of a standing goat with collar; back loop.
M.76.97.720

cf. Potratz, 1968, figs. 128–30; Moorey, 1971, nos. 420–23.

521

Pendant
Luristan; Iron Age II–III
(c. 1000–650 B.C.)
h: 4.3 cm.; w: 3.2 cm.
Bronze, cast; type as in cat. no. 520.
M.76.97.872

522

Pendant
Luristan; Iron Age II–III
(c. 1000–650 B.C.)
h: 6.6 cm.; w: 5 cm.
Bronze, cast; type as in cat. no. 520.
M.76.97.948

523

Pendant
Luristan; Iron Age II–III
(c. 1000–650 B.C.)
h: 6.3 cm.; w: 5.2 cm.
Bronze, cast; type as in cat. no. 520.
M.76.97.954

524

Pendant
Luristan; Iron Age II–III
(c. 1000–650 B.C.)
h: 4.4 cm.; w: 3.3 cm.
Bronze, cast; type as in cat. no. 520.
M.76.97.957

525

Pendant
Luristan; Iron Age II–III
(c. 1000–650 B.C.)
h: 3.2 cm.; w: 3 cm.
Bronze, cast; type as in cat. no. 520.
M.76.97.962

526

Pendant
Luristan; Iron Age II–III
(c. 1000–650 B.C.)
h: 4.5 cm.; w: 4.6 cm.
Bronze, cast; type as in cat. no. 520.
M.76.97.970

527

Pendant
Luristan; Iron Age II–III
(c. 1000–650 B.C.)
h: 3.7 cm.; w: 3.3 cm.
Bronze, cast; type as in cat. no. 520.
M.76.174.53

528

Pendant
Luristan; Iron Age II–III
(c. 1000–650 B.C.)
h: 4.5 cm.; w: 4 cm.
Bronze, cast; in the form of a
standing equid with collar; back
loop.
M.76.97.816

529

Pendant
Luristan; Iron Age II–III
(c. 1000–650 B.C.)
h: 2.1 cm.; w: 3.3 cm.
Bronze, cast; in the form of a
standing equid(?); back loop.
M.76.174.51

530

Pendant
Luristan; Iron Age II–III
(c. 1000–650 B.C.)
h: 2.3 cm.; w: 3 cm.
Bronze, cast; in the form of a
standing equid(?); back loop.
M.76.174.55

531

Pendant
Luristan; Iron Age II–III
(c. 1000–650 B.C.)
h: 1.7 cm.; w: 3 cm.
Bronze, cast; in the form of a
stylized standing lion; legs lost;
back loop.
M.76.97.974

532

Pendant
Western Iran; Iron Age II–III
(c. 1000–650 B.C.)
h: 4.4 cm.; w: 1.8 cm.
Bronze, cast; in the form of a
female holding her breasts; back
loop; authenticity uncertain.
M.76.97.895

533

Pendant
Western Iran; Iron Age II–III
(c. 1000–650 B.C.)
h: 5.3 cm.; w: 2 cm.
Bronze, cast; in the form of a
standing female, nude except for
a girdle; loop at nape of neck.
M.76.97.977

cf. Moorey, 1971, nos. 429, 430.

534

Pendant
Western Iran; Iron Age II–III
(c. 1000–650 B.C.)
h: 3.5 cm.; w: 1.5 cm.
Bronze, cast; in the form of a
standing human figure with arms
at waist; suspension loop on the
shoulders.
M.76.97.979

cf. cat. no. 533.

535

Pendant
Western Iran; Iron Age II–III
(c. 1000–650 B.C.)
h: 3.2 cm.; w: 1.5 cm.
Bronze, cast; in the form of a
standing, nude, ithyphallic male;
suspension loop on back; incised
detail.
M.76.97.980

536

Pendant
Western Iran; Iron Age II–III
(c. 1000–650 B.C.)
h: 2 cm.; w: 3 cm.
Bronze, cast; composed of the
foreparts of two addorsed stylized
animals wearing collars; loop in
the center of the back.
M.76.174.87

537

Pendant
Northwestern Iran; Iron Age III
to Achaemenid period
(c. 800–330 B.C.)
diam: 6.8 cm.
Bronze, cast; composed of three
concentric circles with serrated
outer edges, united at one side by
a vertical bar; top loop missing.
M.76.97.316

cf. Moorey, 1971, nos. 436–39.

538

Pendant
Northwestern Iran; Iron Age III
to Achaemenid period
(c. 800–330 B.C.)
diam: 6.5 cm.
Bronze, cast; in the form of three
concentric circles with serrated
outer edges, united at one side by
a vertical bar; small top loop.
M.76.97.317

cf. cat. no. 537.

539

Pendant
Northwestern Iran; Iron Age III
to Achaemenid period
(c. 800–330 B.C.)
diam: 5.4 cm.
Bronze, cast; composed of two
concentric circles (third one now
lost) with serrated outer edges,
united at top by a vertical bar.
M.76.97.328

cf. cat. no. 537.

540

Pendant
Northwestern Iran; Iron Age I–II
(c. 1350–800 B.C.)
h: 7 cm.; w: 6.3 cm.
Bronze, cast; in the form of a
standing stag with a loop on its
back.
M.76.97.665

541

Pendant
Northwestern Iran; Iron Age I–II
(c. 1350–800 B.C.)
h: 8.3 cm.; w: 9.5 cm.
Bronze, cast; shaped as the
foreparts of two addorsed stags
forming a single body; pierced
horizontally at the shoulders;
some modern restoration.
M.76.97.723

542

Pendant
Northwestern Iran; Iron Age I–II
(c. 1350–800 B.C.)
h: 5.2 cm.; w: 4.8 cm.
Bronze, cast; in the form of a
standing stag; pierced horizontally
both through the shoulders and
rump.
M.76.97.724

543

Pendant
Northwestern Iran; Iron Age I–II
(c. 1350–800 B.C.)
h: 5.3 cm.; w: 4.9 cm.
Bronze, cast; in the form of a
standing quadruped; pierced
through front of body.
M.76.97.682

cf. Hakemi, *Archaeologia Viva* I,
1968, p. 80, fig. 106; p. 81, pl.
XXXVII (Kaluraz).

544

Pendant
Northwestern Iran; Iron Age I–II
(c. 1350–800 B.C.)
h: 2.7 cm.; w: 2.7 cm.
Bronze, cast; in the form of a styl-
ized standing zebu (Bos Indicus).
M.76.97.718

545

Pendant
Northwestern Iran; Iron Age I–II
(c. 1350–800 B.C.)
h: 4.8 cm.; w: 6.3 cm.
Bronze, cast; in the form of a
standing zebu; pierced horizon-
tally through the shoulder.
M.76.97.826

546

Team of Yoked Zebus
Northwestern Iran; Iron Age I–II
(c. 1350–800 B.C.)
h: 3 cm.; w: 4.2 cm.
Bronze, cast.
M.76.97.834

cf. Moorey, 1974, no. 171.

547

Pendant
Northwestern Iran; Iron Age I–II
(c. 1350–800 B.C.)
h: 9.5 cm.; w: 10 cm.
Bronze, cast; in the form of a
standing "wasp waisted" mou-
flon, with ridges around neck and
body; one horn broken; very
corroded; modern restorations.
M.76.97.822

548

Pendant
Northwestern Iran; Iron Age I–II
(c. 1350–800 B.C.)
h: 8 cm.; w: 9.5 cm.
Bronze, cast; in the form of a
standing bovid; back loop; styl-
ized body with some incised
decoration.
M.76.97.823

549

Pendant
Northwestern Iran; Iron Age I–II
(c. 1350–800 B.C.)
h: 4.9 cm.; w: 7 cm.
Bronze, cast; in the form of a
standing ram; stylized, with curl-
ing horns and prominent fore-
lock; pierced horizontally through
the shoulders.
M.76.97.824

550

Pendant
Northwestern Iran; Iron Age I–II
(c. 1350–800 B.C.)
h: 6.1 cm.; w: 7.2 cm.
Bronze, cast; in the form of a
standing bovid; back loop.
M.76.97.825

551

Pendant
Northwestern Iran; Iron Age I–II
(c. 1350–800 B.C.)
h: 3.1 cm.; w: 5.5 cm.
Bronze, cast; shaped as the fore-
parts of two addorsed bulls;
dramatic horn sweep; central
loop.
M.76.97.846

552

Double Ram Protome
Northwestern Iran; Iron Age I–II
(c. 1350–800 B.C.)
h: 3.3 cm.; w: 7.5 cm.
Bronze, cast; foreparts of two ad-
dorsed rams with elongated necks;
badly corroded.
M.76.174.31

553

Pendant
Northwestern Iran; Iron Age I–II
(c. 1350–800 B.C.)
h: 4.8 cm.; w: 7.2 cm.
Bronze, cast; in the form of a
standing water buffalo; back loop.
M.76.174.42

554

Fitting
Western Iran; Iron Age
h: 2.3 cm.; w: 4.1 cm.
Bronze, cast; shaped as the fore-
parts of two addorsed rams;
vertical hole through the center
with vestiges of an iron rivet.
M.76.97.875

555

Pendant
Northwestern Iran; Iron Age I–II
(c. 1350–800 B.C.)
h: 6.3 cm.
Bronze, cast; composed of a short
shaft ending in four axe-shaped
projections (possibly a pair of
double axes).
M.76.174.127

556

Pendant
Northwestern Iran; Iron Age I–II
(c. 1350–800 B.C.)
h: 5.2 cm.; w: 4.6 cm.
Bronze, cast; in the form of a
globular, footed tripod with three
birds perched on top; hole pierced
through at the base of the birds.
M.76.97.953

cf. Moorey, 1974, no. 174.

557

Pendant
Northwestern Iran; Iron Age I–II
(c. 1350–800 B.C.)
h: 4.6 cm.; w: 4.9 cm.
Bronze, cast; in the form of a
woman riding sidesaddle on an
equid; back loop.
M.76.97.752

558

Female Figure
Northwestern Iran; date uncertain
h: 8.1 cm.; w: 3.5 cm.
Bronze, cast; standing steatopygous
woman.
M.76.97.753

559

Pendant
Western Iran; Iron Age I–II
(c. 1350–800 B.C.)
h: 4.1 cm.; w: 1.6 cm.
Bronze, cast; in the form of a nude
woman with hands to breasts;
back loop.
M.76.97.797

560

Female Figure
Northwestern Iran; Iron Age I–II
(c. 1350–800 B.C.)
h: 6.5 cm.; w: 2 cm.
Bronze, cast; seated nude woman
clasping her breasts; headband
and prominent back lock of hair;
chair clearly shown.
M.76.97.784

561

Male Figure
Iran; Iron Age II–III
(c. 1000–650 B.C.)
h: 6.2 cm.; w: 1.8 cm.
Bronze, cast; standing man in an
ankle-length robe with incised
detail; about his chest he clasps the
ends of a scarf passed around his
neck; possibly a modern aftercast.
M.76.98.751

562

Male and Female Figure
Iran; Iron Age II–III
(c. 1000–650 B.C.)
h: 5.5 cm.; w: 4 cm.
Bronze, cast; paired male and
female figures in ankle-length
robes, with hands joined and
raised; very worn.
M.76.97.762

563

Male Figure
Iran; Iron Age II–III
(c. 1000–650 B.C.)
h: 13 cm.; w: 3.7 cm.
Bronze, cast; standing bearded
man in ankle-length robe, with
hands clasped on chest; authen-
ticity uncertain.
M.76.97.764

564

Male Figure
Iran; Iron Age II–III
(c. 1000–650 B.C.)
h: 11.3 cm.; w: 3.3 cm.
Bronze, cast; standing beard-
ed man with flat cap and short
wrapped robe, leaving right
shoulder bare; authenticity
uncertain.
M.76.97.774

565

Male Figure
Western Iran; Iron Age II–III
(c. 1000–650 B.C.)
h: 5 cm.; w: 1.2 cm.
Bronze, cast; standing bearded
man with turban and ankle-length
robe; a dagger stuck through
his belt.
M.76.97.788

cf. Weidner, *AfO* XVI, 1952–53,
pp. 148–49 (an inscribed statuette
from the Pish-i Kuh region of
Luristan).

566

Pendant
Northwestern Iran; date uncertain
h: 8.1 cm.
Bronze, cast; in the form of a
standing human figure in ankle-
length robe with prominent collar
around the neck; neckline plunges
to the waist; loop behind head.
M.76.97.789

cf. Moorey, 1974, no. 144.

567

Male Figure
Iran; date uncertain
h: 8.4 cm.; w: 1.7 cm.
Bronze, cast; standing man.
M.76.97.795

568

Human Figure
Western Iran; Iron Age III
(c. 800–650 B.C.)
h: 6.6 cm.; w: 1.2 cm.
Bronze, cast; crudely modeled
standing human figure with elon-
gated body and short legs; right
arm is held into the side with the
hand touching the ear.
M.76.174.78

For this distinctive gesture, cf.
Muscarella, 1974 (1), no. 146.

569

Male Figure
Iran; date uncertain
h: 6.2 cm.; w: 1.4 cm.
Bronze, cast; standing man with
hands held up to his head.
M.76.97.796

570

Male Figure
Iran; date uncertain
h: 4.6 cm.; w: 2 cm.
Bronze, cast; nude ithyphallic man
wearing a belt and a cap.
M.76.97.798

571

Male Figure
Iran; date uncertain
h: 4.6 cm.; w: 2.6 cm.
Bronze, cast; nude ithyphallic man
standing with arms spread.
M.76.97.978

572

Male Figure
Iran; date uncertain
h: 4.1 cm.; w: 1.6 cm.
Bronze, cast; standing man with
one arm akimbo, the other lost
above the elbow; feet missing.
M.76.97.981

573

Head Pendant
Assyria; 8th–7th centuries B.C.
h: 5.1 cm.; w: 3 cm.
Bronze, cast; shaped as the head of
the demon Pazuzu; top loop.
M.76.97.791

cf. Moorey, *Iraq* XXVII, 1965,
pp. 33ff.

574

Head Pendant
Assyria; 8th–7th centuries B.C.
h: 4.3 cm.; w: 2 cm.
Bronze, cast; shaped as the head of
the demon Pazuzu; top loop; very
worn.
M.76.97.792

565

Piravend Figurines

The following thirteen statuettes belong to a heterogeneous category known as *Piravend figurines*, after the village in western Iran whence the first examples were said to have come (Moorey, 1971, pp. 168ff; 1974, p. 164). It is a category of object much imitated and copied in modern times; the crudity of the originals encouraged production of copies. Without thorough laboratory examination, authenticity is hard to establish.

575

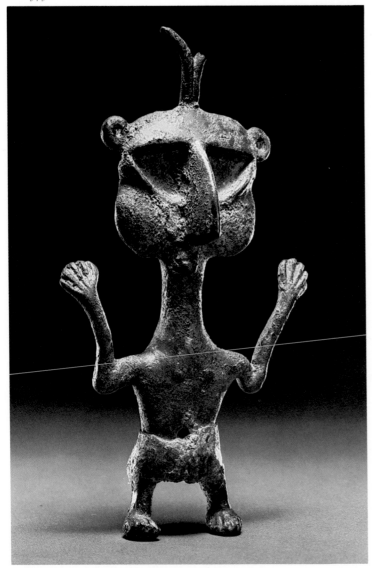

575

Horned Female Figure
Western Iran; Iron Age II–III
(c. 1000–650 B.C.)
h: 15.2 cm.; w: 8.5 cm.
Bronze, cast; horned, nude woman, with arms raised and ears pierced for earrings; perhaps originally seated.
M.76.97.740

Pub. Ghirshman, 1964, p. 53, fig. 65; for general type of this and the following figures, cf. Amiet, 1976, nos. 229–39; for a shield umbo with identical motif, cf. Ghirshman, 1964, p. 69, fig. 90.

576

Female Figure
Western Iran; Iron Age II–III
(c. 1000–650 B.C.)
h: 14.1 cm.; w: 9.5 cm.
Bronze, cast; nude woman with huge face and prominent nose; arms raised; perhaps originally seated.
M.76.97.741

577

Female Figure
Western Iran; Iron Age II–III
(c. 1000–650 B.C.)
h: 27 cm.; w: 9.2 cm.
Bronze, cast; elongated, standing nude woman with large pendent earrings; pubic area clearly depicted; authenticity uncertain.
M.76.97.742; ex-Farhadi Collection

Pub. New York, 1940, p. 124 K.

578

Female Figure
Western Iran; Iron Age II–III
(c. 1000–650 B.C.)
h: 19 cm.; w: 8.1 cm.
Bronze, cast; seated woman balancing a bowl on her head with both hands; snake heads appear over each shoulder, their bodies extending down her back; prominent breasts, beneath which three wriggling snakes are incised.
M.76.97.743; ex-Holmes Collection

Pub. New York, 1940, p. 123 G.

This statuette is not easily attributed and is only provisionally listed here. Its authenticity has been questioned, but preliminary metal studies have not exposed it as modern. The snakes, a leitmotif of Elamite art, suggest a provincial Elamite workshop, perhaps of the early Iron Age.

Illustrated on following page.

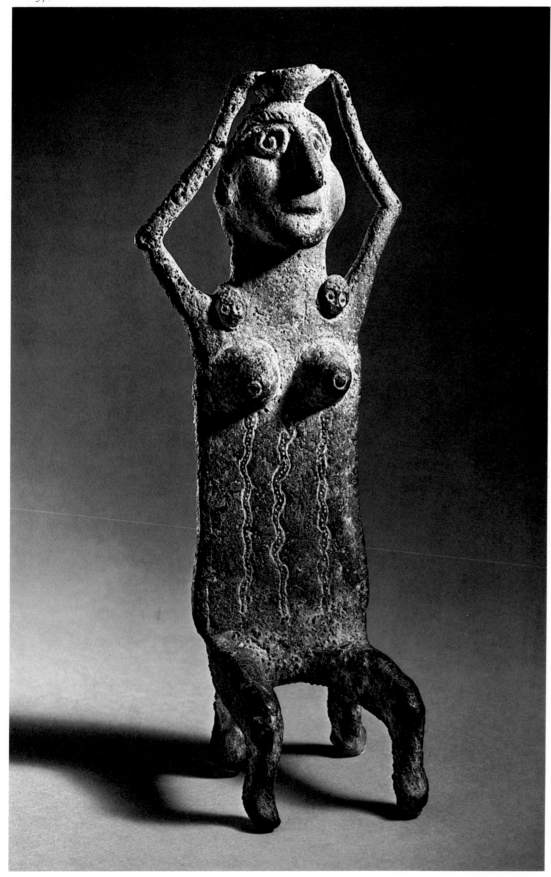

579

Mask
Western Iran; Iron Age II–III
(c. 1000–650 B.C.)
h: 11.7 cm.; w: 8.2 cm.
Bronze, cast; mask with circular
eye holes, puffed cheeks; earrings
pendent from ear loops; promi-
nent nose and small mouth.
M.76.97.744; ex-Holmes Collection

Pub. Pope, 1938, IV, pl. 73 B; cf.
Pomerance, 1966, pp. 40–41.

Although superficially like the
Piravend figurines, this mask and
its relatives are distinctive. Their
attribution to a contemporary cul-
tural horizon is probable, but not
all may be ancient. Some may be
modern imitations.

580

Male Figure
Western Iran; Iron Age II–III
(c. 1000–650 B.C.)
h: 8.9 cm.; w: 3 cm.
Bronze, cast; standing belted
man(?) with prominent nose,
small mouth and chin; modern
steel ball fitted on head.
M.76.97.745

581

Horned Male Figure
Western Iran; Iron Age II–III
(c. 1000–650 B.C.)
h: 9.8 cm.; w: 3.4 cm.
Bronze, cast; standing horned
man wearing belted tunic and
trousers(?); much incised detail;
authenticity questionable.
M.76.97.746

582

Male Figure
Western Iran; Iron Age II–III
(c. 1000–650 B.C.)
h: 9.5 cm.; w: 3.8 cm.
Bronze, cast; standing man with
prominent features; outfitted with
a large dagger in his belt.
M.76.97.747; ex-Holmes Collection

583

Horned Female Figure
Western Iran; Iron Age II–III
(c. 1000–650 B.C.)
h: 10.4 cm.; w: 3.5 cm.
Bronze, cast; standing woman
with forked horns, arms akimbo.
M.76.97.749; ex-Holmes Collection

584

Horned Female Figure
Western Iran; Iron Age II–III
(c. 1000–650 B.C.)
h: 7.5 cm.; w: 3.2 cm.
Bronze, cast; standing woman
with huge head and prominent
features; forked horns; rudimen-
tary body; pudenda emphasized.
M.76.97.761

585

Horned Head
Western Iran; Iron Age II–III
(c. 1000–650 B.C.)
h: 12.6 cm.; w: 5.5 cm.
Bronze, cast; head of Piravend
type with forked horns.
M.76.97.770; ex-Holmes Collection

Pub. New York, 1940, p. 122 A.

586

Horned Head
Western Iran; Iron Age II–III
(c. 1000–650 B.C.)
h: 8.1 cm.; w: 6.8 cm.
Bronze, cast; head of Piravend
type with four horns.
M.76.97.771; ex-Holmes Collection

Pub. New York, 1940, p. 123 D.

587

Female Figure
Western Iran; Iron Age II–III
(c. 1000–650 B.C.)
h: 15.6 cm.; w: 4.4 cm.
Bronze, cast; girdled nude woman
with arms raised.
M.76.97.750; ex-Holmes Collection

Pub. New York, 1940, p. 124 N.

Although broadly in the Piravend
tradition, this statuette, in alloy, in
method of manufacture, and in
style, looks markedly different
and is perhaps modern.

587

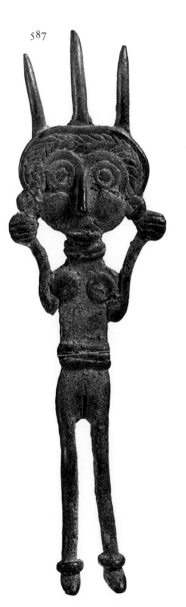

579

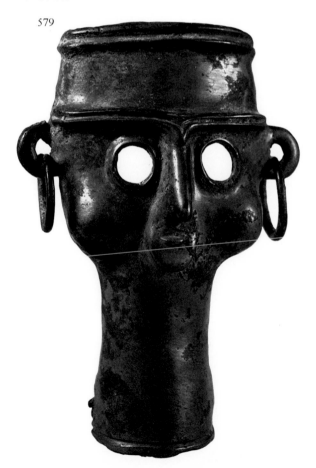

588

Male Head
Western Iran; date uncertain
h: 4.8 cm.; w: 3 cm.
Bronze, cast; male head; hollow;
detached.
M.76.97.755

589

Male Figure
Western Iran; date uncertain
h: 6.5 cm.; w: 3 cm.
Bronze, cast; standing bearded
man; authenticity uncertain.
M.76.97.757

590

Male Figure
Western Iran; date uncertain
h: 10.7 cm.; w: 3 cm.
Bronze, cast; standing man
dressed in long skirt; elongated
tapering torso with narrow waist;
left arm missing; authenticity
uncertain.
M.76.97.759

591

Female Figure
Iran; date uncertain
h: 9.6 cm.; w: 3.2 cm.
Bronze, cast; nude woman with
arms raised as if clasping her ears
or supporting something (now
lost) on her head.
M.76.97.783

592

Stamp Seal
Northern Iran; Iron Age I–II
(c. 1350–800 B.C.)
h: 3.5 cm.; w: 4.2 cm.
Bronze, cast; stem topped by a
ram's head with curling horns;
base engraved with a cross with
linear decoration.
M.76.97.828

593

Stamp Seal
Western Iran; Iron Age I–II
(c. 1350–800 B.C.)
h: 3.1 cm.; w: 3.5 cm.
Bronze, cast; long-horned goat
set on a square base, engraved
with a semi-couchant goat in
profile.
M.76.97.869

594

Stamp Seal
Northern Iran; Iron Age I–II
(c. 1350–800 B.C.)
h: 5.6 cm.; w: 4 cm.
Bronze, cast; stem pierced and
topped by a stylized horned head;
circular base engraved with a
linear pattern.
M.76.97.888

For such seals, cf. Moorey, 1974,
pp. 177ff.; Negahban, *JNES* 86,
1977, pp. 99ff. (Marlik seals).

595

Stamp Seal
Northern Iran; Iron Age I–II
(c. 1350–800 B.C.)
h: 5.7 cm.; w: 5.8 cm.
Bronze, cast; stem pierced and
topped by an addorsed horned
animal head joined by a loop at
top; circular base engraved with
a horned quadruped.
M.76.97.950

cf. cat. no. 594.

596

Stamp Seal
Western Iran; Iron Age I–II
(c. 1350–800 B.C.)
h: 4.4 cm.; w: 3.3 cm.
Bronze, cast; cylindrical ridged
stem topped by three projecting
"cocks'" heads with stemmed
loop between; circular base en-
graved with a simple cross.
M.76.97.957

cf. Moorey, 1971, nos. 464–66.

597

Stamp Seal
Western Iran; Iron Age I–II
(c. 1350–800 B.C.)
h: 3.2 cm.; w: 2.8 cm.
Bronze, cast; quadruped on a
rectangular base engraved with a
linear design; top loop.
M.76.97.960

598

Stamp Seal
Northern or Northeastern Iran;
Iron Age I–II (c. 1350–800 B.C.)
h: 4.5 cm.; w: 4.3 cm.
Bronze, cast; pierced rectangular
stem with two angled rod sup-
ports; circular base engraved with
a linear design in quadrants.
M.76.174.28

599

Stamp Seal
Iran; Iron Age I (c. 1350–1000 B.C.)
h: 6.4 cm.; w: 5.4 cm.
Bronze, cast; cylindrical stem with
encircling ribs pierced toward the
top; cross-shaped base divided
into rectangular hollow boxes.
M.76.174.29

600

Stamp Seal
Iran; Iron Age I (c. 1350–1000 B.C.)
or earlier
h: 3 cm.; w: 3.2 cm.
Bone, carved; handle with elliptical
pierced knob; circular base with a
linear design in quadrants.
M.76.174.30

601

Stamp Seal
Iran; Iron Age I (c. 1350–1000 B.C.)
h: 3.4 cm.; w: 3.9 cm.
Bronze, cast; plain vertical stem
pierced toward the top; circular
base with a linear design in
quadrants.
M.76.174.32

602

Stamp Seal
Western Iran; Iron Age I
(c. 1350–1000 B.C.)
h: 4 cm.; w: 2.5 cm.
Bronze, cast; stem topped by
addorsed mouflon heads with a
loop between; circular openwork
base cast as an eight-spoked wheel
with leaf-like projections; encir-
cling ridges at junction of stem
and base.
M.76.174.33

603

Stamp Seal
Iran; Iron Age I (c. 1350–1000 B.C.)
or earlier
h: 4.2 cm.; w: 4.8 cm.
Bronze, cast; rectangular stem
with ridged top, pierced below;
circular base with a design of
interrupted concentric circles.
M.76.174.34

604

Stamp Seal
Iran; Iron Age I (c. 1350–1000 B.C.)
or earlier
h: 5 cm.; w: 6.2 cm.
Bronze, cast; plain, rounded, ver-
tical stem terminating in a knob,
pierced below; circular base with
linear design in quadrants.
M.76.174.36

Pre-Achaemenid Objects of Iron,
Silver, and Stone

The most significant objects here are those of iron. The period when
Luristan may be regarded as an important center of metalworking
in its own right (Iron Age II–III) largely corresponds to the phase
in the history of metallurgy that forms a transition from bronze to
iron. Two of its characteristics, the combination of iron and bronze in
the same object and the imitation of bronze forms in iron, are well
illustrated here. A considerable number of swords (such as cat. nos.
609 and 610) have now been reported from Luristan; but as none
with such elaborate decoration has yet been recorded in a controlled
excavation, their precise date—between the tenth and eighth
centuries B.C.—has yet to be established. Their complicated structure
depends very much on bronze technology. It would be some time
before techniques suitable to the new, less tractable metal were fully
developed.

Bowl
Western Iran; Iron Age III–
Achaemenid period
(c. 800–330 B.C.)
h: 4.8 cm.; diam: 16 cm.
Silver, hammered; Luschey, 1929,
type 3.29–30; shallow bowl with
regularly fluted body and low
everted neck.
M.76.97.372

For type, cf. Moorey, 1974, nos.
129, 130.

Pendant
Iran; Iron Age II–III
(c. 1000–650 B.C.)
h: 7 cm.; w: 2.7 cm.
Silver, cast; in the form of a stand-
ing woman carrying a baby; she
wears a torque around her neck;
back loop; authenticity and at-
tribution uncertain.
M.76.97.794

Frontlet
Iran; Iron Age II–III
(c. 1000–650 B.C.)
h: 4.8 cm.; l: 19.4 cm.
Silver, hammered; rectangular
strip incised with a bowman to
right, followed by a hunting dog
with rosette above, a hare, and
two mouflon, one with an arrow
in its neck; fragmentary; authen-
ticity doubtful.
M.76.97.917a,b; ex-Brummer
Collection

Pub. Pope, 1945, pl. 30; Ghirsh-
man, 1964, pl. 95.

Roundel
Western Iran; Middle Elamite
(c. 1400–1200 B.C.)
diam: 9.7 cm.
Sheet gold and silver over a bitu-
men core; four loops on the metal
backplate; on the front, four
couchant mouflon around a
bearded face set in a circle.
M.76.97.984

For dating and attribution, cf.
Negahban, 1973, fig. 41 (Haft
Tepe); Muscarella, 1974 (1),
no. 151.

The piece has been extensively re-
paired in modern times; it is no
longer easy to establish by eye
how much of it is ancient.

608

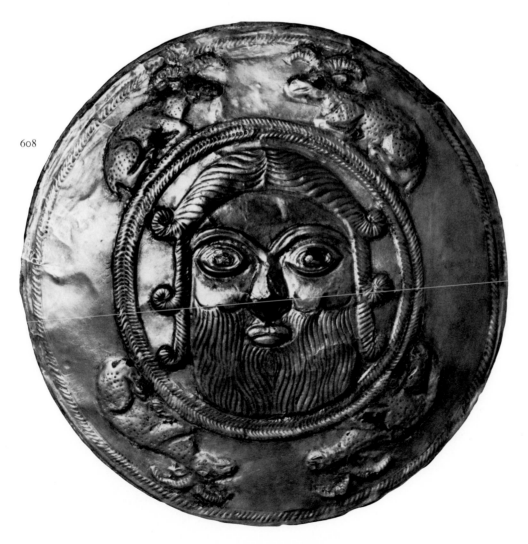

609

Sword
Luristan; Iron Age II–III
(c. 1000–650 B.C.)
l. of hilt: 17 cm.;
l. of blade: 33.5 cm.
Iron, wrought; flat disk pommel
with projecting human heads
backed by lion masks; two grip
ridges; lions couchant on the
guard.
M.76.97.476

For discussion of type, cf.
Porada, 1964, pp. 46ff., and
pls. XII–XIII; Moorey, 1971,
nos. 540, 541.

610

Sword
Luristan; Iron Age II–III
(c. 1000–650 B.C.)
l. of hilt: 16.8 cm.;
l. of blade: 29.5 cm.
Iron, wrought; like cat. no. 609
but without a lion on the guard.
M.76.97.477

611

Bracelet
Luristan; Iron Age II–III
(c. 1000–650 B.C.)
diam: 11.1 cm.
Iron, wrought; elliptical hoop of
round section terminating in a pair
of zoomorphic lion heads.
M.76.97.303

612

Bracelet
Luristan; Iron Age II–III
(c. 1000–650 B.C.)
diam: 7.4 cm.
Iron, wrought; hoop consisting of
three superimposed bands ter-
minating in a pair of lion masks
with stylized human faces behind.
M.76.97.312

613

Anklet
Luristan; Iron Age II–III
(c. 1000–650 B.C.)
diam: 12.2 cm.
Iron, wrought, with cast bronze
terminals; hoop consisting of four
superimposed bands; applied ter-
minals decorated in relief with
stylized lion masks.
M.76.97.311

614

Jar
Iran; Mesopotamian Early
Dynastic II–III (c. 2700–2500 B.C.)
h: 6.5 cm.; diam: 4.6 cm.
Chlorite or steatite, carved; two
lions standing nose to nose, with
tails looped over their backs; be-
hind them, foliage (a palm tree?);
below, a bull's head in profile.
M.76.97.902

For a detailed examination of the
industry producing such vessels,
cf. Kohl, 1974.

615

Weight
Iraq/Iran: date uncertain
h: 4.8 cm.; l: 10.5 cm.
Stone, carved; in the shape of
a sleeping duck; authenticity
uncertain.
M.76.97.903

616

Protome
Iran; date uncertain
h: 4.4 cm.; l: 4.4 cm.
Stone, carved; statuette in the
form of a forepart of a bovine
animal; authenticity uncertain.
M.76.97.743

617

Bowl
Northeastern Iran; c. 2000 B.C.
h: 8.5 cm.; diam: 12.5 cm.
Alabaster, carved; hemispherical
bowl with low foot.
M.76.174.69

cf. Schmidt, 1937, pl. LIX, H5224
(Tepe Hissar).

611

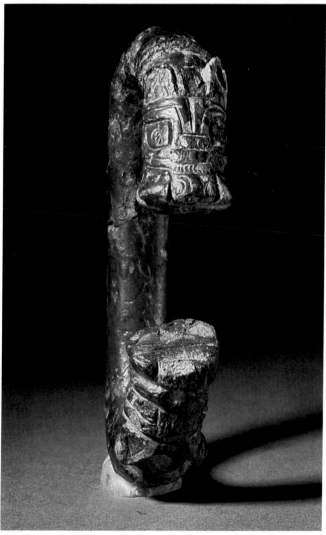

609

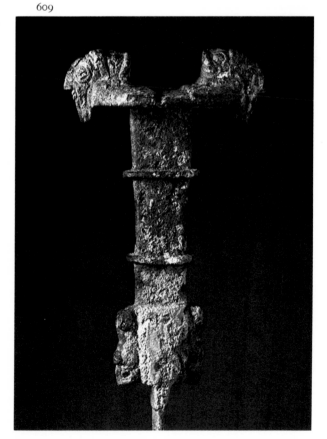

Metal and Faience Objects of the Achaemenid Period (c. 550–330 B.C.)

Very little is known of the material culture of Iran under the Achaemenid kings (c. 550–330 B.C.). Many of the objects labeled "Achaemenid" in textbooks and museum displays come from other parts of their empire. The small selection here, all of which might well be from Iran itself, illustrates the three main categories of metal-work most associated with this period: tableware, cosmetic equipment, and jewelry. Many of the best known of such objects—by no means all of certain authenticity (Muscarella, 1977)—are of gold, silver, or silver gilt. One or two objects here are of these metals, for the Achaemenid international style was a court art, created by royal craftsmen and diffused through the empire by armies or provincial officials. They set fashions copied locally in base metals. The imagery of the court style, which drew on age-old Near Eastern traditions, is best seen in miniature on the finger ring bezels.

618

Kohl Tube
Western Iran; c. 550–330 B.C. or later
h: 8.9 cm.; w: 2 cm.
Bronze, cast; tapering cylindrical tube with flanged top, decorated with a face on one side beneath the lip; horizontal loop behind the head.
M.76.97.81

Kohl is a cosmetic preparation used by women, primarily to darken the edges of the eyelids. It was stored in these tubes and applied with metal sticks (cf. cat. nos. 648–50).

619

Kohl Tube
Western Iran; c. 550–330 B.C.
h: 5.2 cm.; w: 2.2 cm.
Bronze, cast; in the shape of a woman; very worn.
M.76.97.754

cf. Culican, *IrAn* XI, 1975, pp. 100ff.; Amiet, 1976, no. 241.

620

Kohl Tube
Western Iran; c. 550–330 B.C.
h: 10.8 cm.; w: 2.9 cm.
Bronze, cast; in the shape of a woman with nude upper torso and a tasseled belt; arms held across her body.
M.76.97.756

cf. cat. no. 619.

621

Kohl Tube
Western Iran; c. 550–330 B.C.
h: 10.2 cm.; w: 4.8 cm.
Bronze, cast; in the shape of a woman with nude upper torso and long skirt; left hand held to breast, right hand lost.
M.76.97.765

618

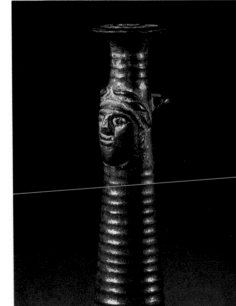

620

622

Bracelet
Western Iran; c. 550–330 B.C.
or earlier
diam: 6 cm.
Silver, hammered; flat band terminating in a pair of ram's-head terminals at each end with a "Hathor" loop behind, all worked in metal strip as if to take inlays of frit or semiprecious stones.
M.76.97.308

623

Bracelet
Western Iran; c. 550–330 B.C.
or earlier
diam: 6.6 cm.
Silver, cast; rounded hoop with ram's-head terminals; a series of encircling grooves behind head; naturalistically modeled.
M.76.97.339

624

Bracelet
Western Iran; date uncertain
diam: 7.2 cm.
Bronze, cast; rounded hoop with ram's-head terminals; very similar to cat. no. 623; possibly a modern copy in bronze.
M.76.97.340

625

Bowl
Western Iran; c. 550–330 B.C.
h: 4 cm.; diam: 19.4 cm.
Bronze, hammered; Luschey, 1929, type 4.2; shallow bowl with central omphalos; encircling frieze of eight tear-shaped ornaments alternating with lotus buds consisting of five calyx petals, joined below in a festoon; around the omphalos, eight circular repoussé bosses joined by a shallow engraved garland.
M.76.97.382

cf. Langdon, *Iraq* I, 1934, pl. XVIIb (Barguthiat, Iraq); Vanden Berghe, 1959, pl. 124c (Dumavizah, Luristan).

626

Bowl
Western Iran; c. 550–330 B.C.
h: 2.4 cm.; diam: 19.3 cm.
Silver, hammered; Luschey, 1929, type I.C.8; shallow bowl with central omphalos; encircling frieze of twelve tear-shaped bosses between which are a series of radiating, leaf-shaped tongues terminating in lotus buds.
M.76.174.111

627

Bowl
Western Iran; c. 550–330 B.C.
h: 3.5 cm.; diam: 15.8 cm.
Bronze, cast; Luschey, 1929, type I.C.8; shallow bowl with low omphalos; encircling frieze of nine alternating tear-shaped bosses and leaf-shaped tongues as in cat. no. 626, each tongue enclosing a smaller one of identical form; on the inside, around the omphalos, a chain of inward-pointing buds.
M.76.97.387

cf. Woolley, *LAAA* VII, 1914–16, pl. XXI, top (Deve Hüyük).

628

Bowl
Western Iran; c. 550–330 B.C.
or earlier
h: 3.2 cm.; diam: 15 cm.
Bronze, hammered; Luschey, 1929, type 4.2; shallow bowl with central omphalos; double encircling frieze of alternating tear-shaped bosses and lotus buds with three calyx petals; traced floral frieze around the omphalos.
M.76.174.93

629

Pendant
Western Iran; c. 550–330 B.C.
h: 2 cm.; l: 4.1 cm.
Gold, hammered; addorsed lion heads; part of an earring or necklace pendant; crushed and damaged.
M.76.97.891

630

Finger Ring
Western Iran; c. 550–330 B.C.
diam: 2.8 cm.
Bronze, cast; flat oval bezel decorated with a winged, horned griffin advancing right.
M.76.174.292

631

Finger Ring
Western Iran; c. 550–330 B.C.
diam: 2 cm.
Bronze, cast; flat oval bezel decorated with a pair of flanking figures (male?) holding a standard topped by a crescent.
M.76.174.293

632

Finger Ring
Western Iran; c. 550–330 B.C.
diam: 2.5 cm.
Bronze, cast; flat oval bezel decorated with the figure of a kneeling helmeted soldier with a sword (?) and round shield.
M.76.174.294

633

Finger Ring
Western Iran; c. 550–330 B.C.
diam: 2 cm.
Bronze, hammered; standing man, with a horse represented by its forepart only.
M.76.174.296

626

627

634

Finger Ring
Western Iran; c. 550–330 B.C.
diam: 2.2 cm.
Bronze, cast; flat oval bezel decorated with a winged bull passant.
M.76.174.298

635

Finger Ring
Western Iran; c. 550–330 B.C.
diam: 2.5 cm.
Bronze, cast; flat oval bezel decorated with a pair of standing lions flanking a tree, oriented at right angles to it.
M.76.174.299

636

Finger Ring
Western Iran; c. 550–330 B.C.
diam: 2 cm.
Bronze, cast; flat oval bezel decorated with the figure of a standing man in "Median" costume carrying a staff or spear.
M.76.174.300

Pub. Porada, 1964, pl. II, fig. 4.

637

Finger Ring
Western Iran; c. 550–330 B.C.
diam: 2.3 cm.
Bronze, cast; flat oval bezel decorated with a lion passant; crescent above and a figure (?) crouching below.
M.76.174.301

638

Finger Ring
Western Iran; c. 550–330 B.C.
or later
diam: 2 cm.
Bronze, cast; flat oval bezel decorated with a deer passant with long undulating horn.
M.76.174.302

639

Finger Ring
Western Iran; c. 550–330 B.C.
diam: 2.5 cm.
Bronze, cast; flat oval bezel decorated with the figure of a trousered man with arms raised, bisected at the waist by a pair of wings with two pendent snake heads.
M.76.174.303

640

Finger Ring
Western Iran; c. 550–330 B.C.
or later
diam: 2.4 cm.
Bronze, cast; flat oval bezel decorated with a lion passant; a second winged animal above.
M.76.174.304

641

Finger Ring
Western Iran; c. 550–330 B.C.
diam: 2.2 cm.
Bronze, cast; flat oval bezel decorated with the figure of a seated man facing right; traces of a second figure in front.
M.76.174.306

642

Finger Ring
Western Iran; c. 550–330 B.C.
diam: 2 cm.
Bronze, cast; flat oval bezel decorated with a winged lion or lion-griffin attacking a bull.
M.76.174.307

643

Finger Ring
Western Iran; c. 550–330 B.C.
h: 5.2 cm.
Bronze, cast; flat oval bezel decorated with a lion passant, its jaws agape, and a tree.
M.76.174.308

644

Finger Ring
Western Iran; c. 550–330 B.C.
diam: 2 cm.
Bronze, cast; flat oval bezel with the figure of a standing man beside an altar (?).
M.76.174.309

645

Finger Ring
Western Iran; c. 550–330 B.C.
diam: 2 cm.
Bronze, cast; flat oval bezel decorated with the foreparts of two winged creatures facing one another (?), a crescent between them.
M.76.174.310

646

Fitting
Iran; Iron Age III–Achaemenid period (c. 800–330 B.C.)
h: 8.1 cm.; w: 4 cm.
Bronze, cast; in the shape of a mountain goat with a bearded human face set on a short cylindrical socket (possibly a modern addition); traces of iron rust.
M.76.97.836

For type of object, cf. Calmeyer, 1964 (I), pl. 63, nos. 127, 128.

647

Lion Couchant
Iran; c. 550–330 B.C.
h: 2.3 cm.; l: 4.5 cm.
Faience, molded; small figure of a reclining lion, his eyes drilled for inlays.
M.76.174.67

This object is made of an artificial material known as "Egyptian blue," related to the glazed faience popular in antiquity in Egypt and the Near East for the production of amulets, seals, and figurines. Objects made of it were widely diffused through the Achaemenid Empire.

Metal Objects of the Parthian Period
(c. 150 B.C.–225 A.D.)

No objects in this collection may be confidently attributed to the Seleucid period in Iran (c. 330–150 B.C.), since there have been virtually no controlled excavations on sites of this time. Although the Parthian period is rather better known, the attribution to it of minor objects out of context is very often problematic. Occasionally, as with the buckle plaques (cat. nos. 667–73), stylistic traits allow for an association with Parthian culture, best known from such sites as Old Nisa (Ghirshman, 1962, pp. 29ff.); but there are other buckles whose closest relations are found deeper inside Soviet Asia (cat. nos. 674–82; Ghirshman, IrAn XIV, 1979, pp. 167ff.). Still other objects, notably the "scepters," might belong in the Sasanian period (see below) and some, such as the openwork pendants, are only placed here because they fit no known category in better documented periods (as is made clear in the catalog). Only a few objects, such as cosmetic tools, have been excavated under proper supervision from graves of the Parthian period in northern Iran (Egami et al., 1965, 1966, 1968, 1971).

651

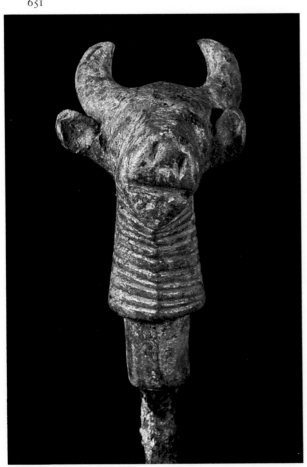

648
Kohl Stick
Iran; c. 150 B.C.–225 A.D.
h: 6.6 cm.; w: 6.1 cm.
Bronze, cast; in the form of a stylized horse with prominent mane; forelegs fused and extended to form a shank, now broken.
M.76.97.250

For type, cf. Moorey, 1974, nos. 122, 123.

These sticks for applying cosmetics are distinguished from pins by having a broad tip rather than a point.

649
Kohl Stick
Iran; c. 150 B.C.–225 A.D.
h: 11.5 cm.; w: 2.4 cm.
Bronze, cast; same type as cat. no. 648; perforated at the shoulder.
M.76.97.268

650
Kohl Stick
Iran; c. 150 B.C.–225 A.D.
h: 9.2 cm.; w: 3 cm.
Bronze, cast; same type as cat. no. 648; perforated at the shoulder.
M.76.97.277

651
"Scepter"
Iran; c. 150 B.C.–225 A.D. or later
l: 67.2 cm.
Bronze on iron, cast; bovid head on an iron shaft terminating at the other end in a bronze handle.
M.76.97.281

The function of this and the following three objects is unknown. They may have been symbols of authority or of special roles in society.

652
"Scepter" Head
Iran; c. 150 B.C.–225 A.D. or later
h: 7 cm.; w: 3.9 cm.
Bronze on iron, cast; in the form of a female head, with traces of gilding, on a fragmentary iron shaft.
M.76.97.283a

cf. Ghirshman, 1962, fig. 268.

Illustrated on following page.

653
"Scepter"
Iran; c. 150 B.C.–225 A.D. or later
l: 44.3 cm.
Bronze on iron, cast; iron shaft with a bronze knob at one end and a bronze molding a short distance below; broken at the other end.
M.76.174.114

cf. cat. no. 651.

654
"Scepter"
Iran; c. 150 B.C.–225 A.D. or later
l: 45.5 cm.
Bronze on iron, cast; iron shaft with a bronze animal head at one end and a bronze molding a short distance below; broken at the other end.
M.76.97.115

For type, cf. cat. no. 651.

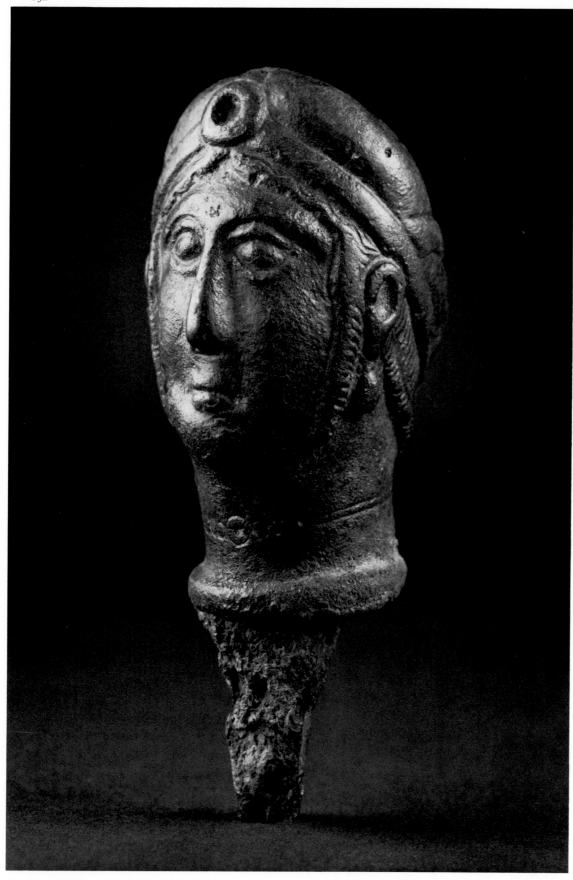

655

Handled Bowl
Iran; c. 150 B.C.–225 A.D.
h: 9.4 cm.; diam: 12 cm.
Silver, hammered; wavy fluting
on the body; cast handle termina-
ting above in a tiny woman's head
with melon coiffure; palmette
stamped design on the broad rim;
engraved tongues around outside
of rim.
M.76.174.17

This vessel is reminiscent of Impe-
rial Roman silver plate found at
Pompeii and Boscoreale (Strong,
1966, pl. 141, fig. 28c, from the
Casa del Menandro; de Cou, 1912,
pls. CL–CLII [no. 24668]). It might
be a direct import to Iran, or pos-
sibly a local Iranian imitation of a
Roman original. There is suffi-
cient evidence to indicate that
traded Roman artifacts strongly
influenced craftsmen in the re-
gions neighboring Iran to the east
and northeast–if not in Iran
itself–during the later Parthian
period.

656

Vessel Handle
Iran; c. 150 B.C.–225 A.D.
w: 3.7 cm.
Bronze, cast; in the form of a
human head with stylized arms
extending forward for attachment
to the rim of a vessel; hair is drawn
back in a high bun.
M.76.174.124

cf. cat. no. 655.

657

Vessel Handle
Iran; c. 150 B.C.–225 A.D.
h: 4 cm.; w: 2.4 cm.
Bronze, cast; fragment of a cast
vessel handle with a projecting
human head, hair parted in the
center; traces of iron rust.
M.76.97.793

658

Vessel Handle
Iran; c. 150 B.C.–225 A.D.
h: 7 cm.; l: 13.4 cm.
Bronze, cast; in the form of a
ram moving at speed, its back legs
lost, its front legs outstretched
and riveted to a crossbar.
M.76.97.840

655

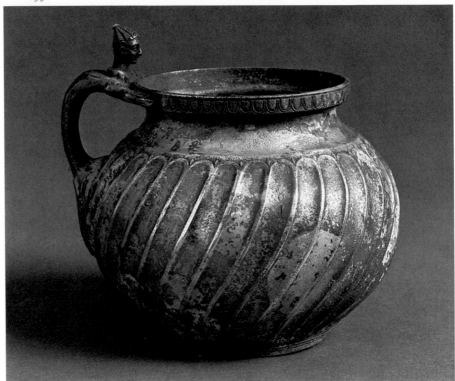

658

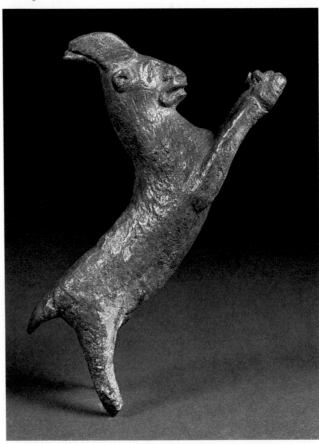

659

Vessel Handle
Iran; c. 150 B.C.–225 A.D.
h: 8.7 cm.; l: 8.7 cm.
Bronze, cast; in the form of a
rampant lion with head turned to
one side.
M.76.97.842

660

Fitting
Iran; c. 150 B.C.–225 A.D.
h: 5 cm.; l: 10.2 cm.
Bronze, hollow cast; couchant
ram on a platform, an iron rivet in
each corner; both date and func-
tion of this object are obscure.
M.76.97.933

661

Zoomorphic Handle
Iran; c. 150 B.C.–225 A.D. or earlier
h: 4.3 cm.; l: 5.8 cm.
Bronze, cast; in the form of a
mouflon passant; position of the
legs suggests that this was once a
handle attachment rather than a
freestanding statuette.
M.76.97.947

662

Male Figure
Iran; c. 150 B.C.–225 A.D.
h: 16.1 cm.; w: 3.1 cm.
Iron, cast; standing nude youth;
left arm is in position down the
side, but the right is missing, leav-
ing a groove at the shoulder that
suggests it was either hinged there
and moved, or made separately
and then attached.
M.76.97.772; ex-Mabon Collection

Pub. Pope, 1938, IV, pl. 107 E; New
York, 1940, p. 536 D.

The male nude figure is rare in
Iranian art, illustrating the impact
of Hellenistic culture. The use of
this metal for statuary is equally
unusual.

662

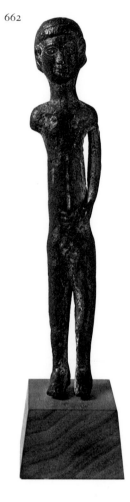

659

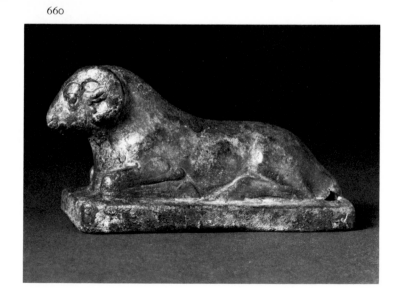

660

663

Male Figure
Iran; c. 150 B.C.–225 A.D.
h: 14.4 cm.; w: 2.7 cm.
Iron, cast; same type as cat. no.
662; lower legs and arms lost.
M.76.97.773

664

Horse
Iran; c. 150 B.C.–225 A.D.
h: 2.5 cm.; l: 5.1 cm.
Bronze, cast; horse with arched
neck, pierced vertically through
the shoulder.
M.76.97.819

cf. Stuttgart, 1972, nos. 82, 83; cf.
cat. nos. 648–50.

665

Horse
Iran; c. 150 B.C.–225 A.D.
h: 3.6 cm.; l: 4.1 cm.
Bronze, cast; same type as
cat. no. 664.
M.76.97.821

666

Belt Buckle
Iran; c. 150 B.C.–225 A.D.
h: 4.5 cm.; w: 7.2 cm.
Bronze, cast; rectangular plaque
with a tongue; openwork design,
in relief, of a horseman on a rear-
ing animal, beside a stag (or elk)
and a young beast, attacked by
two lions or panthers; some
damage.
M.76.97.592

Pub. Bowie, 1966, facing title page
(described as "Bactrian").

Considering its small scale, the
design is remarkable for its detail
and vitality.

Illustrated on following page.

667

Belt Buckle
Iran; c. 150 B.C.–225 A.D.
h: 7 cm.; w: 7.5 cm.
Bronze, cast; rectangular frame
with a stud on one side, a bird's-
head hook on the other; ram
passant left in the frame.
M.76.174.139

For a general study of buckles such
as this and the following, cf.
Ghirshman, *Iran* XIV, 1979, pp.
167ff.

668

Belt Buckle
Iran; c. 150 B.C.–225 A.D.
h: 6.3 cm.; w: 7.3 cm.
Bronze, cast; rectangular frame
with a stud on one side, a bird's-
head hook on the other; within the
frame, a pair of confronted stand-
ing mouflon.
M.76.174.140

669

Belt Buckle
Iran; c. 150 B.C.–225 A.D.
h: 6.7 cm.; w: 7.5 cm.
Bronze, cast; rectangular frame
with a stud on one side, a bird's-
head hook on the other; within the
frame, a stylized mouflon passant.
M.76.174.141

670

Belt Buckle
Iran; c. 150 B.C.–225 A.D.
h: 4.7 cm.; w: 6.6 cm.
Bronze, cast; rectangular frame
with a stud on one side, a bird's-
head hook on the other; within the
frame, the upper part of a man
and woman embracing.
M.76.174.142

cf. Boston, 1976, no. 58.

from left to right: 669, 667, 668

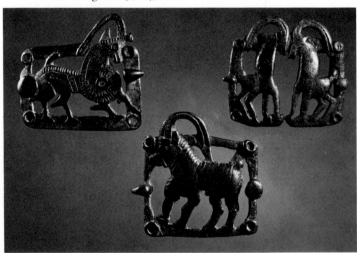

from left to right: 670, 671, 672

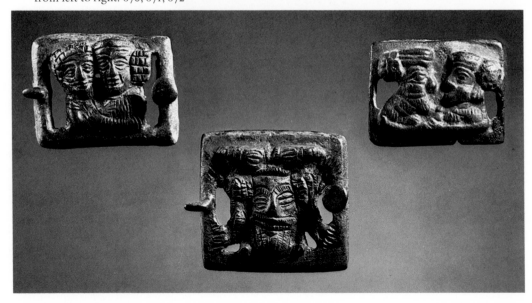

666

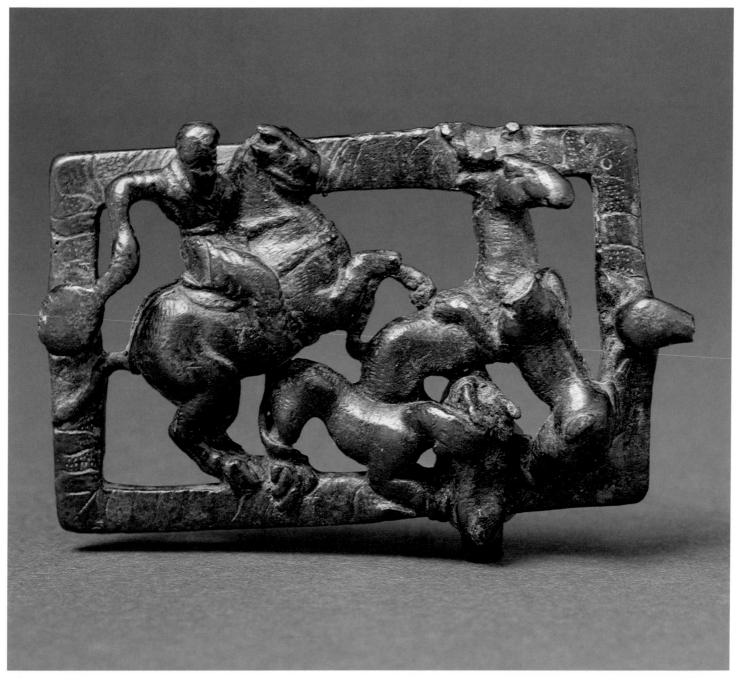

671

Belt Buckle
Iran; c. 150 B.C.–225 A.D.
h: 5.9 cm.; w: 7 cm.
Bronze, cast; rectangular frame
with a stud on one side, a bird's-
head hook on the other; within
the frame, a man's head, adorned
with an elaborate headdress.
M.76.174.143

Illustrated on page 115.

672

Belt Buckle
Iran; c. 150 B.C.–225 A.D.
h: 4.4 cm.; w: 5.8 cm.
Bronze, cast; rectangular frame;
stud and neck missing; within the
frame, profile busts of two men
facing one another.
M.76.174.144

Illustrated on page 115.

673

Belt Buckle
Iran; c. 150 B.C.–225 A.D.
h: 3.5 cm.; w: 2.3 cm.
Bronze, cast; figure eight with
linear surface decoration, including
a pair of "eyes" at the center;
bird's-head hook.
M.76.97.698

674

Belt Buckle
Iran; c. 150 B.C.–225 A.D.
h: 4.5 cm.; w: 3.7 cm.
Bronze, cast; open ring with
bird's-head hook and rectangular
attachment.
M.76.97.704

cf. Moorey, 1971, no. 146.

675

Belt Buckle
Iran; c. 150 B.C.–225 A.D.
h: 4.5 cm.; w: 3.5 cm.
Bronze, cast; open ring in the
form of a coiled feline; bird's-head
hook; worn.
M.76.97.712

676

Belt Buckle
Iran; c. 150 B.C.–225 A.D.
h: 5.2 cm.; w: 2.6 cm.
Bronze, cast; open ring with two
large-eared confronted quad-
rupeds (wild asses?); linear surface
decoration; bird's-head hook;
rectangular attachment.
M.76.97.719

677

Belt Buckle
Iran; c. 150 B.C.–225 A.D.
h: 6 cm.; w: 3.3 cm.
Bronze, cast; figure eight with
elaborate zoomorphic openwork
design in rear ring; bird's-head
hook.
M.76.97.739a

678

Belt Buckle
Iran; c. 150 B.C.–225 A.D.
w: 5 cm.
Bronze, cast; rectangular frame
with a vertical stud and a bird's-
head hook.
M.76.97.963

679

Belt Buckle
Iran; c. 150 B.C.–225 A.D.
w: 4.8 cm.
Bronze, cast; round frame with a
vertical stud and a bird's-head
hook.
M.76.97.964

cf. Egami et al., 1966, pl. XXX: 1;
Moorey, 1971, nos. 144, 145.

680

Belt Buckle
Iran; c. 150 B.C.–225 A.D.
w: 3.5 cm.
Bronze, cast; round frame with a
vertical stud and a hook shaped as
the head of a horned animal.
M.76.97.965

cf. cat. no. 679.

681

Belt Buckle
Iran; c. 150 B.C.–225 A.D.
w: 3.6 cm.
Bronze, cast; round frame with a
vertical stud and a bird's-head
hook.
M.76.97.966

cf. cat. no. 679.

682

Belt Buckle
Iran; c. 150 B.C.–225 A.D.
w: 2.2 cm.
Bronze, cast; round frame with a
vertical stud in the shape of a
human face; hook missing.
M.76.97.967

cf. cat. no. 679.

683

Pendant
Iran; c. 150 B.C.–225 A.D.
h: 8.1 cm.; w: 4.6 cm.
Bronze, cast; female figure with
horns; made in an openwork,
cage-like technique of metal wires
and strips; jugs (?) pendent from
looplike arms; back loop.
M.76.97.766

cf. Pomerance, 1966, no. 35.

684

Pendant
Iran; c. 150 B.C.–225 A.D.
h: 8.6 cm.; w: 4.3 cm.
Bronze, cast; female figure-eight
shape; one looplike arm missing;
back loop.
M.76.97.767

cf. cat. no. 683.

685

Pendant
Iran; c. 150 B.C.–225 A.D.
h: 8 cm.; w: 5.5 cm.
Bronze, cast; male figure with
wheel-shaped body; objects in
looplike hands.
M.76.97.768

cf. cat. no. 683.

686

Pendant
Iran; c. 150 B.C.–225 A.D.
h: 8.9 cm.; w: 4.1 cm.
Bronze, cast; female figure with a
child held to her breast; back loop.
M.76.97.769

cf. cat. no. 683.

687

Pendant
Iran; c. 150 B.C.–225 A.D.
h: 7 cm.; w: 5.5 cm.
Bronze, cast; openwork cage of
wire and blobs; back loop.
M.76.97.898

cf. cat. no. 683.

688

Pendant
Iran; c. 150 B.C.–225 A.D.
h: 6.9 cm.; w: 6.1 cm.
Bronze, cast; openwork cage of
wire and blobs; top loop; bottle-
shaped pendants suspended from
looplike arms.
M.76.97.899

689

Pendant
Iran; c. 150 B.C.–225 A.D.
h: 5.3 cm.; w: 2.3 cm.
Bronze, cast; openwork cage with animal head on top, stud below; back loop.
M.76.97.983

cf. cat. no. 683.

690

Pendant
Iran; c. 150 B.C.–225 A.D.
h: 4.2 cm.; l: 2.9 cm.
Bronze, cast; mouflon set on a small, hollow, rectangular base, pierced around the edge for attachment of pendants (now missing); neck loop; stamped circles on body.
M.76.97.961

cf. Ghirshman, 1964, pl. 124 (dated too early; they appear at Dura-Europas in graves of the Parthian period; see Toll, 1946, pls. 45, 54).

691

Pendant
Iran; date uncertain, possibly Parthian period
h: 7 cm.; w: 6.1 cm.
Bronze, cast; four-spoked wheel with human faces at each axis; loop on top of one head.
M.76.97.801

cf. Pope, 1938, I, p. 862, fig. 300a,b (dated too early).

692

Pendant
Western Iran; c. 150 B.C.–225 A.D.
h: 8.5 cm.; w: 8.8 cm.
Bronze, cast; foreparts of addorsed equids; harnessing in relief; central loop.
M.76.97.858

For this later dating, cf. Moorey, 1971, no. 428; Moorey, 1974, nos. 57, 58.

693

Pendant
Western Iran; c. 150 B.C.–225 A.D.
h: 6.3 cm.; w: 7 cm.
Bronze, cast; type as in cat. no. 692.
M.76.97.859

694

Bell
Western Iran; c. 150 B.C.–225 A.D.
h: 3.8 cm.
Bronze, hammered and cut; conical bell with two horse protomes at the top, flanking the suspension loop; traces of a clapper in iron (?).
M.76.97.894

For comparable bells found in Dailaman in this period, cf. Egami et al., 1966, pl. LIX: 34.

695

Belt Hook
Origin unknown; early first millennium A.D.
h: 3.5 cm.; w: 2.3 cm.
Bronze, cast; figure eight; one open ring with surface decoration reminiscent of a demon mask; the other open ring has a bird's-head hook on the upper edge.
M.76.97.698

696

Buckle
Iran (?); c. 150 B.C.–225 A.D.
h: 4.5 cm.; w: 7.3 cm.
Bronze, cast; plaque (for attachment to the belt) and buckle are cast separately and hinged; plaque consists of a triangular configuration of ten cupules; clasp of two confronted lions' heads rendered full-face, as though seen from above; buckle-tongue fits between heads; two perforations below hinge and a circular boss on reverse of plaque (at its apex) for attachment of belt strap.
M.76.97.1004

cf. Ghirshman, *IrAn* XIV, 1979, pl. IV: 3.

697

Horned Lion's Head
Iran (?); c. 150 B.C.–225 A.D. or later
h: 21 cm.; w: 20 cm.
Marble, carved; support in the form of a snarling lion's head, equipped with a pair of ram's horns extending back from the forehead, the whole surmounted by a rectangular abacus with dowel hole; head projects from a rectangular support with inset margin; finely modeled, with protruding, furrowed brows, deeply inset eyes, and flaring nostrils, all contributing to a fierce expression; end of muzzle and lower jaw broken.
M.76.174.251

This type of creature–a horned lion–is derived from the Achaemenid lion-griffin. The style of this carving suggests a date in the Roman period, perhaps from an eastern province of the empire or beyond, in Iran. As this fragment bears some resemblance to throne supports of the Sasanian period cast in bronze and decorated with various animal and bird heads (Harper, 1978, nos. 32, 35), it may have served a similar function.

696

Objects of the Sasanian Period
(c. 225–650 A.D.)

This, like the preceding historical periods, is a time far better known from standing monuments and rock-cut reliefs (Ghirshman, 1962) than it is from controlled excavations producing small finds of the types listed here. On the antiquities market during the last quarter of a century two particular groups of objects, vessels in precious metals and in cut glass, have characterized the flow of unprovenanced artifacts datable to the Sasanian period. The former have been the most widely forged of all Iranian "antiquities"; indeed, their manufacture between the late 1950s and the early 1970s amounted to a minor industry. Consequently, the separation of the small number of genuine clandestine finds from a whole host of imitations and replicas has much preoccupied students of the crafts of Sasanian times (Grabar, 1967; Muscarella, 1977). Although every attempt has been made to include only genuine examples here, inspection by eye, however careful, does not always reveal every deception, even after a decade of intensive study and isolation of the primary group of genuine objects (Harper, 1978). A distinctive aspect of vessel and mirror production in this period, perhaps not until near the end of it, was the use of speculum, an alloy of copper and up to twenty-percent tin, which gives the metal a golden color. It is usually now covered with an even black patina, and thus is sometimes mistaken for dirty silver. The high percentage of tin makes the metal brittle, and considerable skill is required to hammer vessels out of it at high temperatures.

700

698

Mirror
Iran; c. 225–650 A.D. or later
h: 8.2 cm.; diam: 21.1 cm.
Speculum and bronze, cast; disc of speculum with a bronze lion positioned as handle in the center of the back; as the present join appears to be a modern one, the integrity of the object is open to question.
M.76.174.12

Pub. Grabar, 1967, p. 139, no. 58 (with an illustration).

699

Helmet
Iran; c. 225–650 A.D. or earlier
h: 22 cm.; l: 24 cm.
Bronze and silver over iron, hammered; tall conical helmet made of overlapping iron segments overlaid with a framework of bronze bands alternating with panels of silver bearing a stamped feather pattern; the parts are joined by bronze rivets; perforated around lower rim, presumably for attachment of pendent chain mail to protect the face; much restored.
M.76.174.149

For a very similar helmet in the Metropolitan Museum of Art, cf. Harper, 1978, no. 31; Grancsay, *BMMA* n.s. 21, 1962–63, p. 253ff.

This is one of only five known extant examples. Although widely assumed to be Sasanian, helmets of this type are already represented on Parthian coins.

Illustrated on following page.

700

Half Chanfron (Piece of Horse Armor)
Iran; c. 225–650 A.D. or earlier
h: 28.5 cm.
Bronze, hammered; large piece of sheet metal with a central ridge and holes cut to accommodate the horse's ears; such pieces protected the top of the horse's head.
M.76.174.152

As all examples of this class of object are plain and without recorded archaeological context, their date is conjectured. A date before the Seleucid period is unlikely. They are most likely to be pieces of Parthian or Sasanian horse armor.

701

Chalice
Iran; c. 225–650 A.D.
h: 20.7 cm.; diam: 16.3 cm.
Speculum, hammered (and perhaps turned) in two pieces; large-stemmed chalice with spherical body and steep, inward-tapering neck; set on a large, flaring pedestal with hollow stem and underside; six prominent ribs encircle the midsection of the bowl, with a single collar at the base and two more about the pedestal.
M.76.97.371; ex-Colls. Holmes and Kelekian

Pub. Pope, *ILN,* Oct. 29, 1932, p. 614; ibid., 1938, IV, pl. 66; ibid., 1945, pl. 14.

The date and the authenticity of this vessel are debatable. If ancient, the above date, rather than an earlier one, is most probable.

702

Vase
Iran; c. 225–650 A.D.
h: 14 cm.; diam: 9.3 cm.
Speculum, hammered; vase with rounded body and shoulders, tapering to a flat base; tall concave neck with shallow fluting and gently flaring rim.
M.76.97.378

cf. Harper, 1978, no. 33 C.

703

Bowl
Iran; c. 225–650 A.D. or later
h: 4 cm.; diam: 19.8 cm.
Speculum, hammered; shallow
bowl with an interior medallion
bearing the chased design of a
gracefully rendered winged horse,
with a ribbon near the top of its
forward-curving wings and a
large pendant (?) suspended on a
chain from its neck; exterior deco-
rated with a large rosette with
incised petal tips.
M.76.97.386

This bowl is decorated in a deriva-
tive Sasanian style. It may be in-
terpreted in one of two ways.
Either it is a modern design or it is
from a provincial workshop, pos-
sibly of the late or post-Sasanian
period. However, the heavy sur-
face corrosion appears to extend
consistently across and into the in-
cised lines of the design, arguing
in favor of the bowl's antiquity.

704

Bowl
Iran; c. 225–650 A.D.
h: 6.5 cm.; diam: 10.8 cm.
Speculum, hammered; deep hemi-
spherical bowl; plain.
M.76.97.399

cf. Harper, 1978, no. 33 B.

705

Bowl
Iran; c. 225–650 A.D. or later
h: 4 cm.; diam: 14.5 cm.
Bronze, hammered; shallow bowl
with an interior medallion bearing
the engraved figure of a standing
bird with looping tail, a ribbon set
in its beak; set within a stylized
ivy-band border; below the lip, a
floral chain of stylized heart-shaped
petals; plain exterior.
M.76.97.405

706

Bowl
Iran; c. 225–650 A.D.
h: 7.4 cm.; diam: 9.2 cm.
Speculum, hammered; deep
hemispherical bowl with slightly
inward-curving sides; plain.
M.76.174.61

707

Pedestal Bowl
Iran; c. 225–650 A.D.
h: 8.8 cm.; diam: 12.8 cm.
Speculum; hammered (in two
parts); hemispherical bowl on a
flaring hollow pedestal; plain
interior; fine shallow fluting on
the exterior, with a single incised
line beneath the rim.
M.76.97.379

For type in silver and pewter, cf.
Harper, 1978, no. 9 and p. 86, fig. D.

708

Pedestal Bowl
Iran; c. 225–650 A.D.
h: 7.4 cm.; diam: 14.9 cm.
Silver, hammered (in two parts);
shallow rounded bowl on a hollow
conical pedestal, flaring out-
ward at the base; plain interior;
vertically ribbed exterior as in cat.
no. 707.
M.76.97.402

709

Oval Dish
Iran; c. 225–650 A.D.
h: 6.5 cm.; l: 21.5 cm.
Speculum, hammered (in two
parts); elongated oval dish with
gracefully upturned ends; plain.
M.76.174.112

cf. Harper, 1978, no. 33 (in bronze).

703

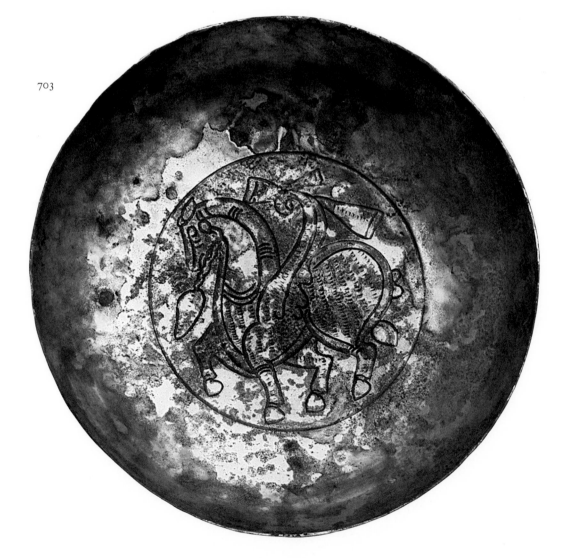

710

Oval Dish
Iran; c. 225–650 A.D.
h: 4.3 cm.; l: 27.5 cm.
Bronze, hammered; elongated oval dish; plain interior; exterior decorated with a pattern of raised lines radiating diagonally out from the center.
M.76.97.411

For form, cf. Harper, 1978, nos. 11 and 33 A.

711

Oval Dish
Iran; c. 225–650 A.D.
h: 6.2 cm.; l: 14.5 cm.
Silver and silver gilt, hammered; elongated oval dish; plain interior; a grape-and-leaf vine scroll beneath the rim; remainder of exterior decorated with a chased pattern of rippling lines.
M.76.174.5

cf. Harper, 1978, no. 11.

712

Oval Dish
Iran; c. 225–650 A.D.
h: 5 cm.; l: 20.2 cm.
Silver, hammered; elongated oval dish; on the inside center, the delicately incised figure of a seated monkey with twisted tail, playing a pipe; an engraved grape-and-leaf vine scroll on the exterior beneath the rim, with a game bird enclosed within every third loop of the tendril.
M.76.174.265

712A

Oval Dish
Iran; c. 225–650 A.D.
h: 5.4 cm.; l: 22 cm.
Silver, hammered; elongated oval dish; plain interior with small fish incised in center; frieze of long-tailed crested birds engraved on the exterior below the rim.
M.76.174.15

712B

Oval Dish
Iran; c. 225–650 A.D.
h: 5 cm.; l: 18.3 cm.
Silver, hammered; wide oval dish; interior medallion in the form of a chased boar's head within two interwoven square frames forming an eight-pointed star.
M.76.174.14

712C

Oval Dish
Iran; c. 225–650 A.D. or later
h: 4 cm.; l: 15.7 cm.
Silver and silver gilt, hammered; wide oval dish; on the interior, an engraved, standing, robed female holding a bunch of flowered stems in her right hand and a cone-shaped object in her left; on the exterior, a male bust within a double beaded roundel surrounded by an arrangement of six similar medallions, each enclosing a boar's head; in the intervals between, a flowering stalk, flanked by two birds, below which is a rosette.
M.76.174.266

713

Elephant Ring
Iran; c. 225–650 A.D.
diam: 16 cm.
Bronze, cast; heavy hollow-cast open ring with crescentic terminal plates (nearly abutting); behind the terminals, a beaded band and simple incised decoration; the object seems too weighty for a human anklet but might have been a rattling ring worn on an elephant's lower leg.
M.76.97.331

712B

712

714

Plaque

Iran; 7th century A.D.

h: 38 cm.; w: 31 cm.

Stucco, molded; rectangular panel decorated with the figure of a mounted king in Sasanian costume spearing a boar (now lost); king's head is surmounted by a nimbus of stylized flames and a royal crown topped by a crescent and globe set between symmetrical wings; two pairs of fluttering ribbons extend from king's robe; said to be from Chal-Tarkhan-Eshqabad, near Rayy; much restored.

M.76.174.250; ex-Rabenou Collection

Pub. Grabar, 1967, p. 147, no. 69. cf. Thompson, 1976, pp. 9ff., and pl. 114; Harper, 1978, no. 46.

715

Recumbent Hare

Iran; c. 225–650 A.D. or later

h: 4.5 cm.; l: 9 cm.

Bronze, hollow cast; hare with large ears laid against the back; mouth open; bands of incised lines mark the haunches.

M.76.97.882

cf. Pope, 1938, IV, pl. 169 C: Erdmann, 1969, pl. 88.

716

Footed Goblet

Iran; 4th century A.D.

h: 27 cm.; diam: 7.6 cm.

Clear glass, free-blown and hot-tooled; tall cylindrical beaker on a pad foot; exterior decorated with a series of applied vertical threads, alternating two colorless to one of dark blue.

M.76.174.235

For a very similar vessel, cf. Anon., *JGS* 13, 1971, p. 139, no. 19.

If found in Iran, this vessel was probably an import from a glass factory to the west.

717

Cylindrical Bowl

Iran; c. 7th century A.D. or later

h: 8.8 cm.; diam: 9 cm.

Opaque yellow-green glass, blown and cut; cylindrical bowl with vertical sides and flat bottom; five rows of shallow circular facets on the exterior, surmounted by a double wheel-cut groove (beneath the rim).

M.76.174.237

For this and the following vessels, cf. Saldern, 1974, no. 759; Harper, 1978, p. 150ff. (with bibliography).

Illustrated on page 126.

718

Hemispherical Bowl

Iran; c. 225–650 A.D.

h: 9 cm.; diam: 10.3 cm.

Opaque brown glass, blown and cut; thick-walled hemispherical bowl with slightly constricted lip; seven rows of hexagonal facets on the exterior; those in the lowest row are larger and more liberally spaced, with a small facet cut in the upper area of each interval; large circular facet on the base.

M.76.174.239

cf. Fukai, 1977, no. 4.

719

Bowl

Iran; c. 225–650 A.D.

h: 9 cm.; diam: 11.5 cm.

Translucent green glass, blown and cut; cylindrical bowl with gently outward-flaring walls and slightly bulging lip; two rows of oval facets on the exterior, framed above by two encircling wheel-cut lines set below the rim; large circular facet on the base.

M.76.174.241

cf. Fukai, 1977, nos. 6, 7.

720

Pear-shaped Bottle

Iran; c. 225–650 A.D.

h: 20 cm.; diam: 9.5 cm.

Opaque green glass, blown and cut; piriform vase with small, flanged rim; twelve rows of oval facets on the exterior; large circular facet on the base.

M.76.174.236

cf. Fukai, 1977, no. 30; Hasson, 1979, no. 49.

Illustrated on page 126.

721

Goblet

Iran; c. 225–650 A.D.

h: 11.5 cm.; diam: 10.7 cm.

Translucent pale-yellow glass, blown and cut; deep hemispherical bowl on short stem and flaring base; four rows of square facets on the exterior, divided by a frieze of eight contiguous arcs encircling the midsection.

M.76.174.245

cf. Fukai, 1977, no. 19.

Illustrated on page 126.

714

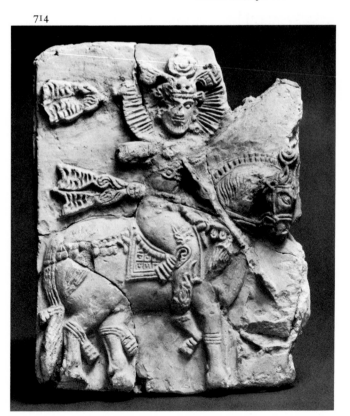

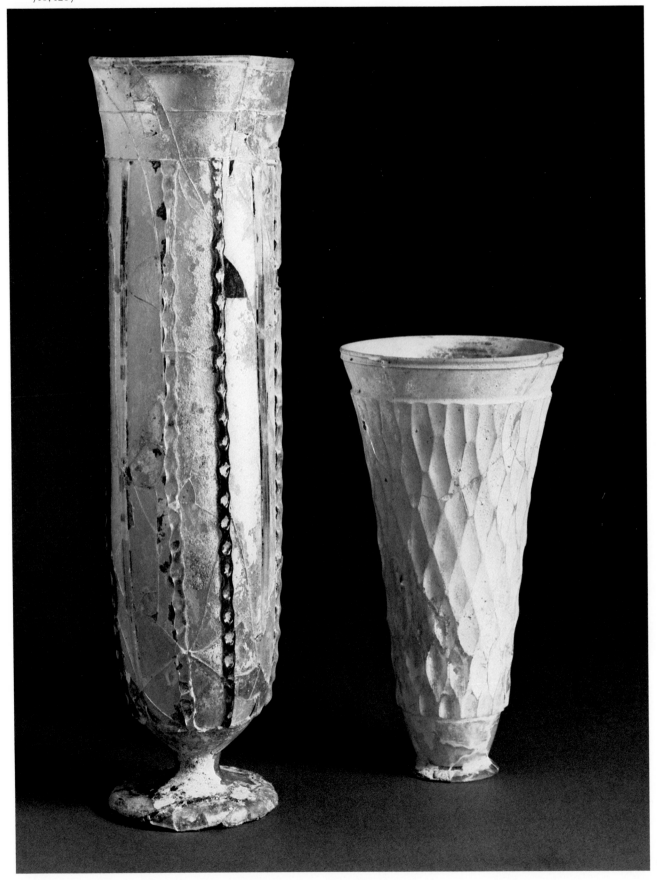

716, 1287

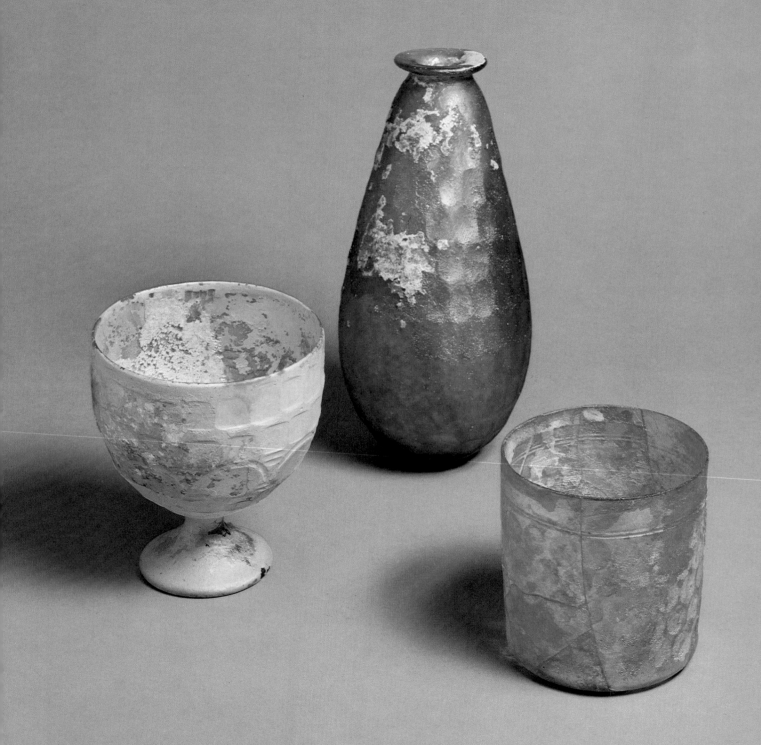

Ancient Iranian Pottery

A brief discussion of the various pottery styles represented in this section of the catalog may be found in the Introduction. In the following listing, pottery found with the so-called Amlash bronzes appears first (cat. nos. 723–39), followed by the painted pottery styles of Luristan and adjacent parts of the Iranian plateau (cat. nos. 740–63). The section closes with various vessels whose dates are not at present clear; some are certainly Achaemenid or later. In Gilan particularly, the Iron Age gray burnished wares survived down into the early first millennium A.D.; much research remains to be done on separating the earlier from the later forms.

725

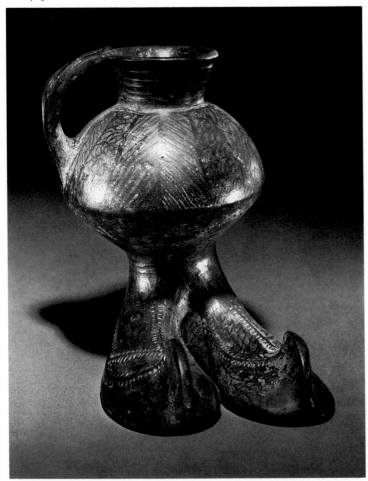

Unless otherwise noted, *h.* is the measurement from the base of the vessel to its rim; *l.* is the measurement of the vessel's total length, including handles and spouts; *diam.* is the measurement of the maximum diameter of the vessel.

722

Two-Handled Bowl
Northern Iran; c. 2000–1600 B.C.
h: 14 cm.; diam: 22.5 cm.
Buff ware; red slip; black-painted decoration in the "Saqzabad" style; on the shoulder, a triple zigzag frieze bordered below by an alternating pattern of pendent triple triangles and pendent double zigzag lines; small flanking loop handles.
M.76.174.217

723

Vessel on a Pillow-Shaped Support
Northern Iran; Iron Age I
(c. 1350–1000 B.C.)
h: 17 cm.; w: 14.2 cm.
Reddish brown burnished ware; small one-handled ovoid vessel with conical neck, emerging from a cushion-shaped support, each corner of which terminates in an upward-coiled spiral; two incised circles with drilled nucleii beneath the rim, flanked by small, perforated, semicircular lugs; some modern restoration; possibly a pastiche.
M.76.174.167

724

Double Vessel
Northern Iran; Iron Age I
(c. 1350–1000 B.C.)
h: 15.3 cm.; w: 20 cm.
Reddish brown burnished ware; tripod pitcher attached to an open tripod bowl with upturned legs; goat's head projecting from the shoulder of the pitcher with its muzzle positioned over the rim of the receptacle bowl; series of perforations on the inside wall of the bowl at the juncture with the pitcher indicate that the vessel served as a straining device; heavy surface accretion.
M.76.174.168

725

Handled Jar Set on a Pair of Boots
Northern Iran; Iron Age I–II
(c. 1350–800 B.C.)
h: 16.8 cm.; diam: 11.3 cm.;
l: 16.7 cm.
Black burnished ware; biconical vase with cylindrical neck set on a pair of elongated upturned boots; side loop handle attached to shoulder and lip; shoulder decorated in black paint with panels of herringbone design in alternation with narrow frames of looping squiggles; boots marked by ridges adorned with "stitching."
M.76.174.179

726

Female Statuette
Northern Iran; Iron Age I–II
(c. 1350–800 B.C.)
h: 25.7 cm.; w: 13.7 cm.
Red burnished ware; standing steatopygous woman, with rounded prominently ridged shoulders, long tubular neck (with encircling grooves), and oval face with perforated ears; incised decoration on body; heavy surface accretion.
M.76.174.181

727

Female Statuette
Northern Iran; Iron Age I–II
(c. 1350–800 B.C.)
h: 34.3 cm.; w: 10.6 cm.
Reddish brown burnished ware;
standing steatopygous woman
with curling arms held against the
chest below the breasts; incised
perforated circles denote eyes and
decorate conical spout above.
M.76.174.182

728

Zoomorphic Vessel
Northern Iran; Iron Age I–II
(c. 1350–800 B.C.)
h: 14 cm.; l: 13 cm.
Red burnished ware; quadruped
with four stubby legs; projecting
oval face on front of vertical
spout adorned with bronze ear-
rings inserted into the ears; pig-
tail in relief down the back of the
neck; tail forms a second spout;
hair and tail incised; surface worn.
M.76.174.185

729

Zoomorphic Vessel
Northern Iran; Iron Age I
(c. 1350–1000 B.C.)
h: 34.6 cm.; l: 34.5 cm.
Brown burnished ware; in the
form of a fallow deer with mouth
forming a spout; surviving ear
is pierced.
M.76.174.189

730

Zoomorphic Vessel
Northwestern Iran; Iron Age I–II
(c. 1350–800 B.C.)
h: 15.6 cm.; l: 28.8 cm.
Mottled, gray-red, burnished sur-
face; in the form of a standing
ram with curled horns (restored);
jawline extended to form an open
spout.
M.76.174.223

cf. Negahban, 1964, pl. IX.

731

Footed Goblet
Northern Iran; Iron Age I
(c. 1350–1000 B.C.)
h: 27 cm.; diam: 14.8 cm.
Gray burnished ware; ribbed body
with elongated cylindrical neck
and splayed foot; side handle.
M.76.174.194

732

Spouted Bowl
Northern Iran; Iron Age or
Parthian period
h: 25 cm.; diam: 21 cm.
Gray ware; loop handle with
braided decoration and a caprid
head at the base on either side;
a frieze of incised starbursts and
double concentric circles on
shoulder; dot rosettes on sides of
loop handle.
M.76.174.195

733

Zoomorphic Vessel
Northern Iran; Iron Age–
Achaemenid period
h: 13.5 cm.; l: 15.3 cm.
Gray-black burnished ware; ram-
shaped with a spout in the center
of its back and truncated rear end,
circumscribed by two lightly stip-
pled rings; modern restorations.
M.76.174.198

727

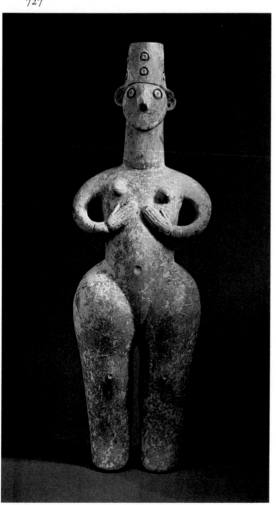

730

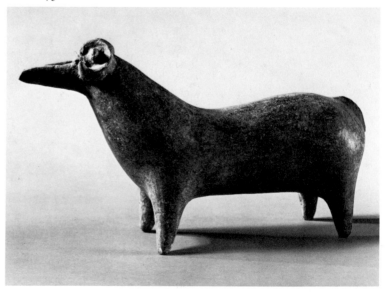

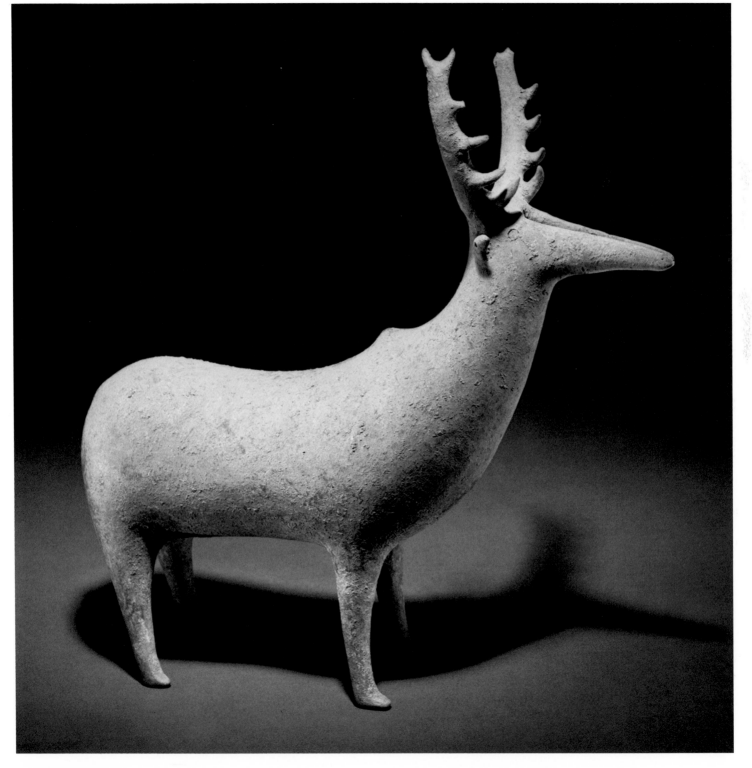

734

Tripod Spouted Bowl
Northern Iran; Iron Age I–II
(c. 1350–800 B.C.)
h: 12 cm.; diam: 6.8 cm.;
l: 19 cm.
Orange-red burnished ware;
engraved decoration of vertical,
notched chains equally spaced
about the body with pendent,
v-shaped, double chains in the
intervals; small beak-shaped pro-
jection at juncture of spout and
body.
M.76.174.205

735

Tripod Jar with Zoomorphic Handle
Northern Iran; Iron Age or
Parthian period
h: 17.8 cm.; diam: 17.8 cm.
Gray ware; single handle in the
shape of a horned animal with its
head turned back; three registers
of incised chevrons on shoulder.
M.76.174.209

736

Spouted Jar on a Pedestal
Northern Iran; Iron Age I–II
(c. 1350–800 B.C.)
h: 20.1 cm.; diam: 18.8 cm.;
l: 28 cm.
Gray-black burnished ware;
biconical body with vertical rim;
on cylindrical stem with flaring
foot; elongated spout angles up-
ward from projecting portion of
the body.
M.76.174.211

737

Spouted Jar
Northern Iran; Iron Age I–II
(c. 1350–800 B.C.)
h: 11.8 cm.; l: 27.3 cm.;
diam: 15.2 cm.
Gray ware; squat, with bowed
cylindrical spout; animal head
facing outward at the base of the
spout; loop handle on shoulder.
M.76.174.212

cf. Vanden Berghe, 1959, pl. 153a,b
(from Khurvin).

738

Spouted Bowl
Northern Iran; Iron Age I–II
(c. 1350–800 B.C.)
h: 21 cm.; diam: 15.8 cm.
Dark orange-colored ware; four
small jars (one a modern restora-
tion) set at regular intervals around
upper side; vertical stitching
around lip and body between jars;
ridge along back opposite spout.
M.76.174.213

739

Spouted Bowl
Northern Iran; Iron Age I
(c. 1350–1000 B.C.)
h: 18.3 cm.; diam: 15.6 cm.;
l: 34 cm.
Gray-black burnished ware;
three vertical ridges depend from
lip opposite spout; chains of
incised stippling between ridges,
around lip, on spout, and around
juncture of spout and vessel body.
M.76.174.218

740

Jar
Western Iran; second half of 3rd
millennium B.C.
h: 16.2 cm.; diam: 18.2 cm.
Buff ware; dark-painted decora-
tion in "Giyan IV" style; on the
shoulder, two elongated horned
animals (a goat and a gazelle?);
much restored and overpainted.
M.76.174.160

cf. Vanden Berghe, 1959, pl. 109a,b.

734

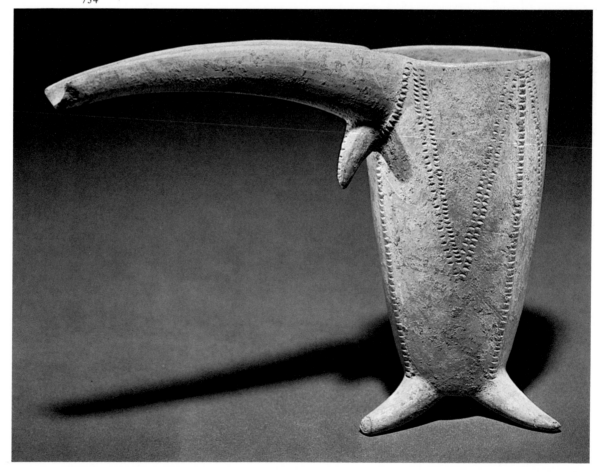

741

Jar

Western Iran; second half of 3rd millennium B.C.

h: 28.8 cm.; diam: 30.4 cm.

Buff ware; dark-painted decoration in "Giyan IV" style; on the shoulder, a frieze of "bird-combs."

M.76.174.169

cf. Vanden Berghe, 1959, pl. 109a,b.

Illustrated on page 131.

742

Goblet

Western Iran; late 2nd millennium B.C.

h: 11.4 cm.; diam: 10.2 cm.

Buff ware; cream slip; dark-painted decoration in "Giyan II" style; some modern additions.

M.76.174.161

743

Jar

Western Iran; early 2nd millennium B.C.

h: 18.7 cm.; diam: 17.3 cm.

Buff ware; dark-painted decoration in "Giyan III" style; on the shoulder, a pair of goats separated by multiple zigzag lines framed by an undulating border; restored and somewhat overpainted.

M.76.174.177

For type, cf. Vanden Berghe, 1959, pl. 110d.

744

Spouted Jar

Western Iran; 2nd millennium B.C.

h: 17 cm.; diam: 16.3 cm.

Buff ware; dark-painted decoration in "Giyan III–II" style; on the shoulder, an encircling frieze of birds framed below by an undulating band.

M.76.174.178

745

Footed Goblet

Western Iran; late 2nd millennium B.C.

h: 14.9 cm.; diam: 8.5 cm.

Buff ware; cream slip; dark-painted decoration in "Giyan II" style; on the shoulder, a frieze with alternating panels of birds and cross-hatching; on the neck, a frieze of birds interrupted at one end by two consecutive panels bearing a crosshatched hour-glass pattern of two opposed triangles set tip-to-tip.

M.76.174.162

For type, cf. Vanden Berghe, 1959, pl. 113d.

746

Footed Goblet

Western Iran; late 2nd millennium B.C.

h: 11 cm.; diam; 9.8 cm.

Buff ware; dark-painted decoration in "Giyan II" style; three vertical panels of superimposed birds equally spaced about the exterior; foot restored.

M.76.174.199

For slightly taller version of same, cf. Vanden Berghe, 1959, pl. 111d.

747

Chalice

Western Iran; late 4th millennium B.C.

h: 16.5 cm.; diam: 17 cm.

Buff ware; dark-painted decoration in "Sialk III" style; on the shoulder, a frieze of goats with forward-coiled horns and multiple zigzag tails; crisscross network below.

M.76.174.180

cf. Stuttgart, 1972, no. 4.

748

Chalice

Western Iran; late 4th millennium B.C.

h: 16.7 cm.; diam: 15 cm.

Buff ware; dark-painted decoration in "Sialk III" style; on the shoulder, a frieze of stylized goats with elongated backward-sweeping horns; row of vertical frames below.

M.76.174.230

cf. cat. no. 747.

749

Spouted Jug

Western Iran; Iron Age I (c. 1350–1000 B.C.)

h: 17 cm.; diam: 20 cm.; l: 27 cm.

Gray ware; fluted body flaring outward from a flat base; rounded shoulder with inset, tall, inward-sloping rim; ram's head facing outward on handle; spout broken.

M.76.174.164

cf. Vanden Berghe, 1959, pl. 172 (Sialk).

750

Spouted Jar

Western Iran; Iron Age II (c. 1000–800 B.C.)

h: 15.3 cm.; l: 35.5 cm.; diam: 20 cm.

Buff ware; cream slip; reddish orange-painted decoration in "Sialk Cemetery B" style; on each side, a horned animal and a paneled square; elongated loop handle on shoulder.

M.76.174.173

cf. Vanden Berghe, 1959, pl. 168b,c.

751

Spouted Jar

Western Iran; Iron Age II (c. 1000–800 B.C.)

h: 18.9 cm.; l: 29 cm.; diam: 18.8 cm.

Buff ware; cream slip; reddish orange-painted decoration in "Sialk Cemetery B" style; at the rear, a checkerboard lozenge between two larger ones; loop handle attached to shoulder and rim.

M.76.174.174

cf. Vanden Berghe, 1959, pl. 169.

Illustrated on page 134.

750

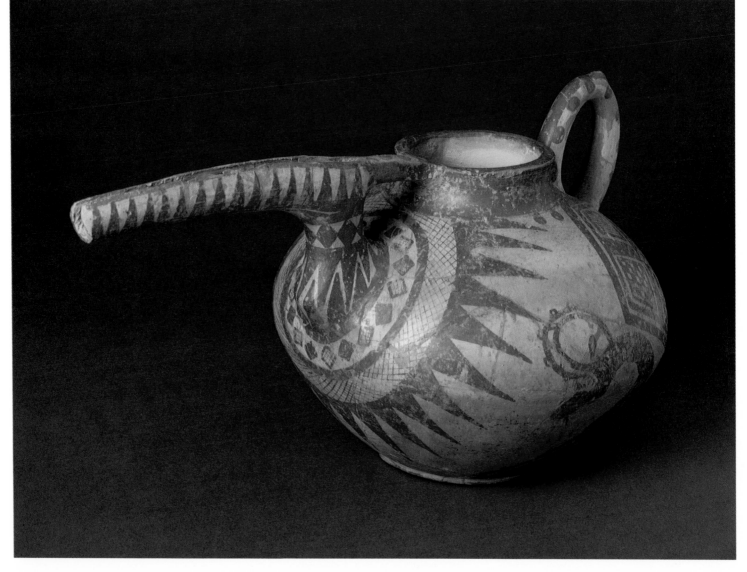

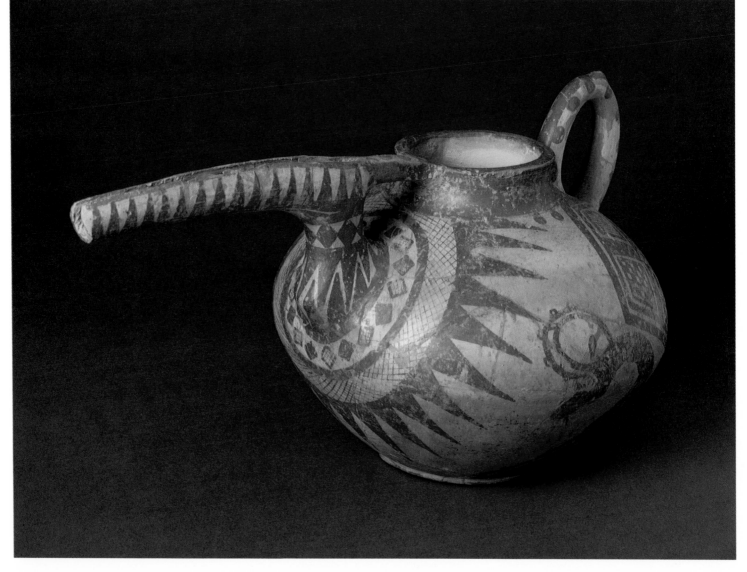

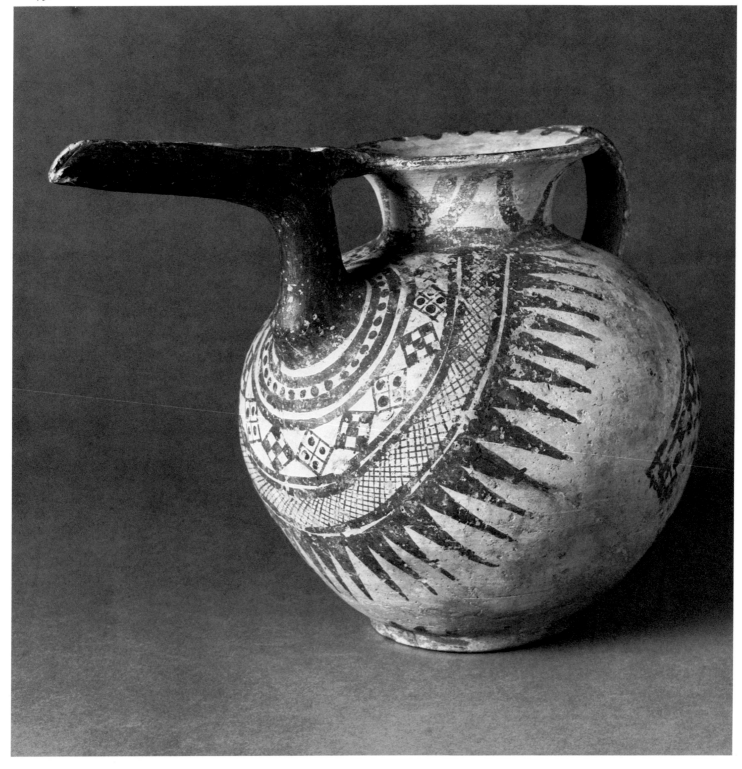

752
Spouted Jar
Western Iran; Iron Age II
(c. 1000–800 B.C.)
h: 19.7 cm.; diam: 18.7 cm.
Buff ware; cream slip, reddish
orange-painted decoration in
"Sialk Cemetery B" style; fan-
shaped spout and loop handle.
M.76.174.233

cf. Vanden Berghe, 1959, pl. 170
(lower right).

753
Tripod Jar
Western Iran; early 2nd
millennium B.C.
h: 24 cm.; diam: 24.4 cm.
Buff ware; symmetrical checker-
board pattern in brown paint
around body of vessel.
M.76.174.170

For shape, cf. Vanden Berghe,
1959, pl. 115c.

754
Spouted Anthropomorphic Vessel
Western Iran; Iron Age II–III
(c. 1000–650 B.C.)
h: 28.5 cm.; w: 9.5 cm.
Buff ware; cream slip; reddish
orange-painted decoration in
"genre Luristan" style, consisting
of an encircling frieze of goats be-
tween hatched, pendent triangles;
in the shape of an ithyphallic male
pouring a libation from a large,
spouted vessel; he wears a pointed
cap and a bracelet on his right
wrist; loop handle.
M.76.174.165

cf. Goff, *Iran* XVI, 1978, fig. 13
(from Baba Jan Tepe, Luristan).

755
Jug with Vertical Spout
Western Iran; Iron Age II–III
(c. 1000–650 B.C.)
h: 26.3 cm.; diam: 26 cm.
Buff ware; dark-painted decora-
tion in "genre Luristan" style; on
the shoulder, a frieze of galloping
animals; ribbon handle; spout
flared at the top; modern restora-
tion in places; camel on shoulder is
a modern addition.
M.76.174.159

For such pottery, cf. Goff, *Iran*
XVI, 1978.

756
Squat Jar
Western Iran; Iron Age II–III
(c. 1000–650 B.C.)
h: 10 cm.; diam: 14 cm.
Buff ware; cream slip; reddish
orange-painted decoration in
"genre Luristan" style; restored
and overpainted with recent
designs.
M.76.174.187

757
Jar
Western Iran; Iron Age II–III
(c. 1000–650 B.C.)
h: 9 cm.; diam: 10 cm.
Buff ware; cream slip; reddish
orange-painted decoration in
"genre Luristan" style, consisting
of an encircling frieze of goats;
substantial modern restoration.
M.75.62.35

758
Spouted Jar
Western Iran; Iron Age II–III
(c. 1000–650 B.C.)
h: 11.2 cm.; diam: 10.7 cm.
Buff ware; cream slip; orange-
painted decoration in "genre
Luristan" style, consisting of an
encircling frieze of goats; front end
is decorated with a bird head; loop
handle; spout restored.
M.76.174.188

759
Jar with Nipple Base
Western Iran; Iron Age II–III
(c. 1000–650 B.C.)
h: 15.7 cm.; diam: 9.9 cm.
Buff ware; cream slip; orange-
painted decoration in "genre
Luristan" style, consisting of a
frieze of crosses between hanging
kite design.
M.76.174.197

760
Jar
Western Iran; Iron Age II–III
(c. 1000–650 B.C.)
h: 16.3 cm.; diam: 17.5 cm.
Buff ware; cream slip; brownish
orange-painted decoration in
"genre Luristan" style, consisting
of an encircling frieze of goats;
three projections at equal intervals
about the shoulder; some modern
restoration.
M.76.174.208

752

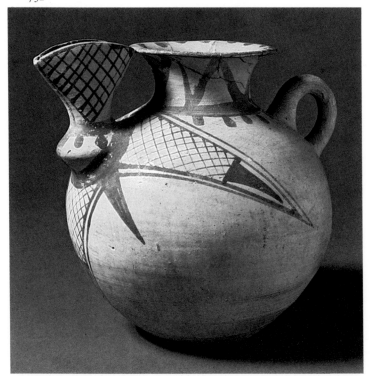

753

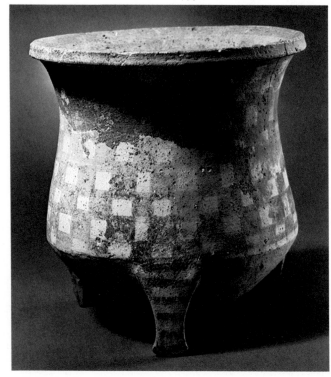

761
Spouted Jar
Western Iran; Iron Age II–III
(c. 1000–650 B.C.)
h: 17.3 cm.; diam: 19.8 cm.
Buff fabric; cream slip; reddish orange-painted decoration in "genre Luristan" style, consisting of a frieze of double concentric circles with dotted periphery between hanging-kite design; undulating border above; double shoulder handles united at rim; coiled loop handle terminating in an animal head at the base; spout broken.
M.76.174.210

cf. Vanden Berghe, 1959, pl. 123a,b.

762
Spouted Jug
Western Iran; Iron Age II–III
(c. 1000–650 B.C.)
h: 21.5 cm.; diam: 16.1 cm.
Buff ware; cream slip; orange-painted geometric decoration in "genre Luristan" style; wide band of diamond network below rim and on spout, with downward-pointing rays on neck and shoulder; herringbone pattern on handle; shoulder handle with applied bull's head above junction with shoulder; some modern restoration.
M.76.174.214

763
Spouted Pitcher
Northwestern Iran; Iron Age III
(c. 800–650 B.C.)
h: 20 cm.; diam: 22.8 cm.
Yellowish orange buff ware; frieze of incised zigzags on shoulder with pendent chevrons in the intervals, bordered above by a narrow zigzag frieze; shoulder handle; projecting tab on lip at junction with handle; some modern restoration; spout may not be original.
M.76.174.215

764
Boar's Head
Western Iran; Iron Age III–Achaemenid period
(c. 800–330 B.C.)
h: 9.5 cm.; l: 13.5 cm.
Buff ware; cream slip; "floral" decoration in dark paint; worn and much restored.
M.76.174.163

765
Boar's Head
Western Iran; Achaemenid–Parthian period
(c. 550 B.C.–225 A.D.)
h: 7 cm.; l: 9 cm.
Buff ware; cream slip; geometric decoration in dark paint consisting of triangles and crossed lines.
M.76.174.204

766
Fragment of a Lion's-Head Rhyton
Western Iran; Iron Age III–Achaemenid period
(c. 800 B.C.–330 B.C.)
h: 10 cm.; w: 12.4 cm.
Buff burnished ware; vividly rendered, naturalistic representation of a snarling lion's head with jaws agape; running zigzags on mane.
M.76.174.228

Pub. Pope, 1938, I, p. 307, fig. 73; New York, 1940, p. 301 D; Pope, 1960, pl. 21 (top); Wilkinson, 1963, p. 120, pl. 12.

This is possibly a ceramic imitation of a hollow-cast metal original.

767
Zoomorphic Vessel
Northwestern Iran; Achaemenid period (c. 550–330 B.C.) or later
h: 23 cm.; l: 30.5 cm.
Buff ware; orange-red slip; red-painted crosshatched decoration (badly worn); in the form of a quadruped with bulbous fore- and hindquarters, waisted at the center; a vertical spout rises from the midsection, connected to the rump by a short handle; horned animal head (both horns broken) on a long neck; two stubby front feet to give stability; feet and mouth perforated.
M.76.174.226

For such vessels (attributed to Ardabil), cf. Ghirshman, 1964, pl. 345 (dated too early); Stuttgart, 1972, no. 60.

768
Spouted Bowl
Western Iran; Parthian period
(c. 150 B.C.–225 A.D.)
h: 12.5 cm.; diam: 21 cm.
Highly fired orange-red ware; squat, rounded body tapering to a small disc base, with wide, gently flaring, cylindrical neck and conical outward-flaring spout; shoulder handle.
M.76.174.216

769
Zoomorphic Vessel
Iraq or Iran; Sasanian period
(c. 225–650 A.D.)
h: 17.5 cm.; l: 31 cm.
Buff ware; in the shape of a boar; extensive but cracked and discolored remnants of turquoise glaze which originally covered entire animal; cylindrical vertical spout in the middle of the back; snout also functions as a spout; right foreleg missing.
M.75.62.1

cf. Erdmann, 1969, fig. 90 (a hare in the British Museum).

761

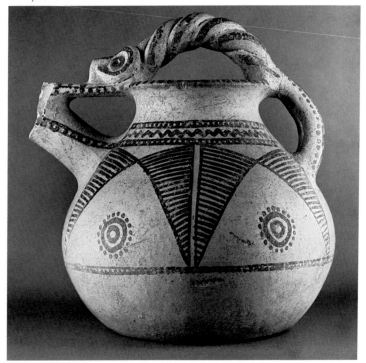

767

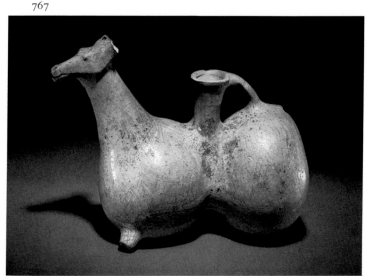

Ancient Art of
Central Asia, Mongolia,
and Siberia

Emma C. Bunker
The Denver Art Museum

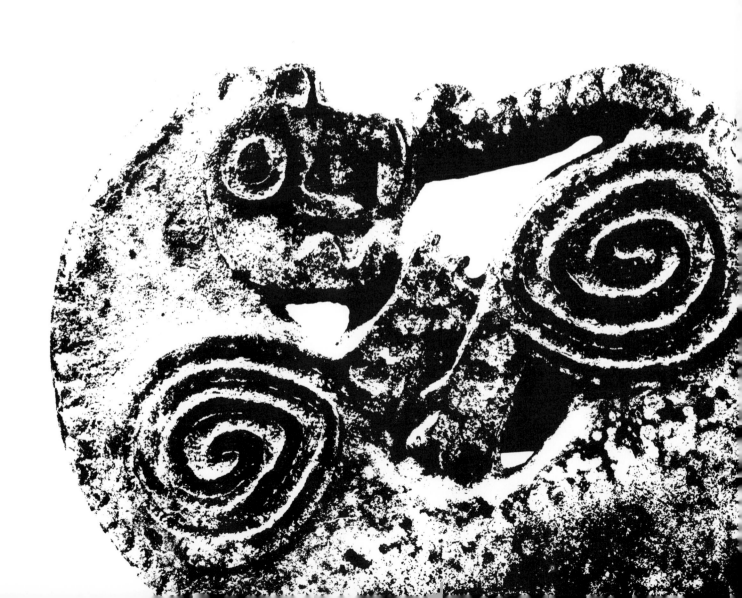

Introduction

Art of the Steppes

By the middle of the second millennium B.C., the steppe lands stretching from the Carpathian Mountains in the west to the northern borders of China were occupied by numerous pastoral tribes speaking Indo-European dialects. Their ancient Central Asian and southern Siberian cultures are known today as the Andronovo, which developed into the Karasuk by the first millennium B.C. Primarily of European physical type, these tribes organized around a strong patriarchal warrior aristocracy, with an economy based primarily on animal husbandry, supplemented by a minimal amount of agriculture.

Through the adoption of horseback riding and transhumance—the seasonal migration between summer and winter pastures (cf. preceding chapter, p. 15)—sometime early in the first millennium B.C., a new society of nomadic, mounted warrior-herdsmen emerged, uniquely adapted to the steppe environment. Firsthand descriptions by classical historians such as Herodotus, Ctesias, and Sima Qian, the great Han historian, indicate that a remarkable degree of cultural homogeneity had developed among these tribes. Among the various customs recorded is that of immortalizing the defeated enemy by converting his skull into a drinking vessel lined with gold. Superb horsemen and masters of the art of archery from horseback, their military prowess gave them a dreaded reputation throughout the civilized world. Their traditional riding costume consisted of a loosely fitting tunic belted at the waist, trousers, and soft boots; their dwelling—still used by pastoral tribes today—was a trellis tent consisting of a round, portable, felt-covered framework of wooden poles, more popularly known as a yurt.

Although they left no written records of their own, their legacy is one of the great artistic traditions of the world. Their brilliantly colored textiles, weapons, horse gear, and personal ornaments are primarily adorned with intriguing configurations of birds and beasts, as well as with narrative scenes illustrating heroic episodes from the various oral epics that grew out of the pastoral nomadic tradition. For the most part, theirs was a conservative tribal art in which motifs, often reduced to predominantly decorative schemes, persisted over long periods of time, unlike the art of urban areas, whose rapid stylistic changes were governed by the shifting breezes of fashion.

In spite of certain shared customs, each tribe or group of tribes had its own characteristic traits, artifacts, and artistic vocabulary. These varied from region to region, depending upon the blend of local traditions, fauna, and influences from the urban centers with which they came in contact. Because the exchange of cultural traits and artistic styles was quickened by an active, ever-fluctuating, trade-route network of East-West communication, the sources of those traits and styles continue to be a matter of debate.

The study of steppe art is still in its infancy. Great collections such as the Heeramaneck, however, interpreted in light of new archaeological discoveries, may substantially illuminate this little-known but intriguing segment of history.

Art of the Far Eastern Steppes during the Eastern Zhou Period

Ancient Chinese texts dealing with the Eastern Zhou and Han periods abound with references to the numerous equestrian tribes who inhabited southern Siberia, Mongolia, and what is now northern China, in the region of the Great Wall. However, no mention is made of their art. The strength of the Heeramaneck Collection lies in its wealth of art objects from these areas. Since all were curiosity-shop discoveries, however, it is not always possible to attribute them to specific tribes and regions. Nonetheless, tentative dates and provenance have been suggested for each piece by comparison with recently excavated finds in the People's Republic of China and the USSR.

Much of the eastern steppe art has been known as "Animal Style." This is a misleading term, coined originally by M. Rostovtzeff, to describe the various objects in the collections of romantic laymen, for which, as Karl Jettmar has pointed out, no general "style" existed. Scholars consequently tended to treat the Animal Style as though it were some magical, stylistic disease that spread across the steppes and into other more civilized areas; thus it explained any intriguing animal decoration, even in the most remote places, that seemed culturally intrusive, often obscuring the real art historical picture.

The Far Eastern steppe tribes frequently formed large confederacies and political alliances, consisting of numerous tribes and sub-tribes, each characterized by its own artistic style and paraphernalia. Culturally, one finds a persistence of certain Indo-European traits among these tribes, such as the inclusion of wives, concubines, and horses in a chieftain's tomb while, in varying mixtures, the ethnic makeup was of both European and Mongoloid physical type.

The equestrian barbarians of eastern Inner Mongolia and the lower Liao Valley in southern Manchuria during the Eastern Zhou period are represented by the later so-called Bronze Dagger Tombs of the upper Xiajiadian culture found in this area. Ethnically, the deceased were primarily Mongoloid and were apparently related through trade to tribes of western Inner Mongolia. The earliest known representation of an East Asian mounted warrior-herdsman appears in the form of two such figures cast in the round on the rim of a bronze ornament from Nanshangen, dated to the fifth century B.C. by the inclusion of Chinese bronze ritual vessels of the late Spring and Autumn period often encountered in the central plains. According to Sima Qian, King Wuling of Zhao adopted *hu fu* (barbarian riding clothes) and the art of mounted archery from the nomads in 307 B.C. There is no textual evidence for horseback riding in China before this date nor any real notice of its earlier existence among the northern barbarians. The fact that archaeological material dated at least as early as the sixth century B.C. proves its existence beyond the borders of ancient China suggests that it may not have been universally practiced in the steppes nor of real consequence to the Chinese until the Warring States period.

Current Chinese scholars agree that these tombs contain the remains of ancestors of such tribes as the Huimo, Zhenfan, and Chaoxian. Actually, the earlier Bronze Dagger Tombs, such as Zhengjiawazi, which contain only chariot equipment, may well be associated with these tribes, but the later tombs which indicated riding, such as Nanshangen and Shiertaiying-zi, could be those of the Dong Hu, proto-Mongol speakers whom Sima Qian locates in these regions. The art of horseback riding, together with the coiled feline (*KGXB*, 1980, no. 1, p. 51, fig. 2:2) appears around the fifth century B.C. as intrusive elements in the upper Xiajiadian culture. None of the pieces in the Heeramaneck Collection can be specifically identified with this tribal group, although the two small masks (cat. nos. 907 and 908) are similar to the face on a plaque from Shiertaiyingzi (*KGXB*, 1960, no. 1, pp. 63–71, pl. III) and an example collected in nearby Jehol (Egami and Mizuno, 1935, fig. 115).

Archaeologically speaking, the artistic remains of the mounted warrior-herdsmen who inhabited western Inner Mongolia (especially the Ordos), Outer Mongolia, and southern Siberia differ quite noticeably from those found in eastern Inner Mongolia. One such group of stylistically related finds displays many earmarks of the Scythian culture, identified by late Iron Age material excavated largely in the Ukraine in southern Russia. A chieftain's burial dating from the eighth to seventh–sixth centuries B.C. was recently uncovered at Arzhan in the eastern Sayan Mountains of southern Siberia. Among the riches it yielded were 138 saddled and bridled horses, a large coiled feline of bronze, and a pair of finials surmounted by standing rams. Similar finials, surmounted by cervids, have also been discovered in western Inner Mongolia at Taohongbala and Yulongtai, tentatively dated fifth–fourth century B.C. by the inclusion of an *akinakes*-type dagger with double bird-head handle of this date (Smirnov and Petrenko, 1963, pl. II) and certain objects of a type also found at Nanshangen (cf. *KGXB*, 1976, no. 1, p. 136, no. 10 with *KGXB*, 1975, no. 1, p. 137, no. 12).

The personal paraphernalia of these tribes–horse gear, finials, plaques, knives, daggers, and archers' equipment–reflect the cultural priorities of a militant nomadic tradition. The primary artistic motifs employed are the coiled feline, a bird-of-prey head with a large eye, and an herbivore–frequently a stag with flowing antlers (the leitmotif of Scythian art)–represented either standing or with legs folded. Certain motifs, such as the bird head and coiled animal, suggest a Chinese ancestry, while others, such as the folded leg pose, derive from ancient Near Eastern traditions.

The legend, found in Zhou literature, about the rescue of Duke Mu of Qin in 645 B.C. affords further evidence of a Scythian-type culture in the Far East, characterized by rituals clearly incomprehensible to the Chinese. According to the legend, the rescuers were comprised of a band of "savages who had drunk wine and eaten a good horse on the slopes of Qi mountain." This clearly alludes to the male custom of swearing brotherhood by drinking wine mingled with horse blood, a well-known Scythian practice described by Herodotus.

The other major group of tribes is best represented by the plaques with the fabric-like appearance on the reverse in the unprovenanced Siberian Treasure of Peter the Great, by the celebrated frozen tombs of the Altai region, by finds in the Tuva region, and at recently excavated sites at Aluchaideng

and Xigou in western Inner Mongolia. Their art, comprised of a diversity of artistic styles of common origin, belies the presence of strong inter-tribal relationships. Among the characteristic features of this group are the use of contorted and confronted real and fantastic beasts, animal combat, zoomorphic juncture, and a highly sophisticated narrative tradition. The roots of most of these motifs can be traced ultimately to the ancient Near East, tempered slightly, from the fourth century B.C. onward, by Hellenistic taste filtered through Central Asia. The objects consist predominantly of horse gear, weapons, and personal ornaments, especially for the belt, an object that held a mythico-magic power for the warrior-herdsman of the steppes. For the Avars, who migrated west from Central Asia in several waves beginning in the sixth century A.D., the warrior's belt was a piece of regalia exclusive to the horseman, denoting his clan and rank.

Ancient Chinese texts mention a number of tribes who may have been responsible for much of this art, but, unfortunately, their individual artistic styles cannot yet be identified. According to Sima Qian, the Lin Hu and Loufan tribes inhabited western Inner Mongolia until the third century B.C., when they were either conquered or driven off by the Xiongnu, a confederacy of nomads which may have originated in Transbaikalia. Sima Qian locates the Yuezhi tribes "in the area between the Qilian, or heavenly mountains, and Dunhuang." He describes them as "...a nation of nomads, moving from place to place with their herds...with customs...like those of the Xiongnu. [They] dressed in felt and furs and shot from bows." Of European physical type and speaking an Indo-European dialect known as Tocharian, their ancestors had arrived on the northwestern border of Shang China sometime during the second millennium B.C. Located to the north and west of China, presumably in southern Siberia, were the Hunyu, Chushi, and the proto-Turkish-speaking tribes of the Gekun, Dingling, and Xinli, whom the Xiongnu conquered after subduing the Dong Hu in the east and the Yuezhi in the west. Future discoveries may help pinpoint the individual tombs and art styles of many of these tribes now known only by name and reputation.

Emma C. Bunker
The Denver Art Museum

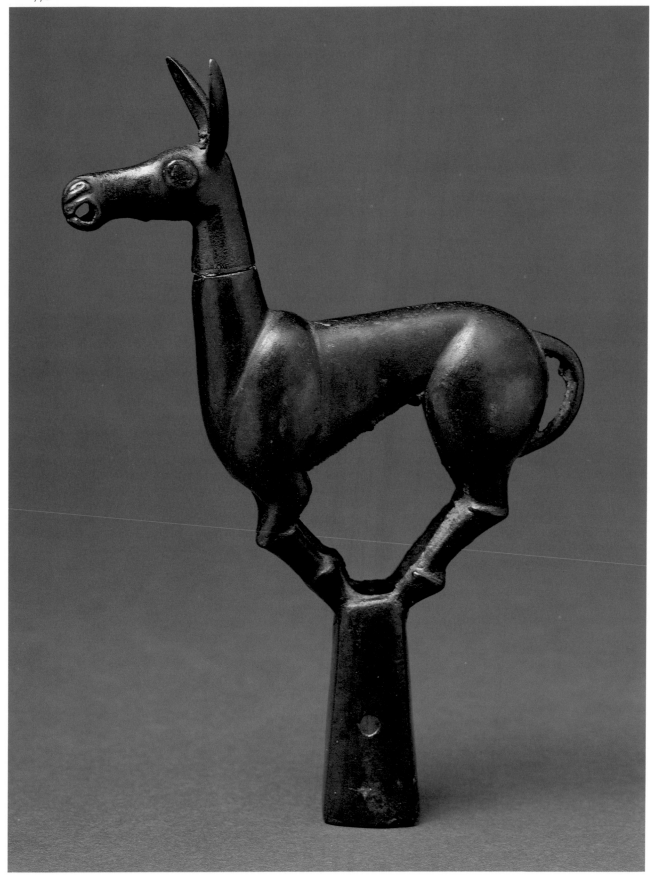

Finials

Finials terminating in bird and hooved animal forms are typical of Scythian art throughout Asia beginning in the eighth–seventh century B.C. The eastern steppe finials with standing herbivores appear to continue a Shang Chinese convention. It must be remembered, however, that such finials appeared even earlier, in Anatolia. The cervid with folded legs derives its pose from pre-Achaemenid Near Eastern traditions which arose in the eastern steppes in the fifth century B.C., possibly attributable to the influence of Saka refugees who had fled from the Central Asian invasions of Darius I. Like the "flying gallop" (cat. no. 871), the folded leg pose was occasionally used as a convention for expressing speed. Proof of this is furnished by a belt ornament in the Buffalo Museum of Science (Salmony, 1930, pl. XX, no. 16), which illustrates a chariot pulled by four horses set in this pose, a motif that appears suddenly in the artistic vocabulary of Chinese pictorial bronze vessels of the fifth century B.C. (Weber, AA XXX, 2/3, 1968, figs. 75 and 80, and p. 194).

The following finials and objects in the Heeramaneck Collection compare favorably with recently excavated pieces in western Inner Mongolia and Hebei province.

770

Finial
Southern Siberia;
7th–5th century B.C.
h: 17.6 cm.; w: 11.5 cm.
Bronze, cast; in the form of a wild ass with a moveable head; originally one of a pair; hollow cast with a seam mark down the back; one vertical loop and two attachment holes on socket sides.
M.76.97.663a,b; ex-Colls. Holmes and Sauphar

Pub. Rostovtzeff, 1929, pl. XXXI: 1; Andersson, BMFEA 4, 1932, pl. XXX: 2; New York, 1940, p. 424 X; Minns, PBA 28, 1942, pl. XXI; Bowie, 1966, p. 53, pl. 56; Anon., *Arts of Asia*, Sept.–Oct., 1978, p. 121.

Several examples of this finial type are said to come from the Ordos (Egami and Mizuno, 1935, fig. 90). Stylistically, this piece is closely related to a finial found in Krasnoyarsk, north of Minusinsk in southern Siberia (Metropolitan Museum of Art, 1975, no. 144) and to those recently excavated at Arzhan and at a site near the Ob River in southern Siberia (SA, 1970, no. 2, p. 170; *Arkheologicheske Otkrytiia*, 1973).

771

Pair of Finials
Southern Siberia;
6th–5th century B.C.
h: 14.5 cm.; w: 9 cm.
Bronze, cast; pair of finials, each surmounted by two hollow-cast standing *kulans* (wild asses) with pierced eyes, mouths, and nostrils; of thick, heavy metal and with oval sockets, like the finials from Arzhan *(Arkheologicheskie Otkrytiia*, 1973, p. 193).
M.76.97.602 and .603; ex-Holmes Collection

Pub. New York, 1940, p. 424 S and p. 425 DD.

Similar finials have also been found at Yulongtai in western Inner Mongolia (KG, 1977, no. 2, pp. 111–14 and plates).

772

Finial
Western Inner Mongolia;
5th–4th century B.C.
h: 9.5 cm.; w: 19.5 cm.
Bronze, cast; in the form of a crouching ram; hollow cast, with pierced eyes, ears, and nostrils; heavy metal with a squared socket which has a circular hole in the top and a rectangular slot in the bottom for attachment.
M.76.97.659

Pub. Bowie, 1966, p. 61, pl. 73.

Similar types have been found at Yulongtai in western Inner Mongolia (KG, 1977, no. 2, pp. 111–14 and plates).

771

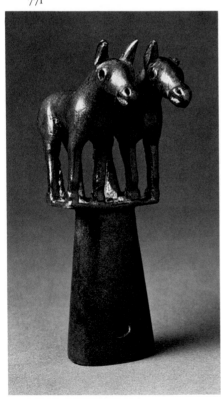

772

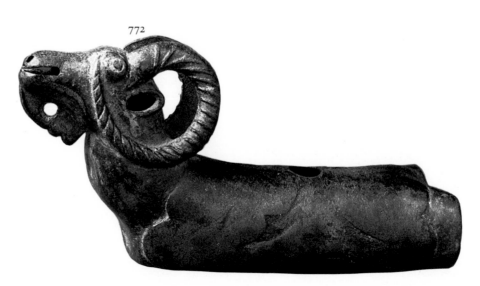

773

Finial
Western Inner Mongolia;
5th–3rd century B.C.
h: 11.7 cm.; w: 5.9 cm.
Bronze, cast; in the form of a bird
head with tiny residual ear inden-
tations; two holes in back of
socket for attachment; heavy metal
but no seams.
M.76.97.608

Similar but later examples have
been found in Sujigou, western
Inner Mongolia (*WW*, 1965, no. 2,
pp. 44–46 and plates).

774

Finial
Western Inner Mongolia;
5th–4th century B.C.
h: 5.5 cm.; w: 5.2 cm.
Bronze, cast; in the form of a stand-
ing mountain goat with feet drawn
together on a squared socket;
horns missing.
M.76.97.564

Stylistically, this piece is related to
material recently excavated at
Yulongtai in western Inner Mon-
golia (*KG*, 1977, no. 2, pp. 111–14
and plates).

775

Finial
Western Inner Mongolia;
5th–4th century B.C.
h: 6.6 cm.; w: 5.4 cm.
Bronze, cast; surmounted by a
Saiga antelope with gathered
hooves from which extend attach-
ment tangs.
M.76.97.572

A similar type has been excavated
at Yulongtai, western Inner Mon-
golia (*KG*, 1977, no. 2, pp. 111–14
and plates).

776

Finial
Western Inner Mongolia;
5th–4th century B.C.
h: 7 cm.; w: 11 cm.
Bronze, cast; in the form of a re-
cumbent ram; folded legs are
missing.
M.76.97.637

For a complete example, cf. Sal-
mony, 1933, pl. XXXIV: 5.

Stylistically, this piece is related to
material excavated at Yulongtai,
western Inner Mongolia (*KG*,
1977, no. 2, pp. 111–14 and plates).

773

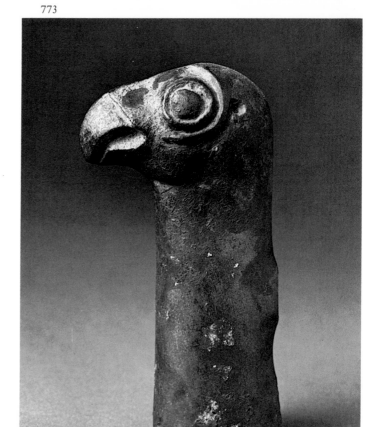

774

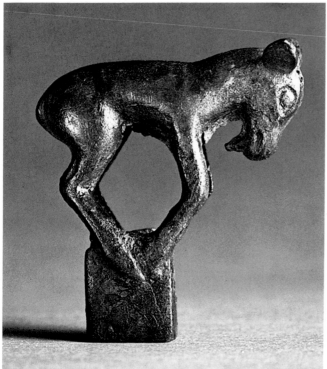

775

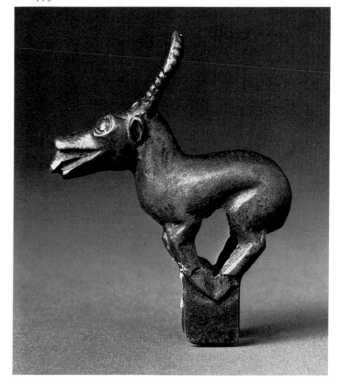

777

Finial
Western Inner Mongolia;
5th–3rd century B.C.
h: 4.3 cm.; w: 6.2 cm.
Bronze, cast; in the form of a fantastic creature; clay core.
M.76.97.573

The combination of a hooved animal body with a strong, beaked head is more characteristic of the fantastic creatures depicted on plaques found at Xigou (*WW*, 1980, no. 7, p. 2); finials constructed in this way are typical of those found at Yulongtai (*KG*, 1977, no. 2, pp. 111–14 and plates), and at Sujigou (Li, 1963, pl. 82) in western Inner Mongolia.

778

Finial
Western Inner Mongolia;
5th–3rd century B.C.
h: 9.5 cm.; w: 11.3 cm.
Bronze, cast; in the form of a standing doe on a baseline; hollow-cast light metal with seam marks down the back; clay core; remnants of some reddish substance around the face.
M.76.97.662

Pieces less crisply detailed, but similarly constructed, have been found at Sujigou in western Inner Mongolia (*WW*, 1965, no. 2, pp. 44–46 and plates).

779

Finial
Western Inner Mongolia;
5th–3rd century B.C.
h: 10 cm.; w: 19.2 cm.
Bronze, cast; in the form of a cervid with bumps where antlers have been shed; hollow cast with seam marks; original projecting tongue is now lost; reddish substance in ears and mouth.
M.76.97.601

Pub. Bowie, 1966, p. 52, pl. 54.

780

Pair of Finials
Western Inner Mongolia;
5th–3rd century B.C.
h: 10.2 cm.; w: 5 cm.
Bronze, cast; pair of hollow-cast birds; seam marks and remnants of a red substance.
M.76.97.607 and .661

This piece has the same round eye, light metal, and groundline as catalog number 778.

781

Finial
Western Inner Mongolia;
5th–4th century B.C.
h: 10.5 cm.; w: 13.5 cm.
Bronze, cast; in the form of a doe with protruding tongue; seam marks.
M.76.97.636

Similar pieces have been found at Yulongtai, western Inner Mongolia (*KG*, 1977, no. 2, pp. 111–14 and plates).

777

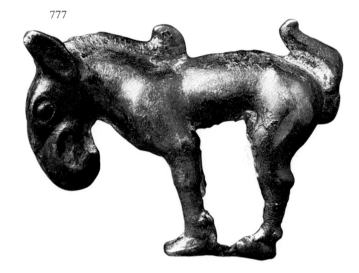

780

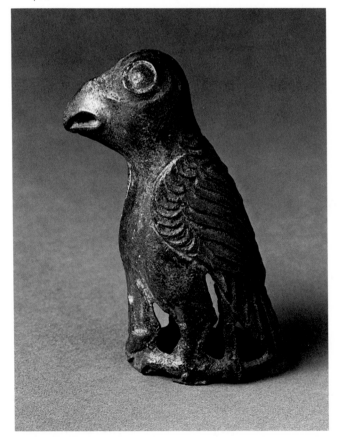

778

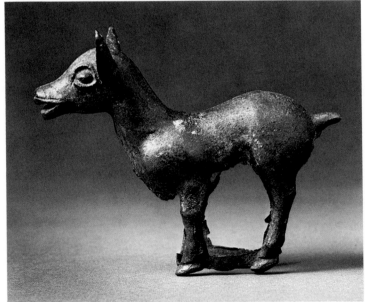

782

Finial

Western Inner Mongolia; modern
h: 6 cm.; w: 9.5 cm.
Bronze, cast; very crude hollow-cast ram; imitates ancient examples; no seams.
M.76.97.638; ex-Holmes Collection

783

Vessel

Western Inner Mongolia; modern
h: 7.2 cm.
Bronze, cast; with two bird-head handles which serve as spouts; a fanciful, unfunctional, modern fabrication with absolutely no precedent in antiquity.
M.76.97.676

784

Finial

Western Inner Mongolia;
5th–4th century B.C.
h: 4.2 cm.; w: 4 cm.
Bronze, cast; in the form of an onager head with protruding tongue; side attachment holes; seam mark down the back.
M.76.97.609

785

Finial

Western Inner Mongolia;
5th–4th century B.C.
h: 5.1 cm.; w: 6 cm.
Bronze, cast; in the shape of Przywalski's horse with incised eyes and mane; hollow cast; two attachment tangs with rectangular slits below both hind legs.
M.76.97.558c; ex-Holmes Collection

Pub. New York, 1940, p. 421 LL.

786

Finial

Western Inner Mongolia;
5th–4th century B.C.
h: 5.2 cm.; w: 6 cm.
Bronze, cast; small finial; probably formed a pair with the previous example; attachment tang with a horizontal slit occurs below left back leg; right back leg is missing.
M.76.97.558b; ex-Holmes Collection

Pub. New York, 1940, p. 421 MM.

787

Finial

Western Inner Mongolia; modern
h: 5.5 cm.; w: 6 cm.
Bronze, cast; a copy similar to the two preceding examples; maker produced a solid cast with tangs on front and back legs, instead of a hollow cast with tangs only below back legs.
M.76.97.565

788

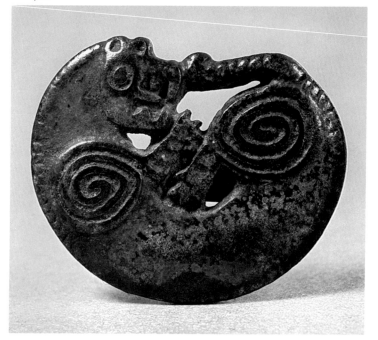

785

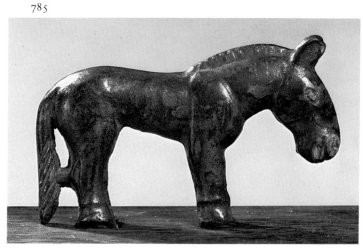

Coiled Felines

Coiled felines are among the major motifs of Scythian art and have been found throughout the Eurasian steppes. The steppe tribes borrowed this motif, as well as the bird-of-prey head with prominent eye, from China, where both originated. Few datable examples have been found in archaeological context in eastern Asia, but it appears that the coiled feline survived from the eighth–sixth century to the third century B.C. One fine coiled tiger seen en face was excavated in northern Hebei province (WW, 1960, no. 2, p. 60) along with a bird-shaped bell finial which, by comparison with similar bells from the upper Obi in southern Siberia, is datable to the sixth–fifth century B.C. (SA, 1970, no. 2, p. 170). Other examples were found in the High Altai region in kurgans of the Majemir period, dating to the seventh–sixth century B.C. (Jettmar, BMFEA 23, 1951, pl. IV and p. 152), and at Arzhan, dated to the eighth to seventh–sixth centuries B.C. (Griaznov, 1969, p. 39). Only the coiled felines from the Ordos region and northern China are represented with bodies in profile and heads en face. The others are entirely in profile.

793

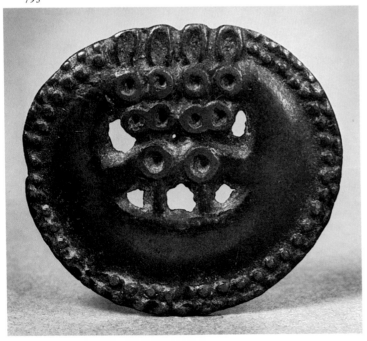

788

Horse Accoutrement
Southern Siberia;
6th–5th century B.C.
h: 2.4 cm.; w: 3 cm.
Bronze, cast; in the form of a coiled tiger with open toothy jaws and visible tongue; spirals mark the shoulder and haunch; horizontal attachment loop on the reverse.
M.76.97.647

Stylistically, this piece is related to an example from Minusinsk in southern Siberia (Artamonov, 1973, no. 136).

789

Horse Accoutrement
Western Inner Mongolia and northern China;
5th–4th century B.C.
diam: 2.8 cm.
Bronze, cast; in the form of a coiled tiger seen *en face,* with circular cells emphasizing eyes, nostrils, haunch, and tail tip.
M.76.97.993

A similar type was excavated in northern Hebei province. (*WW,* 1960, no. 2, p. 60).

790

Horse Accoutrement
Western Inner Mongolia and northern China;
5th–3rd century B.C.
diam: 2.5 cm.
Bronze, cast; in the form of a coiled tiger seen *en face* within a band of eight vulture heads; attachment loop on the reverse.
M.76.97.685b

791

Plaque or Button
Western Inner Mongolia and northern China;
5th–3rd century B.C.
diam: 3.3 cm.
Bronze, cast; in the form of a coiled tiger seen *en face* within a band of eight vulture heads, as in preceding example; attachment loop on the reverse.
M.76.97.685a

792

Horse Accoutrement
Western Inner Mongolia and northern China;
5th–3rd century B.C.
diam: 2.8 cm.
Bronze, cast; boss within a pearl border surrounded by six bird-of-prey heads; attachment loop on the reverse.
M.76.97.688

793

Horse Accoutrement
Western Inner Mongolia and northern China;
5th–3rd century B.C.
h: 3.5 cm.; w: 4 cm.
Bronze, cast; two confronted animal protomes seen *en face* within a double-pearl border; horizontal attachment loop on the reverse; circles used to emphasize eyes, nostrils, ears, and forepaws; the long rounded ears suggest wolves rather than tigers.
M.76.97.627

794

Fitting
Southern Siberia;
5th–3rd century B.C.
h: 1.3 cm.; w: 3.1 cm.
Bronze, cast; in the form of two coiled felines with faces in profile.
M.76.97.542

Numerous knives and daggers with complex zoomorphic decoration have been found along the northern Chinese border and in western Inner Mongolia. Few, however, have turned up in proper archaeological context. The knives have Chinese as well as Andronovan and Karasuk affinities, and the daggers relate to Scythian akinakes. A typology set up by Max Loehr permits a tentative dating for these stray finds, within which the Heeramaneck examples can be included (Loehr, AA XII, 1/1, 1949; ibid., AA XIV, 1/2, 1951).

797, 870

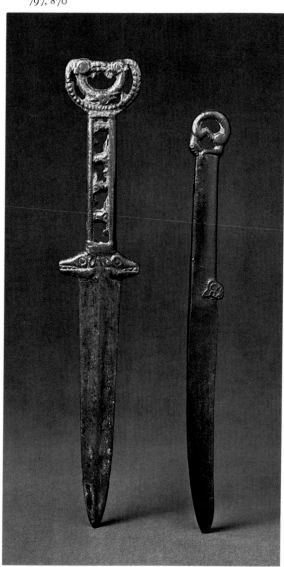

795

Knife
Western Inner Mongolia
and southern Siberia;
6th–5th century B.C.
l: 21.9 cm.
Bronze, cast; with a goat-head pommel; hilt is decorated in raised outlines, with four wild horses in a row on one side and two bovines confronting a boar and a coiled feline in profile on the other.
M.76.97.734; ex-Holmes Collection

Animals in a similar pose are found on a halberd butt and plaque from Nanshangen in Liaoning province (Li, 1963, pls. 32 and 45) and on a knife of seventh–sixth century B.C. date (Loehr, AA XIV, 1/2, 1951, type IX, no. 34).

796

Knife
Western Inner Mongolia
and northern China;
6th–5th century B.C.
l: 19.7 cm.
Bronze, cast; long narrow blade; hilt decorated with incised wavy lines and terminates in a griffin head.
M.76.174.135

Stylistically, this piece is related to contemporary griffin heads found in art from Minusinsk and the Altai region (Loehr, AA XIV, 1/2, 1951, p. 104). A knife with a less dynamic wavy-line pattern on the handle was recently found in Xigou, western Inner Mongolia, in tombs dated fifth–third century B.C. (WW, 1980, no. 7, p. 4).

797

Dagger
Western Inner Mongolia and northern China; 5th century B.C.
l. of hilt: 12 cm.; l. of blade: 14.2 cm.
Bronze, cast; *akinakes* type with a pommel in the form of confronted mountain goat heads; openwork hilt design of three cervid heads; guard made of two addorsed bear heads.
M.76.97.735

This piece is related to Group VII (*akinakes* types with ornate hilts), dated sixth–fifth century B.C. (Loehr, AA XII, 1/1, 1949, pp. 44–46).

Plaques and Ornaments

Numerous small plaques and ornaments decorated with animal and bird forms have been found in the Ordos region of the Great Wall and in recently excavated tombs in western Inner Mongolia, along with Scythian-type finials and fifth–fourth century B.C. dagger types. Many of these pieces were presumably horse accoutrements, but some may have enhanced one of the warrior's major accessories, his belt. The Heeramaneck Collection contains a great many of these delightful ornaments. Some are startlingly similar to objects from the Black Sea region, like the crouching feline and stag with folded legs and flowing antlers, providing further evidence for a vast cultural continuum throughout the Eurasian steppes.

798

Plaque
Western Inner Mongolia and northern China; 6th–5th century B.C.
h: 3 cm.; w: 8.8 cm.
Bronze, cast; in the form of a stylized feline with circular cells on paws, shoulder, and haunch; open, toothy jaws; two vertical low loops for attachments on the reverse.
M.76.97.568

This feline seems to be a descendant of earlier Chinese tigers such as those on the handles of a Shang *ding*, or cauldron (Fong, 1980, no. 17), which may also be part of the ancestry of the carnivorous felines found on Scythian work around the Black Sea (*SA*, 1971, no. 2, p. 71). A very similar fragmentary example was found at Xuanhua in northern Hebei province (Arne, *BMFEA* 5, 1933, pl. x: 10), dated sixth–fifth century B.C. by Loehr (*AA* XII, I/I, 1949, p. 47).

799

Plaque
Western Inner Mongolia and northern China; 5th century B.C.
h: 2 cm.; w: 4.5 cm.
Bronze, cast; in the form of a feline with haunch, shoulder, and eye perforations; two vertical loops on the reverse, one now broken off.
M.76.97.693

This is a similar, highly stylized version of the previous example.

800

Plaque
Western Inner Mongolia and northern China; 5th–4th century B.C.
h: 2.1 cm.; w: 3.9 cm.
Bronze, cast; in an s-shape terminating in two feline heads enhanced by a dotted texture; horizontal attachment loop on the reverse.
M.76.97.696

This piece is related to Liyu decor from northwestern Shaanxi (Rawson, 1978, p. 58). The design derives from a Chinese zoomorph found on the sixth–fifth century B.C. vessels (Weber, 1973, pp. 166 and 245). An identical piece has been found at Taohongbala in western Inner Mongolia (*KGXB*, 1976, no. I, pp. 131–44 and plates).

801

Plaque
Western Inner Mongolia and northern China; 5th–4th century B.C.
h: 2.3 cm.; w: 3.8 cm.
Bronze, cast; in the form of two griffin heads with scalloped mane and serpent's body; horizontal attachment loop behind center boss.
M.76.97.680

The griffin head is actually an eared bird-of-prey head which ultimately derives from the ancient Near East and occurs in the Anan'ino culture of eastern Russia and the Tagar culture of Minusinsk (Bunker, 1970, nos. 43 and 48). A very similar example was excavated with Scythian material at Guyuan xian in the vicinity of the Great Wall (*WW*, 1978, no. 12, p. 89).

798

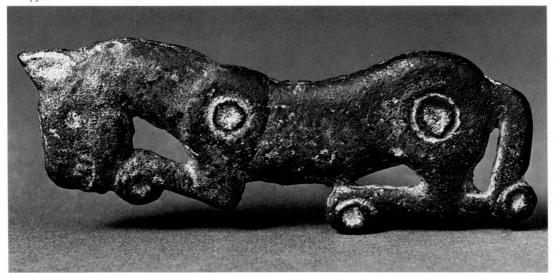

802

Plaque
Western Inner Mongolia
and northern China;
5th–4th century B.C.
h: 4.7 cm.; w: 3.3 cm.
Bronze, cast; openwork design
depicting three horses, alternately
arranged within a simple frame.
M.76.97.697

An identical piece has been found
at Taohongbala in western Inner
Mongolia (*KGXB,* 1976, no. 1,
pp. 131–44 and plates).

803

Plaque
Western Inner Mongolia
and northern China;
5th–4th century B.C.
h: 4.8 cm.; w: 2.6 cm.
Bronze, cast; openwork design
depicting two pairs of wild ass
protomes in a simple rectangular
frame; stylistically related to the
previous example.
M.76.97.996

Pub. Yamanaka and Company,
1943, no. 140.

804

Plaque
Western Inner Mongolia and
northern China; 5th century B.C.
h: 5 cm.; w: 2.8 cm.
Bronze, cast; openwork design de-
picting two pairs of wild ass pro-
tomes within a simple rectangular
frame, as in the preceding example.
M.76.97.707

Pub. Yamanaka and Company,
1943, no. 140.

805

Plaque
Western Inner Mongolia
and northern China;
5th–4th century B.C.
h: 5.2 cm.; w: 2.2 cm.
Bronze, cast; depicting four small,
horned sheep, alternately placed
within a simple rectangular frame;
back legs of each are folded under
as is one front leg, while the other
front leg is extended forward.
M.76.97.991; ex-Loo Collection

Pub. Salmony, 1933, pl. XVI: 16.

806

Plaque
Western Inner Mongolia
and northern China;
4th–3rd century B.C.
h: 2.5 cm.; w: 2.7 cm.
Bronze, cast; in the form of a stag
with folded legs and flowing ant-
lers; horizontal loop on the reverse.
M.76.97.999

A similar, less stylized example
was excavated near Huhehaote,
western Inner Mongolia (*WW,*
1957, no. 4, p. 30). Deer in this
pose also occur alternately placed
within a simple rectangular frame
as in the previous example (An-
dersson, *BMFEA* 4, 1932, pl. XXIX:
no. 4).

807

Horse Accoutrement
Western Inner Mongolia;
4th–3rd century B.C.
h: 3.7 cm.; w: 4.5 cm.
Bronze, cast; decorated with two
horses' heads of modeling very
similar to that of the preceding
piece; large ring below and tiny
attachment loop above; eyes
marked as tiny depressions.
M.76.97.683

808

Plaque
Western Inner Mongolia;
4th–3rd century B.C.
h: 3.5 cm.; w: 3.7 cm.
Bronze, cast; in the shape of a
two-humped camel; horizontal at-
tachment loop on the reverse like
that on cat. no. 806.
M.76.97.699

809

Plaque
Western Inner Mongolia;
5th–3rd century B.C.
h: 1.8 cm.; w: 2.4 cm.
Bronze, cast; in the form of two
frontal *kulan* heads; horizontal bar
on the reverse; worn.
M.76.97.547

Similar to a fox-head plaque exca-
vated at Taohongbala in western
Inner Mongolia (*KGXB,* 1976,
no. 1, pp. 131–44 and plates).

805

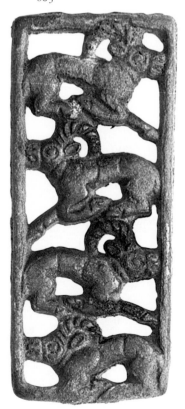

802

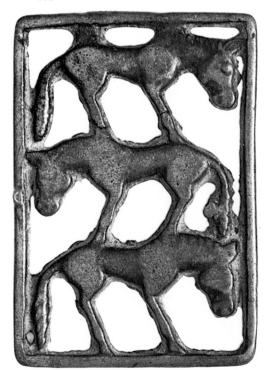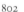

803

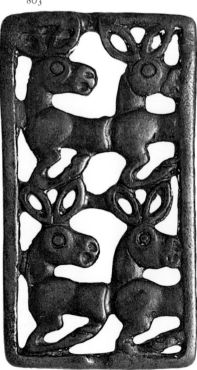

807

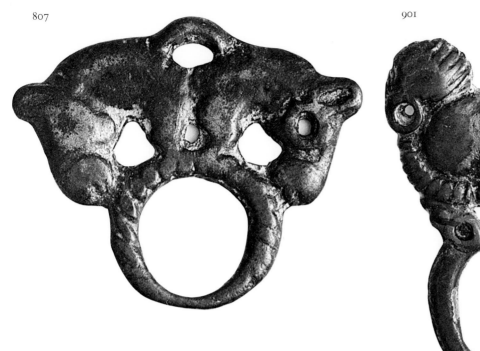

901

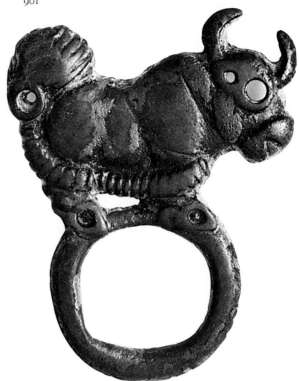

808

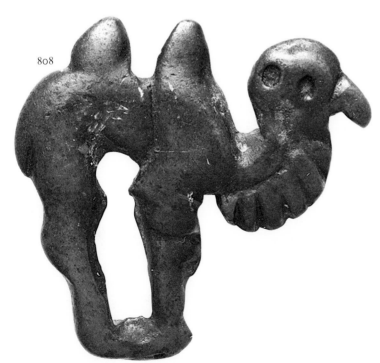

806

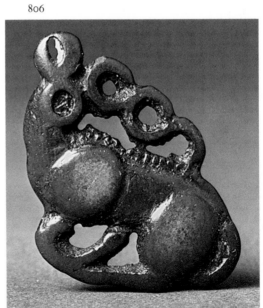

151

810

Plaque
Western Inner Mongolia;
5th–3rd century B.C.
h: 1.8 cm.; w: 2 cm.
Bronze, cast; in the form of a
frontal animal head, horned, with
pierced nostrils.
M.76.97.684b

The horizontal bar on the reverse
resembles that found on a fox-
head plaque excavated at
Taohongbala in western Inner
Mongolia (cf. cat. no. 809).

811

Plaque
Western Inner Mongolia;
5th–3rd century B.C.
h: 4 cm.; w: 1.5 cm.
Bronze, cast; in the form of a wild
ass head; vertical bar on the reverse
of the muzzle.
M.76.97.678

Numerous examples of this type
were excavated in the vicinity of
the Great Wall in the Ordos region
(Egami and Mizuno, 1935, pl. xv).

812

Plaque
Western Inner Mongolia;
5th–3rd century B.C.
h: 4.2 cm.; w: 1.8 cm.
Bronze, cast; in the form of a
stylized ass head as in the preced-
ing example but with pierced
holes; vertical bar on the reverse
of the muzzle.
M.76.97.550

817

813

Plaque
Western Inner Mongolia;
5th–3rd century B.C.
h: 2.2 cm.; w: 6 cm.
Bronze, cast; in the form of a
long-beaked bird head; vertical
attachment bar on the reverse.
M.76.97.694

Similar examples were found in
the Ordos region (Egami and
Mizuno, 1935, pl. LXV) and in
southern Siberia (Jettmar, *BMFEA*
23, 1951, pl. IV: no. 14).

814

Plaque
Western Inner Mongolia;
5th–3rd century B.C.
h: 3.6 cm.; w: 3.5 cm.
Bronze, cast; in the form of a
bovine head with pierced eyes.
M.76.97.692

Similar examples are said to have
come from the Ordos region and
Hattinsum in western Inner
Mongolia (Andersson, *BMFEA* 4,
1932, pl. XXIV: nos. 7–9; Egami
and Mizuno, 1935, fig. 67).

815

Plaque
Western Inner Mongolia;
5th–3rd century B.C.
h: 3.7 cm.; w: 2.7 cm.
Bronze, cast; in the form of a
bovine head with pierced eyes as
in the preceding example.
M.76.97.645

816

Amulet
Western Inner Mongolia;
5th–3rd century B.C.
h: 3.3 cm.; w: 3 cm.
Bronze, cast; in the form of a gal-
loping stag with stylized antlers
and folded legs.
M.76.97.634

A similar example was found in
the Ordos region of western Inner
Mongolia (Egami and Mizuno,
1935, pl. XIX).

817

Pendant
Western Inner Mongolia;
5th–3rd century B.C.
h: 3.3 cm.; w: 3.3 cm.
Bronze, cast; in the form of a stag
with folded legs and flowing
antlers.
M.76.97.706

818

Amulet
Western Inner Mongolia;
5th–3rd century B.C.
h: 2.5 cm.; w: 1.8 cm.
Bronze, cast; in the form of a stag
with body stylized in spiral shape.
M.76.97.559

This body stylization is a southern
Siberian feature seen in art forms
from the Tuva region (Artamonov,
1973, pls. 106, 107).

820

819

Pendant
Western Inner Mongolia;
5th–3rd century B.C.
h: 2.6 cm.; w: 2.8 cm.
Bronze, cast; in the form of a
horse; cast in the round.
M.76.97.648b

This posture is stylistically related
to that found on catalog num-
ber 802.

820

Spoon Pendant
Western Inner Mongolia;
5th–3rd century B.C.
l: 5.1 cm.
Bronze, cast; miniature spoon;
handle in the shape of a stag with
folded legs and flowing antlers.
M.76.97.703

Similar spoons with zoomorphic
handles were collected in Hat-
tinsum and the Ordos region of
western Inner Mongolia (Anders-
son, *BMFEA* 4, 1932, pl. XVII:
no. 6; Egami and Mizuno, 1935,
pl. XLV). Several large spoons have
been excavated in northern China
with predominantly barbarian
material (*KG*, 1979, no. 3, p. 227).

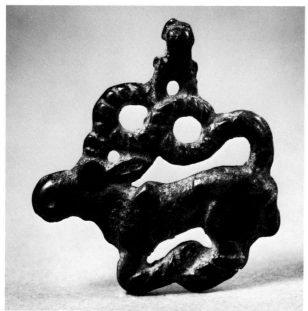

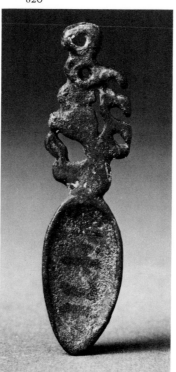

Plaques and Buckles

Numerous plaques and buckles in the Heeramaneck Collection can be stylistically related to material excavated in sixth century B.C. tombs at Tuekta and Bash-Adar in the central Altai Mountains of southern Siberia. One of the major themes is a carnivore preying on an herbivore, a theme which ultimately derives from the ancient Near East, where it flourished beginning in the third millennium B.C. and was prevalent in the Assyrian period. Beginning in the sixth–fifth century B.C., it also occurs as an exotic element on Chinese bronzes.

821

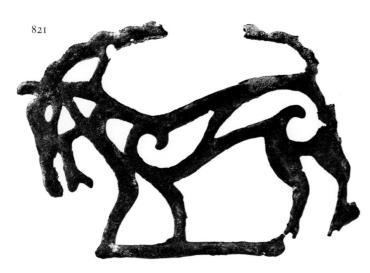

823

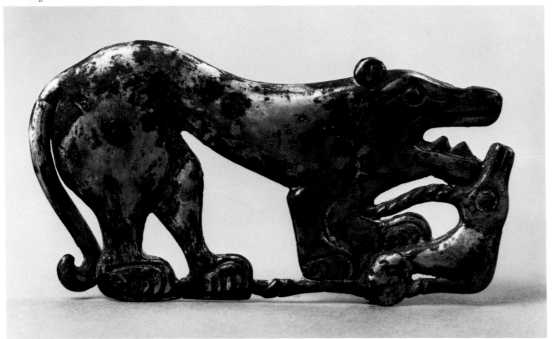

821

Plaque
Southern Siberia;
6th–5th century B.C.
h: 11.3 cm.; w: 17 cm.
Bronze, cast; flat openwork plaque in the form of a mountain goat with comma-shaped hip and shoulder markings.
M.76.97.598; ex-Holmes Collection

Pub. New York, 1940, p. 163 B.

This piece is similar to cutout leather animals found in Tuekta I, central Altai (Jettmar, 1967, fig. 105, p. 25), dated 530 (±130) B.C. Similar markings indicating barbarian influence have been found on sixth–fifth century B.C. Chinese vessels (Fong, 1980, no. 70).

822

Plaque
Southern Siberia;
6th–5th century B.C.
h: 6 cm.; w: 9 cm.
Bronze, cast; in the shape of a tiger attacking a doe; tail is broken.
M.76.97.655

Pub. Bunker, 1970, p. 144, no. 123 and p. 135, pl. 123; Trippet, 1974, p. 95.

The composition and striated treatment of the fur are stylistically related to the tigers and prey carved on the sides of the coffin from Bash-Adar in the central Altai but are of a later date (Rudenko, 1970, pp. 268–69). Originally this type came in pairs. For a complete pair, cf. an example in the David-Weill Collection (Hôtel Drouot, 1972, no. 57).

823

Plaque
Southern Siberia;
6th–5th century B.C.
h: 6.3 cm.; w: 12.3 cm.
Silver, cast; in the form of a bear attacking a gazelle; two small vertical loops on the reverse.
M.76.97.652

Pub. Bunker, 1970, p. 143, no. 113 and p. 130, pl. 113.

A similar pose is found on the Bash-Adar coffin from the central Altai (Rudenko, 1970, p. 269).

824

Plaque
Southern Siberia;
6th–5th century B.C.
h: 6.3 cm.; w: 11.2 cm.
Bronze, cast; in the form of a
feline eating a gazelle; two small
vertical loops on the reverse, ex-
actly as in the preceding example.
M.76.97.554

825

Plaque
Southern Siberia;
5th–3rd century B.C.
h: 4.8 cm.; w: 10.9 cm.
Bronze, cast; in the form of a wolf
eating the remains of a ram;
vertical attachment loop on the
reverse.
M.76.97.578

826

Buckle
Southern Siberia;
5th–3rd century B.C.
h: 5.5 cm.; w: 9.7 cm.
Bronze, cast; in the form of a wolf
attacking a mountain goat; hole
in the shoulder; prong and vertical
loop under the rump; character-
istic southern Siberian attachment
features.
M.76.97.553

827

Belt Plaque
Southern Siberia;
5th–3rd century B.C.
h: 5.7 cm.; w: 10.9 cm.
Silvered bronze, cast; in the form
of a tiger attacking a wild ass (rep-
resented only by its head); tiger
has a toothy, open jaw and a tail
terminating in a griffin head, a
fantastic feature found on many of
the Siberian Treasure plaques of
Peter the Great; hole in the shoul-
der; four vertical attachment
loops on the reverse.
M.76.97.577

A similar example without the
griffin-head tail comes from
Krasnoyarsk in southern Siberia
(Chlenova, 1967, pl. 17, no. 3).
The shoulder hole occurs on
plaques of single animals from the
Tagar culture (British Museum,
1978, no. 120).

828

Plaque
Southern Siberia;
5th–3rd century B.C.
h: 5.7 cm.; w: 9.1 cm.
Silvered bronze, cast; s-shaped
plaque in the form of two wolf
protomes with returned heads.
M.76.97.576

This is an obviously stylized ver-
sion of a plaque in the Varaschini
Collection illustrating two
complete wolves (Venice, 1954,
no. 151). There are two vertical
loops on the reverse as in the pre-
ceding piece.

829

Plaque
Southern Siberia;
5th–3rd century B.C.
h: 5 cm.; w: 8.8 cm.
Silvered bronze, cast; worn,
stylized version of the preceding
example; the wolves have been
reduced to a bold s-shape with
curled ends.
M.76.97.552

This is the same kind of ornamen-
tal treatment that produced such a
strong decorative effect on the
cervids on the Bash-Adar coffin
lid, where a rhythm of curves
and scrolls energetically enlivens
the surface.

830

Plaque
Southern Siberia;
6th century B.C. (?)
h: 4.8 cm.; w: 3.2 cm.
Bronze, cast; decorated with a
design of two griffin heads with
scaled necks; a feline mask be-
tween the ears; two cervid heads
below; horizontal loop on the
top reverse.
M.76.97.632

This is a bewildering piece, be-
cause the decoration appears to
parody a type of plaque found in
the sixth century B.C. barrow I at
Tuekta in the central Altai (British
Museum, 1978, no. 79). The ears
on this piece are conceived as a
spiral beginning over the eye and
curling outward, whereas the
feline ears on all other examples
from the Altai display a spiral
which begins over the eye and
curls inward. The piece lacks the
vitality and rhythm one would
expect to find, suggesting that the
maker was producing something
he did not understand. Without
further archaeological evidence,
it is difficult to guarantee its
authenticity.

824

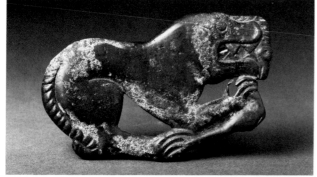

826

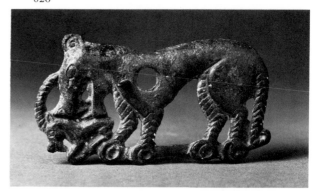

825

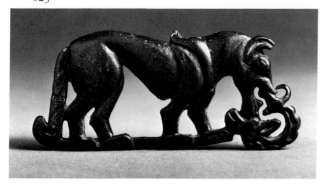

827

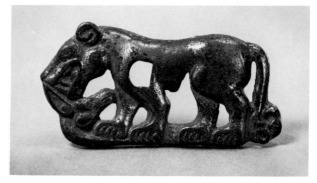

Horse Accoutrements and Belt Plaques

Several belt plaques in the Heeramaneck Collection are very closely related both stylistically and technically to certain gold plaques in the Siberian Treasure of Peter the Great, especially examples with the appearance of a coarse textile on the reverse. These may be dated to the fifth–fourth century B.C. on the basis of comparison to similar compositions on the tattooed man (barrow 2) and the great felt hanging (barrow 5) at Pazyryk. The suggestion that they originated in the Altai region is discredited by the appearance in the zoological repertoire of snakes, which were unknown in the area. Several of the Heeramaneck pieces are similar to examples recently excavated at Aluchaideng and Xigou in western Inner Mongolia.

831

Phalera
Southern Siberia and western Inner Mongolia; 5th–4th century B.C.
5th–4th century B.C.
diam: 3.4 cm.
Silver, cast; decorated with four griffin heads in relief.
M.76.97.649

Similar small gold examples set with polished agates, some bearing a positive textile appearance on the reverse, occur in the Siberian Treasure of Peter the Great in The Hermitage (Griaznov, 1969, pl. 166).

832

Belt Buckle
Southern Siberia and western Inner Mongolia; 4th century B.C.
h: 7.2 cm.; w: 14.5 cm.
Bronze, cast; in the form of a couchant *kulan*, with residual inlay cells marking ears, mane, and hooves.
M.76.97.621

Pub. Bowie, 1966, p. 51, pl. 50.

The marking of the knees with circles is a convention also found on certain pieces from the Altai region (Rudenko, 1970, pl. 139 K). Two identical examples made of silver have the appearance of a coarse fabric on the reverse, as do certain pieces in the Siberian Treasure of Peter the Great (Bunker, 1970, no. 116; and 1978). An identical bronze example in the National Museum of Denmark (0.32.1722), said to have been collected in Baotou, does not have the textile appearance on the reverse. This is support for the theory that this was a briefly employed method for strengthening the wax model in the casting process (mainly when using precious metals), since it allowed for a thin, economically desirable final product (Bunker, 1978, pp. 125–26).

831

832

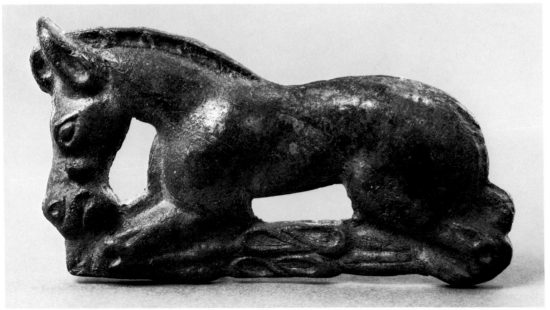

Plaque

Southern Siberia and western Inner Mongolia; 4th–2nd century B.C.
h: 4.8 cm.; w: 6 cm.
Bronze, cast; in the shape of a recumbent horned sheep with head shown frontally.
M.76.97.623

Pub. Bunker, 1970, p. 145, no. 128 and p. 137, pl. 128.

Stylistically, this example is related to the preceding piece by the knee circles and residual inlay cells on the hooves. An identical example was excavated at Huhehaote near Baotou, Inner Mongolia (*WW,* 1957, no. 4, p. 29, fig. 2), and dated 4th–2nd century B.C. (Watson, 1971, pl. 93).

Plaque

Southern Siberia and western Inner Mongolia; 4th–3rd century B.C.
h: 3.7 cm.; w: 7.8 cm.
Gilt bronze, cast; in the form of two boar protomes joined at the midriff; two horizontal attachment loops on the reverse.
M.76.97.586

The shape is similar to a plaque in the Siberian Treasure of Peter the Great with a fabric-like appearance on the reverse which depicts two feline protomes also joined at the midriff (Rudenko, 1962 (1), pl. V.1). The plaque has residual inlay cells like those on the two previously discussed.

Plaque

Southern Siberia and western Inner Mongolia; 5th–3rd century B.C.
h: 3.9 cm.; w: 8.6 cm
Bronze, cast; decorated with a disintegrated design of a crouching feline and two argali sheep whose bodies are slung over their heads; above, a frieze of antelope heads; beneath, another frieze of smaller equine heads; hole and vertical, rounded loop on the reverse for attachment purposes; second loop has been broken off.
M.76.97.563

An earlier, clearer version displays the appearance of a coarse fabric on the reverse (Andersson, *BMFEA* 4, 1932, pl. XXIII: 3; one of a pair), a technical feature found on certain Siberian Treasure of Peter the Great pieces discussed above. A newly published find from Aluchaideng in western Inner Mongolia, dated fifth–third century B.C., yielded several round plaques adorned with argali sheep in the same pose, their bodies slung over their heads (*KG,* 1980, no. 4, p. 335).

833

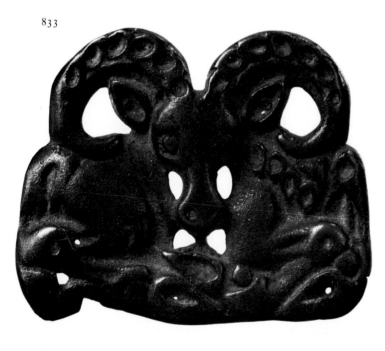

834

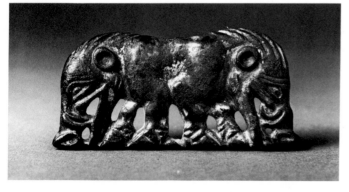

835

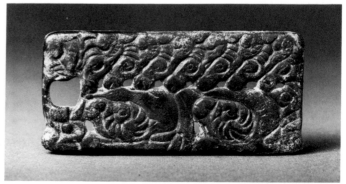

836

Plaque

Southern Siberia and western Inner Mongolia; 5th–3rd century B.C.
h: 10 cm.; w: 6.7 cm.
Bronze, cast; depicting two tigers attacking two confronted, fantastic, hooved creatures whose horns terminate in griffin heads; within a rope-like frame; only the tigers' masks and forepaws are visible; two vertical, rounded loops on the reverse.
M.76.97.579

This is probably the mate to the identical example in the British Museum (Bunker, 1970, p. 143, no. 109 and p. 128, pl. 109). It is stylistically related to the fantastic antlered creature on a plaque from Verkhne-Udinsk near Lake Baikal in Outer Mongolia, which incidentally displays the fabric-like appearance on the reverse (Bunker, 1970, fig. 18), and to two gold plaques excavated at Aluchaideng in western Inner Mongolia, dated fifth–third century B.C. (*La Chine,* 1977, no. 10, p. 33; *KG,* 1980, no. 4, p. 33).

837

Plaque

Western Inner Mongolia; 4th–3rd century B.C.
h: 5.2 cm.; w: 8.8 cm.
Gilt bronze, cast; depicting a Bactrian camel, with a human face peering from between the humps; two vertical, squared attachment loops on the reverse.
M.76.97.616

The striated enclosures on the body derive from a wood carving tradition like that of the Tuva region of southern Siberia (British Museum, 1978, no. 101). A plaque with less stylized enclosures in the Museum of Far Eastern Antiquities in Stockholm has the fabric-like appearance on the reverse discussed previously, thus relating it and this plaque to examples in the Siberian Treasure of Peter the Great displaying the same feature. This would suggest that the Heeramaneck plaque may illustrate an episode in some long lost heroic epic and should be added to the growing body of Anecdotal plaques that appear to date from the fifth–fourth to second century B.C., the later examples being associated with the Xiongnu (Bunker, 1978).

838

Plaque

Western Inner Mongolia and southern Siberia; 4th–3rd century B.C.
h: 4.2 cm.; w: 6 cm.
Gilt bronze, cast; depicting a yak within a herringbone-patterned rectangular frame; two vertical, squared loops on the reverse.
M.76.97.543

The frame and loops on this piece are similar to those on a plaque in the David-Weill Collection which depicts an animal with striated enclosures on its body. It resembles the preceding plaque, which also has squared attachment loops (Hôtel Drouot, 1972, no. 47).

839

Belt Buckle

Western Inner Mongolia and Southern Siberia; 4th–3rd century B.C.
h: 3.7 cm.; w: 6.2 cm.
Bronze, cast; depicting two fighting fantastic creatures within a herringbone-patterned rectangular frame; squared horizontal loop on reverse as on the preceding example; hook on border at proper right.
M.76.97.588

840

Shadow Box

China; modern
h: 18.4 cm.; w: 18.4 cm.
Gilt bronze, cast.
M.76.97.604; ex-Colls. Holmes and Loo

Pub. Rostovtzeff, 1929, pl. XXV: 5; New York, 1940, p. 420 GG; Dittrich, 1963, no. 84.

Depiction of three animals in combat is typical of several plaques in the Siberian Treasure of Peter the Great, some of which display the fabric-like appearance on the reverse. This extraordinary object is a broad, framed shadow box which encloses a misunderstood rendition of three entwined animals whose parts are completely unreadable. It has no precedent in the art of the steppes and would be unthinkable within a Chinese context. Scientific examination shows the patina is embellished by paint.

836

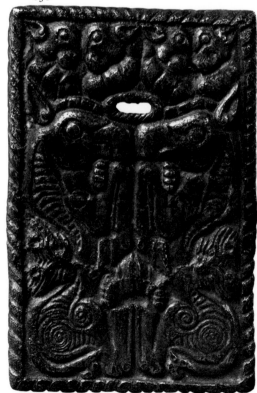

837

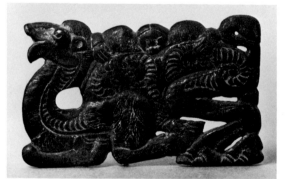

839

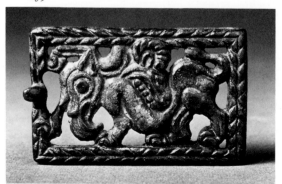

841

Strap Crossing
Western Inner Mongolia;
5th–3rd century B.C.
h: 3.2 cm.; w: 4.5 cm.
Bronze, cast; in the form of a knob adorned with a griffin head; stylized bird's-head flange below.
M.76.97.681

The Heeramaneck example is stylistically related to similar ornaments in wood from Pazyryk in southern Siberia, dated fifth–fourth century B.C. (Rudenko, 1970, pls. 98 and 112). The reverse displays a squared attachment device of a type found in Inner Mongolia and Minusinsk, discussed extensively by Janse (Janse, *BMFEA* 4, 1932, p. 201). A newly excavated tomb at Xigou in western Inner Mongolia yielded several similar strap crossings dated fifth–third century B.C. (*WW*, 1980, no. 7, pp. 2–3).

842

Plaque
Western Inner Mongolia;
5th–3rd century B.C.
h: 4.8 cm.; w: 2.2 cm.
Bronze, cast; in the form of a feline head emerging from two confronted bodies; horizontal attachment bar on the reverse; worn.
M.76.97.710

A strap crossing with similar decoration was found at Xigou in western Inner Mongolia, dated fifth–third century B.C. (*WW*, 1980, no. 7, pp. 2–3).

843

Strap Crossing
Western Inner Mongolia;
5th–3rd century B.C.
h: 3.5 cm.; w: 3 cm.
Bronze, cast; adorned with a griffin head; square attachment device on the reverse for cross-straps.
M.76.97.713

Similar strap crossings occur in the Scythian West from the seventh–sixth century B.C. onward (Artamonov, 1973, p. 14).

844

Plaque
Western Inner Mongolia;
5th–3rd century B.C.
h: 2 cm.; w: 5.2 cm.
Bronze, cast; in the form of an eared bird in flight; neck feathers are indicated by scales; horizontal attachment loop on the reverse.
M.76.97.708

A very similar example was recently excavated at Xigou in western Inner Mongolia (*WW*, 1980, no. 7, p. 5, fig. 7, no. 4).

844

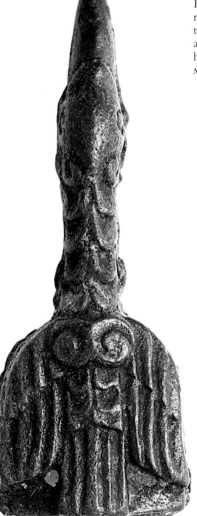

845

Pendant
Western Inner Mongolia;
5th–3rd century B.C.
l: 5.9 cm.
Bronze, cast; in the shape of a caprid head with a horizontal attachment loop on the reverse below the ears; the egg-shaped eyes are very sensitively conceived; part of a belt or bridle.
M.76.174.79

In form, this piece may be compared with an ornament exhibiting the same long, thin projection beneath, recently discovered at Aluchaideng in western Inner Mongolia, dated fifth–third century B.C. (*KG*, 1980, no. 4, p. 335, fig. 3, no. 4).

846

Pendant
Western Inner Mongolia;
5th–3rd century B.C.
l: 4.8 cm.
Bronze, cast; in the form of a ram's head with a horizontal attachment loop on the reverse and a long projection beneath the head, as on the previous example.
M.76.97.715

841

Ornamental Plaques

This group of ornamental plaques is stylistically related to examples found together with an antenna dagger of fifth–fourth century B.C. type at Helingeer xian in western Inner Mongolia, and at Xigou. Their main artistic feature is the surface patterning typically seen on tigers, ibex heads, and bird heads. All display the same type of low attachment loop on the reverse (WW, 1959, p. 79). The animal motifs and surface decoration all derive from wood carving traditions found at Bash-Adar in the central Altai region (Rawson, 1978) and at Sagla-Bazha II in the western Tuva region.

847

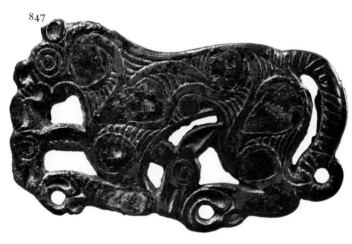

850

847

Plaque
Western Inner Mongolia;
5th–4th century B.C.
h: 4.4 cm.; w: 8.2 cm.
Bronze, cast; depicting a tiger devouring a deer head with a second deer head beneath; surface decoration of c-shaped spiral and striated enclosures; two vertical attachment loops on the reverse.
M.76.97.587

A similar example was excavated at Helingeer xian in western Inner Mongolia (WW, 1959, no. 6, p. 79).

848

Plaque
Western Inner Mongolia;
5th–4th century B.C.
h: 4.7 cm.; w: 7.5 cm.
Bronze, cast; depicting a feline standing on a gazelle head with a doe head under his back paw; c-shaped surface decoration; two vertical attachment loops on the reverse.
M.76.97.537

A similar example was excavated at Helingeer xian in western Inner Mongolia (WW, 1959, no. 6, p. 79).

849

Plaque
Western Inner Mongolia; modern
h: 5.7 cm.; w: 8.2 cm.
Bronze, cast; in the form of a crudely rendered tiger with three antelope heads; two vertical attachment loops on the reverse.
M.76.97.639

850

Horse Accoutrement
Western Inner Mongolia;
5th–4th century B.C.
h: 2.5 cm.; w: 3.7 cm.
Bronze, cast; in the form of a stylized griffin head or eared bird-of-prey head; horizontal attachment loop on the reverse.
M.76.97.646

851

Horse Accoutrement
Western Inner Mongolia;
5th–4th century B.C.
h: 2.1 cm.; w: 3.1 cm.
Bronze, cast; in the form of a stylized bird; vertical loop on the reverse.
M.76.97.701

A very similar example was recently found at Xigou in western Inner Mongolia among finds of an unrelated style, suggesting that it may have belonged to a tribe other than that represented by the burials there (WW, 1980, no. 7, p. 9).

852

Bridle Fitting
Western Inner Mongolia;
5th–4th century B.C.
h: 2.8 cm.; w: 3 cm.
Bronze, cast; depicting two bird-of-prey heads; vertical loop on the reverse.
M.76.97.546

853

Bridle Fitting
Western Inner Mongolia;
5th–4th century B.C.
h: 2 cm.; w: 3.1 cm.
Bronze, cast; depicting an ibex head; vertical loop on the reverse; traces of a reddish substance in the design channels.
M.76.97.544a

854

Bridle Fitting
Western Inner Mongolia;
5th–4th century B.C.
h: 2.2 cm.; w: 3.1 cm.
Bronze, cast; depicting an ibex head as in the previous example; vertical attachment loop on the reverse; worn.
M.76.97.544b

These bronzes relate stylistically to pieces said to come from western Inner Mongolia. A recently excavated example dated to the fourth–second century B.C. was discovered at Huhehaote. The chief animal motifs are predatory beasts and their herbivore victims (often represented by their heads only), and boars, all themes found earlier on the coffin lid from Bash-Adar in the central Altai region.

855

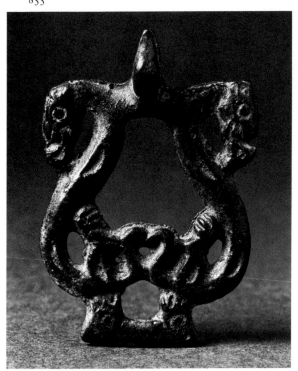

856

855

Plaque
Western Inner Mongolia;
4th–3rd century B.C.
h: 5.8 cm.; w: 4.2 cm.
Bronze, cast; in the form of two felines with returned heads, round eyes, and three-clawed paws, nibbling on fawn heads; two animal heads form the loop; bird's head forms the prong.
M.76.97.570

An object depicting the same type of three-clawed feline was discovered at Huhehaote in western Inner Mongolia (*WWCKZL*, 1957, no. 4, p. 30).

856

Plaque
Western Inner Mongolia;
4th–3rd century B.C.
h: 1.8 cm.; w: 4.9 cm.
Bronze, cast; decorated with two sinewy felines with returned heads, round eyes, and three-clawed paws, each devouring a fawn head; within a rectangular frame; mold seam along the edge.
M.76.97.716

An identical piece was acquired in the Ordos region (Egami and Mizuno, 1935, fig. 73).

857

Plaque
Western Inner Mongolia;
4th–3rd century B.C.
h: 5 cm.; w: 3.2 cm.
Bronze, cast; openwork design depicting four felines, each eating a fawn head, alternately placed within a simple frame.
M.76.97.714

858

Pendant
Western Inner Mongolia;
4th–3rd century B.C.
h: 3.7 cm.; w: 3.3 cm.
Bronze, cast; in the form of a feline with three-clawed paws and round eyes, eating a fawn head; rope-like loop surmounted by a vertical bird head.
M.76.97.690

859

Pendant
Western Inner Mongolia;
4th–3rd century B.C.
h: 2.5 cm.; w: 3.2 cm.
Bronze, cast; mirror image of the preceding example, with the exception of the bird head, which has been broken off.
M.76.97.702

860

Pendant
Western Inner Mongolia;
4th–3rd century B.C.
h: 3.4 cm.; w: 3 cm.
Bronze, cast; in the form of a
feline with prominent jaws, trian-
gular ear, and round eye; rope-like
loop above.
M.76.97.648a

861

Fitting
Western Inner Mongolia;
4th–3rd century B.C.
l: 4.6 cm.
Bronze, cast; in the shape of a
feline protome seen from above,
joined to a feline protome in pro-
file with a fawn head in its mouth;
vestiges of two loops on the
reverse; the first feline has a three-
clawed paw and a round eye.
M.76.97.717

862

Buckle
Western Inner Mongolia;
4th–3rd century B.C.
h: 6 cm.; w: 3.3 cm.
Bronze, cast; in the form of two
felines with three-clawed paws
attacking two horned cervids with
returned heads; bird's-head prong.
M.76.97.739a

863

Harness Accoutrement
Western Inner Mongolia;
4th–3rd century B.C.
h: 3.5 cm.; w: 4.2 cm.
Bronze, cast; decorated with a
feline with three-clawed paws eat-
ing a fawn's head; two small feline
masks above; three loops below.
M.76.97.548

864

Plaque
Western Inner Mongolia;
4th–3rd century B.C.
h: 5 cm.; w: 3.3 cm.
Bronze, cast; openwork design
depicting felines, feline masks, and
fawn heads; felines have three-
clawed paws and round eyes.
M.76.174.92; ex-Loo Collection

Pub. Salmony, 1933, pl. XVI: 13.

865

Pendant
Western Inner Mongolia;
4th–3rd century B.C.
h: 3.3 cm.; w: 1.8 cm.
Bronze, cast; in the form of three
stacked animals; very worn.
M.76.97.557b

866

Buckle
Western Inner Mongolia;
4th–3rd century B.C.
h: 5.6 cm.; w: 3.8 cm.
Bronze, cast; in the form of two
confronted felines with round eyes
and three-clawed paws, topped
by a boar; bird's-head prong.
M.76.97.571

867

Buckle
Western Inner Mongolia;
4th–3rd century B.C.
h: 4.5 cm.; w: 3.5 cm.
Bronze, cast; in the form of a
coiled feline with three-clawed
paws and round eyes; bird's-head
prong.
M.76.97.712

A similar example was acquired in
the Ordos region (Andersson,
BMFEA 4, 1932, pl. XII: 10).

868

Pendant
Western Inner Mongolia;
4th–3rd century B.C.
h: 2.4 cm.; w: 2.2 cm.
Bronze, cast; in the form of a wild
boar with strongly delineated
tusks and crest; hollow cast in the
round with a noticeable seam
down the forehead; attachment
loop is ribbed to simulate rope.
M.76.97.613

A very similar boar is combined
with felines devouring fawns'
heads on a plaque in the Museum
of Far Eastern Antiquities, Stock-
holm (Andersson, *BMFEA* 4, 1932,
pl. XXV: 8).

869

Plaque
Western Inner Mongolia;
4th–3rd century B.C.
h: 1.6 cm.; w: 2.9 cm.
Bronze, cast; in the form of a
stylized animal; curly tail and
tusks suggest a boar.
M.76.97.689

864

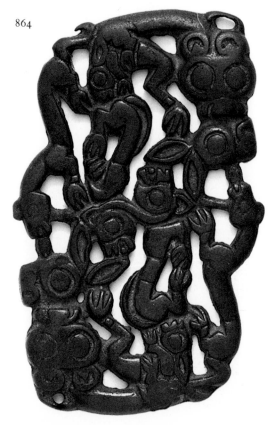

869

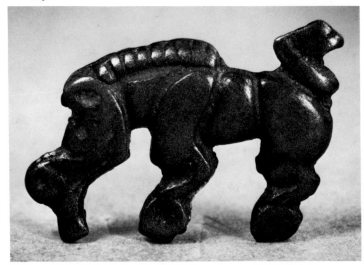

Tagar Culture Bronzes

The Tagar culture developed among a European group of tribes in the Minusinsk region of southern Siberia. Their chief occupations were herding, hunting, and some irrigation-aided agriculture. Transhumance was unnecessary due to favorable geographic conditions; horses were not included among their grave goods. Their culture, named after excavations by Lake Tagar, lasted from the seventh century B.C. until the Xiongnu expansion into the area in the second century B.C. Their major artistic output consisted of weapons, finials, mirrors, ornaments, and horse paraphernalia, all embellished with an animal decoration of a predominantly Scythian type. On the basis of the stylistic affinities, the following pieces have been tentatively associated with the Tagar, or with the Tashtyk culture which succeeded it.

871

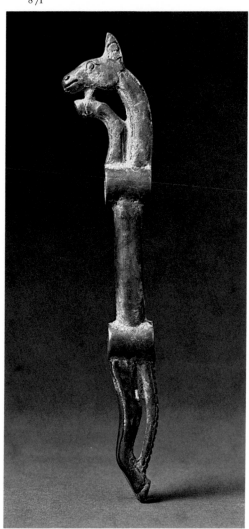

870

Knife
Southern Siberia;
6th–5th century B.C.
l: 23.5 cm.
Bronze, cast; in a two-part mold, with a coiled feline on the end of the hilt and a feline head at the haft; manner in which feline's tail connects with shaft and method of marking haft are typical Tagar features (Martin, 1893, p. 16; Merhart, 1926, pl. XIII; Artamonov, 1974, pl. 66).
M.76.97.733

Illustrated on page 148.

871

Horse Accoutrement
Southern Siberia;
6th–5th century B.C.
l: 15.2 cm.
Bronze, cast; cheekpiece from a bridle bit in the form of a Przywalski horse in "flying gallop" pose; incised eyes, mouth, and nostrils; two vertical attachment holes occur at shoulder and haunch areas, a feature typical of Tagar culture examples from the Minusinsk region (Merhart, 1926, pl. XII).
M.76.97.558a

872

Fitting
Southern Siberia; 1st century B.C.
h: 3.5 cm.; w: 4.4 cm.
Bronze, cast; in the form of a young doe; cast in the round.
M.76.97.555

The fore- and hind legs are folded under to form a horizontal line, a feature frequently found in the art of the Tashtyk culture of the Minusinsk region (Kyzlasov, 1960, p. 92; and Martynov, 1979). Two identical but unidentified examples exist in the Sackler Collection at The Metropolitan Museum of Art.

873

Horse Accoutrement
Southern Siberia; 1st century B.C.
h: 1.5 cm.; w: 2.3 cm.
Bronze, cast; in the form of a crudely cast, highly stylized stag with flowing antlers; legs folded under to form a horizontal line.
M.76.97.566

The shoulders and haunches are marked by concentric circles, a feature found in Central Asian Saka art (Belenitsky, 1968, pl. 22). The circular marks and round openings in the antlers are also typical of material from the southern Siberian forest-steppe (Martynov, 1979).

874

Horse Accoutrement
Southern Siberia; 1st century B.C.
h: 1.5 cm.; w: 2.4 cm.
Bronze, cast; horse, constructed as previous piece.
M.76.97.687

Art Associated with the Xiongnu during the Western Han Period

The most prominent warrior-herdsmen of the Far Eastern steppes were the Xiongnu, who by the second century B.C. had conquered all the equestrian tribes of northeastern Asia to create a vast steppe empire that lasted almost two centuries. According to Sima Qian, they were primarily herdsmen of horses, cattle, and sheep but also raised such rare beasts as camels, asses, and mules. "They moved about in search of water and pasture," he observed, "and had no walled cities or fixed dwellings, nor did they engage in any kind of agriculture.... For long-range weapons they use bows and arrows, and swords and spears at close range, (and eat)...the meat of domestic animals, and wear clothes of hide or wraps made of felt or fur." The Xiongnu, apparently, were already present along the northern frontiers of China by the end of the fourth century B.C.

According to Sima Qian, they occupied the great northern loop of the Yellow River during the third century until they were driven north by Qin Shihuangdi in 214 B.C. Shortly thereafter, the Shanyu, ruler of the Xiongnu, wishing to rid himself of his son Modun as heir in favor of a younger son, sent him as a hostage to the Yuezhi, the tribal group apparently in control of the area at the time. The Shanyu then attacked the Yuezhi, intending that Modun be killed. But the son stole a fast horse and made his way home. The father, struck by his offspring's bravery, gave him a large cavalry command; Modun was not appeased. Having cultivated the blind loyalty of his followers, he murdered his father during a hunt with a whistling arrow (several examples of which were found at Xichagou). Soon afterward he assumed his father's title, and a war of tribal supremacy followed. By 176 B.C., the new Shanyu was able to report to Emperor Gao Zu that he had defeated and united all the northern barbarians, effectively controlling the Ordos region north of present-day Shaanxi and south of the great northern bend of the Yellow River. Xiongnu dominion over this area lasted from 177 until 127 B.C., when the Chinese again pushed them back north.

The Xiongnu Shanyu wrote the Han court that he had wiped out the Yuezhi, "slaughtering or forcing to submission every member of the tribe," so that they "have become a part of the Xiongnu nation." Later, Emperor Wu learned that "the Xiongnu had defeated the Yuezhi chieftain and had made his skull into a drinking vessel." The Yuezhi then split into two factions and fled. The lesser Yuezhi settled among the proto-Tibetan Qiang tribes in the Nanshan Mountains, where their presence was still noted in the third century A.D. The greater Yuezhi fled first to Dzungaria, driving out the Sai in 163 B.C., and then in 160 B.C. were themselves driven out by the Wusun, another Tocharian-speaking European group. Around 130 B.C. they reached Daxia (Bactria), part of present-day Afghanistan. Of the Sai tribes, some fled west to Sogdiana, while others migrated to northwestern India where they founded the kingdom of Jibin. According to the later Han historian Ban Gu, the coins of this kingdom were adorned with the figures of mounted warriors. These Sai tribes spoke Iranian, another Indo-European dialect, and may have been an eastern branch of the Central Asiatic Saka, just as the Scythians have always been considered a western branch. Later, around 35 B.C., the Yuezhi confederacy became united under one of its five tribes, the Guishuang (Kushan), and ultimately went on to found the great Kushan Empire of northern India.

The relationship between the Western Han and the Xiongnu was characterized by war and intermittent attempts at peacemaking. Peace offerings frequently came from the Han to the Shanyu in the form of costly gifts. In 192 B.C., for example, Modun received a gold-ornamented leather belt, silk, brocade, and an imperial princess. In 162 B.C. the Emperor Wen sent the Shanyu gifts of grain, silk thread, and other luxuries. Chinese gifts in 51 B.C. included a belt, clothing, a sword with a jade guard, gold, and bolts of fabric. The Chinese intention was to bribe the Xiongnu with Han riches and to make it conceivable that a future Shanyu would be half-Chinese. By 152 B.C. the Chinese had established markets on the northern frontier. Certain goods such as weapons, iron, agricultural tools, and breeding animals were prohibited from crossing the border. The existence of a flourishing contraband trade, however, is attested by the presence of iron swords found in Xiongnu context that appear to be of Chinese manufacture.

During the first part of the Western Han dynasty, the Xiongnu were a constant irritant to the Chinese, raiding and plundering their countryside and even coming within striking distance of Changan in 166 B.C. By the first century B.C. the Xiongnu were no longer entirely nomadic; they had some permanent settlements and evidently engaged in a limited amount of agriculture. Millet seeds were found at the great Xiongnu site of Noinula, along with Chinese clothes and chopsticks. The collapse of the Xiongnu empire appears to have coincided with the decline of the Western Han dynasty (c. first century B.C.). During the first half of the first century A.D. they managed to regain some independence but were soon superseded by the Wuhuan and Xianbei. They were never to restore their original empire.

Predominantly Mongoloid with some admixture of European physical stock, the Xiongnu spoke a palaeo-Siberian language. Nevertheless, they shared many cultural traits with their Indo-European neighbors, such as horse racing, sword worship, and the swearing of oaths by drinking wine mixed with blood. Consistent with earlier burial practices among the steppe tribes, the chieftain's wife was represented in the grave by her pigtails alone; similarly, the horse's head, rather than its entire body, was interred.

Xiongnu art is best manifested by finds from Ivolga, Xichagou, Minusinsk, and Noinula. Most important are the innumerable belt plaques and the Noinula carpet, adorned with marvelous representations of animal combat, confronted and addorsed animals, both real and imaginary, and anecdotal narrative scenes. The animal combat and Anecdotal plaques are stylistic continuations of the motifs and compositions found on the plaques with fabric-like appearance on the reverse in the Siberian Treasure of Peter the Great and on the

tattooed Mongoloid man from kurgan 2 at Pazyryk. Frequently these plaques reveal a highly sophisticated pictorial tradition, illustrating episodes from oral epics sung by Xiongnu bards. All these motifs and compositions derive ultimately from the art of the ancient Near East, having filtered through Central Asia, where they were transformed by Hellenistic influence and local taste. Like the great felt hanging from Pazyryk, these plaques were merely reflections of some long lost painting tradition translated into brilliantly colored textiles which served as murals for a nomadic society. The role played by the textile trade in antiquity has been greatly underestimated; it may well have supplied the missing stylistic links between many cultures that existed far apart in time and space. In this regard, it is worth mentioning that scraps of pre-Pazyryk period Iranian textiles (as yet unpublished) have been found at Arzhan.

Among those pieces of known provenance that are stylistically or technically related to the Peter the Great plaques, the findspots, interestingly enough, can be associated with the Xiongnu. Verkhne-Udinsk, where one plaque with the fabric-like appearance on the reverse was found, is close to Lake Baikal, where, according to Sima Qian, the northern campsite of the Xiongnu was located. The majority of the Siberian Treasure of Peter the Great was presented to the Russian court by Gagarin and Demidov, two governors of Siberia who acquired the pieces from free-lance grave robbers and then shipped them from Tobolsk, the capital of Siberia, situated to the west of Lake Baikal. Recently, several tombs excavated at Aluchaideng and Xigou in western Inner Mongolia have yielded gold and bronze buckles that are similar in shape and style to a gold buckle with fabric-like appearance on the reverse in the Metropolitan Museum (cf. *KG,* 1980, no. 4, p. 335, no. 10; *WW,* 1980, no. 7, p. 5; fig. 7, no. 5; and Bunker, 1970, no. 118). These tombs have been tentatively associated with the Xiongnu by Chinese archaeologists.

Belt Ornaments

These belt plaques and buckles are all versions of or stylistically related to objects recently discovered in Inner and Outer Mongolia and associated by their excavators with the Xiongnu. Several examples were found at the waists of both male and female skeletons, suggesting that they may have been insignia denoting clan or rank (SA, 1971, no. 1, pp. 93–105). That these plaques were items that may have been cherished for some length of time is affirmed by the discovery of a repaired example like catalog number 882 found at Urbiun in the Tuva of southern Siberia (SA, 1979, no. 1, pp. 254–56), and by a fragment of a second century B.C. type which turned up in a Northern Wei brick tomb near Huhehaote. The occurrence of belt ornaments in Xiongnu style in Liaoning province, Minusinsk, and Krasnoyarsk attests to the far-reaching influence of the Xiongnu in their heyday.

By the first century B.C., the Wuhuan, a southern branch of the proto-Mongol-speaking Dong Hu, were an important sub-tribe of the Xiongnu; they may have been responsible for some of the plaques in foreign styles found at Xichagou, well inside Wuhuan territory. The same admixture of styles occurs among Xiongnu period material from Minusinsk. Nevertheless, the Xiongnu must have controlled a vast confederacy of ethnically mixed peoples, a fact which makes specific attribution of any work of art to a particular sub-tribe too risky without further evidence.

875

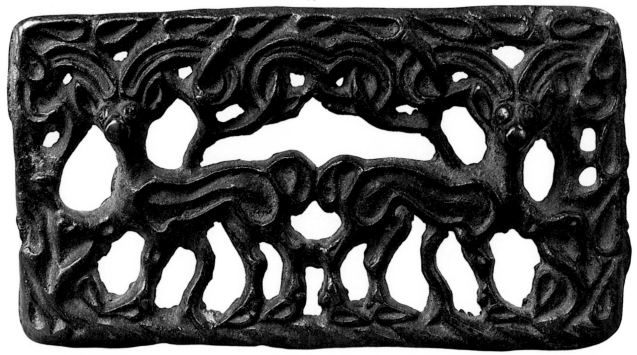

875

Plaque
Inner Mongolia, Outer Mongolia, and southern Siberia;
3rd–2nd century B.C.
h: 6.3 cm.; w: 11.8 cm.
Bronze, cast; openwork design of two addorsed horned sheep, with heads shown frontally; in a wooded setting within a frame of tear-shaped cells.
M.76.97.620; ex-Holmes Collection

Pub. New York, 1940, p. 421 D.

The design of this piece is like that found on a pair of plaques excavated at Ivolga in northern Mongolia (*SA*, 1971, no. 1, p. 96). The design is derived from a convention found earlier on a plaque with the fabric-like appearance on the reverse from the Siberian Treasure of Peter the Great (Jettmar, 1967, p. 193). The residual inlay cells in the hooves, mentioned earlier in connection with catalog numbers 832 and 833, are also a Peter the Great treasure convention.

876

Plaque
Inner Mongolia, Outer Mongolia, and southern Siberia;
3rd–2nd century B.C.
h: 6.7 cm.; w: 12.3 cm.
Bronze, cast; same as preceding example.
M.76.97.615

877

Plaque
Inner Mongolia, Outer Mongolia, and southern Siberia;
3rd–2nd century B.C.
h: 5 cm.; w: 11.5 cm.
Bronze, cast; depicting two stallions fighting amid highly stylized foliage; within a rectangular frame.
M.76.97.556

The tear-shaped cells relate it stylistically to the two previous examples and ultimately to the Peter the Great plaques with fabric-like appearance on the reverse. Identical types were also found in Minusinsk, thus reflecting Xiongnu expansion into that region (Kiselev, 1951, pl. XXI).

878

Belt Buckle
Inner Mongolia, Outer Mongolia, and southern Siberia;
2nd century B.C.
h: 5 cm.; w: 9.1 cm.
Bronze, cast; in the shape of a tiger carrying off an herbivore whose body is slung over his shoulders as in cat. no. 835.
M.76.97.575

A few tear-shaped cells under the tiger's belly, perhaps meant to represent stylized vegetal forms, relate this piece stylistically to the three preceding examples. An earlier version of this composition is a horizontal B-shaped plaque excavated near the remains of the Qin dynasty Great Wall (*WW*, 1978, no. 12, p. 87, no. 1), strongly reminiscent of similar plaques with the fabric-like appearance in the Siberian Treasure of Peter the Great (Jettmar, 1967, p. 184).

879

Plaque
Inner Mongolia, Outer Mongolia, and southern Siberia;
2nd–1st century B.C.
h: 11.5 cm.; w: 5.3 cm.
Bronze, cast; openwork geometric design punctuated with six stylized griffin heads with ears and beaks.
M.76.97.666; ex-Holmes Collection

An identical example was found with other Xiongnu material at Xichagou in Liaoning province in eastern Inner Mongolia, where the Xiongnu conquered the Dong Hu during their war of tribal supremacy (*WW*, 1960, nos. 8–9, p. 33).

879

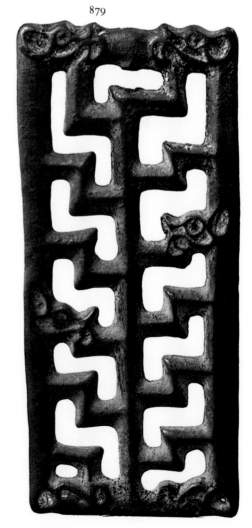

877

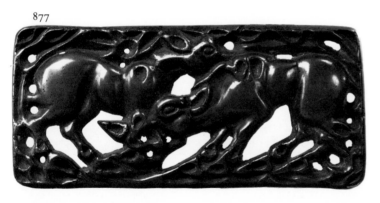

878

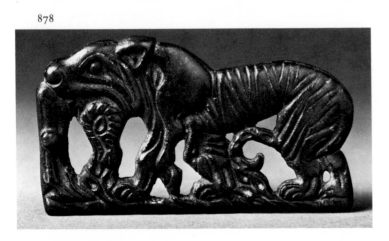

880

Plaque

Inner Mongolia, Outer Mongolia, and southern Siberia;

2nd–1st century B.C.

h: 7 cm.; w: 11.7 cm.

Bronze, cast; openwork design depicting a wolf attacking a fantastic beaked animal with hooves whose antlers and mane terminate in griffins' heads; antlers have been broken off.

M.76.97.581

An unbroken example was found at Xichagou in Liaoning province in eastern Inner Mongolia (*WW*, 1960, nos. 8–9, p. 33). The composition is certainly a later example of the gold plaque with the fabric-like appearance on the reverse found at Verkhne-Udinsk near Lake Baikal.

881

Plaque

Inner Mongolia, Outer Mongolia, and southern Siberia;

2nd–1st century B.C.

h: 7.3 cm.; w: 11.5 cm.

Bronze, cast; openwork design depicting an ibex being attacked by a fantastic feline, which is in turn attacked by an eagle.

M.76.97.622

Pub. Bowie, 1966, p. 62, pl. 78; cf. Bunker, 1970, no. 125.

Similar animal combat plaques have been found at Xichagou (*WW*, 1960, nos. 8–9, p. 33), and at Troickosavsk near Lake Baikal (Werner, *ESA* IX, 1934, p. 260). An identical example was found at Derestuy on the Dzhida River (Minns, *PBA* 28, 1942, pl. XVIII). The composition certainly derives from the horizontal-type plaques without the fabric-like appearance on the reverse in the Siberian Treasure of Peter the Great; these postdate the examples *with* the fabric-like appearance (cf. Bunker, 1970, figs. 21 and 20, respectively).

882

Plaque

Inner Mongolia, Outer Mongolia, and southern Siberia;

2nd–1st century B.C.

h: 5.6 cm.; w: 10.8 cm.

Bronze, cast; openwork design of two confronted yaks within a frame decorated with sunken rectangles.

M.76.97.541

Pub. Bunker, 1970, no. 127.

The sunken rectangle as border motif replaces the earlier tear-shaped and rope-like borders.

Identical examples were found both in Minusinsk (Kiselev, 1951, pl. XXII) and Xichagou (*WWCKZL*, 1957, no. 1, pp. 53–66). A small buckle from Hattin-sum in Inner Mongolia displays an identical treatment of the head (Werner, *ESA* IX, 1934, pp. 260–64). The residual inlay cells on the hooves are the same as on the other Xiongnu pieces discussed.

883

Plaque

Inner Mongolia, Outer Mongolia, and southern Siberia;

2nd–1st century B.C.

h: 5.3 cm.; w: 10.7 cm.

Bronze, cast; openwork design of two swans with entwined necks within a border decorated with sunken rectangles as in the preceding plaque.

M.76.97.606

880

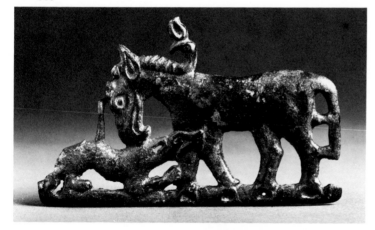

882

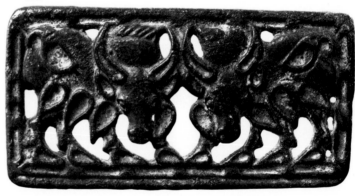

881

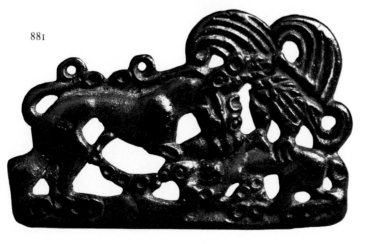

883

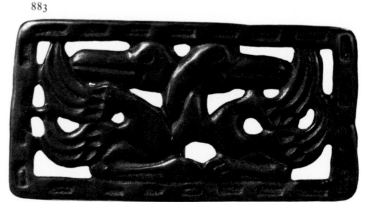

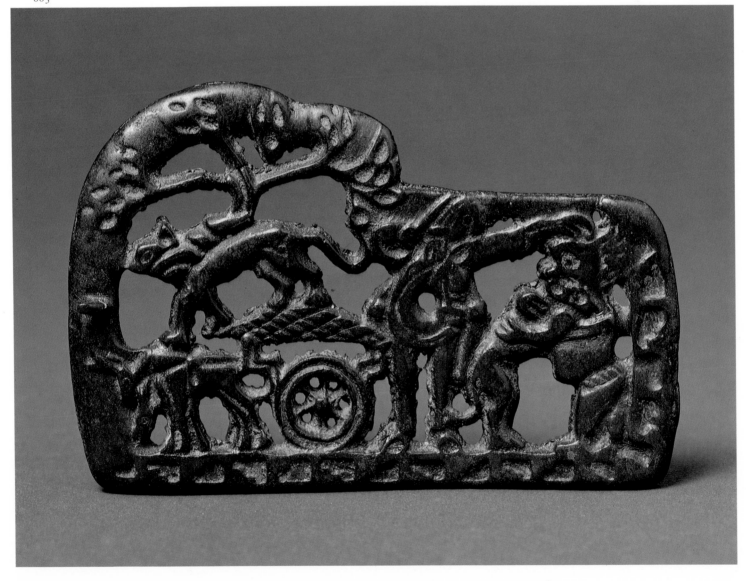

884

Belt Buckle
Inner Mongolia, Outer Mongolia, and southern Siberia;
2nd–1st century B.C.
h: 5.5 cm.; w: 11.4 cm.
Bronze, cast; openwork design of two grazing horses within a rectangular frame as in the two preceding plaques.
M.76.97.562

cf. Bunker, 1970, no. 126.

Similar plaques are said to have come from Minusinsk (Jettmar, 1967, pl. 13).

885

Belt Buckle
Inner Mongolia, Outer Mongolia, and southern Siberia;
2nd–1st century B.C.
h: 6.8 cm.; w: 10.4 cm.
Bronze, cast; openwork, horizontal, B-shaped Anecdotal plaque illustrating an episode from some heroic epic in which a mounted warrior with drawn sword reaches out to a dog struggling with a pot-bellied demon; the scene is further embellished by a feline on a covered cart pulled by two reindeer, a beast of burden used in the Lake Baikal regions, where the Xiongnu had their northern campsites; hook on proper right front.
M.76.97.583

Pub. Bunker, 1978, pl. 3a.

This is probably a translation into metal of a pictorial textile. The costume and hairstyle continue the fashions worn by figures on the famous gold hunting plaques (with the fabric-like appearance on the reverse) and on the third century B.C. wrestling plaques found at Keshengzhuang, a barbarian grave near the ancient Han capital of Changan. Its occupant may have been part of the Xiongnu raiding party of 166 B.C. recorded by Sima Qian, "when the Xiongnu came in sight of the capital." Like the repaired example from Urbiun in the Tuva region of southern Siberia (*SA,* 1979, no. 1, p. 255), these plaques had been in use for a long time before burial. The foreshortened view of horse and rider suggests knowledge of a highly developed pictorial tradition which achieves this kind of three dimensionality, a Greek painting convention well known in the Bactrian oasis settlements of Central Asia by the end of the fourth century B.C. An identical example, one of a mirror-image pair, has been excavated at Xichagou in Liaoning province (*WW,* 1960, nos. 8–9, p. 30).

Illustrated on preceding page.

886

Plaque
Inner Mongolia, Outer Mongolia, and southern Siberia;
2nd–1st century B.C.
h: 6.2 cm.; w: 11.1 cm.
Bronze, cast; openwork design depicting two standing warriors holding swords.
M.76.97.585

Pub. Bunker, 1978, pl. 4a, and p. 124.

This is perhaps an allusion to the Xiongnu custom of worshiping a god of war in the form of a sword. The warriors' trousers and belted jackets, like those on the plaques discussed in the preceding entry, are typical of nomad attire. The four geese suggest a remote influence from Pazyryk, where geese were favorite subjects (Griaznov, 1958, pl. 6). The blank space in the center is presently inexplicable.

887

Belt Buckle
Inner Mongolia, Outer Mongolia, and southern Siberia;
2nd–1st century B.C.
h: 5.8 cm.; w: 11 cm.
Bronze, cast; openwork design depicting a nomad family on trek; a walking man in belted jacket and trousers precedes a horse-drawn covered cart through a wooded area, whose tree forms are stylistically related to those on cat. no. 885; a seated man drives the cart; remains of a hook on front proper right.
M.76.97.582

Pub. Bunker, 1978, pl. 5b and p. 125; Boyles, *Oriental Art* XXV, 1, 1979, fig. 4.

The covered cart may actually be intended to represent a tent mounted on a cart, a well-known nomadic practice (Maenchen-Helfen, 1973, pp. 217–18).

888

Belt Buckle
Inner Mongolia, Outer Mongolia, and southern Siberia;
2nd–1st century B.C.
h: 7 cm.; w: 11.2 cm.
Bronze, cast; horizontal B-shaped belt plaque depicting a two-humped camel with folded legs and tree forms similar to those on plaques already discussed, as are the residual inlay cells on the hooves and tree leaves; small prong at proper right on the border.
M.76.174.86

Illustrated on page 170.

889

Belt Buckle
Inner Mongolia, Outer Mongolia, and southern Siberia;
2nd–1st century B.C.
h: 6.9 cm.; w: 10.6 cm.
Bronze, cast; very worn version of the preceding plaque.
M.76.174.85; ex-Colls. Holmes and Loo

Pub. Rostovtzeff, 1929, pl. XXVI: 5; New York, 1940, p. 423 L.

884

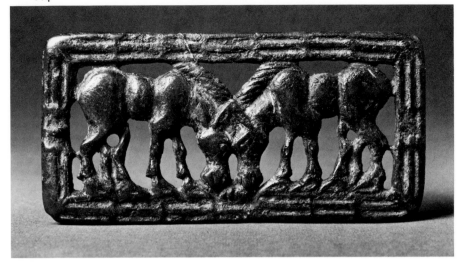

886

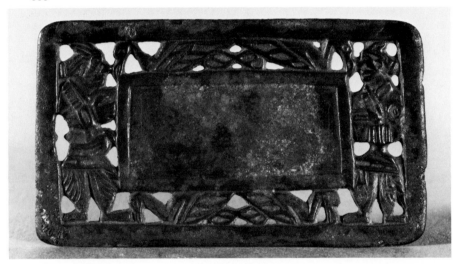

887

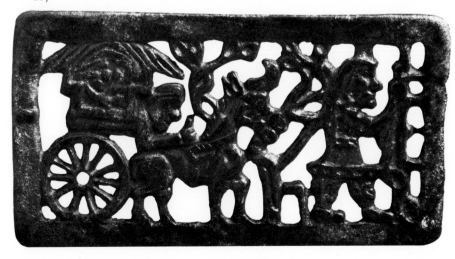

169

890

Plaque
Inner Mongolia, Outer Mongolia, and southern Siberia;
2nd–1st century B.C.
h: 5 cm.; w: 10.1 cm.
Bronze, cast; openwork design depicting two confronted two-humped beasts munching on foliage within a double-banded frame.
M.76.97.614a

The stylization of the leaves suggests a relationship with similar examples already discussed and with the camel plaques from Xichagou (*WW*, 1960, nos. 8–9, p. 33).

891

Plaque
Inner Mongolia, Outer Mongolia, and southern Siberia;
2nd–1st century B.C.
h: 4.9 cm.; w: 10.8 cm.
Bronze, cast; same as the preceding example.
M.76.97.614b

892

Buckle
Inner Mongolia, Outer Mongolia, and southern Siberia;
2nd–1st century B.C.
h: 3.4 cm.; w: 2.7 cm.
Bronze, cast; openwork design of two confronted feline masks and a bird's-head prong.
M.76.97.691

Stylistically, this piece is related to larger buckles with more recognizable Xiongnu motifs (Salmony, 1933, pl. XXV; *SA*, 1979, no. 2, p. 196).

893

Plaque
Inner Mongolia, Outer Mongolia, and southern Siberia;
2nd–1st century B.C.
h: 4 cm.; w: 7.7 cm.
Bronze, cast; openwork design depicting two fantastic creatures with gazelle heads, feline bodies, clawed paws, and entwined tails which terminate in griffin heads; within a simulated rope border.
M.76.97.990

The two creatures seem to be descendants of the beasts on one of the Peter the Great plaques with the fabric-like appearance on the reverse (Jettmar, 1967, p. 193). There are no attachment loops on the reverse, but several have been punched into the corners and border.

888

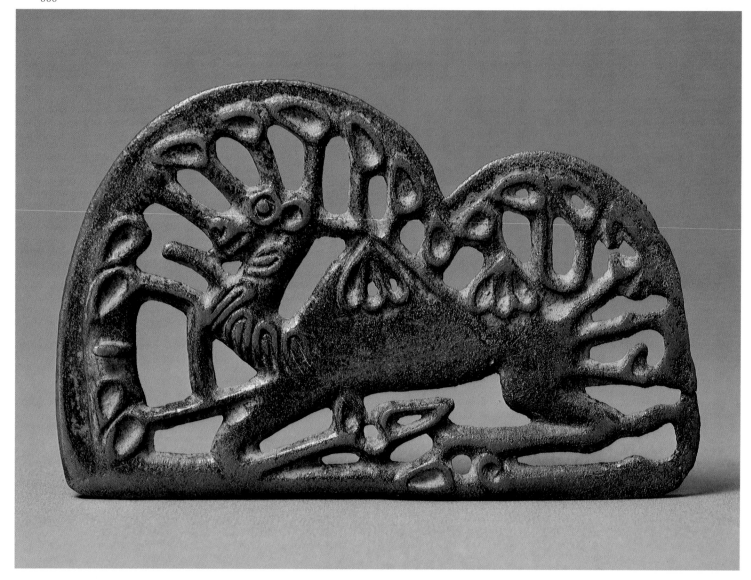

890

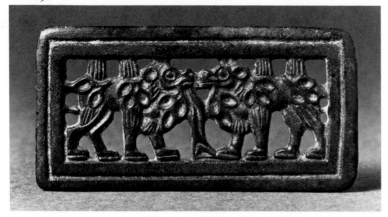

893

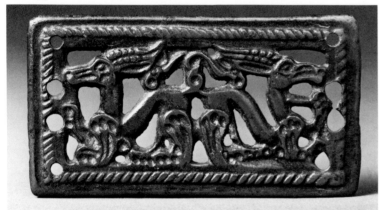

894

Plaque
Inner Mongolia and Outer
Mongolia; 2nd–1st century B.C.
h: 5 cm.; w: 6.5 cm.
Gilt bronze, cast; in the form of
two stylized horses, one atop the
other, each with a fan-shaped
forelock; two vertical loops on the
reverse.
M.76.97.545

Another version of this plaque
was discovered at Xichagou, again
perhaps the style of a sub-tribe
or enemy (*WW*, 1960, nos. 8–9,
p. 33).

895

Plaque
Inner Mongolia and Outer
Mongolia; 1st century B.C.
h: 3.1 cm.; w: 5 cm.
Gilt bronze, cast; in the form of a
stylized walking horse; no details
or attachment loops.
M.76.97.1003

A much less stylized version oc-
curs in the David-Weill Collection
(Hôtel Drouot, 1972, no. 2). A
plaque in the form of a similar
walking horse occurs in the
Xiongnu finds from Il 'movaya
Pad' in Outer Mongolia (Ruden-
ko, 1962, (I), pl. XXXII: I).

894

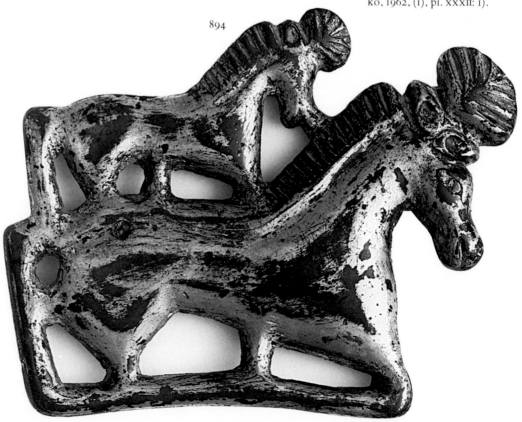

896

Belt Buckle
Inner Mongolia or southern
Siberia; modern
h: 7.5 cm.; w: 11.1 cm.
Gilt bronze or copper, cast; in the
form of a fantastic wolf-like beast
whose tail and mane terminate in
griffin heads.
M.76.97.617; ex-Holmes Collection

Pub. New York, 1940, p. 418 U;
Bunker, 1970, p. 107, fig. 15.

This is the only known mirror
image of a type found both at
Xichagou and Minusinsk, perhaps
reflecting the taste of a subjugated
sub-tribe (Kiselev, 1951, pl. XXI,
no. 18; and WW, 1960, nos. 8–9,
p. 33). This fantastic beast is de-
scended from similar creatures on
the Peter the Great plaques with
fabric-like appearance on the re-
verse and on the tattoo designs
from kurgan 2 at Pazyryk. Unfor-
tunately, this splendid example is
of modern manufacture and much
heavier than the originals, a judg-
ment borne out by laboratory
examination which disclosed the
modern gilding technique used
on the piece.

Xianbei Plaque

*By the end of the first century A.D.
the Xianbei, a northern branch
of the proto-Mongol-speaking
Dong Hu in Manchuria, had
succeeded the Xiongnu as masters
of the eastern steppes; they
continue to be mentioned in
Chinese texts through the Wei
period. What little we know of
their art suggests they may have
borrowed certain Xiongnu motifs
as well as developed an animal-
oriented style of their own. The
following fragment may be part of
a Xianbei plaque.*

897

Plaque Fragment
Inner Mongolia; 3rd century A.D.
h: 4 cm.; w: 5.5 cm.
Bronze, cast; half of a four-headed
plaque, of which two bird heads
and central boss are preserved.
M.76.97.628

A complete example of a similar
plaque, dated to the third century
A.D., has been excavated at Liang-
zhen, southeast of Huhehaode
in western Inner Mongolia
(Li, 1963, pl. 95).

899

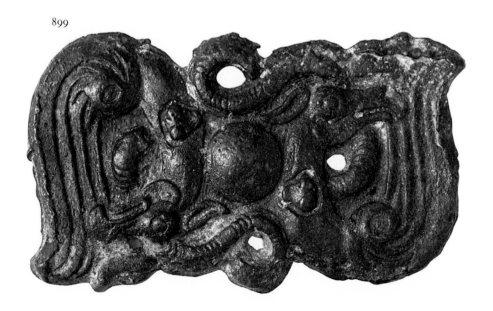

Unidentified Plaques from the Eastern Steppes

These plaques and pendants appear to have come from the eastern steppe regions; however, no related archaeological discoveries have as yet been made that would permit attribution to specific groups or areas.

898

Plaque
Inner Mongolia;
7th–6th century B.C.
h: 3.4 cm.; w: 5.3 cm.
Bronze, cast; in the form of a striped tiger with enormous jaws; vertical loop on the reverse; crudely cast.
M.76.97.629

The style of this piece is very similar to that of a feline on a dagger of seventh–sixth century B.C. date from northern China (Watson, 1971, pl. 82).

899

Plaque
Inner Mongolia;
5th–3rd century B.C.
h: 3.4 cm.; w: 5.8 cm.
Bronze, cast; in the form of two winged griffins entwined with two coiled serpents which bite their necks; horizontal loop on the reverse.
M.76.97.535

Serpents are not prevalent in the steppes, therefore suggesting Chinese influence here. For a Chinese variation on this theme, cf. Dittrich, 1963, p. 194.

900

Plaque
Inner Mongolia;
5th–3rd century B.C.
h: 3.7 cm.; w: 4.5 cm.
Silvered bronze, cast; depicting two crested griffins with sweeping wings and a center rosette flanked by two frontal boar heads; remains of a horizontal loop on the reverse.
M.76.97.641

This plaque is stylistically related to the preceding example.

901

Harness Ring
Inner Mongolia;
4th–3rd century B.C.
h: 4.6 cm.; w: 3.7 cm.
Bronze, cast; topped by a stylized yak, with a horizontal loop on the reverse.
M.76.97.997

A similar harness fitting rendered in a different style (cat. no. 807) occurs in Inner Mongolia.

Illustrated on page 151.

902

Plaque
Inner Mongolia and northern China; 5th–3rd century B.C.
h: 7 cm.; w: 2 cm.
Gilt bronze, cast; in the form of a well-modeled *kulan* head; vestiges of a button or loop in center of the reverse.
M.76.97.658

903

Plaque
Inner Mongolia and northern China; 5th–3rd century B.C.
h: 2.6 cm.; w: 2.2 cm.
Bronze, cast; in the form of an owl mask with well-defined features; horizontal loop on the reverse; reddish substance in recessed design areas.
M.76.97.642

904

Plaque
Inner Mongolia and northern China; 5th–3rd century B.C.
h: 1.4 cm.; w: 4 cm.
Bronze, cast; in the form of a double bird's head with a single eye; vertical attachment device on the reverse.
M.76.97.700

A disintegrated example was found in the Ordos region (Egami and Mizuno, 1935, pl. XV: 28).

900

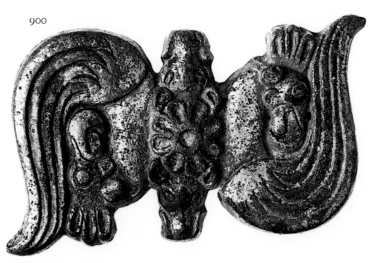

905

Plaque
Inner Mongolia;
5th–1st century B.C.
h: 3.9 cm.; w: 2.9 cm.
Bronze, cast; in the form of a
highly stylized carnivore mask.
M.76.97.992

906

Plaque
Inner Mongolia;
5th–1st century B.C.
h: 3.3 cm.; w: 2.7 cm.
Bronze, cast; in the form of a
highly stylized carnivore mask
with open eye sockets.
M.76.97.679

907

Plaque
Inner Mongolia and northern
China; 5th–1st century B.C.
h: 3.5 cm.; w: 3.5 cm.
Bronze, cast; in the shape of
a human head with pierced ears.
M.76.97.995

908

Pendant
Inner Mongolia and southern
Siberia; 5th–1st century B.C.
h: 3.4 cm.; w: 3.3 cm.
Bronze, cast; in the form of a hu-
man mask with protruding ears.
M.76.97.643

Numerous human masks decorate
horse gear in the Altai (Rudenko,
1970, pl. 92).

909

Plaque
Inner Mongolia; post-Christian era
h: 5.5 cm.; w: 3.2 cm.
Bronze, cast; in the form of a
human mask without ears.
M.76.97.625

910

Plaque
Eastern Steppes; post-Christian era
h: 4.7 cm.; w: 2.6 cm.
Bronze, cast; in the form of a
seated human figure with rhyth-
mically rounded contours; four
pierced attachment holes.
M.76.97.650

911

Pendant
Inner Mongolia and northern
China; post-Christian era
h: 5.8 cm.; w: 5.2 cm.
Bronze, cast; crude mold-cast
pendant decorated with an animal
mask centered between two
human figures and two felines.
M.76.174.57

A similar example may be found
in the David-Weill Collection
(Hôtel Drouot, 1972, no. 19).

912

Ornament
Inner Mongolia; post-Christian era
h: 7.2 cm.; w: 3.3 cm.
Bronze, cast; in the form of a stag
mask with perforations for at-
tachment below ears and on either
side of mouth.
M.76.97.624; ex-Singer Collection

A similar piece may be found in
the Seligman Collection at the
British Museum (Hansford, 1957,
pl. L).

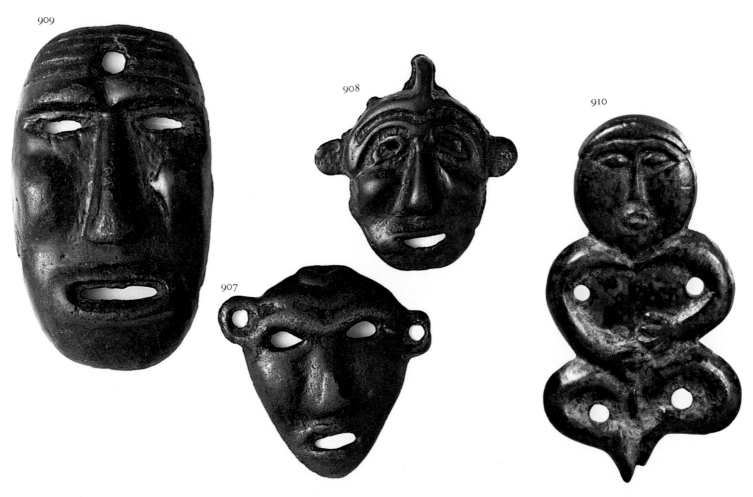

909

908

907

910

*Belt Hooks and Belt Ornaments
from the Northern Border
of China and the Ordos Region*

These belt accessories in the Heeramaneck Collection belong to a
category of objects traditionally associated with the northern border of
China and the Ordos region. Stylistically, they exhibit a mixture
of both Chinese and steppe features. Some may actually have been
of Chinese manufacture, designed for barbarian tastes.

915

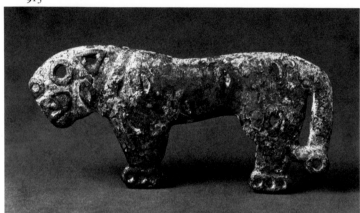

914

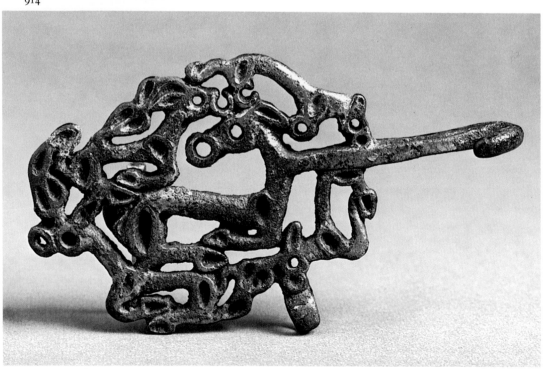

913

Belt Hook
Northern China and Inner
Mongolia; 5th–4th century B.C.
h: 4.5 cm.; w: 6 cm.
Bronze, cast; in the shape of a
feline with a reverted head and
shoulder and haunch; spiral mark-
ings; hook on chest and button on
reverse at the rump.
M.76.97.989

This motif derives from fifth cen-
tury B.C. Chinese zoomorphs
(Weber, 1973, p. 245). There are
similar examples from the Ordos
region (Andersson, *BMFEA* 4,
1932, pl. XIII).

914

Belt Hook
Northern China and Inner
Mongolia; 5th–3rd century B.C.
l: 10 cm.
Bronze, cast; adorned with an
openwork design consisting of a
feline and five deer whose shoul-
ders, haunches, and hooves are
indicated by oval sockets; button
on the reverse and a ring project-
ing from the lower part.
M.76.97.560

Similar examples are said to have
come from the Ordos region (An-
dersson, *BMFEA* 4, 1932, pl. XIII;
Karlgren, *BMFEA* 38, 1966, pl.
68, p. 14).

915

Plaque
Northern China and Inner
Mongolia; 5th–3rd century B.C.
h: 6.1 cm.; w: 13.7 cm.
Bronze, cast; in the form of a
stylized tiger with eight semi-
lunar body perforations similar to
those on belt hooks related to the
previous examples (Andersson,
BMFEA 4, 1932, pl. XIII: 4); two
small vertical attachment loops on
the reverse.
M.76.97.561; ex-Holmes Collection

Pub. New York, 1940, p. 418, 39 W.

The feet are treated in the same
fashion as those of a rhinoceros on
the Curtis *hu* (wine vessel), which
is dated to the fifth century B.C.
(Weber, *AA* XXX, 2/3, 1968, fig.
67b). In this instance, the Chinese
must have borrowed the motif
from the northern barbarians.

916

Belt Ornament
Northern China and Inner
Mongolia; 5th–3rd century B.C.
h: 5 cm.; w: 5.4 cm.
Bronze, cast; in the shape of two
highly conventionalized con-
fronted felines whose shoulders,
haunches, eyes, and paws are indi-
cated by open circular cells; two
attachment loops at side and top
and a projecting button on the re-
verse; originally part of a com-
plete ensemble which included
belt hook and chain (Andersson,
BMFEA 4, 1932, pl. XIV).
M.76.97.630

917

Belt Hook
Northern China and Inner
Mongolia; 5th–3rd century B.C.
h: 4.1 cm.; w: 10 cm.
Bronze, cast; in the form of a
feline with a reverted head
mouthing a cub; button on the
reverse.
M.76.97.656

This example is typical of belt
hooks collected in the Ordos re-
gion and at Shou xian, where sev-
eral pieces that can be associated
with the steppes have been found
(Karlbeck, *BMFEA* 27, 1955, pl.
27; Karlgren, *BMFEA* 38, 1966,
pl. 64).

916

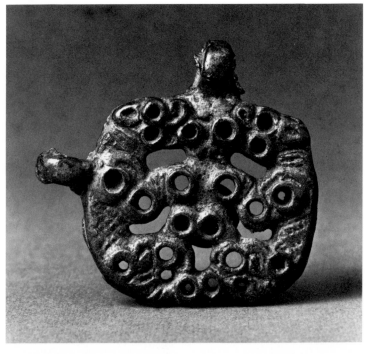

917

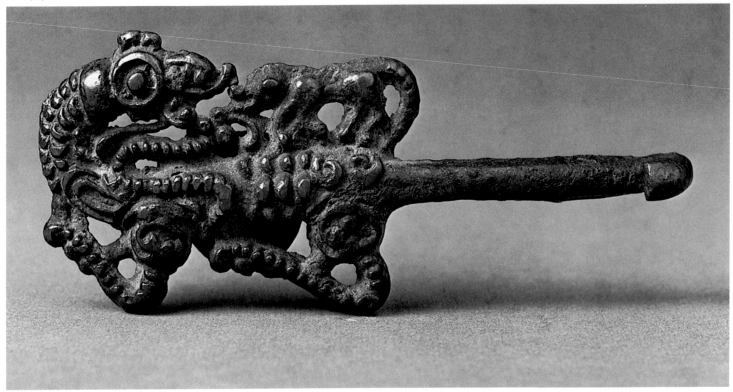

Chinese Bronzes

The Chinese bronzes in the Heeramaneck Collection are mainly
northern examples. Some display stylistic features that relate them to
the art of the steppes, such as the Warring States coiled feline. Others,
like the belt hook depicting musicians (cat. no. 1002), are types that
actually have been found in barbarian graves in Inner Mongolia,
supplying evidence for the brisk trade between the Chinese and
steppe tribes referred to in Han dynasty texts.

918

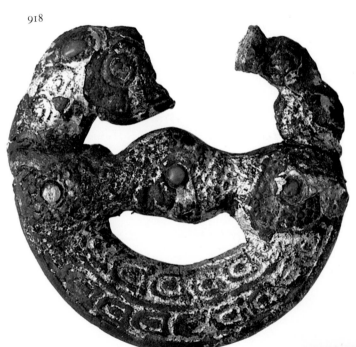

918

Ornament
China; Warring States period
(481–221 B.C.)
diam: 3.5 cm.
Bronze, cast; covered with gold
foil and inlaid with turquoise; in
the form of a coiled feline, its
body indicated by a double row of
scales (a 5th century B.C. Chinese
feature); eyes, shoulders, and
haunches are accented with tur-
quoise inlay; jaws originally
grasping the tail are broken off.
M.76.97.1001

For a complete example,
cf. Mueller, 1930, pl. VIII, H-130.

The coiled animal motif origi-
nated in the bronze vocabulary of
Western Zhou, then became one
of the artistic hallmarks of numer-
ous steppe tribes, who in turn
reintroduced it into the art of
Eastern Zhou (Weber, 1973, p. 239).

919

Openwork Fragments
China; Warring States period
(481–221 B.C.)
h: 12.8 cm.; w: indeterminate
Gilt bronze, cast; flat, openwork,
scroll-patterned fragments; may
have originally formed some sort
of a box, perhaps a birdcage like
the example in the Brundage Col-
lection (d'Argencé, 1966, p. 100 D).
M.76.174.101

920

Belt Accessory
China; Warring States period
(481–221 B.C.)
h: 9 cm.; w: 5.2 cm.
Bronze, cast; rectangle with two
bird-head prongs embellished
with spirals and granulation.
M.76.97.985

This piece is typical of late
Warring States material found at
Shou xian (Karlbeck, BMFEA 27,
1955, pl. 20: 5).

921

Belt Hook
Northern China; Qin dynasty
(221–206 B.C.)
w: 6.5 cm.
Bronze, cast; in the form of a
warrior figure dressed in trousers
and a mail jacket; button on the
reverse.
M.76.97.988

This example is of a type known
from the kiln remains of the Qin
capital site in Xianyang, Shaanxi
(KG, 1974, no. 1, p. 25).

921

922

Button

Northern China; Western Han dynasty (206 B.C.–9 A.D.)
diam: 3.5 cm.
Gilt bronze, cast; small button adorned with a frontal bear protome in high relief; two vertical loops on the reverse.
M.76.97.580

Possibly this piece was made to suit Xiongnu taste, since small plaques depicting this subject occur in second century B.C. sites (*SA,* 1971, no. 1, p. 99).

923

Button

Northern China; Western Han dynasty (206 B.C.–9 A.D.)
diam: 1.5 cm.
Gilt bronze, cast; tiny button adorned with an abstract bear protome; horizontal bar on the reverse.
M.76.97.626

924

Belt Hook

Northern China; Western Han dynasty (206 B.C.–9 A.D.)
h: 2.7 cm.; w: 5.2 cm.
Bronze, cast; depicts two kneeling figures playing music; figure on left, viewed frontally, plays a five-stringed *qin*; figure on right is shown in profile blowing a *sheng,* a whistle-like instrument played by moving fingers on the holes; large round button on the reverse.
M.76.97.1002

This piece compares with a similar painted musical scene discovered in a Han dynasty tomb from Shandong (*WW,* 1977, no. 11, p. 30). Both the costumes and instruments are typically Chinese. Similar examples were also found at Shou xian (Palmgren, 1948, pl. 32: 7) and in Inner Mongolia along with barbarian material (Li, 1963, pl. 53).

925

Belt Hook

China; Western Han dynasty (206 B.C.–9 A.D.)
h: 2.3 cm.; w: 4.7 cm.
Bronze, cast; in the form of a recumbent tiger wearing a collar of cowrie shells; button on the reverse; hook which originally projected from its chest is broken off.
M.76.97.994

Similar examples have been found at Shou xian (Karlbeck, *BMFEA* 27, 1955, pl. 27: 3) and at Hui xian with Western Han material (Zhongguo kexueyuan kaogu yanjiusuo, 1956, pl. 37). For a complete example, cf. Karlgren, *BMFEA* 38, 1966, pl. 67.

926

Fitting

China; Han dynasty (206 B.C.–220 A.D.)
h: 2.4 cm.; w: 1.2 cm.
Bronze, cast; in the form of a kneeling bear with forepaws resting on its knees (a feature typically found on Han dynasty vessel supports); slot and rectangular projection in the back for attachment.
M.76.174.48

924

927

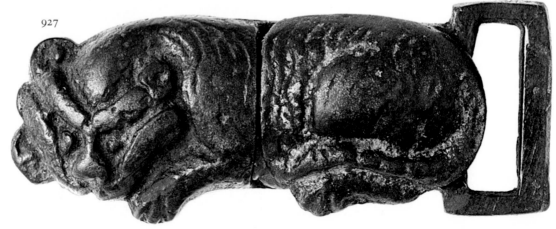

927

Buckle
China; Han dynasty
(206 B.C.–220 A.D.)
h: 2.3 cm.; w: 6 cm.
Bronze, cast; in the shape of a
sleeping tiger, its stripes indicated
by indented lines.
M.76.97.640a,b

The buckle, which is in two parts,
is similar in construction to one
adorned with a figure in typically
Han dress in the collection of
Dr. Paul Singer.

928

Figurine
China; Han dynasty
(206 B.C.–220 A.D.)
h: 6.3 cm.; l: 6.3 cm.
Lead, cast; horse and rider of
Han type.
M.76.97.986

929

Ornament
China; Han dynasty
(206 B.C.–220 A.D.)
h: 2.5 cm.; w: 4 cm.
Bronze, cast; in the shape of a
crouching monkey.
M.76.97.549

Several undecorated examples of
this type were found in Han con-
text (Zhongguo kexueyuan kaogu
yanjiusuo, 1959, p. 179, no. 18).

930

Xi (water vessel)
China; Eastern Han dynasty
(A.D. 23–220)
h: 7.6 cm.; diam: 35.5 cm.
Bronze, cast; decorated with a
raised design of a curled dragon
on the inside center.
M.76.174.147

931

Button
China; Han dynasty
(206 B.C.–220 A.D.) or later
l: 2 cm.
Bronze, cast; in the form of a
highly stylized bird's head with a
horizontal bar on the reverse.
M.76.97.684a

932

Rhyton
China; The Six Dynasties
(265–589 A.D.)
h: 6.2 cm.; l: 13.5 cm.
Bronze, cast; horn-shaped vessel
terminating in a tiger's head with a
protruding tongue; customary
mouth spout has been omitted.
M.76.97.610

Rhytons terminating in animal
heads were typical of pre-Islamic
Central Asia and the Near East. A
Northern Qi relief from Changde
fu made for a Sogdian official
depicts a dignitary drinking from a
rhyton (Sickman, 1956, pls. 40, 41).
The Chinese apparently adopted
this form, as evidenced by the
Tang ceramic example in the
British Museum, which terminates
in an open-jawed feline (Parlasca,
AA XXXVII, 4, 1975, pl. 6). The
use of striations to indicate fur
on the head of the Heeramaneck
vessel is a pre-Tang convention.

933

Nursing Sow
China; The Six Dynasties
(265–589 A.D.)
l: 10.5 cm.; w: 5.2 cm.
Bronze, cast; recumbent sow
suckling five offspring.
M.76.97.889

In type and style this piece is suf-
ficiently similar to a Chinese
ceramic example of Western Wei
(535 B.C.–56 A.D.) manufacture to
suggest a similar origin (*WW,*
1979, no. 3, p. 29, fig. 39).

932

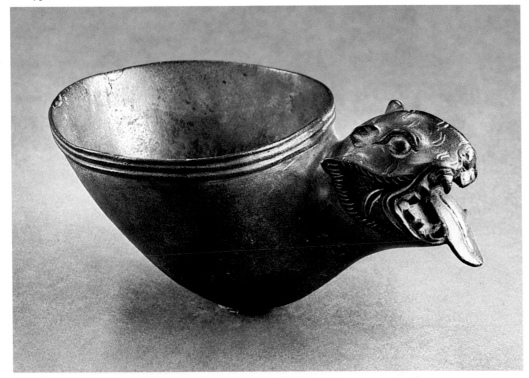

Works of Saka Art
from Central Asia

According to ancient Greek and Persian texts, the Iranian-speaking pastoral tribes who occupied the area east of the Amu Darya basin and the Kazakhstan steppes during the first millennium B.C. were known as Sakas. Two bronzes in the Heeramaneck Collection display stylistic earmarks characteristic of Saka finds from the upper reaches of the Amu Darya River in the Pamirs region.

Plaque
Central Asia; 6th century B.C.
h: 2 cm.; w: 2.8 cm.
Bronze, cast; in the form of a bear protome with a pierced ear; horizontal loop on the reverse.
M.76.97.534

A very similar example, dated to the sixth century B.C., has been excavated in the upper reaches of the Amu Darya River in the Pamirs (Artamonov, 1973, p. 19, no. 10).

Plaque
Central Asia; 5th–4th century B.C.
h: 2.8 cm.; w: 2 cm.
Bronze, cast; in the shape of a ram with folded legs.
M.76.97.635

The ram's posture is very similar to that of the horned animal on a dagger hilt found in a Saka kurgan in the Pamirs (Belenitsky, 1968, pl. 22).

934

Sarmatian Roundel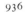

Roundel
West Asian Steppes;
1st century B.C.–1st century A.D.
diam: 11.7 cm.
Bronze, cast, decorated with a
repoussé relief of three highly
stylized griffin heads, all turned
to the right, within a rim of semi-
circular cells.
M.76.97.593

When the Sai and the Yuezhi were driven west during the Xiongnu expansion, the Aorsi moved from central Kazakhstan and held control of the lower Volga and southern Urals until the first century A.D. The Aorsi were a Sarmatian tribe, known to the Chinese as the Yancai, who lived in the Lake Aral region before their trek west. The Sarmatians, a European people who spoke an Iranian dialect, were a strong confederacy of many tribes which, by the end of the second century B.C., dominated the area from the Don to the Danube, having conquered their famous predecessors, the Scythians.

This is a mirror image of the roundel in the Azizbeglou Collection in Tehran. The decoration of these roundels derives from Near Eastern-inspired Siberian traditions recognizable among grave goods found at Tuekta in the central Altai Mountains (Farkas, *MMJ* 8, 1973, fig. 7). The Azizbeglou piece is said to have been found in the southwestern Caspian Sea region of Iran along with another damaged piece which was abandoned (Ghirshman, 1969, p. 10). A dealer's provenance is hardly valid archaeological evidence; if correct, however, the piece was clearly intrusive, the result of trade or loot. Dr. Ann Farkas has attributed these roundels to the Aorsi (Farkas, *MMJ* 8, 1973, pp. 77–88). The original backing has been lost, but the lip is bent over as if to contain some kind of backing which presumably would have had attachment loops on it. Also of interest is an exotic ornament in the shape of a three-griffin-headed whorl found in a first-century B.C. Chinese tomb (*WW*, 1972, no. 5, p. 65). This must be an eastern steppe counterpart to the Heeramaneck piece, both of which must ultimately trace their ancestry to a common source in southern Siberia.

936

Caucasian Belt
Fragments and Buckles

These belt fragments and buckles are typical examples of the art of the Koban culture, which flourished in the north-central Caucasus and in Transcaucasia in the late second–first millennium B.C. Their decorative repertoire was chiefly zoomorphic—deer, mountain goats, bulls, dogs, horses, serpents, and birds. Many of these are shown with slim waists, arched necks, and exaggerated horns, and are frequently displayed within a geometric framework. Excavated examples in USSR collections pointed out by Ann Farkas provide dating criteria (Bunker, 1970, pp. 19–27). Several of the Heeramaneck examples display motifs, namely animals confronted and in combat, ultimately derived from the art of the Near East, with which Caucasia had very close relations during the latter second and early first millennia B.C. Other motifs, such as snakes and birds perched on various animals, derive from local Caucasian art styles already present on the silver vases from Maikop dating to the late third millennium B.C. (Hančar, 1937, pl. XLVII).

937

Buckle
North-Central Caucasus;
early 1st millenium B.C.
l: 16 cm.
Bronze, cast; in the shape of a stylized galloping horse with geometric designs on its body; hook on the reverse.
M.76.97.654; ex-Brummer Collection

Pub. New York, 1940, p. 416 G; Bowie, 1966, p. 51, pl. 48.

For a similar type, cf. an excavated example from a Koban burial in northern Ossetia (Metropolitan Museum of Art, 1975, no. 7).

938

Three Fragments of a Belt
North-Central Caucasus and Transcaucasia; 8th–7th century B.C.
h: 9 cm.; l: 63.5 cm.
Bronze, hammered; chased decoration in one register (from left): bull attacked from behind by a feline and confronted by a second bull; two large, long-beaked birds flanking a central horned animal lying on its back; two confronted kneeling goats with long, sweeping, profile horns; two horsemen advancing right, with a grazing, prominently antlered stag between; second rider is positioned with body twisted 180°; he holds the reins in his left hand and an arrow in his right; above the stag's back and attacking his shoulder is a long serpent; in the field, chains of connected dotted circles and dot rosettes (perhaps astronomical symbols); the plaque is framed by a triple border consisting of a row of opposed semicircles (inner), a multiple guilloche band (middle), and a multiple zigzag band (outer), delineated from the main frieze by a chain of minute punched dots; intact left end with looped terminal and four perforations on the edge; all of the animals' bodies are richly embellished with geometric patterns reminiscent of embroidery designs.
M.76.97.920a–c

939

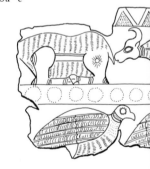

937

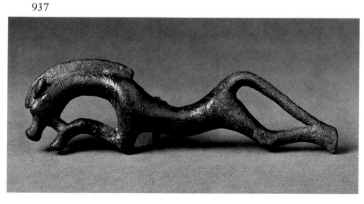

938

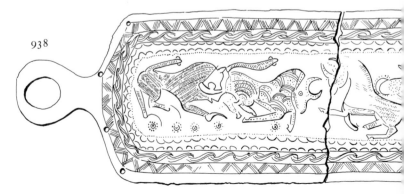

939

Four Fragments of a Belt
North-Central Caucasus and
Transcaucasia; 8th–7th century B.C.
h: 8.3 cm.; w: 54.6 cm.
Bronze, hammered; chased decoration in two registers separated by a narrow band of repoussé bosses; upper (from left): three recumbent bulls facing left, forelegs tucked beneath their bodies; three recumbent leopards, the first facing left, the second and third confronted over a detached animal's head; lower (from left): two converging files each of four large standing birds flanking central panel, the latter decorated with a pair of large repoussé bosses in each of the upper and lower frames; framed above (and below?) by a fragmentary border of double-incised outward-facing chevrons with pointilée decoration; at either end, a wide border of outward-facing chevrons; the animals' bodies are elaborately patterned as in the previous example.
M.76.97.922a–d

The haunches of the animals are marked by pinwheels, a sun symbol which frequently occurs in ancient Near Eastern art (Kantor, *JNES* 6:4, 1947, pp. 250–74).

Bronze belts such as the two previous examples (cat. nos. 938 and 939) must have formed an important part of a warrior's equipment. Consequently, their decoration had a definite cult and magical significance with which to ward off the powers of evil. The belts themselves were hammered out of a single sheet of bronze to which a fabric or leather backing was sewn. The triple border with dog-tooth band and the general treatment of the animals are reminiscent of the lively scenes found on earlier Transcaucasian Bronze Age examples, such as that from Maral Deresi, where the archers are depicted wearing wide decorated belts (Schaeffer, 1948, fig. 275), and two other examples in the British Museum (Curtis, 1978, pl. 4). Any comparison with the Urartian bronze strips can be dismissed, since their designation as belt fragments has been convincingly disproved (Hamilton, *Anatolian Studies* XV, 1965, pp. 41–51).

940

Buckle
Eastern Caucasus;
7th–6th century B.C.
h: 12.2 cm.; w: 13.8 cm.
Bronze, cast; incised decoration of two fantastic crouching beasts; pierced holes for attachment of bronze sheathing which once covered the end of the leather belt; hook on the reverse.
M.76.97.594

A similar example was excavated at Isti-su, northeastern Caucasus (Jettmar, 1967, p. 48).

941

Plaque
Transcaucasia;
late 1st millenium B.C.
h: 6.6 cm.; w: 8.5 cm.
Bronze, cast; in the shape of a stylized goat.
M.76.97.597; ex-Holmes Collection

This piece is similar to a plaque recently excavated near Tbilisi, Georgia, USSR (information supplied by Professor Japaridze to Ann Farkas, 1977).

941

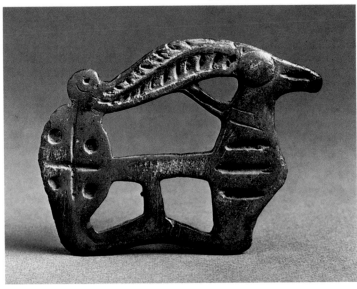

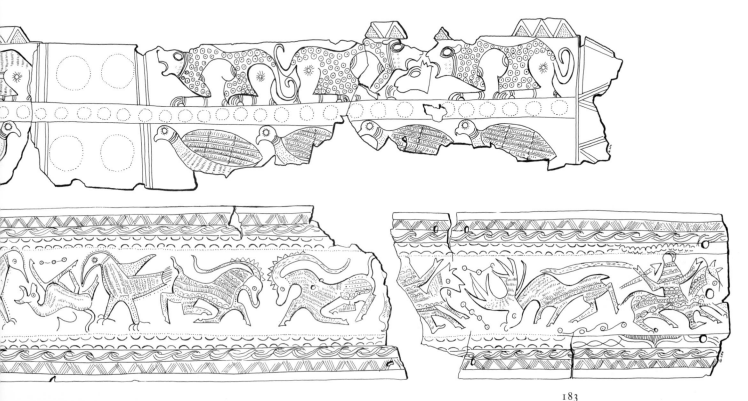

942

Belt Plaque
Caucasus; 1st–2nd century A.D.
h: 9.5 cm.; w: 10.5 cm.
Bronze, cast; openwork design
of a Tur goat, with its head turned
to the front; attacked by a dog
above and a bird below; within a
double string border with a boss
at each corner; turned-back hook
and horizontal attachment loop
on reverse.
M.76.97.605; ex-Holmes Collection

Pub. New York, 1940, p. 417 P;
Bowie, 1966, p. 59, pl. 68.

943

Belt Plaque
Caucasus; 1st–2nd century A.D.
h: 9.8 cm.; w: 10.5 cm.
Bronze, cast; openwork design
of a stag attacked by a dog and
two birds, within a double string
border; a boss at each corner;
turned-back hook and horizontal
attachment loop on reverse.
M.76.97.611; ex-Brummer
Collection

Pub. New York, 1940, p. 415 C.

944

Belt Plaque
Caucasus; 1st–2nd century A.D.
h: 12.7 cm.; w: 13 cm.
Bronze, cast; openwork design of
a stag attacked by dogs and a bird,
within an elaborate border; triple
running-spiral patterns; a boss at
each corner; a turned-back hook
and horizontal attachment loop on
the reverse.
M.76.97.612; ex-Holmes Collection

Pub. New York, p. 418 s.

The above three belt plaques all
depict animals in a highly stylized,
flamboyant manner, with wasp
waists and concentric circle mark-
ings on the shoulders and haunches,
all stylistic continuations of the
decoration found on earlier
Koban culture bronze belts.

For recently excavated Geor-
gian examples, cf. Curtis, 1978,
pp. 88–114.

Central Asian Plaque Fragment

945

Plaque Fragment
Central Asia; 1st–4th century A.D.
h: 2.1 cm.; w: 4 cm.
Gilt bronze, cast; fragment of a
plaque illustrating a reclining war-
rior who grasps part of a vine
scroll; his costume consists of a
necklace, trousers with overskirts,
bracelets, and a baldric for sup-
porting a short sword; incised
nipples and navel indicate that he
is topless.
M.76.97.633

The use of a baldric was a Roman
fashion; the costume itself is a
misinterpretation of the typical
tunic and trousers worn by Asiatic
horsemen, while the semi-nudity
suggests Indian influence. This
piece is evidence for the charac-
teristic conglomeration of art
styles that were found in Central
Asian cities along the Silk Route.

942

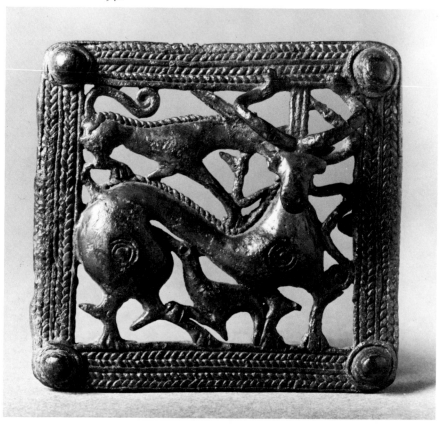

Permian Plaques

These five rather crude openwork plaques are typical examples of the Permian animal designs found in the Volga/Kama region of the USSR. The "X-ray" style reflects the shamanistic view prevalent among early hunters that animals could be resuscitated or their number increased by the portrayal of certain vital internal organs. Several examples have also been found in Finland, witness to continued contacts between this area and the Kama River and Ural Mountains during the Viking period, suggesting a date between 800 and 1050 A.D. (Tallgren, ESA III, 1928, p. 161). Similar pieces have also been found in the forests of western Siberia, tentatively dated between the fourth and ninth centuries A.D., in Tarskii County, Omsk Province, western Siberia (Černecov, MIA 35, 1953, pp. 121–78). Their lack of individual stylistic features makes a more specific identification impossible.

946
Stag
Western Siberia or Volga/Kama
region; 4th–11th century A.D.
h: 8.8 cm.; w: 13.5 cm.
Bronze, cast.
M.76.97.667; ex-Holmes Collection

Pub. New York, 1940, p. 416 L.

947
Boar
Western Siberia or Volga/Kama
region; 4th–11th century A.D.
h: 2.9 cm.; w: 6 cm.
Bronze, cast.
M.76.97.536; ex-Holmes Collection

Pub. New York, 1940, p. 416 N.

948
Horse or Moose
Western Siberia or Volga/Kama
region; 4th–11th century A.D.
h: 7.4 cm.; w: 11.2 cm.
Bronze, cast.
M.76.97.599

949
Bird
Western Siberia or Volga/Kama
region; 4th–11th century A.D.
h: 6.8 cm.; w: 6.2 cm.
Bronze, cast.
M.76.97.567; ex-Holmes Collection

Pub. New York, 1940, p. 417 R.

950
Fantastic Beast or Bear
Western Siberia or Volga/Kama
region; 4th–11th century A.D.
h: 5.9 cm.; w: 10.5 cm.
Bronze, cast.
M.76.97.591; ex-Holmes Collection

Pub. New York, 1940, p. 417 Q.

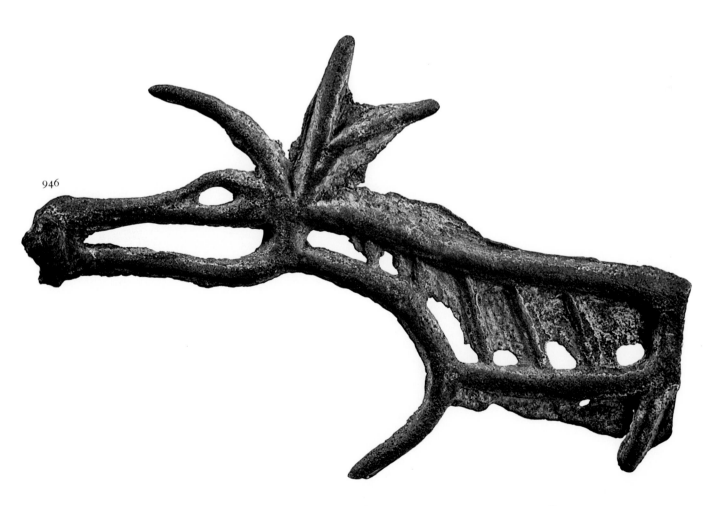

946

Stamp and Cylinder Seals
of the Ancient Near East

Edith Porada
*Arthur Lehman Professor
of Art History and Archaeology
Columbia University*

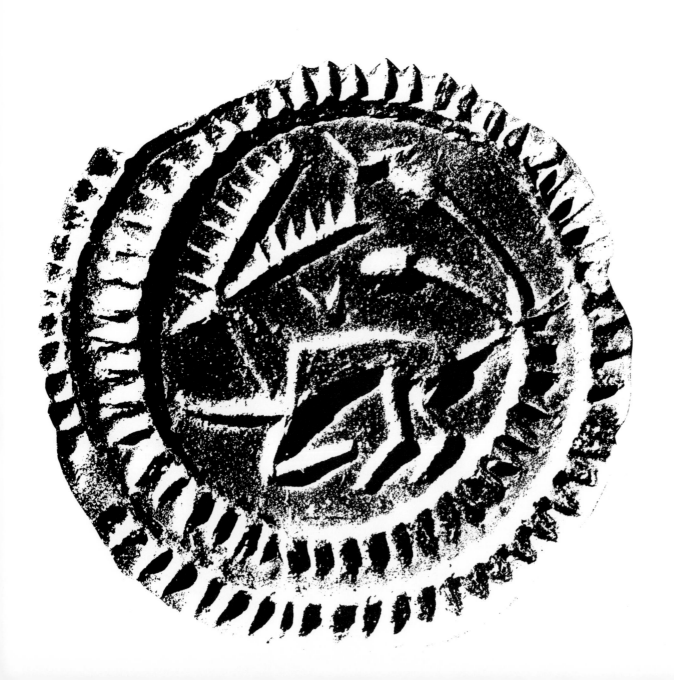

Introduction: Stamp Seals

The Earliest Stamps of Southeastern Anatolia, Northern Syria, and Northern Mesopotamia (c. 6th–4th millennium B.C.)

Earliest Stamps of Northern Syria and Southeastern Anatolia

The earliest objects bearing a mark that can be stamped upon an impressionable surface derive from Neolithic levels of the first half of the sixth millennium B.C. The sites of Çatal Hüyük and Haçilar, excavated by James Mellaart, have yielded clay stamps which typically have a flat base of oval or subrectangular shape, often carved with complicated symmetrical or asymmetrical patterns perhaps derived from mat weaves. Handles are in the shape of stalks and ledges. The purpose of these objects is not known, but they were certainly not seals in our sense of the word; hence, the term *stamp* is used here. One of the stamps in the Heeramaneck Collection (cat. no. 951) may belong to this early group.

A second group, somewhat later than the first, has appeared in the excavations of Robert J. Braidwood at the sites of the Amuq, the plain of Antioch in southeastern Turkey, formerly part of Syria. (This area will here be referred to as northern Syria.) These consist of stamps made of stone pebbles, flattened on one side and often shaped with a back in the form of a ridge or stalk perforated for suspension. In phase A of the Amuq–dated in the first half of the sixth millennium B.C.–the patterns consist of simple parallel lines, often crossing. This is followed by a second stage, Amuq phase B, dated in the second half of the sixth millennium B.C.–typified by designs utilizing lines that are thinner and more evenly distributed than before; the shapes themselves are more regular as well. Stamp 952 probably belongs to this phase. Symmetrical forms and patterns, as well as the use of a drill to make circles with a central dot–a favored pattern–or simply holes in the sealing surface, distinguish stamps of phase E, datable to about 4500–3500 B.C. Characteristic of the seal designs in this phase is the use of thin, typically short, parallel lines or strokes drawn in from the edges of the sealing surface toward the center. The stone utilized in all these examples is a greenish black, rather soft serpentine rock or chlorite. Stamps 953–55 probably belong to this phase.

In phase F of the Amuq, dated about 3500–3100 B.C., two groups of stamps may be distinguished. The first group–known as "gables"–are characterized by a rectangular sealing surface and a back rising to a straight ridge, the second–known as "hemispheroids"–consist of a circular sealing surface and rounded back which may be high or low. A major innovation in these designs is the introduction of animal forms.

Gables of Northern Syria and Southeastern Anatolia

Gables are by far the most popular and most distinctive early seal shape of northern Syria and Anatolia. They vary in size from large pieces (of ten centimeters or more in length) to small ones (measuring less than two centimeters). The earliest gables may well be those displaying linear designs, in the tradition of the earlier stamps with linear patterns previously discussed. The two examples in the Heeramaneck Collection have different shapes and designs. The first (cat. no. 956), a sharply defined angular gable, displays a branch-like design composed of two rows of chevrons flanking a vertical median line suggesting the stem of a plant. The second gable (cat. no. 957) has a rounded back; in fact, only its subrectangular surface links it with the real gable-shaped stamps. Here the sealing surface is filled by an abstract pattern of chevrons arranged in quadrants, each composed of chevrons of diminishing size, their tops all pointing to the center.

The two different gable shapes–one with quasi-naturalistic design, the other with an abstract one–are also to be found among the stamps depicting horned animals, the most frequently represented subject on this type of stamp seal. Here, the use of the stamp as a *seal* is, in fact, confirmed by discoveries in excavations of actual sealings (seal impressions) made with such gables.

Gables with rounded backs (cat. nos. 958–68) are likely to have very simple linear forms of horned animals, often stags, recognizable by the tines on their horns. Stamps 959 and 960, with their seemingly abstract designs achieved by the use of parallel lines for the animals' legs and horns, are placed here at the beginning of the group, perhaps suggesting that the figured design evolved from an abstract one. Such semi-abstract designs, however, may also be the result of simplification, a process which frequently occurs at the end rather than at the beginning of an artistic development. This group is probably best located in a specific area of northern Syria. In fact, two related examples are listed by Hogarth (Hogarth, 1920) as coming from the site of Tell Basher. These, however, do not provide sufficient justification for locating the entire group at this particular site. The question of provenance remains an open one.

Generally, the horned animals in gables are shown with four legs, but in stamp 968, only two legs are depicted. This may be an indication of a relatively late date for this seal, in the period corresponding to level VIII at Tepe Gawra, where such seal designs of animals with two instead of four legs are common. Moreover, with its more rounded style, the animal's design differs from that seen in both types of gables discussed here.

Examples of the second type–the angular gable (cat. nos. 969–84)–are more numerous than those with rounded backs, and have somewhat more natural designs illustrating a great variety of subjects. Parallels for examples in the group are found among stamps said to come from Cilicia (Hogarth, 1920). However, as the numerous subgroups attest, this group does not derive from one workshop but from several. Gables of the first group depict the head in a specific fashion–by use of a straight gouge running from the top of the head to the tip of the nose, with a second short gouge added to indicate the lower part of the head, somewhat resembling an open beak. Stamps 970 and 971 indicate the head in such a fashion. Also within the group is a large fragmentary gable (cat. no. 969) with three stags whose deeply gouged-out bodies suggest natural forms and proportions, as do the short tail and the hocks on the lower legs.

In this group stags are in the minority; long-horned goats and round-horned mountain sheep (mouflon) are at least as frequent. A fragmentary gable belonging to a particularly well-executed group, depicting a sheep with double-curved horn, is important because the design that points at the animal's breast is clearly recognizable as an arrowhead. This seal enables one to interpret correctly other such seals with similar designs, none as clearly identifiable, suggesting also that the representations on the gable may, in fact, be hunting charms. Other subjects include a crouching feline animal (cat. nos. 981 and 983), a dog (cat. no. 982), and a boar (cat. no. 984). The appearance of a serpent over one of the felines and over the boar is enigmatic.

In two cases the style typical of the gables is found on stamps of different shape. One (cat. no. 985), with a rectangular surface and a loop handle, depicts a stag and an animal turned upside down with an arrow beside its neck. Perhaps the inverted position indicates that the animal has already been killed. The second (cat. no. 986), a plaque engraved on two sides, depicts, on one face, a pair of stags, one of which is inverted with one of its forelegs merged with that of the animal opposite. On the other side of the plaque another animal appears, perhaps also a stag, its horns drawn separately from the head, with an arrow pointing toward its breast. Again, the suggested meaning is that of a successful hunt.

Hemispheroids of Northern Syria and Southeastern Anatolia
In Syria the second most common stamp form after the gable was the hemispheroid. Its prototype was a river pebble, flattened on the underside to form the sealing surface. An early type is the high hemispheroid, the back of which is actually a half-sphere (cat. nos. 987–89). These apparently date to a period corresponding to levels XII to XI A at Tepe Gawra, where the shape occurs, as noted under stamp 987. The large hollowed-out forms of the design, deeply and crudely executed, in this case, a three-legged horned animal with a serpent above its back, correspond closely to the engraving noted in a similar high hemispheroid from phase H in the Amuq. However, this is certainly a survival from an earlier period, since phase H is dated about 2800–2700 B.C., while levels XII and XI A at Tepe Gawra belong to the second half of the fourth millennium (3500–3000 B.C.). Thus, the example from the Amuq merely serves to locate the group in northern Syria.

On the basis of their more flattened shape, stamps 990–92 may be dated slightly later than those of the first group, since lower hemispheroids seem to have been favored at Tepe Gawra in levels XI A and XI. Moreover, the linear execution of the two animals on catalog number 992 may be compared with that of a hemispheroid from phase G of the Amuq.

The irregularly shaped stamp (cat. no. 990), cut down from a larger stone, shows the crude, deeply hollowed-out forms characteristic of the earlier style, although the animal forms themselves are less coherent here than in the foregoing three examples (cat. nos. 987–89). Catalog number 991 deserves mention here because of the material used—red jasper—a stone common to northern Syria, although it is occasionally found in other regions as well.

A third small subgroup consists of high hemispheroids (cat. nos. 993–97), two of which have small circular hollows for inlays, one of which is preserved (on cat. no. 993). Such inlays constitute a criterion for a date no earlier than the middle of the fourth millennium B.C. Inlays of this type are found on plugs from the Amuq (phases F and G) as well as on kidney-shaped stamps from Tell Brak in the Khabur Valley. The latter also display multiple animal forms, sketchily rendered, although not in exactly the same style as stamp 993. Nevertheless, the stamp probably belongs to the same period as the examples cited from Tell Brak, dated by Mallowan to the Jamdat Nasr period. At any rate, they cannot be dated much earlier because of the above-cited relation with stamps from Tepe Gawra.

The same type of inlay can be found on a stamp with quartered-circle design (cat. no. 994), each of its quadrants filled with chevrons—a decorative motif common on small seals at Tepe Gawra and, in fact, throughout the Near East during the centuries before and somewhat after 3000 B.C.

A second, somewhat lower hemispheroid without the circular holes for inlays (cat. no. 995) probably belongs to the same stamp type as do the two high hemispheroids, one with radial design (cat. no. 996), the other with a leaf-like pattern (cat. no. 997); both were created by making deep incisions in the sealing surface. To judge by a related example from Tell Basher (Hogarth, 1920, pl. III: 82), this type of decoration seems to be specifically Syrian.

Lentil-shaped Hemispheroids of Northern Mesopotamia A very distinctive early stamp seal shape is a flat, well-made, lentil-shaped hemispheroid with figured or geometric designs differentiated by chevron patterns. The date of the group can be set in the late Ubaid period, contemporary with Gawra level XIII, which has yielded several sealings with related designs; most of these are geometric, but one has a mountain goat with leaf-like designs or chevrons.

The designs on the seals of this group include a large, coiled serpent (of some poisonous species) with the characteristic triangular head (cat. no. 998), a rosette formed of leaf-like chevrons (cat. no. 999), two addorsed mouflon heads marked by chevrons (cat. no. 1000), and a monkey or human figure surrounded by vultures (cat. no. 1001). The last example is the most interesting because it recalls the birds of prey on a large fragmentary lentil-shaped stamp published by Hogarth (Hogarth, 1920). That stamp shows an archer whose bow alone is preserved, together with a bull attacked from above by a lion, the aforementioned bird of prey below, and what appears to be a prostrate human figure above the lion. The birds of prey surrounding the figure in the center make one think of later battlefield scenes of Mesopotamia, as well as of earlier paintings from the Neolithic site of Çatal Hüyük. Included within the collection is a curiously shaped seal with a lozenge form cut out of the middle, and a chevron-filled triangular design in each of its four projecting corners (cat. no. 1002). No parallels for this type of seal shape are known, but the sophisticated decoration corresponds nicely with glyptic designs from level XIII at Tepe Gawra.

In the common subject of a single animal and in the execution of the design by delicate lines, a number of some-

what higher (although still lentil-shaped) seals in the Heeramaneck Collection resemble numerous seals and sealings from Tepe Gawra. The one notable exception to this scheme (cat. no. 1003) depicts what appears to be a prostrate human figure above a dog or lion, the latter apparently about to devour a mouflon head held between its head and forelegs. The meaning of the human figure in these seals is difficult to determine; one might suppose the seemingly prostrate pose indicates that the individual is dead; this posture may be interpreted differently, however, if the circumference itself is taken as the groundline for the figures.

If the subject depicted on stamp 1003 is in fact a dog, the animal illustrated on stamp 1004 may be similarly identified. Such a representation (i.e., a single canine) would be very rare in Mesopotamian art.

A single horned animal, rendered in linear manner, with or without accompanying branches, was a favorite motif at Tepe Gawra; its appearance on a number of the Heeramaneck seals (cat. nos. 1005–1008) suggests a dating in the same period, that is, after level XIII. Among these, catalog number 1007 does not have the plain lentil shape of the others but is carved instead with a median ridge through which the perforation for the seal is threaded. Here, the position of the legs can be well observed; as in numerous representations of the period, the hind legs are bent and one of the forelegs is raised. Equally different from the typical arrangement of a single animal are those seals illustrating the heads of several mouflon (cat. no. 1009). As the type is absent among the seals from Syria published by Hogarth (Hogarth, 1920), but is common among the sealings and seals from Tepe Gawra, there is reasonable justification for identifying these seals as northern Mesopotamian.

Early Seals of Western Iran (c. 4th millennium B.C.)

Only one example of the small geometrically decorated stamps—the earliest seals to be used in western Iran—is included in this collection. The seal (cat. no. 1023), however, is not characteristic enough to be securely classified as an early example; hence, it appears at the end of Group I. The mass of early seals of western Iran have been stylistically divided into two major groups, each with several subgroups. The first (cat. nos. 1010–23) consists of seals with deeply gouged, mostly angular designs with rather abstract forms. In the second group (cat. nos. 1024–36) the designs are more naturalistically conceived and delicately executed; geometrically decorated seals are also included here.

The division into these two major groups may reflect geographical differences. Amiet assumes that most of the figured seals come from Luristan, but these seals are obviously products of an evolved style. This, in turn, implies the existence of a well-developed permanent settlement or settlements. Where such communities should be located is problematic. In her forthcoming dissertation on Proto-Elamite glyptic art, Holly Pittman assumes a northern origin for the plaques and hemispheroids featuring goat- or mouflon-headed demons in poses characteristic of human figures. Such a northern origin, in the region of Tepe Giyan, where Ernst Herzfeld acquired stamps of this type belonging to both Groups I and II, would accord well with the fact that

such demons are also found at Tepe Gawra and occasionally in northern Syria. The road which, to the present day, links these two areas probably follows the actual route of communication used in prehistoric times. Considering that the gouged angular style of Group I was found in the same area as the more modeled style of Group II, I believe the first to have been earlier, although that style may have persisted to some degree into later times. While I have only tenuous indications to support my opinion, such as the fact that at Tepe Gawra the bent-knee posture of the demons in Group I appears in earlier levels (mainly Gawra level XIII) than the upright walking stance characteristic of demons of Group II (a good example of which is seen in level XI at Gawra), this chronological differentiation is, nonetheless, used as a working hypothesis.

Group I Most characteristic of the early glyptic products of Iran are the large subrectangular plaques and hemispheroids with oval sealing surfaces and high backs. These are often described as carinated; however, that term is somewhat misleading, since they lack the sharp arris normally characterizing a carinated surface. These plaques and hemispheroids should be dated to the time span from the end of the Ubaid period to the Protohistoric period; the lack of properly excavated contexts precludes a more precise dating. A frequent subject of these plaques and hemispheroids is a horned demon (cat. no. 1010) with hands upraised as though in the act of conjuration, standing or walking with knees bent like an animal. In the Heeramaneck example, two serpents with obliquely striated bodies are situated with their heads directly under the demon's armpits. On the reverse of the plaque are three serpents, each characterized by a triangular head separated from its body, the latter consisting of two separate halves. This manner of representation may either be a simple decorative device, or a manner of indicating that the head was actually cut off from the body and that the body was cut in two. That this obliquely striated design is indeed that of a serpent and not an architectural feature seems fairly clear from actual depictions of houses (cf. Amiet, *Syria* LVII, 1980, no. 1578A) whose architectural elements are horizontally striated, in contrast to the obliquely marked serpent. Occasionally, however, these conventions are broken, and the reverse occurs. (These obliquely striated shapes recur on another very small plaque (cat. no. 1011), strongly recalling the serpents' bodies from which they may in fact be derived.) That the aforementioned Heeramaneck example represents an early stage in this group's sequence of development may be inferred from the posture of the figure with bent knees. Quite possibly meant to imitate the shuffling gait of animals, it is later replaced by the upright gait of human figures on seals which I consider to be of a subsequent phase.

In stamp 1012 a well-organized design in the same deeply gouged style as stamp 1010 depicts a figure with a related leg posture, here so strongly bent that the figure seems to be sitting above a serpent whose angular windings echo the human figure's forms. In the upper field, a second serpent appears at the right. Originally, another was perhaps carved on the left, now unfortunately obliterated by damage to that area of the seal. The head of the human figure is represented by a simple line, pointed at the top. That this is a figure quite distinct from the horned demon is indicated by the above-

mentioned plaque (Amiet, *Syria* LVII, 1980, no. 1556B), where both are shown in the same field.

The snake coil depicted on a large flat stamp with loop handle (cat. no. 1013) is, judging from its curvaceous contour, of somewhat later date than the angular serpents depicted in the previous example.

In another context, I will deal extensively with the relation of demons, humans, and horned animals to serpents in the early glyptic art of western Asia. Attention may be drawn, however, to the frequent appearance of this theme on the earliest figured stamps of western Iran, Syria, and northern Mesopotamia; this suggests that they may have served as charms against snakebite. On the basis of its looser composition and the more rounded forms of the animal–here a stag surrounded by a gigantic two-headed serpent–stamp 1014 appears again to be later than the aforementioned seal with angular serpent (cat. no. 1012). The stag is shown here with bent legs, a convention perhaps meant to indicate that the animal is collapsing on his forelegs.

The v-shaped position of the goat's forelegs on stamps 1015 and 1016 is very characteristic of this type of seal design, in which the mountain goat is the most frequently depicted of horned animals. Several seals (cat. nos. 1017–19) illustrate more than one animal. Stamp 1017, for instance, depicts a boar menaced by a serpent, together with a dog and the head of a horned animal added above the rim of the seal. Perhaps the dog, represented here and in stamps 1018 and 1019, signifies that the composition was intended to represent a hunting scene and that the stamps themselves were meant to assure the huntsman's success.

A favored motif on these seals of somewhat later date is that of a bird of prey swooping down upon a horned animal (cat. nos. 1020 and 1021); concerning the precise meaning of this theme, I have no suggestion. Stamp 1022 depicts two addorsed mountain goats in a pattern that might have evolved from a series of chevrons enlivened by the animal's horns and tails. It may have been further dramatized by adding a head and tail to one of the chevrons, thus transforming it into a hunting dog. The style itself reflects a stage when geometrically decorated stamps were giving way to those with figured designs. Amiet wisely leaves the stamps of this type with the semi-geometric group, arguing that seals such as stamp 1022 represent a disintegration of the figured design. I, however, favor the reverse process, according to which such stamps would be dated somewhat earlier.

Group II The magnificent red steatite hemispheroid (cat. no. 1024), bearing the figure of a goat-horned demon with human body and feet formed by the heads of horned animals, is one of a large number of representations of this figure, frequently associated with gigantic serpents; the type will be fully discussed elsewhere. Of equal quality is a disk engraved on both faces (cat. no. 1025) depicting on one side a series of lions in various positions and, on the other, a group of leaping, running, and standing men. The leaping posture of the two men located at the top of the middle column corresponds with a similar design on a hemispheroid from Luristan (now in the Louvre) illustrating a man situated above three rearing animals.

The animals on the reverse are rendered in lively postures, the forms themselves removed from the sealing surface as flat planes. The same manner of engraving, with large round hollows serving as the felines' eyes, is employed on stamp 1026; here, a lion is depicted menacing a bull upon whose horns a serpent descends. The contest between lion and bull was to become a venerable motif of western Asiatic art; the addition of the serpent, however, is unusual.

To this group of naturalistically rendered animal representations can be added that of a lizard apparently grasping a pair of monkeys. This motif is illustrated on a small seal with ridge handle (cat. no. 1027). Since a lizard appears between two feet on a stamp seal impression which Amiet assigns to his "proto-urban" period, the Heeramaneck seal may well fit within this group, which precedes the urban phase of Susa.

In contrast to the carefully executed details of the foregoing seals in this group, on two examples–a hemispheroid (cat. no. 1028) and a subrectangular tabloid (cat. no. 1029)–the bird and animal forms appear to have been swiftly engraved with the aid of a few strong, assured lines. The strong curves creating the main accent of the pattern in stamp 1031 are reminiscent of the animal designs of the foregoing seals.

A number of the seals in this group are decorated with geometrical patterns. Of these, stamp 1030 is of interest because its symmetrical pattern of outward-radiating circles on both sides of a median line is closely related to a seal found by Vanden Berghe at Hakalan in Luristan.

Forming part of this group, as well, are a number of tabloids (cat. nos. 1031–34), all quite regularly formed, again suggesting a somewhat later stage than that of the nearly uniform hemispheroids in Group I.

Two examples in this group display a sealing surface divided by a cross of diagonals, the intervals of which are filled with chevrons (cat. nos. 1032 and 1033). The greater variety in the sizes of these intervals in stamp 1034 creates a more interesting pattern. A sure hand and a sharp eye were needed to execute this pattern as well as the cross on stamp 1035. Also within this group is a delicate design with central cross and arcs in each quarter segment (cat. no. 1036).

Stamp Seals of Iran and Mesopotamia (late 4th–2nd millennium B.C.)

Drilled Designs on Hemispheroids and Tabloids (before and about 3000 B.C.) Drilled designs on stamps and cylinders were long thought to belong to the second stage of Mesopotamia's Protohistoric period, the Jamdat Nasr phase. Excavations of the past decade, however, have shown that the undisguised use of the drill was common in designs beginning in the Uruk phase, the earliest segment of the Protohistoric period.

Many seals of this type in the Heeramaneck Collection, which was largely acquired in Iran, probably come from that country. Numerous hemispheroids of the type represented in this collection resemble those gathered in the excavations at Susa. They tend to be flatter than earlier examples and are typically made of white or pink marble and several hard, colorful stones. These objects served as charms and adornments first and seals only rarely, if at all. Among the recognizable designs, depictions of dogs are most common (cat. nos. 1037, 1040, and 1041). As protectors of herds, they were a

favorite subject on seals of this type from Susa. Lozenge-shaped stamps as well as tabloids were used there; these, too, were often engraved with dogs. The depiction of a single scorpion also occurs on stamps from this site; a representation of two such creatures appears on stamp 1048. Although its style is not strongly drilled, stamp 1049, a tabloid depicting horned animal heads and what appear to be birds of prey, is included here for its unusual design. The animals' double-curved horns are somewhat similar to those depicted on a collared hemispheroid from Susa. Unlike the Heeramaneck example, however, only the animals' heads are shown here; these heads lack the neck extension so clearly marked on the present seal.

On the basis of their relatively large size and big beaks, the birds depicted may be identified as raptors. The combination of birds of prey and goat heads is reminiscent of an excavated find from Shanidar with a context of about 9000 B.C., consisting of the bones of large predatory birds and goat skulls.

A small group of stamps (cat. nos. 1050–52) show a specific engraving technique utilizing a relatively thin drill to trace the outlines of the forms by gliding it along the seal's surface. This technique occurs as well on a seal at Susa and on one acquired by Herzfeld at Nihavend. It is probably from the seal cutters of the latter site that craftsmen of southeastern Iran learned to carve their seals, based upon the earlier technique, which they retained long after it had been abandoned in the West. The representation of a human figure with spread legs on stamp 1050 is comparable to that on a seal from Susa; in both cases the spread legs may have been meant to indicate a female in the act of parturition. The representation of what appears to be a vulva between the legs of the figure on the Heeramaneck example may indicate a similar meaning for this stamp and the previously mentioned example from Susa. The designs on two additional seals (cat. nos. 1051 and 1052) were similarly produced with a drill in the manner described for stamp 1050. In both cases the designs involve a triple form, the closest parallels for which may be found among examples recently obtained at cemeteries in Afghanistan. Because of its related shape, stamp 1053 may belong in the same group. On the basis of associated finds, these seals may be assigned a date in the second half or end of the third millennium B.C.

Seals of Iran and Mesopotamia (c. 3rd millennium B.C.) The depiction of a recumbent goat on a conical stamp of translucent marble (cat. no. 1054) resembles that engraved on a unique lion-headed stamp found in the back of the Square Temple at Tell Asmar and dated in the Early Dynastic II period. Even closer parallels, however, may be found on goat heads of Early Dynastic I date, thus suggesting a similar dating for the Heeramaneck example. A clay seal of related form (cat. no. 1055) displays an atypical design on the base which cannot be identified.

The seal resembling a miniature temple tower (cat. no. 1056) is unique. Parallels for the scorpions may be found on seals from Ur, two of which are pyramidal but not in the stepped form of stamp 1056.

Stamp Seals of Iran, Bactria, and Mesopotamia (c. 2nd millennium B.C.) On the basis of seals ascribed by Sarianidi and Amiet to Bactria, a number of seals in the Heeramaneck Collection can be tentatively ascribed to this region as well. The decoration of strongly curving lines on stamp 1057 is reminiscent of lines used in wing designs on some Bactrian seals. Catalog number 1058 displays the pillow shape distinctive of these seals. The horse depicted on stamp 1059 exhibits the rounded, unarticulated legs of the bull illustrated on the preceding example, and probably belongs in the same area. Although the date for these seals cannot be determined by any tangible criteria, a date within the latter part of the second millennium seems plausible on a general consideration of style.

The two conical seals, one with a long-haired human figure (cat. no. 1060), the other depicting two masks (one upside-down, cat. no. 1061), are unique and unparalleled. Nonetheless, they are well-shaped and give the impression of being genuine. A determination of origin, however, must await the arrival of excavated material from the area.

The bird on top of stamp 1062 is distantly related to those on seals from the Marlik region. The fact that the body of the present seal is not a disk but a gently rising curve differentiates it from those known further west. It may be contemporary with examples found by Negahban at Marlik and dated by him to the end of the second millennium B.C.

Stamp Seals of Northern Syria (10th–8th century B.C.)

Northern Syrian seal owners appear to have reverted to the use of stamp seals following the destruction caused by the "Sea Peoples" at the end of the second millennium B.C. These invasions brought an end to the international trade for which the cylinder seal had been a necessary tool.

The greatest number of northern Syrian stamp seals were recovered by the expedition of Braidwood to sites in the plain of Antioch, Judaidah, Çatal Hüyük, and Tell Tainat. In 1950 Mr. Braidwood kindly permitted me to leaf through the records of the seals found at these sites. On the basis of that very cursory survey, I would suggest a date in the tenth and ninth centuries B.C. for the handled and elaborately shaped stamps (cat. nos. 1065–69). The earliest scaraboids (cat. nos. 1070 and 1071) probably belong in this period, too, as does the interestingly shaped female (?) head (cat. no. 1072). The design on the base of this stamp, consisting of a notched frame surrounding two figures in flounced garments, which probably indicate that they are deities, is especially characteristic of Syrian-style seals of this period. Cylinder seals of contemporary date also share this preference for notched features in the designs.

The small tabloids (cat. nos. 1073 and 1074) are later in date–probably assignable to the eighth century B.C. The larger tabloid (cat. no. 1075) is perhaps earlier, as its engraving is reminiscent of the Assyrian linear style.

The Hittite semi-bulla of the fourteenth or thirteenth century B.C. (cat. no. 1063) has been placed at the head of the group even though the seal was reused. A series of incoherent lines and drillings obliterate the original design, indicating that the seal was reused at a later date.

The hammer-shaped seal (cat. no. 1064), although retaining the earlier shape of the hammer-handle which became

fashionable in Hittite lands in the seventeenth century B.C. is of later date, ninth to seventh century B.C. These later examples are plainer than the magnificent hematite hammer-shaped seals of the Old Hittite period but are unquestionably derived from them.

The unique stamp 1076 is included in this section, but there are no tangible reasons why the piece should be assigned a northern Syrian origin.

Neo-Assyrian and Neo-Babylonian Stamp Seals (8th–6th century B.C.)

Neo-Assyrian Stamp Seals and Seal Amulets (late 8th–7th century B.C.) In the seventh century B.C., stamp seals in scaraboid or conical form with rounded top were the common seal shape. Such stamps were first used by Assyrian kings in the time of Shalmaneser III (858–824 B.C.) and continued to be made in the eighth century B.C., but they became numerous only in the time of Sargon II (721–705 B.C.), from which period impressions of delicately and naturalistically engraved stamps are found on tablets from Nimrud. Three conical stamps (cat. nos. 1077–79) and one scaraboid (cat. no. 1080) are tentatively assigned to the Assyrian style of the late eighth and seventh centuries B.C.

The excavations at Nimrud have also documented the use in this period of amulets in the shape of duckweights. The example closest to one in the Heeramaneck Collection (cf. cat. no. 1082) was found within a context suggesting a date at the end of the seventh century B.C. An amulet in the shape of a kneeling bull (cat. no. 1085) has the same type of base engraving as the duckweight amulet (cat. no. 1082) and is therefore included in the present group.

Conical or Pyramidal Neo-Babylonian or Neo-Assyrian Stamp Seals (late 7th–6th century B.C.) The most common type of late Neo-Assyrian and Neo-Babylonian stamp is that of a conical or pyramidal seal stone with rounded top, usually made of chalcedony with bluish hues (cat. nos. 1086–94). The engraving is normally reserved for the base, but a single figure may occasionally appear on the cone itself or in one of the facets of the pyramidal seals. The usual subject is that of a worshiper standing with raised hand before an altar bearing the symbols of Marduk (a spade) and Nabu (a stylus), the latter symbolizing the god's function as patron of writing and learning. Most of the seals are engraved in an abbreviated drilled style; some are more carefully executed in a modeled style. Differences in date, however, are difficult to determine.

Peripheral Neo-Assyrian Stamp Seals (8th–7th century B.C.) A number of stamps of Neo-Assyrian type have one or another feature differentiating them from the style most common in Assyria during the eighth and seventh centuries B.C. For example, the unusually detailed, linear execution of stamp 1095, depicting a worshiper before the dog of the goddess Gula which is seated on an altar, differs from the modeled or drilled style of the theme in conventional Assyrian art. Similarly, the goat with parallel hatching on the body and neck (cat. no. 1080) is not found in Assyrian seals. The style of both seals, however, may be related to a cylinder found at Tarsus in

Cilicia (Goldman, 1963) which may have been made under the influence of Urartian glyptic style. Related seals of Urartian manufacture may again be cited in connection with stamp 1100.

Stamps 1095–1100 have, therefore, been assembled in the present "peripheral" group; it is quite possible, however, that seals such as stamps 1097 and 1098, placed here because of their hammer shape, were actually produced by Mesopotamian seal cutters who had long accepted this originally Syrian shape for some of their stamps.

Achaemenid Stamp Seals (6th to late 4th century B.C.)

Stamp seals from Iran and Mesopotamia are not very numerous in the extant glyptic material of the Achaemenid Empire. Great officials and members of royalty appear to have used cylinders for the sealing of government documents; the most common seals were seal rings with a design on the flattened circular or oval plate. The conical seal with rounded top (cat. no. 1101), which has a design engraved on the base and the figure of a lion on the cone, belongs to a small group of seals decorated in a distinctively curvaceous, linear style, two examples of which were found at Gordion. The style, therefore, may tentatively be located in Asia Minor.

The elegant, confronted lion-griffins of stamp 1102, with heads turned back in opposite directions, flank a plant which is illustrated in a somewhat similar manner on a seal impression from Nippur. Since the composition of the Heeramaneck example resembles that of several impressions on tablets from the same site, it is not inconceivable that stamp 1102 was made in Mesopotamia.

A related composition, far less accomplished in its execution, is found on stamp 1103. It depicts two crowned sphinxes confronting each other on either side of a censer. The theme occurs again at Nippur, among the seal impressions of the time of Darius II (424–404 B.C.), but the engraving here is not equal to those of the seal impressions.

A seal of somewhat unusual form, cone-shaped with rounded top and almost rectangular base (cat. no. 1104), depicts a hero grasping the neck of a rearing bull of nearly equal height. The hero's gesture is possible only in Achaemenid representations, where the hero's opponent is equal in size. Earlier, in Mesopotamian scenes, the small size of the animal or monstrous victim prefigured its certain defeat and precluded the gesture seen here. Neither the hero's garment nor his hairstyle, however, conform to Achaemenid conventions. The problem posed by this discrepancy cannot presently be explained.

A late or post-Achaemenid style is represented by a kneeling winged bull with body composed of globular forms (cat. no. 1105). A representative of this style was found at Alisar in Asia Minor where it was probably produced. However, Boardman mentions several examples of the style from India and cites Bivar as the originator of the term Indo-Ionian for this group of seals (Boardman, 1970).

Magical Amulets (4th century B.C. and later)

Two groups of magical amulets are represented in the Heeramaneck Collection. The first is an earlier group of

four-sided prismatic stones usually engraved with a horse on one side and a figure in a flowing garment on the other (cat. nos. 1106 and 1107). The engraving is rudimentary but manifests a definite style. Amulets of arched form (cat. no. 1108) are engraved in the same style; one such was found at Tarsus under the Hellenistic mosaic pavement, indicating a date no later than the early Hellenistic period for the group.

The second group consists of examples of considerably later date, usually with more than four sides. These are engraved with the figures of serpents and demons interspersed with single inscriptions containing divine names as seen on stamp 1109. There is little doubt that this amulet belongs to the group of so-called gnostic amulets of which these little stone prisms constitute a rather crude form.

Sasanian Seals (3rd–7th century A.D.)

Within the collection is a small group of Sasanian seals (cat. nos. 1110–15). For further information on those examples, all of well-known types, the reader may consult the relevant literature given under stamp 1110.

Edith Porada
 Arthur Lehman Professor of Art History and Archaeology
 Columbia University

954

Earliest Stamps of
*Southeastern Anatolia,
Northern Syria, and
Northern Mesopotamia
(c. 4th millennium B.C.)*

Earliest Stamps of
Northern Syria and
Southeastern Anatolia
(c. 6th–4th millennium B.C.)

951

Stamp, gabled with large ridge handle
h: 3.4 cm.; l: 5.7 cm.; w: 3.3 cm.
Clay; crouching figure in an
abstract geometric pattern; re-
mains of ochre on one side of seal
surface.
M.76.174.640

952

Stamp, square with knob handle
h: 0.77 cm.; l: 2.93 cm.; w: 2.9 cm.
Black serpentine rock; pattern of
incised cross-hatching.
M.76.174.447

953

*Stamp, wedge-shaped with
triangular base*
h: 0.7 cm.; l: 3.12 cm.;
w. of base: 2.45 cm.
Black serpentine rock; sym-
metrical pattern of oblique lines
on either side of a median line.
M.76.174.448

954

Stamp, triangular with ridge handle
h: 0.5 cm.; l: 4.2 cm.; w: 3.5 cm.
Gray serpentine rock; series of
center dot circles; short parallel
incisions drawn in from the rim.
M.76.174.449

955

Stamp, ridge-handled
h: 0.6 cm.; l: 2.86 cm.; w: 2.64 cm.
Black serpentine rock; field
divided by diagonals into quad-
rants, each of which is filled with
notches drawn in from the rim.
M.76.174.450

Gables of Northern Syria
and Southeastern Anatolia

956

Stamp, gabled
h: 0.73 cm.; l: 2.85 cm.; w: 1.8 cm.
Black serpentine rock; geometri-
cal pattern consisting of two rows
of chevrons on either side of a
horizontal median line.
M.76.174.517

For a gable of related shape and
design from the Amuq, level F, cf.
Braidwood, 1960, *OIP* LXI, p. 254,
fig. 191: 6.

957

Stamp, gabled with rounded back
h: 0.93 cm.; l: 3.06 cm.;
w: 2.66 cm.
Black chlorite; geometrical pattern
consisting of a median diagonal
line with short parallel strokes on
either side, parallel or at right
angles to it.
M.76.174.518

958

Stamp, gabled with rounded back
h: 1.33 cm.; l: 3.55 cm.; w: 2.3 cm.
White-mottled serpentine rock;
two horned animals stylized into
parallel lines, set at right angles to
the field, one face up, the other
face down.
M.76.174.510

959

Stamp, gabled with rounded back
h: .094 cm.; l: 2.79 cm.;
w: 2.63 cm.
Black chlorite; two highly
abstracted walking stags, with
parallel lines for horns, body, and
legs; additional lines form back-
ground pattern.
M.76.174.493

960

Stamp, gabled with rounded back
h: 0.86 cm.; l: 3.25 cm.; w: 2.2 cm.
Black serpentine rock; two walk-
ing stags, with deeply gouged
parallel lines for horns, body, and
legs.
M.76.174.491

961

Stamp, gabled with rounded back
h: 0.77 cm.; l: 3.3 cm.; w: 2.1 cm.
Black serpentine rock; design as in
cat. no. 960.
M.76.174.490

962

Stamp, gabled with rounded back
h: 0.85 cm.; l: 3.7 cm.; w: 2.3 cm.
Greenish gray chlorite; two walk-
ing long-legged animals with
horns behind as in cat. no. 960.
M.76.174.492

The details on the animals' tails
and hocks are reminiscent of
examples from Tepe Gawra, level
VIII (*Gawra I*, 1935, pl. LVII: 29).

963

Stamp, gabled with rounded back
h: 0.8 cm.; l: 2.35 cm.; w: 1.96 cm.
Black chlorite; walking stag; thin
lines for horns; heavier forms for
body and legs.
M.76.174.494

961

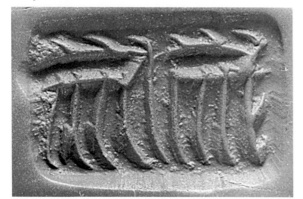

964

Stamp, gabled with rounded back
h: 0.84 cm.; l: 2.14 cm.; w: 1.9 cm.
Weathered marble; walking
horned animal, executed in paral-
lel lines.
M.76.174.498

For related stamps, cf. Hogarth,
1920, pl. IV: 99; pl. V: 118 (from
Tell Basher).

965

Stamp, gabled with rounded back
h: 0.6 cm.; l: 2.3 cm.; w: 1.8 cm.
Black serpentine rock; walking
stag; thin lines for horns, body,
and legs.
M.76.174.495

966

Stamp, gabled with rounded back
h: 0.67 cm.; l: 2.09 cm.; w: 1.56 cm.
Dark brown serpentine rock;
walking long-horned animal;
deeply gouged parallel lines for
horns, body, and legs.
M.76.174.497

967

Stamp, gabled with rounded back
h: 0.92 cm.; l: 2.54 cm.; w: 2.14 cm.
Black serpentine rock; walking
animal, a horn (?) over its back;
plant in front.
M.76.174.499

968

Stamp, gabled with rounded back
h: 0.65 cm.; l: 2.14 cm.; w: 1.74 cm.
Black chlorite; animal with a large
horn behind the head; fillers not
recognizable.
M.76.174.502

For a design of somewhat related
style, cf. *Gawra I*, 1935, pl. LVI: 9.

969

Stamp, gabled
h: 1.7 cm.; l: 6.31 cm.; w: 6.2 cm.
Black chlorite; three walking
stags, the first and third only
partially preserved; fragmen-
tary gable.
M.76.174.489

A gable of similar form (with two
mouflons instead of stags, and a
third animal which may be tenta-
tively identified as a stag) is listed
by Hogarth (Hogarth, 1920, pl. IV:
93) as coming from Marash in
Cilicia. An impression of a gable
with three horned animals was
found in level XI-A at Tepe Gawra
(*Gawra II*, 1950, pl. CLXVIII: 155).

970

Stamp, gabled
h: 0.75 cm.; l: 2.8 cm.; w: 2.8 cm.
Black serpentine rock; recumbent
sheep with recurved horns; near
foreleg folded beneath body, far
foreleg outstretched; arrow di-
rected at breast of animal; one-half
of gable broken off.
M.76.174.500

For gables of similar shape, style,
and subject, cf. Hogarth, 1920, pl.
IV: 101, 102 (from Cilicia), and 103
(near Antioch).

971

Stamp, gabled
h: 0.9 cm.; l: 4.5 cm.; w: 3.5 cm.
Black chlorite; walking stag; plant
motif in field above; poorly drawn
arrow in front of stag's breast.
M.76.174.501

The details of the hocks are ren-
dered in a fashion similar to those
found on seals from Tepe Gawra,
level VIII (*Gawra I*, 1935, pl. LVII: 29).

972

Stamp, gabled
h: 0.76 cm.; l: 4.8 cm.; w: 2.9 cm.
Black chlorite; mouflon and plant
(?); small animal in the field above.
M.76.174.505

973

Stamp, gabled
h: 0.78 cm.; l: 2.88 cm.; w: 2.5 cm.
Dark brown marble; animal with
a pair of recurved horns in profile;
legs naturalistically rendered; part
of design missing.
M.76.174.496

974

*Stamp, gabled with
slightly rounded back*
h: 0.88 cm.; l: 2.66 cm.;
w: 2.24 cm.
Black serpentine rock; walking
animal with recurved horn, a plant
in front of it.
M.76.174.506

975

Stamp, gabled
h: 0.75 cm.; l: 2.51 cm.; w: 2.44 cm.
Black chlorite; standing mouflon;
two small, indefinable designs in
the field.
M.76.174.507

976

Stamp, gabled
h: 0.9 cm.; l: 2.6 cm.; w: 2.3 cm.
Black serpentine rock; animal
with flappy ears (?); in the field, a
curving line and a four-pointed
star.
M.76.174.504

971

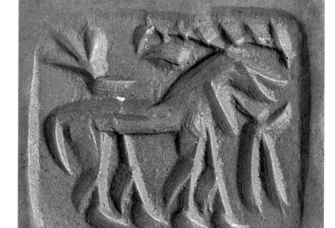

969

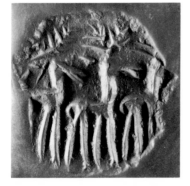

970

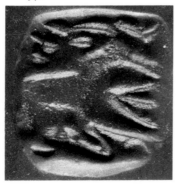

977

Stamp, gabled
h: 0.82 cm.; l: 2.7 cm.; w: 1.94 cm.
Black chlorite; walking animal
with long, horizontal, notched
horn; unusual stylization.
M.76.174.508

978

Stamp, gabled
h: 1.2 cm.; l: 2.44 cm.; w: 1.93 cm.
Black serpentine rock; walking
animal with frontally rendered
recurved horns; bird and globule
in the field.
M.76.174.503

979

Stamp, gabled
h: 1.6 cm.; l: 3.9 cm.; w: 2.1 cm.
White-mottled serpentine rock;
surface recently covered with blue
or purple dye; horned animal
with short tail; behind, an uniden-
tifiable form, perhaps a serpent; in
the field to the right, a globular
drilling and two-pronged form,
perhaps the inverted head of a
horned animal.
M.76.174.511

980

Stamp, gabled
h: 1.6 cm.; l: 3.36 cm.; w: 2.7 cm.
White-mottled serpentine rock;
recumbent mouflon followed by a
standing or walking mountain
goat; beneath the latter, a spray
with leaves; unusual design and
arrangement.
M.76.174.509

981

Stamp, gabled
h: 1.23 cm.; l: 4.86 cm.; w: 2.51 cm.
Black chlorite; crouching feline;
serpent in the field above.
M.76.174.513

982

Stamp, gabled, elongated
h: 2.05 cm.; l: 4.55 cm.;
w: 2.46 cm.
Gray-mottled serpentine rock;
crouching animal, possibly a dog;
highly stylized, with tall ears,
elongated torso, and tail with
right-angle bend.
M.76.174.514

983

Stamp, gabled
h: 0.98 cm.; l: 4.36 cm.; w: 2.52 cm.
Black serpentine rock; recum-
bent feline with elongated torso
marked by diagonal ribbing; head
rendered as though seen from
above; rows of chevrons in the
field above.
M.76.174.515

984

Stamp, gabled
h: 0.86 cm.; l: 3.95 cm.; w: 2.55 cm.
Black serpentine rock; crouching
boar with legs extended; serpent
in the field above.
M.76.174.516

985

*Stamp, rectangular with knob-shaped,
perforated handle*
h: 0.91 cm.; l: 2.55 cm.; w: 1.92 cm.
Black serpentine rock; stag with
long, tined antlers; beside it,
an inverted dog with an arrow-
shaped design over its back.
M.76.174.519

For the stamp shape, cf. Braid-
wood, 1960, *OIP* LXI, p. 254, fig.
191: 2.

986

Stamp, tabloid
h: 1.2 cm.; l: 3 cm.; w: 2.24 cm.
Gray serpentine rock; decorated
on both faces: a) two stags, one
inverted, combined into a single
form; b) a horned animal, perhaps
a stag, with antlers curved over
its back and dissociated from
the body.
M.76.174.512

For a comparable composite de-
sign of two animals, one upright
and one inverted, cf. Hogarth,
1920, pl. IV: 94.

Hemispheroids of Northern Syria and Southeastern Anatolia

987

Stamp, hemispheroid
h: 2.85 cm.; diam: 3.02 cm.
Black serpentine rock; horned
animal with a serpent (?) above.
M.76.174.468

For the shape, cf. *Gawra II*, 1950,
pl. CLXVI: 124; pl. CLXVII: 132, 139
(all from Tepe Gawra, level XII).

988

Stamp, hemispheroid
h: 2.9 cm.; diam: 3 cm.
Black serpentine rock; horned
animal with an indefinable form
above its back.
M.76.174.469

A similar form appears above the
back of a horned animal on a
closely related seal from the
Amuq, phase H (Braidwood, 1960,
OIP LXI, p. 387, fig. 297).

989

Stamp, hemispheroid
h: 1.4 cm.; diam: 2.8 cm.
White-mottled dark brown ser-
pentine rock; horned animal, its
horns dissociated from its head
and indicated by two parallel lines
above its back.
M.76.147.470

990

Stamp, hemispheroid, cut down from a larger form
h: 1.3 cm.; diam: 2.5 cm.
Black serpentine rock; series of gouged forms, perhaps representing an animal; triangles in the field.
M.76.174.471

991

Stamp, hemispheroid
h: 1 cm.; diam: 2 cm.
Red jasper; simplified horned animal.
M.76.174.472

The design may be related to a sealing from Tepe Gawra, level VIII (*Gawra I*, 1935, pl. LVI: 11).

992

Stamp, hemispheroid
h: 1.2 cm.; diam: 2.58 cm.
Dark brown serpentine rock; calf (?) set above a cow, both recumbent; crescent-shaped form below; decoration possibly secondary.
M.76.174.473

The design is perhaps comparable to that of a hemispheroid found in the Amuq, phase G (Braidwood, 1960, *OIP* LXI, p. 330, fig. 253: 12).

High Hemispheroids of Northern Syria

993

Stamp, hemispheroid
h: 1.26 cm.; diam: 2.9 cm.
White marble; boar surrounded by five long-tailed animals, probably dogs; on the upper surface, a circular impression for an inlay.
M.76.174.463

For plugs with inlays, cf. Braidwood, 1960, *OIP* LXI, p. 254, fig. 192: 2 (phase F); p. 333, fig. 255: 2 (phase G); for hemispheroids with inlays, cf. *Gawra II*, 1950, pl. CLXV: 109, 112 (Tepe Gawra, levels XII and XI, respectively); also M.E.L. Mallowan, *Iraq* IX, 1947, pl. XVIII: 9, 13, and 23 for the small circular holes for inlays there drilled in the back of kidney-shaped seals; for the style of animal carving on the sealing, cf. ibid., pl. XVII: 16–24. Though not identical in style, the design with multiple sketchily indicated figures is somewhat related.

994

Stamp, hemispheroid
h: 1.37 cm.; diam: 2.3 cm.
Black serpentine rock; cross design, each quadrant filled with chevrons; on the upper surface, perforations for inlays.
M.76.174.464

995

Stamp, hemispheroid
h: 0.9 cm.; l: 2.24 cm.; w: 2 cm.
White-mottled brown serpentine rock; design as in cat. no. 994.
M.76.174.465

For a stamp with comparable design, cf. *Gawra II*, 1950, pl. CLIX: 20 (level XI).

996

Stamp, dome-shaped
h: 1.05 cm.; diam: 2 cm.
Greenish gray serpentine rock; stylized design formed by a central vertical wedge and radiating wedges.
M.76.174.466

A somewhat related design is seen on a high hemispheroid acquired at Tell Basher (Hogarth, 1920, pl. III: 82).

997

Stamp, dome-shaped
h: 1.12 cm.; diam: 2.3 cm.
Gray serpentine rock; stylized leaf-vein motif executed in depressed wedges.
M.76.174.467

Lentil-Shaped Hemispheroids of Northern Mesopotamia

998

Stamp, flat, lentil-shaped
h: 0.7 cm.; diam: 4.7 cm.
Black serpentine rock; coiled-up serpent with triangular head.
M.76.174.451

999

Stamp, flat, lentil-shaped
h: 0.7 cm.; diam: 4.8 cm.
Black serpentine rock; eight-petaled rosette with a dot in the center and chevrons in the petals; v-shaped lines in the intervals.
M.76.174.452

Leaves like those of this seal are seen on an impression from Tepe Gawra, level XIII (*Gawra II*, 1950, pl. CLXV: 105).

1000

Stamp, flat, lentil-shaped
h: 0.5 cm.; diam: 2.82 cm.
Black serpentine rock; two addorsed mouflon heads, marked by chevrons; two triangles as space-fillers.
M.76.174.453

998

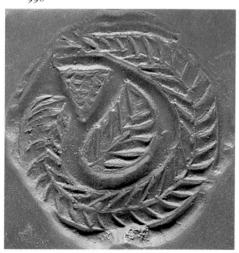

993

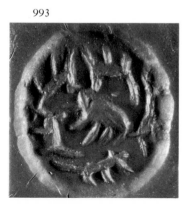

1001

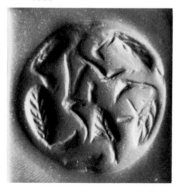

1001

Stamp, lentil-shaped
h: 6.6 cm.; diam: 2.6 cm.
Black serpentine rock; man or monkey surrounded by five vultures with chevron-patterned bodies.
M.76.174.455

Birds which may be related to those of this seal are seen as minor figures below a bull on a large, fragmentary, lentil-shaped stamp discussed by Hogarth (Hogarth, 1920, pl. IV: III).

1002

Stamp, flat with angular, indented sides and diamond-shaped perforation in center
h: 0.46 cm.; l: 3.27 cm.; w: 2.33 cm.
Black serpentine rock; four triangular areas composed of chevron patterns.
M.76.174.454

1003

Stamp, lentil-shaped
h: 0.84 cm.; diam: 3.4 cm.
Black serpentine rock; dog or lion; human (?) form above, one leg extended, the other bent; head and torso not visible; mouflon head in front of dog or lion.
M.76.174.457

1004

Stamp, lentil-shaped
h: 0.66 cm.; diam: 2.14 cm.
Black serpentine rock; dog or lion.
M.76.174.461

1005

Stamp, gabled with circular base
h: 0.45 cm.; l: 2.75 cm.; w: 2.5 cm.
Black serpentine rock; horned animal; sprays or branches in the field.
M.76.174.456

cf. *Gawra II*, 1950, pl. CLXVI: 127 (level XI-A).

1006

Stamp, lentil-shaped
h: 0.74 cm.; l: 3.6 cm.; w: 3.44 cm.
White-mottled black serpentine rock; large-eared animal; chevrons in the field.
M.76.174.458

1007

Stamp, circular with ridge handle
h: 1.3 cm.; diam: 2.9 cm.
Black serpentine rock; walking wild goat, highly geometricized.
M.76.174.460

1008

Stamp, lentil-shaped
h: 0.9 cm.; diam: 2.7 cm.
Black serpentine rock; horned animal, perhaps a mouflon.
M.76.174.459

1009

Stamp, lentil-shaped
h: 1.03 cm.; diam: 2.7 cm.
White-and-green-mottled black serpentine rock; three mouflon heads; horizontal form incised in the center.
M.76.174.462

Early Seals of Western Iran
(*c. 4th millennium* B.C.)

Group 1

1010

Stamp, plaque
h: 0.7 cm.; l: 4.3 cm.; w: 3.3 cm.
Black serpentine rock; decorated on both faces: a) mouflon-headed demon with bent knees, arms outstretched; serpent below each armpit, chevrons above; b) three serpents with triangular heads; an interval between head and body; a second interval through middle of body.
M.76.174.545

Pub. Porada in Mellink, 1964, pl. v, fig. 4; Porada, 1965, p. 31; Barnett, *Syria* XLIII, 1966, pl. XXII: 5; Porada in Mellink, *PKG* 13, 1974, pl. 63d. For a discussion of this and related figures, cf. Amiet, *Syria* LVI, 1979, pp. 333–52 and Amiet, *Syria* LVII, 1980, pp. 194ff.

1011

Stamp, tabloid
h: 0.82 cm.; l: 2.54 cm.; w: 2.2 cm.
Gray serpentine rock; field divided into two panels, each containing a rectangle filled with diagonal hatching.
M.76.174.557

1012

Stamp, gabled, hemispheroid
h: 1.3 cm.; l: 3.07 cm.; w: 2.87 cm.
Green serpentine rock; human torso in bent-knee squatting posture, with elongated torso and arms bent outward at the elbow; serpents (?) in the field.
M.76.174.546

1010

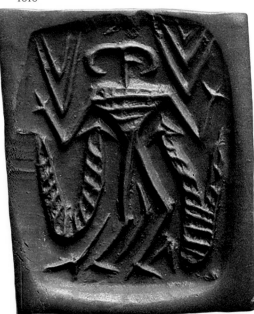

1005

1012

1013

*Stamp, lentil-shaped with
small knob handle*
h: 1.1 cm.; l: 4.5 cm.; w: 4.1 cm.
Black serpentine rock; coiled
serpent motif.
M.76.174.547

The subject of a snake as the sole
decoration of a sealing surface is
also found in Amiet, 1972, *MDAI*
XLIII, pl. 47: 191–94, but the exe-
cution differs from that of the
present stamp.

1014

Stamp, gabled, hemispheroid
h: 1.67 cm.; l: 4.72 cm.; w: 4.6 cm.
Black serpentine rock; stag with
collapsed forelegs, surrounded by
a snake-coil ending in two heads;
chevron over stag's back.
M.76.174.548

1015

Stamp, gabled with rounded apex
h: 1.5 cm.; l: 3.56 cm.; w: 3.2 cm.
Black serpentine rock; mountain
goat with a serpent above its back;
spray of verdure in front of it;
chevrons in the field.
M.76.174.549

For the v-shaped position of the
forelegs and the bent hind legs, cf.
Amiet, 1972, *MDAI* XLIII, pl. 46:
170, 173.

1016

Stamp, hemispheroid
h: 1.1 cm.; diam: 2.5 cm.
Black serpentine rock; mountain
goat; serpent in the field above.
M.76.174.550

1017

Stamp, gabled with rounded apex
h: 1.2 cm.; diam: 3.4 cm.
Black serpentine rock; boar facing
a rearing, triangular-headed ser-
pent; figure of a dog (reversed) in
the field above, a tree and branch
below, and the head of a horned
animal to the right.
M.76.174.553

1018

Stamp, hemispheroid
h: 1.3 cm.; l: 3.4 cm.; w: 3.03 cm.
Gray-mottled black serpentine
rock; two mountain goats and a
leaping dog; chevrons or arrow-
heads in the field.
M.76.174.551

1019

Stamp, lentil-shaped
h: 1.24 cm.; l: 3.7 cm.; w: 3.4 cm.
Black serpentine rock; two horned
(?) animals, arranged with their
backs toward the rim of the seal;
one animal is in a convoluted
pose, with hind legs bent up over
its back; the figure of a dog, its
hind legs no longer visible, is re-
versed over the back of the second
animal; behind each, a tree; two
crosses joined and a short simple
line in the field.
M.76.174.552

1020

*Stamp, hemispheroid with flattened
end, back reworked*
h: 1.42 cm.; l: 4.55 cm.; w: 4.03 cm.
Gray-mottled black serpentine
rock; horned animal; before it, a
tree; bird (?) and five circular
drillings in the field.
M.76.174.554

As the back of the seal was cut and
reworked at a later date, the design
may be modern, perhaps copied
from an ancient one.

1021

Stamp, hemispheroid
h: 1.4 cm.; diam: 3.4 cm.
Brown serpentine rock; horned
animal; bird with outspread wings
in the field above; crescent-shaped
form in front of animal's snout.
M.76.174.555

1022

Stamp, hemispheroid
h: 1.97 cm.; l: 4.1 cm.; w: 3.84 cm.
Orange and buff marble; two
horned animals arranged on either
side of the seal surface with backs
turned toward each other, facing
head to tail; between them, three
chevrons and a leaping dog (?)
with angular outline; each of the
animals has five chevron-shaped
legs; the curved horns of the ani-
mal follow the curve of the cir-
cular base; small v-shaped design
set above each pair.
M.76.174.556

The position of the mountain
goats, back-to-back facing in op-
posite directions, with chevrons
and what appears to represent a
leaping dog between them, is
closely paralleled on a stamp pub-
lished by Amiet (Amiet, 1972,
MDAI XLIII, pl. 44: 134; numbers
127 and 128 are less closely related).

1023

Stamp, hemispheroid
h: 1.38 cm.; l: 2.35 cm.; w: 2.18 cm.
White marble; radial design, with
circular hollow in center.
M.76.174.558

1014

1024

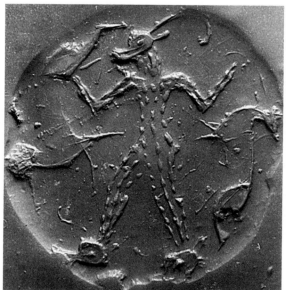

Group II

1024

Stamp, hemispheroid
h: 1.7 cm.; diam: 4.8 cm.
Red steatite; demon with the head of a mountain goat, human body, and feet in the form of the heads of horned animals (perhaps bovines); he holds one mountain goat by the horns and raises a second by a hind leg; demon's body covered with short striations which probably indicate tufted skin.
M.76.174.520

Pub. Porada in Mellink, 1964, pl. v, fig. 3; Porada, 1965, p. 31; Barnett, *Syria* XLIII, 1966, pl. XXII: 4.

1025

Stamp, disk-shaped with rounded sides
h: 1.2 cm.; diam: 5.2 cm.
Black serpentine rock; decorated on both faces: a) seven nude male figures with arms and legs outspread, arranged in three columns; two top figures in the center appear to be leaping; figure at their right appears to be running; b) three large and two small felines, arranged in a free-field composition.
M.76.174.522

For the leaping men, cf. a similar leaping figure on a gray stone seal from Luristan, now in the Louvre (Godard, 1931, pl. LXV: 232; Amiet, *Syria* LVI, 1979, p. 336, fig. 8).

1026

Stamp, hemispheroid
h: 1.58 cm.; l: 4.5 cm.; w: 4.25 cm.
Black serpentine rock; bull attacked by a lion; serpent in the field overhead, its head directly above the bull's horns; branch (?) under bull's body.
M.76.174.523

The style of this stamp somewhat resembles that of a seal in the Louvre, probably from Luristan (Amiet, *Revue du Louvre* 23, 1973, p. 217, fig. 8).

1027

Stamp, oval with handle
h: 0.7 cm.; l: 1.75 cm.; w: 1.5 cm.
Black serpentine rock; lizard in outspread posture, grasping two monkeys (?) by the neck.
M.76.174.521

1028

Stamp, hemispheroid
h: 1.35 cm.; diam: 3.84 cm.
Gray-mottled serpentine rock; horned animal; beneath it, a smaller animal; two crescent-shaped lines over large animal's body probably indicate its horns.
M.76.174.524

1029

Stamp, tabloid
h: 0.8 cm.; l: 3.3 cm.; w: 2.5 cm.
Black serpentine rock; decorated on both faces: a) stylized stag with long, curving horns; b) bird of prey with outspread wings.
M.76.174.528

1030

Stamp, hemispheroid
h: 1.2 cm.; diam: 3.8 cm.
Black serpentine rock; symmetrical design divided by a vertical median line, consisting of concentric arcs radiating from circle with central dot.
M.76.174.527

The pattern is related to that depicted on a seal from the site of Hakalan in Luristan (Vanden Berghe, *Archéologia* 57, 1973, p. 57, top left).

1031

Stamp, tabloid
h: 1.2 cm.; diam: 3.2 cm.
Dark brown serpentine rock; decorated on both faces: a) field filled by semicircles placed back-to-back in the middle, each semicircle with two vertical lines down to the rim; triangular wedges in the areas between; b) field divided vertically into three columns, each filled with chevrons set in alternating directions.
M.76.174.532

1015
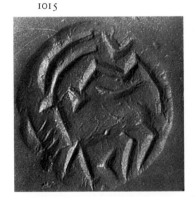

1025
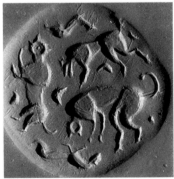

1022
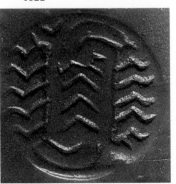

1026
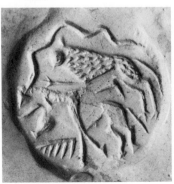

1029a

1029b

1032

Stamp, tabloid
h: 6.4 cm.; diam: 3.3 cm.
Pale gray serpentine rock; field
divided diagonally into quadrants,
each filled with chevrons.
M.76.174.529

1033

Stamp, tabloid
h: 1.15 cm.; l: 3.4 cm.; w: 2.5 cm.
Greenish gray serpentine rock;
field divided diagonally into quad-
rants, each filled with chevrons;
a dot in each of two opposed
triangles.
M.76.174.530

1034

Stamp, tabloid
h: 1 cm.; l: 2.6 cm.; w: 2.48 cm.
Greenish gray serpentine rock;
decorated on both faces: a) central
lozenge outlined by a double line,
triangles on the sides; b) crossing
diagonal pattern, each quadrant
filled with chevrons.
M.76.174.531

1035

*Stamp, hemispheroid with
flattened ends*
h: 1.35 cm.; l: 2.78 cm.; w: 2.65 cm.
Black serpentine rock; equilateral
cross with circular center marked
by two lines; arms of the cross are
marked by parallel hatchings;
triangles in the voids between the
points of the cross.
M.76.174.526

1036

Stamp, hemispheroid
h: 1.4 cm.; diam: 2.9 cm.
Green-mottled black serpentine
rock; circle with inscribed cross-
shaped design, each quadrant
decorated with three or four
quarter arcs.
M.76.174.525

*Stamp Seals of Iran
and Mesopotamia
(late 4th–2nd millennium B.C.)*

Drilled Designs
on Hemispheroids and Tabloids
(before and about 3000 B.C.)

1037

Stamp, hemispheroid
h: 1.35 cm.; diam: 3.7 cm.
Travertine; three crouching dogs,
placed one above the other, the
outer two facing right, the middle
facing left.
M.76.174.535

For dogs (numbering two or
more) in the field of drilled
hemispheroids, cf. Amiet, 1972,
MDAI XLIII, pl. 56: 350ff.

1038

Stamp, hemispheroid
h: 1.3 cm.; diam: 3.5 cm.
White marble; design composed
of seven groups each of three
globular drillings indicating ani-
mals, some of whose tails are
indicated.
M.76.174.534

1039

Stamp, oval hemispheroid
h: 1.4 cm.; l: 4 cm.; w: 3.3 cm.
Black serpentine rock; design
composed of globular drillings,
some with "tails"; partially recut
in modern times.
M.76.174.533

1040

Stamp, hemispheroid
h: 1.22 cm.; diam: 3.47 cm.
Buff marble; two pointed-eared
dogs, set one above the other;
drilled style.
M.76.174.539

1041

Stamp, hemispheroid
h: 1.27 cm.; l: 3.4 cm.; w: 3.05 cm.
Limestone; two tailed animals
(dogs?) placed one above the other
in crouching position; drilled style.
M.76.174.538

1042

Stamp, hemispheroid
h: 1.6 cm.; diam: 3 cm.
Green jasper; stag above a dog; a
serpent (?) in front of each animal;
circular drillings in the field;
drilled style.
M.76.174.537

1041

1043

Stamp, hemispheroid
h: 1.3 cm.; diam: 3.6 cm.
Red marble; design of two figures composed of globular drillings.
M.76.174.536

1044

Stamp, with lozenge-shaped base
h: 9.3 cm.; l: 3.56 cm.; w: 2.8 cm.
White marble; indefinable configurations of drillings.
M.76.174.544

For seals of similar shape with small uninterpretable drillings, cf. Amiet, 1972, *MDAI* XLIII, pl. 52: 269–71.

1045

Stamp, hemispheroid
h: 1.5 cm.; diam: 3.2 cm.
Green jasper; unidentifiable animal; double drillings above and below; drilled style.
M.76.174.540

1046

Stamp, hemispheroid
h: 1.3 cm.; diam: 3 cm.
Dark brown serpentine stone; crudely drilled pattern in the form of a "z" (perhaps a serpent); triangular forms in the intervening spaces.
M.76.174.541

1047

Stamp, tabloid
h: 1.28 cm.; l: 3.9 cm.; w: 3.72 cm.
Pink marble; six dogs in crouching position, arranged in a free-field composition; drilled style.
M.76.174.542

For tabloids with dogs, cf. Amiet, 1972, *MDAI* XLIII, pl. 57: 399ff.

1048

Stamp, tabloid
h: 0.7 cm.; l: 2.25 cm.; w: 2.13 cm.
Pink marble; two scorpions, set back to back; drilled style.
M.76.174.543

For a scorpion on a stamp of this style, cf. Amiet, 1972, *MDAI* XLIII, pl. 57: 378.

1049

Stamp, tabloid
h: 8.3 cm.; l: 3.6 cm.; w: 2.7 cm.
White calcite rock; three horned animal heads in profile above a row of four birds; in the field, a fourth small horned head and four circular drillings, one at each corner.
M.76.174.559

For related heads of horned animals, cf. Amiet, 1972, *MDAI* XLIII, pl. 53: 294. Evidence for the occurrence of skeletons of large birds of prey in association with goat heads was reported at the site of Shanidar (Solecki, *Sumer* XXXIII, 1, 1977, pp. 42–47).

1050

Stamp, tabloid
h: 0.84 cm.; l: 3.34 cm.; w: 2.7 cm.
Black serpentine rock; frontal female figure, highly abstracted, with legs outspread and arms redoubled; on either side of the legs, a short upright stroke; between the legs, a vulva (?).
M.76.176.560

For a human figure with spread legs, cf. Amiet, 1972, *MDAI* XLIII, pl. 57: 381; for the engraving technique, cf. ibid., pl. 53: 288.

1051

Stamp, tabloid
h: 8.8 cm.; l: 2.2 cm.; w: 1.8 cm.
Green-mottled black serpentine rock; indefinable design composed of a three-pronged object flanked beneath by two upright tubular marks.
M.76.174.561

1052

Stamp, disk-shaped with large button-shaped handle
h: 1.9 cm.; diam: 1.1 cm.
Black serpentine rock; unidentifiable tripartite design; drilled style.
M.76.174.563

For small seals of the late third millennium B.C. with drilled designs of somewhat related type, cf. Sarianidi, 1977, p. 141, fig. 64 (amuletic seals).

1053

Stamp, pillow-shaped with rectangular base
h: 2.4 cm.; diam: 1.8 cm.
White marble; dog (?) with lowered head and upturned tail; drilled style.
M.76.174.562

Seals of Iran and Mesopotamia (c. 3rd millennium B.C.)

1054

Stamp, conical with loop handle (broken)
h: 1.86 cm.; diam: 2 cm.
Marble; recumbent mountain goat; in the field, a drilled rosette; eleven small hollows drilled on seal exterior for inlays.
M.76.174.564

A closely comparable design is found on a stamp seal of translucent marble in the form of a lion's head from the level of the Square Temple (Early Dynastic II period, c. 2750–2500 B.C.) at Tell Asmar (Frankfort, *OIC* 19, 1935, p. 22, fig. 22). However, the style more closely resembles that of Early Dynastic I (c. 2900–2750 B.C.) as exemplified by *Corpus I*, 1948, no. 49 and seal impressions of Early Dynastic I date from Ur (Legrain, 1936, *Ur Excav* III, nos. 191, 207).

1055

Stamp, conical with loop handle (broken)
h: 1.45 cm.; diam: 2.1 cm.
Clay; goat, dog, and serpent (?) in free-field composition.
M.76.174.565

1056

Stamp, stepped pyramidal
h: 1 cm.; l: 1.9 cm.; w: 0.9 cm.
Burnt marble (?); two juxtaposed scorpions; in the field, a crescent and a star.
M.76.174.566

Several seals engraved with scorpions were found at Ur (Legrain, 1951, *Ur Excav* X, nos. 642–47). Of these, nos. 644 and 645 have a pyramidal shape somewhat related to that of the Heeramaneck example, which is probably of post-Agade date.

Stamp Seals of Iran, Bactria, and Mesopotamia (c. 2nd millennium B.C.)

1057

Stamp, disk-shaped with conical loop handle
h: 2.5 cm.; diam: 2.4 cm.
Bronze; design of volutes and parallel curves.
M.76.174.569

The curves of the seal are reminiscent of the wings of some creatures on Bactrian seals (Amiet, *Revue du Louvre* XXVIII, 1978, p. 160: 23 and p. 161: 30).

1058

Stamp, pillow-shaped plaque
h: 0.6 cm.; l: 2.1 cm.; w: 1.9 cm.
Bronze; decorated on both faces: a) bull facing left; beneath his feet, a serpent writhes with head upraised and jaws agape; b) winged lion with scorpion tail and open jaws; serpent below as in (a).
M.76.174.571

For a seal of similar shape and related style, cf. Amiet, *Revue du Louvre* XXVIII, 1978, p. 161: 28.

1059

Stamp, tabloid
h: 1 cm.; l: 3.7 cm.; w: 3.3 cm.
Black serpentine rock; decorated on both faces: a) horse; one bird above its back, a second inverted in the corner; b) saltire square with two of its triangular compartments further subdivided by median lines; surrounding, a rectangular frame similar to (a).
M.76.174.572

1060

Stamp, tall, conical with loop handle
h: 2.4 cm.; l: 2.1 cm.; w: 1.8 cm.
Black serpentine rock; human figure with long pigtail advancing with staff in one hand and an un-identifiable object in the other; from the arm of the staff-bearing hand depends a long spear-shaped object; two drillings flank the head.
M.76.174.567

1061

Stamp, pyramidal with loop handle
h: 2.14 cm.; diam: 1.57 cm.
Green serpentine rock; two ad-joining frontal masks, one in-verted; an unparalleled motif.
M.76.174.568

1062

Stamp, conical with tall handle surmounted by a bird
h: 2.7 cm.; diam: 1.9 cm.
Bronze; serpent; parallel lines in the field.
M.76.174.570

For seals of related but not iden-tical shape, cf. Negahban, *JNES* 36: 2, 1977, pp. 99–100, figs. 19–25.

Stamp Seals of Northern Syria (10th–8th century B.C.)

1063

Stamp, semi-bulla-shaped
h: 1.5 cm.; diam: 2.5 cm.
Brown serpentine rock; surface shows traces of delicate linear pat-terns, chevrons, parallel hatching, etc.; base recut with incoherent lines and drillings.
M.76.174.474

The seal represents a characteristic Hittite shape of the fourteenth–thirteenth century B.C., but the de-sign on the base is obliterated by secondary engraving.

1064

Stamp, hammer-shaped
h: 2.16 cm.; diam: 1.74 cm.
Buff limestone; walking lion; in the field above, the figure of a sit-ting gazelle placed upside down in relation to the lion.
M.76.174.487

For an Old Hittite seal with a hammer-shaped handle, dated late seventeenth or sixteenth century B.C., cf. Boehmer in Orthmann, 1975, *PKG* 14, pl. 375c and p. 447. Such forms were ancestral to those of the ninth or eighth cen-tury B.C.

1065

Stamp, circular with knob handle
h: 2.5 cm.; diam: 1.8 cm.
Black serpentine rock; two pairs of confronted animals consisting of a seated stag and lion and two inverted, standing, four-legged animals; indefinable lines in the field between the pairs and around the perimeter.
M.76.174.475

1066

Stamp, rectangular with perforated ridge handle
h: 3.6 cm.; diam: 3.24 cm.
White-mottled black serpentine rock; hero grasping two horned animals.
M.76.174.476

1067

Stamp, in the shape of an abbreviated lion's head (?)
h: 2.9 cm.; diam: 2 cm.
Soft red stone; walking lion.
M.76.174.477

1068

Stamp, rectangular with knob handle with crisscross decoration
h: 1.4 cm.; l: 2.2 cm.; w: 1.8 cm.
Black serpentine rock; griffin over a notched triangle.
M.76.174.478

1069

Stamp, oval with knob handle with crisscross decoration
h: 1.74 cm.; l: 3.2 cm.; w: 2.4 cm.
Black serpentine rock; horse(?) with lion above; bird at right angle in field beneath.
M.76.174.479

1070

Stamp, scaraboid
h: 1.16 cm.; l: 3.7 cm.; w: 2.6 cm.
Greenish black serpentine rock; goat with blossom(?) above its back and below its head.
M.76.174.480

1071

Stamp, scaraboid
h: 1.14 cm.; l: 2 cm.; w: 1.78 cm.
Black serpentine rock; leonine animal with forefeet extended; serpent below its body; several short lines in the field.
M.76.174.481

1072

Stamp, in the shape of a female head
h: 1.2 cm.; l: 2.6 cm.; w: 2.5 cm.
Black serpentine rock; two confronted figures with arms up-raised, dressed in flounced gar-ments; in the field above and to the right, horizontal and vertical strings of triangular notches, respectively; arch-shaped border of triangular notches around seal periphery.
M.76.174.482

For notched borders on Syrian seals, cf. the examples in Hogarth, 1920, p. 79, figs. 86–89 (from cremation graves at Merj Kamis near Carchemish, which preceded the graves of the Yunus cemetery with characteristic Assyrian cylin-ders of the 9th–8th century B.C.); cf. Riis, 1948, pp. 153, 202, figs. 195A,D for seals from Hama dated c. 1200–1075 B.C.

1073

Stamp, tabloid
h: 1.3 cm.; l: 2.4 cm.; w: 2 cm.
Black serpentine rock; decorated on both faces: a) recumbent horse(?), spray above; b) stag, curved line in the field above.
M.76.174.483

1074

Stamp, tabloid
h: 0.9 cm.; l: 2 cm.; w: 1.74 cm.
Green-mottled black serpentine rock; decorated on both faces: a) horse and rider with arms ex-tended; b) mountain goat with head reverted.
M.76.174.484

1075

Stamp, tabloid
h: 2.2 cm.; diam: 2.1 cm.
Black serpentine rock; decorated on both faces: a) kneeling sheep with greatly extended hind leg, head turned backward; in the field above, a notch and chevron; b) multi-rayed design.
M.76.174.485

1076

Stamp, plaque with loop handle
h: 4.4 cm.; diam: 3.5 cm.
Bronze; pair of confronted hooved animals with forelegs raised, seated(?) on hind legs and tail; tripartite plant between them.
M.76.174.486

No comparable stamp of this variety is known to the author.

1069

1072

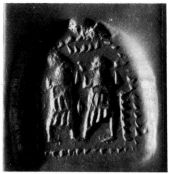

*Neo-Assyrian and
Neo-Babylonian Stamp Seals
(8th–6th century* B.C.*)*

Neo-Assyrian Stamp Seals
and Seal Amulets
(late 8th–7th century B.C.)

1077

*Stamp, conical with rounded top and
slightly convex oval base*
h: 1.9 cm.; l: 1.5 cm.; w: 1.2 cm.
Bluish chalcedony; four-winged
nude female, frontally positioned,
holding a mace in each hand.
M.76.174.594

A scaraboid with a very similar
figure was found in a Hellenistic
grave at Nimrud (Parker, *Iraq*
XXIV, 1962, pl. XVII: 7 and pp.
27 and 35). However, such deli-
cately engraved seals must have
been used for the impressions
with different subjects from the
Sargon level of the Northwest
Palace at Nimrud (Parker, *Iraq*
XVII, 1955, pl. XXII: 1–4 and pp.
113–14).

1078

*Stamp, conical with rounded top and
circular base*
h: 2.2 cm.; diam: 0.65 cm.
Lapis lazuli; fish-man holding a
flowing vase.
M.76.174.595

1079

*Stamp, conical with rounded top and
oval base*
h: 2.24 cm.; l: 1.74 cm.; w: 1.24 cm.
Colorless chalcedony; walking
long-eared animal carrying the
symbols of Marduk and Nabu, the
former symbol decorated with a
rosette.
M.76.174.593

The animal depicted is an adap-
tation of the serpent dragon, em-
blematic animal of these gods.
This adaptation is secondary, as is
the rosette added to the Marduk
symbol. The seal was therefore
recut by a person unfamiliar with
Babylonian iconography, but
it is impossible to say whether
this was done in antiquity or in
modern times.

1080

Stamp, scaraboid
h: 0.7 cm.; l: 1.5 cm.; w: 1.46 cm.
White marble; goat with fore- and
hind legs set together and head
turned backward; parallel ribbing
on torso and underside of neck;
crescent in sky.
M.76.175.574

In size, posture of head, and rib-
bing of the body, the subject
depicted closely corresponds to
the figure of a cow on the base of

the stamp cylinder cited below for
catalog number 1095. The present
seal should therefore be associated
with the same type of Assyrianiz-
ing cylinders and stamp seals of
probable Urartian derivation.

1081

Stamp, scaraboid
h: 0.8 cm.; l: 2.1 cm.; w: 1.54 cm.
Yellow chalcedony; goat with
fore- and hind legs set together.
M.76.174.592

The design is not precisely paral-
leled, but is sufficiently close to a
type employed on tablets of the
seventh century B.C. at Nimrud
(Parker, *Iraq* XVII, 1955, pl. XIX: 4).

1082

Seal Amulet, in the shape of a duck
h: 1.4 cm.; l: 1.9 cm.
Colorless chalcedony; goat stand-
ing on a rock, its fore- and hind
legs set close together; head ap-
parently turned back.
M.76.174.590

cf. a similar example with a find-
spot dated to the end of the
seventh century B.C. (Parker, *Iraq*
XVII, 1955, pl. XIX: 4 and p. 109).

1083

Stamp, in the shape of a duck
h: 1.9 cm.; l: 2.5 cm.; w: 1.3 cm.
Colorless chalcedony; deity, fron-
tally positioned, with six stars,
indicated by spheres, radiating
from the deity's upper body.
M.76.174.588

1084

Stamp, in the shape of a duck
h: 1.56 cm.; l: 2.3 cm.
Colorless chalcedony; long-robed
figure with one leg advanced, one
arm raised, the other lowered.
M.76.174.589

1085

Stamp, in the shape of a young bull
h: 2.15 cm.; l: 2.12 cm.; w: 1.12 cm.
Banded agate; horned animal,
with its feet close together, stand-
ing on a knoll (abbreviated by a
single drilling).
M.76.174.591

*Conical or Pyramidal
Neo-Assyrian or
Neo-Babylonian Stamp Seals
(late 7th–6th century* B.C.*)*

1086

*Stamp, octagonal conical with
rounded top*
h: 2.2 cm.; l: 1.76 cm.; w: 1.54 cm.
Bluish chalcedony; worshiper be-
fore an altar; the spade of Marduk
and stylus of Nabu rest on the
back of a serpent dragon which
lies directly upon the altar itself;
crescent in sky.
M.76.174.579

1087

*Stamp, octagonal conical with
rounded top*
h: 2.74 cm.; l: 2.06 cm.; w: 1.5 cm.
Colorless chalcedony; subject
as in cat. no. 1086.
M.76.174.580

1088

*Stamp, octagonal conical with
rounded top*
h: 2.6 cm.; l: 2.02 cm.; w: 1.24 cm.
Bluish chalcedony; worshiper
before an altar supporting the
spade of Marduk and the stylus
of Nabu; star in sky.
M.76.174.581

1089

*Stamp, octagonal conical with
rounded top*
h: 2.64 cm.; l: 2 cm.; w: 1.44 cm.
Yellow chalcedony; worshiper be-
fore an altar supporting the spade
of Marduk and lamp (on stand) of
Nusku; star in sky.
M.76.174.582

1090

*Stamp, octagonal conical with
rounded top*
h: 2.64 cm.; l: 2.04 cm.; w: 1.2 cm.
Black serpentine rock; subject as
in cat. no. 1089; crescent in sky.
M.76.174.583

1091

Stamp, octagonal conical with rounded top
h: 1.7 cm.; l: 1.5 cm.; w: 1.06 cm.
Colorless chalcedony; subject as in cat. no. 1088; altar abbreviated as a single line; crescent in sky; unusually small seal.
M.76.174.584

1092

Stamp, conical with rounded top and oval base
h: 2.14 cm.; l: 1.7 cm.; w: 1.44 cm.
Gray chalcedony; subject as in cat. no. 1088; star in sky.
M.76.174.585

1093

Stamp, conical with rounded top (modern gold pin in perforation)
h: 1.86 cm.; l: 1.5 cm.; w: 1.2 cm.
Bluish chalcedony; worshiper before an altar with the symbol of Marduk.
M.76.174.586

1094

Stamp, octagonal conical
h: 2.2 cm.; l: 1.96 cm.; w: 1.16 cm.
Red carnelian; worshiper standing before the spade of Marduk and stylus of Nabu in the opposite direction of cat. nos. 1086–92; dog of Gula, the goddess of healing, on side.
M.76.174.587

The engraving of the base is detailed and carefully executed, while that of the dog on the side of the seal is cursory and clearly secondary. The fact that the worshiper stands on the side opposite that of the conventional scene–in which the figure stands to the left of the divine symbols that occupy the place of honor on the right–may indicate that the seal was made outside Babylonia.

1102

Peripheral Neo-Assyrian Stamp Seals
(8th–7th century B.C.)

1095

Stamp, conical with rounded top
h: 2.1 cm.; l: 1.7 cm.; w: 1.34 cm.
Yellowish limestone; dog, symbol of Gula, seated on an altar; a worshiper stands before the altar; star and crescent in the sky.
M.76.174.578

The fine linear execution of the scene does not conform to Assyrian style of this period but is reminiscent of the Assyrianizing style of a stamp cylinder of probable Urartian origin found at Tarsus in Cilicia dated by the author after the middle of the eighth century B.C. (Porada in Goldman, 1963, III, fig. 162: 6A,B, and p. 350).

1096

Stamp, flat, scaraboid
h: 0.7 cm.; l: 1.7 cm.; w: 1.5 cm.
Black serpentine rock; kneeling sphinx before a plant; crescent in sky.
M.76.174.573

The posture of the sphinx–here depicted as though ready to rise–is more lively than comparable representations in Assyria and Babylonia.

1097

Stamp, hammer-shaped
h: 2.1 cm.; l: 1.57 cm.; w: 1.2 cm.
Jasper breccia; moon crescent above and below; two daggers flanking a star; these are probably symbols of major deities.
M.76.174.575

The seal shape was probably derived from examples with hammer-shaped handles of Syrian type. It is possible, however, that by this late period the shape had become common in Mesopotamia.

1098

Stamp, hammer-shaped
h: 1.75 cm.; l: 1.88 cm.; w: 1.5 cm.
Gray serpentine rock; crescent above an abbreviated sun disk.
M.76.174.576

cf. remarks for cat. no. 1097.

1099

Stamp, stone imitation of a scaraboid in metal setting
h: 1.74 cm.; l: 2.5 cm.; w: 1.6 cm.
Brownish marble; four-winged genius; upper torso and head marked by drillings.
M.76.174.577

Such imitations of metal settings of the type discussed by Culican ("Seals in Bronze Mounts," *Rivista di Studi Fenici* V, no. 1, 1977, pp. 1–4) may have originated in peripheral workshops.

1100

Stamp, in the shape of a kneeling bull
l: 2.86 cm.; w: 1.44 cm.; base: 1.2 cm.; w: 1.3 cm.
Black serpentine rock; base: winged genius holding a weapon.
M.76.174.488

The sharply gouged style is comparable to that found on Urartian designs as assembled by Seidl (in Kleiss, 1979, pls. 38ff. passim).

1105

Achaemenid Stamp Seals
(6th–late 4th century B.C.)

1101

Seal, conical with oval base and rounded top
h: 1.9 cm.; l: 1.46 cm.; w: 1.2 cm.
Dark brown marble; base: crouching boar beneath a winged sun disk; side: rampant lion with head turned back; crescent in the sky.
M.76.174.597

For a seal of related shape with similar curvaceous linear engraving, cf. *Corpus I*, 1948, pl. CXXV: 832a,b; also a cylinder from Gordion (Young, *AJA* 64, 1960, pl. 84, fig. 9 and an unpublished example, G 7287 55 199).

1102

Stamp, conical with oval base and rounded top
h: 2.54 cm.; l: 2 cm.; w: 1.6 cm.
Agate; pair of seated lion-griffins with heads reverted flanking a plant; crescent in the sky.
M.76.174.598

A much more elaborate plant appears between two sphinxes on a sealing from Nippur (Legrain, 1925, pl. XLV: 953 [the drawing on pl. LVIII is misleading]). Like the Heeramaneck example it displays a large number of leaves in the blossom.

1103

Stamp, conical with oval base and rounded top
h: 2.4 cm.; l: 1.94 cm.; w: 1.66 cm.
Jasper; pair of sphinxes with royal crowns flanking a censer.
M.76.174.599

For a related representation, cf. a seal impression from Nippur (Legrain, 1925, pl. XLI: 891).

1104

Stamp, conical with nearly rectangular base
h: 2.85 cm.; l: 2.2 cm.; w: 1.28 cm.
Burnt agate; hero and bull in combat; pin for suspension loop still in stone.
M.76.174.596

For the hero's gesture, cf. Legrain, 1925, pl. LVIII: 940, 941.

1105

Stamp, scaraboid
h: 0.9 cm.; l: 1.8 cm.; w: 1.4 cm.
Whitish and red carnelian; kneeling winged bull.
M.76.174.600

For this style, cf. Boardman, 1970, p. 322, who calls it "A GLOBOLO."

Magical Amulets
(c. 4th century B.C. and later)

1106

Amulet, prismatic
h: 2.05 cm.; l: 1.76 cm.; w: 0.9 cm.
Black serpentine rock; decorated on four sides: a) crossed lines; b) robed figure with staff; c) triangle dotted in the center, flanked above by a pair of four-pointed stars; d) leaping horse; chevrons in the field.
M.76.174.601

1107

Amulet, prismatic
h: 2.4 cm.; l: 1.6 cm.; w: 0.7 cm.
Black serpentine rock; decorated on four sides: a) figure in flowing robe; b) oblique lines; c) leaping horse; d) bent branch (?).
M.76.174.602

1108

Amulet, arch-shaped
h: 0.6 cm.; diam: 1.8 cm.
Brown serpentine rock; decorated on three sides: a) robed figure frontally positioned with upraised hands; vertical elongated wedge to left; b) galloping horse; c) couch (?) (base).
M.76.174.603

For a similar object found under the Hellenistic pavement at Tarsus in Cilicia, cf. author's remarks in Goldman, 1963, III, fig. 164: 30 and pp. 355–56.

1109

Amulet, pentagonal
h: 2.4 cm.; diam: 1.3 cm.
Brown serpentine rock; decorated on five sides: a) IPKE (?); b) demon; c) griffin with serpent's tail; d) serpent with griffin's head; e) coiled serpent.
M.76.174.604

For remarks on amulets of this type, cf. Bonner, 1950, pls. XIX–XX, pp. 238–39, s.v. 358, 359.

Sasanian Stamp Seals
(3rd–7th century A.D.)

1110

Stamp, hemispheroid
h: 2.3 cm.; diam: 1.5 cm.
Black agate; Gayomard with dog.
M.76.174.605

The description of this and the following seals is based on Bivar, 1969, II.

1111

Stamp, hemispheroid
h: 2.4 cm.; diam: 1.5 cm.
Lapis lazuli; figure on horseback.
M.76.174.606

1112

Stamp, bead-shaped
h: 1.3 cm.; l: 1.2 cm.; w: 1.14 cm.
Bronze; two birds placed one above the other.
M.76.174.607

1113

Stamp, bead-shaped
h: 1.8 cm.; diam: 1.3 cm.
Bronze; modern bezel.
M.76.174.608

1114

Bezel
h: 0.6 cm.; diam: 1 cm.
Banded stone; lion leaping over a crouching dog.
M.76.174.609

1115

Stamp Seal, in 19th century A.D. setting
diam: 1.5 cm.
Dark green jasper; abraded sealing surface; originally, a hunting scene with rider; bird and animal in the field.
M.76.174.610

Stamp Seals of Unknown Styles or Recut in Modern Times

Several stamp seals in the Heeramaneck Collection cannot be properly classified because their styles do not conform to those so far known. Some are probably genuine; others were recut in recent times. In either case, no comment can be made about them.

1116

Stamp, hemispherical with gabled back
h: 1.43 cm.; l: 4.1 cm.; w: 3.55 cm.
Travertine; two horned animals, one above the other; seal recut.
M.76.174.618

1117

Stamp, hemispherical with flattened top
h: 2.3 cm.; diam: 0.88 cm.
Serpentine rock; horned animal rendered in linear style.
M.76.174.619

1118

Stamp, square with rounded protrusions at each corner
h: 0.9 cm.; l: 3.44 cm.; w: 3.2 cm.
Serpentine rock; decorated on both sides with patterns of un-identifiable, irregular lines; the seal shape is unparalleled.
M.76.174.620

1119

Stamp, lentil-shaped
h: 3.3 cm.; l: 3.1 cm.; w: 1.1 cm.
Serpentine rock; horned, goat-headed (?) bird-demon; elongated drillings and rhomb (?) in the field.
M.76.174.621

1120

Stamp, semicircular disk with tall stem handle (fragmentary)
h: 2.4 cm.; diam: 2.7 cm.
Wood; intricate linear pattern; unusual seal shape.
M.76.174.625

1121

Stamp, squat cylinder with truncated conical top
h: 4.2 cm.; diam: 3.8 cm.
Yellow talc; design modern.
M.76.174.623

1122

Stamp, spool-shaped disk
h: 3.1 cm.; diam: 0.9 cm.
Black serpentine rock; decorated on two sides: a) seated figure and plant; b) horned animal; seal abraded and re-engraved; design modern.
M.76.174.624

1123

Stamp, lentil-shaped
h: 2.3 cm.; diam: 2.6 cm.
Black serpentine rock; two horned animals and a plant motif; recut in modern times.
M.76.174.622

Introduction: Cylinder Seals

Early Cylinders of Iran, Mesopotamia, and Syria (c. 3300–2900 B.C)

The Heeramaneck Collection is particularly interesting for its stylistically varied cylinder and stamp seals from Iran. Because their precise provenance is unknown, only the excavated material–of which the seals and impressions of Susa are the richest–helps to classify these seals. On one hand, a difficulty arises from the fact that Mesopotamian–and, in at least one case, Syrian–cylinders were used at Susa in this early period. On the other hand, cylinders from Mesopotamia and Syria proper also form part of this collection. It has seemed best then to assemble the cylinders of the early period in the present section, pointing out the specific characteristics of each piece, or small group of pieces, without attempting to provide a meaningful arrangement for the entire group.

The first cylinder described (cat. no. 1124) is the most interesting because of its style and subject matter. Its style is obviously derived from that of the levels of Uruk-Eanna IV a, equivalent to Late Uruk in terms of Mesopotamian chronology, but it varies from it in a manner to be detailed in an article devoted to a few of the outstanding cylinders of the collection in the *Bulletin* of the Los Angeles County Museum of Art.*

The cylinder's subject matter seems to be concerned with the herders' protection of their cattle. One figure leads a powerful dog, while the other appears to be holding up a large serpent, grasping it just below the head and thus rendering it powerless to bite. Holly Pittman notes that she has seen herdsmen at Tepe Malyan handle serpents in this manner. The cylinder has a loop bore; unlike the normal technique of drilling through the vertical axis, the suspension hole enters the top of the cylinder at the side and turns up again at a distance, thereby forming a loop which has been undercut between the two holes. Such loop bores are characteristic of Syrian cylinders of phase G of the Amuq, corresponding to the Jamdat Nasr period of Mesopotamia (c. 3000–2900 B.C.), but they also occur occasionally–perhaps under Syrian influence–in early cylinders of Iran.

The second cylinder (cat. no. 1125), a highly interesting Iranian example, depicts a bull pursued by a lion with a serpent rising above it. The style is distinctive and is not paralleled on any other known cylinders.

Mesopotamian examples are represented by cylinders 1126–28. The first (cat. no. 1126) shows squatting pigtailed figures juxtaposed with pots. This type appears in the main Mesopotamian sites from the late Uruk period onward, but it is also extensively represented at Susa and in Syria, where a particularly fine example was discovered at the site of Habuba Kabira. It is probably the most widely diffused of the late Uruk seal types.

By contrast, the depiction of horned animals before a temple (cat. nos. 1127 and 1128) seems to have been most common at the temple sites of Khafaje and Tell Agrab. Henri Frankfort thought they might have been dedicatory objects or amulets but that their function was probably not that of seals.

A Syrian origin may be suggested for two cylinders of this group (cat. nos. 1129 and 1130). The first has a double volute in the field, thereby corresponding to a seal impression on a potsherd from Susa considered by Amiet to be a Syrian importation. The second cylinder (cat. no. 1130) in its stylization of the lion's head, shows a kinship with the lion of seal impressions from Byblos and Jericho; the high curve formed by the backs of the horned animals–the lion's intended victims–in the Jericho imprints is also comparable. The intriguing problem of the relationship of the Byblos and Jericho imprints to seals of Elam was pointed out by Ammon Ben-Tor (Ben-Tor, 1978).

The loop bore of cylinder 1131, mentioned in connection with cylinder 1124, may also suggest a link between Iran and Syria, areas greatly distant from one another. The file of animals depicted on this cylinder is quite representative of the flat-bodied, long-necked goats common in numerous seals from Susa in which branches or other features appear in the field over the backs of the animals; a parallel from Tell Asmar may also be cited. The animal file on cylinder 1132, although uncharacteristic in style, may belong to the same series. The subject, a file of what appear to be three dogs, is a highly interesting and unique representation on a seal shaped like a byre. The few examples of such byre-shaped cylinders depict horned animals, ostensibly situated outside the building in which they would seek protection. If correctly identified as such, the dogs on cylinder 1133 offer a parallel to the frequent representation of such animals on the drilled tabloids and hemispheroids, as well as on amulets in animal form, of the late Uruk and Jamdat Nasr periods in Mesopotamia. Depicted on another interesting cylinder (cat. no. 1134) is a seated pigtailed figure facing two gigantic birds. Its style is reminiscent of the Proto-Elamite phase of Susa with respect to the importance given to animal forms. Formally, however, the style, in its linearity and its sharp angularity, is quite different.

The following five cylinders (cat. nos. 1135–39) have geometric patterns similar to those of the Jamdat Nasr period in Mesopotamia and Iran. The double row of single, small-pointed ovals on cylinder 1135 is similar to those on examples from Susa. The double lozenges of cylinder 1136, as well as the pair of pointed ovals of cylinder 1137 are found not only at Susa, but also at Surkh Dum in Luristan. Patterns of curving and oblique lines (cat. nos. 1138 and 1139) are also seen at Susa.

Cylinders of Various Styles, Transitional Period (c. 29th century B.C.)

The period after 3000 B.C. was one of transition and of development of new styles in seal engraving, such as the Brocade style (named by Frankfort) of the Diyala region sites and the styles of Ur, the best known of which utilizes interlocking forms, including signs of writing.

The pattern-like Brocade style probably gave expression to a prevailing desire for overall filling of the field with repeti-

* The seals in this section slated to receive more detailed treatment in the forthcoming article to which the author refers are indicated with asterisks.

tive designs. On cylinders 1140–42 the field has been filled by organized designs–a chevron pattern (cat. no. 1140), chevrons and animal forms (cat. no. 1141), and two walking goats (cat. no. 1142)–resembling in their flat forms the Brocadestyle seals of the Diyala sites.

Interlocking forms are seen on cylinder 1143, which depicts two facing human figures, one seated on a bird, the other on an animal; the lines echo those of the figures and fill the field in an almost symmetrical design, the meaning of which is not quite clear.

A cylinder that was cut in half in antiquity, though doubtless long after it had been made (cat. no. 1144), is included here because the stone and the proportions of the cylinder, as well as the deeply gouged design, probably indicate that the piece was originally made in this or in the preceding period.

Cylinders Related to the Early Dynastic Style of Mesopotamia (c. 2750–2350 B.C.)

Feline animals, such as lions and leopards, as well as ruminants, such as goats, sheep, and bulls standing on their hind legs in postures approximating those of human beings, appeared in works of art of the Early Dynastic period of Mesopotamia. Represented in groups of contest and other activities, they seem to have influenced the art of the surrounding regions, particularly of Iran and Syria. The criteria derived from stratigraphically excavated sites and from sealings–some of them bearing names of historically known persons–cannot be expected, however, to have equal significance outside Mesopotamia. While specific circumstances caused the abandonment of some features in a Mesopotamian style and the adoption of others at certain times, this would not have had any effect on a cylinder inspired by a work of Mesopotamian art at an Iranian site. Hence, features which would dictate an early date if seen in the context of Mesopotamian glyptic art could have been produced at a much later date in Iran. The cylinder seals of the present group, which show the influence of Early Dynastic Mesopotamian art, are therefore arranged according to Mesopotamian dating criteria with the understanding that these may indicate a far earlier date than that of the cylinder's actual origin.

A good example is cylinder 1145,* which shows a man menacing a lion with a curved weapon. The five-pointed star, so prominently featured on the cylinder between the lion and the gazelle, and the oval form over the lion's back occur in Mesopotamian seal designs in sealings from Ur assigned to the First Early Dynastic period (c. 2900–2750 B.C.). But the open composition, the natural forms of the animals, and the graceful figure of the gazelle fit within a context of 2500–2400 B.C. in Mesopotamia. The date could scarcely be earlier in Iran, where the cylinder was probably made, judging by the size and importance of the lion in the scene. By contrast, in Mesopotamian representations, man always dominates his surroundings.

In a different type of representation (cat. no. 1146), a man walks behind two horned animals, perhaps pursuing them in a hunt. The subject, the scene's static character, and its small size, crude execution, and human and animal forms suggest a Syrian origin for the cylinder, perhaps in the middle of the third millennium B.C.

Cylinder 1147 offers another lively Iranian representation; here a rearing lion attacks a stag from behind, burying its claws in its victim's back at the place where the spinal cord can be most easily severed. A lion in the same posture attacking a ruminant is shown in a seal impression from Susa, dated to the Second Early Dynastic period (c. 2750–2500 B.C.).

A feature never encountered in Mesopotamian animal contest scenes appears on cylinder 1148, where a large rosette is seen above a double animal terminating in the head of a lion and that of a bull. Like the well-known Proto-Elamite representation (cf. cat. no. 1148), with its depiction of a gigantic bull dominating two small lions and a lion of comparable size towering over two small bulls, the double creature of the Heeramaneck example probably expresses a basic Iranian concept of a balance of the great powers in nature.

A distinctive Iranian glyptic style of mid-third millennium date was discovered at Shahdad, where the use of the drill survived in refined form from the Protohistoric period of the Uruk and Jamdat Nasr styles, through the period contemporary with Early Dynastic and Agade in Mesopotamia (i.e., until the last quarter of the third millennium B.C.). Cylinder 1149 appears to be an example of this style; moreover, the combination in this contest scene of three stags and no felines would have been unthinkable in Mesopotamian art. On the other hand, the subject of cylinder 1150, a small lapis lazuli piece which depicts a pair of crossed lions, each grasping a ruminant, is a favored Mesopotamian motif, suggesting that this example could well be of Mesopotamian origin.

A different scheme of animal contest, not paralleled in Mesopotamia, may be seen on cylinder 1151.* Instead of restraining beasts of prey such as lions, the two heroes depicted on cylinder 1152 grasp horned animals, suggesting that different concepts underlay the representation of such schemes of animal contest, ones quite different from the protection of herds and ruminants which the Mesopotamian schemes seem to imply. This is also demonstrated by a cylinder of unusual style (cat. no. 1153); here a hero apparently restrains a feline which leaps, in turn, upon another feline which turns back toward a standing goat. This is a scheme that, on present evidence, cannot be interpreted.

The representation of birds in association with undulating lines, probably indicating water, was an enduring motif. It is found on Mesopotamian seals from the late Early Dynastic period–when it was combined with an additional figure featured in the second of the two curves formed by the undulating band, as in examples from Ur and Khafaje–to the post-Agade period, when the bird was repeated upside down in the second curve of the band, as on cylinder 1154. Such a design was especially appropriate for cylinders worn horizontally, as was the case with several examples from Iran on which the wear pattern of the string-holes can be studied. Indeed, a cylinder resembling the Heeramaneck example was found at Susa, indicating that the type was in fact worn in Iran. A similar practice may have applied to the guilloche design of cylinder 1155, for which I know no Mesopotamian parallel. One might suggest a date in the first half of the third millennium B.C., based on the occurrence of a closely related guilloche pattern on a fragmentary steatite or chlorite vessel found at Mari but probably made in southeastern Iran.

Banqueting scenes, of which a large number were found in the tombs of the royal cemetery of Ur, appear to have been imitated in the drilled Shahdad style (cf. cat. no. 1156). A second example of the motif is found on cylinder 1157. While its execution is closer to the linear treatment of the cylinders from Ur, there are small details for which I know no Mesopotamian parallels; for example, the vessel from which the banqueters' drinking tubes protrude has a spout. Once the question about the origin of the cylinder is raised, one may find other features without Mesopotamian parallels, such as the way human faces are indicated. It therefore seems at least possible that cylinder 1157 was also copied from a Mesopotamian prototype outside Mesopotamia, presumably in Iran.

Cylinders of the Agade Period (c. 2334–2154 B.C.)

Cylinders of the Agade period introduce a different character into the art of Mesopotamia: animals, humans, and gods take on a new reality. In the Heeramaneck Collection the earliest cylinder of the Agade period (cat. no. 1158) shows a typically tripartite Early Dynastic motif, a bird of prey grasping two ruminants. Here, however, the bird is shown with an angry open beak that resembles a profiled lion's head with open jaws, and with an exaggeratedly long tail that suggests a man's robe. The bird's supernatural character has thus been given vivid expression. Some of the lively features found in the Agade cylinders of this collection may be due not only to stylistic change but also to the fact that the pieces were made in Iran, where seal cutters appear to have introduced expressive postures and other details of their own which would have been unacceptable within the "classic" style of the Agade seal cutters of the southern Mesopotamian town. Such a motif occurs on cylinder 1160, a bull-man crossed with a lion in a central group in which two lions menace another bull-man. The likelihood that it was made in Iran may be indicated by the fact that a hero attacks the lion at the left with a spear, a feature that may be derived from an early Iranian tradition of hunting scenes.

That such seals were not made by typical Mesopotamian engravers can be shown by the manner in which the stars are carved. These are usually created by a cross, the diagonals of which transform it into an eight-pointed star. In Iranian seals the stars are often made by supplementary irregular lines added to give the impression of an astral body. This is true of the sun god's symbol, or "star spade," in the contest scene of cylinder 1159, and of the star placed in the lower part of the field–unlikely in a truly Mesopotamian contest scene–on cylinder 1160.

Some of the cylinders that look non-Mesopotamian are probably of northern rather than Iranian origin. Thus, a cylinder showing a lion pursuing a goat (cat. no. 1161) in what may be termed "cut style," is almost identical to one found in a late Agade context at Tell Asmar in the Diyala region. Whether unusual iconographic features, such as a bull-man wrestling with a bull instead of with a lion (cat. no. 1162), indicate a different concept of the bull-man or merely a thoughtless provincial carver's combination cannot be determined here.

The cylinders thus far mentioned are obviously earlier than those with only two pairs of figures. Moreover, cylinder

1163 provides a dating criterion in its representation of a bison, which replaces the human-headed bull in cylinders of the Agade III glyptic phase (the time extending from King Naram Sin [2254–2218 B.C.] to the end of the dynasty under Shudur-ul). A second cylinder (cat. no. 1164), with its two pairs of figures in classic Agade scheme, shows the interesting feature of a bull-man pointing a dagger at the hindquarters of a lion, possibly at his sexual parts. The scene is a variation of the one represented on a cylinder in the British Museum where two nude, bearded heroes hold lions up by their hind legs in much the same way.

The cylinders depicting gods and humans in various ritual scenes (cat. nos. 1165–69) range from Boehmer's second phase (the time of kings Rimush and Manishtushu [2278–2255 B.C.]) to his third; cylinder 1165 belongs to Agade II on the basis of the shape of the gods' miters as determined by Boehmer. The enthroned god, who is approached by a procession of minor gods leading a human worshiper, may be identified as the moon god Sin by the crescent in the field above him. Probably from the same phase is cylinder 1166.* Here the enthroned god, rays emerging from his shoulders and an upright saw in his hand, may be identified as the sun god Shamash, favored on cylinder seal designs in this period and again in the Old Babylonian period, probably because of his role as a personal protector of justice.

On cylinder 1167 a goddess seated to the left receives two gods who introduce a female worshiper, her hands clasped at her waist in a typically Elamite pose. This posture and the graceful curve of her dress indicate an Iranian origin for the cylinder.

Cylinder 1168 is problematic because it was probably recut, perhaps by an amateur engraver in antiquity; this unfortunately cannot be determined, however, as the cylinder was not found in a controlled excavation. The subject of cylinder 1169, a procession of figures toward an enthroned personage who is similarly robed and lacks all markings of divinity, is a very unusual representation, suggesting that it, too, was made outside southern Mesopotamia. The fact that the figure standing before the enthroned personage (who seems to raise a cup) extends his hand in a gesture typical of a cupbearer suggests a similar identification for this figure, too. It is also possible that the enthroned personage holds an object which the standing figure is about to receive. Perhaps the origin of the cylinder should be sought in northern Mesopotamia, where a cylinder with similarly robed figures was recently excavated.

Apparently, cylinder 1170 was unfinished. Here again, the fact that the cylinder was not discovered in a controlled excavation makes comments on this unperforated, unfinished seal inadvisable.

Cylinders of the Third Dynasty of Ur (c. 2112–2004 B.C.)

The three cylinders that can be dated to the time of the Third Dynasty of Ur depict the three main themes of that glyptic phase: worship of a god, worship of a deified king, and a contest of two heroes with a lion or winged lion-griffin. Cylinder 1171 depicts an enthroned god, his hand raised toward a goddess who leads a bald-headed worshiper; the god is seated on a platform upon which a dog appears to lie, a feature for

which I know no parallel. A few representations depict a seated lion beside the throne, but none overlaps the central support in the manner seen here, nor, as far as I know, is a dog shown in this position. This feature could have been added when the inscription was erased. At this same time, the rather scrawny, linear, lion-headed eagle and scorpion placed between the figures may also have been added. At Tello the lion-headed eagle, often found below the inscription, is a more massive, heraldic figure than the one inserted here, which was probably the work of a provincial seal cutter.

The scene of the worship of an enthroned, deified king illustrated on cylinder 1172 is of special interest because the figures in this well-cut piece are realistically scaled; the worshiper's head is level with that of the goddesses, but the latter's crowns reach far higher than the top of the mortal's head. This obvious difference between the height of the crown and the worshiper's head is not usually expressed so clearly. It is therefore most regrettable that the inscription, dating the cylinder to the reign of a specific king of the Ur III dynasty, was erased.

The third cylinder of this period (cat. no. 1173) shows two imprecisely stylized heroes fighting a lion, a motif paralleled on a sealing from the time of King Shu-Sin (2037–2029 B.C.). It may be noted that, unlike the previous two hematite cylinders (cat. nos. 1171 and 1172), which, judging by the length of the erased inscriptions, were probably those of officials, cylinders of this period with contest scenes were usually made of softer stones. Perhaps they were made for a different clientele.

Cylinders of the Old Babylonian Period (c. 2000–1600 B.C.)

Old Babylonian cylinders span a period of four hundred years. Despite the useful lists of dated cylinders and impressions assembled by Nagel (*AfO* XVIII, 1958), their chronological differentiation has not yet been firmly established. The task of assigning approximate dates to the Old Babylonian cylinders made before the time of Hammurabi, however, will be greatly enhanced by the publication, in Lamia al-Gailani-Werr's *Studies in the Chronology and Regional Styles of Old Babylonian Cylinder Seals,* of seal impressions from Tell Harmal and Tell El-Dhiba'i in the Diyala region, Sippar and Tell el-Der in the region of Agade and Larsa, and from Ur in southern Mesopotamia. A general division between the seals made before and after the time of Hammurabi was previously suggested by Henri Frankfort, who called cylinders of the earlier phase "Isin-Larsa," after the historical period dated roughly 2000–1800 B.C. Al-Gailani-Werr's contribution consists in her inclusion, in the earlier period, of the majority of iconographically interesting, multi-figured scenes of animal contest and of scenes involving great deities. Restricted to the earlier period, as well, are nearly all the scenes, derived from the glyptic art of the Third Dynasty of Ur, featuring worshipers before an enthroned king.

Animal contest friezes of Early Dynastic and Agade date reappear in the Old Babylonian period (here represented by cylinders 1174* and 1175), augmented by two pairs of figures that probably introduced a new meaning into these scenes: the nude man fallen on his knee, victim of a lion or winged lion-griffin, and the goat on the knoll, typically attacked by a lion-griffin. The fallen man may represent a defeated enemy; the

lion and goat, as I suggested in my *Corpus of Ancient Near Eastern Seals*, may represent two constellations. One, the lion-griffin (MUL UD.KA.DUH.A) was associated with Nergal, god of the netherworld; the other, the goat (MUL UZ), was associated with the "lady of the predictions of the sacrifices." This association of these two figures with constellations is based on the text of an astronomical tablet known as the "twelve times three." The number twelve refers to the months of the year, while the three signifies the constellations which reappear in the nightly sky in the respective month after a period of invisibility. The names given in the list for the ninth month are: "Mars," "demon who opens (wide) his mouth," and "goat." The equivalent meanings are given as "death" (Mars), "Mars" ("demon who opens [wide] his mouth"), and "lady of the predictions of the sacrifices"("goat"). This juxtaposition, suggested in the text, of a death-dealing figure and an apparently protective symbolic figure, explains the otherwise incomprehensible association of the winged lion-griffin generally taken to be the "demon who opens (wide) his mouth" and the goat. How much this influences the meaning of the entire scene remains to be discovered.

The introduction of a worshiper to an enthroned king, a theme illustrated on cylinders 1176–79, continues from the Third Dynasty of Ur. The style is characterized by a hardening of the lines, a feature typical of cylinders resembling that of Ur-Ningizzida of Eshunna, dated about 1900 B.C. The worshiper, formerly bald-headed, is now characterized by a cap-like rendering of the hair, a feature that becomes ubiquitous toward the end of the twentieth century B.C. In the course of the nineteenth century, however, this subject disappears.

Upon comparison with al-Gailani-Werr's groups IV and III from Tell Harmal, to which cylinder 1180 stylistically belongs, this piece is an example of one of the multi-figured scenes of the nineteenth century B.C. It is worth noting that here a water goddess, certainly a kindly, beneficent deity, is placed beside the god with a scimitar, probably Nergal, god of the netherworld. Elsewhere, that god is often accompanied by a priest holding a pail and sprinkler (as noted by al-Gailani-Werr), probably to counteract the influence of the dreaded god.

The fine style of the early Old Babylonian period of the time of the Assyrian king Shamshi-Adad I (1813–1781 B.C.) is exemplified by cylinder 1181. In its tripartite composition (involving the sun god, Shamash) and its well-executed figures, it corresponds to a cylinder (now in the Louvre) inscribed for one of Shamshi-Adad's servants. By a slightly later date, the motif of the king as a warrior facing a suppliant goddess, the former wearing a tunic (one end of which falls between his legs) and holding a mace, had become the most frequent theme on cylinder seals. That it was favored by the kings of the period is shown by the seal impressions from Tell al-Rimah (ancient Karana) to which catalog number 1182 in the present collection may be compared. The posture of the king as a warrior was also employed for male figures (possibly warriors) which wear a headgear not clearly defined as a horned miter but nonetheless probably indicative of divinity (cf. cat. nos. 1183 and 1184).

A remarkable number of cylinders in the Heeramaneck Collection depict the weather god, Adad, easily identified by

his lightning fork. One (cat. no. 1186), a crudely worked and damaged cylinder, is inscribed for a servant of Ibalpiel. Despite the poor quality of the engraving, the cylinder, judging by its open composition, may refer to Ibalpiel II of Eshunna and Tell Harmal, a contemporary of Hammurabi. On the cylinder, the weather god is depicted standing on a bull, holding the reins of his mount as well as his lightning fork. On another cylinder (cat. no. 1187), which again shows the undisguised use of drilling, a feature first appearing in the time of Hammurabi's son, Samsuiluna (1749–1712 B.C.), a small lightning fork appears over the saw of Shamash. This may indicate the association of Shamash and Adad, even though in southern Mesopotamia, Shamash, as the judge of heaven and earth and protector of the poor and wronged, was by far the more important of the two. His importance, in fact, may be seen in the large number of Old Babylonian cylinders either representing him or explicitly naming him in their inscriptions. The fact that relatively few cylinders in the collection represent or name this god confirms an origin outside southern Mesopotamia for the majority of these seals. This accounts for the diversity of subject matter and style of cylinders 1188–90, none of which can be assigned to a specifically known group.

On the other hand, cylinders 1191–93 do belong to a known group featuring suppliant goddesses flanking an inscription. This motif goes back to the time of King Rim-Sin of Larsa (1822–1763 B.C.), an older contemporary of Hammurabi. The appearance of a single suppliant goddess and deity, or of a single deity alone, probably implies a disintegration of the motif by the seventeenth century B.C.

Old Assyrian Cylinders (c. 1920–1700 B.C.)

There are two separate groups of Old Assyrian cylinders among the seal impressions on tablets of the Assyrian merchant colony, the Karum Kanish at modern Kültepe in Anatolia (Özgüç, 1968, TTKY V: 23) The cylinders of the earlier group, belonging to level II of the Karum (c. 1920–1840 B.C.), are carved in a deeply gouged, angular manner; their subjects are mostly limited to scenes of worship of an enthroned king or god. The later group, from level Ib of the Karum (which probably covers a good part of the eighteenth century B.C.), is characterized by more delicate carving and a variety of subjects; frequently represented are groups of animal contest. The use of hatching to differentiate body surfaces of humans and animals is characteristic of this style, which continues to utilize rather angular forms. Distinctive of dress depicted in this style are garments crossed over the breast and caps with small vertical hatchings on the brim, perhaps indicating fur. Cylinder 1194 belongs to the Early Old Assyrian group; cylinders 1195 and 1196 belong to the Late Old Assyrian group.

Two cylinders of the late nineteenth or early eighteenth century B.C. which depict Old Babylonian contest motifs (cat. nos. 1197 and 1198) are included in the present group because they doubtless originated on the periphery of metropolitan Babylonia in the late nineteenth or early eighteenth century B.C. They may be from within the territories of Assyria, or perhaps from some other provincial region.

Cylinders of Classic Syrian Style (c. 1820–1740 B.C.)

There are three cylinders of Syrian style in the Heeramaneck Collection. All three belong to what I call the "classic" style of Syrian glyptic art because of the restrained postures and costumes of the figures and the rather static character of the composition. On cylinder 1199, as on several Syrian examples, the goddess stands at the left and the king at the right, the reverse of the order on Old Babylonian cylinders. The reason for this positioning may have been that in Syria the engraving on the seal stone was more important than its impression–and on the cylinder itself the goddess stands in the place of honor, on the right!

The close relationship of cylinder 1199 to one in the Louvre suggests that the hand of a specific engraver can be discerned here. An unusual motif is the buck mounting the female goat, employed here as a secondary motif oriented at a right angle to the axis of the cylinder. The motif is not paralleled in Syrian cylinders so far published, but it occurs on cylinders of Neo-Assyrian linear style of the ninth century B.C. A lion, his outlines barely discernible, was originally carved on the cylinder, perhaps menacing the goats placed beside him. A secondary use of the cylinder as a bezel or pendant appears to have caused the abrasion of this part of the design.

The central figure of cylinder 1200 is the weather god who holds with one hand a serpent and shoulders a mace with the other. Behind him stands a bareheaded person holding a crook over his shoulder and wearing a long, wrapped, patterned kilt. Before the weather god stands a second person who is bareheaded like the first but is wrapped in a cloak with rolled borders, a feature distinguishing kings in Syrian cylinders. A goddess of Egyptian type stands at the far left. The scene may represent a king and his crown prince, since the crook is often carried by a secondary figure without insignia of royalty. The fact that the crook is carried over the shoulder is uncommon.

The third cylinder (cat. no. 1201) shows the unusual and interesting motif of two figures juxtaposed, each placing one foot upon a platform while "shaking hands." Centered above their hands is a crescent moon. There are several comparable scenes in Syrian art that may perhaps be interpreted as depicting the conclusion of a treaty between two kings. This may be the meaning here. The secondary motif is almost as unusual as the principal one–a row of hares over a row of birds coupled below with a hare in front of a fish. The significance of these animal figures escapes us, but it is likely they had relevance to the main scene and were not simply decorative fillers.

Mitannian Cylinders (c. 1500–1300 B.C.)

A style of engraving characterized by figures largely composed of drillings came into general use in the fifteenth century B.C. The style is generally called Mitannian even though the cylinders bearing such engraving were actually made beyond the frontiers of the Mitannian Empire. In the present collection, cylinder 1202,* engraved in two registers with a series of apparently unconnected motifs, recalls a cylinder seal impression on a tablet of the Assyrian king Assur-nirari II

(1424–1418 B.C.) recording a land grant, thus suggesting an approximate date for the Heeramaneck example in the second half of the fifteenth century B.C. The fly appearing prominently below the bull-men (whose bodies seem to be merged) suggests an Iranian origin for the cylinder, as large flies of a related form were very prominent in Elamite seal designs.

A second cylinder (cat. no. 1203), showing a winged female figure with a sun disk on a pole, flanked by lion-griffins, is typical of a style well represented at Nuzi. A related design on a seal impression from that site shows a similar but wingless figure placed beside lion-griffins spewing fire. This suggests that these creatures are still adjuncts of the weather god and that the nude female represents the god's consort, as she does in several cylinders of the Agade period. In Old Babylonian cylinders the nude female is not only associated with the god's bull and lightning fork, but she also represents the god's consort. The Mitannian designs seem to have preserved the earlier northern tradition of the weather god's lion-griffins.

The appearance of the boars' heads in association with the lion-griffins of the weather god, and possibly also with his consort, may perhaps explain the presence of a large boar's head discovered in temple A at Nuzi.

Two cylinders (cat. nos. 1204 and 1205) apparently depict lion- or bird-headed demons among monsters and animals, two of which are usually symmetrically arranged. Cylinders of this type were acquired in northern Syria (Buchanan, 1966). As no ordering principle can be discerned in the design of cylinder 1206, its geographic origin cannot be suggested.

Four cylinders of this group are made of hematite (cat. nos. 1202 and 1204–06); cylinder 1203 is of yellow chalcedony. Another small cylinder (cat. no. 1207), however, is of faience, placing it in a different category, as does its unusual motif, consisting of two crouching lions, one behind the other, over a guilloche design. No cylinder exactly like this is known from Nuzi or other sites where Mitannian-type cylinders have been found, although the style corresponds to that of the widely distributed faience cylinders of "common" style.

Kassite Cylinder (c. 14th–early 13th century B.C.)

A fine Kassite cylinder seal (cat. no. 1208) showing a seated deity raising its hand toward an inscription of seven lines is carved in the same style as a cylinder in the de Clercq Collection (Menant, 1888). Unfortunately, neither contains the name of a Kassite king which would make possible a more precise dating within the fourteenth or early thirteenth century B.C.

Elamite Cylinders (c. 13th–12th century B.C.)

The lively hunt from a chariot illustrated on cylinder 1209* can be identified as Elamite on the basis of the large fly in the upper field which distinguishes Elamite cylinders of the thirteenth and twelfth centuries B.C. So far no other example of this subject in the same Elamite style is known, but Middle Assyrian impressions of the time of King Ninurta-Tukulti-Assur serve to confirm the date of the seal.

The subject of cylinder 1210, a scorpion-man threatening a goat, may reflect an increase in the popularity of depicting monsters fighting ruminants in Middle Assyrian cylinders of the twelfth century. Heroes in human form had predominated as the opponents of animals and monsters in cylinders of the thirteenth century B.C. The attenuated, almost linear engraving of the scorpion-man, however, differs from the fully modeled examples known from seal impressions on tablets from Assur. Moreover, the eight-pointed squarish form of what may have been intended as a star is not found in Middle Assyrian designs, although there are several somewhat related designs from Susa. The seal is therefore included here tentatively; while it does not belong to any known Elamite style, it probably reflects a Middle Assyrian prototype.

A cylinder of unquestionable Elamite origin (cat. no. 1211) has as its decoration a series of chevrons and inlaid bands of a dark material. It is probably more an ornamental bead than a seal, yet objects like these were included with the cylinders deposited in the chapels of Tchoga Zanbil.

Neo-Assyrian and Neo-Babylonian Cylinders (9th–7th century B.C.)

Neo-Assyrian Cylinders of Linear Style (9th–8th century B.C.)
Neo-Assyrian cylinders are characterized by designs gouged out of such materials as soft chlorite, steatite, marble, or limestone. Although found in large numbers at Assur in the ninth century B.C. context, they were widely diffused over an area ranging from Palestine, Syria, and Anatolia to Iran. Many such seals were surely brought from Assyria proper, but others were imitations made outside Assyria. Cylinder 1212 sufficiently resembles cylinders of the ninth century B.C. found at Assur to be dated to the same period; its apparent use as part of a fibula, however, was not known in Assyria. The subject, moreover, an archer aiming at a sphinx, lacks the plant or lozenge usually placed between the monster and its attacker. In my opinion, it is this object which is threatened by the sphinx and defended by the archer. Hence the reason for the attack has been omitted by an engraver who probably considered the existence of the sphinx reason enough for the archer to attempt to eliminate it. The strange proportions of the sphinx, with its heavy body and short legs (squarely planted on the ground, in contrast to the single raised foreleg of Assyrian compositions), and the large ungainly wing, as well as the misunderstood narrow lozenge above the monster's back, all indicate a provincial origin for the cylinder.

By contrast, cylinder 1213 is so closely related to ones found at Assur that we can assume it was probably made in Assyria. The date is again probably the ninth century B.C. The subject of a very interesting cylinder (cat. no. 1214*)—a moon-crescent on a pole appearing within a gate—is probably meant to represent the symbol of the moon god seen through the gate of the temple. Its date may be inferred from the slender form of the divine symbols beside the temple, which can be compared to examples on cylinders of the late eighth century B.C. An Iranian origin is likely, based on the pointed merlons typical of Iranian cylinders which appear atop the gate and towers.

A different group, related to the gouged Neo-Assyrian cylinders of the linear style, is made of faience instead of stone; its forms are correspondingly more rounded (cf. cat. no. 1215). The ninth–eighth century B.C. date for the group, suggested

by Moortgat, can probably be narrowed down to a late ninth to early eighth century date on the basis of its occurrence outside Assyria.

Neo-Assyrian or Neo-Babylonian Cylinders of Cut Style (9th century B.C.) Cylinders made of chalcedony and other fine hard stones with very shallow engraving (like glass cut with a mechanically agitated drill) usually depict genii flanking a sacred tree, as on cylinder 1216. The earlier cylinders of the group probably date to the ninth century B.C.

Neo-Assyrian Cylinders of Drilled Style, Late Group (8th–7th century B.C.) Hard and often colorful stones were used for cylinders carved with a drill; the figures depicted on them are composed largely of small and larger hollows. This technique imparts a sparkling quality suggestive of the astral splendor of the deities such cylinders were intended to portray. The examples in the Heeramaneck Collection (cat. nos. 1217–19) come from the later phase of the style, probably datable to the late eighth and seventh centuries B.C. The first cylinder (cat. no. 1217) possibly depicts the goddess Ishtar, star goddess par excellence, within her aura of stars. The second (cat. no. 1218) shows a motif which was favored in cylinders of this style, the pursuit by a god or genius of a lion-griffin, the latter probably representing a destructive storm monster.

Symbolic forms, such as a table below a winged disk (cf. cat. no. 1219) were executed in the same drilled style; they were probably intended to bring luck to the seal owner.

Neo-Assyrian or Neo-Babylonian Cylinders of Modeled Style (late 8th–7th century B.C.) At the end of the eighth century B.C. and continuing into the seventh, a number of delicately modeled cylinder seals were produced in Assyria and Babylonia, mostly showing a hero overpowering ruminants or monsters. The Heeramaneck example (cat. no. 1220) displays a plant with outward-bending leaves which is typical of Neo-Babylonian cylinders, thus suggesting a comparable date. The scorpion-man illustrated on cylinder 1221, an example featuring a hero with two stags, confirms an attribution to the same group; the scorpion-man was a frequently depicted motif in the Neo-Babylonian repertoire.

Peripheral Cylinders (9th–7th century B.C.)

A number of cylinders in the Heeramaneck Collection display affinities with seals made in Mesopotamia during the time of the Assyrian Empire, and yet diverge stylistically or iconographically from the Mesopotamian prototypes to such an extent that it seems justifiable to place them in a separate group. For several of these cylinders an Iranian origin may be suggested; others are impossible to locate.

The first (cat. no. 1222*) is engraved in a style that I call serrated because of the predominance of serrated lines in the designs. The subjects and technique of gouged lines are derived from those of the Assyrian linear style, but the serrated lines give a lacy impression to several of the designs produced in this style, which is probably contemporary with the linear Assyrian, dated ninth–eighth century B.C.

The next piece (cat. no. 1223*) derives its technique from that of the drilled style cylinders of Assyria. The use of the drill, however, is manipulated in this instance to give a degree of modeling to the bodies that implies a date later than that of the Assyrian drilled style. The cylinder may therefore be of the late eighth or early seventh century B.C. The expressiveness of the lion-griffin's posture and gesture, in contrast to typical Assyrian models, deserves notice.

On cylinder 1224, the two genii flanking a sacred tree with a winged sun disk above are awkwardly carved in a drilled technique. This, combined with the extension of the tree itself to the lower rim and the upper imaginary baseline for the genii, makes it seem unlikely that the piece was made by an Assyrian engraver. The Aramaic signs in the field suggest that the cylinder may have been produced by an incompetent carver somewhere in a western region.

While the foregoing cylinder was badly carved, the concept of the genii in relation to the winged disk seems fairly clear; they seem to receive the beneficial water of the disk which they may have been meant to distribute. On cylinder 1225 the relationship of the figures to the objects between them and to the disk cannot be determined. Here, too, the drilled style is employed for the apparent portrayal of a ceremony; the location of the workshop where the seal was made is unknown.

In a drilled technique, too, is a four-winged genius (cat. no. 1226), apparently advancing toward a stag which approaches a tree. The extraordinarily stiff lines forming the design are unparalleled. Like the previous example, it cannot be located, though its date in the latter part of the eighth or early seventh century B.C. seems very likely.

Neo-Elamite Cylinders (c. 700–639 B.C.)

Of three small cylinders (cat. nos. 1227–29) the first (cat. no. 1227*) can, on the basis of style, be unequivocally identified as Neo-Elamite, despite the fact that no cylinder with a similar scene has been published. The figures' slender bodies correspond closely to those assembled by Amiet (*AA* XXVIII, 1973) in a group of Neo-Elamite cylinders; two of them display the same use of stars or rosettes in the lower field, rather than in the sky, where a Mesopotamian artist invariably would have placed them. The lion-demon and the hero can be related to the protectors of the gate in the palace of Assurbanipal and also to the remains of such figures at Pasargadae.

Cylinder 1228 shows a typical Neo-Elamite subject, an archer in half-kneeling posture aiming at a leaping goat which turns back its head. The secondary motif of a dog biting a goat adds another characteristic touch. This relationship justifies classification of the piece as Neo-Elamite, although the style of the imprint to which it is compared in this catalog is more delicate than that of the present example.

A third cylinder (cat. no. 1229) exemplifies the vivid Neo-Elamite representation of animals. A stag walks delicately toward an altar surmounted by a star and crescent, these last carved more sharply and perhaps secondarily on this cylinder. The stag's gait can be compared to that of some figures with leonine bodies on Neo-Elamite cylinders, further justifying the present classification; however, the figure of the walking stag is so far unknown among published Neo-Elamite cylinders.

Achaemenid Cylinders (c. 550–330 B.C.)

Five cylinders in the Heeramaneck Collection (cat. nos. 1230–34) derive from the period of the Achaemenid Empire. The first (cat. no. 1230), depicting the king heroically holding up two lions and standing icon-like on crowned sphinxes, may belong to the later period of Xerxes (486–465/4 B.C.) or to that of his successor, Artaxerxes (465/4–425 B.C.). This judgment is borne out by the representation of the king's crown and the sphinxes, neither of which are precisely paralleled by representations on the impressions of the Persepolis tablets of earlier years.

The shape of the upper antennae of the sun disk of the second example (cat. no. 1231) may indicate that the cylinder was made in Lydia. The style and subject of cylinder 1232, a king with two stags, are unusual, but some of the details can be related to those of cylinders found at Persepolis. The motif of two mountain goats flanking a multi-winged vulture depicted on cylinder 1233* is unique. However, the formal arrangement and the stylization of the animals and even of the bird leaves no doubt about the cylinder's Achaemenid style.

Cylinder 1234, with its representation of a huntsman spearing a boar, is also of Achaemenid date, as amply shown by related impressions on tablets from Persepolis. Judging by the powerful representation of the furious animal and the free stance of the hunter, the cylinder was probably made in Asia Minor.

Unclassified Cylinders of Iran

No date or location can be suggested for several cylinders in this collection; they are merely grouped as far as material or style permits a coherent presentation.

One group consists of cylinders made of bronze (cat. nos. 1235–37 and 1239–44) and of iron (cat. no. 1238). Some of the designs are geometric, but the majority are figured. The most elaborate geometric design (cat. no. 1235), with its use of chevrons, is reminiscent of designs of the thirteenth and twelfth centuries B.C. from Tchoga Zanbil, while the border of triangles above and below resembles that on cylinders of the Isin II Dynasty of the twelfth to eleventh centuries B.C. Perhaps this provides an indication for the inception of part of the group at the end of the second millennium B.C. Aesthetically the most interesting and successful example is the highly stylized representation of two seated figures on the one cylinder made of iron (cat. no. 1238). Also of interest are a scene with frontal winged figures and ornamental trees between them (cat. no. 1239) and a crudely scratched scene of two figures with a scorpion between them (cat. no. 1242).

A completely different yet highly sophisticated design is seen on a bronze cylinder (cat. no. 1244) which probably comes from Bactria where related designs have been found. Where these objects should be placed chronologically is still a matter of debate.

Another group of seals (cat. nos. 1245–53) consists of crudely gouged cylinders of rather soft stone with various scenes of animals and/or human figures. One can merely describe what is seen on the cylinder without being able to comment on them in detail. Susa has produced a similar lot of crudely scratched and gouged, probably "homemade," cylinders. Only one cylinder, made of a rather unusual stone (cat. no. 1247), depicting a winged horse before a tree, exhibits a style suggesting the practiced hand of a professional seal cutter.

Seal impressions recently unearthed by Louis Levine at Chogha Maran in the Mahi Dasht have links with several unclassified Heeramaneck pieces. These are the bronze cylinders 1241 and 1243, as well as cylinders 1249 and 1253, which are made of soft serpentine rock. The Chogha Maran material, which should be dated to about the middle of the third millennium B.C., also corresponds to the design of a bronze cylinder of unknown provenance in The Metropolitan Museum of Art.

1124

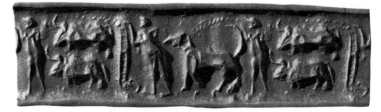

1127

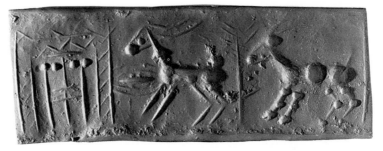

1133

*Early Cylinders of Iran,
Mesopotamia, and Syria
(c. 3300–2900 B.C.)*

1124

Cylinder
h: 2.2 cm.; diam: 2.3 cm.
Black serpentine rock; two bulls, one above the other, with an upright snake behind; standing man, his left arm akimbo, his right arm touching snake head; dog on leash held by second man.
M.76.174.313

1125

Cylinder
h: 2.5 cm.; diam: 2.1 cm.
Stone; bovid pursued by a lion, behind which is a serpent; eleven drillings and an unidentifiable three-lobed design in the field.
M.76.174.314

1126

Cylinder
h: 1.6 cm.; diam: 1.6 cm.
Pink marble; two pigtailed figures, seated or squatting; a large vessel in front of the second; to the right, a round vessel which seems to have two projections, one pointing up, the other down; six more vessels are arranged in two superimposed tiers of three each.
M.76.174.315

cf. a cylinder of this type from the Uruk settlement of Habuba Kabira in Syria (Sürenhagen, *MDOG* 105, 1973, p. 31, fig. 9a,b); for the date of seals with pigtailed figures in the Uruk period, cf. Porada and Hansen, 1965, p. 155 and p. 180, fig. VII: 6; for a discussion of these seals as a group, cf. Van Buren, *Orientalia* 26, 1957, pp. 289–305, pls. IX, X.

1127

Cylinder
h: 3.7 cm.; diam: 3 cm.
White marble; two horned animals, one with horns bent downward, the other with horns bent upward, approaching a shrine; a tree between them; a rimmed lozenge between the shrine and the first animal.
M.76.174.316

This type of representation appears frequently in temples at the Diyala sites of Khafaje and Tell Agrab (Frankfort, 1955, *OIP* LXXII, p. 16).

1128

Cylinder
h: 3.3 cm.; diam: 2.8 cm.
White marble; two pairs of horned animals, one above the other, before a temple, one pair standing, the other recumbent; both pairs are separated by three four-pointed stars.
M.76.174.317

1129

Cylinder
h: 1.47 cm.; diam: 1.25 cm.
Black serpentine rock; sheep or goat and double volute; unrecognizable form with triangles in front of animal.
M.76.174.318

For a related double volute on a contemporary cylinder seal impression from Susa, cf. Amiet, 1972, *MDAI* XLIII, pl. 110: 1023, p. 143 and n. 2.

1130

Cylinder
h: 1.96 cm.; diam: 1.7 cm.
Gray serpentine rock; lion pursuing a mouflon.
M.76.174.319

For a similar outline rendering of the lion's head in impressions from Byblos and Jericho, cf. Dunand, 1945, pl. VII, b,c,i; and Ben-Tor, 1978, p. 25, IIA–3; for comment on relations between Syria, Palestine, and Elam based on stamp and cylinder seal evidence, cf. ibid., p. 94.

1131

Cylinder
h: 2.1 cm.; diam: 2 cm.
Brown serpentine rock; three walking horned animals; over the back of each is an oblique serrated line (branch?) and a v-shaped notch; in the field, between two of the animals, a pair of vertical grooves.
M.76.174.320

For representations of similar walking horned animals, cf. Amiet, 1972, *MDAI* XLIII, pl. 98: 906, 908, and 910; cf. a cylinder from Tell Asmar, Frankfort, 1955, *OIP* LXXII, pl. 52: 541.

1132

Cylinder
h: 2.5 cm.; diam: 1.5 cm.
Brown serpentine rock; three walking animals.
M.76.174.321

1133

Cylinder, byre-shaped
h: 2.5 cm.; diam: 1.9 cm.
Black serpentine rock; three crouching dogs (?).
M.76.174.322

For a carelessly executed cylinder (with a suspension loop) resembling the roof of a byre, cf. Amiet, 1972, *MDAI* XLIII, pl. 112: N1042; for hut-shaped cylinders with engraved designs of herbivores from Khafaje, cf. Frankfort, 1955, *OIP* LXXII, pl. I: b,e.

1128

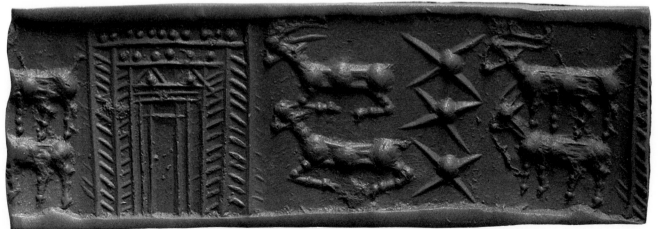

1134

Cylinder
h: 1.8 cm.; diam: 1.9 cm.
Buff and gray marble; two gigantic birds, highly stylized, advancing toward a seated pigtailed figure.
M.76.174.330

1135

Cylinder
h: 1.5 cm.; diam: 1.3 cm.
White marble; pattern of nine small, pointed ovals.
M.76.174.323

For related cylinder seal designs, cf. Amiet, 1972, *MDAI* XLIII, pl. 92: 786–89.

1136

Cylinder
h: 2.2 cm.; diam: 1.9 cm.
Stone; three pairs of lozenges, one above the other, each marked by one deep horizontal groove obliquely crossed by diagonal lines, creating an extended radial pattern.
M.76.174.324

For a closely related design, cf. Amiet, 1972, *MDAI* XLIII, pl. 94: 824. However, the small drilling which recurs at the joining of the upper and lower lozenges is a special feature in the present cylinder.

1137

Cylinder
h: 1.8 cm.; diam: 1.8 cm.
White-and-green-mottled black serpentine rock; pattern of two pointed ovals.
M.76.174.325

For parallels from Susa, cf. Amiet, 1972, *MDAI* XLIII, pl. 93: 813–17. This pattern was favored in the glyptic material from Surkh Dum in Luristan (soon to be published by M. van Loon).

1138

Cylinder
h: 2.4 cm.; diam: 1.06 cm.
Brown serpentine rock; interlocking weave-like pattern composed of curving and straight parallel lines.
M.76.174.328

1139

Cylinder
h: 2 cm.; diam: 1.7 cm.
White marble; pattern composed of deep diagonal grooves and fine parallel hatchings.
M.76.174.326

cf. Amiet, 1972, *MDAI* XLIII, pl. 95: 838–51, especially 847; for cylinders from Khafaje, cf. Frankfort, 1955, *OIP* LXXII, pl. 21: 220 and pl. 42: 443.

Cylinders of Various Styles: Transitional Period
(c. 29th century B.C.)

1140

Cylinder
h: 2.5 cm.; diam: 1.7 cm.
Brown serpentine rock; chevron pattern; unperforated.
M.76.174.329

1141

Cylinder
h: 1.66 cm.; diam: 1 cm.
Gray marble; stag and branches indicated by chevrons in overall pattern.
M.76.174.331

1142

Cylinder
h: 3.1 cm.; diam: 0.9 cm.
White marble; two walking mountain goats; in the field, three lines above, two below.
M.76.174.332

1143

Cylinder
h: 4.6 cm.; diam: 1.6 cm.
Green-mottled black serpentine rock; interlocking design composed of two confronted, seated (?) figures, antithetically arranged, the one at the left, above a bird, the one at the right, above a four-legged animal; in the field, between the human figures and above the quadruped, a series of plant (?) motifs; elsewhere in the field, a busy arrangement of abstract filling motifs.
M.76.174.333

The style seems not unlike some of the seal impressions with interlocking linear designs from the Early Dynastic I period of Ur, especially those published by Moorey (*Iraq* XLI: 2, 1979, p. 111, fig. 3: 577–79).

1144

Cylinder, bisected and pierced for suspension
h: 3.9 cm.; diam: 2 cm.
Black serpentine rock; standing frontal human (?) figure with arms outspread; in the surrounding field, a series of deep rounded grooves; framed above and below by a horizontal groove.
M.76.174.334

1134

1147

*Cylinders Related to the
Early Dynastic Style
of Mesopotamia
(c. 2750–2350 B.C.)*

1145

Cylinder
h: 2.83 cm.; diam: 1.51 cm.
Smooth drab marble (?); hero
with a curved weapon pursuing a
large feline; below the animal's
body, a small globe; large oval
frame situated over its back; pen-
tagram separates the feline from a
gazelle which stands on its hind
legs with head turned back.
M.76.174.339

The hero is comparable to one
with similarly upturned hair from
Khafaje (Frankfort, 1955, *OIP* LXXII,
pl. 36: 375). While that seal's style
was given as Early Dynastic III,
there was no stratigraphic evidence
for the seal, as it was found near
the surface.

1146

Cylinder
h: 1.7 cm.; diam: 0.8 cm.
Black serpentine rock; hero pursu-
ing two horned animals, a mou-
flon and stag, each represented
with three legs. Terminal: tree.
M.76.174.387

1147

Cylinder
h: 3 cm.; diam: 1.9 cm.
Yellow marble; walking horned
animal (stag?) attacked by a sinu-
ous lion.
M.76.174.340

A lion similarly posed on its hind
legs, attacking a ruminant from
the rear, is seen on a seal impres-
sion from Susa (Amiet, 1972,
MDAI XLIII, pl. 31: 1419, dated by
him to the Early Dynastic II
period).

1148

Cylinder
h: 3.56 cm.; diam: 1.54 cm.
White marble; six-pointed rosette
with a line below it, over a double
animal with the head of a bull and
a lion, the whole flanked by a pair
of rampant goats or mouflon with
heads turned back; one of the
goats is grasped by a male figure.
M.76.174.341

The combination of lion and bull
recalls a Proto-Elamite seal impres-
sion depicting a lion dominating
small bulls and a large bull domi-
nating small lions. The interpreta-
tion of the whole must be taken
to mean a balance of great powers
(Amiet, 1980, pl. 38: 585). For a
parallel for the double animal with
the head of a lion and of a goat, cf.
an earlier seal impression from
Susa (Amiet, 1972, *MDAI* XLIII, pl.
II: 577). This occurrence indi-
cates, at least, that such combina-
tions existed at Susa; however,
there is no evidence for them in
Mesopotamia.

1149

Cylinder
h: 2.36 cm.; diam: 1.36 cm.
Banded marble; hero between two
rampant stags which he grasps by
the forelegs; to the right, a second
hero grasps a third rampant stag,
which is in turn threatened by a
rampant feline; between the sec-
ond stag and second hero is a
scorpion; two horizontal lines at
end of scene.
M.76.174.342

The extensive use of the drill in
the engraving of this cylinder
suggests an origin in Shahdad, or
some such place where drill work
survived in a refined form. For a
cylinder of Shahdad style, cf.
Porada in Orthmann, 1975, *PKG*
14, pl. 283b. The unusual appear-
ance of three stags in a contest
frieze suggests an origin outside
the metropolitan centers of the
Early Dynastic period.

1150

Cylinder
h: 2.65 cm.; diam: 0.98 cm.
Burnt lapis lazuli; pair of lions,
bodies crossing, grasping a pair of
rampant herbivores with heads
turned back.
M.76.174.343

The motif of this cylinder–crossed
lions in the center, each grasp-
ing a ruminant–was favored in
Mesopotamia (Woolley, 1934, *Ur
Excav* II, pl. 204: 147–55). Among
the numerous examples from the
sites of the Diyala region is a seal
from Khafaje (Frankfort, 1955,
OIP LXXII, pl. 36: 372), also of
lapis lazuli. For examples from
Kish, cf. Mackay, 1929, pl. XLI: 3,
13, 14, and 16.

1151

Cylinder
h: 2.5 cm.; diam: 1.54 cm.
White marble; lion attacking a
horned animal from behind, pre-
ceded by a bull with a large dagger
under his head; a short-skirted
human figure with raised hands
faces the group.
M.76.174.344

The stylization of the bull and the
posture of the human are unusual
and indicate an origin outside of
Mesopotamia, presumably in Iran.

1152

Cylinder
h: 1.95 cm.; diam: 0.99 cm.
White marble; two heroes and
three horned animals; each hero
grasps two rampant animals, one
serving for both heroes.
M.76.174.345

1151

1152

1153

Cylinder

h: 2.76 cm.; diam: 1.69 cm.
Bitumen; hero restraining (?) a feline; the latter leaps upon a second rampant feline, which turns back toward a buck or mountain goat; horizontal lines above and below.
M.76.174.346

The style of the cylinder is completely unknown.

1154

Cylinder

h: 2.8 cm.; diam: 1.5 cm.
Gray serpentine rock; undulating hatched band with a spread eagle in each curve.
M.76.174.348

For Early Dynastic examples from Mesopotamia, cf. Woolley, 1934, *Ur Excav* II, pl. 199: 85 and Frankfort, 1955, *OIP* LXXII, pl. 39: 416; for a later example, cf. ibid., pl. 69: 749 (from a findspot, perhaps of Agade date, with the style given as "ED or Akk"). Examples from Tello are of different periods (Parrot, 1954, pls. I: 5–7). A cylinder closely related to the Heeramaneck example was found at Susa (Amiet, 1972, *MDAI* XLIII, pl. 140: 1475).

1155

Cylinder

h: 2.5 cm.; diam: 1.2 cm.
Gray serpentine rock; guilloche design with dots in the innermost loops.
M.76.174.327

Extensive guilloche decoration is only found later in the second millennium B.C. However, a fragmentary chlorite vessel, probably dated in the middle of the third millennium B.C., discovered at Mari but probably made in southeastern Iran, shows this motif. For a good illustration of it, cf. Strommenger, 1964, pl. 39, bottom.

1156

Cylinder

h: 2.9 cm.; diam: 2.2 cm.
Shell (?); series of figures, each composed of two major drillings; two figures in the lower register are seated; the remaining figures are no longer intelligible.
M.76.174.349

1157

Cylinder

h: 1.7 cm.; diam: 1.4 cm.
White marble; two seated persons drinking through tubes from a vessel set between them on a folding stool; servant and sideboard behind person at left; lower half of cylinder was probably broken off in antiquity and the edge rubbed smooth.
M.76.174.350

For a similar cylinder, cf. Woolley, 1934, *Ur Excav* II, pl. 200, especially no. 103 and others on that plate; also pls. 193, 194 passim.

Cylinders of the Agade Period
(c. 2334–2154 B.C.)

1158

Cylinder

h: 2.14 cm.; diam: 1.13 cm.
Gray and black serpentine rock; eagle grasping two long-horned antelopes. Terminal: plant.
M.76.174.347

For a discussion of a closely related representation from Tello, cf. Boehmer, 1965, *UA* 4, pp. 18–19, fig. 87. He points out the reasons for placing this and related cylinders in his period Ib. For another illustration of the Tello seal, cf. Parrot, 1954, pl. I: 11.

1159

Cylinder

h: 3.2 cm.; diam: 2.2 cm.
Black serpentine rock; group with hero in center grasping two antelopes; attacking lions at either side. Terminal: staff with star-shaped finial.
M.76.174.354

For cylinders with this motif, cf. parallels cited by Boehmer, 1965, *UA* 4, p. 148, for his discussion of fig. 64, nos. 263–81; for the motif at Susa, cf. Amiet, 1972, *MDAI* XLIII, pl. 142: 1500–1505.

1160

Cylinder

h: 2.4 cm.; diam: 1.3 cm.
Black serpentine rock; animal contest frieze; gazelle attacked by a lion whose body is crossed with that of a bull-man holding a long weapon; a second lion attacks the bull-man and is, in turn, attacked by a hero.
M.76.174.355

For the use of a spear to attack the lion, cf. the archaic lion hunt, Amiet, 1972, *MDAI* XLIII, pls. 13 and 76: 605.

1157

1158

1153

1161

Cylinder

h: 2 cm.; diam: 1 cm.
Black serpentine rock; mountain goat pursued by a lion.
M.76.174.356

For an almost identical cylinder in the same cut style, cf. Frankfort, 1955, *OIP* LXXII, pl. 57: 610 (from a late Agade findspot at Tell Asmar).

1162

Cylinder

h: 2.3 cm.; diam: 2.1 cm.
Black serpentine rock; three combat pairs: a nude, bearded hero and a hero with flat cap, each wrestling with a human-headed bull; at the side of this composition, a bull-man in profile view wrestling with a bull; the latter perhaps recut in modern times.
M.76.174.357

The closest parallel for two pairs of contestants with human-headed bulls may be found on a cylinder in the British Museum (Boehmer, 1965, *UA* 4, pl. VIII: 75). The pairing of bull-man and bull is not found elsewhere in early Mesopotamian glyptic art.

1163

Cylinder

h: 2.4 cm.; diam: 1.5 cm.
Green serpentine rock; two contest pairs: a bison subdued by a nude, bearded hero, and a bull-man overpowering a lion; between the contest pairs, an uninscribed panel.
M.76.174.358

The bison replaces the human-headed bull in the Akkad III phase. For a discussion, cf. Boehmer, 1965, *UA* 4, p. 44, and n. 186.

1164

Cylinder

h: 2.8 cm.; diam: 1.75 cm.
Green jasper; two identical contest pairs, each consisting of a bull-man stabbing a lion which he raises by the tail; the scenes are inverted so that the frontal heads of the lions are paired.
M.76.174.359

For lions similarly held with their hind legs up by nude, bearded heroes instead of bull-men, cf. a cylinder in the British Museum (Boehmer, 1965, *UA* 4, pl. XIV: 158).

1165

Cylinder

h: 3.5 cm.; diam: 2.2 cm.
Serpentine rock; worshiper following four male gods into the presence of an enthroned male deity; crescent before the latter's head may identify him as the moon god Sin; secondary additions are three oblique lines rising from the enthroned god's back and two lines forming an acute angle below his raised arm; a star spade, generally associated with the sun god, may also have been inserted later behind the throne.
M.76.174.360

1160

1163

1162

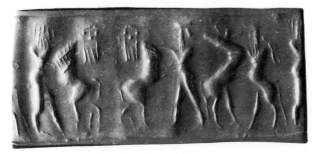

1164

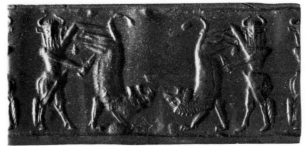

1166

Cylinder
h: 2.95 cm.; diam: 1.74 cm.
Pink marble; minor god led by a second with staff, who follows a third, identically clad, toward an enthroned sun god with rays, who holds his (emblematic) saw aloft; in the field behind throne, a lizard, below the space reserved for the inscription.
M.76.174.362

1167

Cylinder
h: 2.6 cm.; diam: 1.5 cm.
Green jasper; enthroned deity receiving two minor gods, identically clad, followed by a lady in a long robe with a fringe down the center and around the bottom; she stands in typical Elamite pose, with hands clasped at the waist; crescent in the sky before the enthroned deity.
M.76.174.363

1168

Cylinder
h: 3.5 cm.; diam: 2.2 cm.
White-and-green-mottled black serpentine rock; enthroned deity holding plow with attached seed funnel; approaching is a minor god leading a bearded personage, perhaps with horned crown (head damaged), from whose shoulders sprout ears of corn; a bearded human worshiper stands at the end of the scene.
M.76.174.361

The flaring skirts of the figures suggest an Iranian origin.

1169

Cylinder
h: 2.5 cm.; diam: 1.5 cm.
Jasper breccia; three male worshipers, identically clad, approaching a male personage enthroned on a chair with a short back; in the field, before the latter, a crescent surmounted by a star; all the figures are clad in long skirts with prominent hems along the front and bottom.
M.76.174.364

1170

Cylinder
h: 2 cm.; diam: 1.3 cm.
Jasper; hero with staff and doubly recurved object facing a god who stands before a tree with upraised right hand; two figures, probably a pair of fighting gods, are sketched but not fully engraved.
M.76.174.365

For a pair of fighting gods, cf. *Corpus I,* 1948, pl. XXVII: 175 (reproduced by Boehmer, 1965, *UA* 4, pl. XXVII: 315).

1166

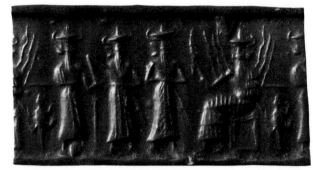

1167

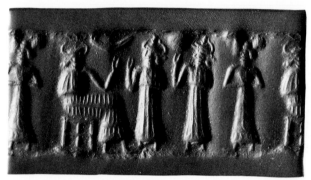

1168

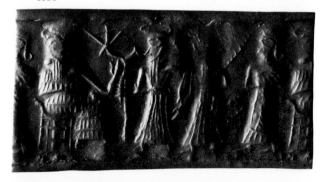

1170

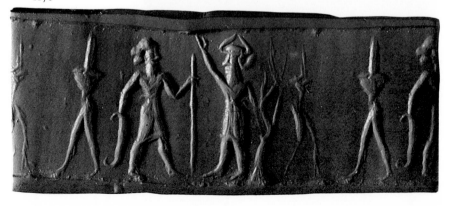

Cylinders
of the Third Dynasty of Ur
(c. 2112–2004 B.C.)

1171

Cylinder

h: 2.75 cm.; diam: 1.62 cm.
Greenish black jasper; worshiper
led by an introducing goddess to-
ward an enthroned god; dog lies
beside the throne on the platform;
linear lion-headed eagle and a
scorpion are placed between the
figures; thin crescent in the sky.
M.76.174.352

The dog whose form overlaps
the central vertical support of the
god's throne is unusual. In the
rare instances where an animal is
shown at the side of the throne, it
appears to be the figure of a lion
that is placed within the frame,
suggesting that the figure itself
was meant to represent a decora-
tive device rather than an actual
animal. (For an example in seal
impression form, cf. Keiser, 1919,
pl. XXX: 143.) In another instance a
bull seems to form the god's seat
(Genouillac, 1910–11, II, pl. III:
3880). A lion-headed eagle with
one or two heads, alone or in vari-
ous combinations with other
figures, is frequently placed under
the panel of the inscription on cyl-
inders of this period (ibid., pl. III:
3911, 3941, 4258) or in the upper
field before the deity (ibid., pl. III:
4239), not in the lower part of the
field between the figures as in the
Heeramaneck example. For a
scorpion inserted on a cylinder of
the Third Dynasty of Ur, cf.
Corpus I, 1948, pl. XLV: 292.

1172

Cylinder

h: 2.7 cm.; diam: 1.64 cm.
Hematite; worship of an enthroned
king; he holds a cup and faces
a goddess leading a worshiper
while a second goddess follows
with hands raised in supplication;
crescent in the sky; an inscrip-
tion in panels of equal size was
erased.
M.76.174.353

The suppliant goddess is infre-
quently added to the pair of intro-
ducing goddess and worshiper;
for examples, cf. Keiser, 1919,
pl. XXX: 142 (from the time of
Shulgi) and pl. XXIII: 159 (from the
time of Shu-Sin, 2037–2029 B.C.).

1173

Cylinder

h: 2.5 cm.; diam: 1.1 cm.
Black serpentine rock; two
heroes fighting a rampant lion;
inscription.
M.76.174.351

This motif is paralleled on a seal-
ing from the time of Shu-Sin
(Genouillac, 1910–11, II, pl. II: 44).

Cylinders of the
Old Babylonian Period
(c. 2000–1600 B.C.)

1174

Cylinder

h: 2.6 cm.; diam: 1.6 cm.
Hematite; symmetrical group of
two standing bull-men flanking
two kneeling, nude, bearded
heroes, each holding a vase; above
them, a pair of symmetrical
human-headed bulls, each with a
crescent moon on a staff over its
back, as though the moon symbol
were supported by the statue.
Terminal: rampant lion-griffin at-
tacking a goat.
M.76.174.370

For the meaning of the pair of lion-
griffin and goat, cf. Walker-Hunger,
1977, *MDOG* 109, pp. 30–31, lines
25–27.

1175

Cylinder

h: 2.4 cm.; diam: 1.7 cm.
Hematite; three groups of contest:
a bull-man and a nude, bearded
hero fighting a lion; a kneeling
man attacked by a lion-griffin; a
second lion attacking a rampant
bull.
M.76.174.371

1172

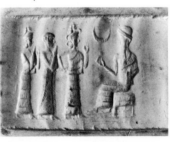

1176

Cylinder

h: 2.7 cm.; diam: 1.6 cm.
Hematite; suppliant goddess and a
bald worshiper, the latter with
hands clasped, standing before a
king holding a cup, enthroned on
a stool with his feet placed on a
platform, the whole supported by
a larger platform; both platforms
are marked by a rhythmic pattern
of triple vertical lines; inscription
erased.
M.76.174.366

For a list of dated cylinders and
seal impressions of the Early Old
Babylonian period, cf. Nagel, *AfO*
XVIII, 1958, pp. 320–24; for the
subject type of this cylinder, cf. the
impression of the cylinder of
Aaduga, official of Lipiteshtar of
Isin (1934–1924 B.C.) in Legrain,
1951, *Ur Excav* X, pl. 29: 440.

1177

Cylinder

h: 2.4 cm.; diam: 1.3 cm.
Hematite; subject as in cat. no.
1176; the worshiper's hair is here
indicated like a cap; legs of the
stool are carelessly drawn down
into the platform; platform for the
feet extends over the throne plat-
form; in the field, a disk and cres-
cent, a dog with a crook before the
enthroned figure, and a star over
a mongoose between goddess and
worshiper; inscription.
M.76.174.367

For worshipers with hair resem-
bling caps, cf. the cylinder of
Ur-Ningizzida of Eshnunna of
about 1900 B.C. (Moortgat, 1940,
pl. 34: 254).

1174

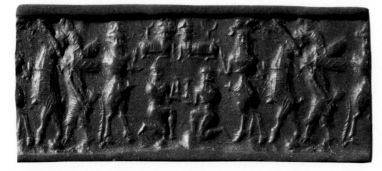

1177

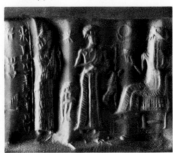

1178

Cylinder
h: 2.6 cm.; diam: 1.6 cm.
Hematite; subject as in cat. no.
1176; probable secondary inser-
tions are an altar-like stand, above
which is a crudely carved bow-
legged dwarf, and a lightning fork
before the enthroned figure; a
crescent belongs to the original
design; inscription.
M.76.174.369

1179

Cylinder
h: 2 cm.; diam: 1.2 cm.
Hematite; subject as in cat. no.
1176, with the addition of the
figure of the king as warrior with
a mace, a mongoose at the knees
of the enthroned figure, and a star
disk and crescent in the sky. Ter-
minal: vessel in the upper field,
loop staff below.
M.76.174.368

1180

Cylinder
h: 2.1 cm.; diam: 1.1 cm.
Hematite; male figure in a short
garment, a worshiper, and a dimin-
utive female with clasped hands
before a god with scimitar and a
goddess with a flowing vase; in
the field, above the small female,
a crescent.
M.76.174.374

1181

Cylinder
h: 2.4 cm.; diam: 1.2 cm.
Hematite; suppliant goddess and
worshiper with a sacrificial animal
before Shamash, the sun god, who
is represented in ascending pos-
ture, holding his emblematic saw.
M.76.174.373

The style of the cylinder corre-
sponds to one in the Louvre (Dela-
porte, 1923, pl. 80: 12 [A.359])
which displays a similar tripartite
composition with well-executed
figures (including a bull-man as
offering bearer), which belonged
to an official of Shamshi-Adad of
Assyria (1813–1781 B.C.).

1182

Cylinder
h: 2.6 cm.; diam: 1.2 cm.
Hematite; king in warrior's garb
before a suppliant goddess; be-
tween them, a lion club over a
crook; inscription.
M.76.174.375

The cylinder corresponds in style
and motif to several seal impres-
sions of the Old Babylonian period
from Tell al-Rimah (Dalley et al.,
1976); cf. especially pl. 109: 18.
It was found on a tablet dating
from the domination of Karana
(ancient Tell al-Rimah) by Hammu-
rabi of Babylon (1792–1750 B.C.).

1183

Cylinder
h: 2.3 cm.; diam: 1.4 cm.
Hematite; figure resembling the
king in warrior's garb facing a
suppliant goddess; he wears an
unusual headdress not of the stan-
dard royal variety; nude, bearded
hero to the left.
M.76.174.376

1184

Cylinder
h: 2.9 cm.; diam: 1.2 cm.
Hematite; male figure in royal
warrior's garb facing a suppliant
goddess; the figure has been
transformed into a god by the sec-
ondary addition of a high head-
dress; between the figures, a star
in a disk and a fly above a small
deity with a crook stepping onto
a gazelle; inscription: first and
third lines recut; middle line
partly erased.
M.76.174.378

1185

Cylinder
h: 2.7 cm.; diam: 1.4 cm.
Hematite; god in a pointed miter
holding a mace and a suppliant
goddess before Adad, the weather
god, represented in ascending
posture and holding his emblem,
a lightning fork; two drillings
in the field between the mace-
holding god and the goddess;
inscription.
M.76.174.377

1182

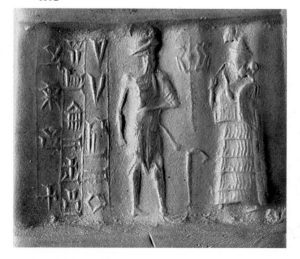

1186

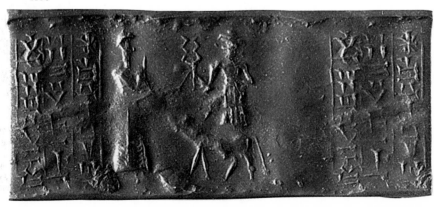

1186

Cylinder
h: 2.6 cm.; diam: 1.5 cm.
Hematite; worshiper before the weather god, Adad, the latter standing on a bull and holding his emblem, a lightning fork; inscription.
M.76.174.379

1187

Cylinder
h: 2.4 cm.; diam: 1.4 cm.
Hematite; worshiper with a sacrificial animal before Shamash, the sun god, represented in ascending posture; a lightning fork is inserted over the sun god's emblematic saw; inscription.
M.76.174.380

The strong use of a drill for the details of the figure suggests a fairly late date in the Old Babylonian period in or after the time of Samsuiluna (1749–1712 B.C.); cf. Buchanan, *Yale Library Gazette* 45, 1970, pp. 59–60, s.v. 11.

1188

Cylinder
h: 2.2 cm.; diam: 1.2 cm.
Hematite; worshiper before a deity who apparently turns toward a large lion scimitar, symbol of Nergal, god of the netherworld; in the field, between the figures, a crook above a crouching bowlegged dwarf; behind the worshiper, a flying bird and Marduk symbol; behind the lion scimitar, a crescent; inscription.
M.76.174.381

1189

Cylinder
h: 2.2 cm.; diam: 1.1 cm.
Hematite; nude female in frontal pose; alongside her, the crook of the god Amurru; deity before a god who stands with lowered hand, below which a bowlegged dwarf crouches in a gesture of greeting; in the field, a star above the crook, a lightning fork, bird, disk, and crescent.
M.76.174.382

1190

Cylinder
h: 1.7 cm.; diam: 1 cm.
Hematite; two deities facing each other, the one on the left in a gesture of worship toward the one on the right; in the field, a crescent and a monkey and frog over a lion on an altar; recut from an older, larger seal; inscription.
M.76.174.383

1191

Cylinder
h: 2.8 cm.; diam: 1.3 cm.
Hematite; inscription, flanked by a pair of suppliant goddesses.
M.76.174.384

For a similar motif of suppliant goddesses flanking an inscription, here datable to the time of King Rim-Sin of Larsa (1822–1763 B.C.), cf. Boehmer in Orthmann, 1975, *PKG* 14, pl. 267f.

1192

Cylinder
h: 2.4 cm.; diam: 1.3 cm.
Hematite; inscription; deity at right, suppliant goddess at left.
M.76.174.385

1193

Cylinder
h: 3 cm.; diam: 1.4 cm.
Red jasper; inscription; worshiper at right; crescent in the field.
M.76.174.386

1187

Old Assyrian Cylinders
(c. 1920–1700 B.C.)

1194

Cylinder

h: 1.4 cm.; diam: 0.7 cm.
Hematite; worshiper and
suppliant goddess before an en-
throned personage; behind, two
rampant lions crossed above a
crouching lion; in the field, a sun
disk in crescent.
M.76.174.391

For a dated example of the Early
Old Assyrian style, cf. Balkan,
1955, *TTKY* VII: 28, figs. 4, 5
(reversed); for other cylinders of
Early Old Assyrian style, cf. T.
and N. Özgüc, 1953, *TTKY* V: 12,
pl. LXI: 681–89.

1195

Cylinder

h: 2.6 cm.; diam: 1.6 cm.
Hematite; lion menacing a goat;
second lion grasped by a semi-
kneeling hero; standard held by a
bull-man; in the field, a detached
human head and seated monkey.
M.76.174.389

The cylinder belongs to the Late
Old Assyrian style; cf. the Old
Assyrian seals of level Ib in Özgüc,
1968, *TTKY* V: 25, pp. 48–49; for
an impression showing the same
scheme but a more modeled en-
graving, cf. ibid., pl. XIX: A; for a
characterization of the style, cf.
Porada, *Reallexicon der Assyriologie*
V: 5–6, 1980, p. 387.

1196

Cylinder

h: 2.3 cm.; diam: 1.3 cm.
Hematite; hero overpowering a
lion; bull-man wrestling with
a second lion; rampant goat at-
tacked by a lion-griffin; the seal is
cut down, probably from a seal of
the Gudea period (c. 2150 B.C.), as
indicated by the stepped hollows
of perforation.
M.76.174.390

1197

Cylinder

h: 1.8 cm.; diam: 0.9 cm.
Hematite; bull-man fighting a
lion; bull suspended by its hind
legs by a nude, bearded hero; king
in warrior's garb looking to left;
bull-man touches his arm in a re-
peated rolling.
M.76.174.372

The representation of the king as
a warrior looking to the left is
unusual, as is the gesture of the
bull-man touching his arm.

1198

Cylinder

h: 1.9 cm.; diam: 1.2 cm.
Green jasper; two nude, bearded
heroes in combat with two
human-headed bulls; worshiper
between two rampant goats.
M.76.174.388

The motif of a worshiper between
two goats, apparently raising his
hand before one of the animals, is
an unusual one.

Cylinders of Classic Syrian Style
(c. 1820–1740 B.C.)

1199

Cylinder

h: 2 cm.; diam: 1.1 cm.
Hematite; suppliant goddess fac-
ing a king with a mace; between
them is a small nude female, above
whom is a disk in a crescent.
Secondary motif: a male goat
mounting a female one; a lion
seems to have been engraved be-
side them, perhaps menacing the
pair.
M.76.174.394

An almost identical scene was
published by Nougayrol (*Syria*
XXXIX, 1962, p. 190: A021.1). The
cylinder was inscribed for a "ser-
vant" of Aplahanda, doubtless
King Aplahanda of Carchemish, a
correspondent of King Zimrilim
of Mari and a contemporary of
Hammurabi of Babylon (ibid.,
p. 188; also reproduced by Safadi,
1968, no. 75). The secondary motif
is unparalleled on Syrian cylinders
but recurs in Assyrian cylinders of
the ninth century B.C. (*Corpus I*,
1948, pl. XCIV: 647). The cylinder
may have been worn as a bezel at
some later date, to judge by the
manner in which part of the
cylinder–including the lion of
the secondary motif–has been
smoothed off.

1200

Cylinder

h: 2.1 cm.; diam: 1.1 cm.
Hematite; in the center, a weather
god holding a serpent and a mace;
before him is a worshiper fol-
lowed by an Egyptianizing god-
dess; behind the god stands a
personage holding aloft a large,
curved crook. Secondary motif: a
lion over a guilloche band above
three figures; star in the sky.
M.76.174.393

Although depicted here holding
only a serpent, the weather god
normally holds, in the same hand,
the reins of his bull and sometimes
a weapon (*Corpus I*, 1948, pl.
CXLVI: 964, 967). Instead of stand-
ing in the typical "smiting" pose
(Collon, *Levant* 4, 1972, pp. 111–
34), the god depicted on the
Heeramaneck seal apparently
holds the mace over his shoulder.

1201

Cylinder

h: 2 cm.; diam: 0.9 cm.
Hematite; two confronted figures
in long robes with hands joined,
stepping onto a platform; crescent
in the sky. Secondary motif: two
hares above a row of three birds
set, in turn, above a hare and a
scorpion (bottom row).
M.76.174.392

The subject of the cylinder has no
known parallels in Syrian glyptic
art. The hairstyle of the figures is
also unusual. For the representa-
tion of two persons joining hands
in a gesture perhaps signifying the
conclusion of a treaty, one may,
however, cite Schaeffer, *Ugaritica*
III, 1956, pl. VI.

1195

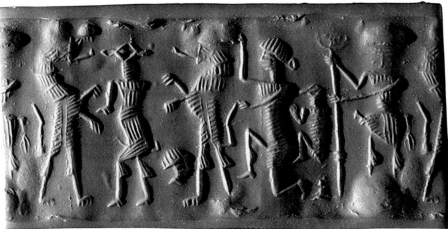

1194

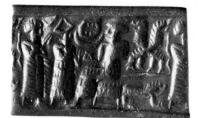

1196

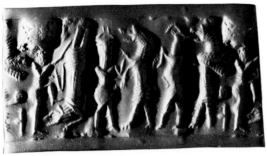

1199

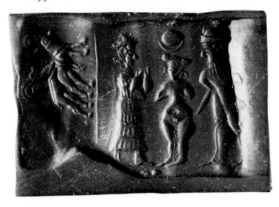

1200

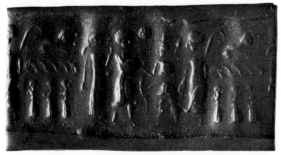

1202

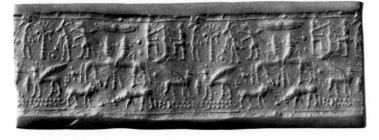

Mitannian Cylinders
(*c. 1500–1300 B.C.*)

1202

Cylinder

h: 2.7 cm.; diam: 1.3 cm.
Hematite; two registers. Central
motif: winged disk over two
crossed human-headed bulls, the
whole set above a fly which soars
over a juxtaposed lion and bull.
Upper register: two heroes over-
powering a bull; two rampant
goats flanking a tree, menaced, in
turn, by a winged lion-demon to
the right. Lower register: two
griffins on a platform; a fish be-
tween them.
M.76.174.395

The division into two registers
and the alignment of various un-
connected motifs, as well as the
use of a fine drill, are all somewhat
related to a cylinder seal impres-
sion on a letter bearing a text of
a land grant by the Assyrian king
Assur-nirari II (1424–1418 B.C.).
For the depiction of large flies in
Elamite glyptic art, cf. Porada,
1970, *MDAI* XLII, pl. III: 27; pl. VI:
63, 65, etc.

1203

Cylinder

h: 1.9 cm.; diam: 1.1 cm.
Yellow chalcedony; nude, winged
goddess standing beside two
lion-griffins flanking a sun disk on
a pole erected on a hillock; above
each griffin, the head of a boar in
profile view.
M.76.174.396

For the representation of a nude
female beside fire-spitting lion-
griffins juxtaposed below a
winged disk, cf. Lacheman, 1950,
pl. 118: 304; for the depiction of a
nude female associated with the
lion-griffin of the weather god on
a cylinder of the Agade period, cf.
Corpus I, 1948, pl. XXXIV: 220; for
that of a nude female, presumably
the weather god's consort, placed
beside the weather god's bull and
lightning fork on an Old Baby-
lonian cylinder, cf. ibid., pl. LXIX:
506; for the boar's head discovered
in G 29 of temple A at Nuzi, cf.
Starr, 1937–39, pl. 112B and p. 435.

1204

Cylinder

h: 2.5 cm.; diam: 1.2 cm.
Hematite; winged, bird-headed
demon; scorpion; two confronted
animals over a rhomb.
M.76.174.397

For a cylinder of the same type
bought in northern Syria, cf.
Buchanan, 1966, pl. 57: 912, 914,
and 918.

1203

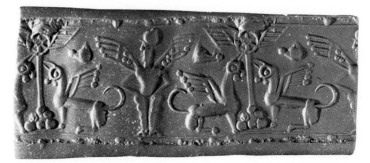

1205

Cylinder
h: 1.7 cm.; diam: 0.9 cm.
Hematite; winged demon between
two kneeling lions; in the field,
a hand, eleven small drillings, and
a large drilling (between the lions).
M.76.174.399

1206

Cylinder
h: 2 cm.; diam: 1.2 cm.
Hematite; horned animal turned
90°; standing nude figure with
arms outstretched, flanked on its
left by pairs of small drillings, and
on its right by a vertical line with
one drilling on top, two below;
plant design; horned animal or
human figure placed upside down;
incoherent drillings in the field.
M.76.174.398

1207

Cylinder
h: 1.5 cm.; diam: 0.6 cm.
Faience; two crouching lions over
two rows of guilloche, one above
the other.
M.76.174.400

For the use of faience as a criterion
for the "common" style of Mitan-
nian cylinders, cf. Porada, *AASOR*
24, 1947, p. 12.

Kassite Cylinder
(c. 14th–early 13th century B.C.)

1208

Cylinder
h: 3.8 cm.; diam: 1.6 cm.
Jasper breccia; seated deity. Ter-
minal: inscription (in seven lines);
two flies secondarily carved in the
field before the seated figure.
M.76.174.401

The style of this cylinder closely
corresponds to that illustrated in
Menant (Menant, 1888, no. 257).
The stylization of the enthroned
god's garment, hair and beard,
and his stool (the latter repre-
sented with drillings at the corners
and for the struts and feet), is
virtually identical, suggesting that
both were the work of the same
seal cutter. Unfortunately, the pre-
cise date of the individuals named
cannot be determined for either
cylinder. Beran's statement (*AfO*
XVIII: 2, 1958, p. 256, n. II) con-
cerning the date of the de Clercq
cylinder in the time of Kurigalzu I
was based on an erroneous read-
ing of the first part of the seal
owner's father.

Elamite Cylinders
(c. 13th–12th century B.C.)

1209

Cylinder
h: 3.7 cm.; diam: 1.8 cm.
Black serpentine rock; three flee-
ing horned animals pursued by
an archer in a chariot accompanied
by a small kneeling charioteer;
leaping dog seen under the raised
forelegs of the horses; large fly be-
fore the archer's bow in the sky.
M.76.174.417

The closest parallel for the subject,
the posture of the horses, the
proportions of the figures, and
the size of the archer's bow and
chariot are seen in seal impressions
on tablets dated to the time of
Ninurta-tukulti-Assur, about 1133
B.C. (Frankfort, 1939, p. 192, fig.
60; also Opitz, *AfO* X, 1935/36, p.
49, figs. 1–4). The large fly in the
upper field is a criterion of Elamite
style of the thirteenth and twelfth
centuries B.C. (Paroda, 1970, *MDAI*
XLII, pl. III: 27; pl. VI: 55, 63, 65,
etc.). For the type of chariot, cf.
Littauer, *Handbuch der Orientalistik*,
VII: 1, 1979, p. 75, fig. 41.

1210

Cylinder
h: 3.38 cm.; diam: 1.3 cm.
Brown marble; scorpion-man
with weapon menacing a goat; in
the field, a crescent above an
eight-pointed, squarish radial de-
sign with central dot.
M.76.174.419

For a Middle Assyrian cylinder
seal design depicting a scorpion-
man attacking a ruminant, cf.
Moortgat, *ZA* 48, 1944, p. 39,
figs. 40a,b; for a monster with a
pointed miter, cf. ibid., p. 33, fig.
27; for somewhat related squarish
ornamental designs, which appar-
ently indicate vegetal elements, cf.
Amiet, 1972, *MDAI* XLIII, pl. 185:
2133, 2137.

1211

Cylinder
h: 5 cm.; diam: 1.3 cm.
Blue material; pattern of chevrons
with two bands of inlaid black
faience.
M.76.174.422

For Elamite cylinders decorated
exclusively with chevron patterns,
cf. Porada, 1970, *MDAI* XLII, pl. XII:
128, 140, 144, and 145.

1210

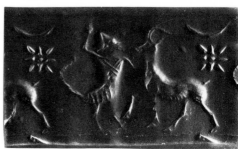

1209

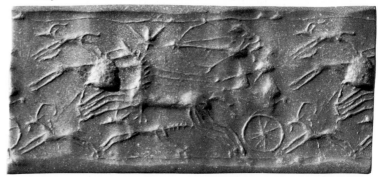

1208

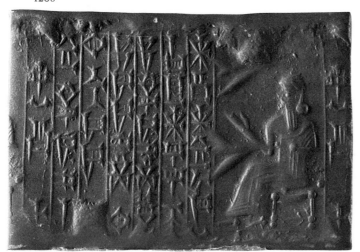

*Neo-Assyrian and
Neo-Babylonian Cylinders
(9th–7th century B.C.)*

Neo-Assyrian Cylinders
of Linear Style
(9th–8th century B.C.)

1212

Cylinder
h: 3.1 cm.; diam: 1.1 cm.
Black serpentine rock; kneeling archer aiming at a sphinx; in the sky, a crescent and asterisks; archer is equipped with dagger (suspended from the waist) and quiver; a narrow lozenge (?) is placed above the back of the sphinx.
M.76.174.403

For cylinders of this type found in Assyrian graves of the ninth century B.C., cf. Moortgat, 1940, pl. 76: 639–42. The present seal was made into a fibula, one end of which is preserved.

1213

Cylinder
h: 2.3 cm.; diam: 1.2 cm.
White marble; kneeling hero with a scimitar menacing a rampant bull. Terminal: plant, crescent in the sky.
M.76.174.404

For comparable cylinders from Assur depicting goats instead of bulls, cf. Moortgat, 1940, pl. 76: 643, 644.

1214

Cylinder
h: 2.2 cm.; diam: 1.1 cm.
Red marble; city or temple gate with two towers; within, the symbol of the crescent moon appears on a stepped platform flanked by two maces; beside the gate on the left stand the symbols of Nusku (god of fire), Nabu (god of writing), and Marduk; on the right, a worshiper.
M.76.174.405

For a tall slender wedge (symbol of Nabu) on an eighth century cylinder, see *Corpus I*, 1948, pl. CXVII: 772; for a "spade" of Marduk of similar proportions, cf. a Neo-Babylonian (late eighth–seventh century B.C.) cylinder in Wiseman, 1959, pl. 94; for both tall slender symbols, cf. the cylinder found on the pavement of the outer gate chamber of the Nabu temple at Nimrud in Parker, *Iraq* XXIV, 1962, p. 26 and pl. IX:1 (Found here, as well, was a tablet dated in 614 B.C.; the cylinder, however, was correctly dated a century earlier on stylistic grounds.); for the representation of a gate in a cylinder of typically Iranian serrated style, cf. Buchanan, 1966, pl. 40: 610 (depicting a gate with towers topped by tall triangular merlons).

1215

Cylinder
h: 3.4 cm.; diam: 1.1 cm.
Composition; mountain goat, with its muzzle above a plant, pursued by a standing archer; large rosette in the sky.
M.76.174.406

The proximity of the goat's muzzle to the plant suggests that the animal is about to nibble at it. For cylinders with very similar subjects and style, cf. Moortgat, 1940, pl. 83: 705, 706 (one found at Assur, the other at Babylon). Moortgat dates the type to the ninth–eighth century B.C. (ibid., p. 92). A closer date in the eighth century is indicated by the evidence of a related cylinder from the Late Assyrian shrine at Tell Rimah, dated c. 800–612 B.C. Parker, *Iraq* XXXVII, 1975, pl. XVI: 51.

1212

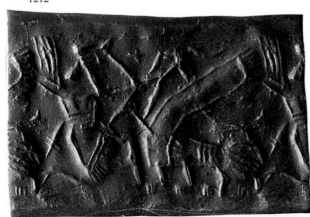

1214

Neo-Assyrian or Neo-Babylonian Cylinders of Cut Style (9th century B.C.)

1216

Cylinder
h: 3.5 cm.; diam: 1.4 cm.
White chalcedony; two kneeling figures flanking a sacred tree; winged sun disk in the field above. Terminal: crescent above a star.
M.76.174.411

For a discussion of the style, cf. *Corpus I*, 1948, p. 88. An indication of a date in the ninth century B.C. is given by the occurrence of a cylinder of cut style in level IV at Hasanlu (Winter in Levine, 1977, pl. 25: 16).

Neo-Assyrian Cylinders of Drilled Style, Late Group (8th–7th century B.C.)

1217

Cylinder
h: 2.5 cm.; diam: 1.1 cm.
Gray chalcedony; deity in an aura of stars (Ishtar?) facing a worshiper. Terminal: winged solar disk above a tree.
M.76.174.408

For an impression of a related figure of a deity on a tablet dated in 622 B.C., cf. Parker, *Iraq* XXIV, 1962, pl. XX: 3 and p. 37, fig. 4.

1218

Cylinder
h: 1.7 cm.; diam: 0.8 cm.
Yellow chalcedony; lion-griffin fleeing from a divine archer.
M.76.174.409

1219

Cylinder
h: 1.7 cm.; diam: 0.8 cm.
White chert; seal design composed of various symbols: a winged sun disk over an offering table; a star, fish, and rhomb, set one above the other; a frontal bull's head over a profile head of a horned animal; a crescent over a goat.
M.76.174.410

A cylinder with a different subject but similar style was found below the earliest Hellenistic level at Nimrud (i.e. late in the Assyrian level); cf. Parker, *Iraq* XXIV, 1962, pl. XVI: 1.

1216

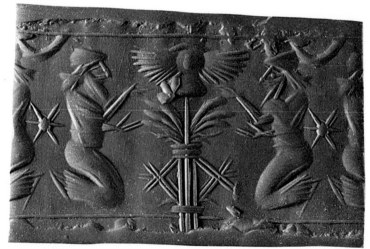

1217

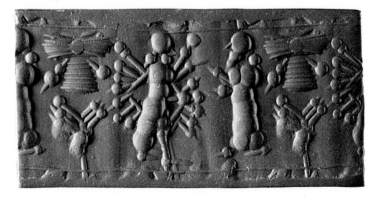

1218

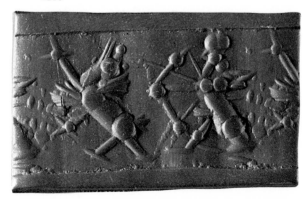

Neo-Assyrian or Neo-Babylonian Cylinders of Modeled Style
(late 8th–7th century B.C.)

1220
Cylinder
h: 2.4 cm.; diam: 1.2 cm.
White chalcedony; hero with scimitar grasping a goat by the foreleg; below the raised hind leg of the goat, the figure of a crouching monkey; star in the sky. Terminal: plant set in a container.
M.76.174.413

For a similar plant (shown with only one pair of leaves), cf. Delaporte, 1923, II, pl. 89: 17 (A.716).

1221
Cylinder
h: 2.6 cm.; diam: 1.5 cm.
Agate; hero grasping two stags, one by the horn, the other by the ear; in the field to the left, a scorpion-man on a platform.
M.76.174.402

For the scorpion-man on cylinders of the Neo-Babylonian period, cf. Delaporte, 1910, pl. XXVI: 387, 388.

Peripheral Cylinders
(9th–7th century B.C.)

1222
Cylinder
h: 2.9 cm.; diam: 1.1 cm.
Agate; fleeing griffin pursued by a hero in archer's stance with one arm bent, the other extended, grasping the griffin's wing feathers; in the field, a star, crescent, unconnected wedges, plant, and several unrecognizable forms.
M.76.174.418

1223
Cylinder
h: 2.9 cm.; diam: 1.2 cm.
Yellow chalcedony; lion-monster fleeing from a divine archer who strides over the body of a bull; archer's legs are extended to suggest the speed of flight; at the right, a worshiper holding a towel; in the field, a star and seven globes. Terminal: tassled spade and stylus on platform.
M.76.174.414

1224
Cylinder
h: 3.2 cm.; diam: 1 cm.
Gray chert; two genii flanking a sacred tree surmounted by a winged sun disk; a recumbent horned animal appears between the genii in a repeated rolling; Aramaic (?) inscription in the field.
M.76.174.407

1225
Cylinder
h: 1.76 cm.; diam: 1 cm.
White chalcedony; two human (?) figures facing each other over two stands and a central object (partly damaged) surmounted by an oval below a rayed disk. Terminal: an oblique cross over a lozenge.
M.76.174.415

1226
Cylinder, barrel-shaped
h: 3 cm.; diam: 1.22 cm.
Colorless chalcedony; four-winged genius advancing toward a stag which approaches a plant; in the sky, a winged disk over a thin, pointed, oval rhomb and angular crescent.
M.76.174.412

1220
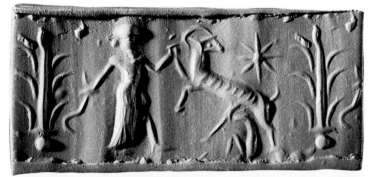

1222
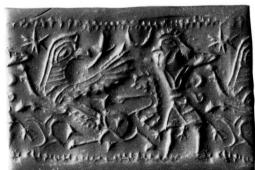

1221
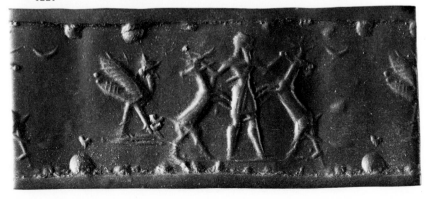

1223
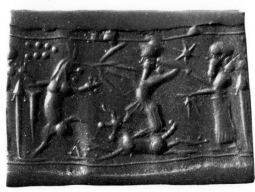

Neo-Elamite Cylinders
(c. 700–639 B.C.)

1227

Cylinder
h: 2.3 cm.; diam: 1.1 cm.
Light brown marble; lion-demon and hero; the latter is clad in a short garment; both figures hold a dagger in their upraised hands; between the figures in repeated rollings, a rosette with small rounded leaves and a star with larger, pointed rays or leaves.
M.76.174.420

For cylinders carved in the same style, cf. Amiet, *Arts Asiatiques* XXVIII, 1973, pl. VIII: 55–59, and 62; for the lion-demon and hero as gate figures in Assyria, cf. Barnett, 1976, pl. IV, XXI, and XXXI (here only the lion-demon holds weapons).

1228

Cylinder
h: 1.9 cm.; diam: 0.9 cm.
White chalcedony; kneeling archer aiming at a goat which is attacked from beneath by a hound; in the field, a crescent over the symbol of Marduk and a rosette.
M.76.174.421

For the motif of a kneeling archer shooting at a fleeing goat which turns its head back, cf. Amiet, *Arts Asiatiques* XXVIII, 1973, pl. V: 21.

1229

Cylinder
h: 1.9 cm.; diam: 1.1 cm.
Buff marble; horned animal (stag?) before an altar surmounted by a star and crescent.
M.76.174.416

The manner in which the stag strides, with foreleg slightly bent and delicately set down, is comparable to the gait of the monsters reproduced by Amiet in *Arts Asiatiques* XXVIII, 1973, pl. VII: 41, 43, and 44.

Achaemenid Cylinders
(c. 550–330 B.C.)

1230

Cylinder
h: 3.1 cm.; diam: 1.6 cm.
Blue chalcedony; king standing on two crouching sphinxes and holding in each hand a lion suspended by the hind leg; winged sun disk in the sky.
M.76.174.442

For comments on such representations, cf. Porada in Ettinghausen, 1979, pp. 82–83.

1231

Cylinder
h: 2.3 cm.; diam: 1.3 cm.
Light yellow chalcedony; king restraining two winged rampant bulls which he grasps by the horns; winged sun disk in the sky.
M.76.174.443

For the possible Lydian form of the antennae on the sun disk, cf. Porada in Ettinghausen, 1979, p. 91.

1232

Cylinder
h: 2.4 cm.; diam: 1.7 cm.
Light yellow chalcedony; king grasping two stags by the antlers; in the field, a bird and a seated lion with its head turned back.
M.76.174.446

For the shape of the bird, cf. Schmidt, 1957, *OIP* LXIX, pl. 15: PT 5 351; for the lion's forelegs and head, cf. ibid., PT 5 743.

1233

Cylinder
h: 2.8 cm.; diam: 1.2 cm.
Pink-and-yellow mottled marble; six-winged bird flanked by two rampant goats with heads turned back.
M.76.174.444

1234

Cylinder
h: 3.2 cm.; diam: 1.4 cm.
Hematite; hunter, holding a fringed shawl as a shield, spearing a charging boar.
M.76.174.445

For representations of boars on impressions from Persepolis, cf. Schmidt, 1957, *OIP* LXIX, pl. 14: 73, 74; for the style, cf. Boardman, 1970, pp. 312ff.

1227

1228

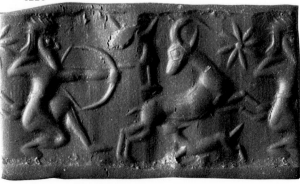

1231

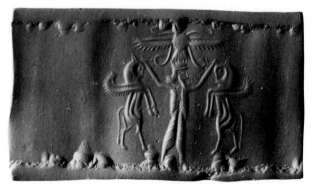

1232

Unclassified Cylinders of Iran

Metal Cylinders
(late 2nd–early 1st millennium B.C.)

1235

Cylinder
h: 3.3 cm.; diam: 1.5 cm.
Bronze; pattern of upright chevrons flanked above and below by a band of zigzag lines with perforations in between the points.
M.76.174.432

For the chevrons, cf. cylinders of Tchoga Zanbil (Porada, 1970, *MDAI* XLII, pl. XII: 126, 128, 140, etc.); for the border of triangles, cf. cylinders of the Isin II period (Buchanan, 1966, pl. 38: 563).

1236

Cylinder
h: 3.5 cm.; diam: 2 cm.
Bronze; two rows of semicircles, each enclosing a T-shaped form.
M.76.174.437

1237

Cylinder
h: 3.5 cm.; diam: 1.6 cm.
Bronze; two rectangles, each filled by a cross.
M.76.174.433

1238

Cylinder
h: 3.7 cm.; diam: 2.2 cm.
Iron; two abbreviated figures in seated posture, separated by vertical lines.
M.76.174.436

1239

Cylinder
h: 3.2 cm.; diam: 1.5 cm.
Bronze; two frontal winged figures with arms upraised, separated by two trees.
M.76.174.438

1240

Cylinder
h: 3.3 cm.; diam: 1.6 cm.
Bronze; enthroned figure facing a standing figure; horizontal lines above and below. Terminal: two crosses, one above the other.
M.76.174.434

1241

Cylinder, projecting rim above and below
h: 2.8 cm.; diam: 1.4 cm.
Bronze; human figure with hands raised and legs spread; tree and horned animal.
M.76.174.435

1242

Cylinder
h: 2.9 cm.; diam: 0.7 cm.
Bronze; two human figures with arms upraised; in the field between them, a scorpion and two concentric circles.
M.76.174.439

1243

Cylinder
h: 2.7 cm.; diam: 0.9 cm.
Metal; quadruped, set at right angles to the perforation, and a vertical line with eight horizontal bars.
M.76.174.441

1244

Cylinder
h: 2.3 cm.; diam: 0.8 cm.
Bronze; boar, with its body arched over the head of a lion or dog; crescent in the field overhead; horizontal groove around upper and lower periphery of seal.
M.76.174.440

For an animal in a related posture, cf. Amiet, *Revue du Louvre* XXVIII, 1978, p. 161: 28 (left).

1234

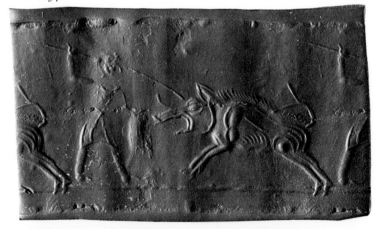

1238

1244

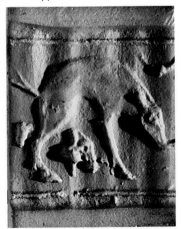

Stone Cylinders

1245

Cylinder
h: 4.3 cm.; diam: 2.8 cm.
Stone; archer aiming over a bull at a large bird of prey; comb-like design in the sky.
M.76.174.423

1246

Cylinder
h: 2.2 cm.; diam: 1.1 cm.
Onyx marble; archer aiming at a large quadruped (feline?) and a mountain goat, both set at right angles to the field, the former, face up, the latter, face down; in the field, six drillings in two rows.
M.76.174.427

1247

Cylinder
h: 1.9 cm.; diam: 0.9 cm.
Yellowish green and black stone; winged horse before a sacred tree.
M.76.174.430

The posture of the horse, with its strongly arched neck and bent foreleg, corresponds to that of a goat on a cylinder (Amiet, 1972, *MDAI* XLIII, pl. 186: 2159) which Amiet associated with seals of the first millennium B.C. from Sialk (ibid., p. 274).

1248

Cylinder
h: 4 cm.; diam: 1.8 cm.
Black serpentine rock; bull with a bird on its back juxtaposed with a goat; large serpent situated above both animals; third goat set upside down.
M.76.174.424

1249

Cylinder
h: 3.3 cm.; diam: 1.2 cm.
Black serpentine rock; two standing human figures with arms outstretched, one figure inverted; in the field, an unrecognizable arrangement of grooves and drillings.
M.76.174.428

1250

Cylinder
h: 1.7 cm.; diam: 1.2 cm.
Black serpentine rock; two persons in an enclosure turned upside down in relation to a winged sphinx or griffin similarly enclosed; separated by two lines, joined at the bottom, from a rayed disk over a crescent situated above two indefinable pointed objects, perhaps frontal animal heads.
M.76.174.337

1251

Cylinder
h: 1.62 cm.; diam: 0.94 cm.
Black serpentine rock; personage enthroned on an animal raising his hand toward a man leading a horned animal to a sacrifice; a second man follows; in the field, an inverted crescent over a drilling, a sun circle, and a large seven-pointed star.
M.76.174.335

1252

Cylinder
h: 2.4 cm.; diam: 1.2 cm.
Gray limestone or marble; archer on a horse.
M.76.174.425

1253

Cylinder
h: 3.3 cm.; diam: 1.9 cm.
Green-mottled black serpentine rock; three standing male figures with outstretched arms; serpents between them.
M.76.174.426

Ancient Art of Europe
and the Eastern
Mediterannean

Glenn Markoe
Assistant Curator
Ancient Art
Los Angeles County
Museum of Art

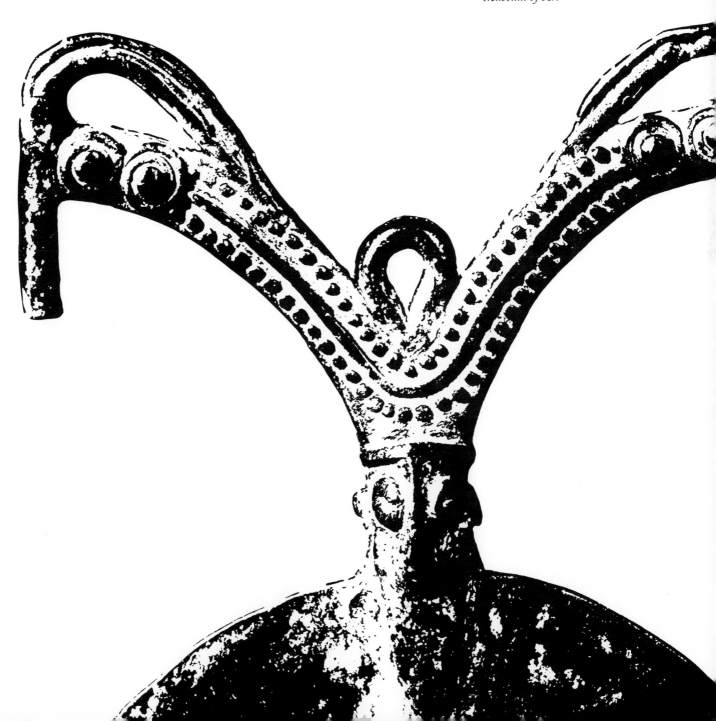

Greek Bronzes

The art of Greece is represented here by a small group of bronze objects dating from the Hellenistic era (c. 330–87 B.C.), the period extending from the time of Alexander the Great until the destruction of the city of Athens by the Roman general Mummius. During this period, through Alexander's own conquests, Greek art and culture penetrated far to the east and was in turn strongly influenced by traditions and artistic impulses from that area. For the first time, Greek art was manufactured extensively in centers outside the traditional Greek sphere (i.e., mainland Greece, southern Italy, which was known as Magna Graecia, and coastal Asia Minor). One of the most illustrious and productive of these manufacturing centers was the city of Alexandria, at the mouth of the Nile Delta in Egypt. In all likelihood, it was here that the two distinctive bronze statuettes (cat. nos. 1254 and 1255) were produced. The caricatured features of both figures—the elongated twisted torso and tall pointed head with elephant-like ears—typify the Hellenistic preference for the comic and the grotesque, a tendency particularly fashionable in Alexandria at this time. The pair borrows heavily in style and conception from Phoenician models of the early first millennium B.C. This influence is particularly noticeable in the exaggeratedly pointed head and floppy ears, but the subject and its attributes are clearly of Greek inspiration. In both instances we find a caricature of a servant weaving from too much drink. One figure (cat. no. 1254) is carrying a small child (now missing except for the legs) on his shoulder; the other (cat. no. 1255) holds a dove in one hand and in the other an animal-headed rhyton, or drinking vessel, the source of his inebriated state.

Also included in the collection are two Hellenistic bronze vessels —a vase and a bowl (cat. nos. 1257 and 1258). Both carry a shoulder decoration consisting of an incised floral pattern in the form of a running ivy band, a very popular decorative motif on black-glazed pottery vessels of this period. The vase (cat. no. 1257) displays traces of the niello (an alloy of sulfur and silver) inlay which originally filled its incised grooves.

1254

Male Figure
Hellenistic period;
3rd–1st century B.C.
h: 12.8 cm.; w: 8.1 cm.
Bronze, cast; standing nude male, legs slightly bent at the knees; elongated neck inclined forward with head twisted sharply to the right; the figure carries a child on his left shoulder (only the legs of which remain) whom he grabs by the knee with one hand; the right arm is outstretched (hand lost) and bent forward at the elbow; the figure wears a necklace with pendent medallion; the head is a grotesque caricature with large elephant-shaped ears, receding forehead, and pointed cranium terminating in a pointed tuft of hair composed of four coils.
M.76.97.776

1255

Male Figure
Hellenistic period;
3rd–1st century B.C.
h: 8.8 cm.; w: 5.5 cm.
Bronze, cast; standing nude ithyphallic male holding a dove in his left hand and an animal-headed rhyton in his right; his legs are bent at the knees; his neck is inclined slightly forward with head angled to the left; the facial caricature is similar to the previous figure; right ear perforated; the figure appears to wear a soft, pointed cap with a peak which falls forward; situated on a circular base with a tab below.
M.76.97.777

For this and the preceding figure, cf. Neugebauer, 1951, I, p. 93, no. 76 and pl. 39.

1255

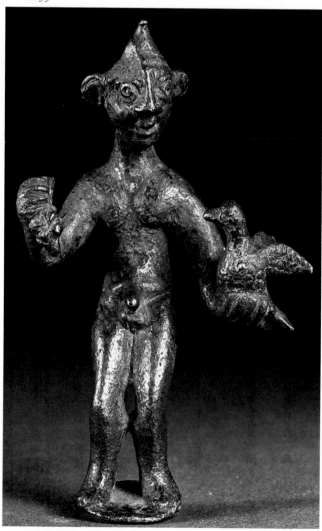

1256

Bull's-Head Attachment
Hellenistic period;
3rd–2nd century B.C.
h: 12 cm.; w: 9.4 cm.
Bronze, cast; handle attachment
in the shape of a bull's head with
four rings about its periphery;
eyes, nostrils, and forehead hair
engraved, the latter with a lozenge
pattern; this object probably
served as the handle of a chest or
vessel (perhaps a cauldron), or as
some form of harness attachment.
M.76.97.657

cf. Mitten, 1967, p. 141, no. 145;
Vermeule, 1971, nos. 404, 405.

The bull's-head motif and its use
as a cauldron attachment derive
ultimately from Phrygian and
Urartian models of the early first
millennium B.C.

1257

Vase
Hellenistic period;
c. 2nd–1st century B.C.
h: 8.3 cm.; diam: 7.5 cm.
Bronze, cast; with closed, ovoid
body and ring base; shallow
double torus molding around
mouth; incised concentric rings
on underside beneath base;
shoulder decorated with an ivy
band inlaid with niello.
M.76.97.409

1258

Bowl
Hellenistic period;
c. 2nd–1st century B.C.
h: 6.4 cm.; diam: 11.8 cm.
Bronze, hammered; deep, open
bowl with hemispherical body
and wide, flaring lip; incised ivy
band on shoulder; engraved line
beneath lip; repaired; fragment
missing from body.
M.76.97.410

1256

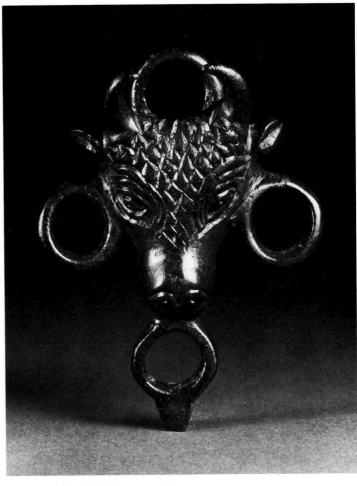

The following objects, chiefly animal figurines and statuettes of Roman origin and manufacture, date primarily from the first three centuries after Christ. Many of these pieces are freestanding; others were originally part of or formed attachments to pins, knives, vessels, etc. All are extremely difficult to date precisely and equally difficult to define geographically. Numerous examples have been found over an area ranging from Spain and Gaul in the west to Iran in the east. During the time of the Roman Empire provincial workshops throughout the area were doubtless producing such items. The range of animal subjects covers the entire spectrum, from the smallest and the most inconspicuous–frogs and turtles (cat. no. 1276)–to the largest and most exotic–panthers and elephants (cat. nos. 1262 and 1269). One very popular subject of this period is a canine or feline, typically a hound, panther, or lion, with its head upraised in a howling posture. Two exquisite and delicately cast examples of this type are featured in the Heeramaneck Collection (cat. nos. 1261 and 1262). A statuette of a howling hound in a similar pose, uncovered in a cremation burial at Cologne, Germany, together with a medallion of the Roman emperor Commodus (180–193 A.D.), affords us a rare indication of date (La Baume, 1964, p. 258 and fig. 244). Geographical references can occasionally be derived from the animal types depicted, such as the Apis bull, sacred animal of ancient Egypt and incarnation of the god Ptah (cat. no. 1273), or the humped zebu (Bos Indicus), native to Asia and India (cat. nos. 1267 and 1272). A number of objects clearly were produced in Iran, such as the two brooches (cat. nos. 1280 and 1281), one in the form of a rhomboid with polychrome enamel inlays, the other shaped as a fanciful winged quadruped. Excavated examples of both have been found in the Iranian province of Dailaman. Also from the region of Iran is the bronze knife handle (cat. no. 1259), delicately cast in the shape of a panther erupting from a double leaf and chewing on a severed boar's head held between its paws. This motif, as well as the general theme of predator and prey, was widely exploited in minor arts of the Roman epoch. Slightly earlier in date is the fluted silver bowl with handle terminating above in a delicately cast female head (cat. no. 655). Reminiscent of Imperial Roman silver plate of the first century A.D., it may represent an import or perhaps a local Iranian product influenced by Western trends.

1259

Knife Handle
Roman; 1st–2nd century A.D.
l: 12.8 cm.
Bronze, cast; in the form of a feline erupting from a double leaf; holds a boar's head between its paws while chewing on one ear; hilt terminates in an inverted proto-Aeolic capital.
M.76.174.129

This motif of a panther devouring its prey was a popular theme in bronzework of the Roman Imperial period; cf. Reinach, 1913, IV, p. 468, fig. 4 and p. 474, fig. 4; Kaufmann-Heinimann, 1977, I, no. 226; pl. 45, no. 9; and pl. 57.

1260

Seated Monkey
Roman; 1st–2nd century A.D.
h: 4 cm.
Bronze, cast; monkey seated with right hand perched on its waist behind the back.
M.76.97.905

For pose and stylization, cf. Reinach, 1898, II, p. 767, fig. 5; Neugebauer, 1951, I, pp. 87ff. and pl. 29, fig. 188.

1261

Howling Lion
Roman; 1st century B.C.– 2nd century A.D.
h: 6 cm.; l: 3.5 cm.
Bronze, cast; lion seated on its hindquarters, with forepaws planted squarely on the ground and head fully upraised, its jaws agape in a howling posture; graceful, naturalistic rendering.
M.76.97.939

This "howling" posture is a common characteristic of animal representations of the Roman Imperial period; cf. a statuette of a howling hound found in a cremation burial at Cologne and dated securely to c. 200 A.D.; the grave contained a medallion of the emperor Commodus (180–193 A.D.) (La Baume, 1964, p. 258 and fig. 244).

1262

Howling Panther
Roman; 1st century B.C.– 2nd century A.D.
h: 4.9 cm.; l: 4 cm.
Bronze, cast; panther seated on its hindquarters with right forepaw upraised, its head raised and turned to the left, its jaws agape in a roaring or howling attitude; graceful, naturalistic rendering.
M.76.97.941

cf. Reinach, 1898, II, p. 725, nos. 3, 5; Fleischer, 1967, pls. 123–25, no. 249.

1261, 1262

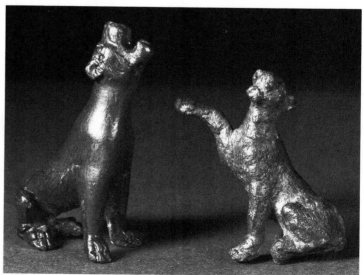

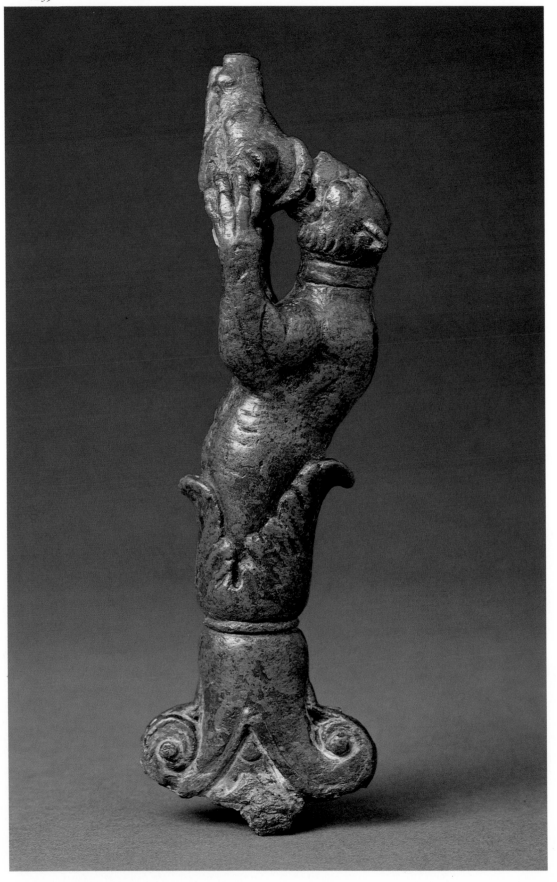

1263

Running Dog
Roman; 1st–3rd century A.D.
l: 3.5 cm.
Bronze, cast; dog running at full speed, fore- and hind legs outstretched; oblique parallel cuttings over entire surface; tail arches to form suspension loop; perforated tabs at terminals for fore- and hind legs.
M.76.97.976

For type, cf. Reinach, 1913, IV, p. 526, fig. 6; Boucher, 1971, no. 68.

1264

Reclining Lion
Roman; 2nd–4th century A.D.
h: 3.1 cm.; l: 6.1 cm.
Bronze, cast; reclining lion; profile body with head turned full face; large fringed mane; tail curled on haunch; on a flat rectangular base; perforated tab beneath forefeet, a second projecting from a tab cast (at right angles) at the rear.
M.76.97.942

This object may have functioned as the clapper ring of a bell; cf. Rolland, 1959, p. 78 and pl. LIII, no. 175; di Stefano, 1975, no. 141.

1265

Charging Lion
Roman; 2nd–4th century A.D.
l: 5.3 cm.
Bronze, cast; lion in full profile, its fore- and hind legs fully outstretched; entire surface decorated with impressed circles; forelegs abbreviated and marked by a circular indentation; beneath the forelegs, a pair of rounded perforated tabs; behind the hind legs, a single tab.
M.76.174.80

For pose, cf. Lebel, 1975, p. 103, no. 212.

1266

Protome
Roman; 2nd–4th century A.D.
h: 4.5 cm.; l: 4 cm.
Iron, cast; in the form of a bull's head; tall spike protruding from the top of the head; rectangular dowel hole drilled vertically through the neck, exposed by a break at the back.
M.76.97.845

1267

Zebu
Roman; 1st–2nd century A.D.
h: 3.9 cm.; l: 3.5 cm.
Bronze, cast; zebu passant with long pendent tail; on an oval base.
M.76.97.815

1268

Bull
Roman; 1st–2nd century A.D.
h: 4.5 cm.; l: 7 cm.
Bronze, cast; standing bull with recurved tail (wrapped about its torso); fore- and hind legs each on individual bases.
M.76.97.940

cf. Popovič, 1969, no. 156.

1269

Elephant's Head
Roman; 1st–2nd century A.D.
h: 5.4 cm.; w: 4.5 cm.
Bronze, cast; statuette or handle in the form of an elephant's head, naturalistically portrayed; entire surface decorated with an elaborate crisscross pattern, each lozenge decorated with a shallow, circular drilling; trunk bifurcates, possibly for insertion into a larger fixture.
M.76.97.931

For the full figure of an elephant with identical surface decoration, cf. Popovič, 1969, no. 159.

The representation of an elephant in its entirety or, more frequently, by its head alone, was a common motif in minor arts of the Roman period; cf. its use on bronze lamps (Vermeule, 1971, no. 490).

1270

Protome
Roman; 2nd–3rd century A.D.
h: 3.5 cm.; w: 3 cm.
Bronze, cast; hollow-cast protome consisting of a prominently beaked rodent's head with forepaw protruding from a rounded, tripartite, wing-like arrangement; openwork rectangular framework on the reverse.
M.76.97.713

The deeply engraved, striated decoration of the wing "feathers" suggests a common origin with the fibula-brooch (cat. no. 1280).

1271

Plaque or Appliqué
Roman; 1st–2nd century A.D.
h: 3.2 cm.; w: 4.8 cm.
Bronze, cast; in the form of a reclining dog with head reverted, nursing itself; forelegs crossed, tail curled beneath its hind legs; circular perforations beneath tail, below belly, and on back.
M.76.97.631

The pose and conception is typically Roman, although known examples are cast in the round, not as plaques (cf. Reinach, 1898, II, p. 762, fig. 4 and p. 763, fig. 1).

1272

Zebu
Roman; 1st–2nd century A.D.
h: 4.8 cm.; l: 4.4 cm.
Bronze, cast; bull standing, feet together, tail pendent; neck folds indicated by parallel incisions; on a flat, rectangular base.
M.76.97.969

cf. Rolland, 1959, p. 64 and pl. 39, no. 130.

1273

Apis Bull
Roman; 1st–2nd century A.D.
h: 4.7 cm.; l: 5.2 cm.
Bronze, cast; standing bull, a solar disk set between its horns; fore- and hind legs represented singly; no base.
M.76.97.973

1274

Ram
Roman; 1st–2nd century A.D.
h: 4.4 cm.; l: 4.2 cm.
Bronze, cast; standing ram with saddlebags on its back; fore- and hind legs set together; entire surface ornamented with shallow depressions.
M.76.97.932

cf. di Stefano, 1975, nos. 123, 124.

1269

1275

Dog
Roman; 1st–2nd century A.D.
h: 2.1 cm.; l: 5 cm.
Bronze, cast; crouching or squatting dog; its hindquarters terminate in a hollow, flaring aperture, possibly for insertion into a fixture.
M.76.97.934

For a fibula with a representation of a dog and hare in similar style, cf. Popovič, 1969, no. 281.

1276

Turtle with Young
Roman; 1st–2nd century A.D.
h: 1.7 cm.; l: 3.5 cm.
Bronze, cast; turtle with offspring perched on its shell; both animals' heads upraised; concave underside; modern pin and rear drilling.
M.76.97.854

For a similar representation of a frog, cf. di Stefano, 1975, no. 149. Playful representations of animals, singly or in pairs, were popular themes in the minor arts of the Roman period; for a Roman bronze fibula with attachments in the form of a hound pursuing a hare, cf. Mano-Zisi, 1954, p. 22.

1277

Vessel Attachment
Roman; 1st–2nd century A.D.
w: 3.8 cm.
Bronze, cast; in the form of a recumbent stylized feline or canine curled head to tail; loop attachments on three sides; hollow, concave underside.
M.76.97.540

The motif of a curled sleeping animal was popular in antiquity (cf. Vermeule, 1971, no. 487). The rounded stylization of the animal depicted here, as well as the highly ornamented border, suggest a strong oriental "steppe" influence.

1278

Vessel Attachment
Roman; 2nd–4th century A.D.
h: 6.5 cm.; l: 5.2 cm.
Bronze, cast; in the form of a stag(?) head on a curved neck, its antlers terminating in three prongs; at base of neck, a rectangular attachment plate with four perforations.
M.76.97.853

1279

Seated Male Figure
Hellenistic-Roman;
2nd century B.C.–2nd century A.D.
h: 7.5 cm.; w: 5 cm.
Bronze, cast; seated nude youth resting a club on his left shoulder and holding a cup (?) on his right knee; full coiffure of curly locks; possibly a representation of Herakles.
M.76.97.781

1280

Fibula-Brooch
Roman; 2nd–3rd century A.D.
h: 3.6 cm.; w: 5.7 cm.
Bronze, cast; in the form of a winged quadruped with head and tail of a cock; only three legs are rendered; body is modeled in four discrete sections: forequarters and neck, midsection and wing, hindquarters, and tail; entire surface is decorated with a series of incised circles with drilled nucleii.
M.76.97.935

For brooches of similar type from Dailaman, cf. Ghirshman, *IrAn* 4, 1964, pl. 28:8; ibid., *IrAn* 12, 1977, pl. 7:3.

1281

Fibula-Brooch
Roman; 2nd–3rd century A.D.
h: 5.3 cm.; w: 4.3 cm.
Bronze, cast; rhomboidal medallion, triple-tiered, with eight circular appendages equally apportioned around the edges; interior is composed of an inlaid pattern of red enamel consisting of a circular medallion flanked by cross-like projections between four semicircles opening onto each of the four sides.
M.76.174.44

For fibulae of a similar type found in excavations at Dura Europos, cf. Ghirshman, *IrAn* 4, 1964, pp. 104ff. and pl. 30:2

1279

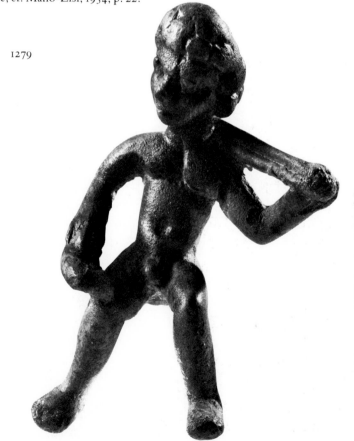

1280

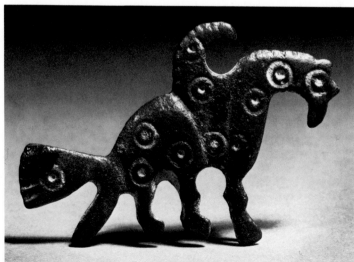

1282

Lamp Lid
Late Roman–Byzantine;
4th–6th century A.D.
h: 5.5 cm.
Bronze, cast; circular; surmounted by a standing bird with flat, triangular wing; perforated strut connects rear portion of wing to base; incised parallel hatching on wing and belly.
M.76.97.936

1283

Lamp Lid
Late Roman–Byzantine;
4th–6th century A.D.
h: 4.5 cm.
Bronze, cast; circular; surmounted by a standing eagle with outspread wings; large circular perforation at rear portion of lid behind tail.
M.76.97.971

1284

Lamp Lid
Late Roman–Byzantine;
4th–6th century A.D.
h: 5.2 cm.
Bronze, cast; circular; surmounted by a standing bird, with legs represented as a single support; recurved tail perforated at juncture with base.
M.76.97.972

For similar stylization, cf. di Stefano, 1975, no. 165.

1285

Lamp
Roman; 1st–2nd century A.D.
l: 19.5 cm.; w: 9.5 cm.
Bronze, cast; decorated on its exterior surface with a central female head (Medusa?); two wick spouts framed by scroll patterns; lamp mouth with open acanthus leaf with five circular drillings projecting above from the head; circular bottom; base missing; authenticity questionable (possibly a modern aftercast).
M.76.97.803

For general type, cf. Popovič, 1969, nos. 261–63; ibid., no 264 for facial type.

1286

Bearded Male Head
Roman; 2nd–3rd century A.D.
h: 14 cm.
Marble, carved; bearded face; large almond-shaped eyes with incised pupils; carved flat at the back; nose and upper forehead damaged; shoulder-length hair and beard composed of long, spiraling locks, the latter falling in inward-curling tresses.
M.76.174.277

1287

Conical Beaker
Roman; 50–150 A.D.
h: 15.8 cm.; diam: 8.5 cm.
Clear or pale yellow glass, blown and cut; tall beaker with carefully profiled lip and flaring foot, the sides expanding gradually from base to rim; rhomboid facets on the exterior, with the upper and lower margins left undecorated.
M.76.174.248

cf. Saldern, 1967, no. 27.

Illustrated on page 125.

1286

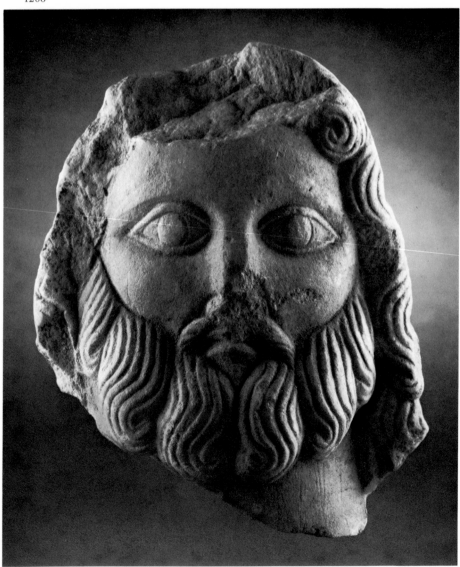

Italic Bronzes

The Villanovan, pre-Etruscan cultures of Italy, like their Iron Age counterparts in Iran, produced a repertoire of bronze items consisting primarily of human and horse apparel. The complete horse bit with cheekpieces cast in the form of stylized equids (cat. no. 1290) clearly reminds one of similar objects from Luristan (cf. cat. nos. 135ff.), while another horse-shaped trapping in the collection (cat. no. 1289) illustrates this connection even more dramatically and shows the phenomenon of cultural diffusion from East to West; the stylized elongated torso and crested mane suggest a strong affinity with buckles from the Koban region in the Caucasus (cat. no. 937). An elaborate belt buckle of roughly contemporary date (cat. no. 1288), with three hooks in the shape of two flanking panther heads (facing outward) and a central human head (facing forward), recalls the "master/mistress of animals" theme so vividly represented on the Luristan finials and openwork pins (cat. nos. 238ff. and 335ff.). The torque, or neck ring, widely adopted among the various tribal units of Central Europe and Italy, represents another borrowing from the East. The Heeramaneck piece (cat. no. 1291), a plain heavy ring with large cone-shaped terminals, is paralleled by a much smaller example, probably a child's fitting, from the Italian cemetery site of Palestrina.

1288

Three-Pronged Clasp and Buckle
Villanovan; 9th–8th century B.C.
h: 6.5 cm.; w: 10.1 cm.
Bronze, cast; in two sections, each consisting of a rectangular open-work frame with concave sides of round section; buckle has three loops; clasp has three corresponding hooks terminating in upright heads: the outer two, panther heads facing outward, the middle, a human head facing inward.
M.76.97.873a,b

cf. von Hase, *JdI* 86, 1971, pp. 11ff., pls. 10–14.

1289

Harness Trapping in the Shape of a Horse
Villanovan; 9th–8th century B.C.
h: 11.8 cm.; w: 14 cm.
Bronze, cast; in the form of a stylized horse with elongated torso, long muzzle, and prominent mane; fore- and hind legs terminate in cast rings; three loops on back; knob-like protuberances on either side of head, perhaps denoting eyes; possibly a rein guard.
M.76.97.596

Pub. Bowie, 1966, pl. 51; cf. von Hase, 1969, fig. 1, no. 2.

1288

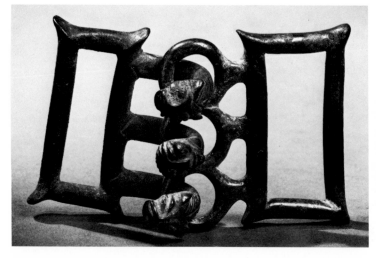

1289

1290

Horse Bit
Villanovan; 7th century B.C.
l. of cheekpiece: 11 cm.;
l. of mouthpiece: 17.3 cm.
Bronze, cast; complete bit and
cheekpieces; rigid mouthpiece bar
with terminals coiled in the same
direction, each loop containing a
single cast ring; cheekpieces cast in
the form of a duck-billed equid
with denticulated mane; eye rings
at the terminals of the fore- and
hind legs, and above the back on
either side.
M.76.174.311

cf. von Hase, 1969, pp. 6ff. and
pl. 2 (Veii type).

1291

Torque (neck ring)
Picene; late 7th–6th century B.C.
diam. of hoop: 17.8 cm.
Bronze, cast; plain heavy ring
with large cone-shaped terminals
turned outward.
M.76.174.312

cf. Vermeule, 1971, no. 305 (Pales-
trina); Randall-MacIver, 1927,
p. 132, fig. 36 (Belmonte).

1292

Male Figure
Etruscan; 6th century B.C.
h: 8.6 cm.
Bronze, cast; standing male,
crudely rendered with arms at
sides; below the feet, a tang for
insertion in a base.
M.76.97.787

cf. Richter, 1915, nos. 145ff.;
Colonna, 1970, pl. 34, no. 125
(Po Valley).

1293

Kouros (youth)
Etruscan; end of 7th–
beginning of 6th century B.C.
h: 8 cm.
Bronze, cast; standing male with
arms at sides, bent at elbows, with
forearms extended (right forearm
lost); feet set close together; face
has prominent nose and chin and
receding forehead with flat hairdo
parted in the middle, evenly
cropped at the back above shoul-
der level; crude, schematic
rendering.

Pub. Del Chiaro, 1981, p. 11, no. 1
and p. 34, pl. 1.

cf. Unpublished, Museo Archeo-
logico, Florence, inv. nos. 112,
499; Museo Etrusco Guarnacci,
Volterra, Italy, inv. no. 94.

1291

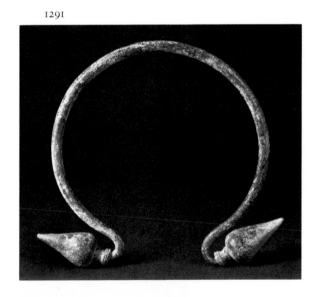

1292

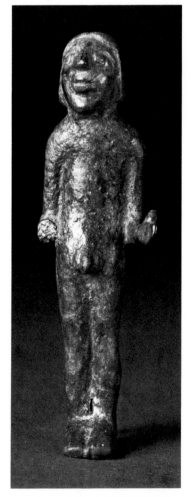

1290

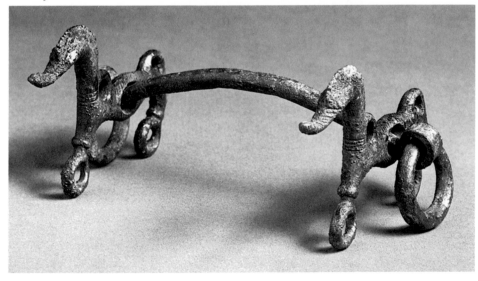

Celtic Bronzes

The art and culture of Europe before the Roman occupation is one of the most problematic and poorly understood areas of art history. In the absence of written texts, the scholar is totally dependent for a chronology upon information provided by Greek and Latin authors of a much later time, or upon archaeological associations with intrusive, independently datable artifacts, such as Greek vases. The dating and attribution of all of the objects in this section, with the exception of a single torque (cat. no. 1301), are problematic and based largely on attributable parallels. The dating scheme utilized refers to the two major chronological divisions of the European or Celtic Iron Age: the Hallstatt (c. 700–500 B.C.), which takes its name from a cemetery in Austria whose artifacts provide the basis of typology for this period, and the La Tene (c. 500–100 B.C.), named after an extensive hoard of objects deposited in the shallows by Lake Neuchâtel, Switzerland. One of the most striking aspects of Celtic art is its emphasis on the abstract. The spiral motif, employed on catalog numbers 1294–96, was a popular and enduring decorative device commonly used on articles of personal apparel, such as pins and rings. The same motif reappears in a more baroque style on a torque of La Tene date from France (cat. no. 1301); the single motif is here combined to form an elaborate and fanciful pattern of curls and scrolls. The second torque (cat. no. 1302), with its stylized swan's-head terminals and abstract symbols (undulating lines for water, the starburst, etc.), reflects a more northerly, Scandinavian tradition. The torque form itself originated in the East (Caucasus region) and then spread south to Iran and west to Europe, illustrating again the debt of European Iron Age art to oriental models. This borrowing from the East can also be seen in the whirligig appliqué of three horses' heads (cat. no. 1299), its form clearly derived from earlier Scythian models. This influx of Scyths to the West can also be traced through the appearance of the distinctive trilobate arrowheads (cat. no. 96) they left behind on their travels.

The quality of abstraction discussed in reference to the spiral motif is even more dramatically evidenced in representations of animal forms. One example is the heavily stylized horse's head with globular nose, the whole projecting from the foot of an animal (cat. no. 1298). This predilection for curves and undulating contours is clearly illustrated by the handle mount (cat. no. 1300) in the form of a hippocamp (a mythical sea horse) and, lastly, by the caricatured representation of a bull with its sweeping horns and rounded surface contours (cat. no. 1297).

1294

Double-Spiral Pin
Eastern Europe; Chalcolithic (c. 5000 B.C.)
h: 19.4 cm.; w: 6.2 cm.
Copper, hammered; shank terminates in a double spiral, each coil consisting of five turns; if pure (rather than alloyed) copper, it is probably an artifact of the so-called Copper Culture of Central and Eastern Europe, the earliest of the metalworking traditions in continental Europe.
M.76.97.672

1295

Spiral Armband
Central or Northern Europe; Late Bronze Age (c. 1450–1250 B.C.)
h: 11 cm.; w: 6 cm.
Bronze, hammered; elongated spiral coil of triangular section, terminating at either end in a spiral plate or tutulus (lower one lost).
M.76.97.730

cf. Gimbutas, 1965, fig. 203: 4 (Central European Tumulus Culture) and fig. 262: 11 (Baltic Middle Bronze Age).

1296

Spiral Pin
Northeastern Europe; Hallstatt period (c. 700–500 B.C.)
h: 25.2 cm.; w: 8.6 cm.
Bronze, hammered; pinhead in the form of a tightly coiled spiral, slightly convex in profile, with tall central tutulus.
M.76.97.670

cf. Jacobsthal, 1956, no. 360 (Pomerania).

1297

Standing Bull
Central Europe; Hallstatt period (c. 700–500 B.C.)
h: 7 cm.; l: 9.8 cm.
Bronze, cast; bull with stylized quadrangular torso, elongated neck and muzzle, and short stumpy legs; long, sweeping horns recoiled at the ends; eyes drilled for inlays of glass or amber.
M.76.97.871

Pub. Bowie, 1966, p. 54, pl. 57; for related examples of Bronze Age date, cf. Kühn, *Ipek* 15–16, 1941/42, pl. 96.

Although representations of freestanding bulls continue through the La Tene period in Central Europe, the caricatured features of this piece suggest a date in the later Hallstatt period.

1295

1298

Utensil Leg
Central Europe; La Tene period
(c. 500–100 B.C.)
h: 6 cm.; w: 4.1 cm.
Bronze, cast; leg attachment in the
form of an animal foot, terminat-
ing above in a stylized horse's
head; a three-pronged extension
(resembling a rooster's crest)
projects horizontally from the
back of the head, serving as the
platform support.
M.76.97.660

The origin and dating of this
object are problematic. The styl-
ized curvilinear treatment of the
whole, particularly the horse's
head with its globular muzzle,
suggests a late Iron Age, Celtic
provenance.

1299

Whirligig of Three Horses' Heads
Central Europe; La Tene period
(c. 500–100 B.C.)
diam: 7.5 cm.
Bronze, cast; appliqué in the form
of a whirligig of three rays, each
terminating in a stylized horse's
head with incised mane; central
opening with raised collar.
M.76.97.893

cf. Jacobsthal, 1944, pl. 239c (from
Magdalenska Gora, Hungary).

Commonly represented in art of
the late Iron Age in Europe, the
type derives ultimately from
Scythian models.

1300

Handle Mount
Central or Eastern Europe;
La Tene period (c. 500–100 B.C.)
h: 4.9 cm.; w: 11 cm.
Bronze, cast; in the form of a sea
horse (hippocamp) surmounted
by a ring, the terminals of which
join above creature's back to form
a v-shaped notch; rectangular
socket in middle of creature's
body for insertion of handle (?); a
series of five incised rings decorate
the animal's neck and forequarters.
M.76.97.998

cf. a bronze handle mount from
Maloměřice, Czechoslovakia
(early 3rd century B.C.), in Megaw,
1970, no. 159; also Babelon, 1895,
no. 796; di Stefano, 1975, no. 178.

1301

Torque (neck ring)
Western Europe; La Tene Ib
(c. 350–275 B.C.)
diam: 16.2 cm.
Bronze, cast; Bretz-Mahler, 1971,
torques à decor spiraliforme (pl. 180:
1); open-ended hoop with hollow,
cup-shaped terminals; hoop and
terminals decorated throughout
with an elaborate spiral pattern in
relief; plug-shaped terminals de-
lineated from hoop by a triple
torus molding.
M.76.97.669

Pub. Bowie, 1966, p. 68, pl. 90a;
cf. Eggers, 1965, fig. 2 (from Saint
Germain-en-Laye).

1302

Torque (neck ring)
Northeastern Europe; La Tene
period (c. 500–100 B.C.)
w: 14.8 cm.
Bronze, cast; open-ended hoop of
flattened section with recurved,
tapering terminals in the form of
stylized swans' heads; exterior sur-
face decorated along its outer edge
with a pattern of alternating chev-
rons and punched circles; at either
end, a series of three motifs, con-
sisting of a group of superimposed
undulating lines, a sunburst, and
an elongated heart-shaped motif.
M.76.97.726

Pub. Bowie, 1966, p. 68, pl. 90d.

The date and origin of the piece
are problematic; the decorative
motifs find general parallels in late
Iron Age Scandinavian art.

1303

Bracelet
Northeastern Europe; Iron Age
diam: 5.4 cm.
Bronze, hammered; small hoop
with flaring, flattened terminals
which closely abut, each decorated
with a prominent median rib with
framing herringbone pattern.
M.76.97.328

For the use of a similar cord
pattern as border motif, cf.
Kivikoski, 1951, II, fig. 686.

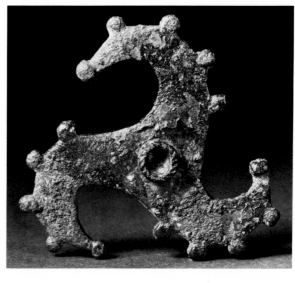

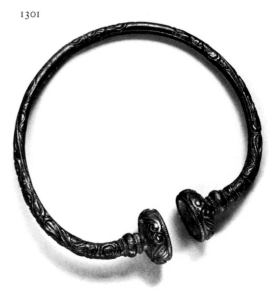

The following series of objects come from the eastern littoral of the Mediterranean, areas comprising present-day Lebanon (ancient Phoenicia) and Syria.

1304

Male Figure
Northern Syria;
c. 15th–12th century B.C.
h: 14.1 cm.; w: 2 cm.
Bronze, cast; standing male with an elongated neck and tall pointed headdress; left leg is advanced, the left arm laid flat against the chest; right arm is bent with forearm extended, the whole cast separately and affixed to the shoulder by means of a pin; figure is dressed in a long, close-fitting, ankle-length robe with embroidered hem and v-shaped collar; sides are grooved to receive a gold or silver leaf overlay (now lost).
M.76.97.775

The features are very crudely and rudimentarily executed. The elongated headdress suggests that it may be a provincial adaptation of the striding Baal-Reshef type; the long robe, however, favors an identification as a priest.

1305

Lion Bowl
Northern Syria;
9th–8th century B.C.
l: 18.4 cm.; diam: 9.8 cm.
Steatite, carved; hemispherical, with a hollow protome attachment in the form of the forepart of a lion with gaping jaws and protruding fangs, its head and forepaws attached to and looking into the vessel; lion's mane rendered in horizontal tiers, with a braided tress suspended below each ear; eyes hollowed for inlay; on the underside of the bowl, an outspread hand in low relief with a rosette medallion engraved on its back and cross-hatching on the wrist.
M.76.97.910

cf. Muscarella, *BMMA* n.s. 32, 1974, pp. 250ff.

The piece belongs to a rather large and well-attested group of bowls with lion-headed terminals, examples of which have been uncovered at various excavated sites in Anatolia and northern Syria. Employed as a stopper to a vase, this piece is unusual in its combined use of the hand motif and of the lion protome. When tilted, the oil or wine of the container would pass from the lion's mouth into the receptacle.

1306

Cylindrical Bowl
Northern Syria;
c. 9th–8th century B.C.
h: 4 cm.; diam: 11.5 cm.
Steatite, carved; on the exterior, an incised frieze bearing a continuous undulating pattern of hook-shaped motifs pointing alternately upward and downward, the whole framed by a double-incised line; this pattern is interrupted at one end by a horizontal, notched relief ridge flanked on either side by a panel depicting an animal behind a plant (left) and a profile male head (right); field above and below frieze is filled with an incised cross-hatched network; walls are blackened by burning.
M.76.97.916

1305

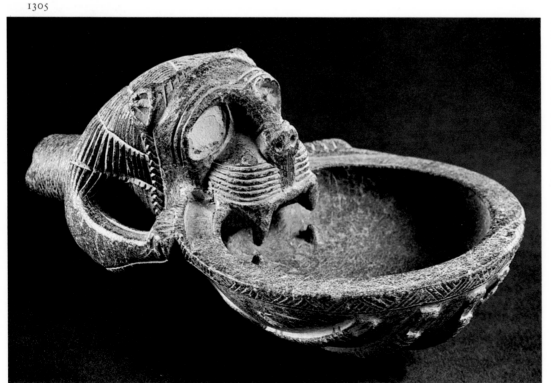

1307

Funerary Bust
Palmyra; 150–200 A.D.
h: 55 cm.; w: 36 cm.
Limestone, carved; Colledge,
1976, group 2.A.b; bust of a
woman clothed in tunic and man-
tle, equipped with a turban, a di-
adem, and a veil which falls in two
strands on either side of the head;
she is adorned with three beaded
necklaces, a bracelet, an armband,
and a pair of earrings in the form
of pendent grape clusters; the
right hand clasps the veil at shoul-
der height; the left clasps a loop of
the veil wrapped about her wrist;
traces of red pigment on face and
tunic; inscription above left
shoulder added in modern times.
M.76.174.249

For a comparable head, cf. Ghirsh-
man, 1962, fig. 93 (Louvre AO 1557).

1308

Mosaic Floor Fragment
Syria; 6th century A.D.
h: 82 cm.; w: 82.5 cm.
Polychrome limestone tesserae;
prancing lion set within a circular
medallion circumscribed by a
vine tendril.
M.76.174.252

This fragment originally formed
part of a larger arrangement of
such medallions, typically featur-
ing various beasts (giraffe, zebra,
leopard, ram, hare) and species
of fowl (duck, hen, partridge,
peacock). The style, the use of an
encircling vine trellice, and the
subject's animated pose are all
closely paralleled in floor remains
of a recently discovered syna-
gogue of early 6th century A.D.
date at Gaza (Avi-Yonah, 1975,
pl. CLXXIX).

1307

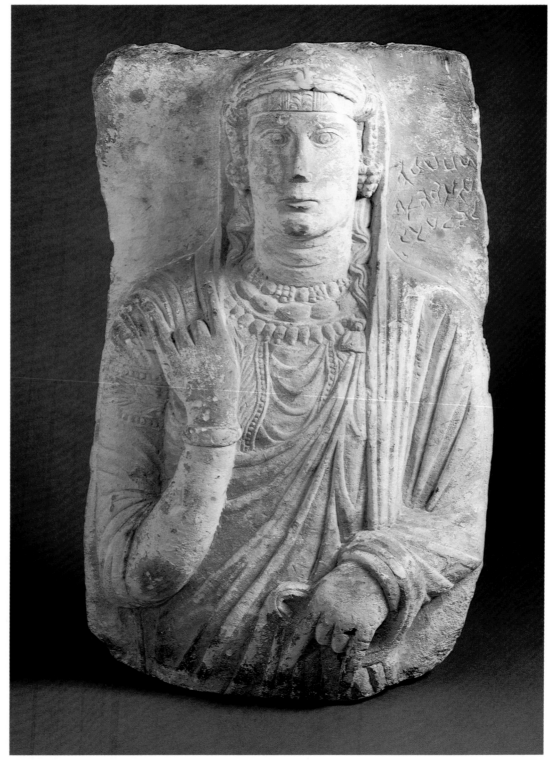

Phoenician Bowls

The following vessels, a series of engraved shallow bronze bowls, belong to an artistic tradition which may properly be called Phoenician. The distinctive scheme of decoration, characterized by the use of concentric bands arranged around a central medallion, and the combined use of Aegean, Syrian, Assyrian, and, most importantly, Egyptian motifs form the hallmark of this artistic style. The bowls' wide geographic distribution—ranging from Italy in the west to Iran in the east—accords well with the Phoenicians' role as merchants and traffickers in the Mediterranean throughout the first millennium B.C., a role noted in both the Old Testament and the ancient classical sources. The six bowls in the Heeramaneck Collection fall into two distinct subgroups. Catalog numbers 1309–1311, with their minutely engraved ornamental floral bands, correspond with a series of bronze bowls found at the site of Nimrud, quite probably the booty of an Assyrian king taken from one or more of the Phoenician coastal cities. Catalog numbers 1312 and 1313, with their friezes of sphinxes and stylized plants, belong to a separate tradition, possibly originating in Iran itself. The sixth example (cat. no. 1314), although related in scheme to the above group, is distinguished by the strongly Egyptianizing style of its sphinxes, as well as their pose—with forepaw placed on the head of a miniature, winged figure—a feature closely paralleled on a bronze bowl from Nimrud (cf. Layard, 1853, II, pl. 63).

1309

Bowl
Phoenician; second half of 8th century B.C.
h: 2.5 cm.; diam: 20.1 cm.
Bronze, hammered; shallow, flat-bottomed; interior decorated with a starfish-shaped medallion enclosing an eight-petaled rosette, the whole enclosed by a circle filled with an interlocking rosette pattern; surrounding the medallion, seven narrow registers (three undecorated), the first and third decorated with a papyrus chain and a string of dotted circles, the fifth and seventh with a file of deer alternating with clusters of papyrus stalks; decoration entirely engraved.
M.76.97.388

cf. Layard, 1853, II, pls. 68 (bottom middle) and 59D.

1310

Bowl
Phoenician; second half of 8th century B.C.
h: 3 cm.; diam: 16.5 cm.
Bronze, hammered; shallow; interior decorated with an incised medallion in the form of a twelve-petaled rosette; *pointilée* decoration between the petals and within the circular interior of the flower pattern.
M.76.97.404

For a similar medallion, cf. Layard, 1853, II, pl. 68 (bottom right).

1311

Bowl
Phoenician; second half of 8th century B.C.
h: 3.8 cm.; diam: 16.3 cm.
Bronze, hammered; shallow; interior decorated with a medallion of interlocking rosettes (the petals of which consist of three equilateral arcs), the whole circumscribed by a minutely incised chain of chevrons; following an undecorated interval, a register of incised outward-facing triangles filled with *pointilée* decoration and capped by a minute dotted circle, the whole resting on a chain of chevrons.
M.76.97.385

For a comparable medallion of interlocking rosettes, cf. Layard, 1853, II, pl. 62A.

1312

Bowl
Phoenician; second half of 8th century B.C.
h: 4.6 cm.; diam: 12.8 cm.
Bronze, hammered; shallow; interior decorated in repoussé; rosette medallion with encircling lotus chain surrounded by a single register consisting of a file of sphinxes with upraised forepaw approaching a palmette; interior heavily corroded; modern repair.
M.76.97.381

For bibliography, cf. cat. no. 1313 below.

1313

Bowl
Phoenician; second half of 8th century B.C.
h: 4.7 cm.; diam: 14.8 cm.
Bronze, hammered; shallow; interior decorated in repoussé; rosette medallion surrounded by three concentric registers, the first two undecorated, the third depicting a file of sphinxes alternating with stylized plants; interior extensively pitted.
M.76.97.380

For bowls with similar sphinx files, cf. Godard, 1965, figs. 74, 75; Geneva, 1966, no. 218; Moorey, 1966, no. 243.

1314

Bowl
Phoenician; second half of 8th century B.C.
h: 4.2 cm.; diam: 14 cm.
Bronze, hammered; shallow; interior decorated with a rosette medallion surrounded by four concentric registers consisting (from the inside out) of: a) bud-and-pomegranate chain, b) a frieze of grazing wild goats, c) an undecorated frieze, d) a frieze of sphinxes represented singly and in pairs around stylized plants.
M.76.97.389

The following group of objects may be assigned to the Iberian artistic tradition of southeastern Spain, which flourished in the third and second centuries B.C., contemporaneous with the Hellenistic period in Greece. The statuette of a standing male worshiper in belted tunic, with palms open in a gesture of prayer (cat. no. 1315), is typical of the inventory of votive objects found at the major sanctuaries of this region. On the basis of style, the two horse figurines (cat. nos. 1316 and 1317) may be tentatively assigned to this period of manufacture as well.

1315

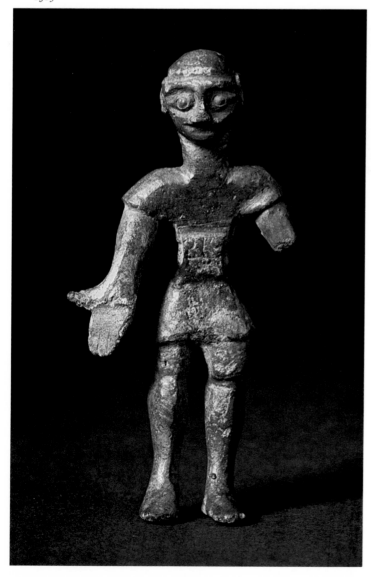

1315

Standing Male
Iberian; 3rd–2nd century B.C.
h: 6.8 cm.
Bronze, cast; male *orant* in short, belted tunic; arms at sides, inclined slightly forward from the waist with palms open in a gesture of worship.
M.76.97.785

cf. Nicolini, 1969, pl. XVI: 1–2 and fig. 30.

1316

Horse
Iberian; 3rd–2nd century B.C.
h: 4.5 cm.; l: 4.5 cm.
Bronze, cast; standing horse with a pronounced, downward-sloping back; loop under neck; crude casting.
M.76.97.884

1317

Horse
Iberian; 3rd–2nd century B.C.
h: 5.5 cm.; l: 4.8 cm.
Bronze, cast; stylized horse with fore- and hind legs outstretched in a galloping posture; a dove-shaped bird perched on its back; crude casting.
M.76.97.938

Egypt

The following group consists of vessels of alabaster or, more properly, banded calcite from Egypt. Although uninscribed, their distinctive shape, characterized by a cylindrical neck and wide disk rim, suggests a dating in the Late Period, most probably the Achaemenid epoch (c. 550–330 B.C.), when Egypt was under Persian domination.

1319

1318

Large Squat Jar
Egypt; Late Period, probably Achaemenid (c. 550–330 B.C.)
h: 19.2 cm.; diam: 7.1 cm.
Banded calcite, carved; of squat, tapering, cylindrical form; flat-based, with wide disk rim, beveled lip, and twin elliptical lug handles situated midway down the side.
M.73.5.319

1319

Large Alabastron
Egypt; Late Period, probably Achaemenid (c. 550–330 B.C.)
h: 32.8 cm.; diam: 11.9 cm.
Banded calcite, carved; of elongated ovoid shape; round-bottomed, with tapering sides, short inset cylindrical neck with beveled disk rim, and twin elliptical lug handles, each with flaring triangular projection below.
M.73.5.353

1320

Tall Alabastron
Egypt; Late Period, probably Achaemenid (c. 550–330 B.C.)
h: 28 cm.; diam: 22.8 cm.
Banded calcite, carved; of elongated form; flat-bottomed, with gently tapering sides, rounded shoulder, cylindrical neck, wide, beveled disk rim, and twin elliptical lug handles situated approximately one-third of the way down.
M.73.5.354

Post-Sasanian Iran

The majority of objects in this section are figurines and statuettes of animals, designed primarily as furniture attachments and appliqués. On the basis of stylistic considerations, they may be broadly assigned to the period spanning the tenth through thirteenth centuries A.D., the period of Seljuk influence in Iran and the Near East.

1321

Container
Iran; 8th–9th century A.D.
h: 5.8 cm.; w: 10.1 cm.
Soapstone, carved; in the config-uration of an eight-lobed rosette, every other lobe marked on the exterior by a squared projecting panel; a leg of triangular section projects at each corner, producing a box-like exterior; engraved circlets with drilled nucleii deco-rate the upper edge; a double reversed spiral engraved on the exterior of each panel.
M.76.174.68

1322

Bowl or Mortar
Iran; 8th–9th century A.D.
h: 4.4 cm.; diam: 7.7 cm.
Soapstone, carved; flat-bottomed; circular; its exterior marked at equal intervals by four projections, consisting, alternately, of a fron-tal human face above an animal head and a seated monkey sur-mounted by a vulture; between, on three sides, a pair of rectan-gular vertical flanges; a bull's head projecting from a square relief panel on the fourth side.
M.76.97.908

1323

Crowing Cock
Syria or Iran; 7th–9th century A.D.
h: 3.9 cm.
Bronze, cast; standing cock, its mouth open in a crowing attitude; probably a vessel attachment.
M.76.97.914

For a similar cock attachment that served as the spout of a bronze ewer, cf. Fehervari, 1976, plate op-posite p. 40 and pl. IA.

1324

Plaque
Iran; 10th–12th century A.D.
h: 6.4 cm.; w: 6.7 cm.
Bronze, cast; rectangular open-work design depicting a winged horse trotting right, with left foreleg upraised; animal's torso is ornamented with an elaborate scheme of interior markings, in-cluding a large almond-shaped configuration on the forequarters; central perforation.
M.76.97.539

1325

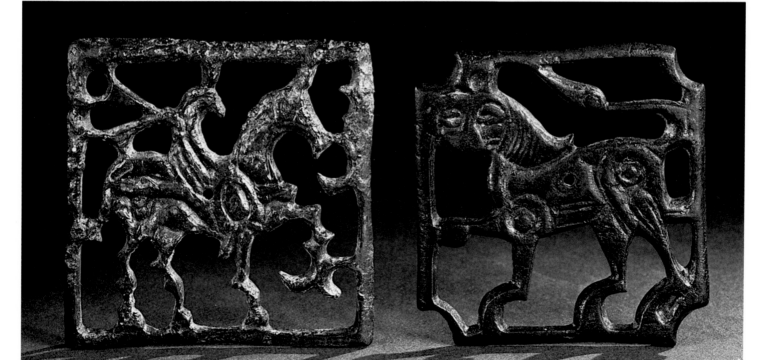

1325

Plaque
Iran; 10th–12th century A.D.
h: 6.3 cm.; w: 6.4 cm.
Bronze, cast; rectangular open-
work design depicting a lion pro-
ceeding left; prominent mane;
legs, head, and tail joined to a rec-
tangular frame; animal's head is
rendered full face; frame is marked
by a curved indentation at each
corner; central perforation.
M.76.97.538

For this and the preceding piece,
cf. Fehervari, 1976, no. 17 and
pl. 5c (two rampant lions).

1326

Plaque
Iran; 11th–12th century A.D.
h: 6.2 cm.; w: 4.9. cm.
Bronze, cast; rectangular open-
work design depicting a standing
eagle posed frontally with out-
spread wings; figure is character-
ized by three large circular bosses
marking the head and the upper
part of each wing; a vine or ten-
dril extends along the line of
the head in the upper section of
the plaque; central perforation,
slightly off-center.
M.76.174.35

cf. Stuttgart, 1972, no. 157; Feher-
vari, 1976, no. 123 and pl. 40e.

1327

Lion
Iran; 11th–13th century A.D.
h: 3.5 cm.; l: 4.5 cm.
Bronze, cast; standing lion with
single fore- and hind legs; back-
ward-leaning stance; rudimen-
tary casting.
M.76.97.675

1328

Lion
Iran; 11th–13th century A.D.
h: 6 cm.; l: 6.2 cm.
Bronze, cast; standing lion; back-
ward-leaning stance; on a rec-
tangular base.
M.76.97.814

1329

Lion
Iran; 11th–13th century A.D.
h: 3 cm.; l: 3.2 cm.
Bronze, cast; statuette similar to
cat. no. 1328; engraved, curling
locks on mane.
M.76.97.975

1330

Lion
Iran; 11th–13th century A.D.
h: 3.1 cm.; l: 3.6 cm.
Bronze, cast; standing lion; highly
stylized, with single fore- and
hind legs and underbelly forming
a continuous arc; parallel striations
on mane.
M.76.97.651

1331

Goat
Iran; 10th–11th century A.D.
h: 6.3 cm.; l: 6 cm.
Bronze, cast; standing goat; fore-
and hind legs each on a separate
plinth; eyes drilled for inlay.
M.76.97.827

1332

Furniture Leg
Iran; 12th or early 13th century A.D.
h: 3.1 cm.; l: 5.5 cm.
Bronze, cast; in the form of a
stylized animal protome.
M.76.174.46

Like cat. no. 1334, it probably
served as the leg or support of
some article of furniture.

1333

Attachment
Iran; 12th or early 13th century A.D.
h: 2.8 cm.; l: 4.5 cm.
Bronze, cast; in the form of a
standing stylized feline; loop
on back.
M.76.174.43

This object may have served as an
attachment to the cover or handle
of an oil lamp.

1334

Furniture Leg
Iran; 12th or early 13th century A.D.
h: 5.2 cm.; l: 4.5 cm.
Bronze, cast; in the form of a
horse protome; perforated muzzle;
triangular platform extends from
base of neck.
M.76.174.45

1335

Handle
Iran; 11th–13th century A.D.
h: 8.2 cm.; l: 13 cm.
Bronze, cast; in the form of a
standing stylized feline with
deeply grooved mane.
M.76.97.618

1336

Handle
Iran; 11th–13th century A.D.
h: 8 cm.; l: 12.6 cm.
Bronze, cast; in the form of a
double-animal protome, each end
terminating in the forequarters
of an animal with stylized feline
head and open mouth; hocks and
pasterns prominently modeled;
loop projects from center of
handle.
M.76.97.810

1337

Bracelet
Eastern Europe; 5th–7th century A.D. or later
w: 7 cm.
Bronze, cast; open-ended hoop with flaring, trumpet-shaped terminals; hoop swelling and median ridge opposite the opening.
M.76.97.728

The type is native to Germanic as well as Sarmatian art; for a closed arm ring with flaring ridge at either end, cf. Hampel, 1905, III, pl. 59 (grave 20 from Bezonye, dated seventh century A.D.).

1338

Razor
Northeastern Europe–Western Russia; 10th–11th century A.D.
h: 14.8 cm.; w: 22 cm.
Bronze, cast; semicircular blade with a straight cutting edge; divided vertically by a median ridge terminating in a pair of outward-facing, stylized, horned animal heads on elongated curving necks; juncture of stem and blade is marked by a frontal human head with prominent eyes; animal heads have recurved horns which sweep back and join to the back of the neck; double relief coils behind head; remainder of neck decorated with a double row of relief dots divided by a median ridge; single loop at juncture of necks.
M.76.97.525

The origin and date of the piece are problematic. The stylized animal heads find a parallel on the aforementioned clasp from the Liada burial ground, dated tenth–eleventh century A.D., suggesting a tentative attribution; cf. Artamonov, 1974, no. 110.

The following objects are primarily of northern and eastern European manufacture, ranging in date from the Late Antique period (fifth–seventh century A.D.; cat. no. 1337) to the modern era (nineteenth century A.D.; cat. no. 1342). On comparison with a clasp excavated from the Liada burial ground (Tambov region, northwestern Russia), catalog numbers 1338 and 1339 may be tentatively attributed to Finnish tribal groups of the early second millennium A.D. This demonstrates the continuity of the nomadic artistic tradition, whose roots extend back to the third millennium B.C.

1338

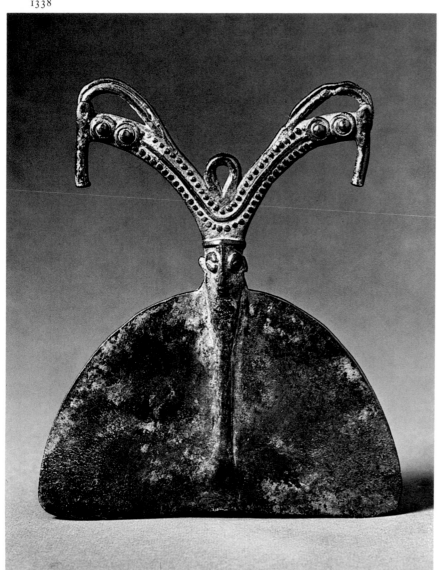

1339

Clasp with Bell Pendants
Northeastern Europe–Western Russia; 10th–11th century A.D.
h: 7 cm.; w: 2.8 cm.
Bronze, cast; openwork clasp consisting of a plaited hoop with globular studs affixed in six groups of three; upper series originally supported an openwork braided pattern, the lower, a series of nine rings, each with a triple cord pendant terminating at either end in a stud with suspended bell.
M.76.97.595a,b

Jingling pendant ornaments such as this one were an essential part of female dress among Finnish tribal groups of the late first millennium and early second millennium A.D.; cf. Artamonov, 1974, no. 110 (Liada burial ground).

1340

Penannular Brooch
Ireland; 17th–18th century A.D.
l. of shank: 13.5 cm.;
w. of head: 6.8 cm.
Bronze, cast; octagonal ring; each side decorated on its exterior surface by a central four-leafed clover flanked by rounded bosses, the background combed with finely engraved parallel lines; flexible shank hinged at top with a recess in the center below for fastening of pin.
M.76.174.91

1341

Penannular Brooch
Ireland; 17th–18th century A.D.
l. of shank: 13.8 cm.;
w. of head: 6.6 cm.
Bronze, cast; lunate-shaped ring of flat section, flaring from top to bottom; exterior surface decorated with an engraved crisscross pattern; flexible shank hinged at top with a recess in the center below for fastening of pin; circular cavity at either side of hinge for inlay.
M.76.174.278

For this and the preceding piece, cf. Callander, *PSAS* 58, 1924, pp. 178ff.

1342

Axegrip of Shepherd's Staff
Hungary; 19th century A.D.
h. of blade: 10.5 cm.; l: 13.8 cm.
Bronze, cast; crescentic blade; decorated with a series of wheel-cut circles; circular shaft-hole with faceted outer contour; tang-shaped tail decorated in similar fashion as blade.
M.76.174.108

cf. a group of related unpublished pieces in the Museum für Völkerkunde, Vienna (cat. nos. 61.024–61.028).

1339

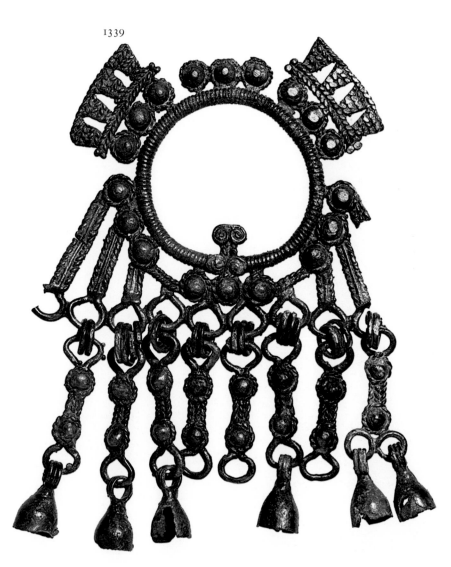

Objects of Uncertain Origin and Date

The following objects, although of uncertain date and origin, have been included because of their aesthetic and art historical interest. Like much of the collection, they are appliqués and decorative attachments.

1343

Tondo
Iran; date uncertain
diam: 16.2 cm.
Bronze, hammered; decorated with the repoussé figure of a dragon or hippocamp, its lyre-shaped body equipped with horse's head, bristly mane, and serpent's tail; with foreclaws and leaf-shaped hind legs; lattice network extending across back from neck to tail; rhomb, rosette, and dotted ring in field; silver appliqué medallion depicting a large oval head set upon two legs; four pairs of perforations around rim.
M.76.97.736

This piece belongs to a small, enigmatic group of hammered bronze tondi presumably from Iran (cf. Stuttgart, 1972, nos. 73–75). Although unprovenanced, an attribution to the Parthian period is suggested by the iconographic repertoire (hippocamp, winged horse) depicted on them.

1344

Openwork Roundel
Origin and date uncertain
diam: 9.8 cm.
Bronze, cast; depicting a kneeling profile figure with bent arms extended in front of and behind the body; three omega-shaped loops above and on either side; central circular opening with projecting collar (probably for insertion of a mouthpiece bar); possibly a cheekpiece.
M.76.97.600

Although no precise parallels exist for this piece, it relates typologically to a class of ornamental openwork disks of Merovingian date (sixth–seventh century A.D.); cf. Renner, *IPEK* 23, 1970/73, pp. 46ff.

1345

Serpent
Origin and date uncertain
h: 2.6 cm.; w: 3.9 cm.
Bronze, cast; openwork ornament in the shape of an elaborately coiled serpent, its body intertwined in a series of knots, its head reverted; finely executed, minute, imbricated surface pattern denoting scaly skin; cast identically on both sides.
M.76.174.27

1344

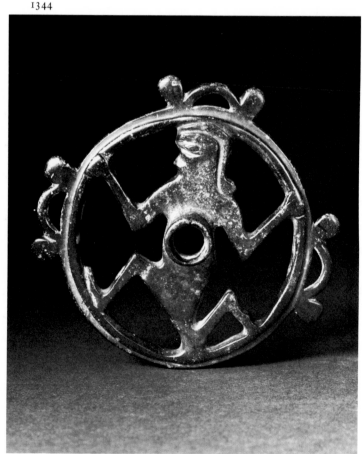

1346

Horse
Origin and date uncertain
h: 7.2 cm.; l: 8.2 cm.
Bronze, cast; standing horse with prominent, crested mane; eyes and ears modeled in relief; backward-leaning stance; torso demarcated by a slightly indented midsection; set on a rectangular base; underside of belly and neck hollowed out in a deep channel; tail broken.
M.76.174.26

The attribution of this piece is problematic; it is possibly Iberian in origin.

1347

Bird-shaped Attachment
Origin and date uncertain
h: 9.2 cm.; w: 7.8 cm.
Bronze, cast; pin surmounted by a stylized bird with gracefully recurved crescentic wing forming a continuous arc; lightly incised decoration on shank and wing; shank of rectangular section terminating below in a horizontally perforated tab.
M.76.174.110

1348

Stirrup
Origin and date uncertain
h: 19 cm.; w: 15.6 cm.
Bronze, cast; elongated oval hoop; flattened at the bottom with a projecting flange on its inner side; rectangular stem projecting at top with rectangular opening in its upper portion; elaborate stylized relief decoration on either face; around upper hoop and stem, an antithetical arrangement of two rampant quadrupeds with heads reverted, perched on a stylized plant, and flanked, in turn, by a pair of stylized birds with long swooping tail feathers (extending down the sides of the hoop), each with three upcurled "tails," the whole framed above and at either side by chevron borders; after an undecorated interval on either side, a scroll-like floral pattern, similarly bordered, occupies the base of the hoop.
M.76.97.737

The general configuration of the stirrup compares rather closely with undecorated examples of Avaric provenance and manufacture (cf. Hampel, 1905, I, figs. 499ff). The decorative ornamentation and technique suggest a more recent date of manufacture.

1349

Handle Attachment
Source and date unknown
h: 10.3 cm.; w: 8.1 cm.
Bronze, cast; in the form of a siren-like figure; frontally positioned with hands at waist, elbows pointing outward; torso emerges from a pair of outspread wings (composed of three horizontal divisions) terminating beneath in a palmette; below the waist is a ring from which two tassels depend; on the reverse, three studs or rivets.
M.76.97.786

1349

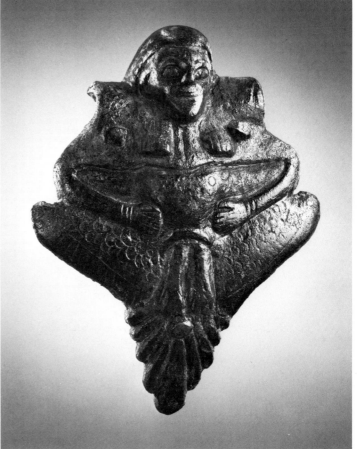

1346

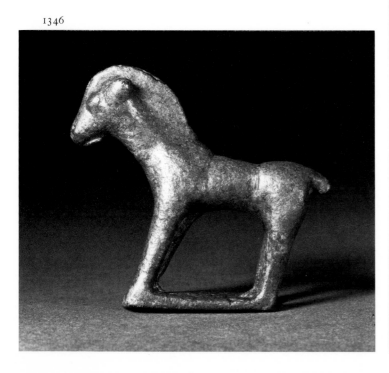

Appendix I

Concordance of Chinese Spellings in the Catalog; Pinyin and Wade Giles

As of January 1979, the government of the People's Republic of China officially adopted Pinyin as the standard system for romanization of Chinese characters.

Pinyin	*Wade Giles*
Aluchaideng	Alu-ch'ai-teng
Ban Gu	Pan Ku
Baotou	Pao-t'ou
Changan	Ch'ang-an
Changde fu	Ch'ang-te fu
Changsha	Ch'ang-sha
Chaoxian	Ch'ao-hsien
Chaoyang	Ch'ao-yang
Chushi	Ch'u-shih
Daxia	Ta-hsia
Ding	Ting
Dingling	Ting-ling
Dong Hu	Tung Hu
Dunhuang	Tun-huang
Fengxi	Fenghsi
Gansu	Kansu
Gao Zu	Kao-tsu
Gekun	Ke-k'un
Guishuang	Kuei-shuang
Guyuan xian	Ku-yüan hsien
Han	Han
Hangjinqiyanchang	Hang-chin-ch'i-yen-ch'ang
Hebei	Hopei
Helingeer xian	Ho-lin-ko-erh hsien
Huhehaote	Hu-ho-hao-t'e
Huimo	Hui-mo
Hui xian	Hui hsien
Hunyu	Hun-yü
Jibin	Chi-pin
Keshengzhuang	K'e-sheng-chuang
Liangzhen	Liang-chen
Liaoning	Liaoning
Lin Hu	Lin Hu
Liyu	Li-yü
Loufan	Lou-fan
Luoyang	Lo-yang
Modun	Mo-tun
Mu	Mu
Nanshan	Nan-shan
Nanshangen	Nan-shan-ken
Ningcheng xian	Ning-ch'eng hsien
Ningxia	Ning-hsia
Qi	Ch'i
Qiang	Ch'iang
Qilian	Ch'i-lien
Qin	Ch'in
Qin Shihuangdi	Ch'in Shih Huang-ti
Qionglu	Ch'iung-lu

Pinyin	Wade Giles
Sai	Sai
Shaanxi	Shensi
Shandong	Shantung
Shang	Shang
Shanglin	Shang-lin
Shanxi	Shansi
Shanyu	Shan-yü
Shaogou	Shao-kou
Shengyang	Sheng-yang
Shiertaiyingzi	Shih-êrh-t'ai-ying-tzu
Shi Ji	Shih chi
Shou xian	Shou hsien
Sima Qian	Ssu-ma Ch'ien
Sujigou	Su-chi-kou
Tang	T'ang
Taohongbala	T'ao-hung-pa-la
Wenwu	Wen Wu
Wuhuan	Wu-huan
Wuling	Wu-ling
Wusun	Wu-sun
Wuzhu	Wu-chu
Xiajiadian	Hsia-chia-tien
Xian	Sian
Xianbei	Hsien-pei
Xianyang	Hsien-yang
Xichagou	Hsi-ch'a-kou
Xifeng xian	Hsi-feng hsien
Xigou	Hsi-kou
Xinli	Hsin-li
Xiongnu	Hsiung-nu
Xuanhua	Hsüan-hua
Yuezhi	Yüeh-chih
Yulongtai	Yü-lung-t'ai
Zhao	Chao
Zhenfan	Chen-fan
Zhengjiawazi	Cheng-chia-wa-tzŭ
Zhou	Chou
Zhungeer Qi	Chun-ko-erh Ch'i

Appendix II

Selected Bibliography of Recently Excavated Sites in the People's Republic of China and the USSR Referred to in the Catalog

For a more extensive bibliography, see K. Jettmar's *Art of the Steppes,* New York, 1967; and E. Bunker et al., *"Animal Style" from East to West,* New York, 1970.

Aluchaideng, Hangjin Banner, western Inner Mongolia

La Chine, 1977, no. 10, p. 34.
KG, 1980, no. 4, pp. 333–38 and plates. Dated 5th–3rd century B.C. by the excavators.

Arzhan near Uyuk in the eastern Sayan Mountains of southern Siberia

Griaznov, M., "Horses for the Hereafter," in "The Scythians," *UNESCO Courier,* December 1976, pp. 38–41.
Rolle, 1979–80, pp. 38–44. Dated 8th–7th century B.C. by Carbon–14 and dendrochronology.

Bash-Adar, Tuekta, the Tuva and Pazyryk

Rudenko, 1970.
British Museum, 1978.

Keshengzhuang, Shaanxi, south of Xian

Zhongguo kexueyuan kaogu yanjiusuo, 1962. Dated 2nd century B.C.

Guyuan xian sites, southern Ningxia province, western Inner Mongolia

KG, 1978, no. 12, p. 89, pl. 9, nos. 1–13. Dated 5th–4th century B.C. by the inclusion of a plaque similar to those found at Taohongbala and Yulongtai.
WW, 1978, no. 12, p. 87. Dated to the late Warring States period.

Hebei

WW, 1960, no. 2, pp. 59–65.

Helingeer xian, western Inner Mongolia

WW, 1959, no. 6, p. 79.
Cheng, 1963, p. 134. Dated 5th century B.C. by the inclusion of a dagger of 5th century B.C. type with double bird-head antennae terminal (Smirnov and Petrenko, 1963, pl. 11) which has also been found in early Warring States period context (*KG,* 1966, no. 5, p. 235).

Huhehaote, western Inner Mongolia

WW, 1957, no. 4, pp. 29–30, no. 5.
Li, 1963, no. 44. Dated 4th–2nd century B.C. (Li, 1963, pl. 44).

Ivolga

SA, vol. XXV, 1956, pp. 261–300.
SA, 1971, no. 1, pp. 93–105. Dated 2nd century B.C.

Liangzhen, southeast of Huhehaote, western Inner Mongolia

WW, 1977, no. 11, pp. 38–39.
Li, 1963, pls. 93–97. Dated late 3rd century A.D.

Nanshangen, Ningcheng xian, Liaoning province, eastern Inner Mongolia

KG, 1962, no. 5, p. 272.
KGXB, 1973, no. 2, pp. 27–39; ibid., 1975, no. 1, pp. 117–40. For a general discussion of Bronze Dagger Tombs, cf. *KGXB,* 1980 no. 2, pp. 160–61.

Shiertaiyingzi, Chaoyang county, Liaoning province, eastern Inner Mongolia

KGXB, 1960, no. 1, pp. 63–71. Dated 5th century B.C. due to the inclusion of psalia with both two and three holes. The two-hole type superseded the three-hole variety by the 5th century B.C.

Sujigou, Zhungeer Banner, western Inner Mongolia

WW, 1965, no. 2, pp. 44–46. Chronologically later than Taohongbala and Yulongtai; nevertheless, the finds resemble those from these sites.

Taohongbala, 45 km. southeast of Hangjinqiyanchang, western Inner Mongolia

KGXB, 1976, no. 1, pp. 131–44.

Urbiun, in the Tuva

SA, 1979, no. 1, pp. 254–56.

Xichagou, Xifeng xian, northeastern Liaoning province

WW, 1960, nos. 8–9, pp. 25–35.
WWCKZL, 1957, no. 1, pp. 53–56. Dated late 2nd century B.C. by the inclusion of Wuzhu coins (not minted before 118 B.C.).

Xigou, Zhungeer Banner, western Inner Mongolia

WW, 1980, no. 7, pp. 1–10.

Yulongtai, Zhungeer Banner, western Inner Mongolia

KG, 1977, no. 2, pp. 111–14. Dated 5th–4th century B.C. Buckles similar to those found at Taohongbala.

Zhengjiawazi, suburbs of Shengyang, Liaoning province, eastern Inner Mongolia

KGXB, 1975, no. 1, pp. 141–56.

Appendix III

Inventory of Seal Inscriptions

Tentative transcriptions
and translations
by Johannes Renger

Cat. no. 1173 M.76.174.351	Ur. dNirah dumu Lugal–EN.TAR ša IGI.DU$_8$	Ur-Nirah Son of Lugal–EN.TAR the man of the . . .
Cat. no. 1177 M.76.174.367	dSîn [EN.ZU]–gi–im–la–ni mâr I–din–É–⌐a⌐ warad dE n . k i	Sîngimlanni Son of Iddin–Ea Servant of the god Enki
Cat. no. 1178 M.76.174.369	Warad [ÌR]–dSîn [EN.ZU] mâr A–pil–dSîn [EN.ZU]	Warad–Sîn son of Apil–Sîn
Cat. no. 1182 M.76.174.375	Ì–lí–ma-a-ḫi mar Šu–mi–a–ḫu–um warad dN i n . BAR	Ilima'aḫi Son of Šumi-'aḫum servant of the god Nin–BAR
Cat. no. 1184 M.76.174.378	A–lu–lu–um mâr Li–pí–it–dSîn [EN.ZU] warad dSin [EN.ZU]	Alulum son of Lipit–Sîn servant of the god Sîn
Cat. no. 1185 M.76.174.377	Sú–ḫa–pu–um mar A–ḫi–a–sa–ad warad dAdad [IM]	Suḫāpum Son of Aḫi'asad Servant of the god Adad
Cat. no. 1186 M.76.174.379	dSin [EN.ZU]–⌐mu⌐–ba–lí–iṭ mâr A–bi–⌐x–x⌐ warad I–ba–al–⌐pi⌐–el	Sînmuballiṭ Son of Abi–x x Servant of Ibalpi'el
Cat. no. 1187 M.76.174.380	Še–le–bu–um ⌐mâr⌐ Li–pí–it–Ištar [XV] warad dNa–ra–am–dSîn [EN.ZU]	Šelebum Son of Lipit–Ištar Servant of [king] Naram–Sîn
Cat. no. 1188 M.76.174.381	dSîn [EN.ZU] dN i n . gal	[God] Sin [Goddess] Ningal
Cat. no. 1190 M.76.174.383	dL a m a x dx l a b a
Cat. no. 1191 M.76.174.384	Zi–na–tum mâr I–din–dSîn [EN.ZU] warad AN.AN.MAR.TU	Zinatum son of Iddin–Sin Servant of AN.AN.MAR.TU
Cat. no. 1192 M.76.174.385	dN i n . s i . a n . n a DINGIR DA! MA ŠÈ u$_4$. g i m è . a	[Goddess] Ninsianna who goes forth like the daylight
Cat. no. 1193 M.76.174.386	Ib–ni–dAdad [IM] mâr x–ra(?) – sa–x warad dAdad [IM]	Ibni–Adad Son of servant of the god Adad

Cat. no. 1208 ᵈMes dingir.sag zalág.gál God Marduk, foremost god who . . . ,
M.76.174.401 en.é.dingir.gal.gal.meš lord of the temples of the great gods
 lú ní.tuku.a(!)ḫé.èn.tar he shall appoint the man who is obedient
 lú tuku.tuku.⌈a⌉ḫé.silim he shall keep well the man who has wealth (?),
 ki tituku.tuku.[(x)] with life . . .
 sag ni.tuku.za.áš
 x.mu.ra.x

Appendix IV

Glossary of Geological Terms

Agate a variegated translucent chalcedony frequently mixed or alternating with opal, characterized by colors arranged in alternating stripes or bands (onyx), in irregular clouds, or in mass-like forms. Agate is found in virtually all colors, usually those of low intensity.

Alabaster 1) a firm, very fine-grained, massive or compact variety of gypsum, usually snow white and translucent but sometimes delicately shaded or tinted with light-colored tones of yellow, brown, red, orange, or gray. It is used as an interior decorative stone (especially for carved ornamental vases and figures) and for statuary. 2) *onyx marble*.

Bitumen a generic term applied to natural inflammable substances of variable color, hardness, and volatility, composed of petroleum, asphalt, natural mineral waxes, etc.

Bloodstone 1) a semitranslucent green variety of chalcedony speckled with red or brownish red spots of jasper resembling spots of blood. 2) *hematite*.

Calcite calcium carbonate.

Chalcedony ultra-fine crystalline quartz (silica), the material of much chert. Chalcedony has a very porous structure and easily absorbs impurities, giving rise to a wide range of colors, depending upon the nature of the impurities present. Since differently colored chalcedony has often been given several popular names, we adopt the following descriptive scheme, established by the British Museum for its *Catalogue of Western Asiatic Seals* (London, 1969).

Carnelian: translucent, red and orange-red chalcedony

Chalcedony: translucent, light blue, gray, and gray-brown chalcedony

Agate: a banded chalcedony in which successive layers differ in color and degree of translucency

Jasper: opaque chalcedony

Chert a hard, extremely dense, very finely crystalline, is sedimentary rock, consisting mostly of quartz, with some impurities. It may be gray, white, green, blue, pink, red, yellow, brown, or black. Flint is essentially synonymous, although it is commonly used for the dark-colored varieties of chert.

Chlorite a hydrous silicate of iron, magnesium, and aluminium; platy, greenish mineral.

Dolomite calcium magnesium carbonate.

Hematite a lustrous gray-black iron oxide, dense, often metallic in appearance; it has a distinctive cherry-red-to-reddish-brown streak. See *bloodstone*.

Jasper a variety of chert associated with iron ores and containing any iron oxide impurities that give it various colors; characteristically red, although yellow, green, grayish blue, brown, and black cherts have also been applied to any red chert or chalcedony irrespective of associated iron ores. See *chert*.

Lapis Lazuli a blue, semitranslucent-to-opaque, granular, crystalline rock used as a semiprecious stone for ornamental purposes, and composed essentially of lazulite and calcite. It usually has a rich azure color, and probably was the "sapphire" of the ancients.

Limestone a sedimentary rock consisting chiefly of calcite. Limestones include chalk and travertine, and they effervesce freely with any common acid.

Marble 1) a metamorphic rock consisting predominantly of fine-to-coarse-grained recrystallized calcite and/or dolomite, usually with an even-grained, sugary texture. 2) any crystallized carbonate rock, including true marble (see definition 1) and certain types of limestone, that will take a polish and can be used as architectural or ornamental stone.

Onyx Marble a compact, usually banded, generally translucent variety of calcite, used as a decorative or architectural material or for small ornamental objects. See *alabaster*.

Serpentine Rock a rock consisting almost wholly of serpentine minerals (mica-like minerals that are hydrated iron and magnesium silicates); accessory chlorite, talc, and magnetite may be present. Translucent varieties are used for ornamental or decorative purposes. Etymol.: Latin *serpentinus,* resembling a serpent, from the mottled shades of green present in some varieties. See *steatite, talc,* and *chlorite*.

Soapstone a common term for any soft, unctuous rock.

Steatite 1) a compact, massive, fine-grained rock consisting chiefly of talc but usually containing much other material; an impure talc-rich rock. See *soapstone*. 2) a term originally used as an alternative mineral name for gray-green or brown massive talc that can be easily carved into ornamental objects.

Talc extremely soft, light green or gray hydrous magnesium silicate mineral.

Travertine a dense, highly crystalline, massive or banded calcite of white, tan, or cream color, often having a fibrous, concentric, or splintery structure. See *onyx marble*.

Bibliography

The Art of Ancient Iran

Amiet, P., *Les Antiquités du Luristan,* Paris, 1976.

Amiet, P., "L'iconographie archaïque de l'Iran. Quelques documents nouveaux," *Syria,* vol. LVI, 1979, pp. 333ff.

Anonymous, "Recent Important Acquisitions," *Journal of Glass Studies,* vol. 13, 1971, p. 137.

Barbier, J. P., *Bronzes antiques de la Perse: Collection J. P. Barbier* (sales catalog, Hôtel Drouot, Paris, 1970).

Belloni, G. G. and L. F. d'Arsen, *Iranian Art,* London, 1969.

Boston Museum of Fine Arts, *Romans and Barbarians,* 1976.

Bowie, T., *East-West in Art,* Bloomington, Indiana, 1966.

Brinkman, J. A., *A Political History of Post-Kassite Babylonia 1158–722 B.C.,* Rome, 1968.

British Museum, *A Guide to the Antiquities of the Bronze Age in the Department of British and Medieval Antiquities,* London, 1920.

Calmeyer, P., "Archaische Zügelringe," *Vorderasiatische Archäologie* (Moortgat Festschrift), ed. K. Bittel et al., Berlin, 1964, pp. 68ff.

Calmeyer, P., *Altiranische Bronzen der Sammlung Bröckelschen,* Berlin, 1964 (I).

Calmeyer, P., *Datierbare Bronzen aus Luristan und Kirmanshah,* Berlin, 1969.

Calmeyer, P., *Reliefbronzen in babylonischem Stil,* Munich, 1973.
Clercq-Fobé, D. de, *Épingles votives du Luristan, Iran,* Brussels, 1978.

Cleuziou, S., "Les pointes de fleches 'scythiques' au Proche et Moyen Orient," *Le Plateau Iranian et l'Asie Centrale des origines à la conquête islamique,* ed. J. Deshayes, CNRS, Paris, 1977.

Columbus Gallery of Fine Arts et al., *The Arts of Persia,* exh. cat., Columbus, Ohio, 1951.

Contenau, G., *Manuel d'archéologie orientale depuis les origines jusqu'a l'époque d'Alexandre,* Paris, 1947.

Culican, W., *The Medes and Persians,* London, 1965.

Culican, W., "Syro-Achaemenian Ampullae," *Iranica Antiqua,* vol. XI, 1975, pp. 100ff.

de Cou, H. F., *Antiquities from Boscoreale in Field Museum,* Chicago, 1912.

Deshayes, J., "Marteaux de bronze iraniens," *Syria,* vol. XXXV, 1958, pp. 284ff.

Deshayes, J., *Les Outiles de bronze de l'Indus au Danube (IVᵉ au IIᵉ millénaire),* 2 vols., Paris, 1960.

Diez, E., *Iranische Kunst,* Vienna, 1944.

Egami, N., et al., *Dailaman I: The Excavations at Ghalekuti and Lasulkan, 1960,* Tokyo, 1965.

Egami, N., et al., *Dailaman II: The Excavations at Noruzmahale and Khoramrud, 1960,* Tokyo, 1966.

Erdmann, K., *Die Kunst Irans zur Zeit der Sasaniden,* Mainz, 1969.

Frankfort, H., *The Art and Architecture of the Ancient Orient,* Baltimore, 1956.

Fukai, S. and J. Ikeda, *Dailaman III: The Excavations at Hassani Mahale and Ghalekuti, 1964,* Tokyo, 1968.

Fukai, S., *Persian Glass,* Tokyo, 1977.

Ghirshman, R., *Persian Art; the Parthian and Sasanian Dynasties,* New York and London, 1962.

Ghirshman, R., *The Arts of Ancient Iran from Its Origins to the Time of Alexander the Great,* New York and London, 1964.

Ghirshman, R., "La Ceinture en Iran," *Iranica Antiqua,* vol. XIV, 1979, pp. 167ff.

Godard, A., "Nouveaux bronzes du Luristan. Fouilles de Zalu-Ab," *Gazette des Beaux-Arts,* vol. LXXV, 1933, pp. 129ff.

Godard, A., *L'Art de l'Iran,* Paris, 1962.

Goff, C., "Excavations at Baba Jan: The Pottery and Metal from Levels III and II," *Iran,* vol. XVI, 1978, pp. 29ff.

Goldman, B., "The Asiatic Ancestry of the Greek Gorgon," *Berytus,* vol. XIV, 1961, pp. 1ff.

Grabar, O., *Sasanian Silver,* exh. cat., University of Michigan Museum of Art, Ann Arbor, 1967.

Grancsay, S. V., "A Sasanian Chieftain's Helmet," *Metropolitan Museum of Art Bulletin,* n.s., vol. 21, 1962–63, pp. 253ff.

Hakemi, A., "Kaluraz and the Civilization of the Mardes," *Archeologia Viva,* vol. I, 1968, pp. 63ff.

Harper, P. O., *The Royal Hunter: Art of the Sasanian Empire,* Metropolitan Museum of Art, New York, 1978.

Hasson, R., *Early Islamic Glass in the L. A. Mayer Memorial Institute for Islamic Art,* Jerusalem, 1979.

Herzfeld, E., *Iran in the Ancient East,* London, 1941.

Huot, J. L., "Le diffusion des épingles à tête à double enroulement," *Syria,* vol. XLVII, 1969, pp. 57ff.

Kohl, P., *Seeds of Upheaval,* Doctoral thesis, Harvard University, 1976.

Langdon, S., "Excavations at Kish and Barguthiat, 1933," *Iraq,* vol. I, 1934, pp. 113ff.

Langdon, S., "Some Inscriptions on the Bronzes of Luristan," *Survey of Persian Art,* ed. A. U. Pope, vol. I, 1938, pp. 279ff.

London, *International Exhibition of Persian Art,* exh. cat., Burlington House, 1931.

Luschey, H., *Die Phiale,* Bleicherode am Harz, Germany, 1939.

Moorey, P. R. S., "A Bronze 'Pazuzu' Statuette from Egypt," *Iraq,* vol. XXVII, 1965, pp. 33ff.

Moorey, P.R.S., *Catalogue of the Ancient Persian Bronzes in the Ashmolean Museum,* Oxford, 1971.

Moorey, P.R.S, *Ancient Persian Bronzes in the Adam Collection,* London, 1974.

Moorey, P.R.S., "Some Elaborately Decorated Bronze Quiver Plaques Made in Luristan, c. 750–650 B.C.," *Iran,* vol. XIII, 1975, pp. 19ff.

Muscarella, O., "A Bronze Vase from Iran and Its Greek Connections," *Metropolitan Museum Journal,* vol. 5, 1972, pp. 25ff.

Muscarella, O., "Decorated Bronze Beakers from Iran," *American Journal of Archaeology,* vol. 78, 1974, pp. 239ff.

Muscarella, O., ed., *Ancient Art: The Norbert Schimmel Collection,* Mainz, 1974 (I).

Muscarella, O., "Unexcavated Objects and Ancient Near Eastern Art," *Mountains and Lowlands: Essays in the Archaeology of Greater Mesopotamia,* ed. L. Levine and T. Cuyler Young, Jr., Malibu, 1977, pp. 153ff.

Muscarella, O., "The Archaeological Evidence for Relations between Greece and Iran in the First Millennium B.C.," *The Journal of the Ancient Near Eastern Society of Columbia University,* vol. 9, 1977 (I), pp. 31ff.

Nagel, W., "Die Königsdolche der zweiten Dynastie von Isin," *Archiv für Orientforschung,* vol. XIX, 1959–60, pp. 95ff.

Negahban, E. O., *Preliminary Report on Marlik Excavation,* Tehran, 1964.

Negahban, E. O., *Haft Tepe,* exh. cat., Iran Bastan Museum, Tehran, 1973 (in Persian).

Negahban, E. O., "The Seals of Marlik Tepe," *Journal of Near Eastern Studies,* vol. 36, 1977, pp. 81ff.

New York, *Guide to the Exhibition of Persian Art,* exh. cat., Iranian Institute, 1940.

Orthmann, W., ed., *Der Alte Orient,* Propyläen Verlag, Berlin, 1975.

Overlaet, B. J., "Pointed Helmets of the Iron Age from Iran," *Iranica Antiqua,* vol. XIV, 1979, pp. 51ff.

Pomerance, L., *The Pomerance Collection of Ancient Art,* Brooklyn Museum, 1966.

Pope, A. U., "More Light on Luristan Bronzes," *Illustrated London News,* October 29, 1932, pp. 666–67.

Pope A. U., *A Survey of Persian Art from Prehistoric Times to the Present,* London, 1938.

Pope, A. U., *Masterpieces of Persian Art,* New York, 1945.

Pope, A. U., *Masterpieces of Persian Art,* London, 1960.

Porada, E., "Nomads and Luristan Bronzes," *Dark Ages and Nomads,* ed. M. Mellink, Istanbul, 1964, pp. 9ff.

Porada, E., *The Art of Ancient Iran; Pre-Islamic Cultures,* New York and London, 1965.

Potratz, J. A. H., "Über ein Corpus Aerum Luristanensium," *Iranica Antiqua,* vol. III, 1963, pp. 124ff.

Potratz, J. A. H., *Die Pferdetrensen des Alten Orient,* Rome, 1966.

Potratz, J. A. H., *Luristanbronzen,* Istanbul, 1968.

Rome, *Mostra d'arte iranica,* exh. cat., Palazzo Brancaccio, 1956.

Saldern, Axel von, *Ancient Glass in the Museum of Fine Arts, Boston,* Greenwich, Connecticut, 1968.

Saldern, Axel von, *Gläser der Antike,* Hamburg, 1974.

Schmidt, E. F., *Excavations at Tepe Hissar, Damghan,* Philadelphia, 1937.

Speiser, E., *Vorderasiatische Kunst,* Berlin, 1952.

Stein, A., *Old Routes of Western Iran,* London, 1940.

Stronach, D., "The Development of the Fibula in the Near East," *Iraq,* vol. XXI, 1959, pp. 181ff.

Strong, D. E., *Greek and Roman Gold and Silver Plate,* Ithaca, New York, 1966.

Stuttgart, *Das Tier in der Kunst,* exh. cat., Museum für Länderund Volkerkunde, 1972.

Thompson, D., *Stucco from Chal Tarkhan-Eshqabad near Rayy,* Warminster, England, 1976.

Toll, N. P., *The Excavations at Dura-Europos: Ninth Season, 1935–36,* II, *The Necropolis,* New Haven, 1946.

Vanden Berghe, L., *Archéologie de l'Iran ancien,* Leiden, 1959.

Vanden Berghe, L., *La nécropole de Khurvin,* Istanbul, 1964.

Vanden Berghe, L., *Het archeologisch onderzoek naar de bronscultuur van Luristan: opgravingen in Pusht-i Kuh,* I, *Kalwali en War Kabud, 1965 and 1966,* Brussels, 1968.

Vanden Berghe, L., "Excavations in Pusht-i Kuh. Tombs provide evidence on dating typical Luristan Bronzes," *Archaeology,* vol. 24, 1971, pp. 263ff.

Vanden Berghe, L., "Les fibules provenant des fouilles au Pusht-i Kuh, Luristan," *Iranica Antiqua,* vol. XIII, 1978, pp. 35ff.

Vanden Berghe, L., "Les Bronzes du Luristan de l'Age du Fer III: Resultats des fouilles au Pusht-i Kuh," *Archäologische Mitteilungen aus Iran, Ergänzungsband* 6, 1979, pp. 138ff.

Weidner, E., "Persien," *Archiv für Orientforschung,* vol. XVI, 1952–53, pp. 148ff.

Wilkinson, C. K., *Iranian Ceramics,* New York, 1963.

Woolley, C. L., "A North Syrian Cemetery of the Persian Period," *Liverpool Annals of Archaeology and Anthropology,* vol. VII, 1914–16, pp. 115ff.

Bibliography

*Ancient Art of
Central Asia, Mongolia,
and Siberia*

Andersson, J.G., "Hunting Magic in the Animal Style," Museum of Far Eastern Antiquities, Stockholm, *Bulletin* no. 4, 1932, pp. 221–321.

Andersson, J.G., "Selected Ordos Bronzes," Museum of Far Eastern Antiquities, Stockholm, *Bulletin* no. 5, 1933, pp. 143–54 and plates.

d'Argencé, R-Y. L., *Ancient Chinese Bronzes in the Avery Brundage Collection*, Berkeley, 1966.

Arne, T.J., "Die Funde von L'uanping und Hsüan-hua," Museum of Far Eastern Antiquities, Stockholm, *Bulletin* no. 5, 1933, pp. 155–75.

Artamonov, M.I., *Sokrovishcha skifskikh kurganov*, Leningrad, 1966.

Artamonov, M.I., *Sokrovishcha Sakow*, Moscow, 1973.

Artamonov, M.I., ed., *The Dawn of Art*, Leningrad, 1974.

Belenitsky, A., *Central Asia*, Cleveland and New York, 1968.

Blagg, T., *The Nomads of Eastern Siberia*, London, 1978.

Bowie, T., ed., *East-West in Art*, Bloomington and London, 1966.

Boyles, J., "New Iranian and Eastern Steppe Art Installation in Los Angeles County Museum," *Oriental Art*, vol. XXV, no. 1, 1979, pp. 138–41.

British Museum, *Frozen Tombs*, exh. cat., London, 1978.

Bulliet, R., *The Camel and the Wheel*, Cambridge and London, 1976.

Bunker, E., Farkas, A., and B. Chatwin, *"Animal Style" Art from East to West*, New York, 1970.

Bunker, E., "The Anecdotal Plaques of the Eastern Steppe Regions," *Arts of the Eurasian Steppelands*, London, 1978.

Černecov, V. N., "Bronza use'-polujskogo vremeni," *Materialy i issledovaniia po arkheologii*, Akademia Nauk SSSR, Institut Istorii Arkheologii, vol. 35, 1953, pp. 121–78.

Chang, Kwang-chih, *The Archaeology of Ancient China*, New Haven and London, 1977.

Cheng, Te-k'un, "Chou China," *Archaeology in China*, vol. III, Cambridge and Toronto, 1963.

Chlenova, N.L., *Proiskhozhdenie i ranniaia istoriia plemen tagarskoi kultury*, Moscow, 1967.

Curtis, J. E., "Some Georgian Belt-clasps," *Arts of the Eurasian Steppelands*, London, 1978, pp. 88–121.

Dittrich, E., *Das Motiv des Tier-kampfes in der altchinesischen Kunst*, Wiesbaden, 1963.

Egami, N., and S. Mizuno, *Inner Mongolia and the Region of the Great Wall*, Tokyo and Kyoto, 1935.

Fairservis, W. A., *The Origins of Oriental Civilization*, New York, 1959.

Farkas, A., "Sarmatian Roundels and Sarmatian Art," *Metropolitan Museum Journal*, vol. 8, 1973, pp. 77–88.

Fong, Wen, ed., *The Great Bronze Age of China*, New York, 1980.

Ghirshman, R., "Disque en bronze à décor ternaire," *Forschungen zur Kunst Asiens*, ed. O. Aslanapa and R. Naumann, Istanbul, 1969, pp. 9–17.

Goodrich, D. W., *Anecdotal Plaques Excavated in China*, Masters thesis, Yale University.

Griaznov, M., *L'art ancien de l'Altaï*, Leningrad, 1958.

Griaznov, M., *Southern Siberia*, New York, 1969.

Hamilton, R. W., "The Decorated Bronze Strip from Gushchi," *Anatolian Studies*, vol. XV, 1965, pp. 41–51.

Hančar, F., *Urgeschichte Kaukasiens*, Vienna, 1937.

Hansford, S. H., *The Seligman Collection of Oriental Art*, London, 1957.

Hôtel Drouot, *Bronzes antiques des steppes et de l'Iran: Collection D. David-Weill* (sales catalog, Paris, 1972).

Hulsewé, A. F. P., *China in Central Asia. An annotated translation of chapters 61 and 96 of the History of the Former Han Dynasty*, Leiden, 1979.

Janse, O., "Tubes et boutons cruciformes trouvés en Eurasie," Museum of Far Eastern Antiquities, Stockholm, *Bulletin* no. 4, 1932, pp. 187–220.

Jettmar, K., "The Altai before the Turks," Museum of Far Eastern Antiquities, Stockholm, *Bulletin* no. 23, 1951, pp. 135–223.

Jettmar, K., *Art of the Steppes*, New York, 1967.

Karlbeck, O., "Selected Objects from Ancient Shou-chou," Museum of Far Eastern Antiquities, Stockholm, *Bulletin* no. 27, 1955, pp. 41–130.

Karlgren, B., "Chinese Agraffes in Two Swedish Collections," Museum of Far Eastern Antiquities, Stockholm, *Bulletin* no. 38, 1966, pp. 83–192.

Kerr, R., "The Tiger Motif: Cultural Transference in the Steppes," *Arts of the Eurasian Steppelands*, London, 1978, pp. 74–87.

Kiselev, S. V., *Drevniaia istoriia iuzhnoi Sibiri*, Moscow, 1951.

Kyzlasov, L. R., *Tashtykskaia epokha v istorii khakasskominusinskoi kotloviny*, Moscow, 1960.

Li, I-yu, *Nei Menggu chutu wenwu xuan ji*, Peking, 1963.

Littauer, M. A. and J. H. Crouwel, *Wheeled Vehicles and Ridden Animals in the Ancient Near East*, Leiden, 1979.

Loehr, M., "Ordos Daggers and Knives. First Part: Daggers," *Artibus Asiae*, vol. XII, no. 1/1, 1949, pp. 23–83.

Loehr, M., "Ordos Daggers and Knives. Second Part: Knives," *Artibus Asiae*, vol. XIV, no. 1/2, 1951, pp. 77–162.

Loehr, M., "Ordos," *Enciclopedia universale dell'art*, vol. 10, Venice, 1967.

Maenchen-Helfen, O., *The World of the Huns*, Berkeley, Los Angeles, and London, 1973.

Martin, T. R., *L'Age du Bronze au Musée de Minoussinsk*, Stockholm, 1893.

Martynov, A. I., *Lesostepnaia tagarskaia kultura*, Novosibirsk, 1979.

McGovern, W., *The Early Empires of Central Asia*, Chapel Hill, North Carolina, 1939.

Merhart, G. von, *Bronzezeit am Jenissei*, Vienna, 1926.

Metropolitan Museum of Art, *From the Lands of the Scythians*, exh. cat., New York, 1975.

Minns, E. H., "The Art of the Northern Nomads," *Proceedings of the British Academy*, vol. 28, 1942, pp. 47–99.

Mueller, H., *The Sunglin Collection of Chinese Art and Archaeology, Peking*, New York, 1930.

New York, *Guide to the Exhibition of Persian Art*, exh. cat., Iranian Institute, 1940.

Palmgren, N., *Selected Chinese Antiquities from the Collection of Gustaf Adolf*, Stockholm, 1948.

Parlasca, K., "Ein hellenistisches Achat-Rhyton in China," *Artibus Asiae*, vol. XXXVII, no. 4, 1975, pp. 280–90.

Piggott, S., *Prehistoric India*, London, 1950.

Prusek, J., *Chinese Statelets and the Northern Barbarians in the Period 1400–300 B.C.*, Dordrecht, the Netherlands, 1971.

Pulleyblank, E. G., "Chinese and Indo-Europeans," *Journal of the Royal Asiatic Society*, April 1966, pp. 9–39.

Rawson, J., "The Transformation and Abstraction of Animal Motifs on Bronzes from Inner Mongolia and North China," *Arts of the Eurasian Steppelands*, London, 1978, pp. 52–73.

Rolle, R., *Die Welt der Skythen*, Lucerne and Frankfort, 1979–80.

Rostovtzeff, M., *The Animal Style in South Russia and China*, Princeton, 1929.

Rudenko, S. I., *Kultura khunnov: Noinulinski kurgany*, Moscow and Leningrad, 1962.

Rudenko, S. I., *Sibirskaia kolleksiia Petra I*, Moscow and Leningrad, 1962 (1).

Rudenko, S. I., *The Frozen Tombs of Siberia*, London, 1970.

Salmony, A., *Sino-Siberian Art in the Collection of C. T. Loo*, Paris, 1933.

Schaeffer, C., *Stratigraphie comparée et chronologie de l'Asie occidentale, III*e *et II*e *millénaires*, London, 1948.

Sickman, L. and A. Soper, *The Art and Architecture of China*, Baltimore, 1956.

Smirnov, K. F. and V. G. Petrenko, *Sauromaty Povolzhia i iuzhnogo Priurala*, Moscow, 1963.

Tallgren, A. M., "Permian Studies," *Eurasia Septentrionalis Antiqua*, vol. III, 1928, pp. 63–92.

Trippett, F., *The First Horsemen*, New York, 1974.

UNESCO Courier, "The Scythians," December 1976.

Venice, *Mostra d'arte cinese*, exh. cat., 1954.

Watson, B., *Records of the Grand Historian of China*. Translated from the Shih Chi of Ssu-ma Ch'ien, New York and London, 1961.

Watson, W., *Cultural Frontiers in Ancient East Asia*, Edinburgh, 1971.

Watson, W., "The Chinese Contribution of Eastern Nomad Culture in the Pre-Han and Early Han Periods," *World Archaeology*, vol. 4, no. 2, October 1972, pp. 139–49.

Weber, C. D., "Chinese Pictorial Bronze Vessels of the Late Chou Period," *Artibus Asiae*, vols. XXVIII, nos. 2/3, 1966, pp. 107–40; XXVIII, no. 4, 1966, pp. 271–302; XXIX, nos. 2/3, 1967, pp. 115–74; XXX, nos. 2/3, 1968, pp. 145–213.

Weber, G., *The Ornaments of Late Chou Bronzes*, New Brunswick, New Jersey, 1973.

Werner, J., "Zur Stellung der Ordosbronzen," *Eurasia Septentrionalis Antiqua*, vol. IX, 1934, pp. 260–64.

Yamanaka and Company, *Collection of Chinese and Other Far Eastern Art Assembled by Yamanaka and Company*, New York, 1943.

Zhongguo kexueyuan kaogu yanjiusuo, *Hui xian fajue baogao*, Peking, 1956.

Zhongguo kexueyuan kaogu yanjiusuo, *Luoyang Shaogou Han mu*, Peking, 1959.

Zhongguo kexueyuan kaogu yanjiusuo, *Fengxi fajue baogao*, Peking, 1962.

Bibliography

Stamp and Cylinder Seals of the Ancient Near East

Amiet, P., *Glyptique susienne des origines à l'époque des Perses achéménides: cachets, sceaux-cylindres et empreintes antiques découverts à Suse de 1913 à 1967*, Mémories de la délégation archéologique en Iran, vol. XLIII, Paris, 1972.

Amiet, P., "Quelques aspects peu connus de l'art iranien à propos des dons de M. Mohsène Foroughi," *La Revue du Louvre*, vol. XXIII, nos. 4–5, 1973, pp. 215–24.

Amiet, P., "La glyptique de la fin de l'Elam," *Arts Asiatiques*, vol. XXVIII, 1973, pp. 3–32.

Amiet, P., "Antiquités de Bactriane," *La Revue du Louvre*, vol. XXVIII, 1978, pp. 154–64.

Amiet, P., "L'iconographie archaïque de l'Iran. Quelques documents nouveaux," *Syria*, vol. LVI, 1979, pp. 333–52.

Amiet, P., *La glyptique mésopotamienne archaïque*, 2nd ed., Paris, 1980.

Balkan, K., "Observations on the Chronological Problems of the Karum Kaniş," *Türk Tarih Kurumu Yayinlar*, series VII, no. 28, 1955.

Barnett, R. D., "Homme masqué ou dieux-ibex?" *Syria*, vol. XLIII, 1966, pp. 259–76.

Barnett, R. D., *Sculptures of the North Palace of Ashurbanipal at Nineveh (668–627)*, London, 1976.

Ben-Tor, A., *Cylinder Seals of Third Millennium Palestine*, Cambridge, Massachusetts, 1978.

Beran, T., "Die Babylonische Glyptik der Kassitenzeit," *Archiv für Orientforschung*, vol. XVIII, part 2, 1958, pp. 255–78.

Bivar, A. D. H., *Catalogue of the Western Asiatic Seals in the British Museum. Stamp Seals II: The Sasanian Dynasty*, London, 1969.

Boardman, J., *Greek Gems and Finger Rings: Early Bronze Age to Late Classical*, New York, 1970.

Boehmer, R. M., *Die Entwicklung der Glyptik während der Akkad-Zeit*, Untersuchungen zur Assyriologie und vorderasiatischen Archäologie, vol. 4, Berlin, 1965.

Bonner, C., *Studies in Magical Amulets, Chiefly Greco-Egyptian*, Ann Arbor, Michigan, 1950.

Braidwood, R., *Excavations in the Plain of Antioch*, vol. I, The University of Chicago Oriental Institute Publications, vol. LXI, 1960.

Buchanan, B., *Catalogue of Ancient Near Eastern Seals in the Ashmolean Collection*, vol. I, Oxford, 1966.

Buchanan, B., "Cylinder Seal Impressions in the Yale Babylonian Collection Illustrating a Revolution in Art Circa 1700 B.C.," *Yale Library Gazette*, vol. 45, 1970, pp. 53–65.

Collon, D., "The Smiting God: a Study of a Bronze in the Pomerance Collection in New York," *Levant* 4, 1972, pp. 111–34.

Dalley, S., Walker, C. B. F., and J. D. Hawkins, *The Old Babylonian Tablets from Tell al Rimah*, British School of Archaeology in Iraq, 1976.

Delaporte, L. J., *Catalogue de cylinders orientaux et des cachets assyrobabyloniens, perses et syro-cappadociens de la Bibliothèque Nationale*, Paris, 1910.

Delaporte, L. J., *Catalogue des cylindres, cachets et pierres gravées de style oriental*, Musée du Louvre, 2 vols., Paris, 1920–23.

Dunand, M., *Byblia grammata: documents et recherches sur le développement de l'écriture en Phénicie*, Beirut, 1945.

Ettinghausen, R., and E. Yarshater, eds., *Highlights of Persian Art*, Boulder, Colorado, 1979.

Frankfort, H., "Oriental Institute Discoveries in Iraq, 1933/34," *Oriental Institute Communications*, vol. 19, 1935, pp. 1–103.

Frankfort, H., *Cylinder Seals*, London, 1939.

Frankfort, H., *Stratified Cylinder Seals from the Diyala Region*, The University of Chicago Oriental Institute Publications, vol. LXXII, Chicago, 1955.

Genouillac, H. de, *Inventaire des tablettes de Tello conservées au Musée imperial ottoman II: Textes de l'époque d'Agadé et de l'époque d'Ur*, Paris, 1910–11.

Godard, A., *Les Bronzes du Luristan*, Paris, 1931.

Goldman, H., ed., *Excavations at Gözlü Kule, Tarsus*, 3 vols., Princeton, 1950–63.

Hogarth, D., *Hittite Seals*, Oxford, 1920.

Keiser, E., *Selected Temple Documents of the Ur Dynasty*, New Haven, London, and Oxford, 1919.

Kleiss, E., ed., *Bastam I*, Berlin, 1979.

Lacheman, E. R., *Miscellaneous Texts from Nuzi*, Harvard Semitic Series, vol. XIV, Cambridge, 1950.

Legrain, L., *The Culture of the Babylonians from Their Seals in the Collections of the Museum*, Pennsylvania University, Philadelphia, 1925.

Legrain, L., *Archaic Seal-Impressions . . .*, Ur Excavations, vol. III, Oxford, 1936.

Legrain, L., *Seal Cylinders*, Ur Excavations, vol. X, Oxford, 1951.

Levine, L. D. and T. Cuyler Young, eds., *Biblioteca Mesopotamica: Mountains and Lowlands; Essays in the Archaeology of Greater Mesopotamia*, Malibu, 1977.

Littauer, M. and J. H. Crouwel, "Wheeled Vehicles and Ridden Animals in the Ancient Near East," *Handbuch der Orientalistik*, series VII, no. 1, Leiden, 1979.

Mackay, E. J. H., *A Sumerian Palace and the "A" Cemetery at Kish, Mesopotamia*, Chicago, 1929.

Mallowan, M. E. L., "Excavations at Brak and Chagar Bazar," *Iraq*, vol. IX, 1947, pp. 1–259.

Mellink, M. J., ed., *Dark Ages and Nomads c. 1000 B.C.*, Istanbul, 1964.

Menant, M. J. and M. de Clercq, *Catalogue: Collection de Clercq*, 2 vols., Paris, 1888.

Moorey, P. R. S., "Unpublished Early Dynastic Sealings from Ur in the British Museum," *Iraq*, vol. XLI, part 2, 1979, pp. 105–40.

Moortgat, A., *Vorderasiatische Rollsiegel: ein Beitrag zur Geschichte der Steinscheidekunst*, Berlin, 1940.

Moortgat, A., "Assyrische Glyptik der 12 Jahrhunderts," *Zeitschrift für Assyriologie und Vorderasiatische Archäologie*, vol. 48, 1944, pp. 23–44.

Nagel, W., "Glyptische Probleme der Larsa-Zeit," *Archiv für Orientforschung,* vol. XVIII, 1958, pp. 319–27.

Negahban, E. O., "The Seals of Marlik Tepe," *Journal of Near Eastern Studies,* vol. 36, no. 2, 1977, pp. 81–102.

Nougayrol, J., "Notes épigraphiques," *Syria,* vol. XXXIX, 1962, pp. 188ff.

Opitz, D., "Die Siegel Ninurta-tukul-Aššurs und seiner Frau Rîmeni," *Archiv für Orientforschung,* vol. X, 1935/36, pp. 48–52.

Orthmann, W., *Der alte Orient,* Propyläen Kunstgeschichte, vol. 14, Berlin, 1975.

Özgüç, T. and N., "Ausgrabungen in Kültepe," *Türk Tarih Kurumu Yayinlar,* series V, no. 12, 1953.

Özgüç, T., "Seals and Seal Impressions of Level Ib from Karum Kaniş," *Türk Tarih Kurumu Yayinlar,* series V, no. 22, 1968.

Parker, B., "Excavations at Nimrud, 1949–53; Seals and Seal Impressions," *Iraq,* vol. XVII, part 2, 1955, pp. 93–125.

Parker, B., "Seals and Seal Impressions from the Nimrud Excavations, 1955–1958," *Iraq,* vol. XXIV, parts 1–2, 1962, pp. 26–40.

Parker, B., "Cylinder Seals from Tell al Rimah," *Iraq,* vol. XXXVII, part 1, 1975, pp. 21–38.

Parrot, A., *Glyptique Mésopotamienne,* Paris, 1954.

Porada, E., *Seal Impressions of Nuzi,* Annual, American Schools of Oriental Research, vol. 24, New Haven, 1947.

Porada, E., and B. Buchanan, *The Collection of the Pierpont Morgan Library,* Corpus of Ancient Near Eastern Seals in North American Collections, 2 vols., Washington, D.C., 1948.

Porada, E., *The Art of Ancient Iran; Pre-Islamic Cultures,* New York, 1965.

Porada, E., and D. Hansen, *Chronologies in Old World Archaeology,* Chicago, 1965.

Porada, E., *Tchoga Zanbil IV, la glyptique,* Mémoires de la délégation archéologique en Iran, vol. XLII, 1970.

Porada, E., "Achaemenid Art, Monumental and Minute," *Highlights of Persian Art,* ed. R. Ettinghausen, E. Yarshater, Boulder, Colorado, 1979.

Porada, E., *Reallexicon der Assyriologie und vorderasiatischen Archäologie* V: 5–6, 1980.

Riis, P. J., *Les cimetières à crémation [de la ville pré-hellénistique de Hamath],* Copenhagen, 1948.

Safadi, H. B., *Die Enstehung der syrischen Glyptik...,* Dissertation, Berlin, 1968.

Sarianidi, V. I., *Drevnie zemledeltsy Afganistana,* Moscow, 1977.

Schaeffer, C. F.-A., *Ugaritica III, Mission de Ras Shamra,* vol. XIII, Paris, 1956.

Schmidt, E. F., *Persepolis. II. Contents of the Treasury and Other Discoveries,* The University of Chicago Oriental Institute Publications, vol. LXIX, Chicago, 1957.

Seidl, U., "Die Siegelbilder," *Bastam I,* ed. W. Kleiss, Berlin, 1979, pp. 137–49.

Solecki, R., "Predatory Bird Rituals at Zawi Chemi Shanidar," *Sumer,* vol. XXXIII, no. 1, 1977, pp. 42–47.

Speiser, E., *Excavations at Tepe Gawra,* vol. I, Philadelphia, 1935.

Starr, R. F. S., *Nuzi,* 2 vols., Cambridge, Massachusetts, 1937–39.

Strommenger, E., *5000 Years of the Art of Mesopotamia,* New York, 1964.

Sürenhangen, D. and E. Töpperwein, "Kleinfunde," *Mitteilungen der deutschen Orientgesellschaft,* no. 105, 1973.

Tobler, A. J., *Excavations at Tepe Gawra,* vol. II, Philadelphia, 1950.

Van Buren, E. D., "The Drill-Worked Jamdat Nasr Seals," *Orientalia,* vol. 26, 1957, pp. 289–305.

Vanden Berghe, L., "La nécropole de Hakalan," *Archeologia* no. 57, April 1973, pp. 48–58.

Walker, C. B. F. and H. Hunger, "Zwölfmaldrei," *Mitteilungen der deutschen Orientgesellschaft,* no. 109, 1977, pp. 27–34.

Wiseman, D. J., *Cylinder Seals of Western Asia,* London, 1959.

Wiseman, D. J., *Catalogue of the Western Asiatic Seals in the British Museum,* London, 1962.

Woolley, C. L., *The Royal Cemetery; A Report on the Predynastic and Sargonid Graves Excavated between 1926 and 1931,* Ur Excavations, vol. II, London, 1934.

Young, R. S., "The Gordion Campaign of 1959: Preliminary Report," *American Journal of Archaeology,* vol. 64, 1960, pp. 227–43.

Bibliography

Ancient Art of Europe and the Eastern Mediterranean

Artamonov, M., ed., *The Dawn of Art*, Leningrad, 1974.

Avi-Yonah, M., "Une école de mosaïque à Gaza au sixième siècle," *La Mosaïque gréco-romaine*, vol. II, ed. H. Stern and M. Le Glay, Paris, 1975.

Babelon, E. and J. A. Blanchet, *Catalogue des bronzes antiques de la Bibliothèque Nationale*, Paris, 1895.

Boucher, S., *Vienne: Bronzes antiques*, Inventaire des Collections Publiques Francaises, no. 17, Paris, 1971.

Bowie, T., ed., *East-West in Art*, Bloomington, Indiana, 1966.

Bretz-Mahler, D., *La Civilisation de la Tène I en Champagne*, Paris, 1971.

Callander, J. G., "Fourteenth-Century Brooches and Other Ornaments in the National Museum of Antiquities of Scotland," *Proceedings of the Society of Antiquaries of Scotland*, vol. 58, 1924, pp. 160–84.

Colledge, M., *The Art of Palmyra*, Boulder, Colorado, 1976.

Colonna, G., *Bronzi votivi umbro-sabellici a figura umana*, Florence, 1970.

Del Chiaro, M. A., *Re-Exhumed Etruscan Bronzes*, exh. cat., University Art Museum, Santa Barbara, California, 1981.

di Stefano, C. A., *Bronzetti figurati del Museo Nazionale di Palermo*, Rome, 1975.

Eggers, H., et al., *Les Celtes et les Germains à l'époque paienne*, Paris, 1965.

Erdmann, K., *Die Kunst Irans zur Zeit der Sasaniden*, Mainz, 1969.

Fehervari, G., *Islamic Metalwork*, London, 1976.

Fleischer, R., *Die römischen Bronzen aus Österreich*, Mainz, 1967.

Geneva, Musée Rath, *Trésors de l'ancien Iran*, 1966.

Ghirshman, R., *Persian Art: The Parthian and Sasanian Dynasties*, New York, 1962.

Ghirshman, R., "Fibule en Iran," *Iranica Antiqua*, vol. 4, 1964, pp. 90ff.

Ghirshman, R., "Fibule en Iran, II," *Iranica Antiqua*, vol. 12, 1977, pp. 21ff.

Gimbutas, M., *Bronze Age Cultures in Central and Eastern Europe*, The Hague, 1965.

Godard, A., *The Art of Iran*, New York, 1965.

Hampel, J., *Alterthümer des frühen Mittelalters in Ungärn*, 3 vols., Braunschweig, 1905.

Jacobsthal, P., *Early Celtic Art*, Oxford, 1944.

Jacobsthal, P., *Greek Pins and Their Connexions with Europe and Asia*, Oxford, 1956.

Kaufmann-Heinimann, A., *Die römischen Bronzen der Schweiz*, vol. I, Mainz, 1977.

Kivikoski, E., *Die Eisenzeit Finnlands*, 2 vols., Porvoo, Finland, 1951.

Kühn, H., "Mitteilungen," *IPEK*, vols. 15–16, 1941/42, pp. 261ff.

La Baume, P., *Römisches Kunstgewerbe*, Braunschwieg, 1964.

Layard, A. H., *The Monuments of Nineveh*, 2 vols., London, 1849–1853.

Lebel, P., *Catalogue des collections archéologiques de Besançon*, vol. 5, Paris, 1959.

Lebel, P., and S. Boucher, *Bronzes figurés antiques: grecs, étrusques et romains*, Musée Rolin, Paris, 1975.

Mano-Zisi, D., *The Antique in the National Museum in Belgrade*, Belgrade, 1954.

Megaw, J. V. S., *Art of the European Iron Age*, New York, 1970.

Mitten, D. G. and S. F. Doeringer, *Master Bronzes from the Classical World*, Mainz, 1967.

Moorey, P. R. S. and H. W. Catling, *Antiquities from the Bomford Collection*, Ashmolean Museum, Oxford, 1966.

Muscarella, O. W., "The Third Lion Bowl from Hassanlu," Metropolitan Museum of Art *Bulletin* n.s., vol. 32, 1974, p. 250.

Neugebauer, K. A., *Die griechischen Bronzen der klassischen Zeit und des Hellenismus*, Katalog der statuarischen Bronzen im Antiquarium, vol. I, Berlin/Leipzig, 1951.

Nicolini, G., *Les bronzes figures des sanctuaires iberiques*, Paris, 1969.

Parrot, A., *The Arts of Assyria*, New York, 1961.

Popovič, L. V. et al., *Antička Bronze u Jugoslaviji*, Belgrade, 1969.

Randall-MacIver, D., *The Iron Age in Italy*, Oxford, 1927.

Reinach, S., *Répertoire de la statuaire grecque et romaine*, 4 vols., Paris, 1897–1913.

Renner, D., "Die Runden, durchgebrochenen Zierschieben der Merowingerzeit," *IPEK*, vol. 23, 1970/73, pp. 46ff.

Richter, G., *Greek, Etruscan, and Roman Bronzes*, New York, 1915.

Rolland, H. and E. Espérandieu, *Bronzes antiques de la Seine Maritime*, Paris, 1959.

Saldern, A. von, *Ancient Glass in the Museum of Fine Arts*, Boston, 1967.

Strong, D., *Greek and Roman Gold and Silver Plate*, Ithaca, New York, 1966.

Stuttgart, *Das Tier in der Kunst*, exh. cat., Museum für Länderund Volkerkunde, 1972.

Vermeule, C. and M. Comstock, *Greek, Etruscan, and Roman Bronzes in the Museum of Fine Arts, Boston*, Greenwich, Connecticut, 1971.

von Hase, F.-W., *Die Trensen der Früheisenzeit in Italien*, Munich, 1969.

von Hase, F.-W., "Gürtelschliessen des 7. und 6. Jahrhunderts v. Chr. in Mittelitalien," *JdI*, vol. 86, 1971, pp. 1ff.